ARTHUR DOVE

The American Art Journal/University of Delaware Press Books

Editorial Committee

THE INLANDER: *Life and Work of Charles Burchfield, 1893–1967*
 By John I. H. Baur

EDWARD HICKS: *His Peaceable Kingdoms and Other Paintings*
 By Eleanore Price Mather and Dorothy Canning Miller

ERASTUS D. PALMER
 By J. Carson Webster

J. ALDEN WEIR: *An American Impressionist*
 By Doreen Burke

SCULPTURE IN AMERICA
 By Wayne Craven

ARTHUR FITZWILLIAM TAIT: *Artist in the Adirondacks*
 By Warder Cadbury

JOHN QUINCY ADAMS WARD: *Dean of American Sculpture*
 By Lewis I. Sharp

ARTHUR DOVE: *Life and Work*
 By Ann Lee Morgan

ARTHUR DOVE

Life and Work,
With a Catalogue Raisonné

ANN LEE MORGAN

AN AMERICAN ART JOURNAL/KENNEDY GALLERIES BOOK

Newark: University of Delaware Press
London and Toronto: Associated University Presses

Associated University Presses
440 Forsgate Drive
Cranbury, NJ 08512

Associated University Presses
25 Sicilian Avenue
London WC1A 2QH, England

Associated University Presses
2133 Royal Windsor Drive
Unit 1
Mississauga, Ontario, Canada

Library of Congress Cataloging in Publication Data

Morgan, Ann Lee.
 Arther Dove: life and work, with a catalogue
raisonné.

 (An American art journal/Kennedy Galleries book)
 Bibliography: p.
 Includes index.
 1. Dove, Arthur Garfield, 1880–1946. 2. Artists—
United States—Biography. 3. Dove, Arthur Garfield,
1880–1946—Catalogs. I. Title. II. Series.
N6537.D63M67 1984 759.13 84-40062
ISBN 0-87413-222-3

Printed in the United States of America

Contents

Acknowledgments 7

The Life of Arthur Dove 11
The Art of Arthur Dove 38
Context and Theory 73

Catalogue of Works 83

Appendixes
 Exhibitions 319
 Bibliography 360

Photo Credits 372

Subject Index 373

Index to Titles of Works by Arthur Dove 376

Acknowledgments

This book could not have been compiled without the generosity of many individuals whose lives have been linked to Arthur Dove's, either personally or through his work. Virtually everyone I located who had known Dove was willing—indeed, often eager—to share memories and, when such material existed, to grant access to letters, other papers, and photographs. Collectors of Dove paintings could hardly have been more helpful in providing information about their paintings and photographs of them.

Interviewing was a special pleasure because of the kindness of those who had known the artist. Foremost among them is the artist's son, Bill Dove, who patiently answered questions, provided documents, supplied insights, and in the process became a valued friend. He and his wife Aline repeatedly extended a hospitality that I shall always cherish for its gracious conviviality. Before his death, Dove's brother Paul made every effort to be helpful on my visits to the artist's hometown of Geneva, New York. Among the artists of the Stieglitz circle, the only one still alive when I started my research is Georgia O'Keeffe; she generously shared several hours and supper at her Abiquiu, New Mexico home.

Among others who knew Dove personally, Sue Davidson Lowe, Stieglitz's grand-niece and biographer, has my warmest gratitude; in many long discussions, often in her home, she not only shared her reminiscences of the artist and other personalities in the Stieglitz group, but immeasurably enlarged my understanding of Dove's era. Among others who have my gratitude for their personal time and, in many cases, for their hospitality, are Dr. J. Clarence Bernstein, Dove's physician in his later years, and his wife Julia; Dr. Mary Holt, a psychiatrist who was a personal friend of Dove's for many years; Lila Howard, an artist who knew Dove in Westport; John Marin, Jr., son of the painter; Dorothy Norman, photographer and Stieglitz's associate at An American Place; Mary Rehm, the sister of Dove's wife Reds; and Herbert Seligmann, a writer close to Stieglitz in the 1920s. Although we never met, I had a useful correspondence with Charles Brooks, son of the writer Van Wyck Brooks and in his youth a friend of Dove's through the artist's son Bill; he also kindly provided copies of many letters to and from Dove.

Besides the numerous private collectors and public institutions that provided material on their Dove paintings, several galleries also were particularly generous. The gallery that represents the Dove estate was endlessly helpful; special thanks go to Terry Dintenfass and her assistant Brent Wiggans. Ellery Kurtz at the Andrew Crispo Gallery gave encouragement as well as time and provided many photographs. Other

7

galleries that were particularly helpful included Hirschl and Adler, John Berggruen, and Asher/Faure. Sotheby Parke Bernet also aided my efforts.

To the staff of the Beinecke Library at Yale University and to Donald Gallup, who supervised the Stieglitz Archive when I was doing most of my work there, go my thanks for their solicitous attention to my endeavors. I am also grateful to the staff of the Archives of American Art, several of whom were not only helpful on many occasions but in some instances went out of their way to aid my research.

I am also grateful to the Yale University Library and to the Research Board of the University of Illinois at Urbana-Champaign for financial support. Because the origins of the present work go back to the Ph.D. dissertation I completed at the University of Iowa, obviously I owe much to the faculty there for their assistance then; but perhaps even more important to me later as I went on with my research was their continued interest. To all of them, but especially Frank Seiberling and Wallace J. Tomasini, my thanks. Also, to my colleagues Howard Risatti and Dee Kilgo, I am grateful for their time to read and comment on early drafts of the text.

Finally, there is really no way to thank the caring friends and family, especially my husband, who encouraged, sustained, nourished, and cheered as needed over the years in which my research and writing proceeded. I hope they will take some pride in this volume.

ARTHUR DOVE

The Life of Arthur Dove

LIKE MOST ARTISTS, ARTHUR DOVE LIVED SIMPLY. YET WHAT HE DID AND HOW HE LIVED ARE of interest, for this life produced one of the most significant American contributions to art of the twentieth century. Furthermore, the style of his existence says much about the values by which he lived, and these values also find expression in his art.

Dove's life spanned sixty-six years, from 1880 to 1946. When he was born in upstate New York, the United States was still largely rural and provincial; outside the largest cities, nineteenth-century culture was not yet threatened. By the time Dove died on Long Island, not far from New York City, American civilization had evolved into something no less distinctive but thoroughly modernized and internationalized.

As the artist himself in a literal sense journeyed from hinterlands to cosmopolitan center, so his life—and art—recapitulated the national evolution of the time in which he lived. When he was a child, Dove belonged to middle-class, small-town, Victorian America. Later, he sought out advanced international ideas. By amalgamating what was vital in these disparate sources, Dove synthesized a distinctive modernism that expressed an American spirit as well as internationally significant contemporary ideas.

The eldest child of William George and Anna Elizabeth Chipps Dove, both of whom were of English ancestry, Arthur Garfield Dove was born in Canandaigua, New York, on 2 August 1880. He was named for the soon-to-be-elected Republican vice-presidential and presidential candidates of that year. The father must have been particularly interested in politics at this time, for he was serving an elected, two-year term as county clerk. For this reason, the Doves resided in Canandaigua, seat of Ontario County, but in 1882, when William Dove's term was finished, they moved back to Geneva, from which they had come.

In this small city at the head of Seneca Lake, one of the Finger Lakes in central New York State, William Dove prospered as a brick-maker and building contractor. Active in civic affairs, over the years he acquired considerable commercial property and farm land. A second child born to the Doves died in infancy, and the third, a son whom they named Paul, was not born until Arthur was twelve and already possessed of a strong-minded liberalism. At this age, as he later told the story, he "resigned from the church owing to a difficulty over Robert Ingersoll [an atheist] having the right to his opinions whether we agree with them or not."[1]

Otherwise, as Dove was growing up on tree-shaded North Main Street in a comfortable house with a large front porch, his life was apparently typical of an upper-middle-

class child in late-nineteenth-century America. He had the usual material advantages of such a family, as well as some painting lessons from a female schoolteacher, and he learned to play the piano. It seems almost a sign of excessive normality that Dove was pitcher for his high school baseball team. In his later recollection, however, the single most important influence on his early years was a middle-aged neighbor, Newton Weatherly, who was a truck farmer by trade but a naturalist and painter by avocation. He passed on both these loves to his young friend as he took Dove fishing and hunting and gave him bits of canvas to paint. Until his death in 1935, Weatherly remained a respected friend whom Dove once included in his personal list of four great men, along with Jesus Christ, Alfred Einstein, and Alfred Stieglitz.[2] "He was like cloth and vegetables and leaves in the woods,"[3] Dove wrote shortly after he had completed *Holbrook's Bridge to Northwest* (38.10)[4] as a memorial to Weatherly.

When Dove was a teenager, the family moved to an ornate mansion on the stretch of South Main Street that was the most fashionable address in town. After Geneva High School, from which he graduated in 1899, Dove went on to Hobart College in Geneva, then transferred to Cornell University in Ithaca to study law. In his first year there he took law courses, along with courses in economics and politics and one course in Spanish, but he also enrolled in two art courses: industrial art and clay modeling. In his senior year he took fewer law courses, along with courses in German, physics, history of art, drawing, modeling, life drawing, and drawing from the antique, while he also did illustrations for *The Cornellian* yearbook. By the time he received his A.B. degree in 1903, he was ready to strike out for New York City to become an artist. His decision to support himself by illustrating probably was indebted to the example of Charles Wellington Furlong, a Cornell instructor, who was a widely published writer-illustrator of travel and adventure stories.

Within a few years Dove was saving money as well as making a living from his quick, sure drawings for such high-quality, mass-circulation magazines as *McClure's*, *Century*, *Collier's*, *St. Nicholas*, and *The Illustrated Sporting News*. These popular illustrations brought to life the characters they depicted and lucidly visualized situations described in the stories they accompanied. Dove's sense of humor enabled him to veer, when he wished, with a winning charm toward caricature or cartooning.

On 21 July 1904 in New York City, Dove married a Geneva woman, Florence Dorsey. They lived in an apartment on Livingston Place, overlooking Stuyvesant Square. By this time, Dove was making the acquaintance of the large community of magazine and newspaper illustrators who worked in New York in the first decade of this century. At that time the distinction between fine artists and commercial artists was less severe than it is now. Many illustrators were also artists, and the two professions often fraternized. Being a sociable fellow, Dove frequented Mouquin's restaurant and other artist hangouts during these years in New York.[5] He knew John Sloan through such social occasions, was a friend of Ernest Lawson, and had at least a passing acquaintance with other artist-illustrator members of the rebellious, realist group that exhibited together as The Eight in 1908.

If relatively little is known of the outward circumstances of Dove's life during the early years of his maturity, when he was in college and establishing himself professionally, virtually nothing is known about his thoughts and feelings. Surely these New York years were important to the well-educated young man who left the relatively sheltered small-town existence of his first twenty-three years to seek a living in the largest, most heterogeneous and sophisticated city in the country. What were his goals as an artist? What sort of art did he see? And where did he see it—in friends' studios, in museums, in the city's few art galleries? What ideas engaged his attention? What did he read? All that can be readily inferred is that Dove, in the midst of the general ferment, became acquainted with that early-modernist complex of interrelated ideas

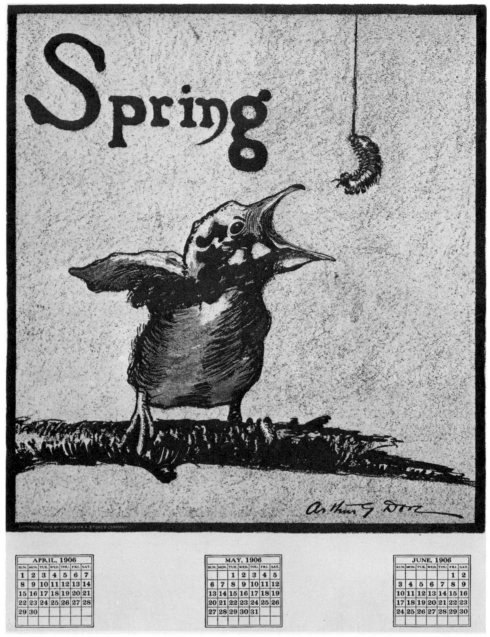

"Spring" from Calendar of Birds and Beasts. 1905. Commercial lithograph. Corcoran Gallery of Art, Washington, D.C. (Mary E. Maxwell Fund purchase).

opposing tradition, championing liberation of the individual, and welcoming science's objective investigation of every aspect of life, while at the same time insisting upon the unassailable sanctity and autonomy of art. But apart from absorbing ideas, how much attention did he give to his own development as a serious artist? Perhaps he painted very little, for from this period we can today identify only one oil, a subdued Impressionist view from his apartment window (07.1).

At any rate, by the time he had been in New York for almost five years, Dove was ready to forsake illustration and go to Europe. He and his wife departed in the late spring of 1908, probably at the end of May or early in June.[6] It must have been almost as a matter of course that Dove chose to go to Paris, for the City of Lights was then the unchallenged capital of art, the place where the most vital new developments had taken place for more than a generation. Furthermore, there was a large community of

"Old Miss Moray Looks Around Astonished," illustration for Century *(April 1907). Ink drawing. Free Library of Philadelphia.*

American artists there. In his New York years, Dove must have heard about them and perhaps met some returning veterans of the experience there.

Dove painted industriously during his year abroad. Many canvases can be documented from the time, but again, there are no letters or other written materials to tell us what Dove saw or thought, whom he met, or exactly where he traveled. Personally,

Dove's most important new acquaintance was Alfred Maurer, who remained a close friend until his suicide in 1932. Maurer had been in Paris for a decade[7] and was widely acquainted. He was, for instance, an "old habitué"[8] of Gertrude Stein's home, where the makers and tastemakers of the new art gathered amidst modern paintings on the walls of an otherwise stuffy-looking interior. Dove probably never went there, but he did enjoy café life with the American community,[9] which included such acquaintances as Jo Davidson and Arthur Carles.

Maurer was important to Dove's artistic education in Paris. Dove had very likely not experienced at first hand in New York anything that could be considered distinctly modern. The most advanced art to be seen through the spring of 1908 were Rodin drawings and Matisse lithographs, watercolors, and drawings at Alfred Stieglitz's "291." Dove probably had not seen these intimations of the new movement, since all the evidence suggests that Dove's acquaintance with "291" postdated his European trip. Aside from what Maurer may have escorted him around to see privately or in informal artist-supply shops cum galleries, perhaps the most important demonstration of new tendencies that Dove was able to view was the "Salon d'automne" of 1908, in which he himself exhibited a painting.[10] This progressive salon drew an international group of independently minded exhibitors. Whatever he saw, Dove's palette quickly brightened in France, and much of the work he did during the year consists of freely brushed Impressionist landscapes that demonstrate Dove's awareness of the late work of Monet and Renoir. Before his sojourn ended, however, the fauve approach with which "Alfy" Maurer was experimenting had become the predominant inspiration.

Dove's predilection for rural life affected his travel while he was in Europe. Apparently he spent much of his time outside of Paris. Sometimes he stayed at a pension in Moret, on the outskirts of Paris, and perhaps here, as well as elsewhere, he went sketching with Maurer.[11] Dove also traveled south during the winter of 1908–9. He apparently dipped briefly into Spain and Italy, but spent most of his time, perhaps as much as several months, in the hilltop town of Cagnes, near Nice on the Mediterranean coast. Perhaps he was attracted to that particular location by the fact that Renoir lived on an estate just outside the city.[12]

When Dove sailed back to New York in July 1909, leaving behind a painting to be shown in the autumn salon, he took with him a clearer sense of himself as an artist. The European experience had been decisive; he had proved to himself that he could be a productive painter who would be taken seriously by his fellow artists. Yet he does not seem to have known precisely how to act on his sharpened self-confidence. For a time he went home to Geneva, where he later recollected having camped out in the woods to reevaluate his situation. He also arranged his first one-person show, a three-day affair at Hobart College in October. There he showed twenty-seven paintings—French landscapes, a Spanish landscape, and an Italian portrait, along with two still lifes and three local landscapes.

Perhaps even before the Hobart College show, Dove returned to New York, where for a few weeks he was a newspaper illustrator—the only regular, fulltime job he ever held.[13] But at some point in this autumn, he decided that he did not wish to live in the city. Dissatisfied with the commercialism of illustration, he was beginning to formulate the idea that to make a living farming and fishing would conflict less with his career as a painter. By December he had bought a house in Westport, Connecticut.[14] This summer resort town on Long Island Sound, only a little more than an hour from New York, was then only just beginning to become the fashionable address for writers and artists (including well-known illustrators) that it was within a few years. Having purchased his new home, however, Dove may have stayed on in New York through the winter, for he and his wife were there the following Fourth of July, when their son, William C. Dove, was born. Apparently they went to Westport immediately afterward.

Meanwhile, sometime late in 1909 or early in 1910, Dove first met Alfred Stieglitz. This encounter was in many ways to shape the rest of his life. Initially the contact with Stieglitz must have reinforced his new-found sense of purpose as an artist. Rapidly, through his contact with Stieglitz and the circle of artists and intellectuals at "291," Dove formulated the principles upon which his career as a painter thenceforth depended and began to produce the body of extraordinary work that established his reputation then and sustains it today. In the long run, his ties to Stieglitz became those of close friends who sustained each other professionally and personally, while at the same time Dove's art was always presented to the public through Stieglitz (who directed three successive galleries over the years), and for better or worse, Stieglitz influenced the way his work was received.

Stieglitz the photographer had been among the first and toughest battlers on behalf of photography as a fine art, to which he had devoted most of his life after abandoning university studies abroad. He had grown up in the privileged environment of a well-to-do family in New York. When he was sixteen, his father had transported the entire family of six children to Germany to further their education. Alfred, the eldest, had studied sciences and engineering until he was overtaken by his passion for photography. With about fifteen years of prize-winning photographic experience behind him, in 1902 Stieglitz had founded both an organization he called the Photo-Secession and its sumptuous magazine, *Camera Work*. In 1905, with considerable initial input from the painter and photographer Edward Steichen, he opened the Little Galleries of the Photo-Secession, which soon came to be known by the number of its address on Fifth Avenue: "291." Exalting creative activity for its own sake, Stieglitz soon discarded distinctions of medium and began to show other arts besides photography. His first, tentative experiment in this direction was the presentation of Pamela Colman Smith's Symbolist watercolors early in 1907. The following year, Stieglitz began in earnest to educate the New York art public by showing increasingly advanced European work, none of which had been shown anywhere else in the United States, along with work by the rising generation of American modernists. Before Dove and Stieglitz met, Stieglitz had arranged one-person shows at "291" for Maurer, John Marin, and Marsden Hartley.

It was, in fact, almost certainly Maurer who brought the two men together. Maurer himself was still in Paris, but he had exhibited his work at "291" (in a joint show with Marin) while Dove had been in Europe, and he knew Steiglitz personally.[15] Surely, he directed Dove to Stieglitz and might have facilitated their meeting with a letter of introduction. When Dove first ascended to the attic sanctuary on Fifth Avenue, an enormous gulf separated his artistic achievements and life experiences from those of Stieglitz. The photographer, who turned forty-six on 1 January 1910, was a New York art-world celebrity, known internationally as one of the finest photographers in the world. Sixteen years younger, Dove had never shown a painting in New York and, in fact, had not yet done any truly notable work. Culturally, the unknown painter and the famous photographer represented opposite poles in American life. In contrast to Dove's Anglo-Saxon heritage and Protestant, small-town background, Stieglitz's experience had been urban, Jewish, intellectual, rooted in European culture. Having spent most of his adolescence on the Continent and sojourned there on several later occasions, he spoke German as easily as English, and he also knew French. The two men also had very different personalities. Gregarious, argumentative, shrewd, and autocratic, Stieglitz already had many "former friends," but he could also be warm and loving. Dove was gentle, contemplative, affectionate, and somewhat ingenuous by comparison to Stieglitz. So softly spoken that his friends in Westport would soon nickname him "the whispering kid,"[16] Dove was universally loved. "No one can help being attracted to him," a mutual friend, the writer Paul Rosenfeld, later observed to Stieglitz.[17]

Whatever their differences, however, Dove and Stieglitz were united by ideas. By this time, Dove must have developed in at least rudimentary form the basic motivations for both his art and life, since these ideas had widespread currency among the more forward-looking young artists. With them and with Stieglitz, Dove shared a critical attitude toward the materialism and narrowness of American life and a belief that the conventional art of their time was inadequate to the expression of contemporary values, which they defined in spiritual terms.

Dove and Stieglitz must have felt an intuitive bond right away. Within a few months of their initial meeting, Dove made his New York debut in a group show at "291." "Younger American Painters" of March 1910 was probably organized to challenge the

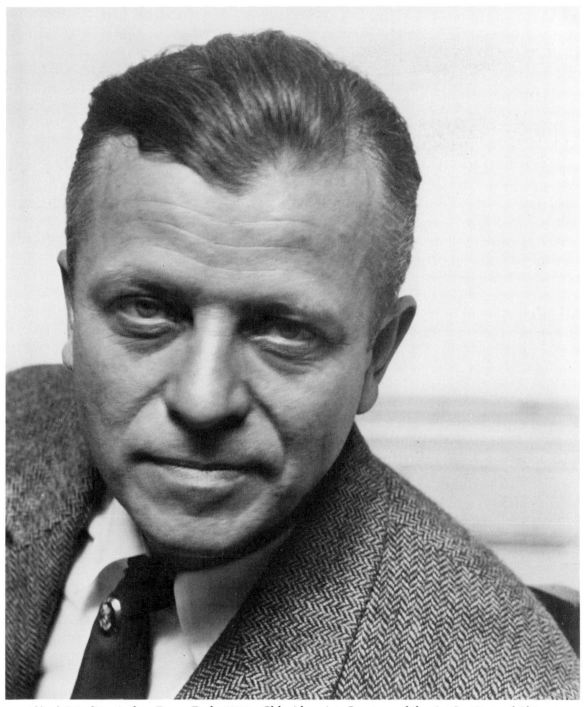

Alfred Stieglitz. Arthur Dove. Early 1920s. Chloride print. Courtesy of the Art Institute of Chicago.

view of contemporary American art about to be presented in a large independents' show controlled by the Ashcan realists, since that show did not include any of the Stieglitz group. The "291" show put Dove in the company of Maurer, Marin, Hartley, Steichen, Carles, Max Weber, and two painters who did not become well-known, G. Putnam Brinley and Lawrence Fellows. Dove showed only one painting, *The Lobster* (08.3),a large still life done in France.

So stimulating was Stieglitz's support for Dove that the painter apparently never did another representational work after meeting his mentor. Instead, he began, first in a set of six oil studies and then in a group of ten pastels, to derive a personal style of abstraction in which organic, or biomorphic, forms predominate. The six oil studies, which probably date to 1910/11, were never shown during Dove's lifetime. Today known as *Abstraction No. 1* through *No. 6* (10/11.1–10/11.6), these completely nonrepresentational little panels must have been sketches not intended for the public eye. However, the succeeding group of pastels[18] attracted much public attention when they appeared at "291" in Dove's only one-person show there, in February 1912. Not titled for the show, they came to be known as the "Ten Commandments," and together they constituted the first public display of nonillusionistic art by an American. The following month, Dove escorted his paintings to Chicago for a showing at the W. Scott Thurber Galleries, where they attracted even greater notoriety than they had in New York. Because of the abstract nature of these paintings, Dove was for the moment the paradigmatic American of the new and incomprehensible modern movement in art. His name meant lunatic, fanatic, freak, and pervert; his art was degrading, insulting, ugly, or hilarious. Even so, some critics noted that although this work was unlike anything seen before, there was in it the spirit of something new, a striving to develop the syntax of a new language of communication.

Within two years, through Stieglitz and the "291" ambience, Dove had transformed himself from a competent but derivative painter to a leader in international, avant-garde developments. Nevertheless, he was one of few forward-looking Americans to decline to participate in the epochal 1913 Armory Show, a huge exhibition of the roots and achievements of modernism in European and American art. Perhaps he held back because Stieglitz, although listed among the sponsors of the show, was not one of the main forces behind it. Perhaps he distrusted the magnitude and sensationalism of the show. Perhaps he was just too busy. However, even in his absence, his reputation as America's most radical modernist persisted from the previous year. A number of articles linked his name to Francis Picabia's when that French exhibitor in the Armory Show brought his very latest abstractions to "291" for a show that opened in March, immediately following the display at the 69th Infantry Regiment Armory. The *New York Sun* critic remembered Dove's 1912 pastels as comparable to Picabia's work, and he reported that as Dove and Picabia confronted each others' work in the gallery, "recognition followed as quickly as though two persons born with strawberry marks upon their arms had suddenly discovered the fact."[19] In a long, philosophical piece for *Camera Work*, Dove was the only American that chemist and poet Maurice Aisen named as working along the same lines of intention as Picabia, Picasso, and Duchamp toward the painting of the *pensée pure*.[20]

Despite the breakthrough pastels of 1912 and the widespread recognition of his achievement, Dove did not immediately capitalize on what he had attained. During the next few years, he continued to produce interesting works that extend the "Ten Commandments" series and then suggest new growth. But he apparently never accumulated enough new work for another one-person show, and much of the work done in the decade after 1912 was never exhibited during the artist's lifetime. The most important show to include him during these years was the Anderson Galleries' 1916 Forum Exhibition, a select showing of modernists. Stieglitz was the force behind it, and Dove exhibited sixteen works, all titled *Nature Symbolized*. Dove was repre-

sented with two works in the first exhibition of the Society of Independent Artists in 1917 and two in an important 1921 survey of "Paintings and Drawings Showing the Later Tendencies in Art" at the Philadelphia Academy of the Fine Arts. Otherwise, before 1925, he exhibited only in a handful of small, group shows, generally exhibitions arranged through Stieglitz, who took responsibility for selecting and sending the paintings. Stieglitz also included his work in a retrospectively oriented show, "Beginnings and Landmarks of 291," at the Anderson Galleries in 1924.

The scant and sometimes ambiguous evidence about these shows suggests that the 1912 pastels were shown repeatedly, usually under the generic title of *Nature Symbolized*, which Dove (or Stieglitz) may have devised to accommodate additions to the original group. Hence, Dove's public image as an artist must have become static, although, thanks to Stieglitz, he continued to be regarded as one of the important modern artists of his day.[21] Why Dove's production fell off quite so precipitously after the 1912 show remains unexplained. However, about 1912 he had purchased Beldon Pond Farm near Westport, and trying to make a living there by raising chickens[22] and growing vegetables to support his wife and small son as well as himself was probably too demanding to allow for much painting.

As time went on in this fashion, however, the psychological consequences of being unproductive must have begun to weigh more and more heavily. To make matters worse, "291" and *Camera Work* were in decline by 1915, and in 1917 both came to an end—victims of the war, loss of cohesion within the "291" crowd, financial problems, and the competition of commercial galleries now promoting modern art. Stieglitz now was more in need of moral support than he was able to give it to Dove. On 24 May 1917, when he was "getting things well under way to move out" of the gallery, Stieglitz wrote, "It's rather a heart-breaking job. The worst of it all is I see no future. At least for myself."

Soon after, Dove sent a reassuring reply, including some optimistic thoughts:

> I somehow feel that something fine is coming out of all that is going on now, "291" is not a place you know.
> I, too, *see* no future, but do *feel* one and know that your idea has and will have a large part in it. We must be cheerful (not as stupid as it may sound).

Although Dove had never frequented the gallery on a social basis, as some of the "291" artists had, nevertheless he had formed important friendships there and had looked to it as a symbol of hope. Despite his admonition to be cheerful, an era had closed along with "291," and for Dove as well as Stieglitz, the memory of "291's" spirit of excitement, excellence, creativity, and camaraderie always symbolized those golden days when the "the idea" was new.

In the spring of 1917, as "291" was about to close, Florence Dove had gone into the summertime business of running the Turnpike Tea House with the wife of another artist. During their two years there, specialties were homemade ice cream and baked goods. Dove had already started scaling down the farm operation and doing more illustration in the previous two or three years, and in the fall of 1918, he responded to the loss of his anchor in the art world, the difficulties of wartime farming, and his family's economic plight by capitulating to his talent for illustration and returning fulltime to the magazine market.[23] Westport became a summer residence (as it was for most of its art colony), while Dove spent two winters in a small apartment at the same Stuyvesant Square address where he had lived before going to Europe. Although his hope had been to earn enough money to free himself for several months of painting each year, the paintings did not get done—whether for pecuniary or internal reasons is not known. By 1920, Stieglitz was wondering whether Dove would ever paint again.[24]

Suddenly, in the summer of 1921, Dove began to paint and draw once more. "It is

great to be at it again, feel more like a person than I have in years," Dove wrote to Stieglitz in August from Westport. Although it would be four more years before Dove showed a significant body of work, his resolve and buoyancy never again faltered. Probably he had saved enough money to spend all of that summer working on his art, enjoying the luxury of being able to concentrate on it fully, but other events that framed the summer probably were more important to his new state of mind.

In June of 1921, Dove's father had died in Geneva. His death must have stirred ambivalent feelings, for the elder Dove had been in conflict with his son over his painting for years.[25] Yet, however much Dove struggled against family expectations, even until his mother died twelve years later, Dove hoped for his parents to accept his dedication to an art career, even if they could not like his paintings. And so, his father's death may have actually had a liberating effect. Stieglitz felt it was a "fortunate thing,"[26] as he wrote to Paul Rosenfeld, who had commented that "father Dove," along with some of the Westport illustrators, by "undermining the fellow's confidence in himself, have made a terrible thing of something that might so readily be fine and pure."[27]

Whatever the effect of his father's death on Dove's psyche, it was limited in comparison to the impact of an autumn event for which Dove had been setting the groundwork that summer. In the fall or early winter, Dove departed with a fellow artist who eventually became his second wife. Helen Torr, or "Reds," as she was known to friends, was married to the artist and witty cartoonist, Clive Weed. They had moved to Westport a couple of years before and had quickly become members of the convivial artists' circle that included the Doves. Dove and Reds apparently did not provoke gossip when they went sketching together,[28] but those expeditions must have had a salutary effect on Dove's self-confidence since he found he could have not only the respect but the love of another artist, whereas his own socially inclined wife, who had no serious interest in art, had chafed at the lifestyle Dove had chosen to support his vocation. By way of example, Stieglitz must have played a role here, too, aiding Dove and Reds to summon the courage to plunge into a new life together in an uncharacteristically "bohemian" gesture. In 1918, after twenty-five years of marriage to a woman who understood little about his aspirations, fifty-four-year-old Stieglitz had fallen in love with the thirty-year-old Georgia O'Keeffe, the painter who had been the last new talent featured at "291." One day that summer, while his wife was out of their apartment, he simply packed and left to take up living with O'Keeffe.[29] Stieglitz was exuberantly reinvigorated by this experience: "I have been living as I never lived before.— O'Keeffe is a constant source of wonder to me . . . ," he wrote to Dove on 15 August 1918. Thus, O'Keeffe and the still-married photographer had been living together for three years when Reds and Dove followed suit.[30]

While the psychological consequences of starting a happy new life with Reds benefited Dove's art, his life with Reds was, for a variety of reasons, not easy. Dove's wife refused to grant him a divorce, so he and Reds were unable to marry. Often they were uneasy about living together without legal sanction,[31] and Dove was unhappy about Florence's flat refusal to let him see his son. Dove nevertheless strained to make regular payments for support of his child. Moreover, when he had departed, he had left behind possessions that his wife sold. Among the things he was careful to salvage, however, were his copies of Camera Work and Stieglitz's letters.[32]

Reds and Dove first lived together on a houseboat moored off upper Manhattan. This was only the first of several unconventional residences they would inhabit, and it was not the last time they would do without all the normal comforts of home. Late in 1922, Dove purchased a forty-two-foot yawl, the Mona, which then became their residence. They moved to a mooring at Halesite in Huntington Bay on the north shore of Long Island in the summer of 1924.

Despite their minute living quarters, which had to serve as studio as well; despite

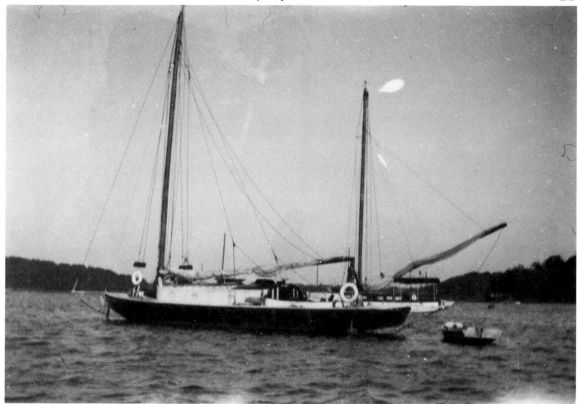

Anonymous photograph. Mona (Arthur Dove's boat). 1920s. Courtesy William C. Dove, Mattituck, N.Y.

the fact that life aboard a sailboat requires a great deal of time-consuming and tiring effort; and despite the fact that Dove continued to illustrate for a living, somehow he managed to continue painting, slowly at first but soon with increasing rapidity. As before, he worked abstractly, primarily from nature themes, but mechanical imagery also appears in his work from the twenties. In April of 1924, Dove took fourteen paintings to Stieglitz,[33] and, perhaps prodded by the thought of an exhibition, he "burst into prolific(k)ness"[34] toward autumn and had fifteen more works ready by December.[35] These included several of the first assemblages, which, as a group, comprise some of his best-known work.

By this time, in the late months of 1924, Dove was helping Stieglitz to plan a major exhibition in commemoration of the twentieth anniversary of the opening of "291." Advising Stieglitz on the catalogue in January, Dove urged that it be "terribly simple. We cannot show any resentment. The crest of the wave is where the power is. Use it."[36] Stieglitz concurred[37] and chose four written pieces for the brochure: a short piece of his own, essays by Sherwood Anderson and the German sculptor Arnold Rönnebeck, and Dove's poem titled "A Way to Look at Things," which Stieglitz had felt was "a classic right off the bat"[38] when Dove sent it in. "Seven Americans," which opened at the Anderson Galleries in March 1925, consisted of "159 paintings, photographs, and things, recent and never before publicly shown."[39] Besides Dove and Stieglitz, the exhibitors were O'Keeffe, Marin, Hartley, Charles Demuth, and Paul Strand. Dove's twenty-five paintings and assemblages (the "things" of the announcement) constituted the equivalent of a one-person show and summarized his work of the preceding couple of years.

The exhibition itself was a major event for the participants, and Dove must have been particularly pleased to be exhibiting a major sample of current work for the first time in thirteen years. Dove and Reds went to New York to assist with the hanging. They worked until 1:00 A.M., stayed overnight with Stieglitz and O'Keeffe, and con-

tinued on the show all the next day. Their labors were capped with a "very amusing" dinner at which Marin, Rönnebeck, Paul Rosenfeld, Strand and his wife Rebecca (also an artist), besides Stieglitz, O'Keeffe and others, were present.[40]

"Seven Americans" brought Dove into the public eye once again, since this exhibition was reviewed in all the major newspapers and art magazines. Particularly because of the novelty of the assemblages, Dove was accorded a substantial portion of the coverage in most reviews. Organizing the exhibition must have revived Stieglitz's interest in once again running a gallery, and in December, when Dove brought his latest work to him, the photographer had told him, "This settles our taking the gallery."[41] Enthused by the work of Dove and the others, Stieglitz arranged to have Room 303 of the Anderson Galleries as his own precinct, beginning the next season. Thus, "Seven Americans" served not only as Dove's reintroduction to the public but as the stimulus for Stieglitz to preside over a showcase where Dove's art would be welcome. In fact, "Seven Americans" set the pattern for the rest of Dove's life. Except for once, he showed his new work in Stieglitz's gallery every winter or spring until his death two decades later.

At The Intimate Gallery, as the new place was christened, Marin had the first show. Dove came next; his first one-person show since 1912 opened 11 January 1926. In the three seasons of this gallery, Stieglitz concentrated on showing American artists. By this time, although the taste for modernism remained limited, Stieglitz felt that the battle for recognition of the European modernists had more nearly been won, and he wished to combat the indifference epitomized in the very year of the "Seven Americans" show by the president of the country; to the invitation of the French government to participate in the international "Exposition des arts décoratifs," Calvin Coolidge had replied that the United States had no arts to send.[42]

As Dove began to show his work regularly, that indifference became a fact of his experience. Although the critics generally greeted his work cordially, they rarely wrote about it with the depth or understanding that might have created a larger audience. The taste for Dove's work remained limited to artists, Stieglitz's friends, and a handful of others. Sales of his work, when they happened, were mostly to friends and at very modest prices. Dove, meanwhile, continued his unfulfilling work as an illustrator in periods that alternated with painting—an existence that he described to Stieglitz as "going bankrupt every six months and then trying to become a 'success.' "[43] Becoming a success, however, became more and more difficult as the twenties went on. The demand for illustrations was diminishing as photographs replaced them, and for those illustrations that were used, a slicker—ironically, more "modern"—style than Dove's was fashionable. By 1928, Dove was in serious financial trouble.

Meanwhile, Dove and Reds were still living on the boat at Halesite. Their space problem had been somewhat alleviated as they became acquainted in that little town and had been able to arrange to use part of the Ketewomoke Yacht Club for storage and studio. Then, quite by accident one day in 1928, Dove met a stranger who offered him a house free of charge across the Sound for the winter. Dove and Reds accepted with pleasure this opportunity to spend their first winter in eight years in a house as caretakers on Pratt's Island, near Noroton, Connecticut, and only a short distance from Westport. Dove produced a lot of work there, and after his show at The Intimate Gallery that spring, discontinued his efforts to find illustration work in New York. He soon felt that it was not worth the train fare to go into the city for this purpose. There were only rare commissions after that, those mostly from editor-friends who remembered his work. Reds' comment that they were "pretty much flabbergasted"[45] in September 1929, when *Liberty* magazine asked Dove to come in with his proofs, suggests that Dove was dropped before he was ready to quit. No doubt, given the opportunity, he would have continued illustrating as a means of support, no matter how much he

had grown to dislike it. When the stock market crashed in October of that year, initiating the Depression of the thirties, Dove had few resources or prospects.

In May of 1929, Dove and Reds had returned on the *Mona* from Pratt's Island to Halesite. That winter, and for succeeding winters there, they moved into the drafty, dockside boathouse that even today serves as the Ketewomoke Yacht Club. Dove offered the club $15 a month for the 30' × 40' room that was used only for infrequent dances, but the club called a meeting and gave them the space rent-free, "just to have someone there." Dove clearly was pleased with their future home as he listed its virtues for Stieglitz: "The room is full of light— . . . gas and electricity—and a wonderful view of the whole harbor, so our wish for a house on a dock where we could tie boat has come true."[46]

Other wishes eventually came true as the result of an event that shocked Dove at the end of that summer, just after he had gotten the commission from *Liberty* and just

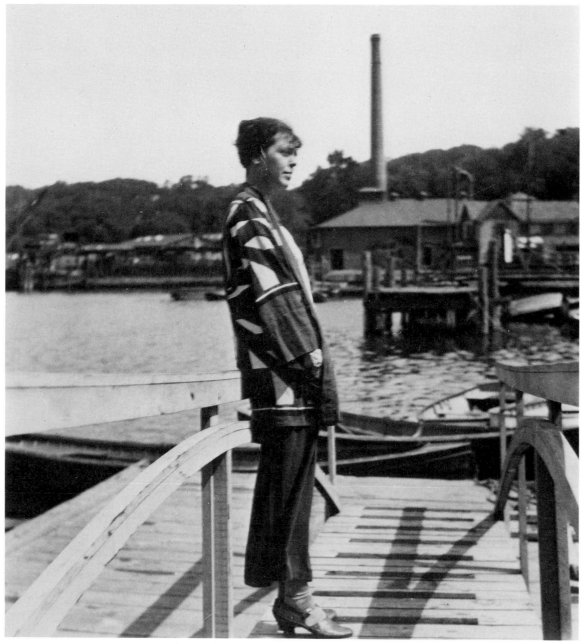

Anonymous photograph. "Reds" (Helen Torr) Dove. 1920s. Courtesy William C. Dove, Mattituck, N.Y.

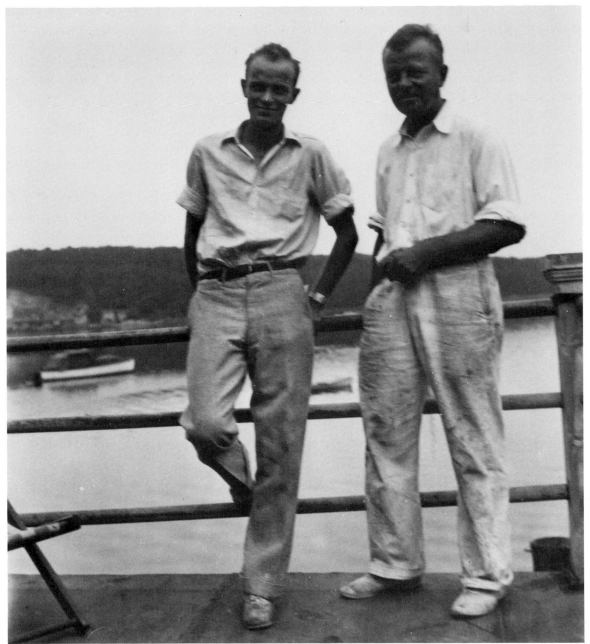

Anonymous photograph. William C. Dove, the artist's son, and Arthur Dove, c. 1930. Courtesy William C. Dove, Mattituck, N.Y.

before the stock market had crashed. On 28 September 1929 Dove received the news by telegram that his wife, Florence, had died quite unexpectedly. Dove immediately left by train for Westport, where he did what he could, including paying $250 in funeral expenses. He returned to Halesite the same evening but was unable to sleep that night and was depressed the next day. He sent flowers for the funeral but did not return to Westport nor go to Geneva for the burial.[47]

Although he was clearly distressed by Florence's unanticipated death, the event did open up two desirable possibilities to Dove: reconciliation with his son and marriage to Reds. About two-and-one-half weeks after Florence's death, Dove went to Westport for his first meeting in eight years with his nineteen-year-old son. They had already exchanged letters (Dove even sent a photograph of himself so Bill would recognize him), and Dove was clearly excited. He took little gifts and, beforehand, even made a list of things to talk about. This tentative meeting went well,[48] and they met once more

in New York before Bill came out to Halesite for a day to meet Reds, who thought he was a "lovely boy."[49] He came to Halesite again the day after Christmas, along with his friend Charles Brooks (son of the writer Van Wyck Brooks, whom Dove had known in Westport) and Alfy Maurer. Thus, cautiously at first, Dove and his son reestablished a friendship, and soon Bill was very much part of the family, visiting often and staying in close touch. He had already decided that he, too, wanted to be an artist, so he and his father had much in common.

Fulfillment of the second possibility opened by Florence's death had to be delayed. As marriage had always seemed impossible while Florence was alive, Reds had done nothing about obtaining a divorce for herself. At that time, divorce was still slow and complicated, so even after Reds had initiated the procedure, the waiting went on. Finally, in April 1932, Dove and Reds went to New York's City Hall for the brief ceremony with a ten-cent-store ring. After ten years of life together, they were pleased to be legally joined, but they treated the wedding itself rather matter-of-factly. After doing errands in the city, they had lunch at the counter in Pennsylvania Station before taking the train back to Huntington, where Dove stopped at the bank to change his account there to a joint one.[50]

Of course, had there been much of anything in the bank account, there would presumably have been more of a celebration. As the Depression had deepened, Dove's financial status had continued to decline. Reds had been trying to help by coloring slides at home, mainly for the New York State Education Department (though the money she had to pay for a course to learn the technique may actually have exceeded anything she was able to earn). Stieglitz had sometimes bailed them out with checks in advance of anticipated payments for paintings. (Or so he said. Some of these "loans" were probably just money out of his own pocket.) Dove had gotten a pilot's license so he could take parties out on his boat, but apparently no one had money for pleasure cruises or fishing. So he tried to sell the boat, but of course there was no market for it. He made frames, painted awnings, and went clamming for something to trade to the neighbors for vegetables. The artist tried to get some money from his mother and brother in Geneva, but, as he put it, "Have wrung the stone again—and no blood."[51]

In 1928, when Dove's financial situation had first become truly oppressive, he must have been somewhat dismayed that Stieglitz did not intend to go on with The Intimate Gallery after the 1928–29 season. Stieglitz knew, before that season began, that the building was scheduled to be torn down; moreover, he had had his first heart attack in the summer of 1928. (This event signaled the onset of years of heart disease, which eventually weakened and killed him.) The combination was too much, and at the end of the season in 1929, he put everything in storage. However, by guaranteeing the financial security of a new gallery, the Strands, Dorothy Norman (then a young photographer who was to become closely associated with the administration of Stieglitz's final gallery) and others prevailed upon Stieglitz to continue. So, in December 1929, he opened An American Place, his professional home until the end of his life seventeen seasons later. Here, he concentrated even more narrowly on a few Americans. Dove, Marin, and O'Keeffe were the mainstays.

Thus it was that Dove was able to continue showing annually, although there continued to be few purchases. However, at least the exhibitions meant that Duncan Phillips's interest was aroused and before long was conveyed—through Stieglitz's intervention—into an instrument of salvation for Dove.

Phillips was a patrician Washingtonian in his forties, a Yale graduate with literary aspirations who had settled into the fulltime business of directing the Phillips Memorial Gallery. Founded in 1918 and opened to the public three years later, the Phillips Collection (as it is now known) was the first museum of contemporary art in the United States. Phillips's tastes were initially conservative (he denounced the Armory Show, for instance),[52] but through thoughtful self-education and the the influence of

his wife, Marjorie, who was a painter, he gradually came to comprehend—and purchase—some of the finest twentieth-century painting, both European and American. Motivated by the desire to educate as well as to give pleasure, passionate about collecting, blessed with the self-disciplined temperament to work diligently at his self-appointed job, Phillips used his inheritance from Jones and Laughlin Steel in Pittsburgh to build a sensitively chosen collection. As it was then, today it is housed unpretentiously in the former family home just off Dupont Circle in Washington, D.C. While he was by any standard wealthy, Phillips did not have one of the turn-of-the-century's unlimited fortunes, so each of his purchases was made with careful consideration.

Phillips later recalled discovering Dove's work as early as 1922; he credited Dove with an important role in his own "evolution as a critic and collector"[53] and had acquired two Dove paintings and an assemblage in the late twenties. But the active period of his purchases from the artist began only in 1930, when Dove's paintings were first seen at An American Place. Phillips bought two paintings from that show and had acquired three more by the early months of 1933, by which time Dove was again financially desperate.

In January 1933, Dove's mother died in Geneva, but instead of receiving an immediate inheritance that might have relieved his plight, Dove was more besieged with new difficulties than released from present ones. He and Reds went to Geneva to attend the funeral and begin what was to become a long process of settling the estate. There was virtually no cash to be had, but the family holdings, which Dove now shared with his brother, were substantial: "the home" (as he usually referred to it) on South Main Street; farmland and two farmhouses on the edge of town; a third house in the vicinity of the farm; a large, commercial building, known as the Dove Block, in the center of town; and brick and tile plants. However, at the height of the Depression, it was impossible to sell any of this real estate, so Dove saw that his only hope was to move to Geneva, perhaps for a year or so; there, he could live rent-free and try to rescue some capital from the estate.

In the midst of preparations to move, Dove assembled his annual show to open at the end of March at An American Place. This year, Reds' work was shown simultaneously in the smaller room there, but two years later, when she sent her new work with her husband's, Stieglitz simply refused to show it. Surely, the name of Helen Torr as an artist would be better known had Stieglitz appreciated her work or had she possessed more initiative about showing elsewhere. As it was, Stieglitz seems to have been unduly harsh, telling her even at the time of her only appearance at An American Place that there was "no search" in her work, although "some of it [was] very good as pictures."[54] Unfortunately, Reds believed him, and her own lack of confidence in her talent led her, more and more, to see herself as artistically unimportant in comparison to her husband. She often sacrificed working time for his sake, and by the late thirties, she neglected her painting virtually altogether. Her lifetime output is simply too small for her to be considered an important artist, but the quality of her extant work confirms her ability.

Reds' depression about her work in the spring of 1933 probably was one of the reasons she was half-sick all the time. Also exacerbating whatever ailed her physically was the grim attitude she and Dove shared about the prospect of moving, since much of their time was given over to packing, selling the boat, and taking care of other chores. "The dread of going there is almost an obsession," Dove wrote to Stieglitz not long before they left for Geneva.[55]

At the end of May, however, a letter from Duncan Phillips directly to Dove had brightened the situation a bit. Phillips proposed to take three paintings that had been in the 1933 show "on condition," as Dove explained to Stieglitz, "that he be allowed to

pay $50 each month at the price you gave him of $200 each. Speaks of sending checks directly to me, and that you and I can arrange that to suit us both. Perhaps we'd better let him have his own way," Dove suggested, and went on to assure Stieglitz that he would nevertheless follow the customary procedure of donating a percentage of the sale price to An American Place for support of its operation.[46]

In subsequent years, through the end of Dove's life, this type of arrangement came to be annually renewed, and the amount gradually rose. Although Phillips thought of the money in terms of monthly checks and soon came to refer to the payments as a "subsidy," he was in fact simply paying a debt on the installment plan. Each year, the amount he paid Dove equalled the value of the paintings he had already taken from Dove's show. Thus, there was little philanthropy in the arrangement, except much later when, in the two years that Dove was very ill, Phillips continued the payments without the assurance of ever receiving paintings. (In both cases, he did later take paintings to settle Dove's debt to him.) Furthermore, since Phillips was dilatory about payments and renegotiated the agreement every year, the arrangement never offered Dove the peace of mind a genuine subsidy would have. Phillips would have been fairer to pay Dove outright each spring for the paintings he took home from Dove's show, especially since he insisted on having first choice every time and sometimes took several paintings off to Washington for months, thus preventing their sale to anyone else while he was making up his mind.[57] On the other hand, as Stieglitz and Dove realized, Phillips meant well, and he is certainly due the credit of being Dove's only regular patron. Phillips may even have felt obligated to continue to buy Dove's paintings each year once the pattern had been established because he knew the artist depended on these purchases. Whatever the pros and cons of the patronage arrangement for Dove, it enabled Phillips to amass the largest single collection of Dove paintings, including many of the best.

In what was an ironic foretaste of things to come, Dove and Reds had to wait for Phillips's delayed check to come at the end of June before they could depart for Geneva in the old truck they now owned. Just before they left, they finally sold the *Mona*—on the installment plan for just enough to cover the mortgage payments on it. On 7 July, the Doves finally set off for Geneva, little dreaming that they would have to stay there for five years. When they arrived, they moved into a small house under the trees on the family's farm property just north of the city limits. It was hardly more elegant than the homes to which they had become accustomed, as it needed repairs and had no electricity.

During the first year in Geneva, Dove was so preoccupied with renovating the house, taking care of the estate, and farming some of the land with his brother that he had almost no time to paint. The extensive Dove holdings turned out to be more a burden than a boon. Only by selling pieces of property—and these at the low prices that the buyer's market of the thirties created—could the artist and his brother even pay taxes to prevent public auction of the rest. They remodeled the commodious family homestead into apartments; Paul continued to live there until his death in 1979, but his brother refused to live in the house he associated with his family's materialistic aspirations. Their different attitudes toward "the home" only symbolized deeper differences between the brothers, who often disagreed on questions of management and disposal of the property. Perhaps the most serious problem, in Arthur's estimation, was Paul's belief in the inflated value of their jointly held properties, which he refused to sell at what Arthur thought were realistic prices.[58] As well, there seemed to be endless complications arising from the legalities of disposition of the estate, maintaining the property, dealing with tenants, and so forth—all drudgeries at which Dove chafed.

Dove's next show at An American Place, in the spring of 1934, was mostly retrospective to make up for the lack of new paintings. But gradually, Dove made more time

to paint, and the years after the first one were productive. However, he and Reds never grew to like Geneva. Although Dove's son, Bill (who married a Genevan, Marian Craib, in 1935), lived there part of the time they were there and although they had visitors—sometimes all too many in summers—they felt isolated in the provincial, small-town environment. "This is like living in exile," Dove lamented to Stieglitz.[59]

Although Dove felt cut off from the art world, he was in fact becoming more a part of it during these years. Once he had reemerged as a regularly exhibiting artist, he had begun to be included in important exhibitions beyond those under the auspices of Stieglitz or Phillips. Despite the fact that sales of his work always remained few, he clearly was not ignored, although opportunities to show modern or contemporary art were relatively few in Dove's day.

In 1926, the year of his reentry into the exhibiting art world, Dove was included in the "International Exhibition of Modern Art," organized by the Société Anonyme (which was directed by Katherine Dreier and Marcel Duchamp) for the Brooklyn Museum. In 1930 he was included in the Museum of Modern Art's "Painting and Sculpture by Living Americans," which was only the second exhibition of its kind at that new museum. From then on he appeared regularly in definitive surveys of contemporary American art. In 1931 he showed for the first time in the "Annual Exhibition of Contemporary American Oils" at the Cleveland Museum of Art; he was included also in 1932, 1935, and 1940. In 1932, he was invited to show in the Whitney Museum's "First Biennial Exhibition of Contemporary American Painting." (This later became an annual exhibition.) Dove was included also in 1935, 1936, 1940, and, for the last time, in the survey that opened in December of 1946, about three weeks after his death. Dove appeared in the Pennsylvania Academy's annual exhibition in 1936, 1939, 1944, and 1945, as well as, here and there, in other annual surveys, including those at the Art Institute of Chicago and the Worcester (Massachusetts) Art Museum.

Landmark exhibitions in which Dove was shown before his death included "Abstract Painting in America" at the Whitney Museum of American Art in 1935, "Fantastic Art, Dada, Surrealism" at the Museum of Modern Art in 1936–37, "Art in Our Time" at the Museum of Modern Art in 1939, and "Pioneers of Modern Art in America" at the Whitney Museum in 1946. He appeared at the Art of This Century gallery in a collage show in 1943 and was included in two large foreign exhibitions (of which there were not many featuring American art during his lifetime); these were "Trois Siècles d'Art aux États Unis" (which was organized by the Museum of Modern Art) at the Musée du Jeu de Paume, Paris, in 1938 and "American Painting from the Eighteenth Century to the Present Day" at the Tate Gallery, London, in 1946. Indicating his growing reputation, besides this last show and two at the Whitney ("Pioneers" and the annual exhibition), Dove was included in three other large surveys in the year of his death alone: "200 Years of American Painting" at the Dallas Museum of Fine Arts, "36 Americans" at the Walker Art Center in Minneapolis, and "60 Americans Since 1800" at the Grand Central Art Galleries in New York. (The latter also toured Europe under auspices of the United States State Department.)

This exhibition record of course depended on the steady output that Dove managed to achieve year in and year out despite all manner of distractions and disruptions. While Dove's show was on display at An American Place in the spring of 1934, he and Reds moved to another, larger farmhouse on the family property. While the space made them feel as though they were living in a warehouse,[60] after so many years of tiny enclosures, this house did not provide much more comfort than they were used to. It was drafty, needed a new roof, and did not have electricity until two-and-one-half years later. Despite their continuingly Spartan life, Reds' health improved substantially following a hysterectomy six months after they had moved, although she did not regain her normal energy for another half year or more. A friend picked up the hospital bill,[61] and Dove confided to Stieglitz, "I do not know what we could have done had the

doctor there on Long Island been keen enough to know what was the matter."[62]

In addition to renewing his agreement to buy paintings on the installment plan in 1934, Phillips showed his concern for Dove by attempting to get him into the Public Works of Art Project of the WPA. When he initially suggested that Dove apply,[63] the artist demurred politely, saying that he would undoubtedly collide with any government committee over the abstract nature of his work.[64] To Stieglitz, however, he wrote:

> I do not want to use any gift horse as a mirror, but expect to go on working as usual and have what there is shown at 1710 [the room number of An American Place] first. . . .
> I think that '34 ought to be good, especially if they are going to have all of the artists on stepladders [i.e., painting murals] at $42.50 a week. There will be more room on the ground. . . .

Nevertheless, Phillips, who was a regional chairman for the project, worked through Juliana Force of the Whitney Museum, who was the New York chairman, to arrange for the Buffalo office to offer Dove $34 a week for easel paintings. Dove was not impressed, as he wrote to Stieglitz in a letter that reveals his distrust of the government program as well as his practical assessment of costs:

> P [hillips] in a former letter said $42.50 per wk. and suggested they might purchase some old work. Wonder if we could substitute some of my work in storage and keep the present and use the $34 for materials. It would help a lot, but I could not think of giving them all present work, that would hardly buy paint and canvas, and the "committee" would have to be satisfied.—How nice! And all your years of building to go for nothing at a Government auction. If they hang these paintings in place of historical prints or what they have now in schools, etc., what becomes of Geo. Washington, etc.?
> Do they know how much it costs to paint a 30-hour week for materials alone? . . .
> The only way I can see it is to trade them some of the past instead of the present.[65]

But, of course, artists were not allowed to do that, so Dove stayed "on the ground," as he preferred. However, without Phillips's financial support, it would have been difficult. Stieglitz and Dove never forgot that, despite the fact that they found Phillips difficult. Some of Stieglitz's typical complaints were voiced in a letter written to Dove on 8 June 1934:

> I wrote him [Phillips] that his generosity he speaks of has been met by at least an equal generosity on your part & on my part.—That as a matter of fact I thought he did very well for himself when all was said and done altho' I fully realized what role he played in letting you "live." . . . He first said he'd give $100 a month if possible. Then he wrote it would be a thousand [for the year].—Now it's $900—& he asks for this picture & that picture—irrespective whether it belongs to you still or not [Stieglitz was thinking of some Dove paintings that belonged to him personally]—acts as if no one else had any rights & he were giving you a kingdom plus a horse for what he demands as his *rights* for his unbounded limitless generosity.—And yet, what can one say or do?

Dove replied in a more moderate temper and characteristically concluded the topic with "Oh well, let's not let it get us. We can go on."[66]

A few days later, Phillips finally concluded the matter for the year by revising his "subsidy" downward once again. He wrote to Dove that he could "only afford" $600 (in exchange for three major oils from Dove's exhibition), but then proposed to bring the total of payments up to $1,000 by taking a fourth painting for $100 and adding in the $300 he had owed for a year and a half as partial payment on another painting. Dove acquiesced.

With Phillips's payments and what little they could get from the estate, Dove and Reds were limited to a frugal existence in Geneva, but they were never so desperate as they frequently had been during their last three or four years on Long Island. As the Depression eased and the estate problems were gradually worked out, the Doves's financial situation slowly improved. In 1936, they were finally able to get ahead a little. In March of that year, Stieglitz sold *The Gale* (32.12) to the University of Minnesota for $1,000, the highest price paid to that date for any Dove work. They were able to put all of that in the bank, and $900 of it was still there a year later when Dove wrote to Stieglitz, "It is the first time in so many years that we haven't been down to nothing. I dread getting there again for anything not absolutely necessary."[67] Nevertheless, Dove and Reds had treated themselves to a two-week trip to New York City at the time of Dove's 1936 show. Their only trip to New York during the five years they lived in Geneva was a busy and sociable sojourn. One of its highlights was the only meeting the Doves ever had with Duncan and Marjorie Phillips, who had been buying Dove's paintings for ten years. They met on the neutral ground of An American Place, and afterwards Dove reported to Stieglitz, "The Phillipses were much less difficult than I expected, and we enjoyed them."[68] In addition, besides seeing Dove's son and his wife (who were then living in New York), they saw Stieglitz almost daily and O'Keeffe frequently. O'Keeffe invited them, along with Bill and Marian, to dinner at the penthouse of 405 East 54th Street, where she and Stieglitz had moved the previous autumn. They also enjoyed meals, some at Italian or Chinese restaurants, with their close friends Elizabeth and Donald Davidson (she was Stieglitz's niece), Charles Brooks, Elizabeth McCausland (a Springfield, Massachusetts, art critic, who had become a personal friend) and Berenice Abbott (the photographer, who was a close friend of McCausland's, and had thus come to know the Doves), Marin, and other friends. At the gallery, among those with whom they socialized were Cary Ross, Lewis Mumford, Waldo Frank, Malvina Hoffman, and Ralph Flint. Of the art they saw, the most important show was Alfred Barr's definitive "Cubism and Abstract Art" at the Museum of Modern Art. The trip refreshed them both. "Reds was a new woman after we left here," Dove reported to Stieglitz. "Here is quite a contrast from there. . . . Liked N.Y. better than ever."[69] Still, Dove's responsibilities in Geneva and his insecure financial situation precluded thinking about leaving upstate.

A year later, however, Dove and Reds were moving once again—to yet another piece of family property. Having sold the farmhouse in which they had been living for three years, they moved to the late-Victorian, three-story Dove Block at the intersection of the two main streets in downtown Geneva. Here, they lived in the loft-like top floor that had previously served as a sports arena and roller skating rink. The main room, which was sixty by seventy feet, had a fifteen-foot ceiling, nineteen ten-foot-high windows, and a view of Seneca Lake a few blocks away. "Walk about 10 miles before noon in this huge hall," Dove told Stieglitz.[70]

The main disadvantage, in the Doves' eyes, to this residence was not its unconventionality—they were used to that—but its Geneva location. "It is swell from 3 A.M. until 6.—Then the people begin to appear," Dove joked sardonically. "Being high above the street has its advantages."[71]

About the same time that they moved into the Dove Block, Phillips was negotiating his annual agreement with Stieglitz, and this year he did exceptionally well by Dove. Not only did he raise the monthly payments to $100 per month, he purchased *Goin'*

Fishin' (25.9) outright from Stieglitz for $2,000, the largest sum paid to that date for any work by Dove. Stieglitz took none of the money for himself but sent half to Dove and gave half to the gallery's Rent Fund, while "reimbursing" himself with another Dove painting for his personal collection. Stieglitz also persuaded Phillips to begin sending his checks to Dove through an American Place (as the collector did for his Marin and O'Keeffe purchases and as he should reasonably have been doing all along since the gallery functioned in lieu of a commercial dealer). There was some truth to the excuse that Stieglitz used to become Dove's watchdog: that Dove's personal finances should be clearly separated from those of the estate so that his money could not be taken for estate purposes. "Do not want to bother you with forwarding statements," Dove wrote apologetically in confirming Stieglitz's judgment,

> but these damned Federal Housing Acts make you hock your soul to save what there is. And the N.Y. Central R.R. may hop us for something that father signed 60 years ago about paying for labor in removing switch to old brick yard.[72]

Forwarding the checks through Stieglitz probably was at least a factor in reducing tensions within the Dove-Stieglitz-Phillips *ménage à trois*, as the photographer had once dubbed it.[73] Complaints about Phillips subsided after this, and, as events of the next year changed the picture, the ongoing relationship with Phillips worked better.

When Phillips once again renewed the agreement in March of 1938, Dove wrote exuberantly to Stieglitz:

> You're remarkable. It settles the whole situation for us. It will get us out of Geneva. I felt it coming, but it was a complete surprise nevertheless.[74]

Although the Doves got out of Geneva within a month, events did not transpire as they had hoped.

In mid-April, while his show was on view at the gallery, Dove and Reds departed for New York City with the intention of seeking a residence nearby while they visited the

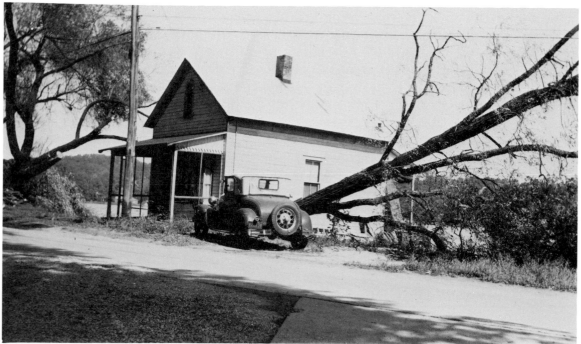

Anonymous photograph. Dove's house in Centerport, N.Y., after the 1938 hurricane. Courtesy William C. Dove, Mattituck, N.Y.

city. As it turned out, Dove became ill while they were in New York and never saw Geneva again. A week before the painter had come down with pneumonia, he and Reds had decided on a tiny house on the edge of Long Island Sound. Bill and Marian were around to help, as they had moved nearby on Long Island early that spring. Bill returned with Reds to Geneva to pack and transport the Doves' belongings, while the artist stayed with his daughter-in-law. This period of illness was the beginning of a drastic decline in Dove's health. While up to this time he had always been active, performing strenuous chores while maintaining the boat, farming, and rehabilitating the estate property, as well as frequently running and swimming in Geneva, from now on his physical activities were curtailed. Except for a couple of periods when he did more than he should have and worked himself into relapses, he was at best sedentary during the remaining eight-and-one-half years of his life. Much of the time he was an invalid, and sometimes he was confined to bed. It is no longer possible to trace precisely what afflicted Dove at each stage of his illness. Dove believed that his problem was a weak heart, but the heart condition was aggravated by Bright's disease, a kidney malfunction that tends to elevate blood pressure.

In the spring of 1938, of course, Dove foresaw none of the poor health of his future, although he seems to have been temporarily sobered by the weakness that followed the initial attack. "Don't try to do anything," he wrote at the end of June to Stieglitz, who, ironically, had also been stricken with a heart attack and then pneumonia in April. "I was stupid about it—came over here and tried to work on ladders etc., so set myself back about three weeks,"[75] Dove wrote from the new home where he would spend the rest of his life. The little frame structure had previously served as the post office of Centerport, a tiny town on the north shore of Long Island, only a few miles from Huntington and from the Doves' former yacht-club home in Halesite. Dove and Reds paid only $1,000 for the structure, although they had to put more money and labor into it to make it truly liveable. Jutting over the bank of an inlet of the Sound and affording views across the water and along the shore, it was a delightfully suitable place for an artist of Dove's temperament to live during his years of restricted mobility. "We are so much happier here. Inconveniences and everything considered," Dove told Stieglitz.[76] A few months later, when he was a little more active, he added, "I love this swash-buckling around the salt water."[77]

Despite his sporadic attempts to get back to a normal life in the late months of 1938, Dove suffered a chronic "infection" and tendency to run a temperature. These were the prelude to a massive relapse that virtually immobilized him for the first eight or nine months of 1939. During this episode, Dove was bedridden, then confined to a wheel-chair, and he had a nurse at the house every day. In the spring of 1939, he had completed only three new canvases since his show the year before, so his exhibition was otherwise made up of works from earlier years. Stieglitz doubted that Dove would ever paint again.[78] but Duncan Phillips generously agreed to continue his monthly payments despite a lack of new work from which to make his annual selection. To aid Dove further, his son, Stieglitz, and others conspired to channel money to him through Stieglitz, who could be vague to the painter about its precise source.[79]

In bed or in a wheelchair in these months, Dove was not only remarkably dogged about working (he could do only drawings or watercolors), but optimistic about the results. In May, he wrote to Stieglitz:

> Work is a lift, if I don't overdo it. Have about 40 watercolors. Think they offer more possibilities than any yet. . . . The conceptions seem more complete to me.[80]

Indeed, he was entering an especially creative phase, in which he defined his abstract approach of the forties, a period that saw some of his most innovative and fully realized work.

In a letter written two months later to Stieglitz, Dove suggested the frustrations of continuing to be an invalid, as well as his own growing awareness that he would need to be physically careful of himself in the future:

> This convalescence is quite a game I find—more subtle than getting one's foot out of the grave. They have a way of getting onto me when I am not in the mood for it, and that makes improvement pretty intricate and even compulsory. The nurse worries because she has so little to do even daytimes, and the doctor thinks it best to keep her, to watch me, as long as we can, which we can't, so life goes beautifully on, and now the only time we have had any finances to think about, I am not allowed to think about them.[81]

By the end of September, he was "left to [his] own discretion"[82] without a nurse and allowed to paint. By working slowly but consistently, he had a show of nineteen new canvases and fifteen framed watercolors ready by the spring of 1940. "How it all became done, damned if I know," he commented to Stieglitz. "The steady pace without interruption makes a great difference."[83]

The 1940 show was, in fact, a remarkable comeback. Stieglitz saw it as a dramatic success, and nearly everyone who saw the show responded enthusiastically to the paintings, which, as a group, were more completely abstract than those of any previous year. Phillips reimbursed himself for his 1939 advance with a painting and agreed to send Dove a total of $2,000 in monthly installments during the coming year. Though the artist still suffered occasional setbacks that required him to rest completely, before his show was over he was able to visit it. On 9 May, he drove into the city with Reds and their psychiatrist-friend, Dr. Dorothy Loynes (whom they had met in Geneva and who now also lived on Long Island). On this first trip into New York in about two years, they saw O'Keeffe as well as Stieglitz at the gallery.

Dove continued to be frail but productive for about the next four years continuously. He again visited the gallery during his 1941 show, and in 1942 he went into New York twice, once to take the paintings into the gallery and once while the show was up. By that summer, when Phillips again agreed to renew the payments, Dove and Reds decided they were finally financially secure enough to be able to buy a Stieglitz photograph, one of the "Equivalents." Stieglitz was so pleased that he turned over their check to the gallery and sent them two specially framed prints.

That fall, the war began to impinge on the Doves personally. In October, Dove's beloved Dr. "Jake" Bernstein left for war duty in the army. Although Dove had been in fairly stable health for some time when Bernstein left, he was nevertheless so weak that the doctor did not expect to see him again.[84] Shortly after Bernstein departed, Bill, who had been working in a factory in support of the war effort, was drafted. He had been divorced, apparently rather abruptly, during the summer and was married to his second wife, Aline de Lara, just before he left. In addition, a friendly brother-in-law who had been living nearby left for Europe to work for Allied broadcasting.

Dove kept up the pace of his work and his spirits, too. After thirty-five years as a painter, Dove wrote delightedly to Stieglitz in November, "Am *learning* so many things."[85] He had another successful show ready in 1943 and tried to make plans to get into New York to see it. His substitute doctor forbade him to take the train because there would be too much walking in the Pennsylvania Station. "He says you have to fight for seats," as well, the artist told Stieglitz, "and I'd better try to ride in on a delivery wagon or with some invalid person that has a permit . . . to go to see a doctor. Pretty difficult."[86] Apparently wartime restrictions made it too difficult, and Dove did not get into the city that spring. In March of the following year, he and Reds had their outing to the city during the O'Keeffe show, when they went in with their friend Dr. Loynes. Dove did not get to see his own show, although his health remained fairly

stable in the early part of 1944. In June, he suffered a severe setback; in bed for four weeks, he was not allowed to paint for much longer than that. Although his 1945 show was delayed until early May, it was entirely retrospective.

Dove was better during that summer than he had been for many months previously, but Bill was shocked by his father's aged appearance when he was discharged from the army. After Bill's return, he and Aline lived in Flushing and were able to see the senior Doves only occasionally, by taking the train to Centerport. Dr. Bernstein also returned that summer, as Dove told Stieglitz:

> "Jake," our doctor, is back all safe. Maybe that is why I haven't been so well. Seem to think I am safe as long as he is up the hill. Having saved my life a couple of times, I seem to think that is what he is for.[87]

Dove had nine new paintings ready for his 1946 show, the last of his lifetime, and while it was on display, he made his final visit to the gallery and saw Stieglitz for the last time. It could not have been easy for these two to say goodby this time. Stieglitz thought it pathetic to see how Dove had aged,[88] and Dove must have been sobered by Stieglitz's loss of vigor in the two years since their last visit. However, in the same month, the Doves were cheered by the birth of Bill's only child, Toni. Reds and Dove went by taxi to see their newborn granddaughter.

Stieglitz, whose health had prevented him from doing any of his own photographic work for several years, finished the season at An American Place and continued to attend to Dove's financial well-being afterward. Early in July, he was still hoping to make his usual summer trip to Lake George, but his heart finally gave out, a little more than a month after Dove's show had closed. Dove was badly shaken by the loss of his old friend.[89] He lived on for only another four months. Although he became partially paralyzed by a stroke and too weak to wield a brush unaided, he tried to go on by having Reds guide his hand as he painted. In November, he collapsed and was taken to Huntington Hospital, where he died.

Both the *New York Times* and the *New York Herald Tribune* carried obituaries,[90] but neither of them commented on the poignancy of Dove's passing almost at the same moment as Stieglitz. Perhaps it was not immediately clear that the era those two had helped to create was over.

NOTES

1. Frederick Wight, *Arthur G. Dove* (Berkeley and Los Angeles: University of California Press, 1958), 25.

2. Dove to Stieglitz, December 1934. This and all letters cited in the text are, unless otherwise indicated, in the Stieglitz Archive, Collection of American Literature, Beinecke Rare Book and Manuscript Library, Yale University, New Haven, Connecticut.

3. Dove to Stieglitz, 25 March 1938.

4. Catalogue numbers are designated in parentheses for Dove's paintings to which reference is made in the text. Other particulars about the individual paintings are not generally given, since this information is available in the catalogue. The catalogue number of a painting indicates the year in which the work was completed. The digits preceding the period refer to the year of completion; those after, to the painting's alphabetical listing within that year. Hence, *Holbrook's Bridge to Northwest* was completed in 1938 and is the tenth painting listed under that year.

5. In his memoir, *Between Sittings* (New York: The Dial Press, 1951), the sculptor Jo Davidson recalled that Dove was responsible for introducing him to the West Twenty-Fifth Street Carlos Café, which "was then frequented by newspaper men, artists and writers" (p. 65).

6. The best documentation for the dates of Dove's departure and return are the entries John Sloan made in his diary about seeing Dove in New York. See Bruce St. John, ed., *John Sloan's New York Scene* (New York: Harper and Row, 1965), 220 and 328. Dove him-

self seems to have inadvertently muddied the waters of his own biography concerning his European trip by writing for Samuel Kootz's *Modern American Painters* (New York: Brewer and Warren, 1930) that he had been in Europe for eighteen months. As a result, it has usually been concluded that he left in 1907 (since evidence and secondary sources generally agree that he returned in 1909). Thinking back from more than two decades later, Dove probably meant, by saying that he had been abroad for eighteen months, that it was something more than a year.

7.He stayed until driven home by World War I and never went back.

8. Gertrude Stein, *The Autobiography of Alice B. Toklas* (1933; reprint, London: Arrow Books, 1960), 15.

9. Many years later he would still remember Le Dôme and André, the waiter. "The Versailles (evening better) and across the street from the Dôme—& Les Deux Maggots [*sic*] way down the rue de Rennes are good places to see people," he continued to reminisce. "Also Lucien LeFebvre–Foinet art shop—Café L'Avenue—and the one on the corner of the Montparnasse & the Boul' Miche [La Closerie des Lilas?]." (Dove to William and Aline Dove, after 1942; William Dove collection.)

10. Dove was not properly listed in the catalogue of the 1908 *Salon*, but he is presumably the "Arthur E. Door," born in New York.

11. William Dove, the artist's son, recalled in conversation having heard from his parents about a pension in Moret, and the titles of documented paintings refer to that locale. Maurer's biographer does not mention Moret but says that Dove and Maurer worked together outdoors. See Elizabeth McCausland, *A. H. Maurer*, (New York: A. A. Wyn for Walker Art Center, Minneapolis, 1951), passim, esp. 71 and 91.

12. Interestingly enough, Dove was not alone among the young avant-gardists of his day in respecting Renoir's work, which has, in later times, not often been considered in its relation to modernism.

13. Conversation with William Dove, who could not identify the newspaper.

14. Reported in the local *Westporter-Herald*, 10 December 1909. It noted that "Mr. Dove will make many improvements to the place."

15. Douglas Hyland, "Alfred H. Maurer," in William Innes Homer, ed., *Avant-Garde Painting and Sculpture in America 1910–1925* (Wilmington: Delaware Art Museum, 1975), 100. Dove's sojourn in France actually overlapped Stieglitz's 1909 visit to Europe. Stieglitz was in Paris the last week in June, but then went to Germany for most of the summer. He was back in Paris at the end of the summer,

but by then Dove had returned to America. Perhaps Dove was traveling elsewhere when Stieglitz was in Paris in June, although Maurer could have seen him then. There is no account of the first time Dove and Stieglitz met, but all indications are that it was in New York.

16. Conversation with artist Lila Howard, Westport, Connecticut, July 1976. The appellation may have originated in a humorous poem written for Howard by Clive Weed, who was at the time the first husband of the second Mrs. Dove.

17. Paul Rosenfelt to Stieglitz, 30 August 1920.

18. For a discussion of the problems involved in identifying these pastels today, see chap. 2.

19. Samuel Swift, *New York Sun*, March 1913. Reprinted in *Camera Work* 42–43 (April–July 1913): 48–49.

20. Maurice Aisen, "The Latest Evolution in Art and Picabia," *Camera Work*, special issue (June 1913): 14–21.

Even years later, in 1924, when Charles Demuth did one of his amusing poster portraits of Dove, he used a large sickle as one of the central elements in the composition to denote Dove's radicalism as well as refer to his farming. (The work now belongs to the Yale University Art Gallery.)

21. As well as being included in exhibitions at Stieglitz's behest, Dove was also treated as a leading modernist in significant articles and books, including Willard Huntington Wright, *Modern Painting and Its Tendency* (New York: John Lane, 1915); Marsden Hartley, *Adventures in the Arts* (New York: Boni and Liveright, 1921); and, most importantly, Paul Rosenfeld, *Port of New York* (New York: Harcourt Brace, 1924), of which a whole chapter was devoted to Dove, as was one to Stieglitz. All of these writers were personally influenced by Stieglitz.

22. He even won an award from the state farm board.

23. In future years, he had frequent assignments from *Pictorial Review, Life, American Boy, Elks' Magazine*, and other popular journals, as well as, less often, from book publishers.

24. Stieglitz to Herbert Seligmann, 9 August 1920.

25. Prosper Buranelli, "Bricks *vs.* Art—A Family Drama," *New York World Magazine*, 30 May 1926, 12, presents a romanticized story, probably based upon what Stieglitz had told the author, about the conflict between the elder and younger Doves. The numerous inaccuracies in the article cast some doubt upon the reliability of the whole.

26. Stieglitz to Paul Rosenfeld, 10 September 1921.

27. Paul Rosenfeld to Stieglitz, 23 August 1921.

28. Conversations with Lila Howard, Westport, Connecticut, July 1976. She sometimes went sketching with them.

29. Stieglitz to Marie Rapp Boursault (a music student who had been the secretary at "291"), 9 July 1918.

30. Stieglitz and O'Keeffe were married in 1924, shortly after Stieglitz's divorce was finalized.

31. As expressed, for instance, in the Diary of Helen Torr Dove, passim, e.g., 30 October 1924. Also recollected by Holly Raleigh Beckwith (the former wife of artist-illustrator Henry Raleigh) in a telephone interview, May 1977. For information on the diaries kept by Dove and Reds, see the introduction to the catalogue.

32. Dove to Stieglitz, late September 1922.

33. Diary of Arthur Dove, 2 April 1924.

34. Dove to Stieglitz, August 1924.

35. Diary of Arthur Dove, 4 December 1924.

36. Dove to Stieglitz, January 1925.

37. Stieglitz to Dove, 27 January 1925.

38. Stieglitz to Dove, 5 February 1925. Dove occasionally drifted into a literary mood and wrote poetry, of which "A Way to Look at Things" is the most successfully constructed example. The text is reprinted in Wight, Dove, 50.

39. Description from the gallery brochure for the show.

40. Diary of Helen Torr Dove, 7 and 8 March 1925.

41. Diary of Arthur Dove, 4 December 1924.

42. Richard McLanathan, The American Tradition in the Arts (New York: Harcourt, Brace and World, 1968), 408.

43. Dove to Stieglitz, 8 September 1927.

44. Letters to Stieglitz are filled with money worries, which were temporarily somewhat alleviated when Dove reluctantly accepted a large loan from his artist-friend Henry Raleigh.

45. Diary of Helen Torr Dove, 21 September 1929. There was a happy ending to this episode: two days later, Dove had a $1,000 commission to illustrate a five-part story.

46. Dove to Stieglitz, probably 8 June 1929.

47. Diary of Helen Torr Dove, 28–30 September 1929.

48. Ibid., 12, 15 and 16 October 1929.

49. Ibid., 21 December 1929.

50. Ibid., 22 April 1932.

51. Dove to Stieglitz, probably 20 August 1931.

52. Duncan Phillips, "Revolutions and Reactions in Painting," International Studio 51 (December 1913): 123–29.

53. Duncan Phillips, foreword to Wight, Dove, 14.

54. Diary of Helen Torr Dove, 9 May 1933. O'Keeffe, however, thought she was quite "hopeful" as a painter, but "you couldn't get Stieglitz intgerested." (Conversation with Georgia O'Keeffe, Abiquiu, New Mexico, November 1975.)

55. Dove to Stieglitz, June 1933.

56. Stieglitz himself never took a commission for sales at any of his galleries, but on a rather informal basis, he made deductions for operating the gallery, for the "Rent Fund," as he called it at An American Place. Often, he took nothing from Dove's sales because of Dove's obviously urgent need for the money.

57. The latter practice, though thoughtless, was not malicious, nor was it different from the practice of many other collectors or museums even today.

58. After Arthur had been in Geneva for a couple of years, Paul started spending long periods of time elsewhere. In conversation with me, he admitted he went off so that Arthur could do what he wanted.

59. Dove to Stieglitz, 2 February 1934.

60. Dove to Stieglitz, 1 or 2 May 1934.

61. Presumably Dr. Dorothy Loynes, a psychiatrist, whom they met in March 1934 and quickly befriended.

62. Dove to Stieglitz, 17 and 21 September 1934.

63. Phillips to Dove, 16 December 1933 (William Dove collection).

64. Dove to Phillips, January 1934 (Phillips Collection archives).

65. Dove to Stieglitz. Among Dove's papers there exists a draft of a letter in Reds's handwriting to the head of the program in Buffalo. Overall, it is a polite inquiry into the possibility of submitting older work to the program and asking for details. It includes some revealing comments:

> You see my work is partly research and it sometimes leads into strange paths—not to painters so much as to the public.
>
> I have never known a government intimately so do not know how it would feel on such questions.
>
> .
>
> This is creative work, so I am told and I am wondering how it can be paid for by the hour. . . . Where values do not exist— well there art begins—so I am writing this to learn more of what is expected.

66. Dove to Stieglitz, 10 or 11 June 1934.

67. Ibid., 17 March 1937.

68. Ibid., 28 April 1936.

69. Ibid., 28 April 1936.

70. Ibid., probably after 17 May 1937.

71. Ibid., 14 or 15 June 1937.

72. Ibid., 14 or 15 June 1937.

73. Stieglitz to Dove, 8 June 1934.

74. Dove to Stieglitz, 25 March 1938.

75. Ibid., probably 30 June 1938.

76. Ibid.

77. Ibid., probably 10 September 1938.

78. Stieglitz to Phillips, 3 June 1939 (Phillips Collection archive).

79. Conversations with William Dove.

80. Dove to Stieglitz, between 5 and 8 May 1939.

81. Ibid., 3 July 1939.

82. Ibid., 26 September 1939.

83. Ibid., 3 March 1940.

84. Conversation with Dr. J. C. Bernstein, Centerport, New York, June 1977.

85. Dove to Stieglitz, probably 17 November 1942.

86. Ibid., 27 January 1943.

87. Ibid., probably 8 August 1945.

88. Stieglitz to Duncan Phillips, 1 June 1946 (Phillips Collection archives)

89. Dove's mournful state of mind later that summer or early in the fall is suggested by a fragment of a draft of a letter to his brother, Paul, and his wife. It includes the following passage:

Everything here and in the rest of the world, radio etc., has been so upset, it is hard to sort things out. With Stieglitz's death, Paul Rosenfeld too, Marin & I with heart attacks, there is more to be done than any of us can. (William Dove Collection)

90. "Arthur Dove Dies; Abstractionist, 66," *New York Times*, 24 November 1946, 78; "Arthur G. Dove, 66, Abstract Painter," *New York Herald Tribune*, 24 November 1946, sec. I, p. 46.

The Art of Arthur Dove

THE UNASSUMING TONE OF DOVE'S BIOGRAPHY REVEALS HIS INDIFFERENCE TO THE CULT OF personality, along with his uncompromising commitment to quality of feeling and facture in the work to which he was so fully dedicated.

In most of this work, Dove amalgamated in varying proportions the two major ingredients of his art: nature imagery and pure, abstract form. The first element derives from a deeply felt American tradition; the second is a response to the most advanced, twentieth-century ideas in art. The balance between these components swings from the extreme, on the one hand, of paintings that come close to being "realistic" (in commonsense terminology, designating interpretations of the world as it is normally experienced) to, on the other hand, paintings in which pure form so predominates that nothing but the smallest vestiges of natural imagery can be perceived. This chapter describes the major tendencies in Dove's art throughout his career. Yet, paintings that do not exemplify the larger pattern are to be found at nearly every point, thus revealing Dove's flexible and undogmatic approach to painting.

Because the documentation is copious and usually clear,[1] there are few major problems in dating Dove's paintings after 1925, in the last two decades of his life. These were the abundant years of his painting career. Earlier, however, for what amounts to nearly an additional two decades, problems of dating abound. Documentation is sparse, and conjecture must play a discreet and intelligent role in establishing chronology.

Of Dove's earliest work, his juvenilia, nothing is known today.[2] There are drawings that date to his college days and, of course, a substantial number of illustrations from the years between 1903 and 1908 when he worked in New York. But from this time, only one oil painting is known (07.1).[3] *Stuyvesant Square*, which is dated 1907, depicts the New York neighborhood where the artist lived at the time when he painted it. The imprecise definition of form and muted colors of this painting relate it to the subjectivist, tonalist late-Impressionism *au courant* in the United States around the turn of the century. Thus the painting indicates Dove's appreciation of that day's "mainstream esthetic,"[4] of which James A. M. Whistler had been the fountainhead. George Inness, Dwight Tryon, Thomas Dewing, Alexander Wyant, and Homer Martin were among the American progenitors of this vogue for inexplicit illusion combined with private but vague and usually somewhat melancholy feeling. Their penchants for mood and suggestion link them to the generalized Symbolist currents that were ubiquitous by about 1900.[5]

In 1908, once he had arrived in France, Dove quickly shed the somber, introspective

temper of his earliest known work. Many of the paintings that can be documented from his sojourn abroad cannot be located today, but those that are known indicate that Dove quickly took up a more forceful approach to brushwork and to compositional definition. He enlivened his works with the bright pastel colors that are so masterfully orchestrated in the late works of both Monet and Renoir[6] and that were to be seen in the contemporary work of their French epigones. Audacious pinks and resounding purple-blues are seen in these works done in 1908 and probably into the early months of 1909.

Before Dove left France, he abandoned Impressionism and began to work in a manner that is clearly indebted to fauvism, a style with which his friend Alfred Maurer had already had some practice. Dove described the process of thinking that had taken place behind his artistic development in a letter he wrote in 1913 to the author and collector Arthur Jerome Eddy at the latter's request:

> This same law held in nature, a few forms and a few colors sufficed for the creation of an object. Consequently I gave up my more disorderly methods (impressionism). In other words I gave up trying to express an idea by stating innumerable little facts, the statement of facts having no more to do with the art of painting than statistics with literature.[7]

Dove's course of departure from "disorderly methods" is not entirely clear, as the two most important paintings he did in France present contradictory evidence. One of these, *Bridge at Cagnes* (09.1), is the largest and most impressive of the known Impressionist paintings he did in France. A winter scene, it must have been painted during the cold months of 1908–9 when Dove was in the south of France. The completion date of February 1909, which appears on the reverse, seems reasonable. However, the second important painting from the French sojourn raises problems for the chronology of Dove's development. *The Lobster* (08.1), a brightly colored painting of strongly defined forms, differs markedly in character from the Impressionist landscapes; suggests a nascent interest in fauvism (although the colors are predominately natural, local ones, rather than the distorted, anti-naturalistic ones of Matisse and his followers); and hints at subsequent developments in Dove's work in its interlocking, rounded shapes and insistent rhythms. However, this painting is signed and dated "08." Did Dove work back and forth between Impressionist and fauve influences while he was in France? Does this brilliantly colored still life in fact predate the more delicate *Bridge at Cagnes*? Perhaps, but maybe Dove signed and erroneously dated *The Lobster* after his return to the United States, when it was shown in New York. The exhibition history of *The Lobster* suggests that this might have been the case.

When Dove sailed for New York in 1909, he left this painting behind to be entered in the "Salon d'automne" a few months later. Then, after he had met Stieglitz at the end of 1909 or early in 1910, this painting alone represented his achievements when he exhibited in a group show of "Younger American Painters" at "291" in 1910. These exhibitions were both shows in which Dove surely wished to present himself well and to display the modernity of his painting. Later, Dove, like most artists, always considered his most recent work his most interesting and important. It might be expected, then, that Dove would show in both these exhibitions one of the last paintings he had done in France, as evidence of the progress he had made during his trip abroad. Thus, because it is difficult to imagine Dove fluctuating between Impressionist and fauve influences, as the dates on the two paintings would suggest, and because it does not seem entirely plausible that Dove would select as the best painting from this important trip one that he had completed more than six months before he left Europe, it seems possible that Dove signed the work later, probably for the 1910 show, when he had forgotten the exact date of completion.

Whether in fact the dates are correct and Dove did alternate between two manners or whether the dates are misleading and his actual line of development was a more logical one through Impressionism to fauvism, the point is much the same: While Dove was abroad, his art became more sophisticated as he attempted to make a personal expression out of available Impressionist and Post-impressionist examples. Whatever the exact sequence of his development, however, his work remained relatively conservative if measured against the most avant-garde developments that transpired in Paris during his stay in France. In *The Lobster* and then in a few other coloristically more adventurous paintings, such as *Landscape* (09.2), he had only begun to experiment with the arbitrary colors of fauvism, which was by this time passé in the French capital. His work shows no evidence of exposure to the early Cubist developments of those years.

Despite its conservatism in the context of international avant-gardism, *The Lobster* gave Dove his first taste of the vituperative reactions his work was to incite in the art press. One critic described the painting as the "delineation of a diabolical lobster who died a horrible death."[8] The opinion of another was that "Arthur Dove used to illustrate, but he went to Europe and was attacked by the epidemic [of modern art] rather badly, too, juding from his picture of fruit."[9]

Although in 1910, in his thirtieth year, Dove was still a follower of tendencies, he was on the verge of a personal artistic breakthrough. It was evidently in this year, or possibly the next, that Dove produced a group of six small, abstract oils (10/11.1–10/11.6). Their sketchy character and the fact that the artist did not exhibit them during his lifetime[10] support the likelihood that Dove considered them studies rather than finished paintings. Though they lack clearly identifiable representation, it is not difficult to see that some of them derive from landscape. As he had done more smoothly in the earlier, representational *Lobster* and would do in a succeeding group of pastels, when Dove wrestled with the problem of abstracting aesthetically successful form from nature, he often echoed the form consciousness of art nouveau, with its love of curvilinear, decorative form suggesting the vitality of nature.[11]

The shapes and color schemes in these paintings are relatively simple, although the irregular forms are not always clearly defined and color does not always conform to shape. However, as is the case with Dove's oeuvre generally, color is essential to the control of these compositions. For instance, in *Abstraction No. 2* (10/11.2), the simplest of the six compositions, the artist has given order to the effect through color; repeated areas of bright pink and blue and toned-down greens surround the central yellow shape, which is anchored by a splotch of the same pink and blue that occur around the periphery.

There is no documentary evidence for the date of these six oils, but stylistic considerations validate the 1910/11 date. The little paintings belong to a recognizable line of development in the artist's career; as a group, they are closer than any other paintings in spirit, form, and color to the 1909 *Landscape* and other fauve-oriented paintings also presumed to be from 1909. The rhythms of line and placement of shapes in the six abstractions recall the patterned background of *The Lobster*. Also, they are more tentative and less assured than works that can be securely dated to 1911/12. Thus, because they resemble the later examples of illustionistic painting by Dove but fall short of the resolution found in the abstract pastels of 1911/12, these works seem to fit most comfortably into the artist's development if they are dated 1910/11.

If the 1910/11 date is correct, the abstractions were surely original in concept. The very notion of a purely abstract art was unknown before that time, although in Germany in 1910 the Russian-born Wassily Kandinsky was experimenting at the borderline of abstraction. It is virtually impossible that Kandinsky's earliest abstract work directly influenced Dove's, although it is possible that Dove had seen in Paris a few of

Kandinsky's expressionistic landscapes of two or three years earlier. The Russian artist himself had been in Paris for a year in 1906–7,[12] but his departure, of course, predated Dove's arrival in 1908. Nonetheless, Kandinsky exhibited regularly in the "Salon des artistes indépendants" and the "Salon d'automne," including those that occurred in the year that Dove was there.[13] Both artists had entries in the "Salon d'automne" of 1908, but the evidence is insufficient to prove what specific, proto-abstract works Dove might have seen. The first abstract Kandinsky painting Dove undoubtedly saw was the single example in the Armory Show, the 1912 *Improvisation No. 27* (Metropolitan Museum of Art), which Stieglitz purchased from the show.[14] But by 1913, Dove's abstract style had already crystallized into something personal and quite different. Much more important to Dove as an example of the possibility of a purely abstract art was the virtually nonrepresentational Picasso *Nude* (Metropolitan Museum of Art), a charcoal drawing of 1910, which Stieglitz purchased from the show of Picasso work held at "291" early in 1911.[15] (By this time, however, Dove may have already done the six little oils.) What many critics have remarked as formal resemblance between the early Dove abstractions (including both the 1910/11 oils and some of the works from the succeeding few years) and some Kandinsky work from late in the first decade is a superficial correspondence resulting from their similar tactics of starting with the forms of landscape as the basis of nonrealistic compositions.

Whatever the exact date of the six oil abstractions and whatever Dove's awareness of

Wassily Kandinsky. Improvisation No. 27. 1912. Oil on canvas. Metropolitan Museum of Art, New York (Alfred Stieglitz Collection, 1949).

Pablo Picasso. Nude. 1910. Charcoal drawing. Metropolitan Museum of Art (Alfred Stieglitz Collection, 1949).

Kandinsky's development of an abstract art, the important point is that each of these artists "invented" nonillusionistic painting for himself. Moreover, other artists probably did the same. For instance, Abraham Walkowitz and Max Weber may also have done abstract studies as early as Dove's.[16] The extent to which artists in general were intrigued with abstraction is suggested by the fact that the realist painter Robert Henri "occasionallly succeeded in eliminating all representational elements" in color studies as early as 1909.[17] The more evidence that comes in, the more it seems certain that the tendency to abstraction was so much in the air by 1910 that any number of American and European artists experimented with abstraction around that time.

What is much more important is Dove's singular accomplishment with an abstract art before March of 1912 when he was the first American artist to exhibit publicly a body of work in a personal, nonillusionistic style. A show of this work, Dove's only one-person exhibition at "291," opened 27 February 1912 and was seen the following month at Thurber's Gallery in Chicago. In both cities the work created a stir, but unfortunately, the contents of the exhibition are not easy to identify today.[18] There was no catalogue or printed exhibition list to accompany the show, which consisted of ten abstract pastels.[19] Later, these ten works came to be known as the "Ten Commandments," but no contemporary reviewer used that appellation. However, it is clear from the reviews that the ten works formed a stylistically homogeneous group and that they were all nonrepresentational. As well, some reviews describe individual pastels with sufficient specificity to make identification of those pastels reasonably certain.

Ironically, the only one of the "Ten Commandments" that can be identified with absolute certainty is one that is lost today and may well be destroyed. Known as *Based on Leaf Forms and Spaces* or, more simply, as *Leaf Forms* (11/12.1), this pastel was bought from the Chicago show by Arthur Jerome Eddy, a Chicago lawyer and art enthusiast, who illustrated it in color in his 1914 book, *Cubists and Post-Impressionism*. Given this work as a starting point, we may presume that the other nine were stylistically compatible and that they were identical, or nearly so, in size and medium. Although it is certainly possible that one or more of the other items in the original group are lost today, nevertheless there are many more than nine known pastels with dimensions nearly identical to *Based on Leaf Forms and Spaces*. Moreover, all of these are generically related in style in that they are abstractions derived from natural forms.

Five of these seem to match so nicely with contemporary descriptions that their identity as "Commandments" seems quite certain. These are *Nature Symbolized No. 1*, or *Roofs* (11/12.4); *Nature Symbolized No. 2*, or *Wind on a Hillside* (11/12.5); *Nature Symbolized No. 3*, or *Steeple and Trees* (11/12.6); *Sails* (no. 11/12.8); and *Team of Horses* (11/12.9).[20] Including *Based on Leaf Forms and Spaces*, then, we have six fairly certain components of the "Ten Commandments."[21]

These six share stylistic characteristics that aid in choosing among the other candidates for the "Ten Commandments." They all have compositions of clearly defined shapes that are predominantly organic, often recalling a heritage in art nouveau.[22] Earth colors reign, while a rich luminosity of surface and effects of innate radiance enliven the works. The boundaries of shape and color usually coincide, though hue often varies in intensity or value within a given shape. Compositions tend to be ordered by the repetition of identical or similar shapes, and rounded forms are particular favorites. Forms that taper off to a point, like commas or sawteeth, are also frequently used.[23] (As he devised these compressed repetitions of rounded forms, Dove must have looked closely at certain Picasso works that had been shown at "291"— notably the drawing of a head that Stieglitz had purchased.)

On the basis of stylistic characteristics, three other pastels can be ascribed to the "Ten Commandments" with considerable plausibility. They are *Plant Forms* (11/12.7), *Circles and Squares* (11/12.2), and *Movement No. 1* (11/12.3).

Plant Forms, with its large, clear, organic forms in rich, earthy tones, has the same dense packing of overlapping shapes as is the case with others among the six sure "Commandments," such as *Nature Symbolized No. 1* particularly, and some of its forms pulse with the same sort of radiance. This pastel is probably the one described by a 1912 witness as consisting of "fronds of lilies, or agaves."[24] Agaves, which include the century plant, the maguey, and the yucca, consist of fleshy, sharp-edged, thrusting leaves, the character of which would seem to be admirably transcribed by *Plant Forms*. *Circles and Squares*, today unlocated, must be one of the two pastels (*Nature Symbolized No. 1* was the other) described by a 1912 reviewer as "circle-and-right-angle studies."[25]

Movement No. 1 is more thoroughly abstract than any of the other known images in the "Ten Commandments" series,[26] it suggests less three-dimensional space, and it is executed with a more limited palette. These aspects all suggest a slightly later date in Dove's development, yet the work as a whole does not share the character of the later, c. 1912/13 pastels. Possibly, this was one of the last "Commandments" to be done. In any case, on the basis of its simple, clear shapes; the sense of radiance generated from within the forms; the tight composition; and the use of lines only as boundaries, this work can be seen to fall within the general stylistic confines of the "Ten Commandments."[27]

This inventory of the "Ten Commandments" gives us seven extant pastels, one identified through an illustration and one known only by title, for a tital of nine. Given the strong visual coherence of the eight known images, it seems likely that number ten, like *Circles and Squares*, is lost, since a good case can be made on stylistic grounds for excluding all of the other extant pastels of the same dimensions.

If the mystery "Commandment" is not lost, then it must be among the pastels that are here dated to 1912 or 1913. If it is one of these, however, then it is stylistically aberrant within the group, for all of the 1912 and 1913 known images reveal other interests than those that typify the pastels that certainly belong to the "Ten Commandments."

The works here dated c. 1912–13 consist of pastels that extend many of the same qualities as the identified "Ten Commandments" pastels and therefore were presumably completed within a year or so after the 1912 show, while Dove maintained an interest in extending the series that had brought him such attention. During the same two-year period, and perhaps extending into 1913, Dove also produced some oil paintings, in which he can be seen to be pursuing the same objectives and exploring similar picture-making problems as in the concurrent pastels. (These oils are dated c. 1912/14 in the catalogue.)

A clue to Dove's development within his extended pastel series is to be found in the statement he wrote for Arthur Jerome Eddy late in 1913, while the series was possibly still in progress. Dove wrote (in his usual, somewhat impenetrable manner), immediately after his previously cited comments on giving up the "disorderly methods" of Impressionism, as follows:

> The first step was to choose from nature a motif in color and with that motif to paint from nature, the forms still being objective.
>
> The second step was to apply this same principle to form, the actual dependence upon the object (representation) disappearing, and the means of expression becoming purely subjective. After working for some time in this way, I no longer observed in the old way, and, not only began to think subjectively but also to remember certain sensations purely through their form and color, that is, by certain shapes, planes of light, or character lines determined by the meeting of such planes.

With the introduction of the line motif the expression grew more plastic and the struggle with the means became less evident.[28]

When he described the "first step," Dove was probably thinking of the pastels that are here grouped together as the certain components of the "Ten Commandments," since in all of those, identifiable, "objective" forms from nature are clearly visible. Dove then,

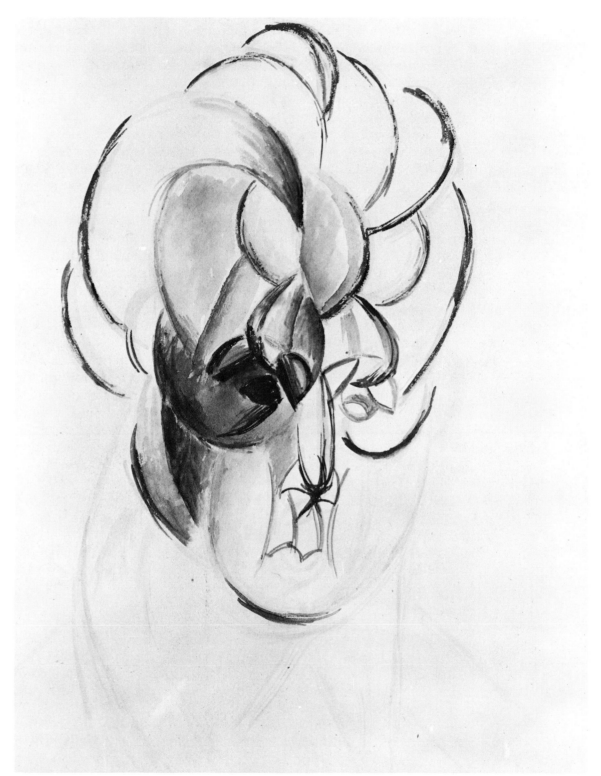

Pablo Picasso. Head. 1909. Ink and watercolor. Courtesy Art Institute of Chicago (Alfred Stieglitz Collection).

in a succeeding group (those here dated c. 1912/13) introduced the "line motif," so that the "expression grew more [purely] plastic [i.e., less representational] and the struggle with the means became less evident" (i.e., the works took on a more relaxed character). Dove's description of his evolution accords quite well with what we can see occurring in the pastels of the c. 1912/13 group. *Cow* (12/13.3),[29] presumably one that Dove and Stieglitz both thought particularly successful, since it went into Stieglitz's collection, clearly exemplifies this development. Obvious here is the introduction of the "line motif," i.e., a free and wandering line that exists independently of illusionistic purpose.[30] None of the "Ten Commandments" pastels displays this kind of linear freedom, which leads to a greater integration of the surface plane and the forms disposed upon it. Once he had discovered this new mechanism, Dove did not go back to the solid, three-dimensional forms that fight for space in the "Ten Commandments" group. Now, his nature-derived "planes of light" flow and melt into one another in an interplay of representation and suggestion. His own "struggle" to wrench abstract forms from natural ones subsides, or at least becomes less obvious. The insistent repetitions of forms, as seen in the "Ten Commandments" compositions, give way to fluid echoes that unify the compositions less obviously but no less successfully. The earth tones of the "Ten Commandments" series continue into the later works, but in at least some of the c. 1912/13 group, Dove seems to have tried to enhance the unity of the surface by further reducing the number of colors displayed upon it.[31] Besides *Cow*, other pastels that clearly manifest these new characteristics are *Calf* (12/13.1), *Yachting* (12/13.6), and *Connecticut River* (12/13.2). *A Walk: Poplars* (12/13.5) contains fewer, more definite forms but seems to belong with the c. 1912/13 group in its use of freely brushed lines on the central "tree trunk" and the wandering line that creates biomorphic shapes on a diagonal off to the right. Its overall flatness and loose dispersal of shapes relate it more nearly to this group than to the earlier one.

In view of the fact that Dove was always more susceptible to verbally transmitted ideas than to visual precedents in his art-making process, the development of this group of pastels might be linked to the philosophy of Henri Bergson, whose admiration for intuition, as opposed to intellection, made him popular with the Stieglitz group. In *Camera Work* late in 1911, Stieglitz had published "An Extract from Bergson," which could have stimulated Dove's thinking when he had time, after his show early in 1912, to read it carefully and cogitate upon its implications for his art. Most relevant from the *Camera Work* passage is the following:

> Our eye perceives the features of the living being, merely as assembled, not as mutually organized. The intention of life, the simple movement that runs through the lines, that binds them together and gives them significance, escapes it. This intention is just what the artist tries to regain . . . in breaking down, by an effort of intuition, the barrier that space puts up between him and his model.[32]

Here, Bergson seems almost to give a verbal description of Dove's method as he developed the "line motif" and the more fluid, flatter compositions. In these, indeed he seems to strive to grasp "the intention of life, the simple movement that runs through the lines," and not just to stylize from the visual appearances of nature, as he had been doing in the "Ten Commandments." He also tried to break down "the barrier that space puts up between [the artist] and his model."

The Armory Show and Stieglitz's immediately following exhibition of the latest, completely abstract paintings by Picabia seem to have deflected Dove's interests, at least momentarily, from the major ones of the c. 1912/13 pastels. At this time, Dove produced two works more directly dependent on Cubism than anything else in his oeuvre. The 1913 date (it is difficult to read, but appears, plausibly enough, to be that year) is inscribed on the reverse of *Music* (13.1), one of the two "Cubist" works, and is

the basis for grouping three works with the date of c. 1913 in the catalogue. *Music*, with its fans of planes, and *Pagan Philosophy* (13.2), with its jagged, interlocking forms, are dynamic interpretations of Cubist devices. *Pagan Philosophy* is a pastel, which again appears to extend the "Ten Commandments" series, as does *Sentimental Music* (13.3), since these are both the same size as the earlier group. *Sentimental Music*, like the other two works here dated to c. 1913, is completely nonreferential in its forms, and its title, like those of *Music* and *Pagan Philosophy*, does not specify anything visual. In both these respects, these three works differ from all the earlier pastels. The blue-and-pink *Sentimental Music* (is the title an ironic reference to the tough-minded *Music*, which he may already have completed?) can be seen as a more personalized response to analytic Cubism than *Music* or *Pagan Philosophy* (both of which adapt the conventions of that style).[33] Its ambiguously undulant surface recalls the flickering tensions of the surfaces of the most abstract phase of orthodox Cubism, but its character is organic rather than crystalline. The freed line of the c. 1912/13 pastels appears here, too, with greater velocity; perhaps its nervous energy betrays Dove's careful study of the Kandinsky painting Stieglitz bought from the Armory Show.[34]

The possible visual relation to Kandinsky seen here is supplemented by an important theoretical one. Dove's most completely abstract paintings to date—*Music* and *Sentimental Music*—demonstrate that he, like Kandinsky, was aware of the philosophical and aesthetic linkage between music and the formal components of visual art. This connection made possible the justification for abstract painting on the grounds that it followed the precedent of music, which relies entirely on abstract means but nevertheless touches the soul.[35] Interestingly, even much later, in the twenties and again in the thirties, Dove reached peaks of purity in abstraction in musically titled works.[36]

Even by the time Dove was doing these paintings of c. 1913, the documentation of his work, sparse to begin with, was diminishing to virtually nothing. On the assumption that a final group of early paintings, both oils and pastels, postdates the others already discussed, these works are here assumed to be no earlier than 1914. The 1917 date for the end of production of this group is conjectural but cannot be too far off. Dove's and Stieglitz's letters indicate that Dove had not been painting for some time, probably more than just a year or two, when he finally went back to it in that fateful last summer in Westport, 1921, just before he and Reds began living together. It seems reasonable to assume, then, that after "291" closed at the end of the 1917 season, Dove painted very little, if at all. He now felt he had no "home" for his work, and he was preoccupied with increased activity in his illustrating career. Furthermore, at some point, he did a group of large, strong, charcoal drawings, several of which served as the basis of paintings done in the early 1920s. A break in his painting late in the second decade would accommodate the production of the drawings.

In the paintings apparently done between 1914 and 1917, the freedom Dove previously had achieved with line now is extended to surface. In a closely related oil painting, *Number 1* (14/17.5), and pastel, *League of Nations* (14/17.4), Dove attained broad, freely executed surfaces within simply structured compositions. Other works from this period, such as *Abstraction* (14/17.2), virtually abolish composition in the traditional sense.

Although the chronology reconstructed here may have to be revised as additional paintings and/or documents come to light, it is clear that by the time Dove stopped painting late in the second decade, he had already accomplished a body of extraordinarily original work in a period of some six or seven years.[37] Following the prelude of the unexhibited six abstract oils, which reach beyond precedent, Dove produced the first truly major work of his career, the astonishing "Ten Commandments," which, independently of Kandinsky, authoritatively posit the existence of organic or

biomorphic abstraction. He shortly went on to create an abstract style based not merely on how things look but on an intuitive expression of the very forces that animate the biological universe.

To achieve all this in so short a time, Dove naturally absorbed precedents available to him, but as would characteristically be the case throughout his career as a painter, what he borrowed he completely transformed. He must have learned much from art nouveau about the potential for achieving decorative and expressive effects through the stylization of natural form. This was less a direct "influence" (in the sense of something he consciously studied) than it was an unavoidable sensibility around the turn of the century. If there was any one direct influence on the formulation of the "Ten Commandments" style, it must have been Picasso's work. The 1910 Picasso *Nude* drawing, already mentioned, was an exemplar of the possibility of a totally nonillustionistic art,[38] but its particular style is not reflected in the "Ten Commandments." More immediately influential on Dove's development were the many slightly earlier Cubist works Picasso showed at "291" in 1911. From these, Dove probably learned much about simplification and abstraction from natural form. For instance, a drawing such as Picasso's Art Institute of Chicago *Head* (which was shown in the 1911 exhibition and was purchased by Stieglitz) demonstrated to Dove how to extract pattern from observed nature, and its insistent, interlocking arcs suggest the same kind of form that would appear in several of Dove's "Ten Commandments."[39]

In the succeeding year or so, as Dove developed the c. 1912/13 pastels, he achieved in works such as *Cow* and *Calf,* two highly original elements. First, he attained an ambiguous resolution of three-dimensional space and picture plane by abandoning the emphatic, illusionistic space of the "Ten Commandments." In this development, he followed the path of Cubism from its analytical to synthetic phase but did so within the terms of his own organic vocabulary. Even more strikingly individual was his development of a free-flowing line that is very different from Kandinsky's energizing, discontinuous strokes and that would seem to have no evident precedent. The quality of the line in Dove's work of this time already anticipates surrealist automatism, a situation that is probably not gratuitous, for Dove, from an early date, was always looking for ways to express the "whole," unmonitored self. In 1916 he put this down in his rather home-grown way as follows:

> My wish is to work so unassailably that one could let one's worst instincts go unanalyzed, not to revolutionize or reform but to enjoy life out loud. . . . That is what I need and indicates my direction.[40]

Dove's on-and-off development of free, linear themes would lead to many points of contact between his work and that of the more abstract surrealists (such as Arp, Miro, and Masson) and their New York School successors, especially Gorky, but also including Baziotes, Stamos, Rothko, and others.[41]

In the works of the c. 1914/17 period, Dove expanded the implications of the unpremeditated line into works of exceptional compositional freedom, works that bear closer relationships to the *informel* painting of the late forties and fifties than to anything of his own day. In fact, the uncomposed structure of *Abstraction* (14/17.2) and the encrusted surface of *Abstraction* (14/17.1) were so radical that Dove himself retreated from such extremes.

After the period from c. 1917 to 1921, during which Dove's creativity was restricted to charcoal drawings, he returned to painting abstractions from the natural world. Some of these are again nature abstractions, but others, which introduce mechanical abstractions into his oeuvre, demonstrate Dove's interest at this time in the machine as a symbol of modernity. In addition, there are a few totally nonrepresentational works that seem to have been done at this time. As is the case with much of the work from the

Abstraction No. 6. 1910/11. 8⅜ × 10½. (cat. no. 10/11.6)

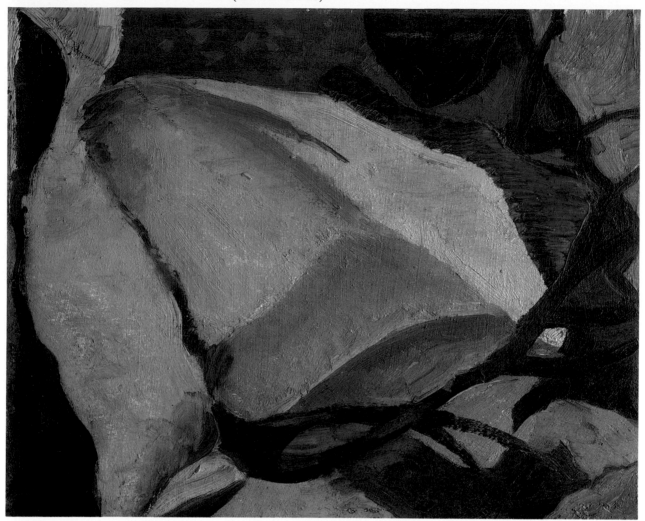

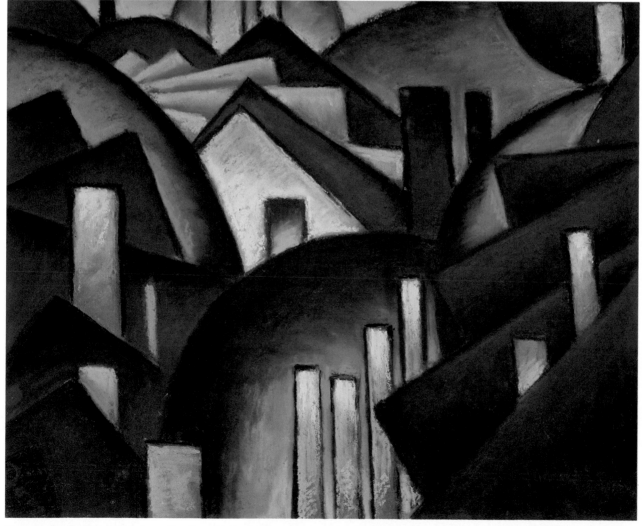

Nature Symbolized No. 1, or Roofs. 1911/12. 18 × 21½. (cat. no. 11/ 12.4)

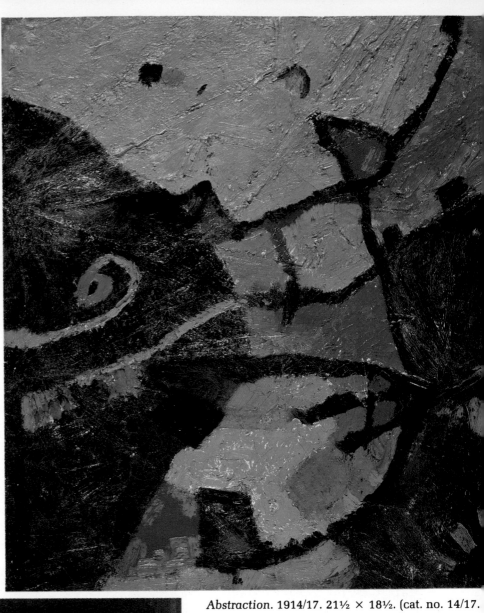

Abstraction. 1914/17. 21½ × 18½. (cat. no. 14/17.

Dark Abstraction. c. 1920. 21½ × 18. (cat. no. 20.2)

Abstraction. 19/14. 10½ × 8½. (cat. no. 14/17.2)

Penetration. 1924. 22 × 18⅛. (cat. no. 24.5)

Starry Heavens. 1924. 18 × 16. (cat. no. 24.8)

The Critic. 1925. 19¾ × 13½. (cat. no. 25.2)

Rope, Chiffon and Iron. c. 1926. 7 × 7. (cat. no. 26.6)

Seaside. c. 1926. 12½ × 10¼. (cat. no. 26.8)

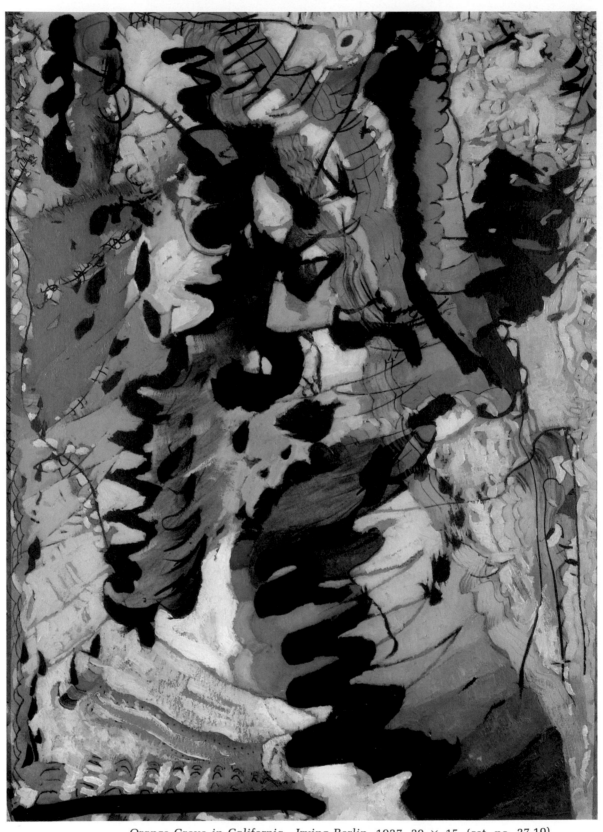

Orange Grove in California—Irving Berlin. 1927. 20 × 15. (cat. no. 27.10)

teens, the work from the early twenties is difficult to arrange chronologically and the sequence proposed here may be subject to revision as additional paintings are located.

The almost nonreferential charcoal drawings done during the hiatus in his painting may have served Dove as sources of ideas over a period of as much as three years. *Dark Abstraction* (20.2), which is closely based upon one of those drawings, seems to have been done soon after Dove's return to painting, while *Penetration* (24.5), which is based on another, is documented in 1924 within a context that suggests it had been recently completed.[42] These drawings and the ensuing paintings are near to complete abstractions, but they are more structured than the very loose compositions of c. 1914/17. They all comprise large, handsome forms that insinuate only very limited three-dimensional space.

After the Storm (23.2) demonstrates the renewal of Dove's interest in stylizing from the natural environment, while *Terre Verte, Golden Ochre* (21.4) and *Chinese Music* (23.3) document his desire to work at times without reference to visual reality. Two of the strongest paintings from the early twenties, *Gear* (22.2) and *Lantern* (22.3), derive from mechanical imagery. The adoption of the machine as a source of forms, particularly for semiabstract contexts, was in itself not original in the early twenties. Dove had, of course, known Duchamp's and Picabia's mechanical abstraction years earlier, and probably he knew Morton Schamberg's. He knew Paul Strand's photographic abstractions from machine-produced items, going back to as early as 1914 or 1915. And he was aware of the developing Precisionist tendency in American modernism of the twenties (including some works by O'Keeffe and Demuth, for instance). As is so often the case, what is remarkable about Dove's adoption of an idea is the thoroughness with which he assimilated it and made it his own. For, in the final analysis, *Grear* and *Lantern* pulse with the same generative rhythms that underlie his nature paintings, and their rich surfaces almost obliterate the mechanical, cold nature of the initial inspiration. Dove did not do many paintings as clearly derived from mechanical forms as these are, but throughout his career, beginning as early as the "Ten Commandments" (*Nature Symbolized No. 1* and *No. 3*), there are many paintings that incorporate the built environment as part of a whole, predominantly organic environment. Whereas most American modernists were attracted, particularly in the twenties, to architectural and mechanical motifs because these forms easily provided the basis for a kind of Cubistic abstraction, Dove always subsumed architecture to the pictorialization of natural forces.

From 1924 on, with only a few exceptions, the dating of Dove's work becomes relatively straightforward because of the existence of exhibition lists, diaries, and other documentation.[43] In that year, Dove began to produce the assemblages that include several of his most popular works.[44] Most of them were completed by 1926; the last was done early in 1931. A handful of them might be called collages,[45] but most of them are more properly assemblages, since they are compositions of three-dimensional objects affixed to a flat ground. In a number of them, the objects project as much as an inch or two from the background, so that a projecting frame is required to protect the work, and sometimes the depth is sufficient to suggest a shadowbox. The assemblages form a group in terms of the way that they were made, but they vary considerably in intent and meaning.

The assemblages that have a distinctly representational aspect are generally lighthearted—sometimes whimsical, sometimes humorous. *Huntington Harbor* (24.2) brings together found and crafted elements to form a "picture" suggestive of life on the island. Beyond a foreground established by a wire mesh "fence" and a post that seems to support a Long Island Railroad sign, sail two boats. The nearer one, on the left, has an enormous mainsail cut from *Yachting* magazine stationery, while the other ship, which sails toward us, is a cut-out magazine illustration. Beyond some fabric hills rises another vision of *Yachting*, while two gargantuan flowers and an out-of-scale

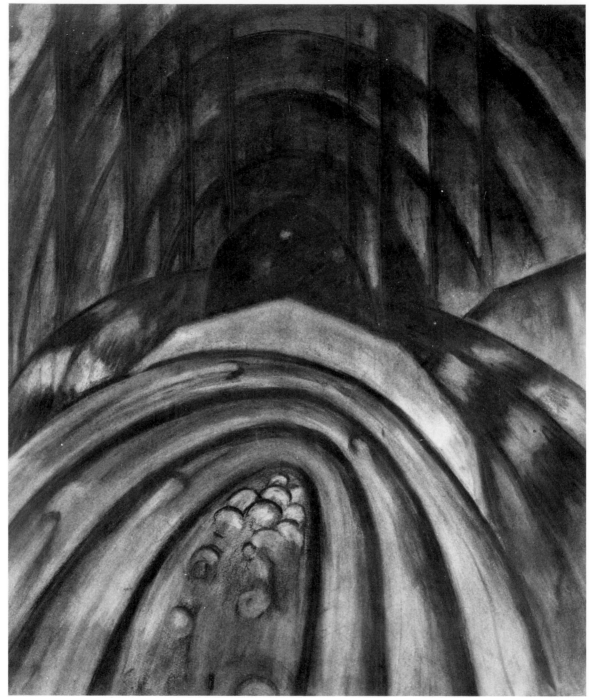

No. 4 Creek. c. 1920. Charcoal drawing. Corcoran Gallery of Art, Washington, D.C.

scallop shell bring elements of fantasy to the scene and aid its formal cohesion. A rope "frame"[46] limits this "reality."

The fanciful charm of *Huntington Harbor* is very different from the ironic humor of *The Critic* (25.2). This figure was probably intended to mock the conservative Royal Cortissoz,[47] who had characterized Dove's entries in the 1925 "Seven Americans" show as "strained pleasantries."[48] Dove's empty-headed "critic," with dangling monocle signifying his inability to "see," careens unsteadily through the art world on roller skates, vacuuming up art like so much dirt. Top-hatted to indicate the old-fashioned formality of his attitudes and made of nothing more substantial than newsprint, he strikes a genuinely funny chord for the viewer who deciphers the several jokes.

A number of the more profound, nonrepresentational assemblages also depend for maximum effect on a reading of the individual identity of each of their constituent parts. The portrait of Stieglitz (24.1), for instance, is an entirely abstract compilation of found objects.[49] Its meaning depends on the indeterminate symbolic values of each component. The major element in the composition is a photographic plate, quite simply signifying Stieglitz's profession. At the top of the assemblage is an element of more ambiguous meaning. It has often been identified as a camera lens,[50] but Dove referred to it as a mirror.[51] In any case, it is smoked to relieve its clarity and probably is intended to suggest, in one way or another, Stieglitz's "vision" or eye on the world. The coiled spring must be intended to suggest Stieglitz's energy, while the steel wool more literally connotes his bristling hair and moustache.

Other assemblages are richly suggestive, although they cannot be "read" in this fashion at all. One of the most successful of these is *Goin' Fishin'* (25.3), which combines the bamboo of a fishing pole with denim clothing, bark, and wood to evoke a Huckleberry Finn ambience within a rich and satisfying formal arrangement. Still others of the assemblages have no referential aspect, but are simply interesting aggregations of materials, more and less transformed by the artist. *Plaster and Cork* (25.13) and *Painted Forms, Friends* (25.11) exemplify this type. A surprising extension of the assemblage technique is to be seen in one of the very few sculptures that Dove exhibited. *Silver Cedar Stump* (29.15) is an unaltered piece of weathered wood, a natural found object, so to speak, and probably the first such object to be exhibited as art in New York.[52]

Naturally, Dove knew collage, assemblage, and found-object precedents for the construction of his assemblages, but as was repeatedly the case in his career, as he borrowed ideas, he transformed them. There are no direct antecedents of his poetic assemblages, even if aspects of them had been anticipated. The idea of pasting a "painting" together had been brought to rare perfection by Braque and Picasso very quickly after they invented the genre in 1912.[53] Their approach, soon amplified by others, depended on a formalistic transmutation of materials from "reality" into "art." But in Dove'a assemblages, materials and objects are usually affirmed instead of transformed by their incorporation into the art object. The raw materials do not lose their "real" identity as they are shifted into a new context—the work of art. Their expressive power remains dependent precisely upon their continued existence as "real" objects. Physically, within their new art-context, the objects are elements of design or representation; but expressively, their importance depends on the associations they bring with them. In this respect, Dove's materials function more like those in dadaist found objects.[54] However, although Dove was capable of poking fun, his assemblages are not the nihilistic exercises that were, for instance, Marcel Duchamp's urinal-fountain and Morton Schamberg's *God*, fashioned from plumbing. There is, rather, in Dove's best assemblages, a web of associations brought together in a satisfying formal structure. They are more like small, lyric poems than they are like any earlier modernist art objects.[55]

Today, we are so used to catch-all art objects fabricated from literally anything at hand that the originality of these assemblages must be emphasized.[56] Also, inasmuch as these gentle constructions presaged so much in terms of fabricating art, it requires an effort of historical imagination to see these as jabs in the side of a complacent art world. But in their time, they were attempts to broaden the limits of the possible within serious art. Stieglitz was delighted with the first group of them (which included his own "portrait") and exclaimed to Dove, "Wait unto Duchamp sees them."[57] The fact that Stieglitz assumed the assemblages would be of interest to the high priest of iconoclasm indicates their radical nature at the time they were produced. In the larger context of Dove's art, the assemblages may be perceived as part of Dove's continuing process of attempting to express in unfettered and unanticipated ways his own, indi-

vidualistic perception of the underlying spiritual reality of existence and to do so without resorting to representation. Although the technique was not a long-term interest for Dove, the assemblages were probably an important episode in Dove's formulation of personal artistic goals that would last him the rest of his life.

When Dove had returned to painting early in the 1920s, his problem then was to proceed with abstract painting at a time when virtually all other American modernist painters were redirecting their attention to various forms of realism. He found Guillaume Apollinaire's 1913 "Aesthetic Meditations: The Cubist Painters" a "help" when it first appeared in English in *The Little Review* in 1922.[58] Stieglitz had brought to Dove's attention the first installment, which opened, "The plastic virtues: purity, unity and truth, hold nature downed beneath their feet." Dove commented in return to Stieglitz, "Apollinaire—yes—by all means. About the plastic virtues—and nature—"[59] Noting that "too many artists still adore plants, stones, the wave, or men," Apollinaire's text proceeds to give a spirited and poetic defense of "pure" painting. Like others who formulated theory for abstract painting, such as Kandinsky in *Über das Geistige in der Kunst*, Apollinaire championed the independence of art from representation. The separation, they thought, would cleanse painting of the dross of material values and free it from the constraints of tradition. Apollinaire believed that purity would humanize painting by consecrating instinct and personality. Similarly, Dove identified "purity" in painting with spirit, which he called "the core of life."[60]

Dove's interest in a ten-year-old document signals his continuing commitment to the fundamental premises of modernism. To a greater extent than most of his American, modernist colleagues, Dove continued to absorb advanced tendencies that had evolved from those premises in Europe. The assemblages as a group had formed a small arena in which he could unify with his own sensibility ideas from the cubist and dadaist traditions. About the time that Dove's interest in assemblages began to abate, he began a startling group of works in which the "line motif" with which he had experimented during the second decade gained new energy. In the late twenties, Dove produced a series of works in which free, sometimes dizzying lines predominate. Sometimes this linear element is combined with abstracted representational elements, as in *The Park* (27.12) or *Violet and Green* (28.9). In others, full abstraction reigns, as in *Yours Truly* (27.17) and *Colored Drawing, Canvas* (29.3), or, most notably, in works on musical themes. These include two fast-moving transcriptions of George Gershwin's *Rhapsody in Blue* (Part I [27.2], which overlaps with the assemblage series, as here coiled springs attached to the surface amplify the painted lines, and *Part II* [27.3]), a rendition of Irving Berlin's *Orange Grove in California* (27.10), and one simply titled *Improvisation* (27.7). The latter title recalls Kandinsky's *Improvisations*, which are in the distant background of these works, but once again, Dove's are really sui generis—inventive personal adaptations of modernist ideas. While it is difficult to find visual prototypes for these works, Dove's renewed interest in unpremeditated line must have been fueled by surrealist ideas that were developing in the twenties.[61] Besides *The Little Review*, in which Dove had read the Apollinaire translation, there were other sources of advanced ideas that kept Dove informed of the latest tendencies of thought. He regularly read *transition*, which was published in Paris and which was the most intellectually distinguished of the little magazines that spread modernist ideas in the twenties.[62] He frequently received copies of the beautifully illustrated *Cahiers d'art*,[63] also from Paris, and painstakingly translated the latest articles on Picasso and other leading modernists, including Léger. (This enterprise was serious enough that Reds would write out the translation as Dove worked through the French.) *The Dial, New Yorker, Harper's, Atlantic,* and other American magazines were among those that brought current tendencies in thought to Dove.[64]

The relationship of Dove's art in the twenties to surrealist art is much like the relationship of earlier phases of his art to Cubism and dadaism. In each case, he was

aware of developments and appropriated what was useful to his own purposes. With surrealism, even more than with the earlier movements, it was the literature of the movement—its theories and verbal explications—that affected the course of Dove's thought and art as much or more than the visual examples.[65] It should also be remembered that at the time of its formulation, surrealism was perceived as one more manifestation of the modern search for liberation of the human spirit and was not interpreted as a movement in opposition to earlier, more formally oriented tendencies, as became the case later. Dove was little interested in the literal illustration of dreams or in bizarre imagery,[66] but the formal means and biomorphic abstraction drew his attention.

Besides the group of late-twenties works that feature his activated, automatic line, a few works of about the same time may exhibit an indebtedness to surrealist ideas in their formlessness, which goes far beyond the tentative, c. 1914/17 experiments with uncomposed surfaces. *Something in Brown, Carmine and Blue* (27.15), *Tree Forms* (28.13), and possibly *Tree Forms and Water* (28.14) might have been experiments in using chance effects. Possibly, Dove did these works with knowledge of Max Ernst's *frottage* drawings, which they somewhat resemble and which had been published in book form soon after his invention of the technique in 1925.[67]

The twenties were a period of search for Dove in both his life and his art. Outwardly, at least, these years were the most unsettled ones in his life. During them he left his wife and son and successfully established a new life with Reds. He had to face the deaths of his father and his estranged wife, while his mother entered a period of declining health and would live only until 1933. He had no real home in these years except the boat. He saw his financial situation deteriorate as his illustrations became less saleable.

Analogously, his art, too, was more "unsettled" than it was during other periods of his career. He experimented more with materials, subjects, and styles than at any other time. He pondered the question of pure painting, he explored the possibilities of assemblage, and he experimented with techniques related to those espoused by surrealism for opening up the unconscious. Concurrently with these aspects of his work, he continued to paint from nature themes. The glimmering *Golden Storm* (25.4), for example, clearly extends Dove's interest (going back as far as the "Ten Commandments") in stylizing natural forms, while the less arbitrary design of the tiny but portentous *Waterfall* (29.12) stands more closely related to Dove's interest in free-flowing line, as seen both earlier and later in his career. In the later twenties, *Sunrise in Northport Harbor* (29.19) is one of a few paintings that reintroduces a more naturalistic vision of nature, one that will continue to weave in and out of his oeuvre through the middle thirties. *Reaching Waves* (29.12), *Sun on the Water* (29.17), and *Telegraph Pole* (29.20) intimate the range of strategies that Dove was developing in the late twenties for amalgamating his responses to significant visual phenomena with pure, nonrepresentational painting, which eventually was to absorb his attention totally.

The magisterial *Alfie's Delight* (29.1) both summarizes his interests in painterly problems and forecasts much of the best work that he was to produce; beyond that, it connects with significant developments in American modernism subsequent to his death. A nonrepresentational painting, its forms are nevertheless distinctly nature-bound in feeling. The dominant circular form, which reverberates and expands throughout the composition, foreshadows Dove's predilection for round shapes during the thirties; often, he used them with procreational significance, and always they suggest the underlying, eternally recurring, healing forces of nature. Although the forms in this painting are simple—again forecasting Dove's direction—complex spatial ambiguities here demonstrate Dove's skill in resolving two- and three-dimensional elements. The wealth of variations on form and of spatial interplay is matched by the

extraordinary voluptuousness of surface effects: within a great variety of brushwork overall, almost flat areas intensify richly variegated ones. The areas where the paint has dripped reveal an acceptance of accident, which is technical but also metaphorically philosophical; they connect his sensibility to the avoidance of rational control in both surrealism and abstract expressionism. Areas of staining suggest a technique that would virtually not be seen again until the fifties, when younger artists would become as entranced with the manipulation of pure color as Dove was here. In sum, the largeness of feeling, the tension and beauty held in just the right proportions, the ineffability of the image, and the unconstrained, sensuous color set up basic themes of Dove's painting as he moved into the thirties, which in general turned out to be a very productive period in his life.

Few of the paintings from the early and mid-thirties are so completely abstract as *Alfie's Delight*, but the feeling for abstract qualities of painting now merges with suggestions of representation with an ease and completeness not seen often in Dove's work of the twenties. In the thirties, subjects (facets of the visual environment) are drawn into the abstract structure of the paintings so completely that it is often difficult to sort out what is abstract, what is representational; what is invented, what is seen. In the best of these paintings, the great rhythms of nature itself seem to hold the compositions together, and the result is a vision, unique to Dove, of the wholeness of experience. The period from roughly 1930 to 1938, then, an important period of consistent fruition, can be seen to summarize Dove's long-standing passion for accommodating sensations of reality within his commitment to abstract art.

Perhaps the increasing breadth and integration in Dove's art beginning about 1930 and culminating in the Geneva years has roots in the changes that were taking place in Dove's life at this time. In 1930, Dove's career as an illustrator was definitely over. For the first time in his life, Dove was literally and psychologically a fulltime artist. He was also now living during the winter, in the early thirties, in the Halesite yacht club instead of on the boat, and after mid-1933, he lived in Geneva; none of the places where he and Reds lived was actually up to middle-class expectations, yet they provided more spacious and less demanding environments than the boat had and perhaps also engendered a greater psychological security. Likewise, Florence's death at the end of the twenties, reestablishment of a relationship with his son, and marriage to Reds were all events that must have helped to reduce anxieties. Moreover, with the opening of An American Place at the end of 1929, Stieglitz had settled into a long-term commitment to directing a gallery, and by this time, there was no question about his willingness to show Dove's work regularly. Moreover, Dove was beginning to be shown more often elsewhere, in a variety of invitational group exhibitions, and critics generally treated his work with respect if without penetrating insight.

Also in 1930, Duncan Phillips began to act on a distinct interest in Dove's work by purchasing it regularly, and in 1933 he started paying his monthly "stipend." While Dove's income had been much higher, at least now it was regular. Finally, a change in Dove's working habits may have contributed to the increasing steadiness of his development. About 1930, Dove took up the practice of sketching extensively out-of-doors in watercolor. After he started doing this, most of his paintings were based directly on watercolors or, less often, drawings in other media, such as crayon or pencil. Often, he transferred the outlines of a successful watercolor to canvas mechanically, using a pantograph. It simultaneously enlarged the sketch as a marker on one arm reproduced the composition while the other arm was traced over the watercolor.

As Dove's life became outwardly more regular, his art also took on a somewhat more regular character; but in the early thirties there is still a great deal of variety, which ranges from the near illusionism of *Gale* (32.10) to the abstraction of *Dawn III* (32.8), from the undisciplined excitement of *Dancing Tree* (31.6) to the icy reserve of *Snow*

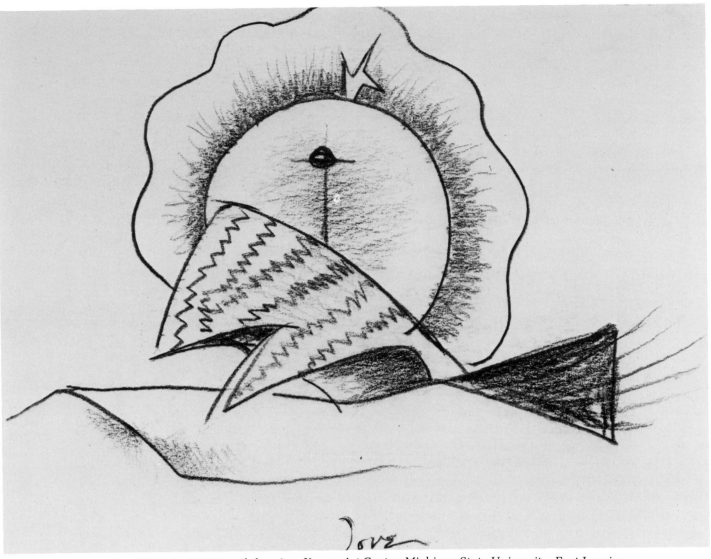

Gas Ball and Roof. 1932. Pencil drawing. Kresge Art Center, Michigan State University, East Lansing.

Thaw (30.19). His most obvious among several failed attempts to anthropomorphize nature, the Disneyesque *Bessie of New York* (32.3) also comes from these years.[68] On the other hand, works such as *Mill Wheel, Huntington Harbor* (30.11), *Silver Tanks and Moon* (30.16), *Sand Barge* (30.13), *Snow Thaw* (30.18), and *Sunset* (30.19) are among the early works in a long series that is the culmination of Dove's unique synthesis of nature and abstraction. *Red Barge, Reflections* (31.15) particularly exemplifies the seemingly effortless accommodation of visual reality and abstract form that marks his work through the next few years. The red barge and the vegetation behind it, with their reflections in the undisturbed water below, form a rich, abstract composition that recalls the success of *Alfie's Delight* of two years earlier.

While Dove was in Geneva, from 1933 to 1938, his subjects were drawn especially from his direct experiences of the farm and the lush, rolling countryside of the Finger Lakes region. *Cows in Pasture* (35.9), *Goat* (35.12), and *Snowstorm* (35.18) are among the paintings that exemplify the characteristically rich interplay of nature imagery and abstract design in the works of these years. Some of the paintings from the same time, such as *Barnyard Fantasy* (35.2) and *Cow I* (36.2), offer only hints of subject, but regardless of subject or degree of illusionism, the Geneva paintings draw on a common fund of shapes, colors, and compositional devices. Not surprisingly, none of these elements is new to his art at this time. Rather, his earlier art can be seen to have

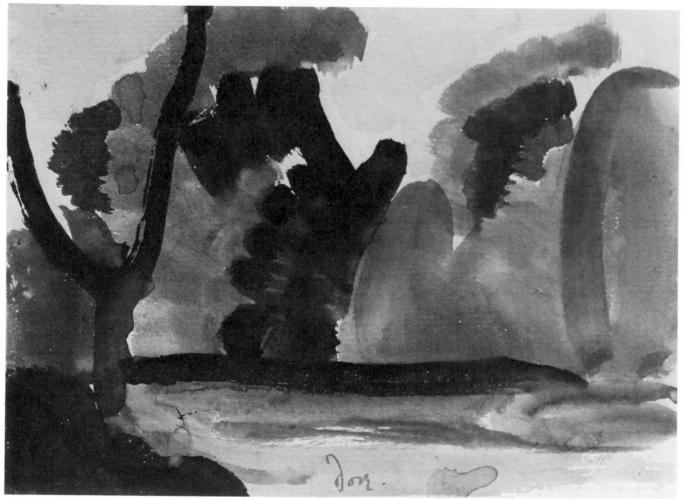

Woodland Pond. 1936. Watercolor. Phillips Collection, Washington, D.C. (photograph by Victor Amato).

prepared the formal elements that come to full realization in these years. Thus, these nature-abstractions may be seen to summarize his most characteristic ways of making the compromise between nature and abstraction.

Shapes in these paintings are taken almost exclusively from the organic world. Virtually all forms are irregular and bounded by curving contours. Straight lines and sharp angles are absent. Even when some architectural or industrial object is suggested, Dove usually disguises its man-made origin by distorting the object to make it harmonize with its biological surroundings, as is apparent, for instance, in *Barn Next Door* (34.2). Among all shapes, approximately circular ones are particularly favored, as in the wheels of *Clay Wagon* (35.7), the sun of *Red Sun* (35.16), the moon of *Rise of the Full Moon* (37.11), the sun and treelike elements of *Naples Yellow Morning* (36.10), the womb-tree of *Willow Tree* (37.16), and the unidentifiable shapes of *Reminiscence* (37.10) and *October* (35.15).

Colors tend to be warm and earthy, rather than brilliant or artificial. Within a given painting, the number of colors is rarely large, and the use of three different basic colors is frequent. A single color may occur in gradations of intensity and value, as well as in slight variations of hue. Colors are subtly adjusted to each other and seem never to have been used in their purest form, right out of a tube. The local colors of objects depicted or suggested are often retained in Dove's paintings, as for instance, the brown-black-white of cows and green field of *Cows in Pasture* (35.9). Often, as here, the color is an important element in communicating the recognizability or the feel of

the subject. However, nonlocal colors occur, as for instance, in the red and blue foreground furrows of *Red Sun* (35.16).

Colors and shape usually accompany each other on a one-to-one basis. That is, each shape is usually associated with a single color, though color is almost never flatly applied. These qualities of color may be clearly seen in *Summer* (35.19) or *Reminiscence* (37.10). The swelling, aquamarine shape on the left of *Tree Composition* (37.14) rather clearly shows Dove's most characteristic way of achieving both a painterly surface and an identity of shape with color. As in this shape, he frequently worked rather methodically from the inner part of the form outwards in a series of graduated color areas. He usually applied the paint heavily enough to leave visible brushstrokes across the bands of color. The *Sunrise* paintings (36.14, 36.15, 36.16, and 37.13) are virtually exercises in this method (which has its ultimate origin in the single brushstrokes of Cézanne and in the Cubist "touch"), especially *Sunrise III*, which relies for formal effect on the rich surface this kind of painting can achieve.

Many compositions in this period of Dove's career are rather simple, sometimes hardly more than a dominant center, as in *Summer* (35.19) and *Willow Tree* (37.16), or a couple of interlocking shapes, as in *Reminiscence* (37.10) and *Tree Composition* (37.14). But often, through the use of radiating colors in combination with single-focus compositions, Dove achieved energized, even explosive images, such as *Moon* (36.8), with its implication of coital ecstasy. Even in the most complex compositions, the central area tends to hold the weight, while forms dissipate near the edges (an additional legacy of Cubist practice). Another frequent compositional device is repetition, either of similar colors or similar shapes. Nearly all compositions depend heavily on color relationships, but usually shapes have enough plasticity to suggest some depth. Dove's method of painting in concentric or radiating lines is often the source of this plasticity, as in *Tree Composition* (37.14) or *Willow Tree* (37.16).

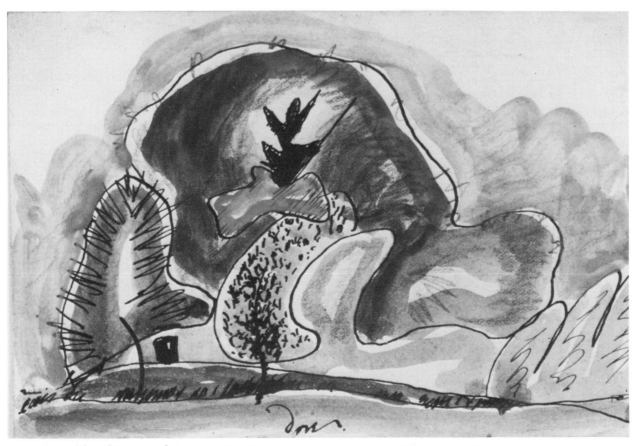

Mars Orange and Green. *1936. Watercolor. Courtesy Terry Dintenfass Gallery, New York.*

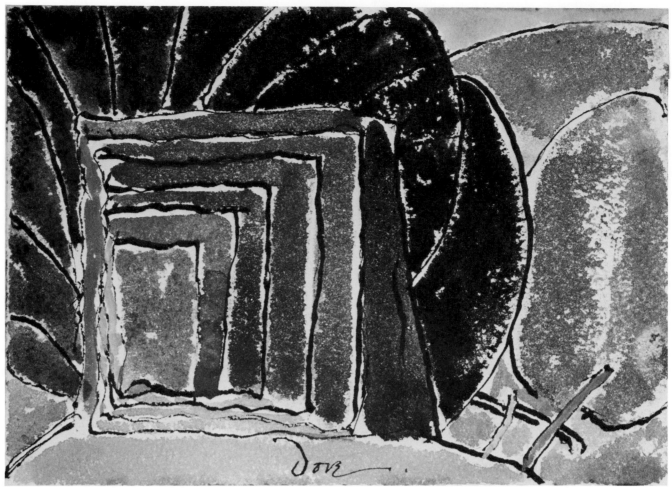

Holbrook's Bridge. 1937. Watercolor. John Marin, Jr. (photograph by Otto E. Nelson).

Subsidiary to these style characteristics of the paintings of Dove's Geneva years is an interesting development of the "line motif" which originally appeared as early as 1912, which was renewed in a more energetic form in the twenties, and which becomes the basis of some of his most accomplished pure abstractions in the 1940s. In *Dancing* (34.4), for example, with this meandering line, Dove develops biomorphic forms that seem to pulse from within and undergo mutation before our eyes. *Cow I* (36.2) and *Life Goes On* (34.7) also make similar use of this freely drawn line. In *Goat* (35.12) and *Cows in Pasture* (35.9), the line is used in complex compositions that accommodate representational elements. *Cows in Pasture* is a particular success; as the moving line creates bovine forms in a grassy field, it simultaneously creates overlapping planes of color that suggest spatial movement but still harmonize on the surface.[69]

After 1935, Dove moved away from recognizable representation with increasing frequency. Perhaps this tendency was stimulated by the art-world climate. The early thirties had been a time of intense interest, both in theory and practice, in regional Americanism. Abstraction was frequently declared dead, as realistic interpretations of the American experience were acclaimed as the most significant new art.[70] However, two important New York shows interrupted this realist hegemony in the middle of the decade. In 1935, the Whitney Museum of American Art mounted a large show of American abstract art. Dove showed several works and must have seen the catalogue,[71] although he was unable to travel from Geneva to New York to see the exhibition. However, in 1936, he saw Alfred Barr's epochal summary of European abstraction at

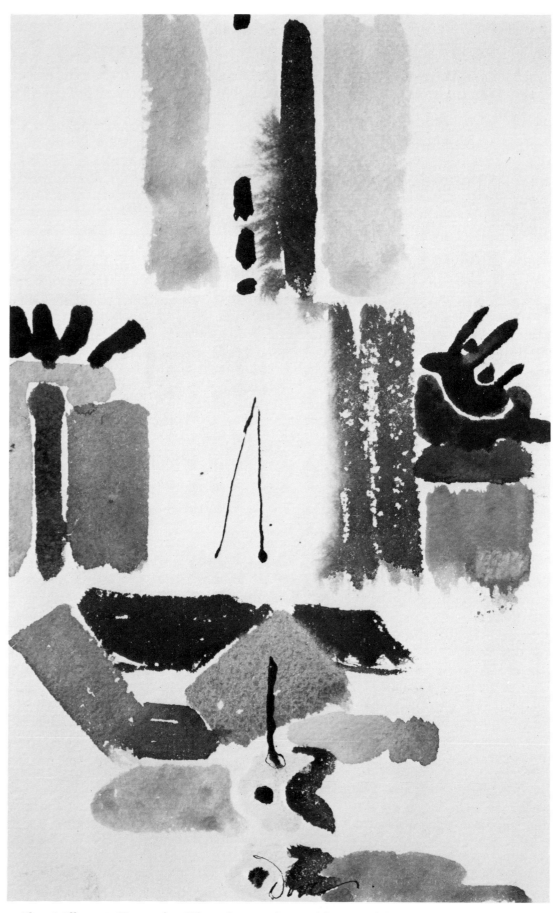

Flour Mill. 1938. Watercolor. Whereabouts unknown (photograph by J. H. Schaefer & Son).

the Museum of Modern Art and, again, presumably at least looked at the catalogue.[72] These shows, along with increasingly frequent ones by American geometric abstractionists in the late thirties, and the attendant discussion they provoked, may have helped to direct Dove's attention toward a more abstract treatment of his themes. In any case, it seems as if the shapes of nature and expressive or symbolic constructs often began to merge for him. The four *Sunrise* paintings, for example, virtually constitute an impregnation series where sun and womb are one. Among Dove's most profoundly simplified images, they also suggest an important formal tendency to be seen in Dove's work from the last couple of years he was in Geneva; forms begin to become flatter and, increasingly, are treated as planes parallel to the picture plane. This had happened in a surprisingly developed way as early as 1935 in the eccentric *October* (35.15). *Holbrook's Bridge to Northwest* (38.10) and the two *Flour Mill* paintings (38.4 and 38.5) authoritatively demonstrate how, by 1938, on the verge of leaving Geneva, Dove was resolving the dichotomy between three-dimensional space and the picture plane in favor of the latter.

Because of his dire state of health during 1938–39, Dove's first year in Centerport, he did almost no painting. Yet, the two new works he showed in 1939 manifested something new. *Hardware Store Window* (38.9) and *Graphite and Blue* (38.7) both evince the seemingly automatic line, now taken to a new level of abstract independence. When Dove got back to working on a more or less regular basis later in 1939, he virtually abandoned his nature-based abstraction for a much more thorough kind of nonillusionistic painting, in which this line plays a major role. Perhaps, having long looked to nature for visual equivalents to his feelings, Dove had discovered as he did watercolors and drawings while confined to his bed that he could invent the forms now from within his own sensibility.

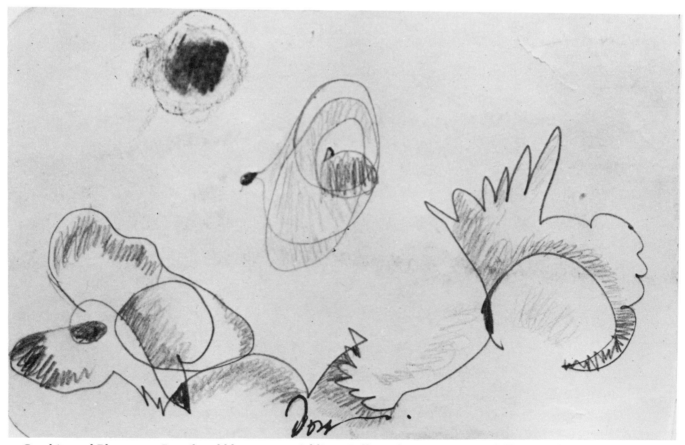

Graphite and Blue. 1938. Pencil and blue crayon. Addison Gallery of American Art, Phillips Academy, Andover, Mass.

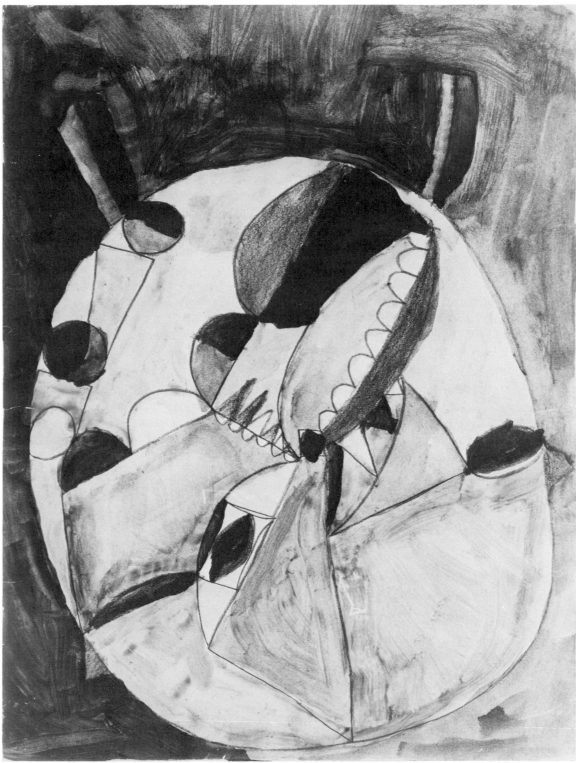

Untitled. Late 1930s. Watercolor. Collection unidentified (photograph by Peter Juley, courtesy Smithsonian Institution).

Dove saw almost no new art firsthand after the spring of 1938. What and how much he saw or read about in art magazines and newspapers is not clear in the documentary evidence from the forties.[73] However, he seems always to have had good antennae for new ideas in the art climate, to which he was perhaps responding once again. For, just at this time, there was a new fascination with abstraction. Though they were not yet very visible, by the early forties, the young painters who would later be known as the

abstract expressionists were beginning the abstract/surrealist experimentation that eventually led to the dominant mode of the late forties and the fifties.[74]

Whatever the situation, Dove only occasionally worked any more in a manner that extends the nature-abstraction of the thirties, though such paintings as *Morning* (40.10), *Rising Moon* (40.15), and *Partly Cloudy* (42.14) are evidence of some continuity into the forties. Instead, his most characteristic work of the early forties consists of intricate, energetic paintings that bring together the freely moving line, with which he had experimented for so long, and his new interest in flat color areas. This way of working had been presaged by *Swing Music* (38.19) and more distantly suggested by a couple of other paintings, but its emergence was relatively sudden and emphatic. *Green Ball* (40.5), *Red, White and Green* (40.14), *U. S.* (40.20), *Across the Road* [No. 2] (41.1), and *Lattice and Awning* (41.8) are particularly good examples of this new style. Concurrently, however, some paintings, such as *Through a Frosty Moon* (41.16), *Green, Gold and Brown* (41.5), and *Pozzuoli Red* (41.13) suggest the larger, organic rhythms that by the mid-forties entirely displace the intricate, supercharged mode. *Through a Frosty Moon* might be seen as an abstract rethinking of the means of some earlier, more representational paintings, such as *Cows in Pasture* (35.9), in which are seen similar abstract lines and planes. *Formation II (Colored Planes)* (42.8),[75] *The Other Side* (44.7), *The Rising Tide* (43.13), and *Rose and Locust Stump* (43.15) exemplify this mode of organic-looking but generally subjectless painting, as Dove practiced it during the next few years.

At the same time, Dove began to develop a more geometric abstract manner, which led to some of his most forward-looking paintings. An early example is *The Brothers* [No. 1] (41.2). Here and in succeeding examples, the only significant difference of composition and facture from the previously described organic abstractions is that in

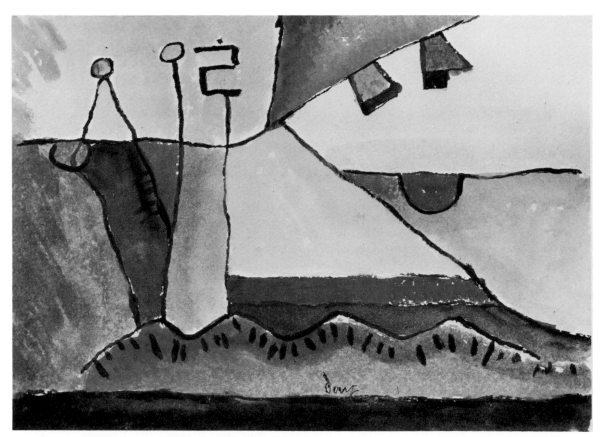

Out the Window. *c. 1940. Watercolor. Private collection (photograph by John F. Waggaman).*

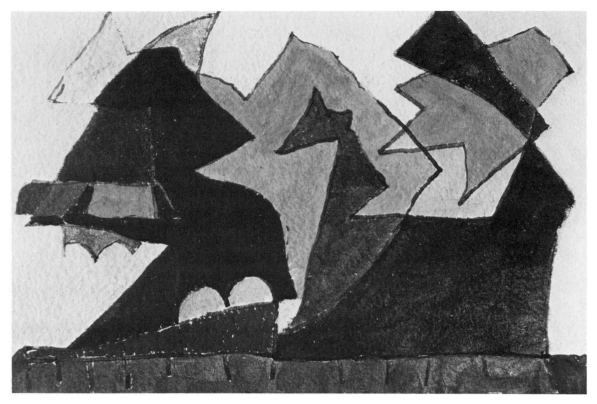

Centerport Series No. 28. 1942. Gouache. Solomon R. Guggenheim Museum, New York.

these, the biomorphic, freely moving line plays little or no part. Instead, straight edges dominate, giving these paintings a crispness not often seen in Dove's earlier work. *That Red One* (44.12), *Rooftops* (43.14), *Primitive Music* (44.11), and *Square on the Pond* (42.19) are particularly strong and clear examples of this type of work, some of which anticipates much later work by Rothko and Noland. Sometimes fundamentally geometric works are softened by the use of ragged rather than straight edges for some of the forms, as in *Pieces of Red, Green and Blue* (44.9) and in *High Noon* (44.5).

Whether predominantly organic or geometric, these forties paintings share other important characteristics. Dove retained from his earlier work a preference for distinctly defined, although sometimes overlapping, shapes clearly separated from each other and individually colored with a single hue. Compositions are varied and free, although Dove tended to retain certain characteristics of his earlier practice. The most notable are a preference for compositions with a dominant central focus, as in *Across the Road* [No. 1] (40.1), *Parabola* (42.13), and *Rising Tide* (43.13), and for the repetition of similar shapes and colors for the sake of compositional unity, as in *Green, Gold and Brown* (41.5) and *Red, Olive and Yellow* (41.14). In this last period, Dove's palette became perhaps a bit richer and more complex, but it did not substantially change from the earlier preference for a limited number of hues in predominantly warm colors. Although Dove abandoned the layering of colors in radiating or concentric bands in favor of a flatter application of paint within a given shape, his paint surfaces are never hard or mechanical; the paint itself always has a visible substance. While Dove characteristically used flattened forms on or parallel to the picture plane in these works, sometimes striking spatial effects occur; in his most Baroque painting, *Pozzuoli Red* (41.13), space rushes back from the picture plane into an infinite void.

Dove's interest in spatial effects led to some experiments that depart quite decisively from his most characteristic work of the forties. These paintings comprise strongly three-dimensional, sculptural forms, which have a hard and decisive quality not often

seen in his previous works. Announced by *The Inn* (42.11) and fully developed in *Arrangement in Form I* (44.2) and *II* (44.3), these paintings recall some earlier Picasso paintings of abstracted, sculptural figures and suggest also actual sculptures by artists such as Seymour Lipton and David Hare.

The period of the forties, which was so limited in other respects for Dove, was a time of great variety in his painting. Besides the organic, geometric, and plastic abstractions, along with a few nature-abstractions growing out of the thirties work, there are other, more stylistically isolated paintings that do not fit easily into any of the categories already described. This is the case, for example, with the Klee-like *Harbor* (40.7) and *.04%* (42.23). The diversity of his work makes all the more remarkable the level of his achievement, for in the forties, there is a higher percentage of fully realized successes than ever before.

The work of the early thirties and the Geneva era constitutes the fruition of his nature-abstraction and is particularly significant for its uniqueness to Dove. The work of the forties, which was perhaps even more original in its time, constitutes the fruition of pure abstraction in his work. Beyond its intrinsic quality, it is particularly significant for the connections it makes with the burgeoning abstract tendencies of the forties and fifties. It anticipated both the gesturalism (albeit in a genteel form) and the color field interests of the upcoming generation.[76]

Even the work of his very last year of painting shows new strengths that make one wonder what he would have achieved had he lived. *It Came to Me* (45.3) is made up of Picasso-esque forms that recall Gorky's work of the thirties and Gottlieb's of the early forties. *Uprights, Mars Violet and Blue* (46.4) shares much with the sensibility of Motherwell's simple compositions of uprights and ovals, while *Green and Brown* (45.2), with its combination of hesitant, unpremeditated line and searching, unresolved brushwork, suggests much that was to occupy painters for some ten or fifteen years after his death. What Dove's late paintings lack most in comparison to the impact of his abstract expressionist successors is their awe-inspiring scale. And yet, he was thinking about that, too, and had his health not been so delicate, perhaps his late paintings would have been larger. In his diary for 5 August 1942, Dove wrote the following note to himself:

> Try larger ones. People do not see small ones. Seem to want to get into them? Large ones give onlooker larger idea of himself.—Identification.[77]

However far Dove had come at the end of his career from his early nonillustionistic work and however great the variety within his production throughout his career, it is useful to remember how fundamentally consistent were Dove's ultimate interests. For thirty-five years his overriding concern was for the expression of the inner life, which was at the root of all his formal experiments and which he consistently felt must be realized through "pure" or nonrepresentational painting. Until the last eight years of his life, he depended on visual stimuli found primarily in the landscape for forms, rhythms, patterns, and color combinations to match those inner sensations; even in those last eight years, his paintings are filled with formal and coloristic remembrances of that natural world he had studied for so long.

Not surprisingly, his painting career as a whole reveals significant formal unities, notably including the predominance of curved lines, repetition of shapes and colors as means to compositional unity, the frequent occurrence of centralized compositions, the clear identification of shapes and their relationship to color, characteristic rhythms of contour, and the preference for forms parallel to the picture plane. There is an emotional unity, too—a kind of stubborn, perhaps even provincial, deep-seated American optimism that beauty, joy, and truth can be expressed in abstract form so as to contribute to the progress of the human spirit.

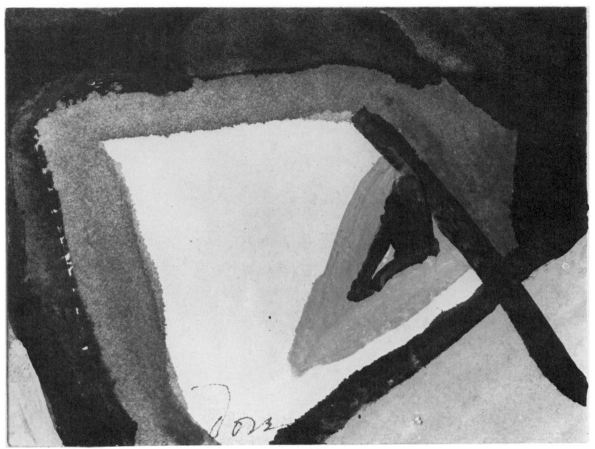

Harbor. 1946. Watercolor. William H. Lane Foundation, Leominster, Mass. (photograph by Geoffrey Clements).

How deeply Dove felt his convictions about his art is suggested by the intricate relationships between his aesthetics and his lifestyle. What he believed about his art, in other words, was very much connected to the beliefs that directed his life. Dove himself often spoke about life and art as if they were practically the same thing, or he referred to ideals and goals without differentiating their applicability to one or the other. For instance, nature was not only a repository of artistic forms, but was a source of personal value. Dove consistently shunned the urban life in favor of one in which he could be in direct contact with the natural world. Even in his final years, when his art became more independent of natural reference and when his outdoor activities were restricted to sitting in the sun on the front porch, he lived in what was virtually an observation post on nature, in the little house on the bank of Long Island Sound. The simple and unpretentious qualities of his life also have their parallels in Dove's art. While a simple routine provided the framework for a rich life, a few uncomplicated shapes and a few colors generally constituted a satisfying painting. Early in his career, Dove had undertaken to "simplify Impressionism," and in his later paintings he worked toward the distilled essences that represented his philosophical conviction that to simplify is to work toward truth.

The positive value that Dove placed on uninhibited sensory reactions is implied in the sensuous, organic forms and earthy colors of his paintings. The surfaces themselves have an appeal not visible in photographs; luxuriant color, tactility, and variety in materials transmit the positive values he attached to rich sensation and parallel those particularly associated with nature on an intimate scale.

The care that went into making his paintings also grew out of the way Dove lived his life. By necessity more than choice, Dove spent much of his time repairing and reno-

Attributed to Dove, Gloxinia with Head. c. 1906. Pastel. T. Stoll, Fla.

vating his residences. He also lavished enormous amounts of time on the mechanical aspects of his art—stretching canvases, gessoing them, making frames and finishing their surfaces (most often with a mat silver), experimenting with "recipes" for whatever medium he was using at the time, making packing crates to ship his paintings, and so on. He tolerated nothing slipshod. The same careful craftsmanship went into the painting process itself, which Dove researched through reading and experiment.[78] By the forties, this concern about materials and their durability became almost an obsession.[79] Dove's thoroughness was enhanced—and as far as he was concerned, sometimes tested—by his interest in the possible uses of offbeat materials, such as metal and plastic panels or metallic paints and sand in combination with his usual

medium. The assemblages are the most obvious manifestation of his pleasure in materials (though, sadly, some of them are suffering from Dove's use of impermanent elements in them), but whatever the medium, Dove's sensitivity to its properties generally leads to a full realization of its expressive potential. Likewise, Dove avoided overpowering the limitations of his materials. Characteristically, then, Dove's creations are free from both tour-de-force and accident.

These parallels between the qualities of Dove's art and life suggest the deep sincerity with which he approached his vocation. In itself, this kind of earnestness is not a necessary precondition for producing great art, but in Dove's case, it helps to provide an interesting perspective on how and why his art came into being.

NOTES

1. For a description of the major sources of documentation available, see the introduction to the catalogue.

2. This may be due to the wishes of the artist himself. When his earliest chronicler, Suzanne Mullett Smith (who wrote a master's thesis on his work in the early 1940s), tried to unearth some of his childhood work in Geneva, Dove was not pleased.

3. An intriguing pastel purported to be a Dove work from these early years came to my attention in 1982 through its owner, a Florida dealer-collector. It depicts a clump of gloxinia with a disembodied, faintly rendered, idealized woman's head hovering behind it. Redolent of Redon's imagery as it is, it offers conclusive evidence of Dove's early interest in French Symbolism if it is genuine. I have not seen the work itself, only photographs. The signature looks authentic in a photograph, and important aspects of the drawing are not inconsistent with Dove's hand. The disparity of approach between the pastel and the *Stuyvesant Square* painting might be explained by a lapse of time between them or by experimentation in different stylistic and expressive directions by the young artist. Yet overall, the pastel is not comparable to any known, certifiably genuine Dove works. Thus, it must be considered an attributed work until further evidence about its origin comes to light or until other, similar works are found.

4. Wanda M. Corn, *The Color of Mood: American Tonalism 1880–1910* (San Francisco: M. H. de Young Memorial Museum and the California Palace of the Legion of Honor, 1972), 4.

5. These painters were christened "tonalists" and defined in terms of formal qualities prevalent in their work ("subtle gradation of color, the predominance of one or two hues, and . . . diffused light," 3) in Wanda Corn's perceptive essay for the *Color of Mood* exhibition catalogue. Previously, approximately the

same group had been brought together under the rubric of "quietism" by E. P. Richardson in *Painting in America* (New York: Crowell, 1956), 304–7. Lewis Mumford long ago identified the pervasive existence of basically the same state of mind in *The Brown Decades*, 2d ed. rev. (1931; reprint, New York: Dover, 1955). Sheldon Reich, *John Marin* (Tucson: University of Arizona Press, 1970), 1:5 employs the term *Late Impressionism* to characterize the style of these painters.

6. Dove apparently admired Renoir above any of the other Impressionists. His respect for Renoir's work (as well as his opinion on the French painter's limitations) is expressed in a letter written to Arthur Jerome Eddy at the end of 1913:

> Renoir was an impressionist, but he achieved what he did in spite of his means, we miss nevertheless that perfect sense of order which exists in the early Chinese painting, and feel that he might have done even greater things had his means been less complicated.

7. Dove to Arthur Jerome Eddy, probably November 1913. Published in Arthur Jerome Eddy, *Cubists and Post-Impressionism*, 2d ed. (Chicago: A. C. McClurg, 1914, 1919), 48.

8. "No Faked Names on These Paintings," *New York World,* March 1910.

9. B. P. Stephenson, *New York Evening Post,* reprinted in *Camera Work,* no. 31 (July 1910): 44.

10. They were first exhibited in 1952 at the Downtown Gallery and were dated to 1910 at that time.

11. Susan Fillin Yeh, "Innovative Moderns: Arthur G. Dove and Georgia O'Keeffe," *Arts* 56 (June 1982): 68–72, notes some interesting comparisons between Dove's early work and turn-of-the-century art pottery, but goes too far in suggesting direct influence. The formal

resemblances she notes, and others of this type, undoubtedly derive from the similarity of processes in abstracting from nature. It has generally been insufficiently recognized, however, how advanced were the decorative arts in formal invention on the eve of abstraction in the "high" arts. Further study of this phenomenon should be revealing.

12. He lived at Sèvres during this time. Will Grohmann, *Wassily Kandinsky, Life and Work*, trans. Norbert Guterman (New York: Harry N. Abrams, [1958]), 48, 251.

13. Ibid.

14. Possibly even before the Armory Show, Dove had acquired his own copy of Kandinsky's *Über das Geistige in der Kunst* (Munich: R. Piper, 1912), which contained two plates illustrating abstract Kandinsky paintings and ten original woodcuts that were abstract embellishments. (Dove undoubtedly got his copy of Kandinsky's book before 1914 when the English translation appeared, since he did not read German easily.) Dove may well have obtained the book through Stieglitz, who had published a short, translated excerpt from it in *Camera Work* (no. 39 [July 1912]: 34) and who gave Dove a copy of *Der Blaue Reiter* (edited by Kandinsky and Franz Marc; Munich: R. Piper, 1912) in November 1913.

15. This first Picasso show in the United States consisted primarily of earlier works, from 1905 to 1909. The analytical-cubist *Nude* was the most abstract piece in the show.

16. Barbara Rose, ed. *American Art Since 1900* (New York: Frederick A. Praeger, 1967), 59.

17. William Innes Homer, *Robert Henri and His Circle* (Ithaca, N.Y.: Cornell University Press, 1969), 260.

18. An attempt to reconstruct the group is presented in William Innes Homer, "Identifying Arthur Dove's 'The Ten Commandments,'" *American Art Journal* 12 (Summer 1980): 21–32.

19. Anguished reviewers mentioned that they were not titled. See "Notes of the Art World," *New York Herald*, 6 March 1912, 8. The show might have included some additional, presumably earlier works, as well, but none of the reviews mentions any.

20. See catalogue entries for relevant contemporary descriptions.

21. Homer also accepts these six in his *American Art Journal* article.

22. Influence of art nouveau's organic, decorative form has already been noted in relation to *The Lobster* (08.3) and the 1910 abstract sketches (10.1–10.6). One contemporary reviewer connected the "decorative pattern" in the pastels to art nouveau: Harriet Monroe, "One-Man Shows Allow Wide Choice," *Chicago Tribune*, 17 March 1912, Part 2, 5.

The two least organic "Commandments," *Nature Symbolized No. 1* (11/12.4) and *Nature Symbolized No. 3* (11/12.6), depend on architectural motifs (which, obviously, suggest geometric forms) in combination with vegetation. Because of the architectural elements, these prefigure two interesting, later developments. First, they suggest what will become Dove's holistic view of "nature," which, by the late twenties comes to include manmade objects (most often industrial or agricultural architecture, such as tanks, power plants, barns, corn cribs, and so on) as part of the totality of the environment. Second, since these two seem to spring compositionally from Dove's knowledge of early Cubism (especially *Nature Symbolized No. 1*), they prefigure what would become after World War I the predominant American response to Cubism—merging it with innately geometric subjects, most often architecture. This Americanized Cubism, which is seen best in the movement often called "Precisionism," reached its finest expression in Charles Demuth's architectural abstractions of the twenties and early thirties. Charles Sheeler, Preston Dickinson, Ralston Crawford, and Niles Spencer, along with Georgia O'Keeffe, were other major contributors to the mode. A few Dove paintings, such as *Silver Tanks and (Moon* (30.16), suggest that he lived in a largely Precisionist art world, but his works never exemplify the feeling for absolute intellectual control that distinguishes the movement.

23. The six pastels that certainly belonged to the "Ten Commandments" share another, perhaps less reliably identifying, characteristic, as well. They are all treated the same way in a documentary source, Dove's card file of paintings, which he began to assemble much later. Probably in 1932, Dove made out entries for five of the six for the card file, which he was at that time putting together—unsystematically, as far as the early works are concerned. (For detailed information on the card file, see the introduction to the catalogue.) Only *Nature Symbolized No. 3* of the six pastels does not appear in the card file (but this is one of the most clearly described in a contemporary review as being one of the "Ten Commandments"). Dove was dating the works from memory, and he often was in error concerning the dates of his own early works. Significantly, however, all five of those that do appear in the card file are dated the same: 1910. Moreover, a couple of years earlier, in 1930, when Dove wrote a fairly lengthy statement about his art at the invitation of Samuel Kootz, who was then compiling his book *Modern American Painters* (New York: Brewer & Warren, 1930), he referred to his important show of the pastels in question as taking place

at "291" in 1910. By the 1930s, then, Dove seems to have consistently dated the "Ten Commandments" to 1910. Thus, whenever one of the "Ten Commandments" appears in the card file, it is dated 1910. This is true not only for the six already discussed but also for the three other pastels here assigned to the "Ten Commandments." Furthermore, no other "1910" pastels occur in Dove's card file, except for *Pagan Philosophy* (13.2). Perhaps this work was in the "Ten Commandments" group, but that seems unlikely since none of the reviews mentioned its entirely different character. Perhaps Dove, thinking of the "Ten Commandments," remembered that he had done *Pagan Philosophy* within the year. If we translate Dove's "1910" to the reality of 1912, then this is plausible, for *Pagan Philosophy*, one of Dove's most frankly Cubist pictures, probably dates to early 1913, or around the time of the Armory Show, with its substantial representation of French Cubism. It might be a little earlier if Dove had some prior access to paintings being assembled for that show or some acquaintance with reproductions of Cubist paintings.

The other pastels that have approximately the same dimensions as the "Ten Commandments" and that appear in Dove's card file are, with his dates, as follows: *Calf* (1911), *Cow* (1911), *League of Nations* (1912), and *Sentimental Music* (1912). There is also a card for *White Horse in Snow* (1912), which has not been identified, so its dimensions are unknown. Possibly, it is an erroneous repeat of *Horses in Snow* (1910).

24. Joseph Edgar Chamberlin, "Pattern Paintings by A. G. Dove," *Evening Mail* (New York), 2 March 1912, 8.

25. George Cram Cook, "Causerie (Post-Impressionism After Seeing Mr. Dove's Pictures)," *Chicago Evening Post Literary Review*, 29 March 1912.

26. The "abstract" title, which does not refer to any specific visual reality, may not be Dove's. Perhaps the work would look less abstract if we knew what was his visual inspiration for it.

27. Homer, "Identifying Arthur Dove's 'The Ten Commandments,'" 30, also accepts this as one of the "Ten Commandments."

28. Eddy, *Cubists and Post-Impressionism*, 2d ed., 48. Many years later, Dove corroborated this account of his early development in the statement he wrote for publication in Samuel Kootz's *Modern American Painters* (1930). As he then put it more briefly:

> The line at first followed the edges of planes, or was drawn over the surface, and was used to express actual size, as

that gave a sense of dimension; later it was used in and through objects and ideas as force lines, growth lines, with its accompanying color condition. (P. 38.)

29. In the statement for Samuel Kootz, cited in the previous note, Dove singled out this work as an example of the freed "line motive."

30. This new interest in line is described at second hand by Hutchins Hapgood in "The Live Line," *Globe and Commercial Advertiser* (New York), 8 March 1913, 7. In this article, he relates that Dove had told Stieglitz that his line had gone dead as the result of working too much from his memory and other inner resources. Probably he had become dissatisfied with the rigidity of some of the "Ten Commandments" forms and was trying to explain his new interest in "vital" line.

31. The purposeful reduction in chromatic variety might have been suggested by the coloristic austerity of analytic Cubism.

32. Henri Bergson, "An Extract from Bergson," *Camera Work*, no. 36 (October 1911): 20.

33. Robert Paul Metzger, "Biomorphism in American Painting" (Ph.D. diss., University of California, Los Angeles, 1973), 45, says of *Pagan Philosophy* that "the subject of this picture is a musical instrument, possibly a guitar, geometrically fragmented in the manner of Braque and Picasso." This is a good suggestion, though I am not sure I can make out the representation. Metzger tends to see a great many more representational elements in Dove's work than I do.

34. Metzger, "Biomorphism," 48, notes the similarity of means in this pastel and Kandinsky's 1911 *Composition IV*. This is only one of many useful comparisons between Dove's early work and Kandinsky's noted in this dissertation. Unfortunately, none are illustrated, though there is a list of sources for reproductions in other publications for those who like to hustle around the library.

35. The idea that music is the preeminent art *because* it is abstract (and therefore not contaminated with the dross of materiality) has a long history and was probably the single most frequently invoked justification for abstract painting before World War I. See Howard Risatti, "The American Critical Reaction to European Modernism, 1908–1917," (Ph.D. diss., University of Illinois, Urbana-Champaign, 1978), and idem, "Music and the Development of Abstraction in America: The Decade Surrounding the Armory Show," *Art Journal* 39 (Fall 1979): 8–13.

36. Some of these (or possibly all) might be considered almost illustrations or transcriptions of the music to which the titles refer, since Dove painted them while listening to

the music on a phonograph or radio. It is characteristic that Dove did these paintings in response to a specific physical stimulus, whereas most other artists who invoked the musical analogy seem to have made use of it on a purely intellectual, theoretical level.

Dove also did a few paintings that "illustrate" nonmusical sounds. He had no particular interest in the theory of synthesia, as Kandinsky and many other early twentieth-century artists did, so his "synesthetic" paintings can be viewed as simply an extension of his "illustrative" approach revealed in the musical paintings. *Fog Horns* (29.6) is the best-known and most successful of Dove's paintings of this sort, illustrating as it does the deep-throated blasts of a foghorn successively approaching through a heavy atmosphere over the water.

37. A rumor that Dove destroyed much of his Westport work (see Wight, *Dove*, 41) is unsubstantiated and unlikely to be true. The story first appears in Suzanne Mullett Smith's 1944 M.A. thesis, with the embellishment that the deed was done with the assistance of the illustrator and printmaker, Ernest Haskell, who was a Westport neighbor. Presumably she got the tale from the artist, although she does not say so, but the artist's son says he is mystified about the account, since he remembers neither the event (though he would have been only a child at the time) nor any later mention of it by his father. It is, at any rate, true that Dove knew Haskell in Westport.

38. This virtually nonobjective work became a sort of talisman for American modernism. Available to be seen at "291," it was also exhibited in the Armory Show and was reproduced more than once in *Camera Work* (e.g., special no. [June 1913]: 53).

39. Throughout Dove's life, Picasso was the European modernist he held in highest regard. Perhaps this admiration stemmed in part from what Dove had learned from Picasso's work at this crucial point in his career.

40. Statement for the catalogue of the Forum Exhibition, 1916.

41. In his investigation of the phenomenon of biomorphism, Metzger, in "Biomorphism in American Painting" correctly locates Dove's art within a continuous form language that was vital from c. 1910–50 and bemoans the lack of scholarly investigation of both spontaneous parallels and direct influences between Dove and other major figures of twentieth-century art.

That the same connections were visible to some years ago is suggested by Aline B. Louchheim, "Venice to Glimpse Our Modernists," *New York Times*, 28 May 1950, Sec. 2, 7. She points out that Alfred Barr saw Gorky, deKooning, and Pollock (his three choices for

the Biennale) "as representing that movement which 'descends from Gauguin and van Gogh, through the Fauves, Kandinsky and Klee, and then on through Arp, Miro and Masson and the Americans, Dove and Tobey, down to the younger generation of the present day.'"

42. It was included in a group of paintings taken to Stieglitz in 1924. While they may have been done over a period of time, none is documentable earlier.

43. See the introduction to the catalogue for description of the useful documentary sources and for an explanation of procedures followed in dating works in the catalogue.

44. These works are surveyed as a group in the exhibition catalogue by Dorothy Rylander Johnson, *Arthur Dove: The Years of Collage* (College Park: University of Maryland Art Gallery, 1967). Dove did at least twenty-five assemblages.

45. Collages are entirely two-dimensional; they consist of pasted papers and, occasionally, other flat materials, such as cloth. Some writers prefer to reserve the term for the classic Cubist *papiers collés* of 1910–20. As none of Dove's "assembled" works (except *Italian Christmas Tree*) consists of pasted papers, I have simply referred to all of them as "assemblages."

46. Picasso had used the same device earlier.

47. Lawrence Campbell, "Reviews and Previews: Arthur G. Dove," *Art News* 69 (January 1971): 18; Abraham A. Davidson, *Early American Modernist Painting 1910–1935* (New York: Harper and Row, 1981), 95.

48. Royal Cortissoz, "A Spring Interlude in the World of Art Shows," *New York Herald Tribune*, 15 March 1925, sec. 4, 12.

49. The idea of symbolic rather than physical portraits had been worked over within the Stieglitz circle for more than a decade. Marius de Zayas and Picabia had produced the most amusing and trenchant examples during the "291" era. In the twenties, Charles Demuth did a series of symbolic "poster portraits," including one for Dove himself.

50. For example, Johnson, *Arthur Dove*, 48.

51. Diary of Arthur Dove, 22 November 1924. Diary of Helen Torr Dove, 25 November 1924, refers to smoking the lens for the work. If the element started out as a mirror, perhaps Dove's intention all along was to suggest a lens.

52. I am indebted to William Dove for his thoughts on the significance of this work.

53. There are, of course, precedents for the technique, but the Cubists lifted the method to a high art. See William C. Seitz, *The Art of Assemblage* (New York: Museum of Modern Art, 1961), 150.

54. William Agee has claimed that Dove's

"collages and reliefs . . . are pure Dada in conception and technique, yet hardly a word about Dada can be found in the Dove literature. . ." ("New York Dada, 1910–1930," in *Avant-Garde Art,* ed. Thomas B. Hess and John Ashberry [New York: Macmillan, 1968], 151). Perhaps Dada has been "neglected" because the essentially negative, destructive aspects of Dadaism are not to be seen in Dove's inherently affirmative art. If Schwitters's relief constructions were the "catalyst," as Agee argues, for Dove's, then why did Dove wait four years after Schwitters's assemblages were shown in New York before he exploited the presumably newly discovered technique? Most of Agee's arguments can be deflated simply by agreeing with him: *of course* Dove knew dada work. Even by the time he met Picabia in 1913, he must have been familiar with dadaist proclivities within the Stieglitz circle, since Stieglitz had shown DeZayas caricatures as early as 1909 and had published DeCasseres by 1912 in *Camera Work.* Later, he had sponsored the publication of the dada-flavored *291.* At any rate, Agee's point of view is vitiated by his attempts to pull under the dada umbrella far more artists than can be sheltered by it; Demuth and Hartley, along with Dove, are better left in the open.

Davidson, *Early American Modernist Painting,* sees the assemblages as the result of influence from the Arensberg salon, where he places Dove as a participant (p. 76). While it is possible that Dove went to parties there, I have found no evidence to suggest that he did so. In the Dove papers, there is no mention of Arensberg. While Dove knew a number of the artists who frequented the Arensbergs', he was not temperamentally suited to be one of them. The kind of wit and irony seen in some of Dove's works can be as easily connected to the "291" spirit as to the Arensberg milieu.

55. It is interesting that although Dove's work was included in the definitive Museum of Modern Art survey of assemblages, the ambitious catalogue text, which deals extensively with the varieties of meaning embodied in this twentieth-century technique, says not one word about Dove's individualistic contributions to the genre. See Seitz, *Assemblage;* Dove's work is illustrated on pp. 42 and 43.

56. Commenting on Dove's assemblages at the time of the 1970–71 Terry Dintenfass Gallery show of them, Lawrence Campbell, in "Reviews and Previews," comments that some of them "seem quite wild even after 40 years." He went on: "Boxes containing emotive objects and paintings were not new when Dove made them, but their history had been more or less vernacular (Charles Dickens describes one in *David Copperfield*). Dove, in his quiet, rather forlorn way, gave them a life in art."

Responding to the same show, Hilton Kramer, in "Art: Witty Collages of Arthur Dove," *New York Times,* 9 January 1971, 23, noted, "The range of invention is still a shock and the perfection of execution a marvel. . . . Some would still look up-to-date if they had been done yesterday."

57. Diary of Arthur Dove, 4 December 1924.

58. Translated by Mrs. Charles Knoblauch, it appeared in three installments: 8 (Spring): 7–19; 9 (Autumn): 41–59; and 9 (Winter): 49–60.

59. Dove to Stieglitz, probably 25 July 1922.

60. Diary of Helen Torr Dove, 20 June 1924.

61. Jeffrey Wechsler, *Surrealism and American Art 1931–1947* (New Brunswick, N.J.: Rutgers University Art Gallery, 1977), surveys the introduction and uses of surrealism in the United States but does not consider Dove.

62. *transition,* which published James Joyce frequently, was probably responsible for Dove's appreciation of this writer, whom he considered the finest modern author. In view of the many parallels between Dove's art and that of the abstract expressionists, it is interesting to note that they shared his appreciation of Joyce. See Evan R. Firestone, "James Joyce and the First Generation New York School," *Arts* 56 (June 1982): 116–21.

63. Reds' sister, then living in Paris, sent the magazines regularly as Christmas presents.

64. As a voracious reader, Reds was an important conduit. She read many more books—both classics and new works—than Dove did and probably read more of the magazine articles. However, it is obvious from many comments in her diaries that they talked a great deal about ideas, and she must have often drawn his attention to things he otherwise might have missed.

65. Surrealism was, after all, initially a literary movement. It is interesting that the critic who knew Dove best, Elizabeth McCausland, pointed out in "Dove: Man and Painter," *Parnassus* 9 (December 1937): 5, that *Goin' Fishin'* (25.3) "is a surrealist work made before the doctrine reached these shores." Earlier, Murdock Pemberton, "The Art Galleries," *New Yorker* 8 (26 March 1932): 34, had noted that Dove had been a surrealist before a name had been given to "that mystic endeavor."

66. *Hand Sewing Machine* (27.4) is a rare, fearsome image. Was it triggered by Isidore Ducasse's oft-quoted image of a "chance encounter of a sewing machine and an unbrella on a dissecting table"? *Ferry Boat Wreck* (31.8), with its woundlike focus impaled on debris, is an unusually painful work, which suggests similar forms that Gorky would later derive as he worked out of surrealism.

67. Max Ernst, *Histoire naturelle* (Paris, 1926).

68. The *Bessie of New York; City Moon* (38.3), with its evocation of a grinning man-in-the-moon; and *Lake Afternoon* (36.6), with its monsters rising from the waters, along with a few other paintings, seem today like naive, almost childish attempts to represent the forces that animate the universe. We should not underestimate the extent to which Dove was attempting to be humorous, but across the years at least, these paintings seem a bit more silly than witty. Nonetheless, their intended meaning—and ultimate seriousness of purpose—should be appraised in light of more sophisticated contemporary parallels to be found among the surrealist artists. For instance, Metzger, "Biomorphism in American Painting," 71, rightly draws attention to parallels in the contemporary work of Arp and Miro for *Lake Afternoon*.

69. In view of Dove's admiration for Picasso, it should be noted that *Cows in Pasture* (and other similarly constructed works, both abstract and semirepresentational) resemble in their curving, flowing lines and overlapping planes works from Picasso's "surrealist" period in the late twenties. A particularly apt example is the Museum of Modern Art's *Seated Woman* of 1927. This painting belonged to James Thrall Soby, and Dove must have seen it illustrated in the catalogue of the 1936–37 "Fantastic Art, Dada, Surrealism" show at the Museum of Modern Art (since he also was included in that show), if he had not seen the painting or a reproduction of it earlier.

70. McCausland, "Dove: Man and Painter," 4, noted that "Today . . . the 'uncompromising abstractionist' that [Dove] is is likely to seem 'conservative' in an era when social art is uppermost."

71. *Abstract Painting in America*, with introduction by Stuart Davis (New York: Whitney Museum of American Art, 1935).

72. Barr, Alfred H., Jr., *Cubism and Abstract Art* (New York: Museum of Modern Art, 1936). The show comprised nearly 400 items, including architectural plans, films, posters, and so on, as well as painting and sculpture.

73. In the forties, Dove took over the responsibility of keeping the diary that documents his life and Reds'. There are not many notes about reading matter in them (as there are in the earlier diaries), but that is probably because Reds was more inclined to record those things.

74. Their early work is surveyed in Robert Carleton Hobbs and Gail Levin, *Abstract Expressionism: The Formative Years* (Ithaca, N.Y.: Cornell University Press, 1981). The book was originally published in 1978 as an exhibition catalogue by the Whitney Museum of American Art and the Herbert F. Johnson Museum.

75. This painting is one of those for which interesting and particularly pointed connections can be made through history, both forward and back. On the one hand, it resembles biomorphic relief constructions made by Arp in the teens (one of these was reproduced in the 1936–37 Museum of Modern Art "Fantastic Art, Dada, Surrealism" catalogue, which Dove is likely to have seen), while on the other hand it anticipates later Morris Louis paintings, such as *Floral Acrylic* of 1959.

76. Writers who saw connections between Dove's work and the emergent abstract expressionism of around 1950 include the following: Emily Genauer, "This Week in Art," *New York World-Telegram*, 9 May 1949; Daniel Catton Rich, "The Stieglitz Collection," *Chicago Art Institute Bulletin* 43 (15 November 1949): 68; Howard Devree, "Pioneer Modernist," *New York Times*, 27 April 1952, sec. 2, p. 9; and James Fitzsimmons, "Dove's Abstract Nature," *Art Digest* 26 (1 May 1952): 16.

77. This sounds like a startling premonition of Pollock's famous 1947 statement about being "in" his paintings. See Jackson Pollock, "My Painting," *Possibilities* (Winter 1947–48): 79.

78. When Dove was young, technical literature was limited. He even consulted Cennino Cennini's fourteenth-century handbook as if it had been written the day before yesterday.

79. The diaries he kept in the forties are replete with records of his experiments with substances in various proportions, all noted in the nearly illegible, highly abbreviated writing he used when making notes for himself.

Context and Theory

THROUGH HIS ART, DOVE CONTRIBUTED TO THE MODERNIST REEXAMINATION OF THE PREM-
ises and ideals of life in America. Toward the end of the nineteenth century, industrial
society, which depends on highly organized urban life, had come into being, and
before 1900, the frontier was believed to be closed.[1] The possibilities as well as the
style of life in the United States were changing. The old values and the myths of
America, which had been operative in the Geneva of Dove's youth, no longer seemed
so incontrovertible as they once had. As a concept, as well as a polity, what was
America now? Had the original dream been abandoned? How could liberty and justice
for all be achieved in the face of massive immigration, the need for factory labor to
keep the industrial behemoth alive, and the social-Darwinists' contention that persons
were not equal? What were the individual's responsibilities to his conscience, to other
individuals, to the society of which they all were members? What did success now
mean, and was it worth the price?

When Dove first arrived in New York City, early in the first decade of the twentieth
century, intellectuals, reformers, and artists were beginning to try to answer those
questions, and in the process, the modern consciousness was being born. "The long-
awaited reckoning with the realities of the new epoch was at hand," Alfred Kazin has
pointed out, suggesting further that this new spirit, one of "active critical realism" in
literature, "stimulated American liberal thought in every sphere."[2] "There was an all
but universal awareness that America was standing at the threshold of a new era," says
historian Richard Hofstadter. "The imperative business of national self-criticism
stirred ideas into life."[3]

Dove was a leader among the young artists who supplied the new art, parallel in its
basic sources and goals to other self-consciously "new" or "radical" phenomena in the
intellectual and emotional life of the United States. The "new psychology," the "new
education," the "new economics," the "new history," the "new philosophy," the "new
jurisprudence," and even the New Freedom of Woodrow Wilson were among other
aspects of this self-willed modernity.[4]

The radicals in other fields of endeavor "understood the end of social and political
reform to be the improvement of the quality of American culture as a whole."[5] This led
to a "confusion of politics and culture"[6] similar to the confounding of art and culture
in the thinking of the Stieglitz circle and other modernists. Art historian Milton Brown
has pointed out that the artist who participated in the intellectual life of the large cities
faced a situation in which "economic, social, cultural, and moral questions were all

mixed together in a mass of indistinguishable ferment and there were few who separated one from the other."[7]

Dove was not one of those few. Quite consciously, Dove, like Stieglitz and other artists, emphasized that art and life belonged to a single, organic process. For Dove, life itself could take on the characteristics of an art. As Dove later wrote to Stieglitz:

> Am convinced that you have a will through living your life as an idea that makes things happen. Treating life as a work of art is a thing that is seldom done. One has to have a terrific love of the sensitive human thing to be able to do it.[8]

Conversely, the test of art's validity was whether it had the power to affect life. "Art does not fulfill its purpose until it talks to us about life," proclaimed a modernist sympathizer in his review of the Armory Show.[9] Later, as one of Stieglitz's associates wrote:

> . . . in the words of Steiglitz, everything within An American Place is tested by whether it functions as a necessary force for what is outside, so everything that is within must stand the test of the light of day; of the world beyond—falling upon it from without.[10]

The insistence on "coming to grips with life, experience, process, growth, context, function"[11] in the first decade resulted from a conviction burgeoning since the 1890s that "logic, abstraction, deduction, mathematics, and mechanics were . . . incapable of containing the rich, moving, living current of social life."[12] To propel art into that "living current" was the goal of Dove and other artists of his generation who wished to create an art commensurate with the modern experience. This they foresaw in spiritual terms as an art based on intuition.

Given the atmosphere in which Dove's ideas matured and his art developed, it is not surprising that the fundamental characteristics of his art—notably his preferences for nature imagery and for abstract form—are deeply rooted in the pre-World War I intellectual and emotional environment. These twin supports of Dove's art can be seen in very general terms as, respectively, the American and European components of his art, for each depended upon a particular tradition to which Dove was exposed.

Landscape had been the most popular—and most philosophically potent—subject matter of American art in the nineteenth century. American thought had elevated landscape to a mystical antidote for the evils and frustrations of civilization.[13] Nature, therefore, had taken on a *moral* and sometimes even heroic dimension that was still intact when Dove was young and even today has not withered entirely.[14] Nature imagery occurs in Dove's art partly because he accepted that moral evaluation and saw nature as a source of positive values as well as aesthetic truth. There is no doubt, too, that Dove simply enjoyed nature, responded strongly to it, and derived a sense of satisfaction from it. Through nature he was in touch with the larger mysteries of life. Even so, the place of nature in his art has frequently been evaluated simplistically. Dove was not a pantheist, nor did he paint in order to proselytize for a philosophical position on nature. Rather, he desired to crystallize his own intense responses to the large, positive, and ineffable forces of reality. Thus would his art express the personal vitality he sought in his own life.

On the other hand, Dove's interest in abstract form comes largely out of a highly refined, European aesthetic context. Symbolist thought, as it fed the early modern movements in art, had elevated abstract form to a position of superiority over representation by stressing its spirituality, its opposition to crass materialism. This movement's most compelling outgrowths in Europe were Cubism, Kandinsky's experimental expressionism, and the more geometric varieties of abstraction, as de-

veloped by the Russians and Mondrian. The meeting place of homegrown American thought and sophisticated Symbolism, in Dove's mind, was in their common elevation of individual experience, individual sensation. Dove's stubborn attachment to the value of personal experience (as opposed to received ideas) is grounded in the strongest current in American nineteenth-century thought: individualism. Emphasis on the individual reinforced the role of nature (rather than the community) as a source of value and had many other ramifications in American thought and lifestyle. Its philosophical manifestations were Transcendentalism and Pragmatism, both of which affected Dove's attitudes toward art and life (the former, especially in its worship of nature; the latter, in its emphasis on doing rather than theorizing). In the longer view of American art, individualism links the sensibility of Dove's art with the intensity, risk-taking, and occasional ungainliness of similarly serious and fiercely independent artists from Fitz Hugh Lane to Albert Ryder to Jackson Pollock and others of the New York School.

When they wrote about the individual, the Symbolists had in mind the superior individual who has already devoured civilization, not one who was ready to do without it (as an Emersonian Transcendentalist would have it), but a young American artist in the early 1900s could overlook that distinction. Thus, through its emphasis on radical individualism—specifically, on the artist as outcast, exile, or seer—the Symbolist ethos could be made to mesh well enough with the characteristically American notion of the importance of individual freedom and with the contemporary radicals' perception that cultural reform originated within the individual. Thus, by about 1910, liberation became the key concept in the direction of Dove's life and art.

Like other radicals, Dove was impressed with vital European contributions to the belief in extreme individual liberty and to its expression in art and life, and he appreciated the Europeans' more artistically inclined, un-Puritanical civilization. Thus, he was an internationalist in his aspirations for the progress of the modern spirit and in his admiration for the cosmopolitan alternative to provincialism. Still, he was convinced that meaningful art had to be indigenous.

In the United States, virtually all early modernists desired to formulate a particularly American definition of modern experience. America had always been a concept as much as a place, and self-consciousness was therefore requisite to America's viability; the country existed in the mind as well as underfoot. The necessity for art to be rooted in the native culture was one of the main points of Van Wyck Brooks's early book, *The Wine of the Puritans,* in which he insisted that "a man . . . cannot be a supreme artist without expressing his race."[15] Optimistically, he hoped for the day when American art could grow in a more nourishing culture:

> . . . I think a day will come when the names of Denver and Sioux City will have a traditional and antique dignity like Damascus and Perugia—and when it will not seem to us grotesque that they have.[16]

For Dove, however, an interest in defining the American experience did not mean that the artist should turn to American subject matter. "When a man paints the El," he has been quoted as saying,

> a 1740 house or a miner's shack, he is likely to be called by his critics, American. These things may be in America, but it's what is in the artist that counts. What do we call "American" outside of painting? Inventiveness, restlessness, speed, change.
>
> Well, then a painter may put all these qualities in a still life or an abstraction, and be going more native than another who sits quietly copying a skyscraper.[17]

The emphasis on an American definition of modernism coincided with a rediscovery of a usable, American, cultural past that could help define the future.[18] "Americana," colonial art and architecture, rural antiques and handicrafts, America as an accumulation of man-made things—all these were rediscovered by those who were looking for a way out of the stale present. Although Dove had no interest in Americana as such, the quaintness of his *Grandmother* assemblage (25.5)[19] and the hominess of materials and imagery in so much of Dove's work provide evidence, as do the writings of Sherwood Anderson and Sinclair Lewis, of a deep attachment to certain aspects of the America against which they rebelled in other respects. The duality of fascination and repugnance reflected a contradiction between the wish to find roots in the American past and the simultaneous wish to eradicate negative elements. Dove lived out this dilemma in small-town America, just as "so many young writers" in the same period "seemed to have endured life in a hundred different Spoon Rivers for the sole purpose of declaring their liberation in their novels."[20]

If Dove, like many others, was ambivalent about the meaning of the American past, he was very clear about his own role. Like other committed artists of his time, Dove wished to participate in reconstructing society without being overtly political or concerning himself directly with social causes. This strategy was possible because of the strength of his belief in individualism. The essential reform had to start with the individual, and the artist was a special case of that responsibility to self. As Van Wyck Brooks put it, "The only writers who can possibly aid in the liberation of humanity are those whose sole responsibility is to themselves as artists."[21] What Brooks voiced for the writer had also been elevated to a principle by Dove's favorite philosopher, Nietzsche, by Stieglitz, and by others who had imbibed the spirit of European Romanticism and Symbolism.

This conception of the artist's role and responsibility deeply affected Dove. The demand to be genuinely responsible to self meant there could be no *a priori* standards—in art as in life. "There is no right or wrong in aesthetics," as Dove put it in 1929. "There is only that thing of finding something that seems more true than the last something that you or someone else found that seemed quite true."[22]

For all Dove's intended radicalism, however, several obvious and traditional assumptions about the nature of art in general and painting in particular limited his progressivism. These more conservative aspects of his art reveal other elements of his aesthetic.

Despite Dove's occasional claims that he was not interested in art, assertions that he was simply doing experiments or something of the kind, the very nature of the work to which he was so dedicated contravenes such statements. Typical of Stieglitzian rhetoric, as part of his circle's calculated campaign to dissociate themselves from the expectations of tradition and to dramatize the new thrust of the modern movement, such radical-sounding statements from Dove were sincerely meant on that level. Yet, in every way, his art and life testify that above all he was deeply and totally committed to being a producing artist in a rather traditional sense.

In physical characteristics, Dove's work—except for the assemblages—adapt the most traditional aspects of the medium to modern needs. Dove's framed, rectangular canvases follow the format that had been standard for 400 years. His paintings were always relatively small, the largest dimension rarely exceeding forty inches; thus, they are a suitable size for the private home, as opposed to monumental public works or gigantic, museum-oriented paintings.

Dove's careful attention to some rather traditional aspects of the art of painting may have seemed particularly necessary sixty or seventy years ago because these links with tradition reinforced the paintings' legitimacy as art, a premise that was more than once publicly questioned by his detractors. Like most of the other American modernists, he

worked his way into the modern world within the limits of accepted formulas for materials, techniques, and formats.

In relation to traditional thinking, Dove subscribed to the idea that art is or should be based on some sort of principles, although his antitheoretical attitudes undercut these ruminations. Perhaps the only principle that is actually visible in his art is his belief in simplicity, his attachment to economical means as the most effective. What seem to be not clearly evident in his art are his attempts, recorded in writing, to devise some laws of painting that could be consistently applicable to his own work. Perhaps one reason his theories do not seem evident in the paintings is that, in their developed form, they are virtually unintelligible.[23] If he used them at all as practical guides to producing good paintings, he must have violated them regularly.

Dove's universalizing theories seem to revolve around his desire to find an irreducible law of both color and form. He came to believe that the basis of form was a cone. Rotated in space, this form would generate all other geometric elements. The color rule had to do with triads taken at equal points on a color wheel.[24] Later he modified the color rule toward greater complexity in the guise of greater simplicity. Just as he had hit upon the "one form," he also formulated the idea of a single color—White Light— as the fountainhead of all colors. But this made his color theory, too, hopelessly abstruse. Perhaps Dove was acknowledging his inability to come up with such principles when he wrote to his mentor at the end of an attempted explanation of them: "Dear Stieglitz, I know you will smile."[25]

In the same letter, Dove mentions "theory, which might be called the conscience." Dove was not alone in feeling that art should have a conscience. Practically every artist, whether vanguard or conservative, was interested in somebody's theory or was promulgating his own, perhaps especially in the twenties. Many artists were interested in Denman Ross's "scientific" theories of composition in art through the centuries and in Jay Hambidge's "dynamic symmetry."[26] The color theories of Hardesty Maratta and others also intrigued many artists.[27] The widespread appeal of systems for the creation of art was undoubtedly much indebted to two factors related to modernism.

First, a widespread emphasis (even among those artists who retained representational subject matters) on the abstract elements of art naturally gave rise to intensified interest in the abstract components of the art of all times. Once pure form took precedence, as Meyer Schapiro has pointed out, "The art of the whole world was now available on a single unhistorical and universal plane as a panorama of the formalizing energies of man."[28] Thus, twentieth-century man, examining the art of the past or of the exotic present with his own new interests in mind, wondered anew if there were universally applicable laws of creation.

Second, if the rules of traditional art were being discarded, it was only natural to think about formulating new ones. Hence, even many of the modernists in painting had a nagging feeling that somehow there ought to be some theoretical basis for what they were doing. To operate in a theoretical vacuum seemed to them irresponsible, though, to be sure, Stieglitz had announced in 1912, "We insist on remaining relaxed and not theorizing."[29]

Thus, it was very much in keeping with the spirit of his times that Dove interested himself in the "laws" of art. This impulse derived from the traditional assumption that great art is based on universal constants, if not stringent rules. Characteristically, Dove turned to nature for guidance.

Dove's belief that some sort of universal principles applicable to art might be found in nature is revealed as early as 1913 in his previously cited letter to Arthur Jerome Eddy. In this statement, written shortly after his abstract pastels had created such a stir in New York and Chicago, Dove explained:

> After having come to the conclusion that there were a few principles existent in all good art from the earliest examples we have, through the masters to the present, I get about it to analyze these principles as they occurred in works of art and in nature.[30]

In other words, the principles of art and nature being parallel if not identical, the study of nature should yield constants applicable to art. Though Dove clearly infers that some sort of higher principle exists for the ordering of both art and nature, the influence of Stieglitz's adamantly nontheoretical point of view must have been one of the reasons that Dove never got around to drawing the conclusions from this proposition (at least not in writing).[31]

Theorizing aside, as Dove's biography reveals, his passion for painting controlled his entire life. Through painting, the artist could give permanence to moments of heightened consciousness. Like Sherwood Anderson, Dove might have said, "I have come to think that the true history of life is but a history of moments. It is only at rare moments that we live."[32] For Dove, his objectivization of "rare moments" in paintings were stepping-stones to self-transcendence. His own letters are filled with references to his latest paintings as being "further on," as having something new that was not in the previous work, and he often speaks of this progress in terms of his own learning from it. From Dove's point of view, these works of art might signify at least the potential existence of an ideal, liberated sensibility, a goal that was the "idea" of which Dove so often spoke.

Stieglitz called many of his photographs (mostly the abstract studies of clouds) "equivalents," a designation of their relationship to the inner life of the artist (and perhaps the viewer). In its implication that the work of art is a plastic manifestation of a specific state within the artist, Stieglitz's idea of the equivalent is not very different from T. S. Eliot's "objective correlative" in literature. Both derive from the Symbolist idea of "correspondences."[33] The rhetoric of equivalents and, more important, an intuitive grasp of this aim, runs through the talk of the American modernists.[34] It is within this context that Dove created paintings that are not descriptions or allegories of specific things, situations, or objects; rather, they are symbols or evocations of an *état d'âme*—a mood or spiritual state. To accomplish this aim, Dove drew upon the belief widely held before there was an abstract art that the abstract components of art were what transmitted its all-important emotional content.[35] Dove, like other modernists, then could believe that a work of art that satisfactorily captured a mood or emotion in nonrepresentational form would therefore awaken the same *état d'âme* in the spectator.

As symbols of feeling, Dove's works bear witness to his search for essences, which he came to describe metaphorically as "conditions of light." In 1929, Reds noted in her diary that Dove was "working on the idea of each thing having it's [sic] own condition of light,"[36] and the following year, he wrote:

> There was a long period of searching for a something in color which I then called "a condition of light." It applied to all objects in nature, flowers, trees, people, apples, cows. These all have their certain condition of light, which establishes them to the eye, to each other, and to the understanding.
>
> To understand that clearly go to nature, or to the Museum of Natural History and see the butterflies. Each has its own orange, blue, black; white, yellow, brown, green, and black, all carefully chosen to fit the character of the life going on in that individual entity.[37]

"Condition of light" probably resembles Sherwood Anderson's notion that a person

has "a certain tone, a certain color."[38] To emphasize that this "color" is an essential, spiritual radiance, he distinguished it from what can be objectively perceived by continuing, "What care I for the person's age, the color of their hair, the length of their legs?"

This desire for an intuitive relationship with objects as the means to discovering their essences recalls the philosophizing of Henri Bergson. Whether or not Dove had carefully studied Bergson's widely influential writings, he was certainly familiar with that writer's contributions to thought early in the century,[39] and the basis of Dove's art-life philosophy, with its emphasis on nonrational vitality, is Bergsonian in spirit. Similarly, there is an infusion of Bergsonian vitalism in Dove's approach to creating symbols of feeling. What Dove meant by feeling was not something abstract and rarified, like the French Symbolist aesthetic Absolute. Rather it was something much closer to everyday life, and it was generally triggered by sensation. Until his last years, Dove could not work with purely abstract form for very long because he felt that without constant reference to the physical substance of nature, his line became lifeless, his expression, meaningless. "Theories have been outgrown, the means is disappearing, the reality of the sensation alone remains," he wrote in 1916.[40] Dove's oft-repeated concern for "wholeness" can be seen as part of his conscious reaction to the destructiveness of middle-class American attitudes, which denied human beings their full range of potential by teaching suppression of physical as well as emotional instincts.

Above all, then, Dove's art was an affirmation of individual liberty, although in some respects, particularly in regard to the physical nature and basic purposes of a work of art, Dove accepted traditional conventions. "Influence," such as it was, on his art was mostly theoretical; a common fund of new ideas was what he shared with his modernist colleagues both in Europe and in the United States. What he shares in terms of form preferences is largely the result of working with similar attitudes and is perhaps more visible today than in his own lifetime, when his "originality"—his distance from other artists—was almost a cliché of contemporary criticism.

Dove's impulses toward experimentalism and pragmatism mitigated against his developing a real theory. What use to elaborate principles if his own desire was to outgrow them? Like his friend Sherwood Anderson, Dove was "essentially indifferent to the old dream of a perfect 'work of art.' "[41]

Convictions about life motivated and shaped Dove's art and his aesthetic. Essentially, the commitment to liberation, to radical individualism, was a life-value rather than an artistic one. If anything, Dove more nearly developed a theory of life than a theory of art. And yet, his own clarity about the purpose of his life made it possible for him to produce a large body of intelligent and deeply felt art, which enlarges some of our notions about what both art and life can mean.

Dove has always had a small, appreciative audience for this art. Yet, the question of how this work has affected the creative life of the twentieth century is not easy to answer. Just as it is difficult to detect specific "influences" on Dove's work, it is likewise difficult to demonstrate his direct influence on other painters.

Despite the generally favorable reviews he received during his lifetime and the visibility he attained through invitational shows and publications, Dove's direct influence was almost entirely limited to the artists of the Stieglitz circle. Even there, his influence was early and general. By providing the precedent for an indigenous abstraction at an early date, Dove naturally impressed the forward-looking artists who were working in the same direction. For instance, John Marin seems to have been notably impressed by the abstractness of his work.[42] But only Georgia O'Keeffe was visibly influenced by his method of abstracting from nature after she first admired his work in Eddy's *Cubists and Post-Impressionism* and the 1916 "Forum Exhibition."[43]

After 1920, Dove's work ceased to mean very much to the mature styles of his fellow

workers in Stieglitz's orbit. Only in O'Keeffe's work from time to time are distinct formal similarities found.[44] However, Dove's lack of immediate influence on the next generation was due not only to his limited production in the years around 1920, nor even to the fact that he personally spent rather little time fraternizing with other artists. The problem, rather, was a cultural one. His situation was similar to that of the other early modernists. Where are the followers of O'Keeffe? Who worked "in the style of" John Marin? Who imitated Demuth or Maurer or Weber or Hartley? The whole movement has an hermetic character. Partly, the group's lack of "influence" may have been the result of the fact that, for whatever they may have shared, they were a group of individualists who never formulated a distinguishable group style. They all believed in the need for a personal resolution to the problems of both style and subject, and none of them taught.

Even more important to their lack of leadership, however, was that for some reason the next generation of modernists produced writers instead of visual artists. Stuart Davis and Alexander Calder were the only abstractionists of distinction to develop in the twenties or early thirties, while their contemporaries—those who came into adulthood around the time of World War I—constituted one of the most talented groups of writers ever to emerge in the United States.[45] These novelists and poets, the "lost generation" of American letters, in many ways carried on the ideals of the artists of Dove's generation. By the thirties, Dove was looked upon by many as a sort of quaint relic of the past for his continued commitment to nature-based abstraction. In that period of enthusiasm for regional realism, his chances of serving as a model for young artists were virtually nonexistent.

When Dove and Stieglitz died in 1946, a new phase of modernism was well under way. But abstract expressionism was big, aggressive, reckless, and measured against these qualities, even Dove's art from the 1940s was overwhelmed. Whether Dove's regular, annual shows at An American Place in the late thirties and early forties may have helped those young people develop the new style is something of a moot point. Theodoros Stamos has noted an affinity for Dove's work, but the other well-known New York School-ers have been silent. It is not likely that they remember Dove's work as a decisive influence, even if they were aware of his work in at least a general way.

Several reasons mitigated against these vital young people looking to Dove. First, the generally *retardataire* art scene of the thirties and, indeed, even much of the twenties led this entire younger generation to evaluate all American art as provincial and uninteresting. For the young artists of 1940, American art had no chic. Second, these artists were the first generation to be brought up on the Museum of Modern Art's view of what constituted modernism. And that view was oriented toward Europe. Third, Dove was never personally available, whereas a number of exiled Europeans of major stature were in New York during the war and participating in the gallery and café life of the city. Fourth, and especially important, Dove had no spokesman for the meaning of his art, at least not in terms that would appeal to the younger generation. Stieglitz may even have gotten in the way of the art public's appreciation of Dove's abstractions at this point. By the forties he was infirm and could be impossibly garrulous or crotchety, depending on his mood and the nature of the visitor. As well, by this time, he may even have impeded an understanding of the significance of Dove's accomplishment, however much he may intuitively appreciated it himself. Years earlier, to protect Dove's privacy and to buttress his own almost maniacal faith in his artists' Americanism and creative purity (no influences allowed in either case), he had invented for the public, including the press, a view of Dove as a virtual hermit who created exclusively from his mystical feeling for nature. By the forties, Stieglitz had been thus oversimplifying Dove's accomplishment for so long that it is likely that he had no appropriate words for the visitor who came to see Dove's paintings, which were indeed so strikingly original that any but the most sophisticated viewer would

Seagull Motif, or Violet and Green. 1928. 28 × 20. (cat. no. 28.9)

Alfie's Delight. 1929. 21¾ × 29⅝. (cat. no. 29.1)

Colored Barge Man. 1929. 22 × 30. (cat. no. 29.2)

Untitled. 1929. 28 × 20. (cat. no. 29.22)

Wind [No. 1]. 1929. 19½ × 24. (cat. no. 29.24)

Brick Barge with Landscape. 1930. 30 × 40. (cat. no. 30.4)

Dancing Tree. 1931. 30 × 40. (cat. no. 31.6)

The Mill Wheel, Huntington Harbor. 1930. 23¾ × 27⅞. (cat. no. 30.11)

Snow on Ice, Huntington Harbor. 1930. 17⅝ × 21½. (cat. no. 30.17)

Cinder Barge and Derrick. 1931. 22½ × 30½. (cat. no. 31.5)

Two Forms. 1931. 33 × 24. (cat. no. 31.18)

After Images. 1932. 10 × 11. (cat. no. 32.1)

Barge and Bucket. 1932. 23½ × 24. (cat. no. 32.2)

Gale. 1932. 25¾ × 35¾. (cat. no. 32.10)

Sun and Moon. 1932. 18¼ × 22. (cat. no. 32.17)

need some clues as to their meaning and their place in history. For all these reasons, then, Dove was cut off from a direct and meaningful relationship with the painters who were in many ways—even if they would never know it—his heirs.

Despite the lack of documentable influences from Dove's work to the next generation, his art lives in a web of visual associations with abstract expressionism—notably the work of Gorky, Gottlieb, Baziotes, Stamos, and Rothko (especially their work from the early forties)—just as it had earlier with artists such as Kandinsky, Picasso, and the surrealists. For all these reasons having as much to do with historical circumstances as with the individualistic nature of his art itself, Dove has been slighted as an innovator and participant in a major sensibility of our time. Realistically, his art deserves to be seen as a major contribution to the early twentieth century's continuous history of interest in organic or nature-based abstraction.

NOTES

1. As announced by Frederick Jackson Turner in his essay "The Significance of the Frontier in American History," read before the American Historical Association in 1893.

2. Alfred Kazin, *On Native Grounds* (1942; reprint, Garden City, N.Y.: Doubleday [Anchor], 1956), 69.

3. Richard Hofstadter, *Anti-Intellectualism in American Life* (New York: Random House [Vintage], 1962), 198.

4. Morton White, *Social Thought in America: The Revolt Against Formalism*, 2d ed. (Boston: Beacon, 1957), 47.

5. Christopher Lasch, *The New Radicalism in America, 1889–1963* (New York: Random House]Vintage], 1965), xiv.

6. Ibid.

7. Milton Brown, *American Painting from the Armory Show to the Depression* (Princeton, N.J.: Princeton University Press, 1955), 7.

8. Dove to Stieglitz, December 1930.

9. Hutchins Hapgood, "Life at the Armory," *The Globe and Commercial Advertiser* (New York), 17 February 1913, 8.

10. Dorothy Norman, "An American Place," in *America and Alfred Stieglitz: A Collective Portrait*, ed. Waldo Frank et al. (Garden City, N.Y.: Doubleday, Doran, 1934), 145. Mrs. Norman, an editor of the volume, was a close student of "the words of Stieglitz."

11. White, *Social Thought in America*, 13.

12. Ibid., 11.

13. This current of thought, which has its roots in Rousseau's writings of the eighteenth century, belonged to the legacy of Romanticism throughout the Western world, but it had a particularly potent and far-reaching history in American thought of the nineteenth century.

14. There is a large body of scholarly literature on the meaning of the American landscape as symbol and metaphor as well as reality. Among the most interesting and persuasive books on this subject are the following: Leo Marx, *The Machine in the Garden: Technology and the Pastoral Ideal in America* (New York: Oxford University Press, 1964); Roderick Nash, *Wilderness and the American Mind*, (New Haven, Conn.: Yale University Press, 1967; rev. ed. 1973); and Henry Nash Smith, *Virgin Land: The American West as Symbol and Myth* (Cambridge, Mass.: Harvard University Press, 1950).

15. Van Wyck Brooks, *The Wine of the Puritans* (London: Sisley's Ltd., 1908), 121. The idea itself was, of course, not original. Having been enunciated by the French philosopher and historian Hippolyte Taine in the 1860s, it had become widespread among intellectuals by the turn of the century. When this book was published, Dove did not yet know Brooks personally.

16. Ibid., 142.

17. Wight, *Dove*, 62.

18. Naturally, there had been instances of recognition of positive qualities in the American artistic past, as, for instance, in the revival of American colonial architecture at the end of the nineteenth century. However, such instances were less a part of the most vital imaginative life of their times than was the case early in the modern era. Earlier instances, which had been few in number, were also more limited in scope.

19. Johnson, *Arthur Dove*, 9–13, mentions the possible relationship of Dove's assemblages to Victorian mixed-media constructions and comments on the general upsurge in interest in American art and history (without mentioning its broader implications) from about 1910 into the 1920s.

20. Kazin, *On Native Grounds*, 166.

21. Quoted in ibid., 93.

22. Arthur Dove, "Notes," pamphlet for Dove exhibition at The Intimate Gallery, New York, N.Y., 9–28 April 1929.

23. Dove's son recalled in conversation that his father had attempted to explain his theories to him and Alfred Maurer in the early 1930s—but they didn't understand, either.

24. Possibly his thinking about color theory was influenced by Hardesty Maratta's, though it is likely that his early thoughts on color triads preceded any contact with Maratta's work.

25. Dove to Stieglitz, July 1932. The relevant parts of the letter are cited in full in my dissertation, "Toward the Definition of Early Modernism in America: A Study of Arthur Dove" (Ph.D. diss., University of Iowa, 1973), 179–80. Dove's interest in theorizing seems to have peaked in the early thirties.

26. George Bellows applied the rules of dynamic symmetry more avidly than any other well-known painter. Dove's friend Alfred Maurer was also intrigued. See McCausland, *Maurer*, 91.

27. For example, Robert Henri and John Sloan. See David W. Scott and E. John Bullard, *John Sloan 1871–1951* (Washington, D.C.: National Gallery of Art, 1971), 23.

It should be noted that Dove was characteristically opposed to using anybody's principles but his own, and he was rather insistent on the flexibility of the principles he tried to use. Writing to Duncan Phillips in 1946 about two people who had started to do some work on a book on him, he said they

> seemed unconsciously to be trying to destroy the very essence of what I had found in nature in the motif choices—two or three colors and two or three forms. He compared that to Denman Ross and his color scale which was more like making a language out of a dictionary whereas the simple choice of a motif took the color range all the way up infinity and a child could have used it and they instinctively do.

(Dove to Phillips, Phillips Collection archive.)

28. Schapiro, "Nature of Abstract Art," 78.

29. "Some Remarkable Work . . .," *New York Evening Sun*, 27 April 1912.

30. Dove to Arthur Jerome Eddy, reprinted in *Cubists and Post-Impressionism*, 48.

31. While Stieglitz publicly repudiated theorizing, interestingly enough, he strongly urged Dove in the early twenties to write a book explaining modern art.

32. Sherwood Anderson, *A Story-Teller's Story* (1924; reprint, New York: Grove Press, 1958), 309.

33. A useful source on Symbolism is Anna Balakian, *The Symbolist Movement: A Critical Appraisal* (New York: Random House, 1967).

34. For instance, Abraham Walkowitz wrote in 1916 of trying "to find an equivalent for whatever is the effect of my relation to . . . a thing." (Abraham Walkowitz, statement in *The Forum Exhibition of Modern American Painters*, unpaged.)

35. Schapiro, "Nature of Abstract Art," 77.

36. Diary of Helen Torr Dove, 21 September 1929.

37. Dove to Samuel Kootz, 1930, reprinted in *Modern American Painters* (p. 37). The exact period of the "long time" to which Dove refers is not clear from the full context, but he probably was thinking all the way back to the period around 1910–11. Despite the similarity in terminology, the "condition of light" and "White Light" seem not to have been related in Dove's mind.

38. Anderson, *Memoirs*, 22.

39. Stieglitz had published an important extract from Bergson (previously cited in part) in *Camera Work* as early as 1911. In 1925, Dove bought several books by Bergson. (Diary of Helen Torr Dove, 15 and 19 December 1925.)

40. Dove, statement for *The Forum Exhibition of Modern American Painters*, unpaged.

41. Kazin, *On Native Grounds*, 164.

42. Reich, *Marin*, 1:104–6.

43. Conversation with Georgia O'Keeffe, November 1975.

44. Stieglitz himself may have been stimulated by Dove's abstract work in his own development of the abstract cloud studies.

45. Interestingly, many writers (though not those of the first rank) gravitated to Stieglitz, the defender of free expression in all its forms, as the slightly older Sherwood Anderson was among the first to do. Paul Rosenfeld, Jean Toomer, Alfred Kreymborg, Waldo Frank, and Lewis Mumford were among those to whom Stieglitz gave the same sort of inspirational support he had given to painters before World War I.

Catalogue of Works

THE PURPOSE OF THIS *CATALOGUE RAISONNÉ* IS, QUITE SIMPLY, TO PRESENT WHAT I HAVE learned about the art of Arthur Dove in as clear and useful a form as possible. Like any catalogue of an artist's oeuvre, this one assembles for each work the facts that define it as a physical and historical entity. Naturally, such a compendium must be put together objectively, rather than with interpretive intent.

Even so, as the catalogue took final form, I still had to make judgments when the data was incomplete or seemed contradictory. I often relied on documentary evidence from the artist's lifetime to resolve these problems. Thus, before introducing the format of the catalogue itself, I would like to review the documentation upon which my reasoning has been based.

Six bodies of documentary evidence were essential to the construction of the catalogue:

Exhibition Records. Printed pamphlets for Dove's individual exhibitions are the best single record of the works he produced. Dove's first one-person exhibition, which took place in 1909 in his hometown of Geneva, New York, was accompanied by such a list. Unfortunately, to judge from remarks made in contemporary reviews, no such list was printed to accompany his first show of significant, avant-garde work—also his first one-person show in New York and his first under Stieglitz's auspices—at "291" in 1912.

Dove did not exhibit another substantial body of new work until 1925, when he participated in the "Seven Americans" exhibition produced by Stieglitz at the Anderson Galleries. While this large exhibition included, as its title reveals, six other artists, the twenty-five previously unexhibited items listed in its catalogue constituted virtually a one-person exhibition of Dove's most recent work. In the following year, Stieglitz opened his Intimate Gallery, and from then on, Dove showed regularly there or, after 1929, at Stieglitz's American Place gallery. There is no extant exhibition list for Dove's 1926 Intimate Gallery show, but his December 1927–January 1928 and April 1929 shows are so documented. At An American Place, Dove had an individual show every year in the late winter or early spring from 1930 through 1946. Printed exhibition lists for all of these shows, except those of 1933 and 1934, are extant. With a show every year, Dove naturally exhibited each year what he had finished since the previous show. Moreover, because of his loyalty to Stieglitz and his identification first with "291" and then with Stieglitz's later galleries, Dove felt that his paintings should be shown first at Stieglitz's. From time to time, he declined to exhibit or sell paintings until they had been seen at Stieglitz's current gallery. Thus, the seventeen one-person

exhibition lists plus the particularly significant "Seven Americans" list constitute a virtually complete record of Dove's production from 1925 through 1946, except for the three years from which the lists are missing.

In fact, given the regularity of Dove's exhibiting habits and the existence of the lists, I am convinced that any work that does not seem to have been exhibited during Dove's lifetime was probably shown under some other title than that by which it is known today. The original connections may be irretrievably lost. I have assigned several such works to the years 1926 and 1934 in the belief that they must be among the otherwise undocumented works that were shown in those years. (Although there is no printed list for the 1933 show, a typewritten preliminary list probably documents the show quite accurately. See "Letters" below for details.)

Diaries. The diaries kept by Dove and his second wife, Reds (Helen Torr), are more nearly daybooks than private, introspective journals. For the most part, they record external events such as the weather, their health, visitors, letters written and received, trips into New York City, sometimes even when the washing was done. What is of interest to the catalogue, however, is that the diaries also detail the art work Dove did, almost on a day-to-day basis.

Since the diaries were never meant to be read by anyone else, nothing in them is ever explained for the outsider: visitors are usually known by their first names, family members appear unannounced, catastrophes are barely noted. Likewise, individual paintings are often so casually described that it is not always possible to match the diary records with known paintings. Still, with a little judicious interpretation, hundreds of paintings can be identified, so the diaries are an invaluable record of when paintings were done and sometimes, as well, of other matters (such as materials, techniques, sources of inspiration, and so on).

The first, fragmentary diary (which Dove called the "Log of the Mona" after the name of the boat on which he and Reds lived at the time) dates from 1923. He continued this log into 1924, the year during which Reds also began to keep daily records. In 1925 and after, she was the main journal-keeper for the two of them until the forties, when Dove took over the responsibility. Occasionally, for fairly short periods, both kept simultaneous diaries, but in general, they seem to have thought of the single diary as a record of their lives together and to have felt a joint obligation for it. Dove occasionally made notes in the diary that was primarily Reds', and when she was, from time to time, away for a few days, he dutifully kept the records during her absence. Thus, when I have made references to the diaries under "Remarks" in each entry, as in the notes to the text, I have simply identified the writer, Arthur or Helen Torr Dove, along with the diary reference. The diaries belong to the artist's son, but they have been microfilmed by the Archives of American Art.

Letters. As they relate to records of individual paintings (as well as to other aspects of Dove's life), the most significant body of letters consists of those that Dove wrote to Stieglitz. Of the hundreds of extant letters to Stieglitz (two belong to the Archives of American Art; the others are at Yale), relatively few discuss individual paintings. However, of some importance to the documentation for the catalogue are lists of paintings; these went with the letters from time to time, enumerating paintings that Dove had just sent to Stieglitz or was about to. The most important of these, for the making of this catalogue, is a sheet (Yale, page 276) headed "Paintings by Dove Taken to Stieglitz March 1933." As this list was made shortly before his exhibition of that year, it documents the paintings that were shown that year and thus helps to compensate for the lack of a printed catalogue for the 1933 show. (Those paintings that are not confirmed by published reviews of the exhibition to have been shown are listed in the present catalogue as shown in 1933, but with the designation "probable" to indicate less than absolute certainty.)

Card file. Dove's own card file of about 275 items contains various useful notes for

establishing the identity and physical characteristics of the paintings listed. The most numerous notes are technical; they document pigments, supports, undercoatings, varnishes, and so on. Other notes indicate ownership or mention exhibitions in which a painting was shown. Because virtually all of the works in the file are dated, the card file would seem on the face of it to be a helpful source of evidence for dating, but in fact, the file's utility is extremely limited in that respect.

Dove hit upon the idea of keeping a file of three-by-five-inch index cards on his paintings in 1932. Apparently beginning about the time his American Place show closed in April, he typed a card for each of the nineteen paintings and twenty "framed sketches" that appeared on the exhibition list for his show. He also added a few cards, generally marked "un fr sk" for "unframed sketch," which corresponded to watercolors that were not in the exhibition. (Some or all of these may have been available at the gallery but were not hung with the show.)

At some point—probably during his initial burst of enthusiasm for the card file project—Dove added about 215 cards for paintings from earlier years. Evidently, he worked from the lists of his own previous exhibitions insofar as he could. All the paintings and watercolors in the 1931 show appear in the file, as do a handful of unframed sketches that he presumably remembered from the year before. From his 1927–28, 1929, and 1930 shows, again all of the paintings listed on the exhibition brochures appear in the card file. However, no watercolors or sketches are represented, since they did not show up on these exhibition lists. For his 1926 show, probably no list was ever printed, since I have never been able to find one and Dove clearly did not have one available: there are no 1926 paintings in the file. (One card corresponds to a painting that was probably in the 1926 show, but it was very likely done two or three years earlier.) There was a printed catalogue for the 1925 "Seven Americans" show, but Dove apparently did not have one. However, for the card file he recalled seventeen items out of the twenty-five works he had shown. (An eighteenth, ambiguous card may document one additional work.) For the works before 1925, Dove presumably continued to work unsystematically, as memory served him.

Not only did Dove glean his titles from the exhibition lists he had before him, but he also dated all but two works in the year in which they were exhibited—except for the paintings in the 1929 show. In this year, each individual work was dated (mostly 1928 or 1929) on the printed list, and Dove faithfully followed the dates on this list in making up the card file. Thus, for the years 1927 through 1932, the card file gives no more evidence about dates than the printed exhibition lists do, whereas the diaries (and sometimes the letters) yield a great deal of useful material for precise dating.

Quite a different problem pertains to the dating in the card file before 1927. When Dove relied on memory alone, he was frequently mistaken about the year. However, he was not often wildly wrong; usually, his dates come within a year or two of the correct date. Of the seventeen listed paintings that were unquestionably in the 1925 "Seven Americans" show, eleven are erroneously dated 1926 or later in the card file. Earlier than 1925, documentation is so sparse that similar estimates of his accuracy cannot be made, but his dates can sometimes be weighed against other evidence, and the conclusion must be drawn that the card file dates are unreliable.

Dove's interest in the card file soon waned. There are no entries for 1933 or 1934. Presumably just before his 1936 show, when Reds' diary indicates that Dove was making notes on paintings, he made up handwritten cards for all but one of the paintings that were in his 1936 show. Three of the cards were not dated by the artist, but the ones that were all list 1935 as the date, even though the diary indicates that he was working on some of these paintings in 1936; perhaps Dove felt that the initial ideas (probably in the form of watercolors) should be dated to 1935, and possibly he had laid in the preliminary compositions on canvas in that year. These cards constitute the last burst of activity on the project. Dove appended three handwritten cards

for paintings that were shown in 1937, and after that no more cards were added. The card file belongs to the artist's son, who has given a photocopy to the Archives of American Art.

Publications. Published sources of particular interest for the catalogue include books and exhibition reviews. Only a few books published during Dove's lifetime treated his work with sufficient specificity to be useful to the compilation of this catalogue, so exhibition reviews, appearing in newspapers and periodicals, are the most significant published sources. Especially for the four one-person shows that are not documented by an extant printed gallery list, the reviews help to identify which works were shown.

American Art Research Council Forms. In the early 1940s, Suzanne Mullett Smith wrote a master's thesis on Dove's work for American University ("Arthur G. Dove (1880–): A Study in Contemporary Art," 1944). While compiling her information, she cooperated with the long-since-defunct American Art Research Council, which was then documenting the work of contemporary American artists. She sent the AARC's standardized form to a number of collectors to obtain particulars about their Dove paintings, but the bulk of the extant forms were filled out by Mullett herself as (or shortly after) she inspected the paintings themselves, which were mostly at An American Place or in storage at the Lincoln Warehouse. Mullett's enormous effort documents hundreds of watercolors, as well as more than two hundred fifty paintings.

Unfortunately, the usefulness of the forms as historical evidence is compromised by later emendations, especially concerning dating, as well as identification of certain early works, notably the "Ten Commandments" of 1911/12. Furthermore, the reliability of dates on Mullett's forms was dubious from the outset because she had access to Dove's card file (see above), because she apparently accepted Dove's hit-or-miss dating by memory of other works, and because she, too (like Dove), relied on exhibition lists for dates. Nevertheless, the AARC forms do provide information on the physical characteristics of paintings otherwise unrecorded today. The AARC forms belong to the Archives of American Art, which has microfilmed them.

The Archives has also microfilmed a card file that Mullett kept for her own purposes. Most of it was apparently put together during the period in which she was working on her thesis and on the AARC forms. This card file, however, remained in her possession, and over the years she updated it extensively, some of these notes being written as late as the mid-1970s, shortly before it was microfilmed. Many of these last additions are based on Barbara Haskell's 1974 retrospective catalogue that in turn incorporated many of the research findings presented in my own dissertation of 1973. Being therefore wary of circular treatment of the evidence, I have not used Mullett's card file in compiling the present catalogue.

Scope

The catalogue encompasses all of Dove's oil paintings and collages or assemblages, as well as most pastels. Listings are included for all examples known today, as well as for all works known through documentary evidence. In most—but not all—cases, the two of course coincide.

Watercolors and drawings are excluded from this catalogue because of their great number, because they are difficult to differentiate and catalogue individually as a result of the fact that many are untitled and undated, and because the artist himself thought of most of them as preliminary to finished or major works. Dove often called the watercolors "ideas." Although they are of fine quality and were often exhibited in the artist's annual one-person shows, the watercolors were seldom titled and numbered for the exhibitions, as the oils always were. That they were treated only as a

group indicates their lesser status in the artist's mind. From the time Dove started producing extensively in watercolor around 1930, nearly all of his oils derived directly from watercolors. Besides those watercolors that are therefore studies for major paintings, there are a great many from which larger works were never developed. The drawings, which occur in various standard media (charcoal, pencil, crayon, and so on), mostly date to the years before 1930. The bulk of them are commercial illustrations and have little to do with Dove's serious work as a painter. Some, however—particularly a group of large, strong charcoal drawings done in the late teens—are central to his creative development, while others are somewhat more peripheral.

Works are arranged in the catalogue chronologically by the year in which they were completed, alphabetically by title within the year. (See "Date" below for information on certain early works grouped within ranges of two or three years.) Information on all entries is as complete as could be obtained by the autumn of 1982. Missing items within entries indicate that the information could not be ascertained.

Format

Each entry consists of the same items of information given in the order described below.

Catalogue number. Each entry in the catalogue is preceded by a number that indicates the year the painting was completed, followed by a period and the number of its alphabetical position by title within that year.

 Example: 30.16.

 (This number indicates the sixteenth painting listed under 1930.)

These numbers are used to make cross-references within the catalogue. They are used in the text to refer to individual paintings.

 Example: See *Red, White and Green* (40.14).

Title. The title appears as the heading for each entry, below the painting's catalogue number. In most cases, the title is not a controversial item, since the majority of paintings are known today by the titles that Dove gave them or by minor variations on the original titles. In most cases, the heading-title is listed exactly as it was given by the artist. However, there are exceptions. A small number of works have become so commonly known by titles other than the original one that it would be confusing and perhaps misleading to list the painting under its original title. In these instances, the common-usage title appears as the heading, but within parentheses, to indicate that it differs substantially from the artist's title. The original title is then given in the painting's exhibition history, under the first time it was shown. In somewhat more numerous instances, the common-usage title differs grammatically from the original one but does not distort the meaning. When the common-usage title and the original one are thus very similar, the heading-title is not in parentheses. However, in all instances, when the heading-title differs in the slightest respect from what is known to be the title under which the artist showed the work, the original title is given in the exhibition history. A few early works appear under my descriptive titles, which are given in brackets.

 Example: [LANDSCAPE]

Quite a few works have at various times been shown or published under deviant or capricious titles. When possible, these variant titles are listed under the appropriate entries in the exhibition history or the references. Further variants are listed under "Remarks." All the variant titles for a given work are listed alphabetically in the index to titles, so that a reader who knows any one of the names for a given painting should be able to locate the proper entry easily.

In a few instances, Dove himself showed or referred to a given painting with more than one title. In these cases, I have listed both of his titles in the heading and

separated them with "or." In the exhibition history, I have when possible indicated which title was used in each instance. In several other cases, Dove gave two or more paintings the same title. In these instances, I have differentiated them by numbering them consecutively (in order of their execution when they span a period of years, as is usually the case; otherwise, in order of their exhibition numbers in the same exhibition). These numbers appear in brackets after the title of the painting.

Example: WIND [No. 2]

Paintings with numerical titles appear after the alphabetical entries for the year in which they were completed.

Example: 1941

(This is the last entry for 1941.)

Date. Very few of Dove's paintings are dated, but documentary evidence makes it possible to date the great majority quite securely. The date of a painting, as given here, is the date in which the painting was completed. In the absence of other evidence, this is taken to be the year in which it was first exhibited. Indeed, as Dove often had to rush to complete pieces for his annual shows in the early months of each year, many pieces were completed in the few months of the year just previous to their exhibition. A great many paintings can be more precisely dated, however, on the basis of documentary evidence, and for these paintings, the abbreviation "doc" (for "documented") is given in parentheses after the date.

Example: 1935 (doc)

This "doc" designation means that conclusive evidence for the year of the painting's execution can be found in the diaries kept by Dove and his wife Reds or, less frequently, in Dove's correspondence, primarily with Stieglitz.

When the card file dates seem to be of some interest, they are noted under "Remarks." (See the section on "Card file" under "Documentation" above for a discussion of the usefulness of the card file for dating.) However, given the problems of reconstructing Dove's early career, the simple fact that some of the early works are recorded in the card file can be significant. Therefore, I have used the abbreviation "rec" (for "recorded") in parentheses after the dates of those works that appear in the card file and that date to 1922 or before.

Example: 1921 (rec)

(This work appears in the card file but may not be dated there to 1921, in which case the catalogue date has been assigned for other reasons.)

The diaries commence in 1923, the extant letters to Stieglitz become more numerous, and other kinds of published and unpublished evidence begins to accumulate around the same time, so from then on, reliable documentation for many works is available.

As the text discussion indicates, it is futile to try to assign most of Dove's early works to a specific year. Therefore, I have tried to make sensible groupings of them, clusters based on style and what other evidence exists, and to assign these groups to what seem to be the most probable spans of years. A slash between years means that the work may have been done in either of the years or, if there are any, in one of the years between.

Example: 1908/09.

(This work was done in 1908 or 1909.)

Occasionally, the documentation (usually in the diaries) demonstrates that a given work was done during the period of time that extended from late in one year into early in the next. To indicate that a work was executed over a period of two years, a hyphen occurs between the years.

Example: 1934–35.

(Evidence indicates that this work was begun in 1934 and finished in 1935.)

In cases where there is genuine uncertainty in my mind about a date, due to the

absence of documentation or limited existence of it, I have used "c." before the year to indicate probable execution in that year.

> *Example:* c. 1926.
>> (My best guess is that this work was done in 1926, but I cannot prove it.)

Medium and Support. Dove frequently experimented with the materials and methods of painting, so it is often difficult to distinguish by sight alone what constitutes the medium of a given painting. Only a thorough examination by a conservator familiar with Dove's methods can be considered a trustworthy analysis to the physical substance of a given Dove painting. Dove favored tempera, mostly for underpainting, in combination with oil from at least the early twenties on, if not before. He began to use encaustic, or wax emulsion, toward the end of 1935, as the result of reading Max Doerner's recently published *Materials of the Artist.*[1] From then on, many, if not most, of his paintings combine oil and encaustic passages. Therefore, in this catalogue, unless there is an indication to the contrary, paintings are in oil or encaustic or a mixture of both, sometimes also including tempera. When they can be clearly identified, other paints or additives (such as sand) used in conjunction with the oil and/or encaustic are noted.

> *Example:* Medium includes silver paint

Throughout his career, Dove preferred canvas as a support, and he used it almost exclusively from the early thirties on. Earlier, particularly in the twenties, he experimented with a variety of supports, including panels of metal and an early form of plastic, in addition to the more traditional wood. In the catalogue, if no indication of a support is given, it may be assumed to be canvas; otherwise, the particular material is specified.

> *Example:* Metal support

If the medium and/or support were unknown at the time the catalogue was compiled, that situation is so noted.

> *Example:* Pastel; support not verified

Dimensions. Dimensions are given in inches, to the nearest eighth of an inch. Height precedes width.

Signature. "Signed" indicates that the artist's characteristic "Dove" occurs on the face of the painting. Deviations from this format are noted, as is the location of each signature.

> *Example:* Signed, lower center
>> ("Dove" is to be found in the middle of the lower edge.)

"Not signed" indicates that there is no signature on the face of the painting. If no notation concerning the signature is given in the catalogue, this signifies that whether or not the work is signed had not been ascertained.

A number of Dove's paintings carry his name on the reverse (often in combination with a title and/or date). When this is the case, I have recorded the particulars as an inscription under "Remarks."

> *Example:* Inscribed on the reverse with the artist's name, the title, and the date
>> ("Dove," the title of the painting as given in the heading to the entry
>> and the date as given in the entry appear on the back of the painting.)

Some of these inscriptions may be authentic signatures. However, a number of them are suspect for various reasons. Some even carry verifiably incorrect dates. Since I have not been able to see all of them personally, I cannot begin to discriminate among those that are genuine and those that are not. Among the reasons I am distrustful of reports from owners that their paintings are signed by Dove on the reverse is the fact that Stieglitz's handwriting was surprisingly similar to Dove's; since he had many of the paintings in the gallery or in storage over a period of years, it seems highly possible

that he sometimes wrote Dove's name on the reverse of a canvas or stretcher for identification purposes.

Collection. The name of the present owner is given, followed by the city and state (or city and country, in the case of foreign ownership). If no location follows the name of a museum or commercial gallery, it is in New York City. Circumstances and date of acquisition follow the collection in parentheses.

> *Example:* Museum of Modern Art (gift of an anonymous donor, 1964)
>> (The Museum of Modern Art in New York City acquired the work from an undisclosed benefactor in 1964.)

If present ownership has not been verified for this catalogue, the collection is designated as "unidentified," and the last known owner then appears as the final entry in the provenance.

Provenance. The successive owners of a particular work are listed in chronological order. Commercial galleries are shown in parentheses. Galleries and museums are in New York City unless otherwise noted. A known gap in the provenance is indicated with a question mark.

> *Example:* (Downtown Gallery)
>> James Smith, New York City (1957)
>> John Jones (bequest of James Smith, 1968)
>>> (?)
>> (XYZ Gallery, Los Angeles, Calif.) (1980)
>> (The painting was sold by the Downtown Gallery to James Smith of New York City in 1957. He bequeathed it to John Jones (address unknown) in 1968. It next surfaced at the XYZ Gallery in Los Angeles, but that gallery did not acquire the painting from Jones. Therefore the question mark indicates one or more unidentified transactions.)

With rare exceptions, the first item in each provenance is the name of the gallery that handled the Dove oeuvre or estate at the time it left the artist's ownership. This succession was as follows: The Intimate Gallery (1926–29), An American Place (1929–46), the Downtown Gallery (1946–70), the Terry Dintenfass Gallery (1970–present). Unless otherwise noted, each painting remained the artist's property or the property of the estate through the successive changes of galleries. Thus, if Terry Dintenfass Gallery is the first entry in a provenance for a painting done in 1927, then "Terry Dintenfass Gallery" implies the succession from The Intimate Gallery to An American Place to the Downtown Gallery and, finally, to the Terry Dintenfass Gallery.

Remarks. Supplementary, controversial, and interesting topics appear under this heading.

Exhibitions. The record of exhibitions for each work is divided into two lists: one for individual shows, the other for group shows. Each section is arranged chronologically, according to the year in which the shows opened. If there is more than one show under a given year, they are arranged alphabetically by the cities in which they were held, with the exception that New York shows are listed first and Washington, D.C., shows second because of their frequency and importance. Foreign shows are listed after the American ones, and touring exhibitions (that is, shows that were organized only to travel and were not shown at their sponsoring institutions) come last.

New York City museums, galleries, and most other exhibition spaces are listed by name or by an easily recognizable shortened form of the name.

> *Examples:* Whitney
>> Dintenfass
>> (These denote the Whitney Museum of American Art and the Terry Dintenfass Gallery, respectively.)

Exhibitions that took place in other cities are listed simply by city and state, except for the following well-known institutions that have frequently shown Dove's work:

Museums *(listed by city)*	Abbreviation *(if any)*
Washington, D.C.	
Phillips Collection	
(formerly Phillips Memorial Gallery)	Phillips
National Gallery of Art	National Gallery
Hirshhorn Museum and Sculpture Garden	Hirshhorn
National Museum of American Art	
(formerly National Collection of Fine Arts)	
Corcoran Gallery of Art	Corcoran
Chicago, Ill.	
Art Institute of Chicago	AIC
Cleveland, Ohio	
Cleveland Museum of Art	Cleveland Museum
Pittsburgh, Penn.	
Museum of Art, Carnegie Institute	Carnegie Institute
Philadelphia, Penn.	
Philadelphia Museum of Art	
(formerly Pennsylvania Museum of Art)	Philadelphia Museum
Pennsylvania Academy of Art	Pennsylvania Academy
St. Louis, Mo.	
St. Louis Art Museum	
(formerly City Art Museum, St. Louis)	
San Francisco, Calif.	
San Francisco Museum of Modern Art	San Francisco Museum

The number of the individual work in an exhibition is given directly after the location of the exhibition. This is followed by indications of title and/or date when they deviate from those of the catalogue entry itself or when they are of particular significance in establishing the correct title or date of a work.

Particulars concerning the exhibitions may be found in the separate lists of "Individual Exhibitions" and "Group Exhibitions," where the exhibitions are listed chronologically, with the same ordering scheme as is used in this item of each entry.

References. The major sources on Dove are exhibition catalogues, and a great many of the lesser sources are exhibition reviews. Since these are listed for each exhibition in the lists of individual and group exhibitions, a bibliography on any given work may be compiled from the exhibition lists. Therefore, I have not listed catalogues for shows in which a given work appears under the references for that entry, nor have I listed reviews of those shows.

The references are not intended to be comprehensive but to point the reader to the more significant books and articles in which the work is discussed or illustrated. (I have sometimes listed catalogues for shows in which the work was not exhibited if those catalogues include some significant discussion of the work.)

"References" also includes all bibliography to which reference is made under "Remarks" for that entry.

NOTE

1. Max Doerner, *Materials of the Artist,* trans. Eugen Neuhaus (New York: Harcourt, Brace, 1934). On 1 October 1935, Dove wrote to Stieglitz, "Am reading every inch of Max Doerner's book. Wish I had it years ago. Georgia [O'Keeffe] says she reads it like the Bible." On 24 October, he continued, "Doerner is the only one I have read who seems to give such complete scientific information, and what a mass of it. He makes even some of the Germans seem almost careless."

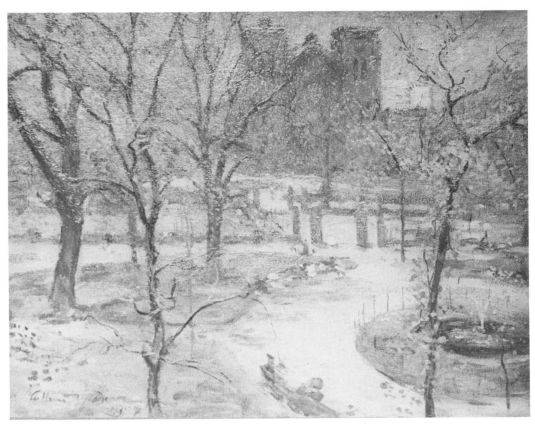

07.1

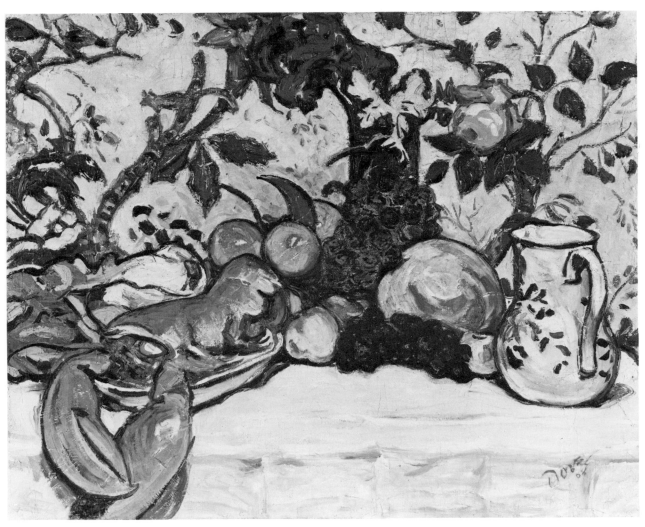

08.1

1907

07.1
STUYVESANT SQUARE
1907
25 × 35
Signed and dated 1907

Collection: Hobart and William Smith Colleges, Geneva, N.Y. (bequest of Paul M. Dove, 1981)

Provenance: Mr. and Mrs. William G. Dove, Geneva, N.Y. (gift of the artist, their son)
Paul M. Dove, Geneva, N.Y. (bequest of his mother, Mrs. William G. Dove, 1933)

Remarks: This painting was done from the window of Dove's apartment at 7 Livingston Place, New York City, according to the artist's brother Paul, who visited him there.

1908

08.1
THE LOBSTER
1908
25¾ × 32
Signed and dated 08, lower right

Collection: Amon Carter Museum, Fort Worth, Tex. (1980)

Provenance: Mrs. Margaret Ayer Cobb, Lakeville, Conn. (gift of the artist)
Mr. and Mrs. Hubbard H. Cobb, East Haddam, Conn.
(Terry Dintenfass Gallery)

Exhibitions: Individual
1947 Downtown, no. 1
1958 Whitney, no. 1
1974 San Francisco Museum
Group
1909 Paris, France, no. 450, titled *Nature morte*
1910 Gallery of the Photo-Secession ("291")

1908/9

08/09.1
COUNTRY ROAD, FRANCE
1908/09
18 × 21½
Signed, lower left

Collection: Mr. and Mrs. Hans Sternberg, Baton Rouge, La. (1975)

Provenance: (Sotheby Parke Bernet auction, 12 December 1975)

Remarks: Probably shown in Dove's 1909 exhibition at Hobart College, Geneva, N.Y., under a different title.

08/09.1

08/09.2

08/09.2
[LANDSCAPE]
1908/09
17½ × 21¾
Not signed

Collection: Mr. and Mrs. Clifford C. Wood, Rocky
 Point, N.Y. (bequest of Mrs. Fred DuPuy)

Provenance: Florence Dove, Westport, Conn.
 Fred DuPuy, Westport, Conn.

Remarks: Probably identical to one of the French
 landscapes shown in Dove's 1909 one-person ex-
 hibition at Hobart College in Geneva, N.Y.

08/09.3
LANDSCAPE [NO. 1]
1908/09

Collection: Unidentified

Exhibition: Individual
 1909 Geneva, N.Y., no. 24

08/09.4
LANDSCAPE [NO. 2]
1908/09

Collection: Unidentified

Exhibition: Individual
 1909 Geneva, N.Y., no. 25

08/09.5
LANDSCAPE [NO. 3]
1908/09

Collection: Unidentified

Exhibition: Individual
 1909 Geneva, N.Y., no. 26

08/09.6
LANDSCAPE [NO. 4]
1908/09

Collection: Unidentified

Exhibition: Individual
 1909 Geneva, N.Y., no. 27

08/09.7
LANDSCAPE, ALPES-MARITIMES
1908/09

Collection: Unidentified

Exhibition: Individual
 1909 Geneva, N.Y., no. 11, titled *Landscape, Alps
 Maritimes*

08/09.8
LANDSCAPE, CAGNES
1908/09
18½ × 21
Signed, lower right

08/09.8

Collection: Herbert F. Johnson Museum of Art, Cornell University, Ithaca, N.Y. (gift of Charles Simon, 1955)

Provenance: Perry M. Shepard, Geneva, N.Y. (purchase from the artist)
Charles Simon

Remarks: This painting must be identical to one of the undifferentiated Cagnes landscapes shown in Dove's 1909 Hobart College exhibition (nos. 08/09.10 through 08/09.16).

Exhibitions: Individual
1909 Geneva, N.Y., no. 5, 6, 7, 8, 9, or 10
1958 Whitney, no. 2, dated 1909
1968 MOMA (touring), no. 1, dated 1908
Group
1961 Wilmington, Del.

08/09.9
LANDSCAPE, CAGNES
1908/09
22 × 18½
Signed, lower left

Collection: Unidentified

Provenance: Mrs. M. B. Torr, Hartford, Conn. (acquired from the artist)

Remarks: This painting must be identical to one of the undifferentiated Cagnes landscapes shown in Dove's 1909 Hobart College exhibition (nos. 08/09.10 through 08/09.16).

Exhibition: Individual
1909 Geneva, N.Y., no. 5, 6, 7, 8, 9, or 10

08/09.10
LANDSCAPE, CAGNES [NO. 1]
1908/09

Collection: Unidentified

Exhibition: Individual
1909 Geneva, N.Y., no. 5

08/09.11
LANDSCAPE, CAGNES [NO. 2]
1908/09

Collection: Unidentified

Exhibition: Individual
1909 Geneva, N.Y., no. 6

08/09.12
LANDSCAPE, CAGNES [NO. 3]
1908/09

Collection: Unidentified

Exhibition: Individual
1909 Geneva, N.Y., no. 7

08/09.13
LANDSCAPE, CAGNES [NO. 4]
1908/09

Collection: Unidentified

Exhibition: Individual
1909 Geneva, N.Y., no. 8

08/09.14
LANDSCAPE, CAGNES [NO. 5]
1908/09

Collection: Unidentified

Exhibition: Individual
1909 Geneva, N.Y., no. 9

08/09.15
LANDSCAPE, CAGNES [NO. 6]
1908/09

Collection: Unidentified

Exhibition: Individual
1909 Geneva, N.Y., no. 10

08/09.16
LANDSCAPE, CAGNES, ALPES-MARITIMES
1908/09

Collection: Unidentified

Exhibition: Individual
1909 Geneva, N.Y., no. 4, titled *Landscape, Cagnes, Alps Maritimes*

08/09.17
LANDSCAPE, CELLE-SUR-SEINE
1908/09

Collection: Unidentified

Exhibition: Individual
1909 Geneva, N.Y., no. 17

08/09.18
LANDSCAPE, MORET [NO. 1]
1908/09

Collection: Unidentified

Exhibition: Individual
1909 Geneva, N.Y., no. 13

08/09.19
LANDSCAPE, MORET [NO. 2]
1908/09

Collection: Unidentified

Exhibition: Individual
1909 Geneva, N.Y., no. 14

08/09.20
LANDSCAPE, MORET [NO. 3]
1908/09

Collection: Unidentified

Exhibition: Individual
1909 Geneva, N.Y., no. 15

08/09.21
LANDSCAPE, MORET [NO. 4]
1908/09

Collection: Unidentified

Exhibition: Individual
1909 Geneva, N.Y., no. 16

08/09.22
LANDSCAPE, MORET-SUR-LOING
1908/09

Collection: Unidentified

Exhibition: Individual
1909 Geneva, N.Y., no. 12

08/09.23
LANDSCAPE, ST. MAMMES
1908/09

Collection: Unidentified

Exhibition: Individual
1909 Geneva, N.Y., no. 18

08/09.24
LAVOIR, GRÉZ-SUR-LOING
1908/09
25½ × 31¾
Not signed

Collection: Herbert F. Johnson Museum, Ithaca, N.Y. (bequest of Paul M. Dove, 1981)

Provenance: Mr. and Mrs. William G. Dove, Geneva, N.Y. (gift of the artist, their son, 1909)
Paul Dove, Geneva, N.Y. (bequest of his mother, Mrs. William G. Dove, 1933)

Exhibitions: Individual
1909 Geneva, N.Y., no. 2
1954 Ithaca, N.Y., no. 1, dated c. 1908

08/09.25
PONT CROIX, FINISTÈRE
1908/09

Collection: Unidentified

Exhibition: Individual
1909 Geneva, N.Y., no. 1

08/09.26
PORTRAIT, ITALIAN
1908/09

Collection: Unidentified

Exhibition: Individual
1909 Geneva, N.Y., no. 19

08/09.27
STILL LIFE
1908/09

Collection: Unidentified

Remarks: Of the two paintings by this title in Dove's 1909 exhibition at Hobart College in Geneva, one is probably the painting now known as *Still Life Against Flowered Wallpaper* (no. 09.7).

Exhibition: Individual
1909 Geneva, N.Y., no. 3 or 20

08/09.24

1909

09.1
BRIDGE AT CAGNES
1908–9
39½ × 39½
Not signed

Collection: Herbert F. Johnson Museum, Cornell University, Ithaca, N.Y. (bequest of Paul M. Dove, 1979)

Provenance: Mr. and Mrs. William G. Dove, Geneva, N.Y. (gift of the artist, their son, 1909)
Paul M. Dove, Geneva, N.Y. (bequest of his mother, Mrs. William G. Dove, 1933)

Remarks: Inscribed on the reverse with the date "February 1909"; the place, "Cagnes"; and an indication that the canvas was coated December 17, 1908.
Probably shown as one of the seven paintings titled *Landscape, Cagnes* in Dove's 1909 Hobart College (Geneva, N.Y.) exhibition.

Exhibitions: Individual
1909 Geneva, N.Y., no. 4, titled *Landscape, Cagnes*
1954 Ithaca, N.Y., no. 2

09.2
[LANDSCAPE]
1909
Wood support
8¾ × 10¾
Not signed

Collection: William C. Dove, Mattituck, N.Y.

Provenance: Acquired from the artist

Remarks: The panel upon which this work is painted is French.

09.3
LANDSCAPE, GENEVA, N.Y.
1909

Collection: Unidentified

Exhibition: Individual
1909 Geneva, N.Y., no. 23

09.4
LANDSCAPE IN RED, YELLOW AND ULTRAMARINE
1909
Wood support
10½ × 8½
Signed

09.1

09.2

Collection: Private collection (1975)

Provenance: Bruce S. Pauley, New Canaan, Conn. (Sotheby Parke Bernet auction, 17 April 1975)

09.5
LANDSCAPE, NAPLES, N.Y. [NO. 1]
1909

Collection: Unidentified

Exhibition: Individual
1909 Geneva, N.Y., no. 21

09.6
LANDSCAPE, NAPLES, N.Y. [NO. 2]
1909

Collection: Unidentified

Exhibition: Individual
1909 Geneva, N.Y., no. 22

09.7
STILL LIFE AGAINST FLOWERED WALLPAPER
1909
25 × 31¾
Signed, lower right

Collection: Unidentified

Provenance: (Sotheby Parke Bernet auction, 12 December 1975)

Exhibition: Individual
1909 Geneva, N.Y., no. 3 or no. 20, titled *Still Life*

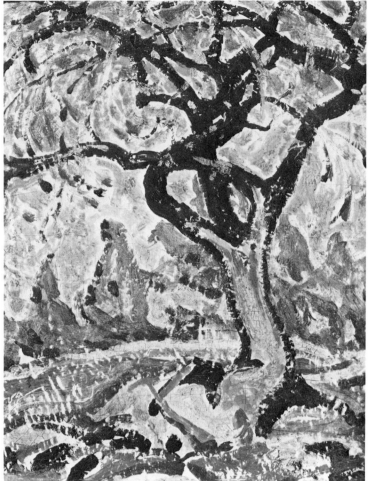

09.4

09.7

1910/11

10/11.1
ABSTRACTION NO. 1
1910/11
Wood support
8⅜ × 10½
Not signed

Collection: Private collection (1977)

Provenance: (Terry Dintenfass Gallery)
 George J. Perutz, Dallas, Tex. (1973)
 (Terry Dintenfass Gallery)

Exhibitions: Individual
 1952 Downtown
 1954 Ithaca, N.Y., no. 7
 1956 Downtown

1958 Whitney, no. 3
1968 MOMA (touring), no. 2
1974 San Francisco Museum (New York only)
1981 Phillips, no. 1
Group
1953 Norfolk, Va.
1960 Downtown
1961 MOMA (touring)
1965 National Museum of American Art
 London, England

10/11.2
ABSTRACTION NO. 2
1910/11
Wood support
8⅜ × 10½
Not signed

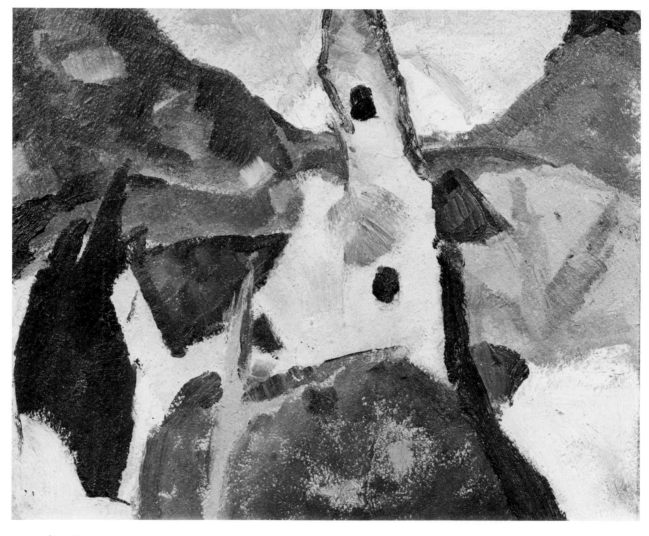

10/11.1

10/11.2

Collection: Private collection (1977)

Provenance: (Terry Dintenfass Gallery)
　George J. Perutz, Dallas, Tex. (1973)
　(Terry Dintenfass Gallery)

Exhibitions: Individual
　1952 Downtown
　1954 Ithaca, N.Y., no. 8
　1956 Downtown
　1958 Whitney, no. 3
　1974 San Francisco Museum (New York only)
　1981 Phillips, no. 2
　Group
　1953 Norfolk, Va.
　1960 Downtown
　1961 Milwaukee, Wis.
　1962 Iowa City, Iowa, no. 14
　1965 London, England

10/11.3
ABSTRACTION NO. 3
1910/11
Wood support
9 × 10½
Not signed

Collection: Private collection (1967)

Provenance: (Downtown Gallery)

Exhibitions: Individual
　1952 Downtown
　1954 Ithaca, N.Y.
　1956 Downtown
　1958 Whitney, no. 3
　1967 Huntington, N.Y., no. 1
　1974 San Francisco Museum
　1981 Phillips, no. 3

10/11.3

Group
1953 Norfolk, Va.
1960 Downtown
1962 MOMA (touring), titled *Abstraction No. 1*
1964 Bloomington, Ind.
1965 National Museum of American Art, titled *Abstraction No. 1*
London, England
1971 Carnegie Institute, no. 20

10/11.4
ABSTRACTION NO. 4
1910/11
Wood support
8⅜ × 10½
Not signed

Collection: Private collection (1977)

Provenance: (Terry Dintenfass Gallery)
George J. Perutz, Dallas, Tex. (1973)
(Terry Dintenfass Gallery)

Exhibitions: Individual
1952 Downtown
1954 Ithaca, N.Y.
1956 Downtown
1958 Whitney, no. 3
1974 San Francisco Museum (New York only)
1981 Phillips, no. 4
Group
1953 Norfolk, Va.
1960 Downtown
1965 London, England

10/11.5
ABSTRACTION NO. 5
1910/11
Wood support
8⅜ × 10½
Not signed

Collection: Private collection (1977)

Provenance: (Terry Dintenfass Gallery)
George J. Perutz, Dallas, Tex. (1973)
(Terry Dintenfass Gallery)

10/11.4

10/11.5

Exhibitions: Individual
 1952 Downtown
 1954 Ithaca, N.Y.
 1956 Downtown
 1958 Whitney, no. 3
 1967 Huntington, N.Y.
 1974 San Francisco Museum (New York only)
 1981 Phillips, no. 5
 Group
 1953 Norfolk, Va.
 1960 Downtown
 1965 London, England

10/11.6
ABSTRACTION NO. 6
1910/11
Wood support
8⅜ × 10½
Not signed

Collection: Private collection (1967)

Provenance: (Downtown Gallery)

Exhibitions: Individual
 1952 Downtown
 1954 Ithaca, N.Y.
 1956 Downtown

10/11.6

1958 Whitney, no. 3
1974 San Francisco Museum
1981 Phillips, no. 6 11/12.1
Group
1953 Norfolk, Va.
1960 Downtown
1965 London, England

1911/12

11/12.1
BASED ON LEAF FORMS AND SPACES, or LEAF
 FORMS
1911/12 (rec)
Pastel; support not verified
23 × 18
Signed, lower left

Collection: Unidentified

Provenance: ("291")
 (Thurber Gallery, Chicago, Ill.) (1912)
 Arthur Jerome Eddy, Chicago, Ill. (1912)

Remarks: Eddy published a color illustration of this
 work in his book *Cubists and Post-Impressionism*
 (the first American book on modern art) along
 with a statement that Dove wrote late in 1913 at
 Eddy's invitation, explaining what he was "driv-
 ing at." Commenting on this pastel, he wrote, "It is
 a choice of three colors, red, yellow, and green
 and three forms selected from trees and the spaces
 between them that to me were expressive of the
 movement of the thing which I felt."
 It is fortunate that Eddy chose to reproduce this
 work in color, for the painting itself disappeared
 many years ago. According to notes made by
 Suzanne Mullett Smith, who worked with the art-
 ist while preparing a master's thesis on his work
 in the early forties, the work had gone into the
 collection of the "former English consul to
 Chicago, who was in Warsaw, Poland, at the out-
 break of World War II."
 Titled *Leaf Forms* in Dove's card file.

Exhibitions: Individual
 1912 "291"
 Chicago, Ill.

References: Eddy, Arthur J. *Cubists and Post-
 Impressionism.* Chicago: A. C. McClurg, 1914.
 Color illustration opposite p. 48.
 Homer, William Innes. "Identifying Arthur Dove's
 'The Ten Commandments.'" *American Art Jour-
 nal* 12 (Summer 1980): 21–32. Illustration p. 28.

11/12.2
CIRCLES AND SQUARES
1911/12 (rec)
Pastel; support not verified

Collection: Unidentified

Provenance: Dr. Frank McLaury, New York City and
 Westport, Conn.

Remarks: Reviewer George Cram Cook, who saw
 Dove's 1912 show in Chicago, reported that the
 exhibition included two "circle-and-right-angle
 studies." One, he described as the pastel now
 known as *Nature Symbolized No. 1,* or *Roofs*
 (no. 11/12.4). This must be the other.

Exhibitions: Individual
 1912 "291"
 Chicago, Ill.

References: Cook, George Cram. "Causerie (Post-
 Impressionism After Seeing Mr. Dove's Pictures)."
 Chicago Evening Post Literary Review, 29 March
 1912.
 Homer, William Innes. "Identifying Arthur Dove's
 'The Ten Commandments.'" *American Art Jour-
 nal* 12 (Summer 1980): 21–32.

11/12.3
MOVEMENT NO. 1
1911/12
Pastel on canvas mounted on board
21⅜ × 18
Not signed

Collection: Columbus Museum of Art, Columbus,
 Ohio (gift of Ferdinand Howald, 1931)

Provenance: ("291")
 (Charles Daniel Gallery)

Ferdinand Howald, New York City and Columbus, Ohio (1920)

Exhibitions: Individual
1912 "291" (probable)
 Chicago, Ill. (probable)
1958 Whitney, no. 5, dated 1911
1981 Phillips, no. 7, dated c. 1911
Group
1931 Columbus, Ohio, no. 79
1951 Cincinnati, Ohio, no. 49
1952 Carnegie Institute
1963 Corcoran
1966 Public Education Association, New York City
1969 Bernard Danenberg Galleries
1970 Wildenstein, no. 59
 Dayton, Ohio
 American Federation of Arts (touring), no. 18
1971 San Diego, Calif., no. 17
1973 London, England, no. 14
1975 Palm Beach, Fla., no. 14

Wilmington, Del., dated c. 1911
1979 Grey Art Gallery, New York University, no. 20, dated c. 1911

Reference: Homer, William Innes. "Identifying Arthur Dove's 'The Ten Commandments.'" *American Art Journal* 12 (Summer 1980): 21–32. Illustration p. 30.

11/12.4
NATURE SYMBOLIZED NO. 1, or ROOFS
1911/12 (rec)
Pastel on paper
18 × 21½
Not signed

Collection: Andrew Crispo Gallery

Provenance: (Downtown Gallery)
Heyward Cutting, Cambridge, Mass. (1959)
Private collection, New York City

Remarks: Has also been titled *Factory Chimneys*.
Titled *Roofs* in Dove's card file.
Reviewer Joseph Chamberlin described it at the time of Dove's "291" show as a picture "of steep

11/12.3

11/12.4

roofs seen through a window." In Chicago, George
Cram Cook wrote that it suggested
 roofs and factory chimneys. It is the cutting,
 vertical lines of the chimneys—their cutting-
 ness, their verticalness, their parallelness that
 interested the artist, not their chimneyness. He
 leaves chimneyness to photography. . . .

Exhibitions: Individual
 1912 "291"
 Chicago, Ill.
 1981 Phillips, no. 10, dated 1911–12
 Group
 1914 National Arts Club
 1916 Anderson Galleries (probable)
 1960 Iowa City, Iowa, no. 16, dated 1914
 1978 Crispo, "20th Century American Masters,"
 no. 46
 1980 Hirschl & Adler, no. 28, dated 1911–12
 London, England, no. 428

References: Chamberlin, Joseph Edgar. "Pattern
 Paintings by A. G. Dove." *Evening Mail* (New
 York), 2 March 1912, 8.
 Cook, George Cram. "Causerie (Post-Impres-
 sionism After Seeing Mr. Dove's Pictures.)"
 Chicago Evening Post Literary Review, 29 March
 1912.

Homer, William Innes. "Identifying Arthur Dove's
 'The Ten Commandments.'" *American Art Jour-
 nal* 12 (Summer 1980): 21–32. Illustration p. 24.

11/12.5
NATURE SYMBOLIZED NO. 2, or WIND ON A
HILLSIDE
1911/12 (rec)
Pastel on paper mounted on plywood
18 × 21⅝
Signed, lower right

Collection: Art Institute of Chicago, Chicago, Ill.
 (gift of Georgia O'Keeffe from the estate of Alfred
 Stieglitz, 1949)

Remarks: In 1930 Samuel Kootz asked Dove to write
 a statement about his art for Kootz's forthcoming
 Modern American Painters. Dove's response in-
 cluded the following about this pastel:
 Then one day I made a drawing of a hillside.
 The wind was blowing. I chose three forms
 from the planes on the side of the trees, and
 three colors, and black and white. From these
 was made a rhythmic painting that expressed
 the spirit of the whole thing. The colors were
 chosen to express the substance of these objects
 and the sky. These colors were made into pas-

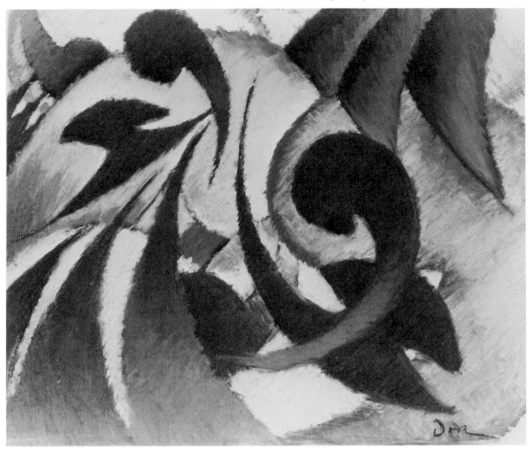

11/12.5

tels, carefully weighed out, and graded with black and white into an instrument to be used in making that certain painting.

Titled *Wind on a Hillside* in Dove's card file.

When this work was shown at "291," Joseph Chamberlin described it as follows:

Here is a strange picture that seems to have, at the right, a large blue comma; and then some upward pointed horns of light blue, dark blue, and other colors. What is it all about? No one can tell—and yet the result is strangely agreeable.

In Chicago, two reviewers responded to this work. George Cram Cook wrote that the

thematic form works like a comma: the form Mr. Dove's interpreter said was a wind pattern. Absurd and unthinkable as a representation of wind, the canvas presents a linear theme in such a way as to make the eye follow the same kind of curve over and over again.

H. Effa Webster wrote:

One of Dove's paintings represents swift and wholesome wind; we could see the refreshing folds and sturdy leaps into repetitions of its force.

Exhibitions: Individual
1912 "291"
 Chicago, Ill.
1937 Phillips, no. 2, dated 1914
1958 Whitney, no. 6, dated 1911–14

1974 San Francisco Museum, dated 1914
Group
1914 National Arts Club
1916 Anderson Galleries
1937 American Place, no. 53, dated 1911
1944 Philadelphia Museum, no. 251
1948 AIC
1958 Whitney, "Nature in Abstraction"

References: Chamberlin, Joseph Edgar. "Pattern Paintings by A. G. Dove." *Evening Mail* (New York), 2 March 1912, 8.

Cook, George Cram. "Causerie (Post-Impressionism After Seeing Mr. Dove's Pictures." *Chicago Evening Post Literary Review*, 29 March 1912.

Herford, Oliver. "The Crime Wave in Art." *Ladies Home Journal* (January 1923): 8 and 98–102. Illustration printed upside down, titled *Cow*.

Homer, William Innes. "Identifying Arthur Dove's 'The Ten Commandments.'" *American Art Journal* 12 (Summer 1980): 21–32. Illustration p. 25.

Kootz, Samuel M. *Modern American Painters*. New York: Brewer & Warren, 1930.

Webster, H. Effa. "Artist Dove Paints Rhythms of Color." *Chicago Examiner*, 15 March 1912.

11/12.6
NATURE SYMBOLIZED NO. 3
1911/12
Pastel on wood panel
18 × 21½

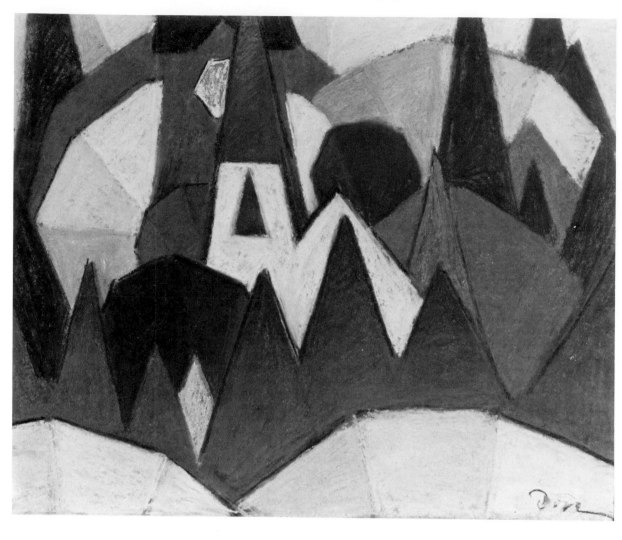

11/12.6

Signed, lower right

Collection: Terra Museum of American Art, Evanston, Ill. (Daniel J. Terra Collection)

Provenance: (An American Place)
George Berson
Mr. and Mrs. Singer (1930)
Myron Singer (1976)
(ACA Galleries)
Daniel J. Terra (1979)

Remarks: When this work was shown in Chicago in 1912, George Cram Cook described it as follows:
There's also the cone-and-polygon picture which projects its theme into the cone of a steeple and the polygon of a tree outline behind the steeple.

Exhibitions: Individual
1912 "291"
Chicago, Ill.
Group
1914 National Arts Club (probable)
1982 Oklahoma City, Okla., no. 17, dated c. 1912

References: Cook, George Cram. "Causerie (Post-Impressionism After Seeing Mr. Dove's Pictures)." *Chicago Evening Post Literary Review,* 29 March 1912.

Homer, William Innes. "Identifying Arthur Dove's 'The Ten Commandments.'" *American Art Journal* 12 (Summer 1980): 21–32. Illustration p. 26.

11/12.7
PLANT FORMS
1911/12
Pastel on canvas
17¼ × 23⅞
Not signed

Collection: Whitney Museum of American Art (gift of Mr. and Mrs. Roy R. Neuberger, 1951)

Provenance: (Downtown Gallery)

Remarks: This is probably the pastel referred to by Joseph Edgar Chamberlin in the New York *Evening Mail,* 2 March 1912, as consisting of "the fronds of lilies, or agaves." William Homer (p. 30) connected that description with *Movement No. 1* (no. 11/12.3), but that painting's forms are less botanical, and its predominately blue coloration makes it unlikely that a viewer would associate its forms with plants, whereas greens reign in this work.

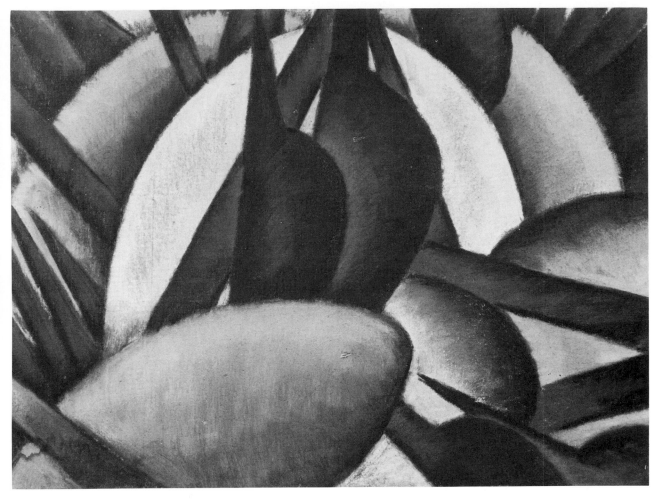

11/12.7

Exhibitions: Individual
 1912 "291"
 Chicago, Ill.
 1947 Downtown, no. 4, dated 1915
 1958 Whitney, no. 10, dated 1915
 1967 Downtown, no. 3, dated 1915
 1974 San Francisco Museum, dated 1915
 Group
 1926 Wildenstein, no. 27
 1963 Whitney, dated 1915
 1966 Whitney

References: Chamberlin, Joseph Edgar. "Pattern Paintings by A. G. Dove." *Evening Mail* (New York), 2 March 1912, 8.
Homer, William Innes. "Identifying Arthur Dove's 'The Ten Commandments.'" *American Art Journal* 12 (Summer 1980): 21–32.

11/12.8
SAILS
1911/12 (rec)
Pastel; support not verified
17⅞ × 21½
Signed, lower left

Collection: Unidentified

Provenance: ("291")

(Anderson Galleries auction, 1922, titled *Moving Boats*)
Philip L. Goodwin, New York City (1922)

Remarks: The *New York Times* reviewer (probably Elisabeth Luther Cary) of Dove's "291" show noted that one of the pastels "has in its fine big curves and beautiful dark blues a suggestion—obvious, not cryptic—of sails and tumultuous sea." Joseph Chamberlin of the *Evening Mail* stated that one "picture consists in a design of boats' sails." In Chicago, George Cram Cook indicated that one of the pastels depicted "three sails."

Exhibitions: Individual
 1912 "291"
 Chicago, Ill.
 Group
 1917 Society of Independent Artists, no. 92, titled *Nature Symbolized, 1*
 1946 Whitney, "Pioneers of Modern Art in America"

References: Chamberlin, Joseph Edgar. "Pattern Paintings by A. G. Dove." *Evening Mail* (New York), 2 March 1912, 8.
Cook, George Cram. "Causerie (Post-Impressionism After Seeing Mr. Dove's Pictures."

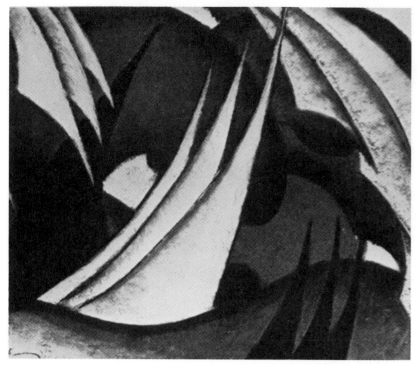

11/12.8 *Chicago Evening Post Literary Review,* 29 March 1912
Homer, William Innes. "Identifying Arthur Dove's 'The Ten Commandments.'" *American Art Journal* 12 (Summer 1980): 21–32. Illustration p. 27.
"News and Notes of the Art World: Plain Pictures," *New York Times,* 3 March 1912, sec. 5, p. 15.

11/12.9
TEAM OF HORSES, or HORSES IN SNOW
1911/12 (rec)
Pastel on linen
18½ × 21½
Signed, lower right

Collection: Private collection

Provenance: (Downtown Gallery)

Remarks: Titled *Horses in Snow* in Dove's card file. Described by an anonymous reviewer in the *Chicago Evening Post* (16 March 1912) as follows: "At another time, the horse suggested a design. Taking the curving line and playing with it, the resulting pattern appeared upon the canvas."

Exhibitions: Individual
 1912 "291"
 Chicago, Ill.
 1947 Downtown, no. 2, dated 1912
 1954 Ithaca, N.Y., no. 9, dated 1912
 1958 Whitney, no. 7, dated 1911
 1967 Huntington, N.Y., no. 34, dated 1912
 1974 San Francisco Museum (San Francisco and New York only), dated 1911
 1981 Phillips, no. 9, dated 1911
 Group
 1963 Whitney

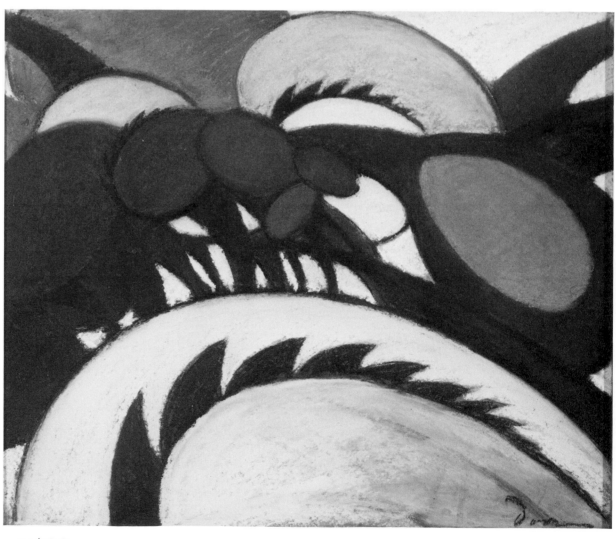

11/12.9

References: Homer, William Innes. "Identifying Arthur Dove's 'The Ten Commandments.'" *American Art Journal* 12 (Summer 1980): 21–32. Illustration p. 23.

c. 1912/13

12/13.1
CALF
c. 1912/13 (rec)
Pastel on linen or very fine canvas
17¾ × 21½
Signed, lower left, and inscribed "To Florence—AGD"

Collection: William C. Janss, Sun Valley, Idaho (1980)

Provenance: Florence Cane, Westport, Conn. (gift of the artist)
Melville Cane, New York City (bequest of Florence Cane)
(Terry Dintenfass Gallery)

Remarks: Has also been titled *Abstract Birth of a Calf.*
In the card catalogue she assembled in the early forties while preparing her master's thesis on Dove's work, Suzanne Mullett Smith noted that this painting was never shown. This was presumably Dove's recollection. (Cited in Homer, p. 31.)

Exhibitions: Individual
1974 San Francisco Museum (New York only, not in catalogue)
1981 Phillips, no. 8, dated 1911

References: Homer, William Innes. "Identifying Arthur Dove's 'The Ten Commandments.'" *American Art Journal* 12 (Summer 1980): 21–32. Illustration p. 31.

12/13.2
CONNECTICUT RIVER
c. 1912/13
Pastel on linen
17¾ × 21¼
Not signed

Collection: Indiana University Art Museum, Bloomington (purchased with funds provided by the Jane and Roger Wolcott Memorial, 1976).

Provenance: (Downtown Gallery)
Edith Halpert, New York City
(Sotheby Parke Bernet auction, 14 March 1973)
(William Zierler Gallery)

Remarks: The composition of this work is derived from an earlier oil study, *Abstraction No. 1* (no. 10/11.1).

Exhibitions: Individual
1926 Intimate Gallery
1956 Downtown, no. 21, dated 1914
1958 Whitney, no. 4, dated 1911–14

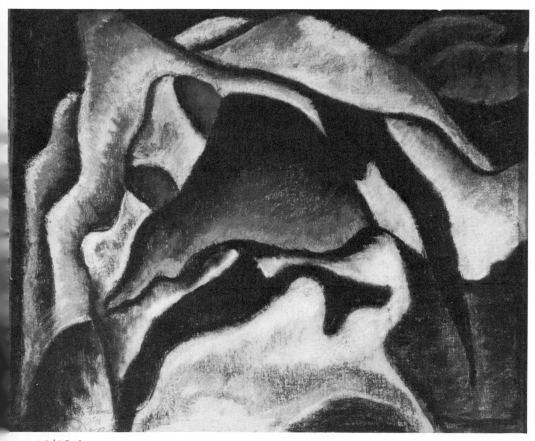

12/13.1

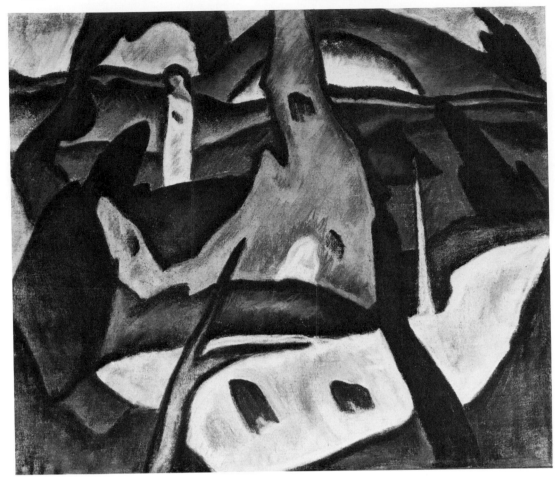

12/13.2

1967 Downtown, no. 1, dated 1911
1974 San Francisco Museum, dated 1911–12
Group
1924 Anderson Galleries
1960 Corcoran
1962 Downtown, "Abstract Art in America,
 1903–23"
1965 Downtown

1944 Philadelphia Museum, no. 252, dated 1914
1947 MOMA, no. 23
1948 AIC, no. 16
1950 Metropolitan
1965 Metropolitan

References: Homer, William Innes. "Identifying Arthur Dove's 'The Ten Commandments.'" *American Art Journal* 12 (Summer 1980): 21–32. Illustration p. 29.

12/13.3
COW
c. 1912/13 (rec)
Pastel on linen
17¾ × 21½
Not signed

Collection: Metropolitan Museum of Art, (Alfred Stieglitz Collection; gift of Georgia O'Keeffe from the estate of Alfred Stieglitz, 1949)

Provenance: ("291")
 Alfred Stieglitz, New York City

Exhibitions: Individual
 1926 Intimate Gallery
 1934 American Place, dated 1914
 1937 Phillips, no. 24, dated 1914
 1974 San Francisco Museum, dated 1911
Group
 1937 American Place, no. 54, dated 1914

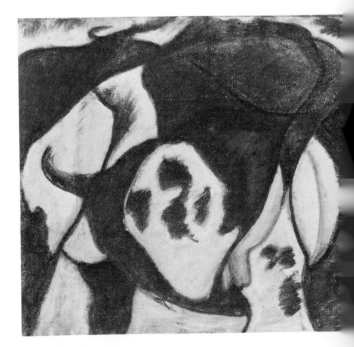

12/13.3

Scenery. 1932. 8¾ × 12. (cat. no. 32.16)

Frozen Pool at Sunset. 1933. 16 × 20. (cat. no. 33.1)

Sea Gull. 1933. 24 × 30 (cat. no. 33.3)

Two Brown Trees. 1933. 20 × 28. (cat. no. 33.8)

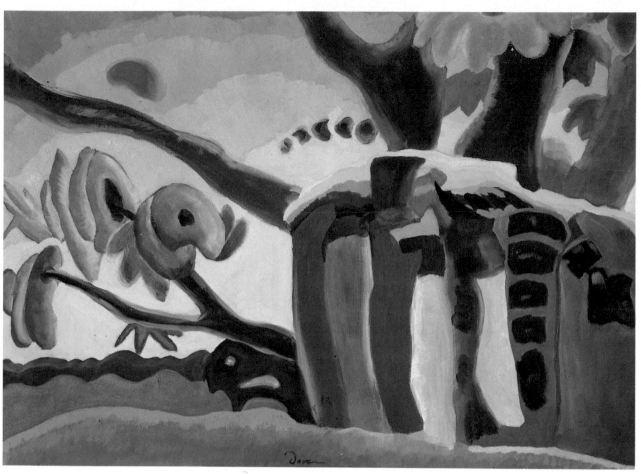

Brickyard Shed. 1934. 20 × 28. (cat. no. 34.3)

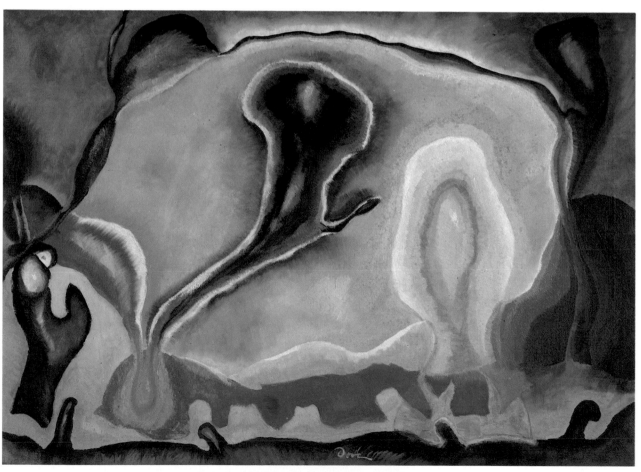

Dancing. 1934. 25 × 35. (cat. no. 34.4)

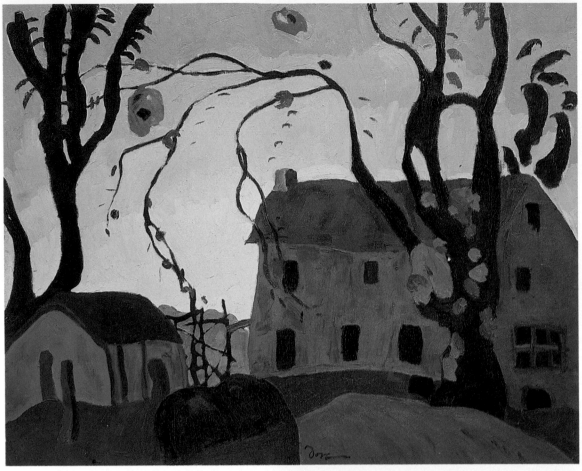

Green House. 1934. 25½ × 31¾. (cat. no. 34.5)

A Cross in the Tree. 1934–35. 28 × 20. (cat. no. 35.10)

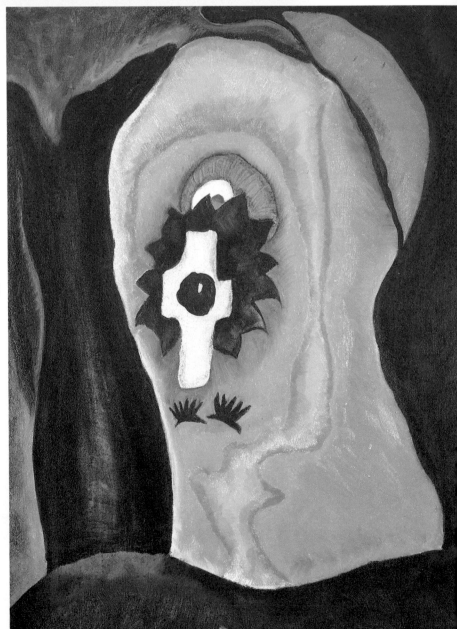

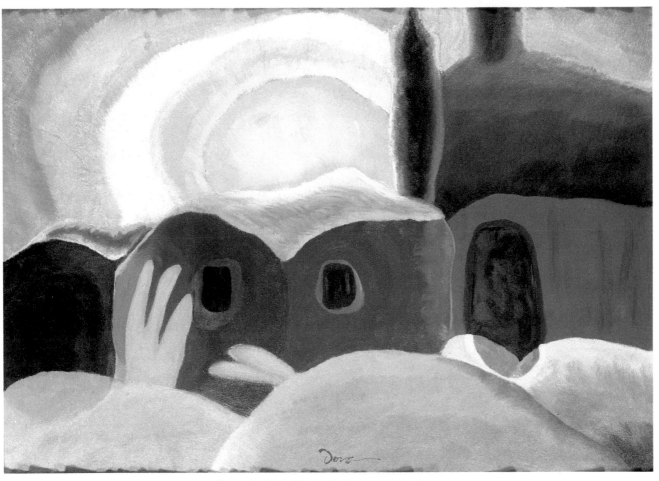

Sunset. 1935. 24 × 33. (cat. no. 35.21)

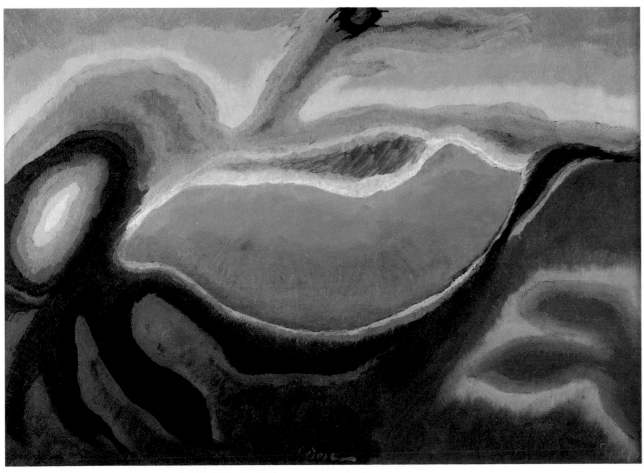

Wind [No. 3]. 1935. 15 × 21. (cat. no. 35.24)

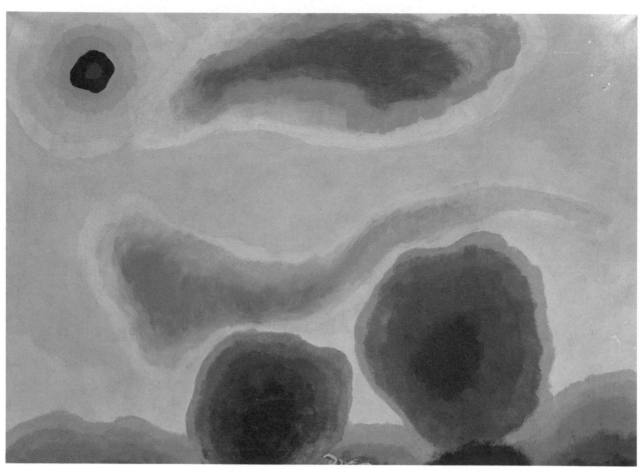

Naples Yellow Morning. 1936. 25 × 35. (cat. no. 36.10)

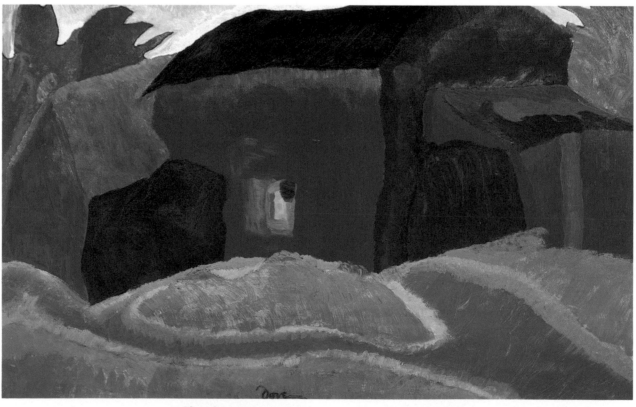

Slaughter House. 1936. 15¾ × 26. (cat. no. 36.12)

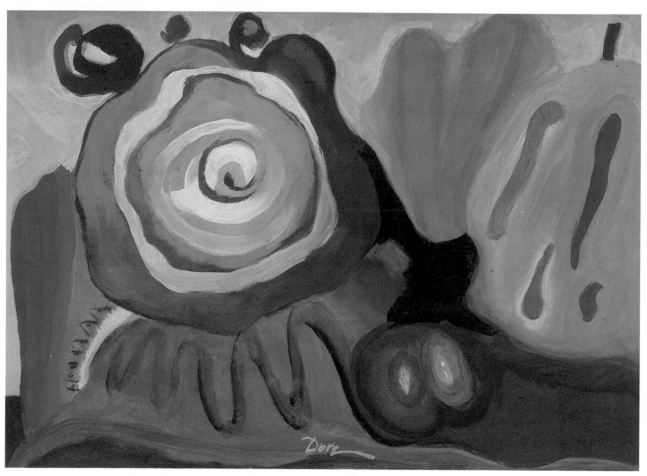

Train Coming Around the Bend. 1935–36. 16 × 21½. (cat. no. 36.17)

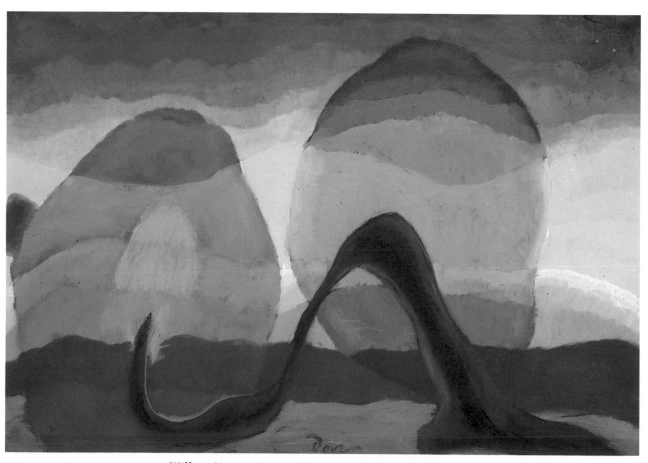

Willow Sisters. 1936. 14½ × 20⅝. (cat. no. 36.18)

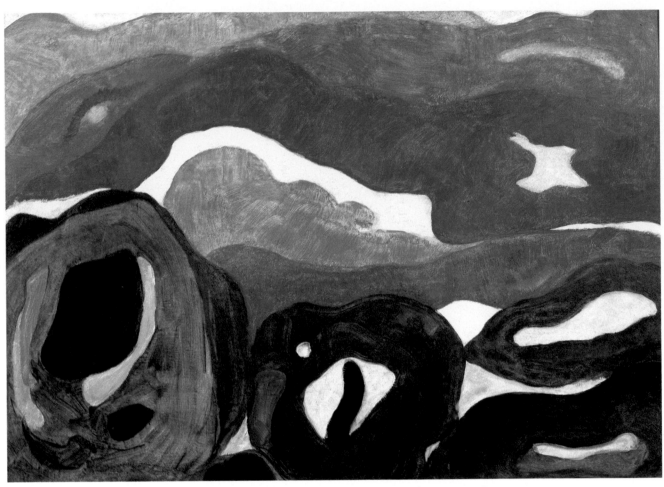

Windy Morning. 1936. 19½ × 27¾. (cat. no. 36.19)

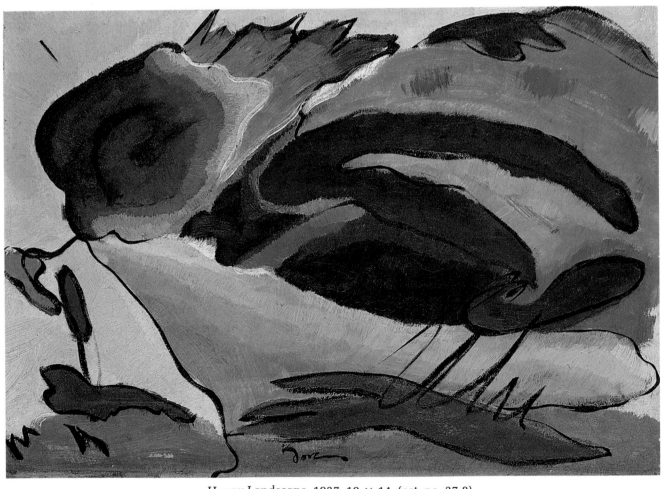

Happy Landscape. 1937. 10 × 14. (cat. no. 37.8)

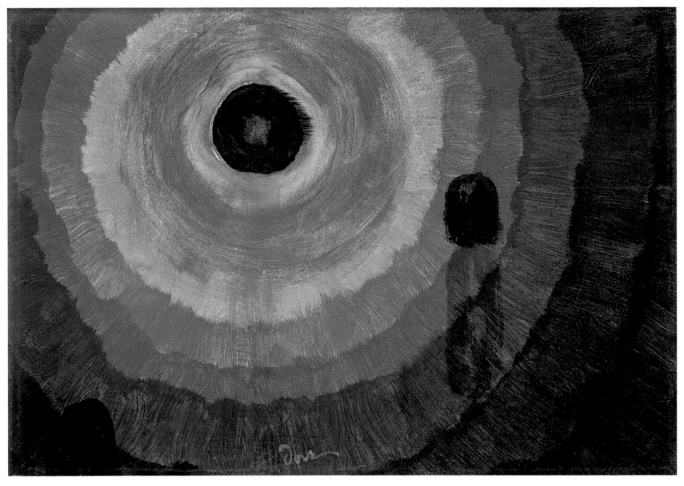

Sunrise IV. 1937. 10 × 14⅛. (cat. no. 37.13)

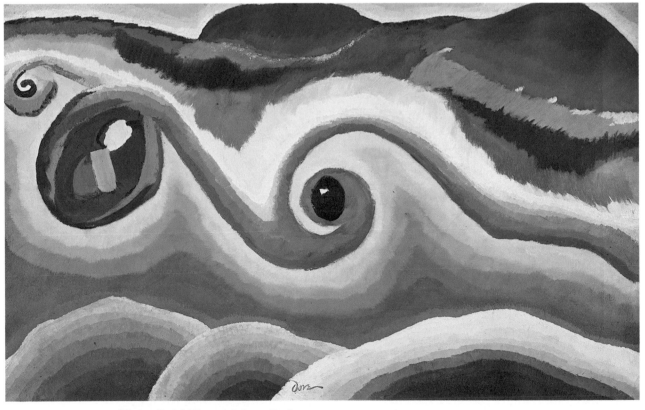

Water Swirl, Canandaigua Outlet. 1937. 16 × 26. (cat. no. 37.15)

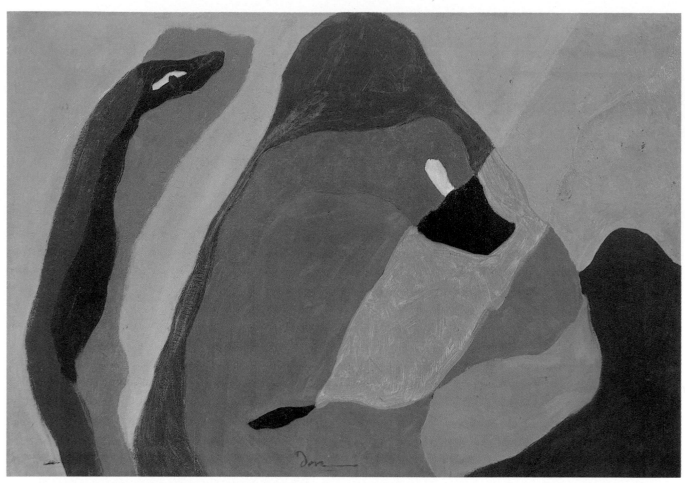

Green, Black and White (Green, Black and Gray). 1938. 17½ × 25½. (cat. no. 38.8)

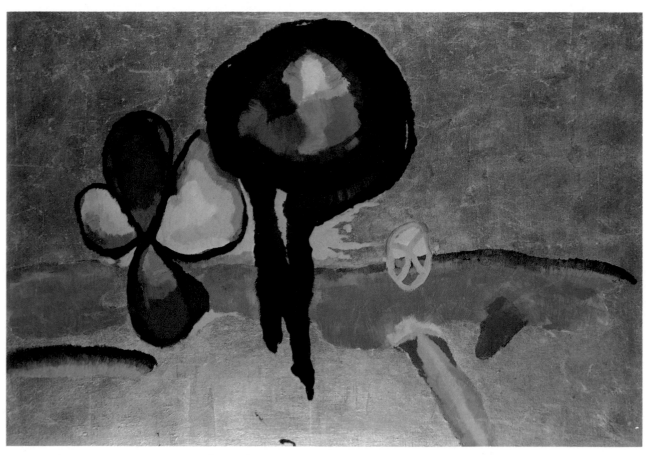

Hardware Store. 1938. 25 × 25. (cat. no. 38.9)

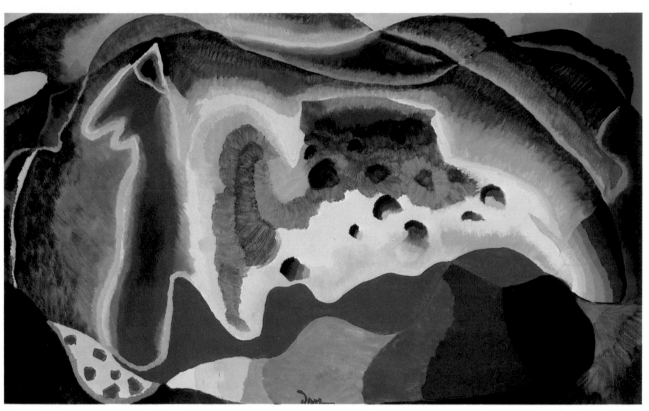

U.S. 1940. 20 × 32. (cat. no. 40.19)

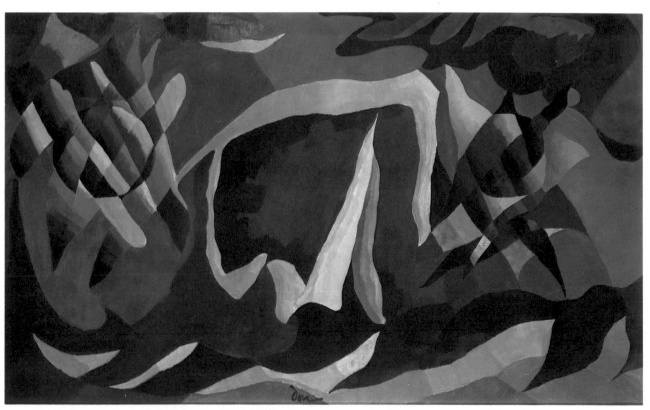

Lattice and Awning. 1941. 22¾ × 36¾. (cat. no. 41.8)

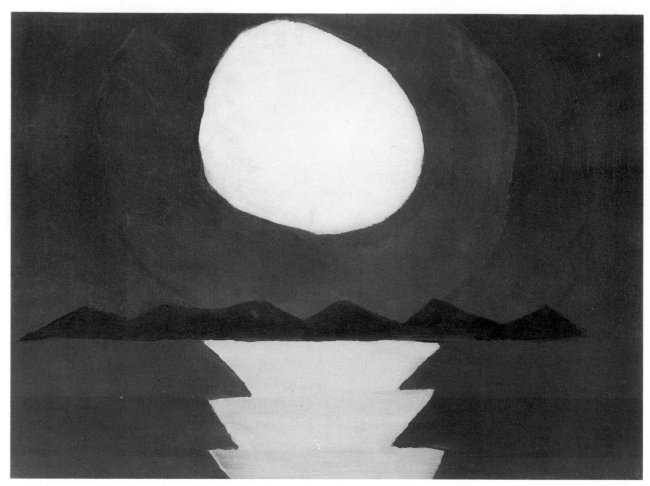

The Moon. 1941. 12 × 16. (cat. no. 41.11)

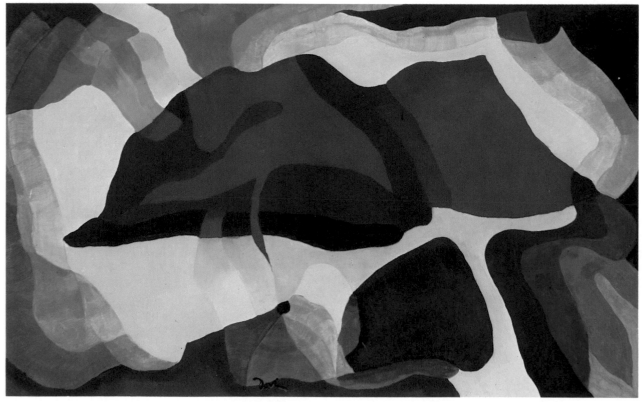

Pozzuoli Red. 1941. 22 × 36. (cat. no. 41.13)

12/13.4
GRAY DAY
c. 1912/13 (rec)
Pastel on board
21½ × 18
Signed, lower left

Collection: Unidentified

Provenance: (Charles Daniel Gallery)
(Knoedler Galleries)
Private collection, Philadelphia, Penn.

Exhibitions: Group
1943 Knoedler, no. 16
1967 Pennsylvania Academy

12/13.5
A WALK: POPLARS, or POPLAR TREE
c. 1912/13 (rec)
Pastel on linen
21½ × 18
Not signed

Collection: Terra Museum of American Art, Evanston, Ill. (1982)

Provenance: (Charles Daniel Gallery)
Paul Rosenfeld, New York City
Edith Halpert, New York City
(Sotheby Parke Bernet auction, New York City, 14 March 1973)
(William Zierler Gallery)

Exhibitions: Individual
1954 Ithaca, N.Y., no. 11, dated 1920
1958 Whitney, no. 12, dated 1920
1967 College Park, Md., painting no. 1, dated 1920
1974 San Francisco Museum, dated 1920
Group
1921 Pennsylvania Academy
1960 Utica, N.Y.
1962 Iowa City, Iowa, no. 18, dated 1920
1963 Whitney
Waltham, Mass.
1965 National Museum of American Art
Washington Gallery of Modern Art
1972 National Museum of American Art, no. 5

12/13.5

12/13.6

13.1

12/13.6
YACHTING
c. 1912/13
Pastel on linen
18 × 21½
Not signed

Collection: William H. Lane Foundation, Leominster, Mass. (1953)

Provenance: (Downtown Gallery)

Exhibitions: Individual
 1947 Downtown (San Francisco only)
 1961 Worcester, Mass., no. 1, dated 1910–14(?)
 1967 Downtown, no. 2, dated 1914

c. 1913

13.1
MUSIC
c. 1913
Cardboard support
15½ × 11½
Not signed

Collection: William C. Dove, Mattituck, N.Y.

Provenance: Acquired from the artist

Remarks: Inscribed on the reverse of the original frame with the artist's name, the title, and a date that is difficult to read but appears to be 1913.

References: Homer, William Innes. *Alfred Stieglitz and the American Avant-Garde.* Boston: New York Graphic Society, 1977. Illustration p. 211.

13.2
PAGAN PHILOSOPHY
c. 1913 (rec)
Pastel on paper
21⅜ × 17⅞
Not signed

Collection: Metropolitan Museum of Art (Alfred Stieglitz Collection; gift of Georgia O'Keeffe from the estate of Alfred Stieglitz, 1949)

Provenance: Alfred Stieglitz, New York City

Exhibitions: Group
 1946 Whitney, "Pioneers of Modern Art in America," no. 39, dated 1913
 1948 AIC, no. 72
 1963 Whitney
 1965 Metropolitan

13.3
SENTIMENTAL MUSIC
c. 1913 (rec)
Pastel on rough paper (possibly sandpaper) mounted on wood panel
21¼ × 17⅞
Not signed

Collection: Metropolitan Museum of Art (Alfred Stieglitz Collection; gift of Georgia O'Keeffe from the estate of Alfred Stieglitz, 1949)

Provenance: Alfred Stieglitz, New York City

Exhibitions: Group
 1935 Whitney, no. 39, dated 1914
 1948 AIC, no. 82
 1965 Metropolitan

c. 1912/14

12/14.1
BROWN, BLACK AND WHITE
c. 1912/14 (rec)
Support not verified

Collection: Unidentified

Provenance: (Charles Daniel)

12/14.2
CHINESE BOWL
c. 1912/14 (rec)
Paperboard support
8⅝ × 10½
Signed, lower left

Collection: Hirshhorn Museum and Sculpture Garden, Smithsonian Institution, Washington, D.C.

Provenance: (Charles Daniel)
 (?)
 (Zabriskie Gallery)
 Joseph H. Hirshhorn, New York City (1960)

Remarks: The title *Study in Still Life* is inscribed on a printed Daniel Gallery label on the reverse, as is the artist's name
 Current museum title is *Still Life.*

12/14.3
FROM A WASP, or WASP
c. 1912/14 (rec)
Wood support
8⅝ × 10½
Not signed

Collection: Art Institute of Chicago, Chicago, Ill. (gift of Georgia O'Keeffe from the estate of Alfred Stieglitz, 1949)

Provenance: Alfred Stieglitz, New York City

Remarks: The face of the painting is inscribed, at lower right, "From a Wasp," but in his card file of paintings, Dove titled this work "Wasp."

Exhibitions· Group
 1948 AIC

12/14.4
HOUSES AND TREES
c. 1912/14 (rec)
Support not verified

Collection: Unknown

Provenance: Heywood Broun, New York City

12/14.5
LITTLE HOUSE
c. 1912/14
Paper support

12/14.2

12/14.3

2½ × 3½
Not signed
Collection: William C. Dove, Mattituck, N.Y.
Provenance: Acquired from the artist.

c. 1914/17

14/17.1
ABSTRACTION
c. 1914/17
Wood support
21½ × 18½
Not signed
Collection: Unidentified

Provenance: (Terry Dintenfass Gallery)
 George J. Perutz, Dallas, Tex. (1973)
 (Terry Dintenfass Gallery)
 William Janss, Sun Valley, Idaho (1978)
 (Terry Dintenfass Gallery)
 Ahmet Ertegun, New York City (1979)

Remarks: This is probably the *Pure Painting No. 1,*
 which Dove described in his card file as consist-
 ing of "many colors of about equal intensity." It
 was exhibited as no. 24 in the Anderson Galleries'
 "Seven Americans" show of 1925.

12/14.5

Exhibitions: Individual
 1947 Downtown, no. 3, dated 1914
 1954 Ithaca, N.Y., no. 10, dated 1914
 1958 Whitney, no. 8, dated 1914
 1975 Dintenfass, "Arthur G. Dove: The Abstract
 Work," no. 1, dated 1914

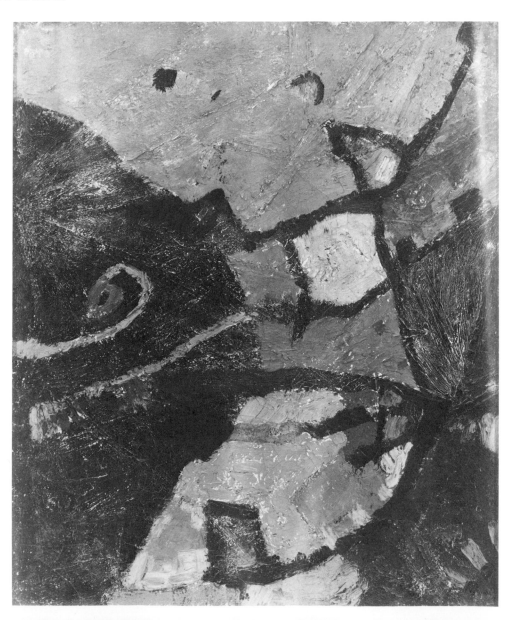

14/17.1

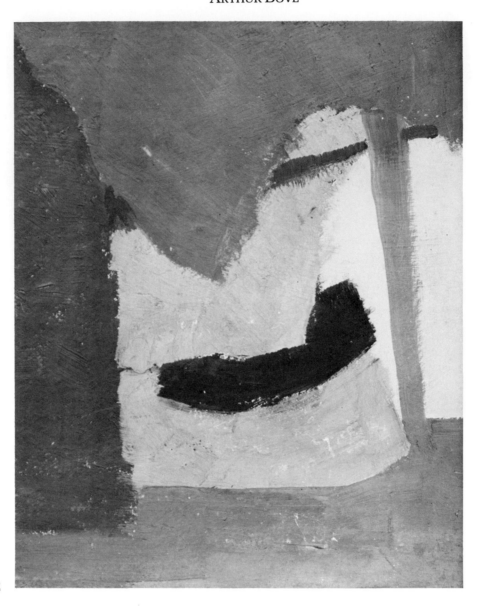

14/17.2

Group
1962 Iowa City, Iowa, no. 15, dated 1914
1978 Whitney, no. 150, dated 1914

References: Homer, William Innes. *Alfred Stieglitz and the American Avant-Garde.* Boston: New York Graphic Society, 1977. Illustration p. 213.

14/17.2
ABSTRACTION
c. 1914/17
Board support
10½ × 8½
Not signed

Collection: Michael Scharf, Jacksonville, Fla. (1980)

Provenance: (Terry Dintenfass Gallery)

Exhibitions: Individual
1956 Downtown, no. 2, dated 1915
1958 Whitney, no. 9, dated 1915

Reference: Homer, William Innes. *Alfred Stieglitz and the American Avant-Garde.* Boston: New York Graphic Society, 1977. Illustration p. 214.

14/17.3
BROOM
c. 1914/17 (rec)
Board support
13 × 11
Not signed

Collection: Unidentified

Provenance: Helen Torr Dove (acquired from the artist)

Remarks: Also known as *Brush Broom.*

14/17.4
LEAGUE OF NATIONS
c. 1914/17 (rec)
Paper support mounted on pulp board
21¼ × 17¾
Not signed

Collection: Georgia Museum of Art, University of Georgia, Athens (Eva Underhill Holbrook Memorial Collection of American Art, gift of Alfred H. Holbrook, 1945)

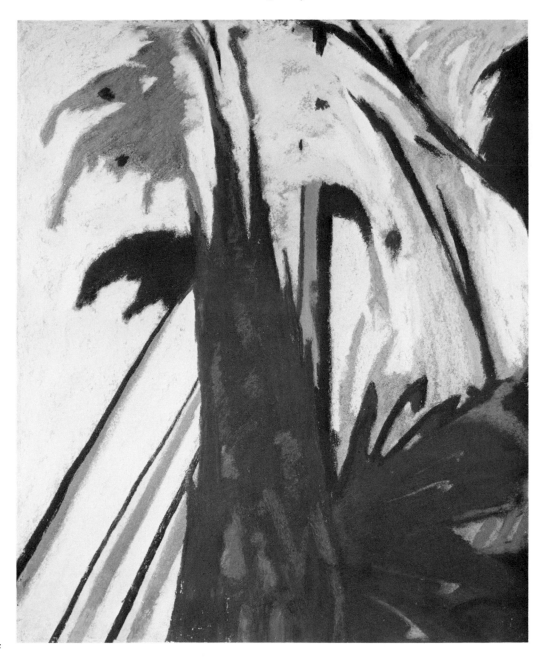

14/17.4

Provenance: (Charles Daniel Gallery)
(Knoedler Galleries)
Alfred H. Holbrook (1942)

Remarks: Inscribed with the artist's name and dated 1914 on reverse.

Exhibitions: Individual
1968 MOMA (touring), no. 4
Group
1921 Pennsylvania Academy, dated 1914
1922 Colony Club, no. 65, dated 1914

14/17.5
NUMBER 1
c. 1914/17
21½ × 18
Not signed

Collection: Philadelphia Museum of Art, Philadel-phia, Penn. (Alfred Stieglitz Collection; gift of Georgia O'Keeffe from the estate of Alfred Stieg-litz, 1949)

Provenance: Alfred Stieglitz, New York City

14/17.6
RUGGEDNESS
c. 1914/17 (rec)
21½ × 18
Not signed

Collection: Unidentified

Provenance: Alfred Stieglitz, New York City

Remarks: Inscribed on reverse with the artist's name and the date 1921. However, the artist dated it 1917 in his card file, presumably remembering it to date to the period before the c. 1917–20 hiatus in his painting activity.

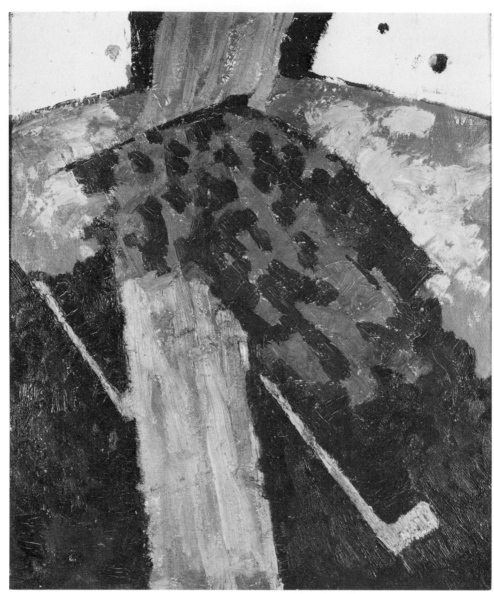

14/17.5

14/17.7
STOVE PIPE
c. 1914/17
Paper support mounted on board
10 × 8½
Not signed
Collection: Jay Braus, New York City (1975)

Provenance: (Downtown Gallery)
 William H. Lane Foundation, Leominster, Mass.
 (Terry Dintenfass Gallery)

Remarks: Inscribed on reverse with the artist's name, the title, and the date 1917.

Exhibitions: Individual
 1956 Downtown, no. 3, dated 1917
 1958 Whitney, no. 11, dated 1917
 1972 Dintenfass, no. 1, dated 1917
 1975 Dintenfass, "Arthur G. Dove: The Abstract Work," no. 25, dated 1917
 Group
 1962 Iowa City, Iowa, no. 17, dated 1917

14/17.8
WESTPORT
c. 1914/17
Pastel on paper
8½ × 10½
Not signed
Collection: Private collection

Provenance: Lila Howard, Westport, Conn. (gift of the artist)
 Edith Halpert, New York City

Remarks: Inscribed on reverse: "Painted by Arthur Dove and given to me in 1921. Lila Howard." This may indicate that the work was done c. 1920–21, but it relates stylistically to other works in the c. 1914/17 group.

Exhibition: Individual
 1974 San Francisco Museum, dated 1920

c. 1920

20.1
CHURCHES
c. 1920
Pastel, support not verified
Collection: Unidentified
Provenance: Cosgrave collection, Conn.

20.2
DARK ABSTRACTION
c. 1920
21½ × 18
Not signed
Collection: Harvey S. Mudd II, Santa Fe, N.M. (1980)

Provenance: (Terry Dintenfass Gallery)
 William C. Janss, Sun Valley, Idaho (1979)
 (Terry Dintenfass Gallery)

Remarks: This painting might be identical to one
 titled *Woods* and dated 1920 in Dove's card file of
 paintings.

Exhibition: Individual
 1981 Phillips, no. 13, dated 1921

20.3
UNTITLED
c. 1920
Support not verified
18 × 24

20.2

Collection: Unidentified

Provenance: (Downtown Gallery)
Rudin (1970)

Exhibitions: Individual
1964 Detroit, Mich., no. 1 (probable)
Group
1963 Whitney (probable)

1921

21.1
HARLEM RIVER BOATS
c. 1921
16¼ × 12⅛
Not signed

Collection: Vassar College Art Gallery, Poughkeep-
sie, N.Y. (gift of Paul Rosenfeld, 1950)

Provenance: Paul Rosenfeld, New York City

Remarks: Although Rosenfeld died in 1946, the
museum lists the painting as a gift, rather than as a
bequest.
This is probably the painting listed in Dove's card
file of paintings as *Derrick, Harlem.*

21.2
MACHINERY, or MOWING MACHINE
1921 (rec)
18⅛ × 21⅞
Not signed

Collection: Vassar College Art Gallery, Poughkeep-
sie, N.Y. (gift of Paul Rosenfeld, 1950).

Provenance: Paul Rosenfeld, New York City

21.1

21.2

Remarks: Although Rosenfeld died in 1946, the museum lists the painting as a gift, rather than as a bequest.
Inscribed on the reverse with the artist's name and the date.

21.3
TANKS AND SNOWBANK
c. 1921
Support not verified
Collection: Unidentified
Provenance: (Downtown Gallery)
 Leshner (1966)
Exhibition: Individual
 1935 Whitney, dated 1921

21.4
TERRE VERTE, GOLDEN OCHRE
c. 1921
8 × 6
Signed, lower half, right of center
Collection: Private collection
Provenance: (Terry Dintenfass Gallery)
Exhibitions: Individual
 1946 American Place, no. 6, dated 1946
 1964 Detroit, Mich., no. 2, dated c. 1921

21.5
THUNDERSTORM
1921
Medium includes metallic paints

21.4

c. 1922

21½ × 18⅛
Not signed

Collection: Columbus Museum of Art, Columbus, Ohio (gift of Ferdinand Howald, 1931)

Provenance: (Anderson Galleries auction, 23 February 1922)
Ferdinand Howald, New York City and Columbus, Ohio (1922)

Remarks: Inscribed with the artist's name and the date on the reverse.

Exhibitions: Individual
1958 Whitney, no. 13
1981 Phillips, no. 14
Group
1931 Columbus, Ohio, no. 80
1935 Cincinnati, Ohio
1952 Carnegie Institute
1953 Norfolk, Va.
1970 Wildenstein, no. 60
American Federation of Arts (touring), no. 19
1972 Austin, Tex.
1973 Minneapolis, Minn.
1977 Madison, Wis., no. 34

22.1
GARDEN, ROSE, GOLD, GREEN or GARDEN
c. 1922
Medium and support not verified

Collection: Private collection, Saint Louis, Mo.

Provenance: (The Intimate Gallery)
DeWald

Exhibitions: Individual
1926 Intimate Gallery, titled *Garden*
Group
1925 Anderson Galleries, no. 25, titled *Garden, Rose, Gold, Green*
1926 Wildenstein, no. 26, titled *The Garden*

22.2
GEAR
c. 1922
22 × 18
Not signed

Collection: William C. Janss, Sun Valley, Idaho (1980)

Provenance: (Terry Dintenfass Gallery)

21.5

22.2

Remarks: Inscribed on reverse with the artist's name
and the date. Stieglitz photographed Dove in front
of this painting in 1923.

Exhibitions: Individual
 1954 Ithaca, N.Y., no. 12, dated 1922
 1967 College Park, Md., painting no. 2, dated 1922
 1967 Huntington, N.Y., no. 3, dated 1922.
 1972 Dintenfass, dated 1922.
 Group
 1951 Houston, Tex.
 1975 Wilmington, Del., dated 1922.

Reference: Frank, Waldo, et al. *America and Alfred
 Stieglitz: A Collective Portrait.* Garden City, N.Y.:
 Doubleday, Doran, 1934. Illustration pl. 23 of
 Stieglitz's photograph (erroneously dated 1915) of
 Dove in front of this painting.

22.3
LANTERN
c. 1922
Medium includes silver paint; support is mahogany
 panel
21⅜ × 18
Not signed

Collection: Art Institute of Chicago, Chicago, Ill. (gift
 of Georgia O'Keeffe from the estate of Alfred Stieg-
 litz, 1949)

Provenance: Alfred Stieglitz, New York City

Remarks: Dove noted on the back of a crayon pre-
 paratory study (belonging today to the artist's son)
 "Try black and white used in line and then pure
 mathematical color."
 In his card catalogue, Dove dated this work 1922.

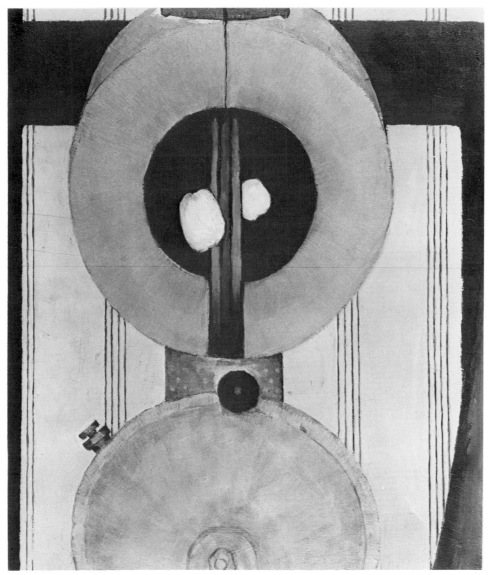

22.3

On a list made up in the early 1940s, he dated it 1923.

Exhibitions: Individual
 1974 San Francisco Museum, dated 1921
 Group
 1948 AIC

Reference: Kootz, Samuel M. *Modern American Painters*. New York: Brewer & Warren, 1930. Illustration pl. 16, dated 1921.

c. 1923

23.1
AFTER THE STORM, SILVER AND GREEN (TRANSLUCENT SKY)
c. 1923
Support not verified (probably wood)
Collection: Unidentified
Remarks: A painting titled *After the Storm*, which must have been this one or *After the Storm, Silver and Green (Vault Sky)* (no. 23.2) was exhibited in the following one-person shows:
 1945 American Place, no. 15, dated 1922
 1964 Detroit, Mich., no. 3, dated 1927
 1967 Huntington, N.Y., no. 4, dated 1923
Exhibition: Group
 1925 Anderson Galleries, no. 19

23.2
AFTER THE STORM, SILVER AND GREEN (VAULT SKY)
c. 1923
Medium includes metallic paint; wood support
24 × 18
Not signed
Collection: New Jersey State Museum, Trenton, N.J. (gift of Mr. and Mrs. L. B. Wescott, 1974)
Provenance: (Downtown Gallery)
 Private collection (1968)

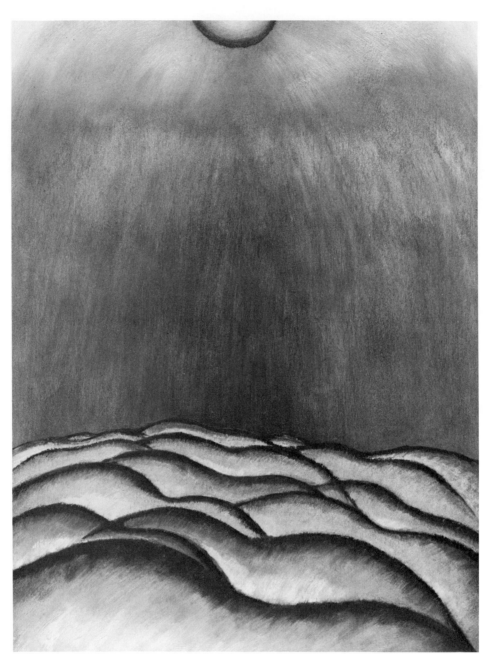

23.2

(William Zierler)
Susan and David Workman, New York City
Mr. and Mrs. L. B. Wescott, Rosemont, N.J.

Remarks: See remarks to no. 23.1.

In the 1925 *Seven Americans* exhibition, Dove showed a painting of this title, along with others titled *After the Storm, Silver and Green (Translucent Sky), Moon and Sea No. I,* and *Moon and Sea No. II.* One would expect the similarly titled pairs to resemble each other visually. However, this painting is formally almost identical to *Moon and Sea No. II* (no. 25.10). The whereabouts of *After the Storm, Silver and Green (Translucent Sky)* and of *Moon and Sea No. I* are today unknown. Further evidence is required to explain the close relationship between this painting and *Moon and Sea No. II.* Possibly all four paintings were closely related. Possibly the original identity of one of them has become confused over the years since they were first exhibited.

Exhibitions: Individual
 1975 Dintenfass, "Arthur G. Dove: The Abstract Work," no. 2, dated 1922
 Group
 1925 Anderson Galleries, no. 20
 1971 Carnegie Institute, no. 21, dated 1922

23.3
CHINESE MUSIC
c. 1923
Wood support
$21\frac{1}{2} \times 18\frac{1}{8}$

Not signed

Collection: Philadelphia Museum of Art, Philadelphia, Penn. (gift of Georgia O'Keeffe from the estate of Alfred Stieglitz, 1949)

Provenance: Alfred Stieglitz, New York City

Exhibition: Individual
 1958 Whitney, no. 14, dated 1923

23.4
FACTORY MUSIC, SILVER, YELLOW, INDIAN-RED AND BLUE
c. 1923
Medium and support not verified

Collection: Unidentified

Exhibition: Group
 1925 Anderson Galleries, no. 23

23.5
LEMON IN A BEDSPREAD
c. 1923
Building board support
10 × 7¾
Not signed

Collection: Unidentified

Provenance: Mrs. George Rankin, Washington, D.C.

Remarks: This painting's existence is first documented in Dove's diary for 2 April 1924, when he took it to Stieglitz.

23.6
RIVER BOTTOM, SILVER, OCHRE, CARMINE, GREEN
c. 1923
24 × 18
Not signed

Collection: Andrew Crispo Gallery

Provenance: (Downtown Gallery)
 Mr. and Mrs. Leon Rudin, New York City
 Private Collection, New York City

Remarks: Inscribed with the artist's name on reverse.

Exhibitions: Individual
 1974 San Francisco Museum, dated 1923
 Group
 1925 Anderson Galleries, no. 22
 1974 Washburn, no. 5
 1976 USIA (touring)
 1977 Crispo, "20th Century American Painting and Sculpture"
 Edinburgh, Scotland, no. 38

1924

24.1
ALFRED STIEGLITZ (PORTRAIT)
1924 (doc)
Assemblage of lens, photographic plate, clock and watch springs, and steel wool on plywood
16⅜ × 12⅜
Not signed

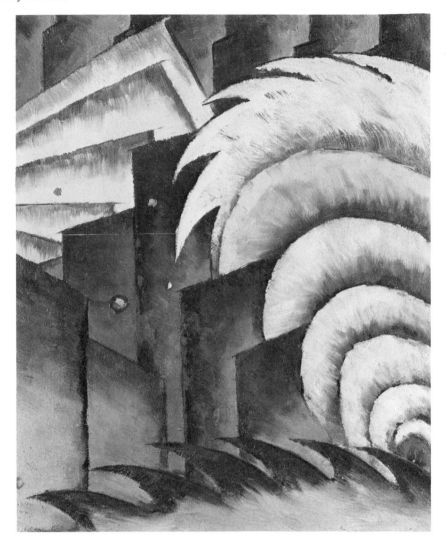

23.3

Collection: Museum of Modern Art (1955)

Provenance: (Downtown Gallery)

Remarks: In a letter to Stieglitz on 3 October 1942, Dove wrote that this "portrait" suggested "what I saw about you when you were speaking of your mother to Bloch the musician at your brother's house."

Exhibitions: Individual
 1954 Ithaca, N.Y., no. 34, titled *Portrait of "A.S."*, dated c. 1925
 1955 Downtown, no. 10, dated 1925
 1971 Dintenfass, no. 5
 1974 San Francisco Museum (not all locations)
 Group
 1925 Anderson Galleries, no. 2
 1948 MOMA, "Collage," dated 1924.
 1955 MOMA
 1960 MOMA
 1961 MOMA, titled *Portrait of Alfred Stieglitz*, dated 1925
 Wilmington, Del.
 1962 Downtown

Reference: Johnson, Dorothy Rylander. *Arthur Dove: The Years of Collage.* College Park, Md.: Univer-

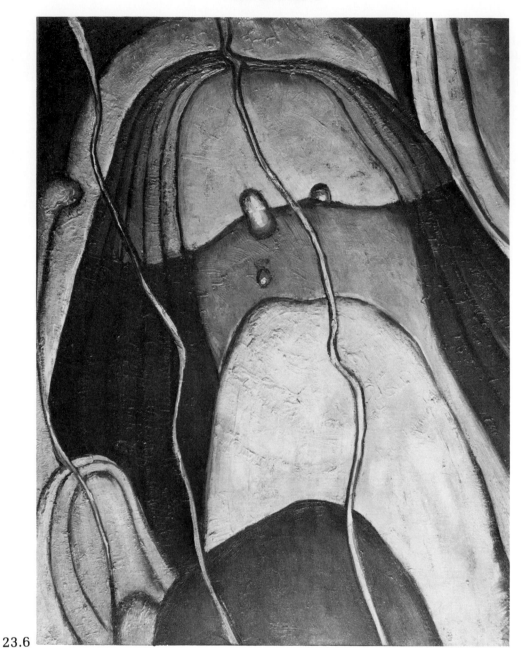

23.6

sity of Maryland Art Gallery, 1967. Illustration
p. 25, titled *Portrait of Alfred Stieglitz*, dated
1925.

24.2
HUNTINGTON HARBOR
1924
Assemblage of shells, corduroy, sticks, paper, large-
 headed thumb tack, and photomechanical repro-
 duction on painted wood panel with rope frame
13⅛ × 19¼
Not signed

Collection: Hirshhorn Museum and Sculpture Gar-
 den, Smithsonian Institution, Washington, D.C.
 (1979)

Provenance: (Terry Dintenfass Gallery)

Remarks: Inscribed with the artist's name, the title,
 and 1924 date on reverse.

Exhibitions: Individual
 1955 Downtown, no. 2, dated 1924
 1967 College Park, Md., dated 1929
 1974 San Francisco Museum, dated 1929
 Group
 1925 Anderson Galleries, no. 5
 1979 Montclair, N.J.

24.3
MARY GOES TO ITALY
1924 (doc)
Watch crystal support

Collection: Unidentified (probably no longer extant)

Exhibition: Group
 1925 Anderson Galleries, no. 15

24.1

24.2

24.4
MISS WOOLWORTH
1924 (doc)
Assemblage of artificial flowers, stockings, mask,
 earrings, cork-and-felt insoles, purse, garden
 gloves, watch, ring, brooch, and bead necklace on
 unverified support
Not signed

Collection: No longer extant

Exhibition: Group
 1925 Anderson Galleries, no. 1

Reference: Johnson, Dorothy Rylander. *Arthur Dove:
 The Years of Collage.* College Park, Md.: Univer-
 sity of Maryland Art Gallery, 1967. Illustration
 p. 29, dated 1925.

24.5
PENETRATION
1924 (doc)
Board support
22 × 18⅛
Not signed

Collection: Andrew Crispo Gallery

Provenance: (The Intimate Gallery)
 Henry Raleigh (1926)
 Mrs. Holly Beckwith, Shelter Island, N.Y.

Exhibitions: Individual
 1926 Intimate Gallery
 Group
 1973 Crispo, no. 47a
 1976 Westport, Conn.
 1978 Crispo, "American Masters of the 20th Cen-
 tury"

24.6
RAIN
1924 (doc)
Assemblage of twigs and rubber cement on metal
 and glass
19½ × 15⅝
Not signed

Collection: Georgia O'Keeffe, Abiquiu, N.M. (on loan
 to the University of New Mexico, Albuquerque)

24.4

24.5

Provenance: (The Intimate Gallery)

Exhibitions: Individual
 1926 Intimate Gallery
 1934 American Place
 1939 American Place, no. 20, dated 1925
 1974 San Francisco Museum (not shown at all locations)
 Group
 1925 Anderson Galleries, no. 17

Reference: Johnson, Dorothy Rylander, *Arthur Dove: The Years of Collage*. College Park, Md.: University of Maryland Art Gallery, 1967. Illustration p. 31.

24.7
RALPH DUSENBERRY
1924 (doc)
Assemblage of wood, page from a hymnal, folding ruler, and oil on canvas
22 × 18
Not signed

Collection: Metropolitan Museum of Art (Alfred Stieglitz Collection; gift of Georgia O'Keeffe from the estate of Alfred Stieglitz, 1949)

Provenance: Alfred Stieglitz, New York City

Remarks: Dove wrote of this painting:
 . . . the Dusenberrys lived on a boat near us in Lloyd's Harbor. He could dive like a kingfish and swim like a fish. Was a sort of foreman on the Marshall Field place. His father was a minister. He and his brother were architects in Port Washington. He drove into Huntington in a sleigh one winter and stayed so long in a cafe there they had to bring a wagon to take him home. He came home to his boat one day with two bottles, making his wife so mad that she threw them overboard. He dived in right after them and came up with one in each hand. When tight he always sang "Shall we gather at the river?" [the hymn included in this work]. (Wight, p. 51.)

24.6

24.7

Exhibitions: Individual
 1926 Intimate Gallery
 1937 Phillips, no. 1
 1939 American Place, no. 6, titled *Ralph Dusenbury*
 1955 Downtown, no. 4
 1967 College Park, Md., collage no. 3
 1974 San Francisco Museum
 Group
 1925 Anderson Galleries, no. 3
 1936 MOMA
 1944 Philadelphia Museum, no. 253
 1947 MOMA, no. 25
 1948 AIC, no. 13
 1965 Metropolitan

Reference: Wight, Frederick S. *Arthur G. Dove.* Berkeley and Los Angeles: University of California Press, 1958. Illustration p. 52.

24.8
STARRY HEAVENS
1924

Oil and gold paint on reverse side of glass, with black paper
18 × 16
Not signed

Collection: Estate of the artist, Terry Dintenfass Gallery

Exhibitions: Individual
 1955 Downtown, no. 3
 1967 College Park, Md., collage no. 2
 1974 San Francisco Museum (San Francisco and New York only)
 Group
 1925 Anderson Galleries, no. 6

24.9
SUNRISE
1924 (doc)
Plywood support
18¼ × 20⅞
Not signed

Collection: Milwaukee Art Museum, Milwaukee, Wis. (gift of Mrs. Edward R. Wehr)

24.8

24.9

Provenance: (Downtown Gallery)
 Mrs. Edward R. Wehr (1959)

Exhibition: Group
 1925 Anderson Galleries, no. 16

24.10
TEN-CENT STORE
1924 (doc)
Assemblage of artificial flowers, pipe cleaners, F. W.
 Woolworth price card, and dried foliage on card-
 board
18 × 16
Not signed

Collection: Sheldon Memorial Art Gallery, Univer-
 sity of Nebraska, Lincoln (Nebraska Art Associa-
 tion, Nelle Cochrane Woods Collection)

Provenance: (Terry Dintenfass Gallery)

Exhibitions: Individual
 1955 Downtown, no. 1
 1967 College Park, Md., collage no. 1
 1974 San Francisco Museum
 Group
 1925 Anderson Galleries, no. 14

24.10

1925

25.1
AFTER THE STORM, MOON AND CLOUDS
1925
Support not verified
Collection: Unidentified
Provenance: Heywood Broun, New York City (1925)
Exhibition: Group
 1925 Anderson Galleries, no. 11

25.2
THE CRITIC
1925 (doc)
Assemblage of cardboard, newspaper clippings,
 magazine cutouts, cord, and velvet
19¾ × 13½
Not signed
Collection: Whitney Museum of American Art (gift
 of the Historic Art Associates of the Whitney
 Museum of American Art; Mr. and Mrs. Morton L.
 Janklow; the Howard and Jean Lipman Founda-
 tion, Inc.; and Hannelore Schulhof, 1976)
Provenance: (Terry Dintenfass Gallery)
Remarks: Probably first shown in Dove's 1926 Inti-
 mate Gallery exhibition.
Exhibitions: Individual
 1955 Downtown, no. 9
 1967 College Park, Md., collage no. 6
 1971 Dintenfass
 1974 San Francisco Museum
 Group
 1961 MOMA

25.3
GOIN' FISHIN'
1925 (doc)
Assemblage of bamboo, denim shirt sleeves, bark,
 and pieces of wood on wood support
19½ × 24
Not signed
Collection: Phillips Collection, Washington, D.C.
 (1937)
Provenance: (The Intimate Gallery)
 Alfred Stieglitz, New York City
Exhibitions: Individual
 1926 Intimate Gallery, titled *Fishing Nigger*
 1934 American Place, no. 23
 1937 Phillips, no. 5, titled *A Nigger Goes A Fish-
 ing*
 1947 Downtown, no. 5, dated 1920
 Phillips
 1953 Corcoran
 1954 Ithaca, N.Y., no. 33
 1955 Downtown, no. 14, dated 1926
 1967 College Park, Md., collage no. 7
 1974 San Francisco Museum
 1981 Phillips, no. 15

25.2

Group
1938 Paris, France, no. 46
1939 MOMA, no. 198
1945 San Francisco, Calif.
1951 Brooklyn Museum
 MOMA, no. 22
1965 National Museum of American Art
1973 LaJolla, Calif.
1977 Edinburgh, Scotland
1979 Düsseldorf, Germany

25.4
GOLDEN STORM
1925
Medium includes copper and gold metallic paint;
 wood support
19¼ × 21

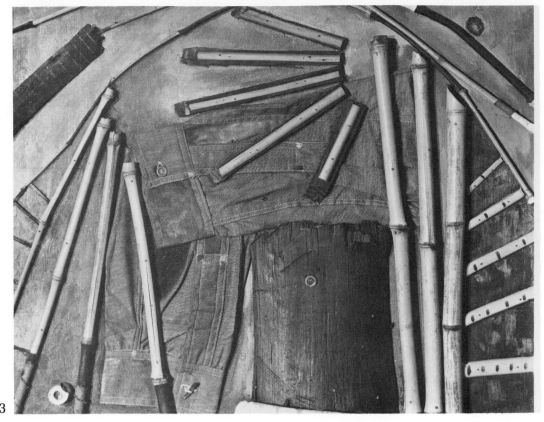

25.3

Not signed

Collection: Phillips Collection, Washington, D.C. (1926)

Provenance: (The Intimate Gallery)

Remarks: Inscribed on reverse with the artist's name, the title, and the date.

Exhibitions: Individual
 1926 Intimate Gallery
 1937 Phillips, no. 9, dated 1924
 1947 Downtown, no. 6
 Phillips
 1953 Corcoran
 1966 Phillips
 1974 San Francisco Museum, dated 1926

Group
 1925 Anderson Galleries, no. 12, titled *Storm-Clouds in Gold*
 1926 Phillips, no. 12
 1930 Phillips, "Marin, Dove and Others," no. 62
 1931 Phillips, "American and European Abstractions," no. 61
 Phillips, "20th Century Lyricism"
 1950 Amsterdam, Netherlands
 1966 National Museum of American Art
 1979 Phillips/Smithsonian Institution (touring)

25.5
GRANDMOTHER
1925

25.4

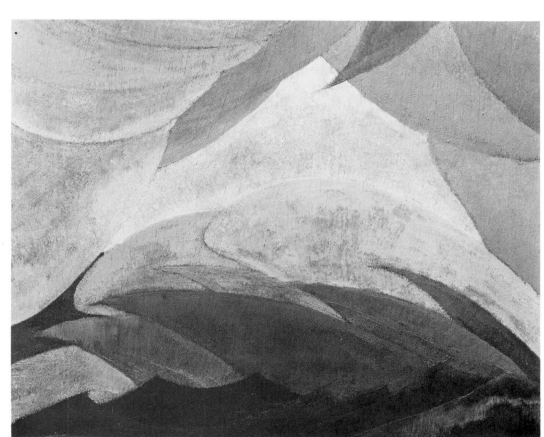

25.5

Assemblage of wood shingles, needlepoint, page from a Bible (Concordance), and pressed flowers and fern
20 × 21¼
Not signed

Collection: Museum of Modern Art (gift of Philip L. Goodwin, 1939)

Provenance: (An American Place)

Remarks: Date is confirmed by the fact that the work was seen at Stieglitz's gallery on 4 January 1926. (Letter from Donald Davidson to Dove, dated 4 January 1926, William Dove collection.)

Exhibitions: Individual
1926 Intimate Gallery
1937 Phillips, no. 3
1939 American Place, no. 18, dated 1925
1974 San Francisco Museum
Group
1936 MOMA
1940 MOMA
1943 Art of This Century
1944 MOMA, "Art in Progress"
1948 MOMA, "American Paintings from the Museum Collection"
MOMA, "Collage"
1955 Wildenstein, no. 10
1961 MOMA, no. 64

Reference: Johnson, Dorothy Rylander, *Arthur Dove: The Years of Collage*. College Park, Md.: University of Maryland Art Gallery, 1967. Illustration p. 27.

25.6
INDIAN SPRING
1925 (doc)
18 × 22
Not signed

Collection: William H. Lane Foundation, Leominster, Mass.

Provenance: (Downtown Gallery)

Remarks: Probably identical to *Indian Shrine*, on which the artist was working on 1 May 1925, according to Reds' diary.

Exhibition: Individual
1961 Worcester, Mass., no. 3, dated 1923

25.7
THE INTELLECTUAL
1925 (doc)
Assemblage of magnifying glass, bone, moss, and scale on scored wood panel
17 × 7⅛
Not signed

Collection: Museum of Modern Art (gift of Philip L. Goodwin, 1958)

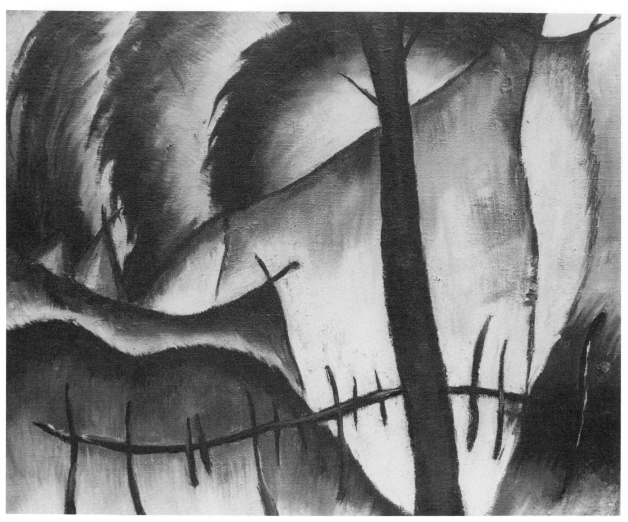

25.6

Provenance: (Downtown Gallery)
 Philip L. Goodwin, New York City (1955)

Exhibitions: Individual
 1955 Downtown, no. 5
 1974 San Francisco Museum (not shown at all lo-
 cations)
 Group
 1958 MOMA

Reference: Johnson, Dorothy Rylander. *Arthur Dove: The Years of Collage.* College Park, Md.: University of Maryland Art Gallery, 1967. Illustration p. 28.

25.8
LONG ISLAND
1925
Assemblage of shells, twigs, sand, painted leaves, and magazine cutout on painted cardboard
15 × 20¾
Not signed

Collection: Museum of Fine Arts, Boston, Mass. (Abraham Shuman Fund [Director's Discretionary Fund], 1962)

Provenance: (Downtown Gallery)

Remarks: Inscribed on reverse with the artist's name, the title, and 1925 date.

Exhibitions: Individual
 1955 Downtown, no. 6
 1967 College Park, Md., collage no. 10
 Group
 1925 Anderson Galleries, no. 4

25.9
MOON AND SEA NO. I
1925
Support not verified

Collection: Unidentified

Exhibition: Group
 1925 Anderson Galleries, no. 9

25.10
MOON AND SEA NO. II
1925
24 × 18
Not signed

Collection: Andrew Crispo Galler

Provenance: (The Intimate Gallery)
Arthur and Edna Bryner Schwab, New York City
(Downtown Gallery)
(New Gallery)
Mr. and Mrs. Herbert M. Rothschild, Kitchawan, N.Y.
Private collection, New York City

Remarks: Inscribed with the artist's name on reverse, which is now covered with backing.
See remarks to no. 23.2

Exhibitions: Individual
1958 Whitney, no. 15, dated 1923
Group
1925 Anderson Galleries, no. 10
1966 Providence, R.I., no. 44
1975 Omaha, Neb., no. 26
1976 Crispo, no. 45

25.11
PAINTED FORMS, FRIENDS
1925
Assemblage of metal rods, spring, wood, nails, wire, staple, metal, and paint on wood
4¾ × 5⅛
Not signed

Collection: Philadelphia Museum of Art, Philadelphia, Penn. (gift of Paul Strand)

Provenance: Paul Strand

Remarks: This may be the "small sculpture painting" on which Dove was working in late November and early December of 1924, according to his diary.

Exhibitions: Individual
1974 San Francisco Museum, titled *Untitled*, dated c. 1924–30
Group
1925 Anderson Galleries, no. 7

25.12
PAINTED FORMS, SACRELIGION
1925
Support not verified

Collection: Unidentified

Provenance: (The Intimate Gallery)
Henry Raleigh, New York City (1926)

Exhibitions: Individual
1926 Intimate Gallery
Group
1925 Anderson Galleries, no. 8

25.13
PLASTER AND CORK
1925 (doc)
Assemblage of plaster, cork, wire mesh, blue cloth, and paint
21½ × 13⅜
Not signed

Collection: Amon Carter Museum, Fort Worth, Tex. (gift of Georgia O'Keeffe)

Provenance: (The Intimate Gallery)
Georgia O'Keeffe, New York City

25.7

25.8

25.10

25.13

Remarks: After Dove's death, Reds wrote some fragmentary reminiscences of her life with him. Concerning this work, she stated:

> One day [Dove] said, "I'm tired of putting brush strokes on canvas." After the next walk we took on the other side of the water in Halesite he collected leaves and things and made his first collage.

> He got some handsome old wire on Marshall [Field?]'s dump.—Put it, a blue chinese silk from a belt of mine in a beautiful white plaster rectangle.

> Brancusi said (at the Intimate Gallery) it was one of the most beautiful things he'd seen in America. I don't think at that time he'd [Dove] seen anything but some newspapers pasted or some of the French in reproduction. We saw very little in New York, not having the car fare. (William C. Dove collection)

Exhibitions: Individual
1926 Intimate Gallery
1940 American Place, no. 36, titled *Composition on Plaster*
1968 MOMA (touring) (Fort Worth only)
1974 San Francisco Museum (not shown at all locations), titled *Untitled*, dated c. 1924

Reference: Johnson, Dorothy Rylander. *Arthur Dove: The Years of Collage.* College Park, Md.: University of Maryland Art Gallery, 1967. Illustration p. 42, titled *Untitled*, dated n.d.

25.14
PEN AND RAZOR BLADE
1925
Assemblage of razor blade, magazine cutout, metal strip, crayon, ink, and paint on paper
$17\frac{1}{2} \times 7\frac{1}{2}$
Not signed

Collection: Beinecke Rare Book and Manuscript Library, Yale University, New Haven, Conn. (Alfred Stieglitz Collection, gift of Georgia O'Keeffe)

Provenance: Alfred Stieglitz, New York City

Exhibition: Group
1925 Anderson Galleries, no. 18

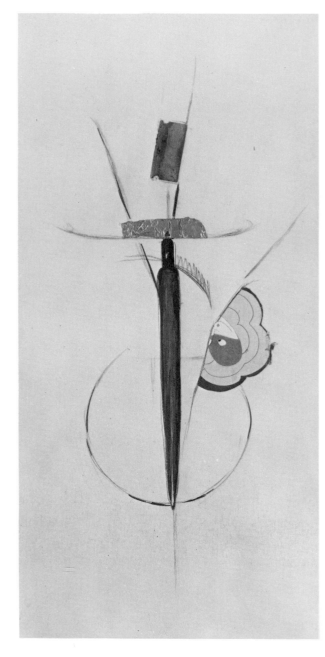

25.14

25.15
SEA I
1925 (doc)
Chiffon on scratched aluminum panel
13 × 21
Not signed

Collection: William H. Lane Foundation, Leominster, Mass. (1956)

Provenance: (Downtown Gallery)

Remarks: Probably shown in Dove's 1926 exhibition at The Intimate Gallery, possibly as *A Sea Drawing Water* (no. 26.7).

Exhibitions: Individual
1955 Downtown, no. 7
1961 Worcester, Massachusetts, no. 4
1967 College Park, Md., collage no. 14

25.16
SEA II
1925 (doc)
Chiffon and sand on scratched aluminum panel
13 × 21
Not signed

Collection: Barney A. Ebsworth, Saint Louis, Mo.

Provenance: (Downtown Gallery)
Edith Halpert, New York City
(Sotheby Parke Bernet auction, 15 March 1973)

Remarks: Inscribed with the artist's name, the title, and the date on panel affixed to reverse.
Probably exhibited in Dove's 1926 Intimate Gallery show.

Exhibitions: Individual
1955 Downtown, no. 8
1974 San Francisco Museum

Reference: Johnson, Dorothy Rylander, *Arthur Dove: The Years of Collage*. College Park, Md.: University of Maryland Art Gallery, 1967. No illustration.

25.15

25.16

25.17
SILVER STORM
1925
Support not verified

Collection: Unidentified

Provenance: (The Intimate Gallery)
 Dr. Silverburg (1926)

Exhibition: Group
 1925 Anderson Galleries, no. 13, titled *Storm-Clouds in Silver.*

Reference: Kootz, Samuel M. *Modern American Painters.* New York: Brewer & Warren, 1930. Illustration pl. 20, titled *Silver Storm,* dated 1923.

25.18
STORM, BLUE AND BROWN (ICE AND SEA-GULL MOTIVE)
1925
Support not verified

Collection: Unidentified

Exhibition: Group
 1925 Anderson Galleries, no. 21

25.19
WATERFALL
1925 (doc)
Masonite support
10 × 8
Not signed

Collection: Phillips Collection, Washington, D.C. (1926)

Provenance: (The Intimate Gallery)

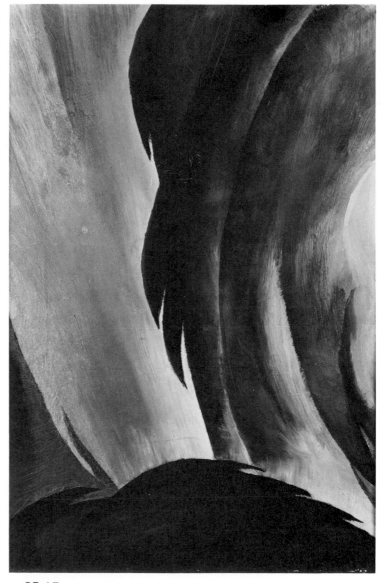

25.17

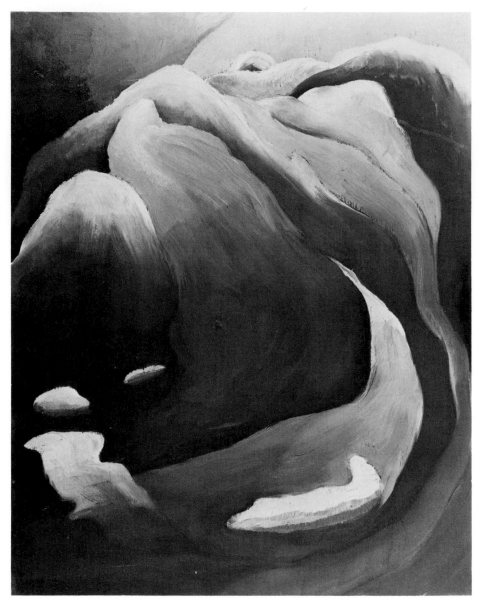

25.19

Remarks: Inscribed on reverse with the artist's
name, the title, and the date.

Exhibitions: Individual
 1926 Intimate Gallery
 1937 Phillips, no. 6, dated 1924
 1947 Phillips
 1958 Whitney, no. 16
 1974 San Francisco Museum
 1981 Phillips, no. 16
 Group
 1925 Phillips
 1930 Phillips, "Marin, Dove and Others"
 1931 Phillips, "American and European Abstrac-
 tions"
 Phillips, "Twentieth Century Lyricism"
 1941 Phillips, no. 154
 1943 Phillips
 1966 National Museum of American Art
 1981 Cincinnati, Ohio

1926

26.1
BOATS AT NIGHT
1926
Medium and support not verified

Collection: Unidentified

Provenance: (The Intimate Gallery)

Remarks: This is probably identical to a work re-
 ferred to as *Sails at Night,* purchased by Henry
 Raleigh in 1926. Dove noted in his card file that it
 had been repainted from an earlier pastel.

Exhibition: Individual
 1926 Intimate Gallery

26.2
FORMS AGAINST THE SUN
c. 1926
Metal support

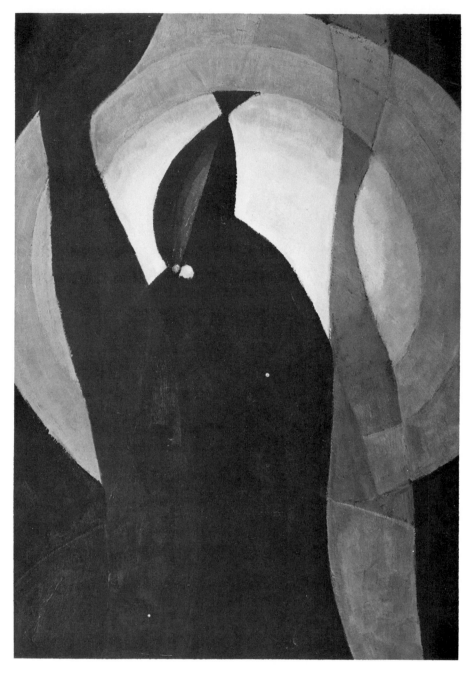

26.2

29 × 21

Not signed

Collection: Wichita Art Museum, Wichita, Kan. (Roland P. Murdock Collection, 1948)

Provenance: (Downtown Gallery)

Remarks: Dating this painting is a problem. There is no record of such a title in Dove's oeuvre. The museum now dates the work c. 1915, but stylistically, the painting more closely resembles works of the later twenties. Also, most of Dove's paintings on metal supports date to the twenties, and no example is documented as being earlier. Possibly, the work was shown under some other title in another exhibition; the 1926 date given here is based on the assumption that it may have been shown in Dove's 1926 show, since my list for that show may not be complete (no catalogue or checklist exists).

26.3

HUNTINGTON HARBOR—I

1926

Collage of sand, wood, and oil on metal support

12 × 9½

Not signed

Collection: Phillips Collection, Washington, D.C. (1928)

Provenance: (The Intimate Gallery)

Remarks: Inscribed with the artist's name, the title *Huntington Harbor*, and the date July 1926 on the reverse.

Referred to also as *Sail Boat* or *Little Sail Boat*,

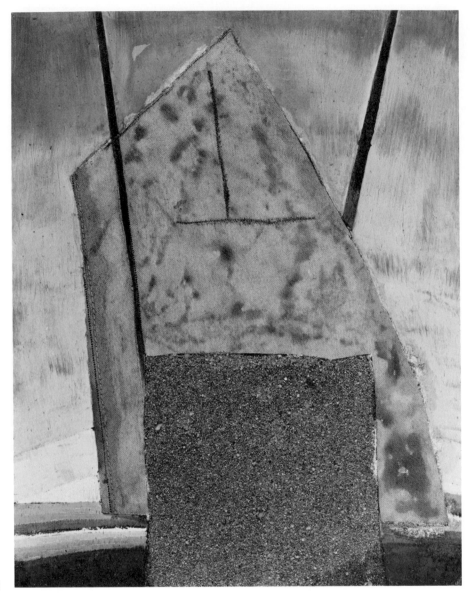

26.3

especially in Duncan Phillips' correspondence.

Exhibitions: Individual
 1927 Intimate Gallery, no. 7
 1937 Phillips, no. 4, dated 1925
 1947 Phillips
 1953 Corcoran
 1954 Ithaca, N.Y., no. 35
 1955 Downtown, no. 13, titled *Huntington Harbor No. 2*
 1967 College Park, Md., collage no. 17
 1974 San Francisco Museum
 1981 Phillips, no. 18
Group
 1930 Phillips, "Marin, Dove and Others"
 1944 Detroit, Mich.
 1968 Pennsylvania Academy
 1973 LaJolla, Calif.
 1976 Huntington, N.Y., no. 19
 1977 Davis and Long
 1979 Düsseldorf, Germany

26.4
HUNTINGTON HARBOR—II
1926
Collage of sand, cloth, wood chips, and oil on metal support
10 × 12
Not signed

Collection: Unidentified

Provenance: (Downtown Gallery)
 Mr. and Mrs. James H. Beal, Pittsburgh, Penn.

Exhibitions: Individual
 1927 Intimate Gallery, no. 8
 1955 Downtown, no. 12
 1958 Whitney, no. 17
Group
 1971 Carnegie Institute, no. 22

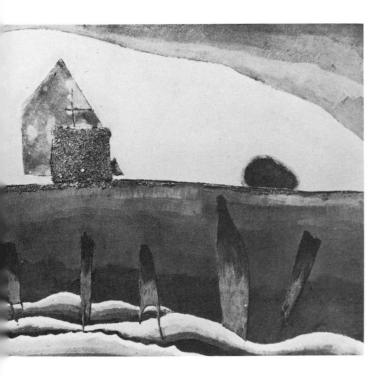

26.5
REDS
c. 1926
Collage of paper, silk, watercolor, pencil, and a lock of Reds' (Helen Torr's) hair
8¾ × 9¼
Not signed

Collection: Barbara Mathes Gallery

Provenance: (Terry Dintenfass Gallery)

Remarks: There is no documentation at all for this work. If it was ever shown by the artist, it must have been among the undocumented works in his 1926 exhibition at The Intimate Gallery.

26.6
ROPE, CHIFFON AND IRON
c. 1926
Assemblage of rope, chiffon, and metal
7 × 7
Not signed

Collection: Private collection (1980)

Provenance: (Terry Dintenfass Gallery)

Remarks: Probably shown in Dove's 1926 Intimate Gallery exhibition.

26.5

26.6

26.7
A SEA DRAWING WATER
1926
Medium and support not verified
Collection: Unidentified
Provenance: (The Intimate Gallery)
Remarks: Probably identical to *Sea I* (no. 25.15).
Exhibition: Individual
 1926 Intimate Gallery

26.8
THE SEASIDE
c. 1926
Assemblage of pine cones, branches, bark, shells, and paint on wood support
12½ × 10¼
Not signed
Collection: William C. Janss, Sun Valley, Idaho (1980)
Provenance: (Terry Dintenfass Gallery)
Remarks: Probably shown in Dove's 1926 Intimate Gallery exhibition.
Exhibitions: Individual
 1964 Detroit, Mich., no. 30, dated 1925
 1967 College Park, Md., collage no. 5, dated 1925
 1970 Dintenfass
 1974 Washburn
 1975 Wilmington, Del., dated 1925
 1977 Crispo, "Twelve Americans: Masters of Collage"

26.9
STORM AT SEA, NO. 1
1926
Medium and support not verified
Collection: Unidentified
Provenance: (The Intimate Gallery)
Exhibition: Individual
 1926 Intimate Gallery

26.10
STORM AT SEA, NO. 2
1926
Medium and support not verified
Collection: Unidentified
Provenance: (The Intimate Gallery)
Exhibition: Individual
 1926 Intimate Gallery

26.11
STORM AT SEA, NO. 3
1926
Medium and support not verified
Collection: Unidentified
Provenance: (The Intimate Gallery)
Exhibition: Individual
 1926 Intimate Gallery

26.12
STORM AT SEA, NO. 4
1926
Medium and support not verified

26.8

Collection: Unidentified

Provenance: (The Intimate Gallery)

Exhibition: Individual
 1926 Intimate Gallery

26.13
STORM AT SEA, NO. 5
1926
Medium and support not verified

Collection: Unidentified

Provenance: (The Intimate Gallery)

Exhibition: Individual
 1926 Intimate Gallery

26.14
TREES
1926
Medium and support not verified

Collection: Unidentified

Provenance: (The Intimate Gallery)

Exhibition: Individual
 1926 Intimate Gallery

26.15
THE WAVE, or SEA THUNDER
c. 1926
Wood support
20½ × 26
Not signed

Collection: Andrew Crispo Gallery

Exhibitions: Individual
 1926 Intimate Gallery (probable)
 1974 San Francisco Museum, titled *Sea Gull
 Motif*, dated 1926
 Group
 1973 Crispo, no. 47, dated 1926
 1977 Crispo, "20th Century American Masters,"
 no. 17
 1978 Washburn
 1979 Düsseldorf, Germany

References: Frank, Waldo, et al. *America and Alfred
 Stieglitz: A Collective Portrait.* Garden City, N.Y.:
 Doubleday, Doran, 1934. Illustration pl. 10, titled
 Sea Thunder, dated 1926.

26.15

Kootz, Samuel M. *Modern American Painters.* New York: Brewer & Warren, 1930. Illustration pl. 17, titled *The Wave,* dated 1924.

1927

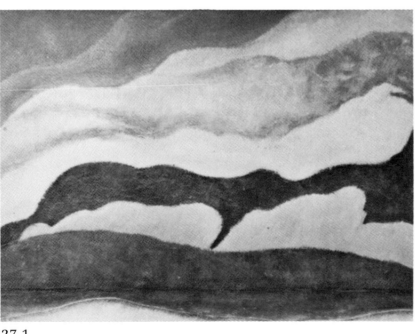

27.1

27.1
CLOUDS
1927
Oil and sandpaper on sheet metal support
16 × 21
Not signed

Collection: William H. Lane Foundation, Leominster, Mass.

Provenance: (Downtown Gallery)

Remarks: Inscribed on reverse with the artist's name and title.

Exhibitions: Individual
　1927　Intimate Gallery, no. 12
　1955　Downtown, no. 17
　1958　Whitney, no. 18
　1961　Worcester, Mass., no. 5
　1967　College Park, Md., collage no. 22
　1974　San Francisco Museum
　Group
　1951　Houston, Tex., no. 17

27.2
GEORGE GERSHWIN—"RHAPSODY IN BLUE,"
PART I
1927 (doc)
Oil and metallic paint with clock spring on aluminum support
11¾ × 9¾
Not signed

Collection: Andrew Crispo Gallery

Provenance: (Downtown Gallery)
Edith Halpert, New York City
(Sotheby Parke Bernet auction, New York City, 14 March 1973)
William Young, Wellesley Hills, Mass.

Remarks: Inscribed on reverse with the artist's name, the title *George Gershwin—Rhapsody in Blue*, and the date.

Exhibitions: Individual
1927 Intimate Gallery, no. 2, titled *Rhapsody in Blue, Part I—Gerschwin*
1955 Downtown, no. 15
1958 Whitney, no. 19
1967 College Park, Md., collage no. 21

1971 Dintenfass
1974 San Francisco Museum
1981 Phillips, no. 19
Group
1960 Corcoran
1965 Washington, D.C., Washington Gallery of Modern Art
1978 Hirschl & Adler, no. 20
1979 Montclair, N.J., no. 15
1980 Crispo

27.3
GEORGE GERSHWIN—"RHAPSODY IN BLUE,"
PART II
1927
Metal support
20½ × 15½
Not signed

Collection: Michael Scharf, Jacksonville, Fla. (1976)

Provenance: (Terry Dintenfass Gallery)

Exhibitions: Individual
1927 Intimate Gallery, no. 3, titled *Rhapsody in Blue, Part II—Gerschwin*

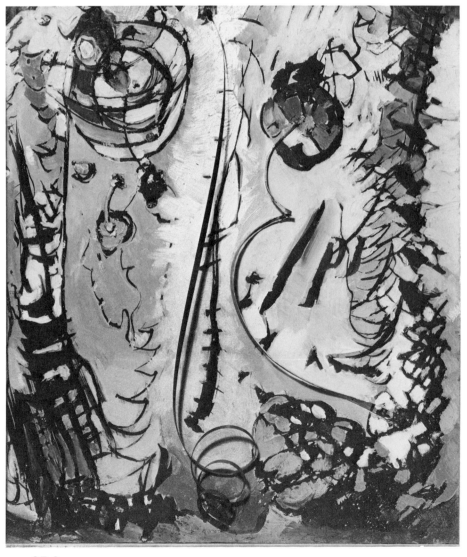

27.2

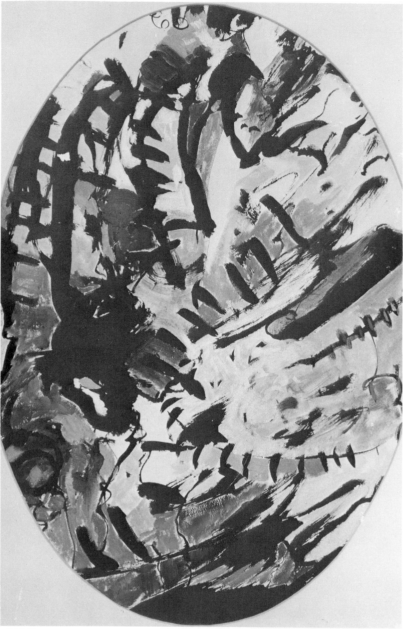

27.3

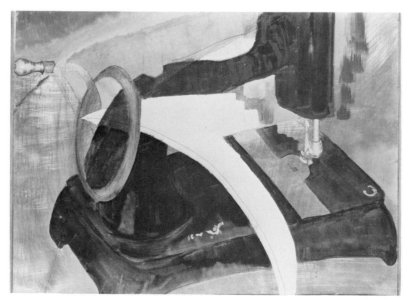

27.4

1956 Downtown, no. 5
1971 Dintenfass
Group
1962 MOMA (touring)

27.4
HAND SEWING MACHINE
1927 (doc)
Collage of oil and cloth on metal support
14⅞ × 19¾
Not signed

Collection: Metropolitan Museum of Art (Alfred Stieglitz Collection; gift of Georgia O'Keeffe from the estate of Alfred Stieglitz, 1949)

Provenance: (The Intimate Gallery) Alfred Stieglitz, New York City

Exhibitions: Individual
 1927 Intimate Gallery, no. 9
 1955 Downtown, no. 16
 1958 Whitney, no. 20
 1967 College Park, Md., collage no. 20
 1974 San Francisco Museum
 Group
 1944 Philadelphia Museum
 1947 MOMA
 1948 AIC
 1965 Metropolitan

27.5
HORSES PLOWING ON A HILL
1927
Pastel; support not verified
15 × 20
Not signed

Collection: Mr. and Mrs. John Marin, Jr., Cape Split, Addison, Me.

Provenance: (Downtown Gallery) (Martha Jackson Gallery) Charles Simon

Exhibitions: Individual
 1927 Intimate Gallery, no. 10
 Group
 1966 New York City, Public Education Association, titled *Red Horse Climbing Hill*

27.6
I'LL BUILD A STAIRWAY TO PARADISE— GERSHWIN
1927 (doc)
Medium includes aluminum paint; cardboard support
20 × 15
Not signed

Collection: William H. Lane Foundation, Leominster, Mass. (1958)

Provenance: Edward Alden Jewell, New York City (gift of the artist) (Downtown Gallery)

Exhibitions: Individual
 1927 Intimate Gallery, no. 1, titled *I'll Build a Stairway to Paradise—Gerschwin*

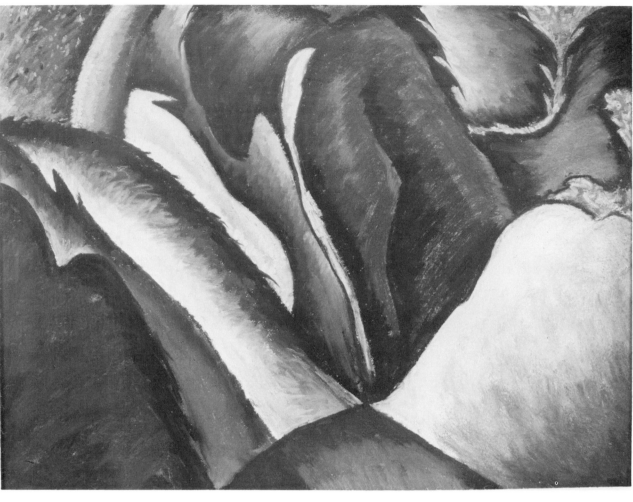

27.5

1947 Downtown, no. 7
1956 Los Angeles, Calif., no. 3
1958 Whitney, no. 21
1961 Worcester, Mass., no. 6
1974 San Francisco Museum (not all locations) (not in catalogue)

27.7
IMPROVISATION
1927
Pressed board support
14½ × 15½
Not signed

Collection: Andrew Crispo Gallery

Provenance: (Downtown Gallery)
 Richard Titelman (1965)

Exhibitions: Individual
 1927 Intimate Gallery, no. 6, titled *Improvisation Group*
 1979 Crispo

27.8
JUST PAINTING
1927
Medium and support not verified

Collection: Private collection, Saint Louis, Mo.

Provenance: (The Intimate Gallery)
 Dewald (1928)

Exhibition: Individual
 1927 Intimate Gallery, no. 11

27.9
MARS AND BLUE HILLSIDE
1927
Wood support
15¾ × 21
Not signed

Collection: Mr. and Mrs. John Marin, Jr., Cape Split, Addison, Me. (1958)

Provenance: (Downtown Gallery)

Exhibitions: Individual
 1927 Intimate Gallery, no. 16
 1956 Downtown, no. 4

27.10
ORANGE GROVE IN CALIFORNIA—IRVING BERLIN
1927 (doc)
Cardboard support mounted on wood
20 × 15
Not signed

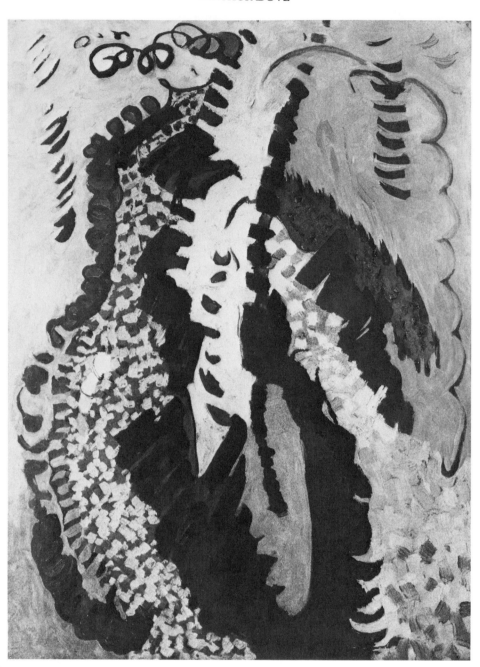

27.6

Collection: Sammlung Thyssen-Bornemisza, Castagnola, Switzerland

Provenance: (The Intimate Gallery)
Edward Alden Jewell, New York City (1928)
Henry Bluestone, Mt. Vernon, N.Y.
(Andrew Crispo Gallery)

Exhibitions: Individual
1927 Intimate Gallery, no. 4
1976 Crispo
Group
1944 MOMA (touring)
1979 Düsseldorf, Germany, no. 55

Reference: Jewell, Edward Alden. *Modern Art: Americans*. New York: Alfred A. Knopf, 1930. Color illustration frontispiece.

27.11
OUTBOARD MOTOR
1927 (doc)
Medium includes silver paint; zinc or aluminum support
20 × 15

Collection: William H. Lane Foundation, Leominster, Mass. (1961)

Provenance: (Downtown Gallery)

Remarks: Inscribed with the artist's name and the title on reverse.

Exhibitions: Individual
1927 Intimate Gallery, no. 16
1956 Downtown, no. 4
1961 Worcester, Mass., no. 7

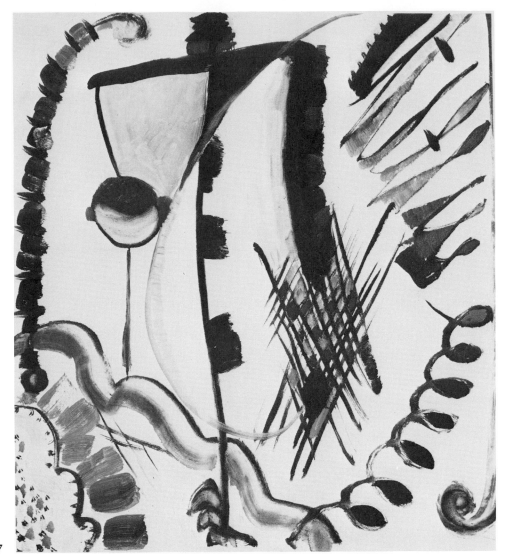

27.7

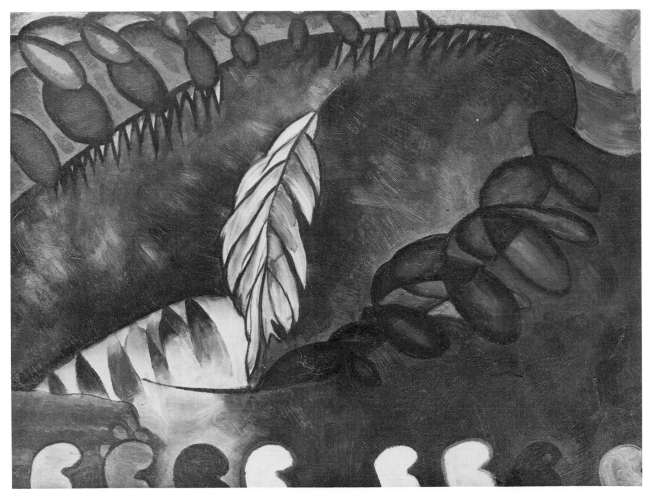

27.9

27.10

27.12
THE PARK
1927 (doc)
Cardboard support
16 × 21
Not signed

Collection: Phillips Collection, Washington, D.C. (bequest of Elmira Bier with life interest to Virginia McLaughlin, 1976)

Provenance: (Downtown Gallery)
Duncan Phillips, Washington, D.C. (1947)
Elmira Bier, Arlington, Va. (gift of Duncan Phillips, 1950)

Remarks: Inscribed on reverse with the artist's name, the title, and the date 1937.

Exhibitions: Individual
1927 Intimate Gallery, no. 13
1947 Downtown, no. 21, dated 1937
Phillips
1974 San Francisco Museum, dated 1937
1981 Phillips, no. 49, dated 1937

27.13
RUNNING RIVER
1927
Tin support
21 × 16

Collection: Unidentified

Provenance: (Downtown Gallery)
Rudin (1970)

27.11

27.12

Remarks: For the exhibition brochure of his 1927–28 show at The Intimate Gallery, Dove wrote a statement that includes the following passage about this painting:

> The colors in the painting "Running River" were chosen looking down into a stream. The red and yellow from the wet stones and the green from moss with black and white. The line was a moving point reducing the moving volume to one dimension. From then on it is expressed in terms of color as music is in terms of sound.

Exhibitions: Individual
 1927 Intimate Gallery, no. 15
 1964 Detroit, Michigan, no. 4
 Group
 1962 Iowa City, Iowa, no. 19

27.14
RHYTHM RAG
1927
Pastel; support not verified
Collection: Unidentified

27.13

Provenance: (The Intimate Gallery)
 Marguerite Mergantine (1928)
Exhibition: Individual
 1927 Intimate Gallery, no. 5

27.15
SOMETHING IN BROWN, CARMINE AND BLUE
1927 (doc)
Tin support
27¾ × 19⅝

Collection: Fisk University, Nashville, Tenn. (gift of Georgia O'Keeffe from the estate of Alfred Stieglitz, 1949)

Provenance: (The Intimate Gallery)
 Alfred Stieglitz, New York City

Remarks: Permission could not be obtained from Fisk University to reproduce this painting.

Exhibitions: Individual
 1927 Intimate Gallery, no. 19, titled *Something in Brown, Carmine & Blue*
 1937 Phillips, titled *Brown, Carmine and Blue*, dated 1929

27.16
TUG BOAT
1927 (doc)
Galvanized tin support
15 × 20
Not signed

Collection: Berry-Hill Galleries (1982)

Provenance: (Terry Dintenfass Gallery)
 Dr. and Mrs. Alex Stone, Moline, Ill. (1973)

Exhibition: Individual
 1927 Intimate Gallery, no. 18

27.17
YOURS TRULY
1927
21 × 16
Not signed

Collection: Coe Kerr Gallery

Provenance: (Terry Dintenfass Gallery)
 (Hirschl & Adler Gallery)

Remarks: Inscribed on reverse with title and date.

Exhibitions: Individual
 1927 Intimate Gallery, no. 14
 Group
 1978 Hirschl & Adler, no. 19
 1980 San Francisco, Calif.
 1982 San Francisco, Calif.

1928

28.1
CHAIR
1928
Medium includes ink and colored pencil; wood support
9 × 8

27.16

27.17

28.1

Not signed

Collection: Private collection (1967)

Provenance: (Downtown Gallery)

Remarks: Inscribed on reverse with the artist's name, the title, and the date

Exhibitions: Individual
 1929 Intimate Gallery, no. 7, dated 1928
 1967 Huntington, New York, no. 5

28.2
COMPOSITION
1928 (doc)
Pastel on wood
8½ × 10

Collection: Unidentified

Provenance: (The Intimate Gallery)
 Dr. Frank McLaury

Exhibitions: Individual
 1929 Intimate Gallery, no. 8, dated 1928
 1967 Huntington, New York, no. 4

28.3
FICTION
1928 (doc)
Medium and support not verified

Collection: Unidentified

Provenance: (The Intimate Gallery)

Exhibition: Individual
 1929 Intimate Gallery, no. 19, dated 1928

28.4
FLOATING TREE
1928
Medium and support not verified

Collection: Unidentified

Provenance: (The Intimate Gallery)

Remarks: Possibly identical to no. 28.14.

Exhibition: Individual
 1929 Intimate Gallery, no. 17, dated 1928

28.5
MONKEY FUR
1928
Assemblage of corroded metal, monkey hide and fur, and tin foil on metal support
17 × 12
Not signed

Collection: Art Institute of Chicago, Chicago, Illinois (gift of Georgia O'Keeffe from the estate of Alfred Stieglitz, 1949)

Provenance: (The Intimate Gallery)
 Alfred Stieglitz, New York City

Remarks: Inscribed on the reverse with the artist's name and the date.

Exhibitions: Group
 1947 MOMA
 1948 AIC

28.5

28.6
MOON
1928 (doc)
Wood support
8 × 10

Collection: Fisk University, Nashville, Tennessee (gift of Georgia O'Keeffe from the estate of Alfred Stieglitz, 1949)

Provenance: (The Intimate Gallery)
Alfred Stieglitz, New York City

Remarks: Likely to have been shown in Dove's 1929 Intimate Place exhibition under some other title. Permission could not be obtained from Fisk University to reproduce this painting.

Exhibition: Group
1958 Whitney, no. 29, dated 1929

28.7
NO TITLE—I
1928 (doc)
Sculpture of oyster shell and razor clam

Collection: Unidentified

Provenance: (The Intimate Gallery)

Exhibition: Individual
1929 Intimate Gallery, no. 21, dated 1928

28.8
NO TITLE—II
1928 (doc)
Sculpture of oyster shell and wood

Collection: Unidentified

Provenance: (The Intimate Gallery)

Exhibition: Individual
1929 Intimate Gallery, no. 22, dated 1928

28.9
SEAGULL MOTIF, or VIOLET AND GREEN
1928 (doc)
Metal support
28 × 20
Not signed

Collection: Dr. and Mrs. Harold Rifkin (1972)

Provenance: (Downtown Gallery)
Dr. and Mrs. Stanley Zuckerman (1970)
(Terry Dintenfass Gallery)

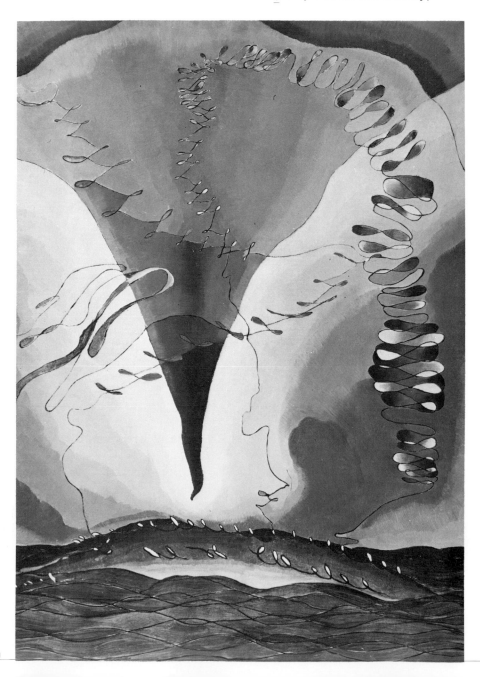

28.9

Exhibitions: Individual

 1929 Intimate Gallery, no. 15, titled *Seagull Motif*, dated 1928

 1939 American Place, no. 8, titled *Violet and Green*, dated 1929

 1956 Downtown, no. 12, titled *Violet and Green*, dated 1931

 1964 Detroit, Michigan, no. 5, titled *Seagull Motif*, dated 1928

 1967 College Park, Maryland, titled *Seagull Motif*, dated 1928

 1974 San Francisco Museum, titled *Violet and Green*, dated 1931

Group

1978 Washburn

1979 Düsseldorf, Germany, no. 54

28.10
SILVER LOG
1928 (doc)
30 × 18

Collection: Unidentified

Provenance: (The Intimate Gallery)
 Morton R. Goldsmith, Scarsdale, N.Y. (1929)

Exhibition: Individual
 1929 Intimate Gallery, no. 6, dated 1928

28.11
SNOW AND WATER
1928
Aluminum support

20 × 27½
Not signed

Collection: Currier Gallery of Art, Manchester, N.H. (gift of Paul and Hazel Strand, 1975)

Provenance: (The Intimate Gallery)
 Paul Strand

Remarks: This painting is probably *Snow, Huntington Harbor*, after which Strand's name appears on Dove's list of paintings at the gallery on 1 March 1929 (Dove-to-Stieglitz correspondence, p. 147). Since *Snow, Huntington Harbor* does not appear on the exhibition list, perhaps Strand took his painting with him before the Dove's show opened 9 April 1929, but more likely, the work was exhibited under a different title, perhaps *Snowstorm on Ocean* (no. 28.12).

Exhibition: Individual
 1974 San Francisco Museum

28.12
SNOWSTORM ON OCEAN
1928 (doc)
Medium and support not verified

Collection: Unidentified

Provenance: (The Intimate Gallery)

Remarks: Possibly identical to no. 28.11.

Exhibition: Individual
 1929 Intimate Gallery, no. 20, dated 1928

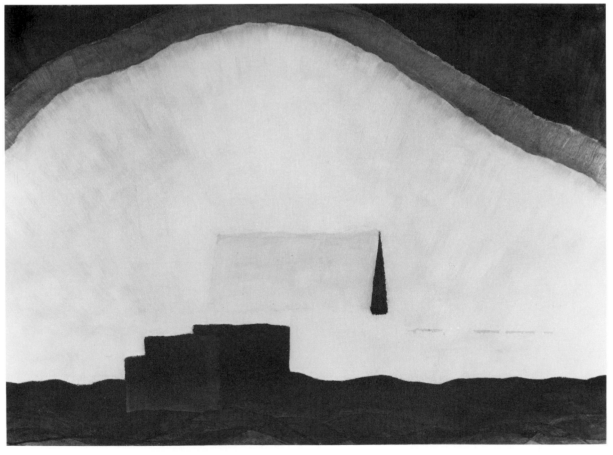

28.11

28.13
TREE FORMS [No. 1]
1928
Pastel on wood
26 × 31
Not signed

Collection: Museum of Art, Carnegie Institute, Pittsburgh, Penn. (gift of Mr. and Mrs. James H. Beal, 1960)

Provenance: (Downtown Gallery)
Mr. and Mrs. James H. Beal, Pittsburgh, Penn. (1957)

Exhibitions: Individual
1947 Downtown, no. 8, dated 1928
1958 Whitney, no. 22
Group
1971 Carnegie Institute, no. 23

28.14
TREE FORMS AND WATER
1928
Pastel on wood
30 × 26⅛
Not signed

Collection: Metropolitan Museum of Art (Alfred Stieglitz Collection; gift of Georgia O'Keeffe from the estate of Alfred Stieglitz, 1949)

Provenance: (The Intimate Gallery)
Alfred Stieglitz, New York City

Remarks: This is probably identical to the "Still Life (T-shaped Trees) of Logs, Pastel and oil on wood" on Dove's list of paintings at The Intimate Gallery on 1 March 1929 (Dove-to-Stieglitz correspondence, p. 147) and to the painting shown as *Floating Tree* (no. 28.4).

Exhibitions: Group
1944 Philadelphia Museum, no. 256
1948 AIC
1950 Metropolitan

28.15
YELLOW, BLUE AND VIOLET
1928
22⅛ × 17⅞
Signed, lower right

Collection: Fisk University, Nashville, Tenn. (gift of Georgia O'Keeffe from the estate of Alfred Stieglitz, 1949)

Provenance: (The Intimate Gallery)
Alfred Stieglitz, New York City

Remarks: Probably shown under some other title in Dove's 1929 exhibition at The Intimate Gallery. Permission could not be obtained from Fisk University to reproduce this painting.

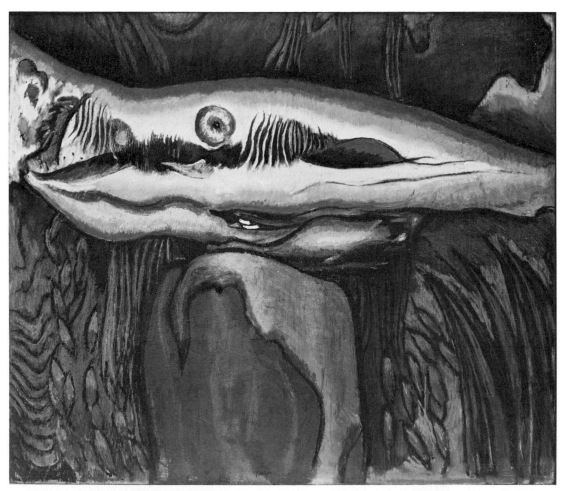

28.13

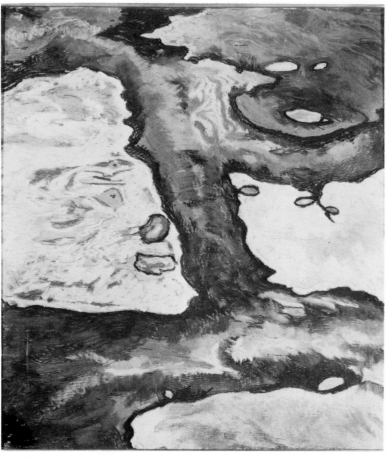

28.14

Exhibition: Individual
 1939 American Place, no. 16, dated 1928

1929

29.1
ALFIE'S DELIGHT
1929 (doc)
21¾ × 29⅝
Not signed

Collection: Herbert F. Johnson Museum, Cornell
 University, Ithaca, N.Y. (bequest of Helen Kroll
 Kramer [the Dr. and Mrs. Milton Lurie Kramer
 Collection], 1977)

Provenance: (Downtown Gallery)
 Dr. and Mrs. Milton Lurie Kramer (1952)

Remarks: Inscribed on the reverse with the artist's
 name, the title, and the date.
 "Alfie" was the artist's good friend, the painter
 Alfred Maurer.

Exhibitions: Individual
 1929 Intimate Gallery, no. 2, titled *Delight*
 1952 Downtown, no. 2
 1954 Ithaca, N.Y., no. 13
 1958 Whitney, no. 23
 1968 MOMA, no. 5
 1972 Dintenfass, no. 3
 1974 San Francisco Museum

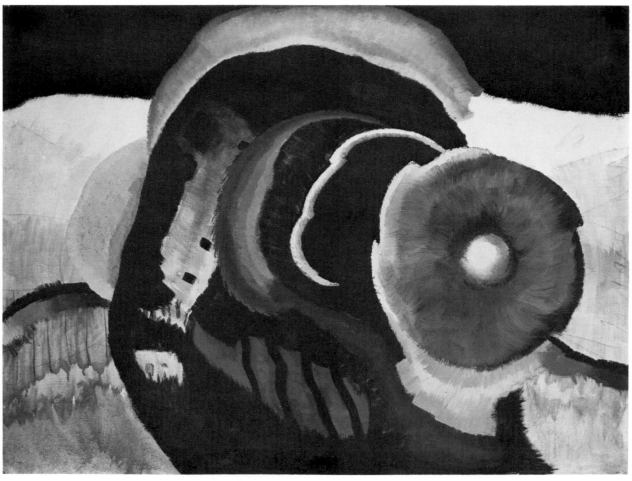

29.1

Group
1966 Ithaca, N.Y., no. 4
1978 Zabriskie, no. 51

29.2
COLORED BARGE MAN
1929 (doc)
22 × 30
Signed, lower right

Collection: Salander-O'Reilly Galleries

Provenance: (Terry Dintenfass Gallery)
Exhibitions: Individual
 1930 American Place, no. 9, titled *Barge Nigger*
 1933 American Place, no. 19, titled *Nigger Barge*
 1956 Downtown, no. 6
 1958 Whitney, no. 24
 1975 Dintenfass, "Arthur G. Dove: The Abstract Work," no. 3
 Group
 1930 MOMA, no. 29

29.3
COLORED DRAWING, CANVAS
1929 (doc)
18 × 22
Signed, lower right

Collection: Dr. George Newton, Kailua, Hawaii (1973)

Provenance: (Terry Dintenfass Gallery)
Exhibitions: Individual
 1930 American Place, no. 15
 1952 Downtown, no. 1, titled *Colored Drawing in Oil*
 1956 Downtown, no. 5, titled *Colored Drawing in Oil*
 1958 Whitney, no. 25, titled *Colored Drawing in Oil*
 1968 MOMA (touring), no. 6
 Group
 1957 Lynchburg, Va.

29.4
DISTRACTION
1929 (doc)
21 × 30
Not signed

Collection: Whitney Museum of American Art (gift of an anonymous donor, 1958)

Provenance: (The Intimate Gallery)
 (?)

Remarks: Inscribed on the reverse with the artist's name, the title, and the date.
 In March 1929, on a list of paintings he sent in a letter to Stieglitz, Dove wrote of this painting, "This is I think further on than any yet. It is as free

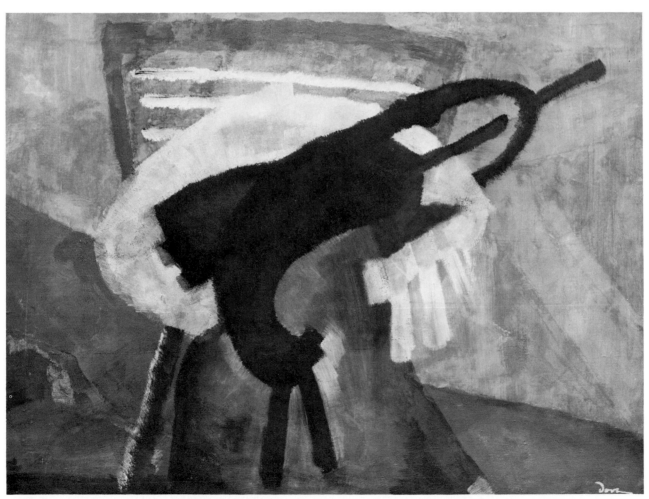

29.2

29.3

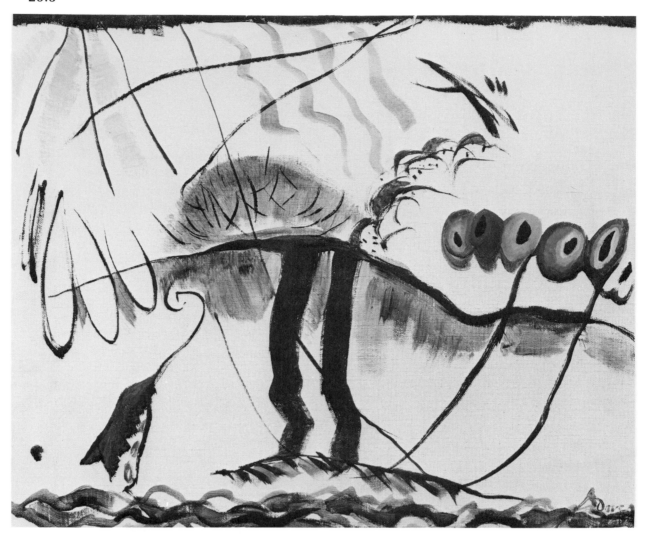

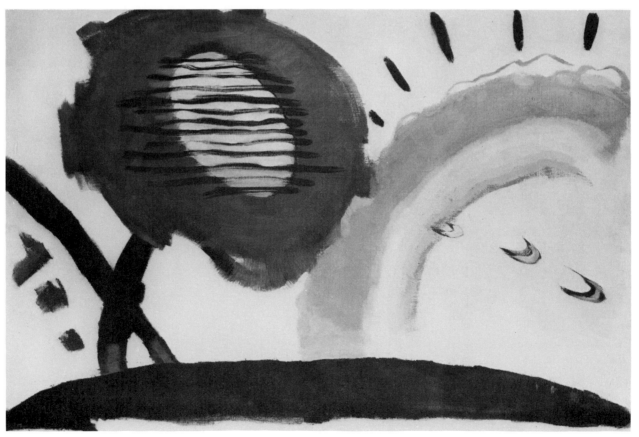

29.4

as anything I can imagine."

In 1930, in reference to this and other unspecified works, Dove wrote in his statement for Samuel Kootz's book, *Modern American Painters,* "Feeling that the 'first flash' of an idea gives its most vivid sensation, I am at present in some of the paintings trying to put down the spirit of the idea as it comes out. To sense the 'pitch' of an idea as one would a bell."

Exhibitions: Individual
 1929 Intimate Gallery, no. 14
 1967 Huntington, New York, no. 20
 Group
 1930 MOMA, no. 28

Reference: Kootz, Samuel. *Modern American Painters.* New York: Brewer and Warren, 1930. Illustration pl. 19, dated 1928.

29.5
(DOGS CHASING EACH OTHER)
1929
18⅞ × 21⅜
Signed, lower right

Collection: Art Institute of Chicago (gift of Georgia O'Keeffe from the estate of Alfred Stieglitz, 1949)

Provenance: (An American Place)
 Alfred Stieglitz, New York City

Remarks: The subject was inspired by the two gray-and-white terriers belonging to Henry and Holly Raleigh. Henry Raleigh, an artist and leading illustrator, had become a good friend of Dove's when both lived in Westport. He later lived near Dove on Long Island.

Exhibitions: Individual
 1930 American Place, no. 6, titled *Running Dogs*
 1958 Whitney, no. 26
 Group
 1948 Art Institute of Chicago

Reference: Kootz, Samuel M. *Modern American Painters.* New York: Brewer & Warren, 1930. Illustration pl. 18, titled *Running Dogs,* dated 1930.

29.6
FOG HORNS
1929 (doc)
17¾ × 25½
Not signed

Collection: Colorado Springs Fine Arts Center, Colorado Springs, Col. (gift of Oliver James).

Provenance: (The Intimate Gallery)

Exhibitions: Individual
 1929 Intimate Gallery, no. 4
 1947 Downtown, no. 9
 1958 Whitney, no. 27
 1967 College Park, Md., painting no. 6
 1968 MOMA, no. 7

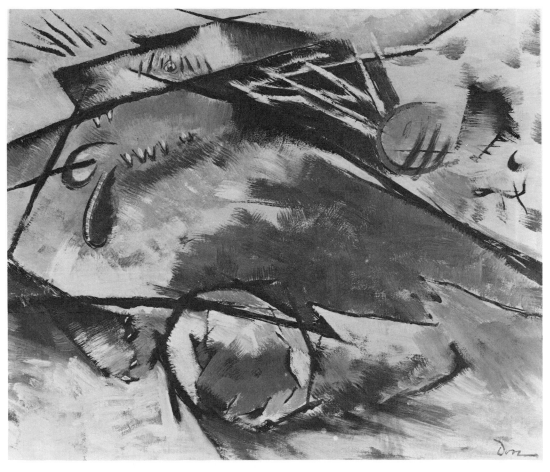

29.5

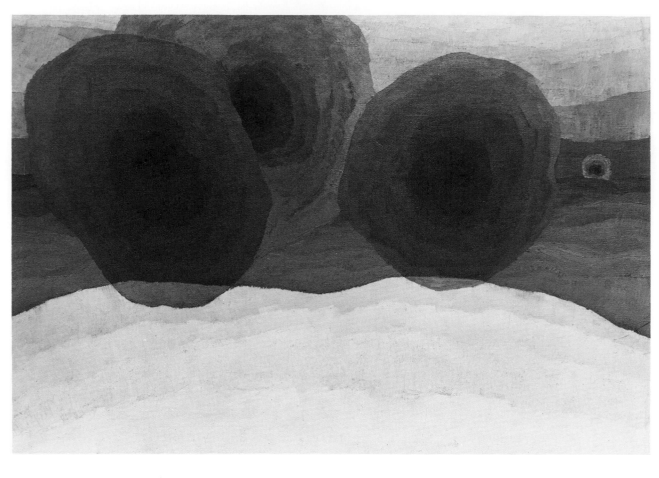

29.6

1974 San Francisco Museum of Art
Group
1966 National Museum of American Art
1971 Carnegie Institute, no. 24

29.7
HARBOR IN LIGHT
1929
30¼ × 22½
Signed, lower right

Collection: Private collection (on loan to the David
and Alfred Smart Gallery, University of Chicago,
Chicago, Ill.)

Provenance: (An American Place)
Sherwood Anderson (1936)

Exhibitions: Individual
1930 American Place, no. 1, titled *Harbour in Light*
Group
1930 MOMA, no. 30, dated 1929

29.8
IMAGE
1929 (doc)
Oil and pastel on wood panel
13 × 17
Signed, lower right

Collection: Unidentified

Provenance: (Downtown Gallery)
Dorment (1970)

Exhibitions: Individual
1930 American Place, no. 11
1956 Downtown, no. 7, dated 1929

29.9
MARCH, APRIL
1929 (doc)
Pastel on canvas
20 × 20

Collection: Private collection

Provenance: (The Intimate Gallery)
Dorothy Norman, New York City (1929)
(The Intimate Gallery, 1929)
(An American Place)
(Downtown Gallery)
J. Walter (1962)
Edith Halpert, New York City

Remarks: Though not listed in the gallery pamphlet,
the work probably was added to Dove's 1929 exhi-
bition at The Intimate Gallery, as the artist took it
to the gallery after the show had opened.

Exhibitions: Individual
1947 Downtown, no. 10
1958 Whitney, no. 28

29.10
MOTH DANCE
1929 (doc)
20 × 26⅛
Signed, lower right

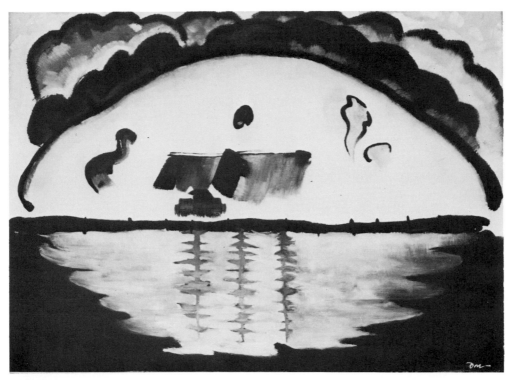

29.7

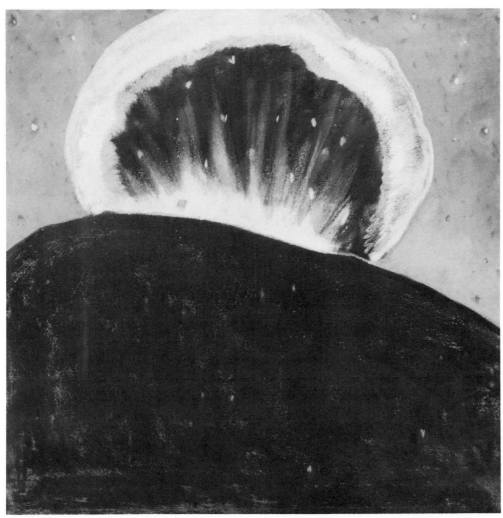

29.9

29.10

Collection: National Gallery of Art, Washington, D.C.
 (Alfred Stieglitz Collection; gift of Georgia
 O'Keeffe from the estate of Alfred Stieglitz, 1949)

Provenance: (An American Place)
 Alfred Stieglitz, New York City

Exhibitions: Individual
 1930 American Place, no. 3
 Group
 1944 Philadelphia Museum, no. 257
 1948 AIC

29.11
PHEASANTS
1928–29 (doc)
22 × 30

Collection: Unidentified

Provenance: (The Intimate Gallery)

Exhibition: Individual
 1929 Intimate Gallery, no. 9

29.12
REACHING WAVES
1929 (doc)
Medium includes silver paint
19⅞ × 23⅞

Collection: Metropolitan Museum of Art (Alfred
 Stieglitz Collection; gift of Georgia O'Keeffe from
 the estate of Alfred Stieglitz, 1949)

Provenance: (The Intimate Gallery)
 Alfred Stieglitz, New York City

Exhibitions: Individual
 1929 Intimate Gallery, no. 5

29.12

29.14

1967 Huntington, New York, no. 19
Group
1948 AIC, no. 68
1950 Metropolitan

29.13
RED TREE AND SUN
1929
31 × 23

Collection: Fisk University, Nashville, Tenn. (gift of
Georgia O'Keeffe from the estate of Alfred Stieg-
litz, 1949)

Provenance: (The Intimate Gallery)
Alfred Stieglitz, New York City

Remarks: Permission could not be obtained from
Fisk University to reproduce this painting.

Exhibitions: Individual
1929 Intimate Gallery, no. 1, dated 1929
1934 American Place
Group
1935 Whitney
1948 AIC

29.14
SILVER BALL
1929 (doc)
18 × 22
Signed, lower right

Collection: Vassar College Art Gallery, Poughkeep-
sie, N.Y. (gift of Paul Rosenfeld, 1950)

Provenance: (An American Place)
Paul Rosenfeld, New York City (1930)

Remarks: The date 1930 appears on the reverse.
Although Rosenfeld died in 1946, the museum

lists the painting as a gift, rather than as a bequest.
Exhibitions: Individual
1930 American Place, no. 2
1968 MOMA (touring), no. 8

29.15
SILVER CEDAR STUMP
1929
Sculpture of weathered wood
Not signed

Collection: William C. Dove, Mattituck, N.Y.

Provenance: Acquired from the artist.

Exhibition: Individual
1929 Intimate Gallery, no. 23, dated 1929

29.15

29.16
SILVER SUN
1929
Medium includes silver paint
21⅝ × 29⅝
Not signed

Collection: Art Institute of Chicago, Chicago, Ill. (gift of Georgia O'Keeffe from the estate of Alfred Stieglitz, 1949)

Provenance: (The Intimate Gallery)
Alfred Stieglitz, New York

Remarks: Inscribed on the reverse with the artist's name, the title, and the date.
Dove described this painting, on a list sent to Stieglitz, as "Sunlight on water, introducing the idea of *size contrast*." (Dove-to-Stieglitz correspondence, p. 147.)

Exhibitions: Individual
1929 Intimate Gallery, no. 3, dated 1929
1958 Whitney, no. 76, titled *Silver and Blue*, dated 1940
Group
1948 AIC, titled *Silver and Blue*, dated 1940

29.17
SUN ON THE WATER
1929
Medium includes aluminum paint; paper support mounted on bristol board
15 × 19½
Not signed

Collection: Unidentified
Provenance: (Downtown Gallery)
Thompson (1951)
Mr. and Mrs. Patrick Morgan, Cambridge, Mass.
Exhibition: Individual
1929 Intimate Gallery, no. 16, dated 1929

29.18
SUNRISE AT NORTHPORT [NO. I]
1929 (doc)
Tin support
20¼ × 28

Collection: Unidentified

Provenance: (An American Place)
Virginia Klemme, Lansing, Mich. (1932)

Exhibition: Individual
1930 American Place, no. 4

29.19
SUNRISE AT NORTHPORT [NO. 2]
1929 (doc)
Metal support
20 × 28
Signed, lower right

Collection: Wichita Art Museum, Wichita, Kan. (R. P. Murdock Collection, 1957)

Provenance: John T. McGovern (gift of the artist)
(Downtown Gallery)

Remarks: The museum's title for this work is *Sunrise in Northport Harbor*.

29.16

29.17

29.19

Exhibitions: Individual
 1930 American Place, no. 5
 1956 Downtown, no. 9

29.20
TELEGRAPH POLE
1929 (doc)
Aluminum support
28 × 19⅞
Signed, lower right

Collection: Art Institute of Chicago (gift of Georgia O'Keeffe from the estate of Alfred Stieglitz, 1949)

Provenance: (An American Place)
 Alfred Stieglitz, New York City

Remarks: The artist's description of the painting is to be found on a typed label affixed to the reverse: "Being a wet telegraph pole, some flying leaves, and silver."

29.20

Exhibitions: Individual
 1930 American Place, no. 12
 1934 American Place
 1937 Phillips, no. 9
 1939 American Place, no. 21
 1958 Whitney, no. 30
 Group
 1944 Philadelphia Museum, no. 255
 1948 AIC

29.21
TREE TRUNK
1928–29 (doc)
Pastel on canvas or linen
22 × 36
Not signed

Collection: William H. Lane Foundation, Leominster, Mass.

Provenance: (Downtown Gallery)

Remarks: This is probably the "Dead Tree (Horizontal) Pastel. On mounted linen" on Dove's list of paintings at The Intimate Gallery on 1 March 1929 (Dove-to-Stieglitz correspondence, p. 147).

Exhibitions: Individual
 1956 Downtown, no. 22, titled *The Tree*, dated 1927
 1961 Worcester, Mass., dated about 1929
 Group
 1929 Grand Central Palace

References: McCausland, Elizabeth. "Water Color by Arthur G. Dove Presented Museum; Life and Work of a Fine American Abstractionist." *Springfield (Massachusetts) Union and Republican*, 21 May 1933. Illustration as a vertical painting titled *Tree Branch*.
 Rosenfeld, Paul. "The World of Arthur G. Dove." *Creative Art* 10 (June 1932): 426–30. Illustration titled *Abstraction*.

29.22
UNTITLED
1929
Copper support
28 × 20
Not signed

Collection: Lee Ehrenworth, Elizabeth, N.J.

Provenance: (Downtown Gallery)
 Zuckerman (1970)

Remarks: This painting was probably shown under some other title within a year of its completion (i.e., presumably in 1929 or 1930).

Exhibitions: Individual
 1956 Downtown, no. 8, dated 1929
 Group
 1962 MOMA (touring)

29.23
WHOW!
1929
Cardboard support
19⅛ × 23⅜
Not signed

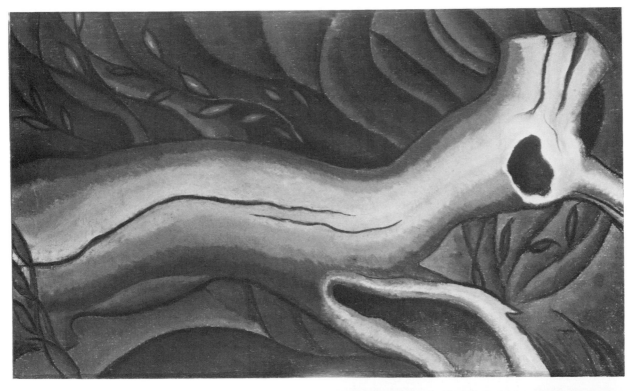

29.21

Collection: Andrew Crispo Gallery

Provenance: (The Intimate Gallery)
Morton R. Goldsmith, Scarsdale, N.Y. (1929)
(?)
Hirschl & Adler Galleries

Remarks: Has sometimes been titled *Whew.*

Exhibitions: Individual
1929 Intimate Gallery, no. 11, dated 1929
Group
1980 Crispo
1982 Miami, Fla., no. 11

29.24
WIND [NO. 1]
1929
Paper support
19½ × 24

Collection: Salander-O'Reilly Galleries

Provenance: Terry Dintenfass Gallery

Exhibition: Individual
1929 Intimate Gallery, no. 13, dated 1929

1930

30.1
BARGE, TREES, SILVER BALL
1930 (doc)
Medium includes silver paint; beaverboard support
23⅜ × 32½
Signed, lower right

Collection: Archer M. Huntington Art Gallery, University of Texas at Austin (James and Mari Michener Collection, 1968)

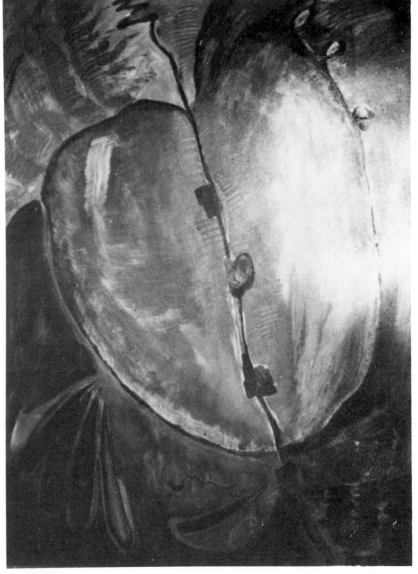

29.22

29.23

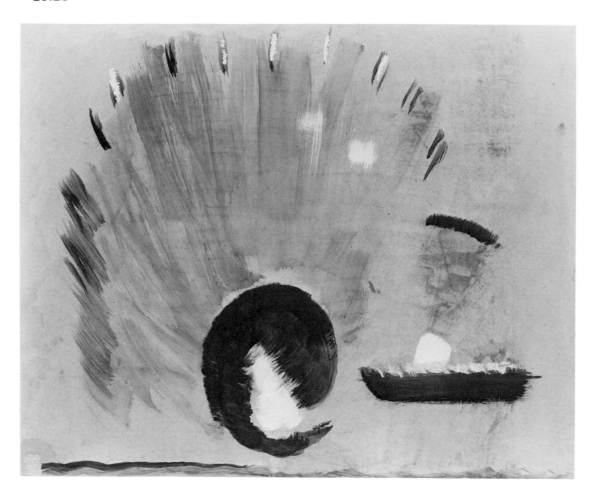

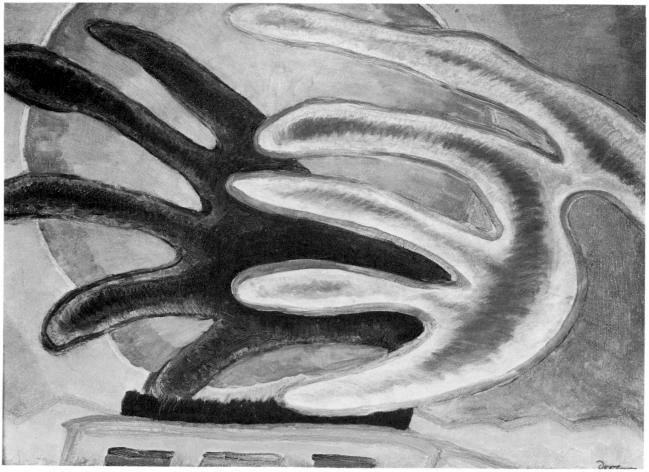

30.1

Provenance: (Downtown Gallery)
James Michener (1962)

Exhibitions: Individual
1931 American Place, no. 3, titled *Barge & Trees & Silver Ball*
1956 Los Angeles, Calif., no. 7
Group
1959 Bennington, Vt.
1963 Allentown, Penn., no. 18
Rochester, N.Y., no. 9

30.2
BELOW THE FLOOD GATES, HUNTINGTON HARBOR
1930 (doc)
24 × 28
Signed and dated 30, lower right

Collection: Private collection, New York City (1969)

Provenance: (Downtown Gallery)
(ACA Gallery)

Exhibitions: Individual
1930 American Place, no. 23
1952 Downtown, no. 4
1967 College Park, Md., painting no. 4, titled *Below the Flood Gates*
1974 San Francisco Museum, titled *Below the Flood Gates*

30.3
BOAT GOING THROUGH INLET
1930
Tin support
21 × 29½
Signed, lower right

Collection: Unidentified

Provenance: (Downtown Gallery)
Mr. and Mrs. Richard Titelman (1965)

Exhibitions: Individual
1930 American Place, no. 8
Group
1951 Houston, Tex., no. 3
1962 Iowa City, Iowa, no. 20
1971 Carnegie Institute, no. 25, titled *Going thro' Inlet*

30.4
BRICK BARGE WITH LANDSCAPE
1930
Beaverboard support
30 × 40
Signed, lower right

Collection: Philip Sills, New York City (1971)

Provenance: (Terry Dintenfass Gallery)

Remarks: In Dove's card file, this painting was dated

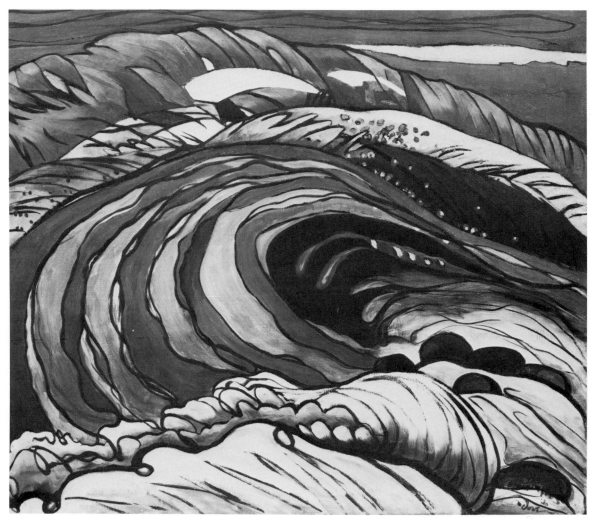

30.2

30.3

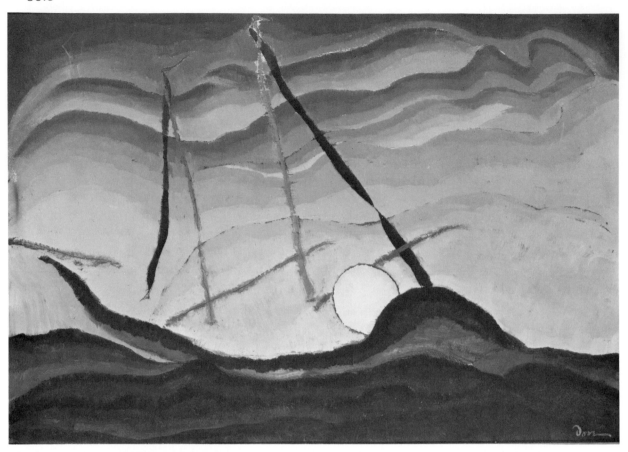

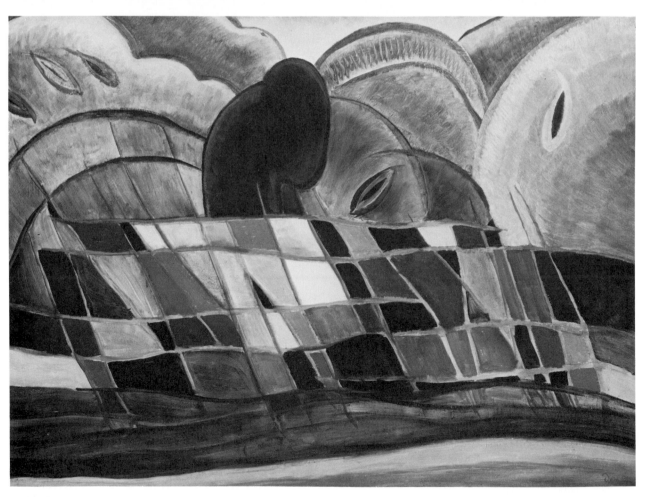

30.4

1931 on the original, typed card. The date was changed by hand to 1930, probably by Dove, thus making this one of two minor exceptions to the rule that Dove simply dated paintings by the year in which they had appeared on exhibition lists.

Exhibitions: Individual
 1931 American Place, no. 6
 1947 Downtown, no. 11
 1956 Los Angeles, Calif., no. 6
 Group
 1951 Houston, Tex., no. 4
 1971 Carnegie Institute, no. 26, titled *Brick Barge and Landscape*

30.5
CLOUDS AND WATER
1930 (doc)
29⅝ × 39⅝
Signed, lower right

Collection: Metropolitan Museum of Art (Alfred Steiglitz Collection; gift of Georgia O'Keeffe from the estate of Alfred Stieglitz, 1949)

Provenance: (An American Place)
 Alfred Stieglitz, New York City

Remarks: Sometimes titled *Wind, Waves, Clouds* or *Wind and Clouds.*

Exhibitions: Individual
 1931 American Place, no. 8, titled *Clouds & Water*
 1939 American Place, no. 14
 1967 Huntington, New York, no. 18
 Group
 1944 Philadelphia Museum, no. 258
 1948 AIC

30.6
COAL CARRIER (LARGE)
1930
20 × 26
Signed, lower right

Collection: Phillips Collection, Washington, D.C. (1930)

Provenance: (An American Place)

Exhibitions: Individual
 1930 American Place, no. 18
 1937 Phillips, no. 13, titled *Coal Car*, dated 1931
 1947 Phillips

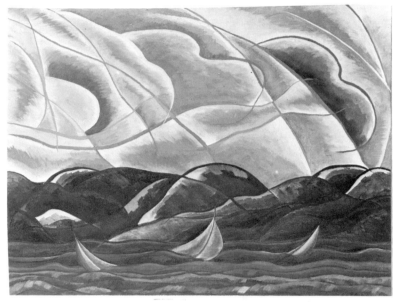

30.5

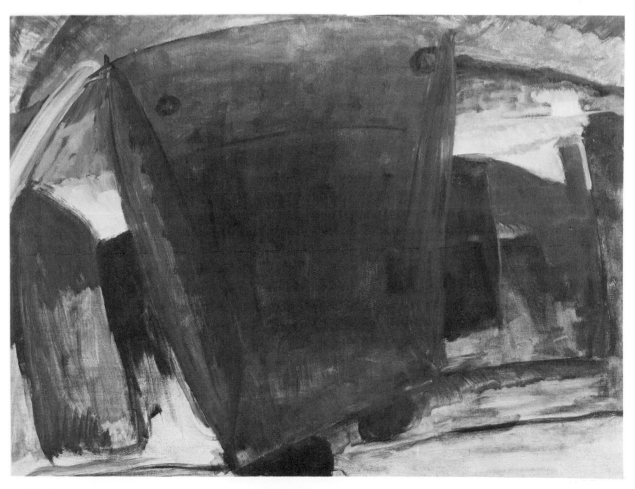

30.6

1953 Washington, D.C.
1958 Whitney, no. 31
1981 Phillips, no. 20, dated 1929 or 1930
Group
1930 Phillips, "Marin, Dove and Others"
1931 Phillips, "American and European Abstrac-
 tions"
 Philadelphia Museum
1939 American Federation of Arts (touring),
 no. 18
1952 Phillips
1953 Norfolk, Va.

30.7
COAL CARRIER (SMALL)
1930
10 × 20
Signed, lower right

Collection: Unidentified

Provenance: (An American Place)

Exhibition: Individual
 1930 American Place, no. 19

30.8
COMPOSITION BROWN, BLUE, VIOLET
1930
Tin support

Collection: Unidentified

Provenance: (An American Place)

Exhibition: Individual
 1930 American Place, no. 22

30.9
FIRE HOUSE
1930
Medium and support not verified

Collection: Unidentified

Provenance: (An American Place)

Exhibition: Individual
 1930 American Place, no. 21

30.10
FISHBOAT
1930 (doc)
Wood support
24 × 38
Signed

Collection: Carl Lobell, New York City (1976)

Provenance: (Terry Dintenfass Gallery)
 (Sid Deutsch Gallery)

Exhibitions: Individual
 1931 American Place, no. 5
 1964 Detroit, Mich., no. 6

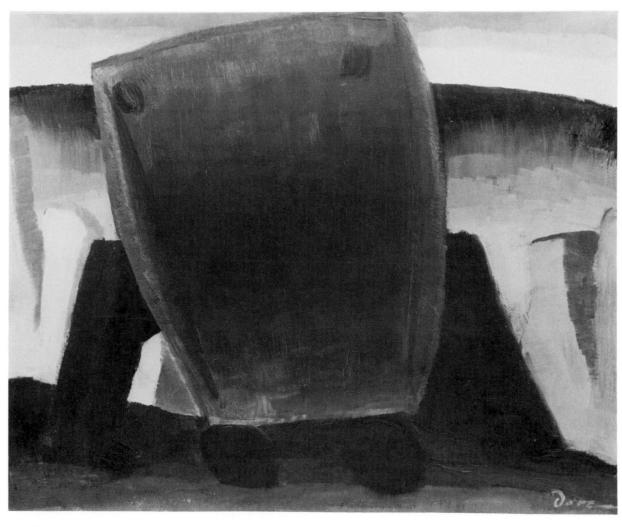

30.7

30.11
THE MILL WHEEL, HUNTINGTON HARBOR
1930 (doc)
23¾ × 27⅞
Signed and dated '30, lower right

Collection: Regis Collection, Minneapolis, Minn.

Provenance: (Terry Dintenfass Gallery)
 (Adelson Gallery, Brookline, Mass.)
 (Coe Kerr Gallery)
 (John Berggruen Gallery, San Francisco, Calif.)

Exhibitions: Individual
 1930 American Place, no. 25
 1967 Huntington, New York, no. 7
 1973 Dintenfass, no. 29
 1975 Dintenfass, "Essences"
 Group
 1978 Hirschl & Adler, no. 26
 Zabriskie, no. 52
 1982 Minneapolis, Minn.
 San Francisco, Calif.

30.12
OIL DRUMS
c. 1930
22¼ × 27¼
Signed A. Dove, lower right

Collection: Museum of Art, Carnegie Institute,
 Pittsburgh, Penn. (gift of G. David Thompson,
 1953)

Remarks: This painting is probably identical with
 the one exhibited as *Tar Barrels, Huntington Har-
 bor* in 1930 (no. 30.21).

Exhibition: Group
 1971 Carnegie Institute, no. 28, dated 1930

30.13
SAND BARGE
1930 (doc)
Beaverboard support
30 × 40
Signed, lower right

Collection: Phillips Collection, Washington, D.C.
 (1931)

Provenance: (An American Place)

Remarks: On 22 August 1930, Reds noted in her
 diary that Dove "nearly finished, and it's a swell
 job, painting of crane, barges, and gravel. The
 gravel would knock your eye out. Don't know the
 name of painting yet, we'll have to break a bottle
 of gin on it."

Exhibitions: Individual
 1931 American Place, no. 10
 1947 Phillips
 1958 Whitney, no. 33
 1972 Dintenfass, no. 4
 1974 San Francisco Museum
 1981 Phillips, no. 23

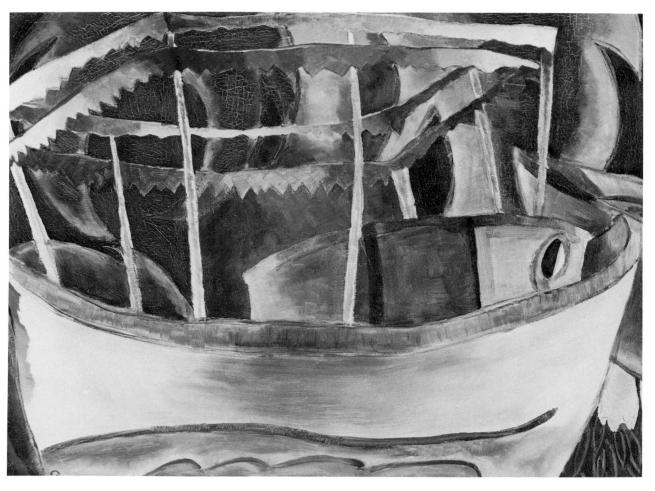

30.10

30.11

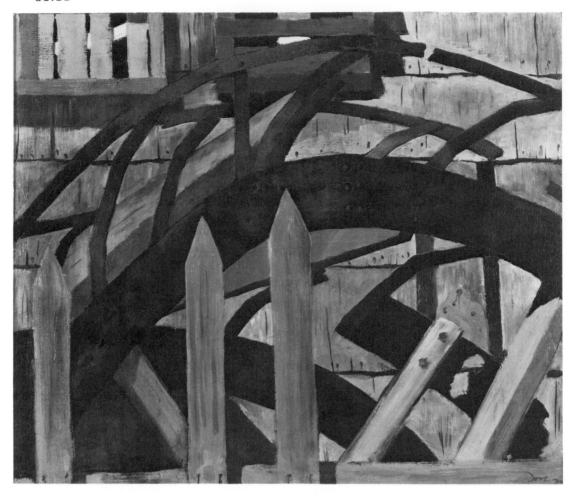

30.12

30.13

Group
1931 Phillips, "An American Show of Oils and Watercolors"
1949 Boston, Mass.
1951 MOMA, no. 23
1952 Wildenstein
1954 Fort Worth, Tex.
1971 Carnegie Institute
1979 Düsseldorf, Germany

30.14
(SILVER BALL NO. 2)
Medium includes silver paint
24 × 31
Signed, lower right

Collection: San Francisco Museum of Modern Art, San Francisco, Calif. (Rosalie M. Stern Bequest Fund Purchase, 1959)

Provenance: (An American Place)
Mrs. Charles J. Liebmann, New York City
(Downtown Gallery)

Exhibitions: Individual
1930 American Place, no. 16, titled *Reflections* [No. 1]
1958 Whitney, no. 34

Reference: Rosenfeld, Paul. "The World of Arthur G. Dove." *Creative Art* 10 (June 1932): 426–30. Illustration, titled *Abstraction*, p. 429.

30.15
SILVER TANKS
1930
Medium includes silver paint; masonite support
30¾ × 23

Collection: Leo S. Guthman, Chicago, Ill. (1958)

Provenance: (Downtown Gallery)

Exhibition: Individual
1930 American Place, no. 7

30.16
SILVER TANKS AND MOON
1929–30 (doc)
Medium includes silver paint
28⅛ × 18
Signed, lower right

Collection: Philadelphia Museum of Art, Philadelphia, Penn. (gift of Georgia O'Keeffe from the estate of Alfred Stieglitz, 1949)

Provenance: (An American Place)
Alfred Stieglitz, New York City

Exhibitions: Individual
1930 American Place, no. 13
1958 Whitney, no. 35
1974 San Francisco Museum
Group
1971 Carnegie Institute, no. 29

30.14

30.17
SNOW ON ICE, HUNTINGTON HARBOR
1930
17⅝ × 21½
Signed and dated '30, lower right

Collection: Private collection

Provenance: (Downtown Gallery)
 Edith Halpert, New York City
 (Sotheby Parke Bernet auction, 14 March 1973)

Exhibitions: Individual
 1930. American Place, no. 24
 1952 Downtown, no. 3
 1967 Huntington, New York, no. 6
 Group
 1965 National Museum of American Art
 1972 National Museum of American Art

30.18
SNOW THAW
1930
18 × 24
Signed, lower right

Collection: Phillips Collection, Washington, D.C.
 (1930)

Provenance: (An American Place)

Exhibitions: Individual
 1930 American Place, no. 20

1937 Phillips, no. 17
1947 Phillips
1953 Washington, D.C.
1954 Ithaca, N.Y., no. 14
1974 San Francisco Museum (not in catalogue)
1981 Phillips, no. 21
Group
1930 Phillips, "Twelve Americans"
1931 Phillips, "American and European Abstractions"
 Phillips, "Twentieth Century Lyricism"
1958 Whitney, "The Museum and Its Friends"
1963 Corcoran, no. 37
1966 National Museum of American Art
1968 Pennsylvania Academy

30.19
SUNSET
1930
27¼ × 16¼
Signed, lower right

Collection: Herbert F. Johnson, Museum, Cornell
 University, Ithaca, N.Y. (bequest of Helen Kroll
 Kramer [Dr. and Mrs. Milton Lurie Kramer Collec-
 tion], 1977)

Provenance: (Downtown Gallery)
 Dr. and Mrs. Milton Lurie Kramer (1956)

30.17

6

30.18

30.19

1939 American Place, no. 4, dated 1930
1958 Whitney, no. 36
Group
1935 Whitney

Reference: Zorach, William. "Ideas on American Sculpture." *The Art of Today* 6 (April 1935): 5–6. Illustration p. 6.

30.21
TAR BARRELS, HUNTINGTON HARBOR
1930
22½ × 27½
Not signed

Collection: Unidentified

Provenance: (An American Place)
 Mrs. Jerome Michaels (1930)

Remarks: This painting is probably identical to the one later known as *Oil Drums* (no. 30.12).

Exhibition: Individual
 1930 American Place, no. 26

30.22
WHITE TANK
1930

Collection: Unidentified

Povenance: (An American Place)

Remarks: This painting belonged briefly to Mrs. Charles J. Liebmann, who soon exchanged it for *Silver Ball No. 2* (no. 30.14).

Exhibition: Individual
 1930 American Place, no. 10

1931

31.1
ABSTRACT FROM THRESHING ENGINE
1931
Wood support
15 × 21
Signed, lower center

Collection: Unidentified

Provenance: (An American Place)

Exhibition: Individual
 1931 American Place, no. 12

31.2
ABSTRACT OF A THRESHING ENGINE SAWING WOOD II
1931
Wood support
15 × 20

Collection: Unidentified

Provenance: (Downtown Gallery)
 Carney (1965)

Exhibitions: Individual
 1931 American Place, no. 11
 1956 Los Angeles, Calif., no. 9, titled *Abstraction of a Threshing Engine No. 2*

Exhibitions: Individual
 1930 American Place, no. 17
 Group
 1966 Ithaca, N.Y., no. 13

30.20
SWINGING IN THE PARK
1930 (doc)
23¾ × 32¾ (sight)

Collection: Fisk University, Nashville, Tenn. (gift of Georgia O'Keeffe from the estate of Alfred Stieglitz, 1949)

Provenance: (An American Place)
 Alfred Stieglitz, New York City

Remarks: Permission could not be obtained from Fisk University to reproduce this painting.

Exhibitions: Individual
 1931 American Place, no. 4

31.1

<table>
</table>

1964 Detroit, Mich., no. 7, titled *Abstraction Threshing Engine II*

31.3
BREEZY DAY
1931 (doc)
20 × 28
Signed, lower center

Collection: Archer M. Huntington Art Gallery, University of Texas at Austin (James and Mari Michener Collection, 1968)

Provenance: (Downtown Gallery)
James Michener (1962)

Remarks: Current museum title is *Good Breeze.*

Exhibitions: Individual
1932 American Place, no. 7
1971 Houston, Tex.
Group
1935 Whitney, no. 37
1963 Swarthmore, Penn.
1966 Reading, Penn.
1967 Chester, Penn.
1969 Austin, Tex., no. 17

31.4
CAR
1931 (doc)

13¼ × 22⅛
Signed, lower left

Collection: Laughlin Phillips, Washington, D.C. (gift of Duncan Phillips, 1953)

Provenance: (An American Place)
Duncan Phillips, Washington, D.C. (1937)

Exhibitions: Individual
1932 American Place, no. 11
1937 Phillips, no. 11
1947 Phillips
1967 Downtown
1981 Phillips, no. 24
Group
1939 Syracuse, N.Y.

31.5
CINDER BARGE AND DERRICK
1931 (doc)
22½ × 30½
Not signed

Collection: Private collection

Provenance: (Terry Dintenfass Gallery)

Exhibitions: Individual
1932 American Place, no. 4, titled *Cinder Barge*
1939 American Place, no. 3, titled *Cinder Barge and Derrick*, dated 1931
1972 Dintenfass, no. 6

31.3

31.4

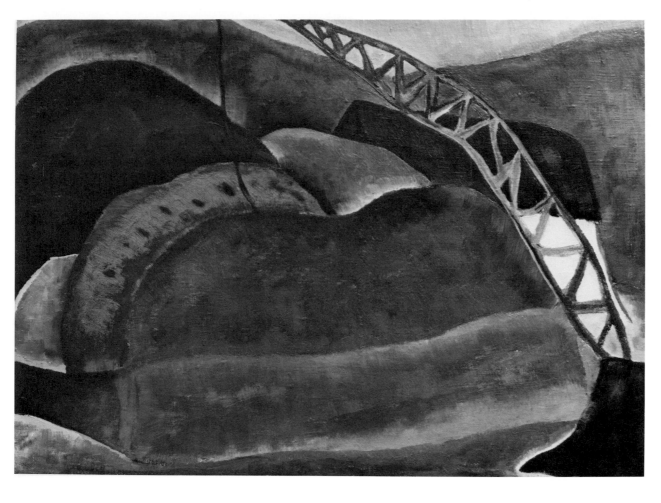

31.5

31.6
DANCING TREE
1931
Beaverboard support
30 × 40
Signed, lower right

Collection: Regis Collection, Minneapolis, Minn. (1981)

Provenance: (Downtown Gallery)
Mr. and Mrs. Donald Winston, Los Angeles, Calif. (1958)
Art Gallery, University of California at Los Angeles (gift of Mr. and Mrs. Donald Winston)
(Sotheby Parke Bernet auction, Los Angeles, 6 October 1981)

Exhibitions: Individual
1931 American Place, no. 7
1958 Whitney, no. 32, dated 1930
Group
1931 Cleveland Museum.
1944 Philadelphia Museum, no. 259, dated 1930
1956 Downtown, "Spring 1956," no. 3
1960 San Francisco Museum
1982 Minneapolis, Minn.

31.7
THE DERRICK
1931

40 × 30
Signed, lower left

Collection: Unidentified

Provenance: (Downtown Gallery)
George J. Perutz, Dallas, Tex. (1966)
(Terry Dintenfass Gallery)
(Sotheby Parke Bernet)
(Stephen Straw Gallery, Boston, Mass.)
(Andrew Crispo Gallery)

Exhibitions: Individual
1931 American Place, no. 9
Group
1965 London, England, no. 27
1980 Berlin, Germany, no. 106

31.8
FERRY BOAT WRECK, OYSTER BAY
1931 (doc)
18 × 30
Signed, lower center

Collection: Whitney Museum of American Art (Purchase, with funds from Mr. and Mrs. Roy R. Neuberger, 1956)

Provenance: (Downtown Gallery)

Exhibitions: Individual
1932 American Place, no. 5
1956 Downtown, no. 10

31.6

31.7

Route 25A. 1941. 11 × 17. (cat. no. 41.15)

Through a Frosty Moon. 1941. 14¾ × 20⅞. (cat. no. 41.16)

Cross Channel. 1942. 21 × 15. (cat. no. 42.5)

Parabola. 1942. 25 × 35. (cat. no. 42.13)

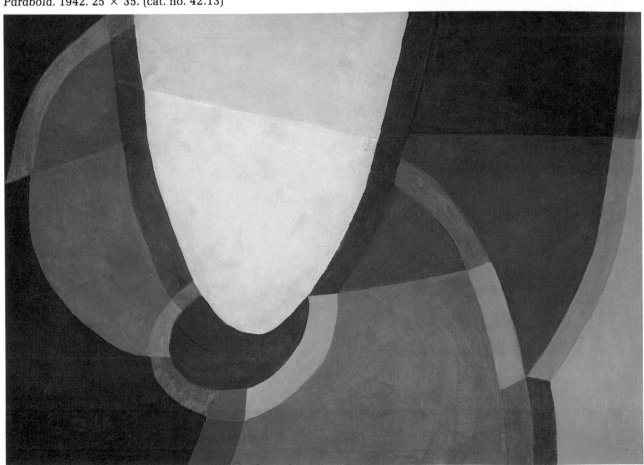

Deep Greens. 1942. 21 × 15. (cat. no. 42.6)

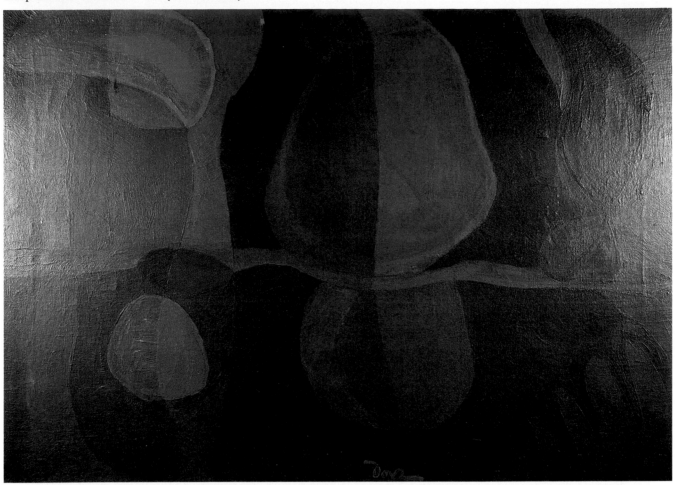

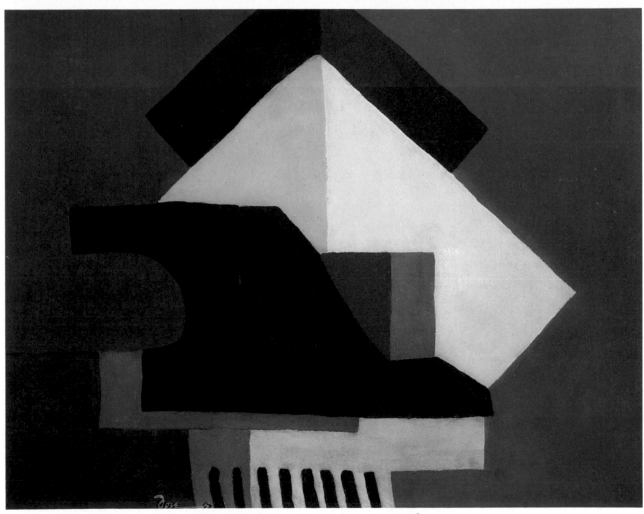

Structure. 1942. 25 × 32. (cat. no. 42.20)

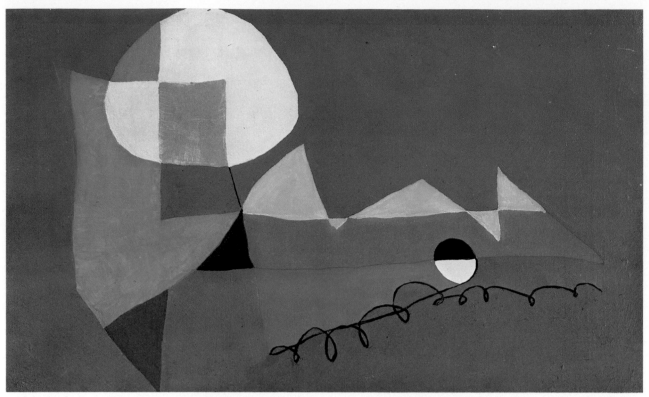

.04%. 1942. 20 × 12. (cat. no. 42.23)

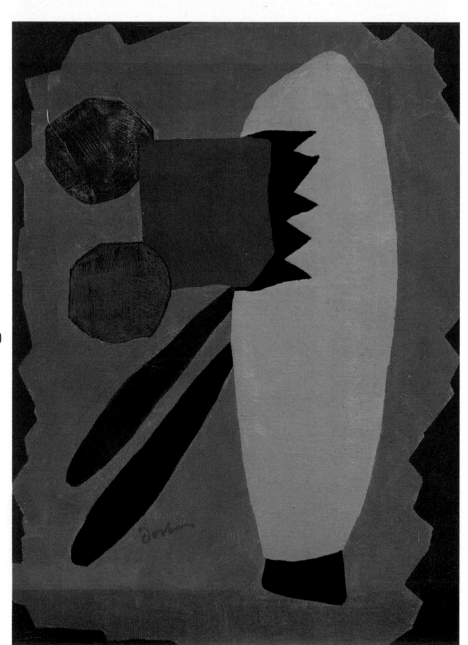

Pink One. 1943. 21 × 15. (cat. no. 43.9)

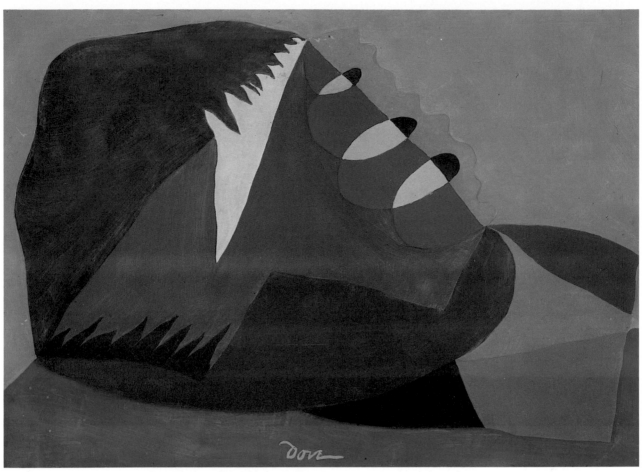

Departure from Three Points. 1943. 20 × 28. (cat. no. 43.4)

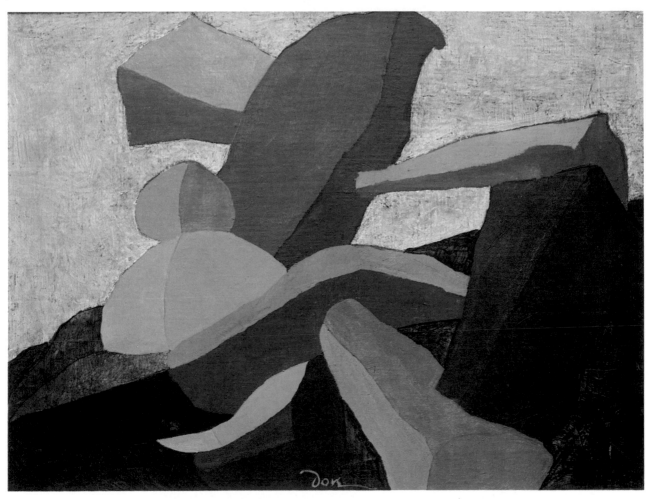

Arrangement in Form I. 1944. 18 × 24. (cat. no. 44.2)

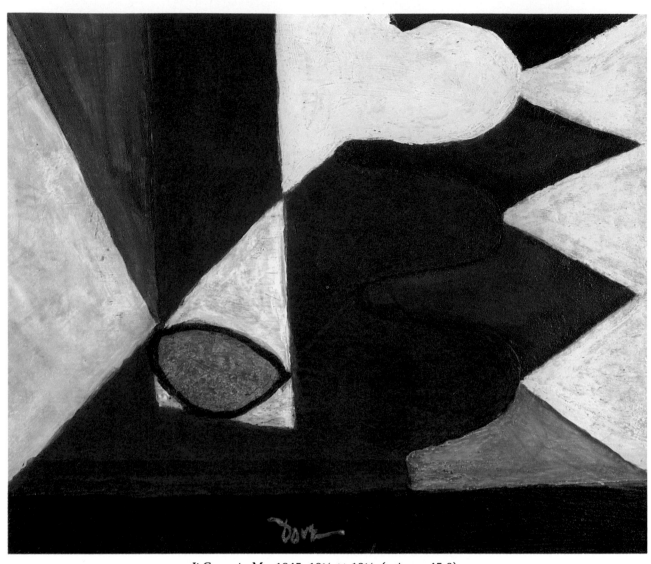

It Came to Me. 1945. 10¼ × 12½. (cat. no. 45.3)

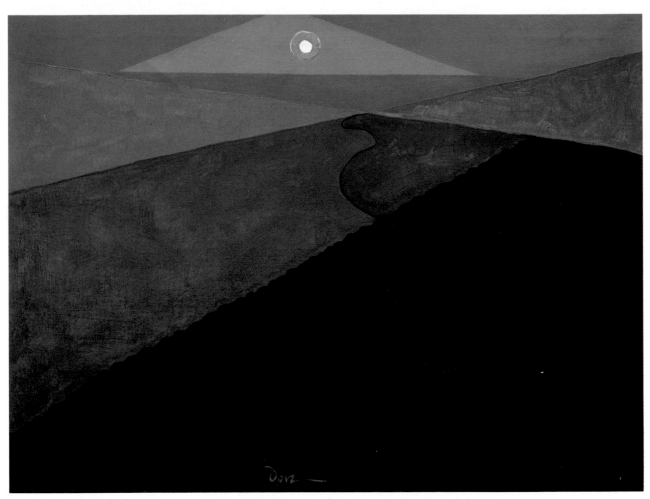

Low Tide. 1944. 24 × 32. (cat. no. 44.6)

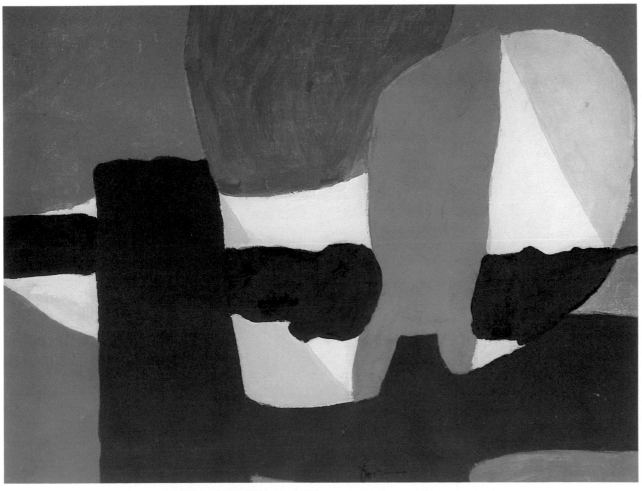

Uprights, Mars Violet and Blue. 1946. 18 × 24. (cat. no. 46.4)

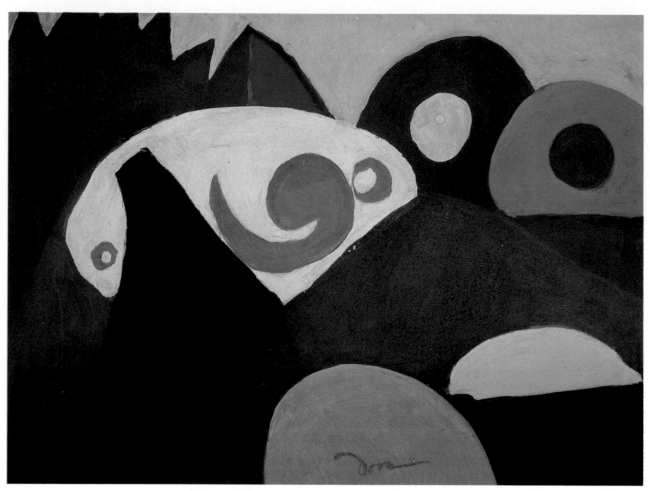

Variety. 1946. 18 × 24. (cat. no. 46.5)

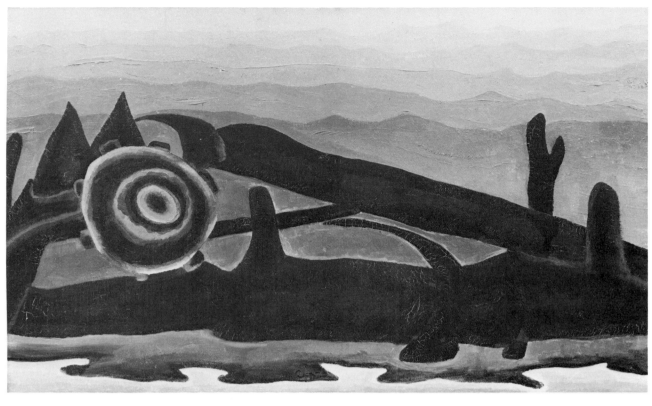

31.8

1958 Whitney, no. 37
1972 Dintenfass, no. 5
1974 San Francisco Museum
Group
1971 Carnegie Institute, no. 30

Reference: Rosenfeld, Paul. "The World of Arthur G. Dove." *Creative Art* 10 (June 1932): 426–30. Illustration, titled *Ferry Wreck*, p. 427.

31.9
(FIELDS OF GRAIN AS SEEN FROM TRAIN)
1931 (doc)
24 × 34
Signed, lower left

Collection: Albright-Knox Art Gallery, Buffalo, N.Y. (gift of Seymour H. Knox, 1958)

Provenance: (Downtown Gallery)
Seymour H. Knox (1958)

Exhibitions: Individual
1932 American Place, no. 9, titled *Fields from Train*
1939 American Place, no. 13
1956 Downtown, no. 11
1958 Whitney, no. 38
1967 College Park, Md., painting no. 7
1974 San Francisco Museum

31.10
HAYSTACK
1931 (doc)
18⅛ × 29
Signed, lower center

Collection: Hirshhorn Museum and Sculpture Garden, Smithsonian Institution, Washington, D.C.

Provenance: (Downtown Gallery)
G. David Thompson, Pittsburgh, Penn.
(Harold Diamond)
Joseph H. Hirshhorn, New York City (1965)

Exhibitions: Individual
1932 American Place, no. 6
Group
1974 Hirshhorn

31.11
ICE AND CLOUDS
1931
Beaverboard support
19¾ × 26½
Signed, lower right

Collection: Butler Institute of American Art, Youngstown, Ohio

Provenance: (Downtown Gallery)

Exhibitions: Individual
1931 American Place, no. 13
1945 American Place, no. 9, dated 1931

31.12
ITALIAN CHRISTMAS TREE
1931 (doc)
Oil, metallic paint, and pencil on paper, mounted on cardboard with Christmas wrapping
9 × 12
Not signed

Collection: William C. Janss, Sun Valley, Idaho

Provenance: (Terry Dintenfass Gallery)

Exhibitions: Individual
1933 American Place (probable)

31.9

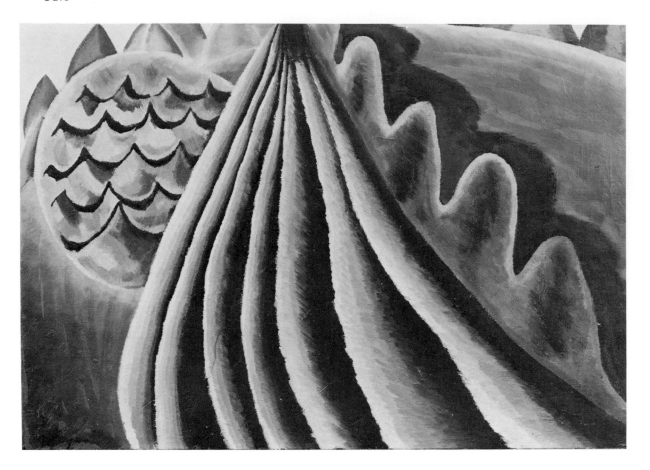

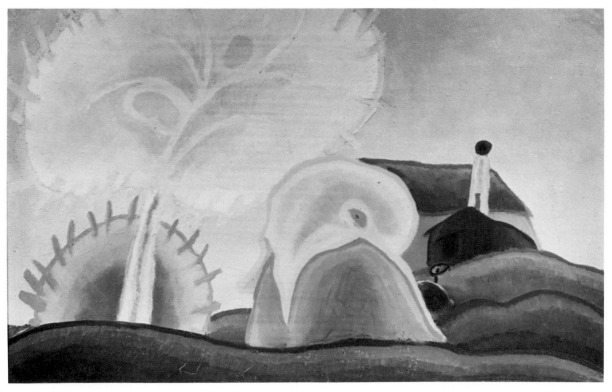

31.10

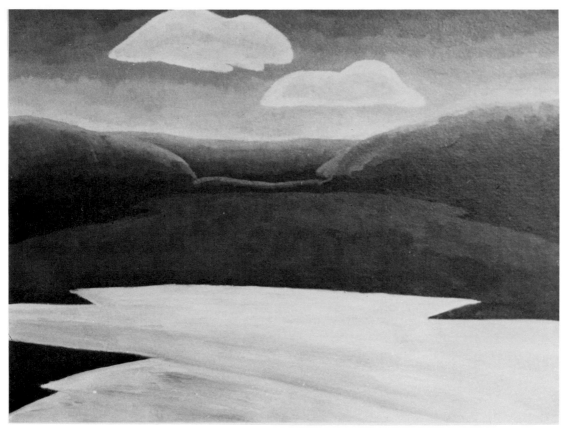

31.11

1955 Downtown, no. 18
1967 College Park, Md., collage no. 24

31.13
PINE TREE
1931 (doc)

Collection: Unidentified
Provenance: (An American Place)
Exhibition: Individual
 1932 American Place, no. 1

31.12

31.14
POWER HOUSE I
1931

Collection: Unidentified

Provenance: (An American Place)

Exhibition: Individual
 1931 American Place, no. 14

31.15
(RED BARGE, REFLECTIONS)
1931 (doc)
30 × 40
Signed, lower center

Collection: Phillips Collection, Washington, D.C.
 (1933)

Provenance: (An American Place)

Remarks: Duncan Phillips sent the painting to the
 artist in Geneva, N.Y., for "restoration" in 1935.
 Recording in her diary for 24 September 1931 that
 Dove was working on this painting, Reds reported
 that he "said he cut loose—Very big."

Exhibitions: Individual
 1932 American Place, no. 2, titled *Red Barge*
 1937 Phillips, no. 14, dated 1932
 1947 Phillips
 1953 Corcoran

1981 Phillips, no. 27, dated 1932
Group
1932 Whitney
1933 Phillips
1934 AIC
1936 Buffalo, N.Y.
1939 Syracuse, N.Y.
1946 Dallas, Tex.
1949 Whitney
 Corcoran
1970 Palm Beach, Fla.

31.16
SANDING MACHINE
1931 (doc)
16 × 21

Collection: Unidentified

Provenance: (Downtown Gallery)
 Branston (1964)

Remarks: Dove probably exhibited this painting
 under some other title.

31.17
STEAM SHOVEL, PORT WASHINGTON
1931 (doc)
30 × 39

Collection: Unidentified

31.15

31.17

Provenance: (Downtown Gallery)

Exhibitions: Individual
 1932 American Place, no. 3
 1956 Los Angeles, Calif., no. 8

31.18
TWO FORMS
1931 (doc)
Beaverboard support
33 × 24
Signed, lower left of center

Collection: Mr. and Mrs. Selig Burrows, Mill Neck, N.Y. (1971)

Provenance: (Terry Dintenfass Gallery)

Exhibitions: Individual
 1931 American Place, no. 2
 1975 Dintenfass, "Arthur G. Dove: The Abstract Work," no. 4

31.19
WOODS
1931 (doc)

Collection: Unidentified

Provenance: (An American Place)

Exhibition: Individual
 1931 American Place, no. 1

1932

32.1
AFTER IMAGES
1932 (doc)
10 × 11
Not signed

Collection: Robert L. Dubofsky, Great Neck, N.Y.

Provenance: (Terry Dintenfass Gallery)

Remarks: On 3 February 1932, the artist's wife noted in her diary that Dove "did small experimental painting from after image of heat bulb."

Exhibition: Individual
 1932 American Place, no. 16

32.2
BARGE AND BUCKET
1932 (doc)
23½ × 24

Collection: Private collection

Provenance: (Downtown Gallery)
 Zuckerman (1970)
 (Maxwell Gallery, San Francisco, Calif.)
 (Bernard Danenberg Galleries)

Exhibition: Individual
 1933 American Place (probable)

31.18

32.3
BESSIE OF NEW YORK
1932 (doc)
28 × 40
Signed, lower center

Collection: Baltimore Museum of Art, Baltimore,
 Md. (Edward Joseph Gallagher III Memorial Col-
 lection)

Provenance: (An American Place)
 Phillips Collection, Washington, D.C. (1933)
 (An American Place, traded for *Reminiscence of
 1937*) (1937)
 (Downtown Gallery)
 Edward Joseph Gallagher, Jr. (1952)

Remarks: This painting was the occasion of the most
 serious disagreement that ever occurred between
Dove and Duncan Phillips. Shortly after he pur-
chased the work in 1933, Phillips proposed to cut
the work in half in order to make a new and better
painting from the right portion. Infuriated, Dove
refused, even though Phillips went so far as to
make it financially advantageous for Dove to ac-
quiesce.

Exhibitions: Individual
 1933 American Place
 1952 Downtown, no. 6
 1958 Whitney, no. 39
 1967 College Park, Md., no. 8
 1981 Phillips, no. 25
 Group
 1969 Baltimore, Md.
 1970 Hagerstown, Md.

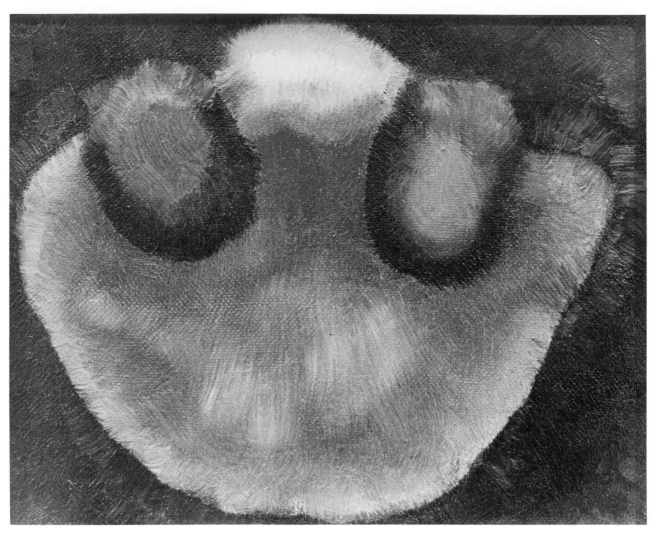

32.1

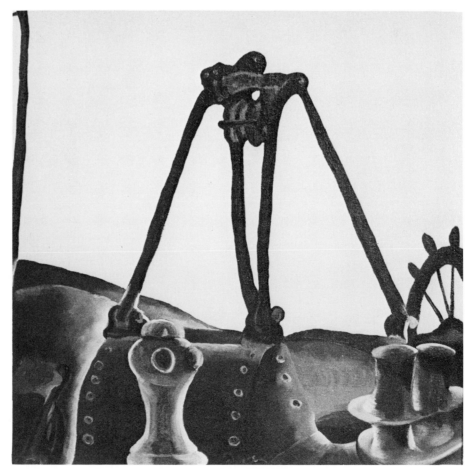

32.2

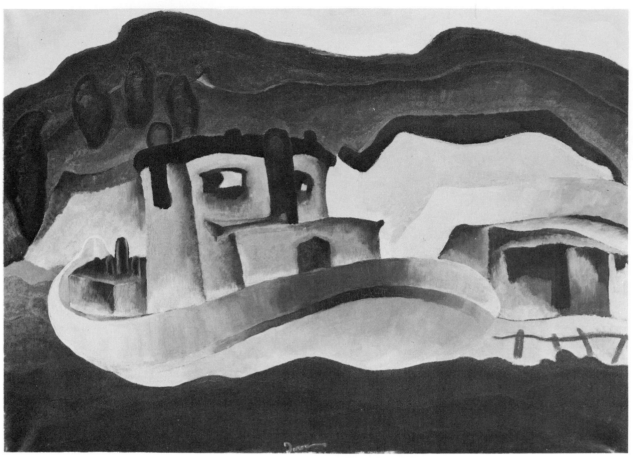

32.3

32.4
BLACK SUN, THURSDAY
1932 (doc)

Collection: Unidentified

Provenance: (An American Place)

Remarks: The exhibition list for Dove's 1932 show
 includes "Addenda" by Dove. In reference to this
 painting, he wrote, "The more gold is burnished
 the blacker it becomes with its own dazzling bril-
 liance."

Exhibition: Individual
 1932 American Place, no. 8

32.5
BROOME COUNTY FROM THE BLACK DIAMOND
1931–32 (doc)
18½ × 24
Signed, lower center

Collection: Vassar College Art Gallery, Poughkeep-
 sie, N.Y. (Bequest of Mrs. Arthur Schwab [Edna
 Bryner '07], 1967)

Provenance: (An American Place)
 Mr. and Mrs. Arthur Schwab, New York City
 (1932)

Remarks: Inscribed on reverse "Broome County from
 the 'Black Diamond.' "

Exhibition: Individual
 1932 American Place, no. 10, titled Broome
 County

32.6
DAWN I
1932 (doc)
22 × 21½
Signed, lower right

Collection: Unidentified

Provenance: (An American Place)

Exhibition: Individual
 1933 American Place

32.7
DAWN II
1932 (doc)
22 × 22
Signed, lower right

Collection: Private collection

Provenance: (Downtown Gallery)

Exhibitions: Individual
 1933 American Place
 1952 Downtown, no. 7
 1954 Ithaca, N.Y., no. 15
 1958 Whitney, no. 40

32.8
DAWN III
1932 (doc)
22 × 22
Signed, lower right

Collection: McNay Art Institute, San Antonio, Tex.
 (Sylvan and Mary Lang Collection)

32.5

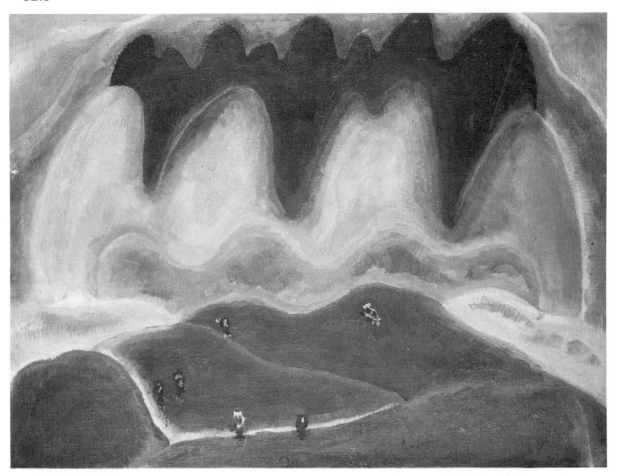

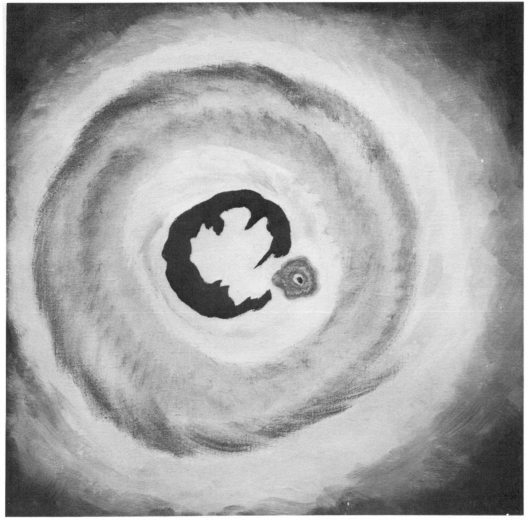

32.7

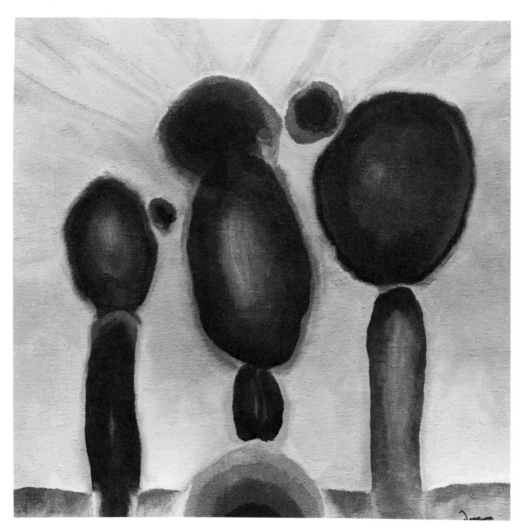

32.8

Provenance: (Downtown Gallery)
 Mr. and Mrs. Sylvan Lang, San Antonio, Tex.
 (1956)

Exhibitions: Individual
 1933 American Place
 1952 Downtown, no. 8
 1954 Ithaca, N.Y., no. 16
 1956 Downtown, no. 10
 1958 Whitney, no. 14

32.9
ECLIPSE OF THE SUN
1932 (doc)
Wood support
8 × 10
Not signed

Collection: Unidentified

Provenance: (An American Place)
 (?)
 (Washburn Gallery)
 Mrs. Daisy Shapiro, New York City (1972)
 Sold c. 1981–82

32.10
GALE
1932 (doc)
25¾ × 35¾
Signed, lower right

Collection: University Gallery, University of Min-
 nesota, Minneapolis. (1936)

Provenance: (An American Place)

Remarks: Identical to a painting referred to in the
 Doves' diaries as "Shorty's Boat," done late in
 1932.

Exhibitions: Individual
 1933 American Place (probable)
 1968 MOMA (touring), no. 10, dated 1932
 Group
 1940 American Federation of Arts (touring)

32.11
HARBOR DOCKS
1932 (doc)
12 × 17

Collection: Unidentified

32.9

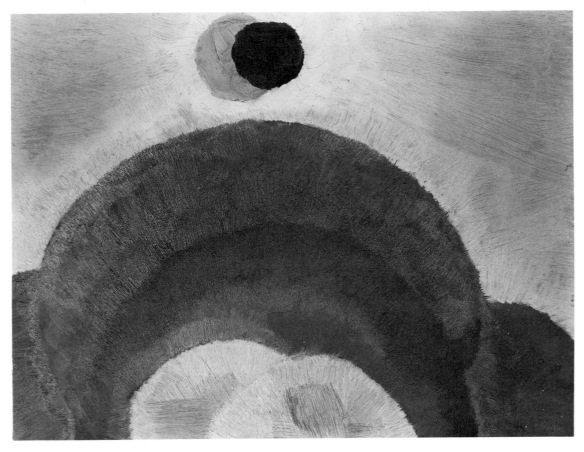

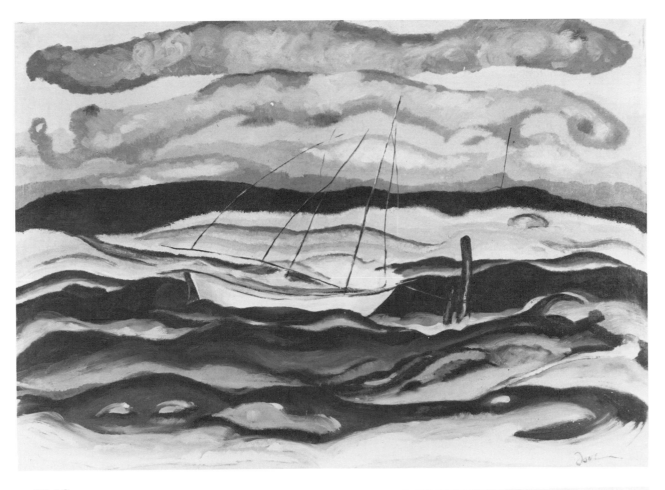

32.10

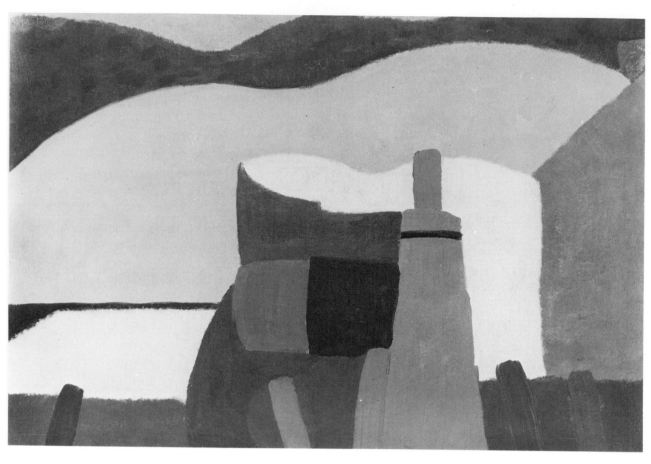

32.11

Provenance: (An American Place)
 Phillips Collection, Washington, D.C. (1933)
 (An American Place) (probably before 1937)
 (Downtown Gallery)
 Ellison (1968)

Exhibitions: Individual
 1933 American Place (probable)
 1967 Huntington, N.Y., no. 8

32.12
NORTHPORT HARBOR
1932 (doc)
Copper support

Collection: Unidentified

Provenance: (An American Place)
 Sold 1932

Exhibition: Individual
 1932 American Place, no. 14

32.13
OIL TANKER
1932 (doc)
18 × 21¾
Signed, lower center

Collection: Inland Steel Company, Chicago, Illinois

Provenance: (An American Place)
 (?Downtown Gallery)

Remarks: Permission to reproduce a photograph of
 this painting was denied by the owner.

Exhibition: Individual
 1932 American Place, no. 17

Reference: Morgan, Ann Lee. "Toward the Definition
 of Early Modernism in America: A Study of Ar-
 thur Dove." Ph.D. diss., University of Iowa, 1973.
 Illustration p. 518.

32.14
PAINTING ONLY
1932 (doc)
Masonite support
8½ × 11½
Signed, lower edge right of center

Collection: Private collection
Provenance: (An American Place)
 Mrs. Foster Boswell, Geneva, N.Y.

Exhibitions: Individual
 1932 American Place, no. 18
 Group
 1933 Springfield, Mass.

32.15
POWER HOUSE
1932 (doc)
Composition board support
6⅛ × 8⅜
Signed, lower left

Collection: Smith College Museum of Art, North-
 ampton, Mass. (gift of Elizabeth McCausland,
 1954)

Provenance: (An American Place)
 Elizabeth McCausland, Springfield, Mass. (1934)

Remarks: Exhibited by Dove as a sketch.

Exhibitions: Individual
 1932 American Place, no. 37
 Group
 1935 Springfield, Mass.

32.16
SCENERY
1932 (doc)
Masonite support
8¾ × 12
Signed, lower center

Collection: Private collection

Provenance: (An American Place)
 Elizabeth Davidson (1932)
 Peggy Davidson McManus (1943)
 (Terry Dintenfass Gallery)

Exhibition: Individual
 1932 American Place, no. 15

32.17
SUN AND MOON
1932 (doc)
18¼ × 22

Collection: Regis Collection, Minneapolis

Provenance: (Downtown Gallery)
 Mr. and Mrs. André Previn (1959)

32.14

Dory Previn
(Salander-O'Reilly Galleries)

Exhibitions: Individual
 1933 American Place (probable)
 1968 MOMA (touring), no. 13, dated 1932

32.18
SUNDAY
1932 (doc)

32.15

32.16

Masonite support
15 × 20
Signed, lower center
Collection: Unidentified

Provenance: (Downtown Gallery)
 Levy (1958)

Remarks: In a letter to Stieglitz on 1 February 1932,
 Dove wrote of this painting as follows:

> . . . the one I did yesterday has found some-
> thing.
>
> Decided to let go of everything and just try to
> make oil paint beautiful in itself with no
> further wish. The result is that this thing, to me,
> exists in light & space as something decidedly
> itself. It seems to have the joy in the means that
> music does. What I have been trying to do is to
> make what would be called an abstraction be
> self creative in its own space and not be
> confined to a flat canvas for its existence. May
> look otherwise to a person just looking at it but
> at least I have had as much joy from it as any-
> thing since the first ten you showed at "291."

On the exhibition list for his 1932 show, Dove
included "Addenda." With reference to this paint-
ing, he wrote:

> Marks an addition in the art of painting, I
> hope. It is in fact bringing the idea of contrast to
> the point of colored light rather than colored
> pigment. Retaining the idea of substance as
> pieces of feeling, each in their own realm, so
> that they may exist in light & space.

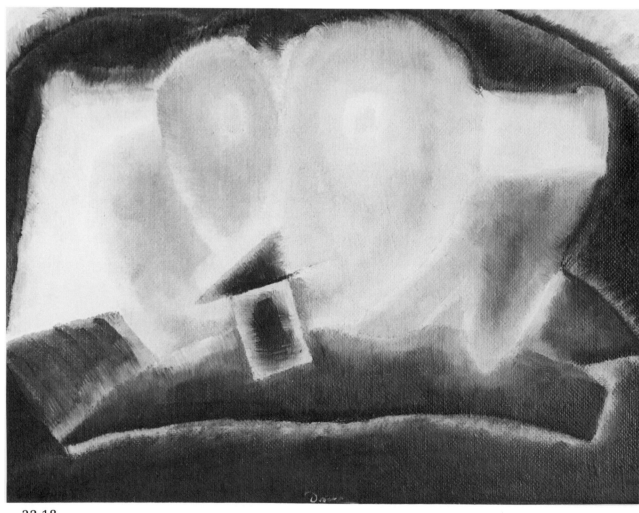

32.18

The past exists, the present must fit the past and the future. As we go on the object ceases more to exist & the painting more to become.

Exhibitions: Individual
 1932 American Place, no. 13
 1952 Downtown, no. 5

32.19
WEDNESDAY, SNOW
1932 (doc)
24 × 18
Signed, lower center

Collection: William H. Lane Foundation, Leominster, Mass.

Provenance: (Downtown Gallery)

Exhibitions: Individual
 1932 American Place, no. 12
 1961 Worcester, Mass., titled *Wednesday—Snow*, dated 1931

32.20
WIND [NO. 2]
1932
Paper support mounted on some rigid material

Collection: Unidentified

Provenance: (An American Place)

Exhibition: Individual
 1932 American Place, no. 19

32.19

1933

33.1
FROZEN POOL AT SUNSET
1933
16 × 20
Signed, lower right
Collection: Andrew Crispo Gallery
Provenance: (Downtown Gallery)
 Private collection
Exhibition: Individual
 1933 American Place (probable)

33.2
NEARLY WHITE TREE
1933
Building board support
24 × 34
Signed, lower center
Collection: William H. Lane Foundation, Leominster, Mass. (1957)
Provenance: (Downtown Gallery)
Exhibitions: Individual
 1933 American Place
 1956 Los Angeles, Calif., no. 12, titled *Nearly White Trees*
 1958 Whitney, no. 44

1961 Worcester, Mass., no. 11, titled *Nearly White Tree (Trees and Stream)*
1972 Dintenfass, no. 7

33.3
SEA GULL
1933
24 × 30
Signed, lower edge right of center
Collection: William C. Janss, Sun Valley, Idaho (1980)
Provenance: (Downtown Gallery)
 Private collection
 (Terry Dintenfass Gallery)
Exhibition: Individual
 1933 American Place

33.4
SUN DRAWING WATER
1933 (doc)
24⅜ × 33⅝
Signed, lower center
Collection: Phillips Collection, Washington, D.C. (1933)
Provenance: (An American Place)
Exhibitions: Individual
 1933 American Place
 1937 Phillips, no. 22

33.1

33.2

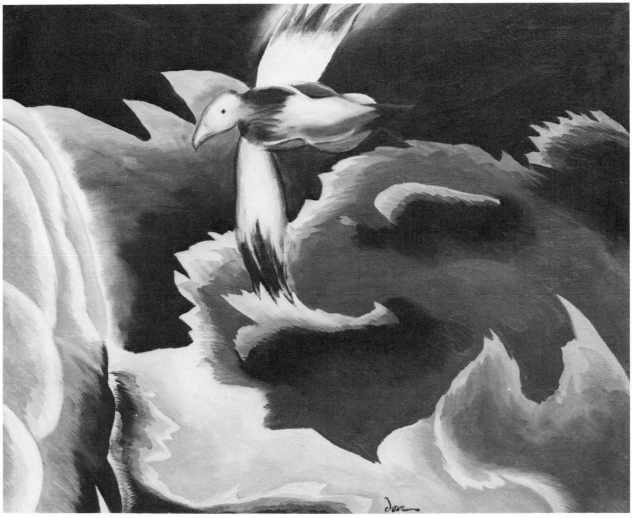

33.3

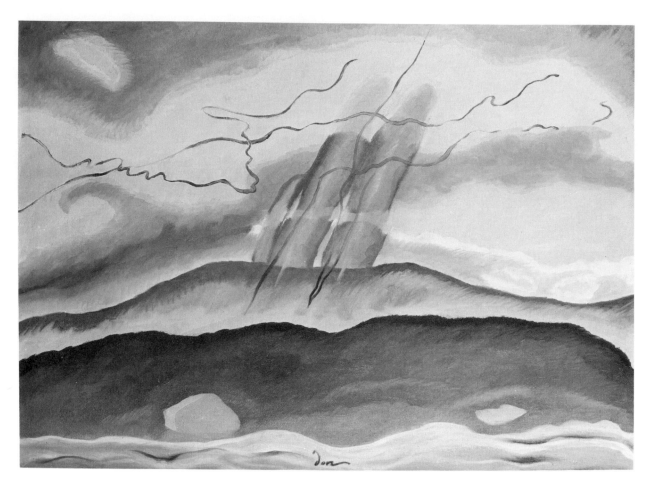

33.4

1947 Phillips
1981 Phillips, no. 28
Group
1941 Phillips
 MOMA (touring)

33.5
TANKS AND SNOWBANK
1933
Medium includes silver paint
18 × 24
Signed, lower center

Collection: Unidentified

Provenance: (An American Place)

Exhibitions: Individual
 1933 American Place (probable)
 1956 Los Angeles, Calif., no. 11, dated 1933

33.6
TOWN SCRAPER
1933
Support not verified
28 × 21

Collection: Unidentified

Provenance: (Downtown Gallery)
 Borman (1970)

Exhibition: Individual
 1933 American Place (probable)

33.7
TREE AND COVERED BOAT
1932–33 (doc)
20 × 28
Signed, lower center

Collection: Private collection (1975)

Provenance: (An American Place)
 Phillips Collection, Washington, D.C. (1933)
 (An American Place) (1933)
 (Downtown Gallery)
 Rifkin (1969)
 (William Zierler)
 Harry Spiro, New York City
 (Andrew Crispo Gallery)

Exhibitions: Individual
 1933 American Place (probable)
 1974 San Francisco Museum, titled *Trees and
 Covered Boat*, dated 1932
 1981 Phillips, no. 26, titled *Trees and Covered
 Boat*, dated 1932
 Group
 1973 Andrew Crispo Gallery

33.8
TWO BROWN TREES
1933
20 × 28
Signed, lower right

Collection: Lee Ehrenworth, Elizabeth, N.J. (1983)

33.5

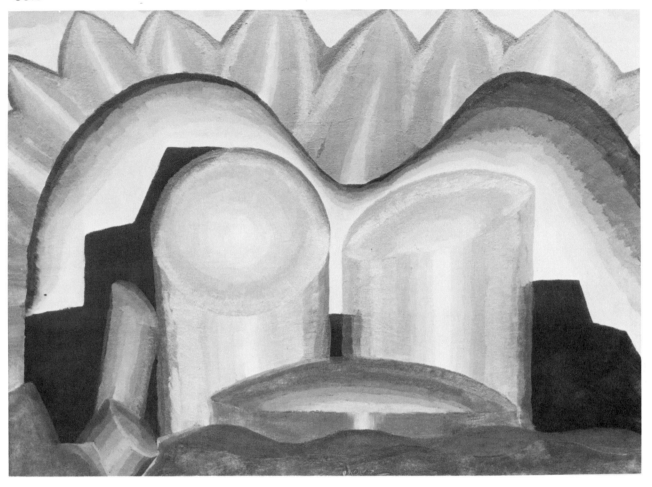

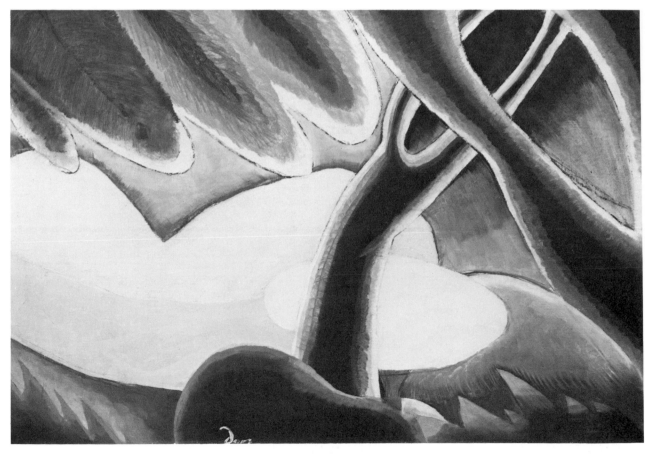

33.7

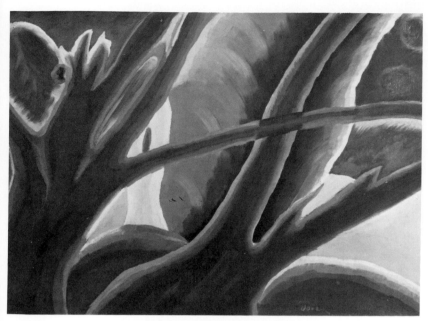

33.8

33.9
WET SUNSET
1933 (doc)
Support not verified

Collection: Unidentified

Provenance: (An American Place)

Exhibition: Individual
 1933 American Place

1934

34.1
APPROACHING SNOWSTORM
1934 (doc)
26 × 32
Signed, lower center

Collection: William C. Dove, Mattituck, N.Y.

Provenance: Acquired from the artist

Exhibition: Individual
 1934 American Place

34.2
THE BARN NEXT DOOR
1934
20 × 28
Signed, lower center

Provenance: (Downtown Gallery)
 Louise R. Noun, Des Moines, Iowa (1960)
 (Barbara Mathes Gallery) (1983)

Exhibitions: Individual
 1933 American Place (probable)
 Group
 1961 Iowa City, Iowa, no. 6

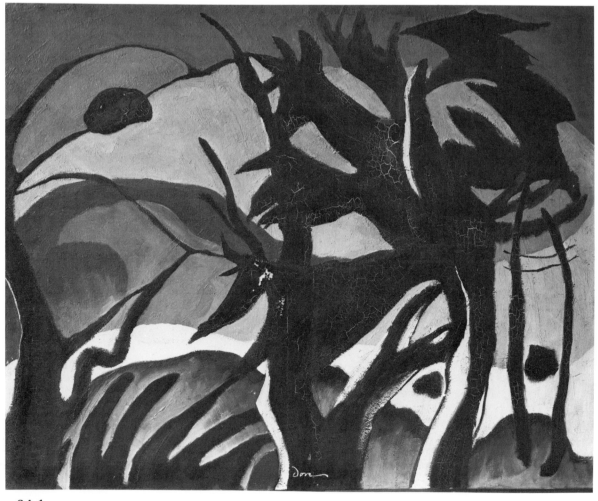

34.1

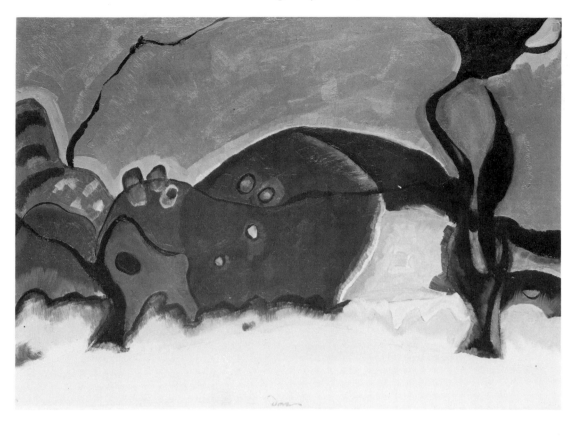

34.2

Collection: Unidentified
Provenance: (An American Place)
 Duncan Phillips, Washington, D.C. (1934)
 Private collection (gift of Duncan Phillips, 1950)
Exhibitions: Individual
 1947 Phillips
 1981 Phillips, no. 30

34.3
BRICKYARD SHED
1934 (doc)
20 × 28
Signed, lower center

Collection: William C. Janss, Sun Valley, Idaho (1980)

Provenance: (An American Place)
 Charles Brooks
 (Terry Dintenfass Gallery)

Exhibition: Individual
 1947 Downtown (San Francisco only)

34.4
DANCING
1934
25 × 35
Signed, lower center

Collection: Private collection

Provenance: (An American Place)
 Charles and Inez Brooks
 (Terry Dintenfass Gallery)

Exhibitions: Individual
 1939 American Place, no. 15, dated 1934
 1947 Downtown (San Francisco only)
 1974 San Francisco Museum
Group
 1940 American Place, no. 19, dated 1935

34.5
GREEN HOUSE
1934 (doc)
25½ × 31¾
Signed, lower center

Collection: Jay Braus, New York City (1975)

Provenance: (Terry Dintenfass Gallery)

Exhibition: Individual
 1973 Dintenfass, no. 28

34.6
HOUND
1934 (doc)
18¼ × 22
Signed, lower center

Collection: Marjorie Phillips, Washington, D.C. (gift of Duncan Phillips, 1943)

Provenance: (An American Place)
 Duncan Phillips, Washington, D. C. (1934).

Exhibitions: Individual
 1934 American Place
 1947 Phillips
 1981 Phillips, no. 32

34.3

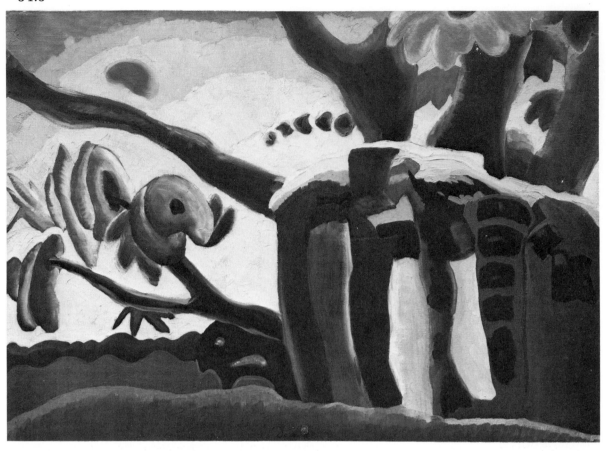

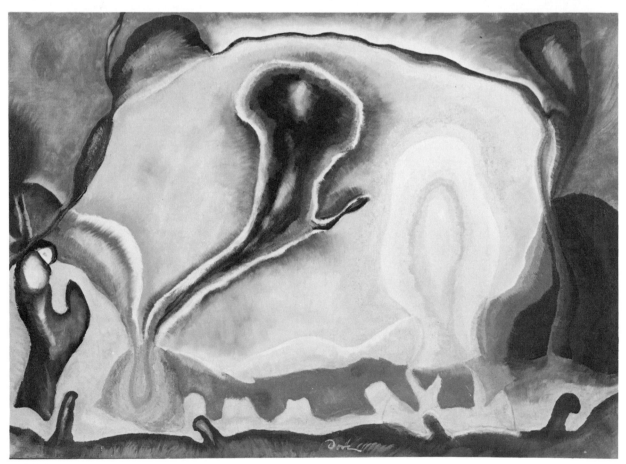

34.4

34.7
(LIFE GOES ON)
1934
18 × 24
Signed, lower center

Collection: Phillips Collection, Washington, D. C. (1934)

Provenance: (An American Place).

Remarks: Sometimes titled *Continuation*.

Exhibitions: Individual
 1934 American Place, as *Tree Trunks*
 1937 Phillips, no. 21, dated 1934
 1947 Phillips
 1958 Whitney, no. 45
 1968 East Lansing, Mich.
 1981 Phillips, no. 31
 Group
 1936 Springfield, Mass.
 1939 Washington, D.C., titled *Tree Trunks*
 1941 Phillips
 1944 Detroit, Mich.
 1968 Washington, D.C.

34.8
SOWING WHEAT
1934
28 × 25

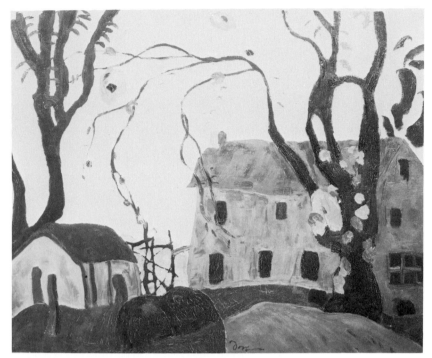

34.5

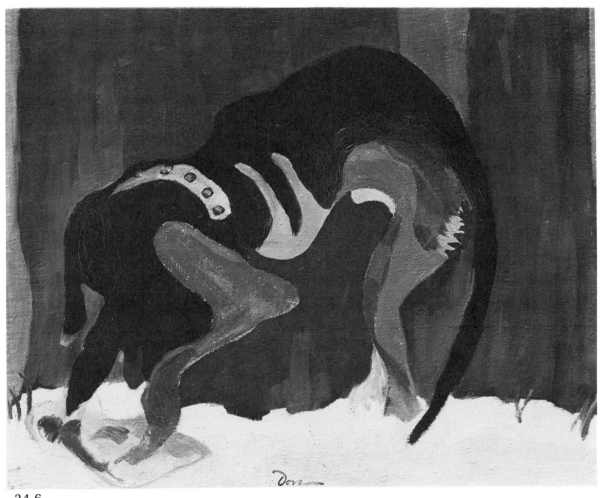

34.6

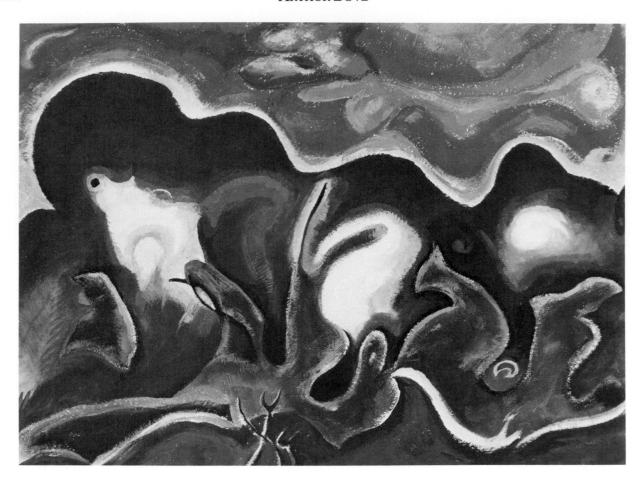

34.7

Collection: Unidentified

Provenance: (Downtown Gallery)
Borman

Exhibitions: Individual
1934 American Place
1947 Downtown, no. 15, dated 1934
1964 Detroit, Mich., no. 8

34.9
SUNRISE, SENECA LAKE
1934
7 × 9
Signed and dated 34, lower center

Collection: William C. Dove, Mattituck, N.Y.

Provenance: Paul Dove, Geneva, N.Y. (acquired from
the artist)
Toni Dove (bequest of Paul Dove, her great-uncle,
1979)

Remarks: Probably one of the undocumented paint-
ings included in Dove's 1934 American Place ex-
hibition.

34.10
THE TRAIN
1934 (doc)
18¼ × 22
Signed, lower center

Collection: Phillips Collection, Washington, D.C.

(bequest of Elmira Bier with life interest to Vir-
ginia McLaughlin, 1976)

Provenance: (An American Place)
Duncan Phillips, Washington, D.C. (1934)
Elmira Bier, Arlington, Va. (gift of Duncan Phil-
lips, 1950)

Exhibitions: Individual
1934 American Place
1937 Phillips, no. 23
1947 Phillips
1981 Phillips, no. 33
Group
1939 Washington, D.C.

34.11
TREE
1934
18 × 24
Signed, lower center

Collection: Unidentified

Provenance: (Downtown Gallery)
Porter (1964)

Exhibition: Individual
1934 American Place

34.12
TREE FORMS [NO. 2]
c. 1934
28 × 20

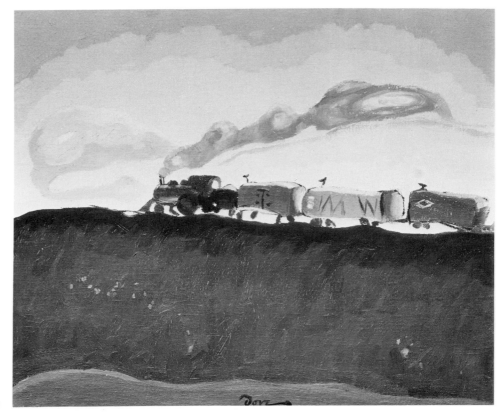

34.10

Signed, lower center

Collection: William Hayes Ackland Memorial Art Center, University of North Carolina, Chapel Hill (1966)

Provenance: (Downtown Gallery)

Remarks: This painting may be identical to the "Twisted Trees" that Dove painted in January 1934, according to Reds' diary. In any case, it is probably one of the undocumented works included in Dove's 1934 American Place exhibition.

Exhibitions: Individual
1947 Downtown, no. 13, dated 1932
Group
1951 Houston, Tex., no. 5

1935

35.1
AUTUMN
1935 (doc)
14 × 23
Signed, lower center

Collection: Addison Gallery of American Art, Phillips Academy, Andover, Mass. (bequest of Edward Wales Root, 1957)

Provenance: (Downtown Gallery)
Edward Wales Root (1951)

Exhibition: Individual
1936 American Place, no. 5

35.2
(BARNYARD FANTASY)
1935
33⅛ × 25½
Signed, lower center

Collection: Yale University Art Gallery, New Haven, Conn. (gift of Duncan Phillips, B.A. 1908, for the Collection Société Anonyme, 1949).

Provenance: (An American Place)
Duncan Phillips, Washington, D.C. (1935)

Exhibitions: Individual
1935 American Place, no. 13, titled *Fantasy*
1937 Phillips, no. 21, dated 1935
1947 Phillips
1981 Phillips, no. 34
Group
1936 Buffalo, N.Y.
1939 Syracuse, N.Y.
1959 Hartford, Conn.

35.3
BUTTONWOOD TREE
1935
25 × 34
Signed, lower center

Collection: Unidentified

Provenance: (Downtown Gallery)
John S. Bolles, San Francisco, Calif. (1956)

Exhibitions: Individual
1935 American Place, no. 17, titled *Button Wood Tree*

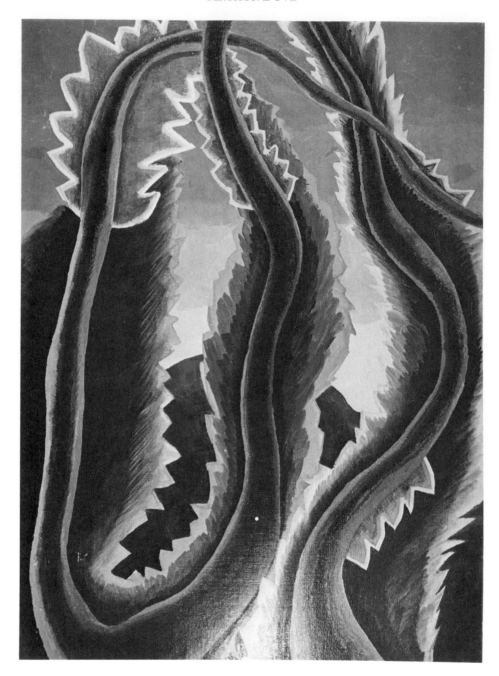

34.12

1956 Downtown, no. 15
1958 Whitney, no. 47

35.4
CAR IN GARAGE
1935
12 × 14
Signed, lower center

Collection: Unidentified

Provenance: (Downtown Gallery)
 Edith Halpert, New York City
 (Sotheby Parke Bernet auction, 15 March 1973)
 (?)
 (Steven Straw, Newburyport, Mass.)

Exhibitions: Individual

 1935 American Place, no. 8

1947 Downtown, no. 14, dated 1934
1961 MOMA (touring)

35.5
CARNIVAL
1935 (doc)
22¼ × 34
Signed, lower center

Collection: Montclair Art Museum, Montclair, N.J.
 (Museum Purchase, Members Acquisition Fund,
 1969).

Provenance: (Downtown Gallery)

Exhibitions: Individual
 1935 American Place, no. 15
 1939 American Place, no. 7
 1967 Geneva, N.Y.
 Huntington, N.Y., no. 9

35.1

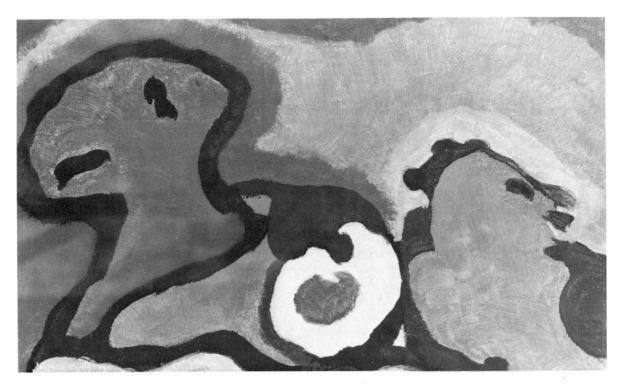

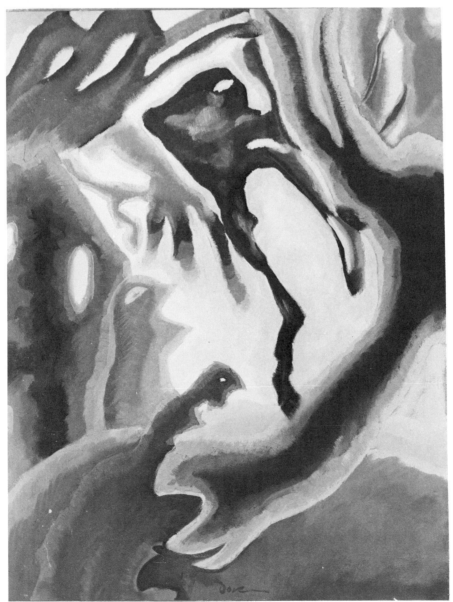

35.2

35.4

35.6
CAT
1935 (doc)
28 × 20
Signed, lower center

Collection: William H. Lane Foundation, Leominster, Mass.

Provenance: (Downtown Gallery)

Exhibitions: Individual
 1936 American Place, no. 6
 1961 Worcester, Mass., no. 17

35.7
CLAY WAGON
1935 (doc)
20 × 28
Signed, lower center

Collection: Charles H. MacNider Museum, Mason City, Iowa (gift of the Francisca S. Winston Trust, 1965).

Provenance: (An American Place)
 Lane and Louise Rehm, New York City (1935)
 Mr. and Mrs. Donald Winston

Exhibitions: Individual
 1935 American Place, no. 10
 1968 MOMA (touring), no. 15
 1974 San Francisco Museum.
 Group
 1970 Huntington, N.Y.

35.8
CORN CRIB
1935 (doc)
20 × 28
Signed, lower center

35.5

Collection: Des Moines Art Center, Des Moines, Iowa
 (Rose F. Rosenfield Fund, 1958)

Provenance: (Downtown Gallery)

Exhibition: Individual
 1935 American Place, no. 4

35.9
COWS IN PASTURE
1935 (doc)
20 × 28
Signed, lower center

Collection: Phillips Collection, Washington, D.C.
 (1936)

Provenance: (An American Place)

Exhibitions: Individual
 1936 American Place, no. 15
 1937 Phillips, no. 15
 1947 Phillips
 1953 Corcoran
 1954 Ithaca, N.Y.
 1958 Whitney, no. 49
 1972 Dintenfass, no. 8
 1974 San Francisco Museum (not in catalogue)
 Group
 1941 Phillips, no. 118
 1944 Phillips

35.10
A CROSS IN THE TREE
1934–35 (doc)
Oil on canvas mounted on panel
28 × 20
Signed, lower center

Collection: Mr. and Mrs. Anthony Fisher, New York
 City.

35.7

35.8

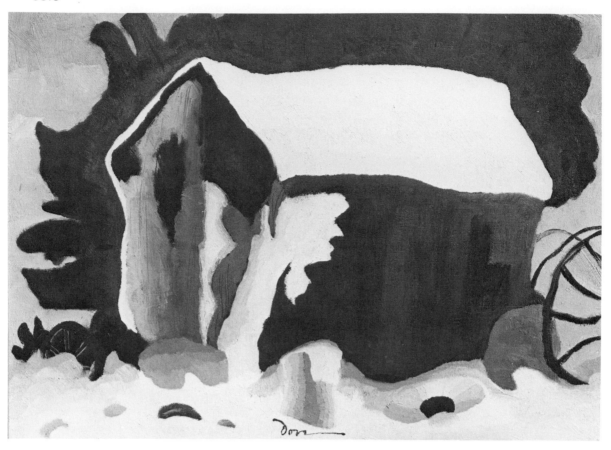

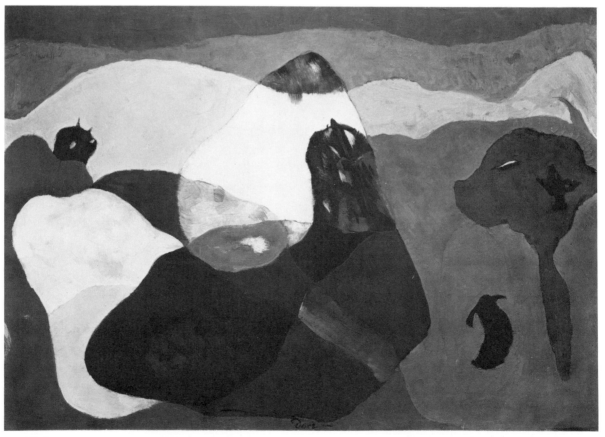

35.9

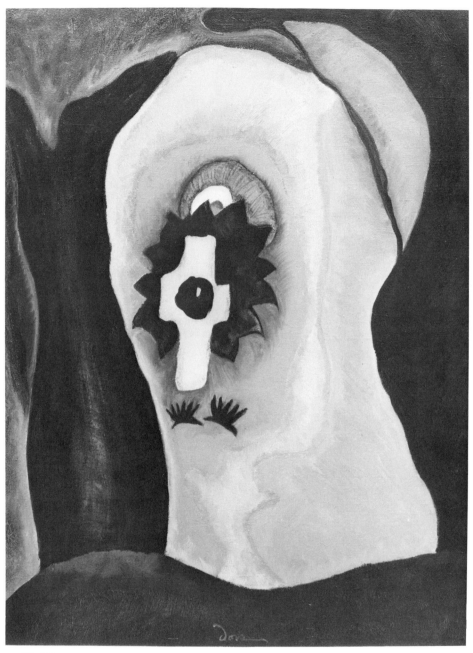

35.10

Provenance: (Terry Dintenfass Gallery)

Remarks: In "Biomorphism in American Painting," Robert Metzger comments on this painting as follows:

> The ordinary tree of *A Cross in the Tree* becomes sacred and its white cross with all-seeing eye guides a lost universe. [It suggests] Dove's awareness of, and familiarity with, the then current Surrealism (pp. 62–63).

Exhibitions: Individual
 1935 American Place, no. 1
 1939 American Place, no. 12, dated 1935
 1947 Downtown, no. 17
 1958 Whitney, no. 50
 1968 MOMA (touring), no. 17
 1972 Dintenfass, no. 9

Group
 1936 Pennsylvania Academy

Reference: Metzger, Robert Paul. "Biomorphism in American Painting." Ph.D. diss., University of California, Los Angeles, 1973.

35.11
ELECTRIC PEACH ORCHARD
1935 (doc)
20 × 28
Signed, lower center

Collection: Phillips Collection, Washington, D.C. (1935)

Provenance: (An American Place)

Exhibitions: Individual
 1935 American Place, no. 3
 1937 Phillips, no. 19, titled *Electric Orchard*

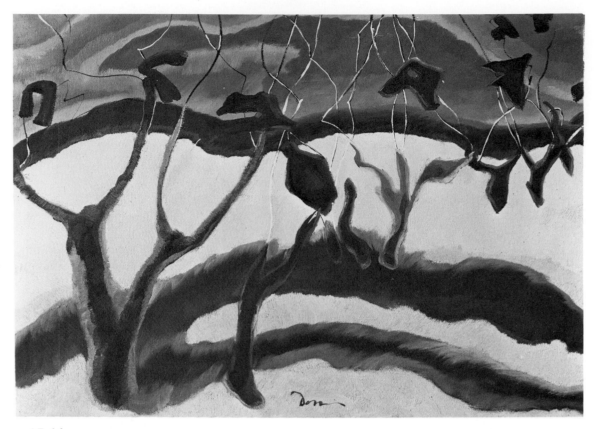

35.11

1947 Phillips
1981 Phillips, no. 43
Group
1935 Cleveland Museum
1941 Phillips
 MOMA (touring)
1955 American Federation of Arts (touring)
1959 Washington, D.C.

35.12
GOAT
1935 (doc)
23 × 31
Signed, lower center

Collection: Metropolitan Museum of Art (Alfred
 Stieglitz Collection; gift of Georgia O'Keeffe from
 the estate of Alfred Stieglitz, 1949)

Provenance: (An American Place)
 Alfred Stieglitz, New York City

Exhibitions: Individual
 1935 American Place, no. 12
 1939 American Place, no. 1
 1940 American Place, no. 35, titled *The Goat*
 1958 Whitney, no. 51
 1974 San Francisco Museum
 Group
 1947 MOMA, no. 30
 1948 AIC, no. 89
 1950 Metropolitan
 1965 Metropolitan

35.13
HOLBROOK'S BRIDGE
1934–35 (doc)
20 × 28
Signed, lower center

Collection: Unidentified

Provenance: (Downtown Gallery)
 Chace (1962)

Exhibitions: Individual
 1935 American Place, no. 11
 1939 American Place, no. 11, dated 1935
 1954 Ithaca, N.Y., no. 20

35.12

35.13

35.14
MORNING SUN
1935
20 × 28
Signed, lower center

Collection: Phillips Collection, Washington, D.C. (1935)

Provenance: (An American Place)

Exhibitions: Individual
 1935 American Place, no. 2
 1937 Phillips, no. 16
 1947 Downtown, no. 16
 Phillips
 1953 Corcoran
 1981 Phillips, no. 38
 Group
 1939 Syracuse, N.Y.
 1940 San Francisco, Calif., no. 1325
 1941 Phillips
 1959 Philadelphia, Penn.

35.15
OCTOBER
1935 (doc)
14 × 70 (two panels)
Signed, lower center

Collection: William C. Janss, Sun Valley, Idaho

Provenance: (Downtown Gallery)
 Marvin Radoff, Yardley, Penn.
 (Terry Dintenfass Gallery)

Remarks: This painting is probably the "long decoration" on which Reds reported Dove was working in her diary of December 1935.

Exhibitions: Individual
 1936 American Place, no. 9
 1956 Downtown, no. 14
 Los Angeles, Calif., no. 13
 1958 Whitney, no. 54
 1975 Dintenfass, no. 8

35.16
RED SUN
1935
20¼ × 28
Signed, lower center

Collection: Phillips Collection, Washington, D.C. (1935)

Provenance: (An American Place)

Exhibitions: Individual
 1935 American Place, no. 5
 1937 Phillips, no. 18, dated 1935
 1947 Phillips
 1953 Corcoran
 1980 Dintenfass

35.14

1981 Phillips, no. 36
Group
1941 Phillips
1942 St. Louis Art Museum

35.17
REFLECTIONS [NO. 2]
1935 (doc)
15 × 21
Signed, lower center

Collection: Unidentified

Provenance: (An American Place)

Exhibition: Individual
 1936 American Place, no. 13

35.18
SNOWSTORM
1935
14 × 20⅛
Signed, lower center

Collection: Private collection

Provenance: (Downtown Gallery)
 Joseph A. Tucker, St. Louis, Mo.
 (Parke-Bernet auction, 11 April 1962)
 Edith Halpert, New York City
 (Sotheby Parke Bernet auction, 14 March 1973)

Exhibitions: Individual
 1935 American Place, no. 6, titled *Snow Storm*
 1974 San Francisco Museum

35.19
SUMMER
1934–35 (doc)
25 × 34
Signed, lower center

Collection: William H. Lane Foundation, Leominster, Mass.

Provenance: (Downtown Gallery)

Exhibitions: Individual

35.15

35.16

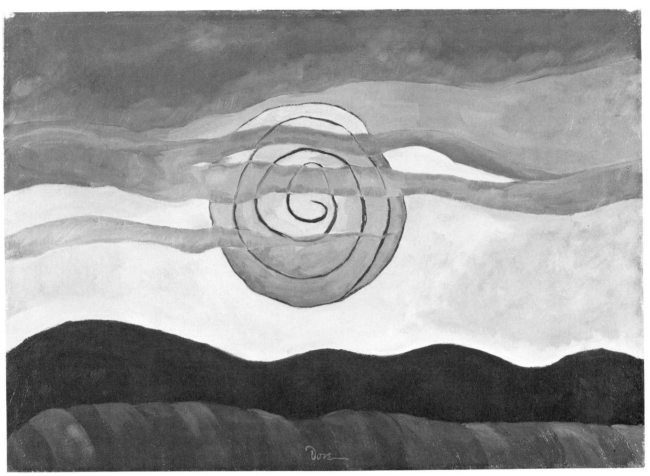

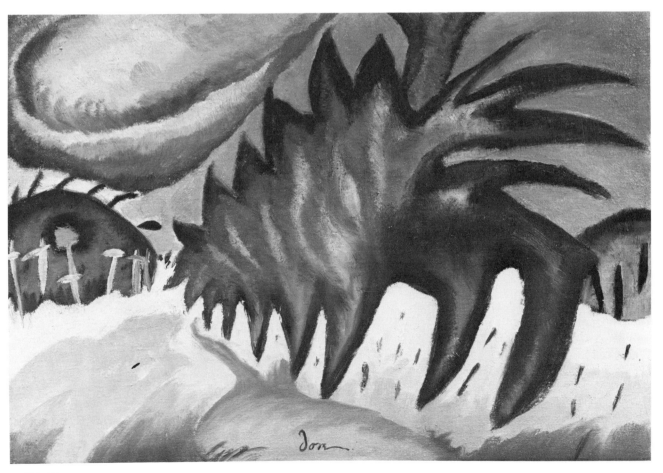

35.18

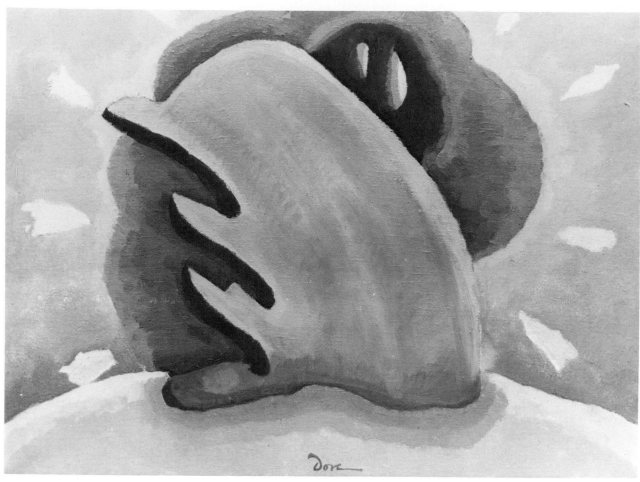

35.19

1935 American Place, no. 16
1956 Downtown, no. 13
1958 Whitney, no. 55
1961 Worcester, Mass., no. 18

35.20
SUNRISE
1934–35 (doc)
10 × 13
Collection: Unidentified

Provenance: (Downtown Gallery)

Exhibitions: Individual
 1935 American Place, no. 9
 1954 Ithaca, N.Y., no. 19

35.21
SUNSET
1935 (doc)
24 × 33
Signed, lower center

Collection: Unidentified

Provenance: (Downtown Gallery)
 Elterman (1959)

Exhibitions: Individual
 1935 American Place, no. 14
 1952 Downtown, no. 11

35.22
SWAMP
1935
Support not verified

Collection: Unidentified

Provenance: (An American Place)
 Private collection, Hartford, Conn. (1935)

Exhibition: Individual
 1935 American Place, no. 7

35.23
TREE FORMS [NO. 3]
1935
20 × 28
Signed, lower center

Collection: Phillips Collection, Washington, D.C.
 (1936)

Provenance: (An American Place)

Remarks: Inscribed on reverse with the title *Tree Forms (2)* and a date that is difficult to read but appears to be 1935.
 Current museum title is *Tree Forms II.*

Exhibitions: Individual
 1936 American Place, no. 10
 1947 Phillips

35.21

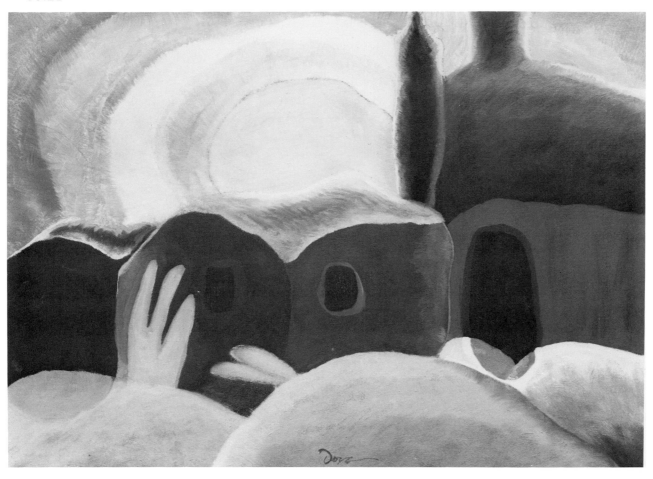

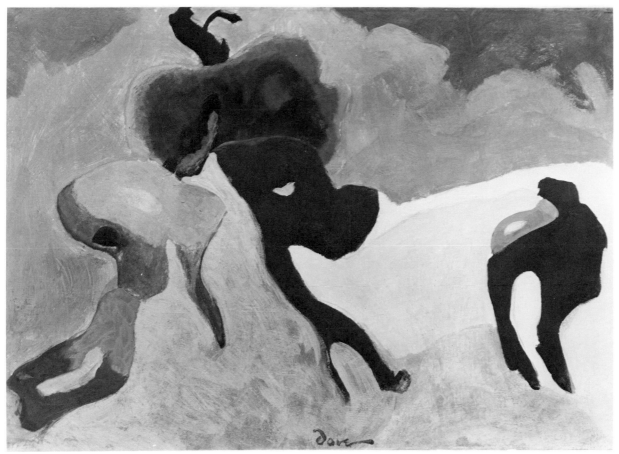

35.23

1974 San Francisco Museum, titled *Tree Forms II*, dated 1934–35
1981 Phillips, no. 35, titled *Tree Forms II*
Group
1980 Richmond, Va. (touring)

35.24
WIND [NO. 3]
1935 (doc)
15 × 21
Signed, lower center
Collection: William C. Janss, Sun Valley, Idaho

Provenance: (Downtown Gallery)
(Alan Gallery)
(Sotheby Parke Bernet)
(Terry Dintenfass Gallery) with William C. Janss, Sun Valley, Idaho

Exhibitions: Individual
1936 American Place, no. 4
1939 American Place, no. 5
1945 American Place, no. 13

1936

36.1
BROWN SUN AND HOUSETOP
1936 (doc)
11 × 18
Signed, lower center
Collection: Unidentified

Provenance: (Downtown Gallery)
Werner (1956)
Exhibition: Individual
1937 American Place, no. 10

36.2
COW I
1935–36 (doc)
15 × 21
Signed, lower center
Collection: Randolph-Macon Woman's College Art Gallery, Lynchburg, Va.

Provenance: (Downtown Gallery)

Exhibitions: Individual
1936 American Place, no. 2, titled *Cow*
1939 American Place, no. 19, titled *Cow, I*, dated 1935
1947 Downtown, no. 19
1958 Whitney, no. 48
1968 MOMA (touring), no. 16
Group
1951 Houston, Tex., no. 9
1957 Lynchburg, Va., no. 5
1964 Ashland, Va.

36.3
COWS AND CALVES
1936
15 × 21
Collection: Newark Museum, Newark, N.J. (1982)
Provenance: (Terry Dintenfass Gallery)

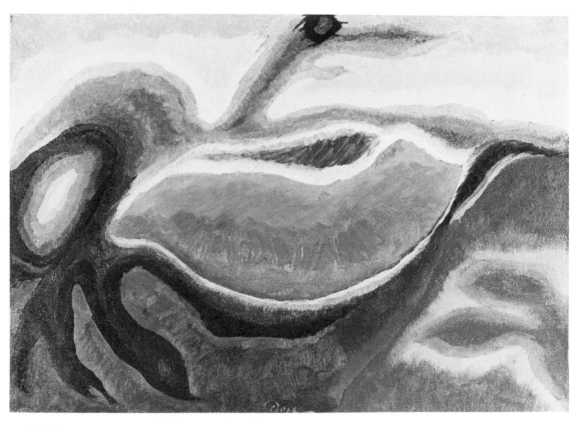

35.24

Exhibitions: Individual
 1936 American Place, no. 12
 1973 Dintenfass, no. 32
 Group
 1978 Zabriskie, no. 53

36.4
CROSS AND WEATHERVANE
1936 (doc)
34¾ × 24⅝
Signed, lower center

Collection: Art Institute of Chicago, Chicago, Ill. (gift of Georgia O'Keeffe from the estate of Alfred Stieglitz, 1949)

Provenance: (An American Place) Alfred Stieglitz, New York City

Remarks: This is presumably the large "Cross Abstraction" on which Dove was working in February 1936, according to Reds' diary.

Exhibitions: Individual
 1936 American Place, no. 17
 Group
 1948 AIC

36.5
EAST FROM HOLBROOK'S BRIDGE
1936 (doc)
13½ × 21½
Signed, lower center

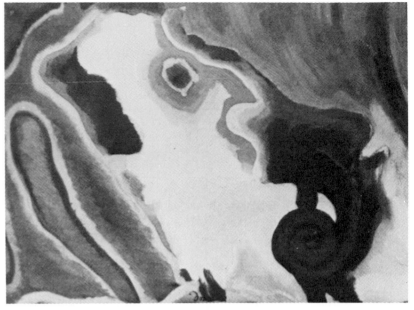

36.2

Collection: John Marin, Jr., Cape Split, Addison, Me. (1953)

Provenance: (Downtown Gallery)

Exhibitions: Individual
 1937 American Place, no. 9
 1952 Downtown, no. 13

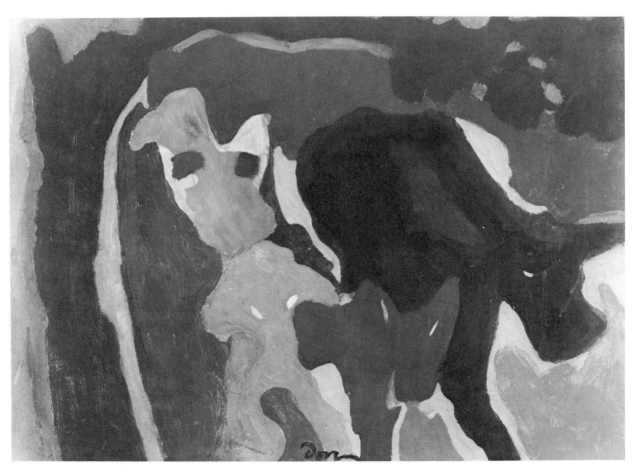

36.3

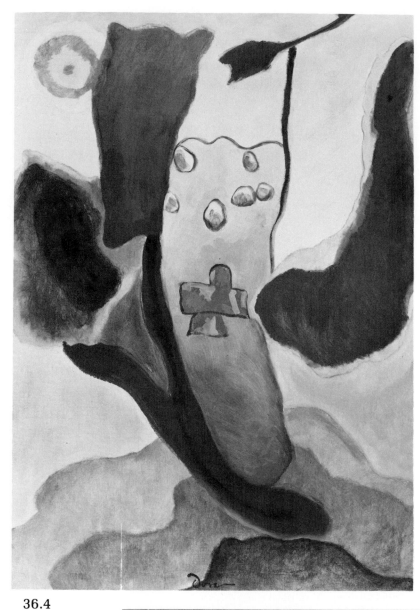

36.4

36.6
LAKE AFTERNOON
1935–36 (doc)
25 × 35
Signed, lower center

Collection: Phillips Collection, Washington, D.C. (1947)

Provenance: (Downtown Gallery)

Exhibitions: Individual
 1936 American Place, no. 19
 1947 Downtown, no. 18
 Phillips
 1953 Corcoran
 1980 Dintenfass
 1981 Phillips, no. 42, dated 1935

36.7
MARS ORANGE AND GREEN
1936
Support not verified

Collection: Unidentified

Provenance: (Downtown Gallery)
 Sold 1948

Remarks: For a reproduction of the study for this painting, see text illustration no. 14.

Exhibition: Individual
 1936 American Place, no. 7

36.8
MOON
1936
35 × 25
Signed, lower center

Collection: Max M. Zurier, Palm Springs, Calif.

Provenance: (Downtown Gallery)

Remarks: In "Biomorphism in American Painting," Robert Metzger comments on this painting as follows:

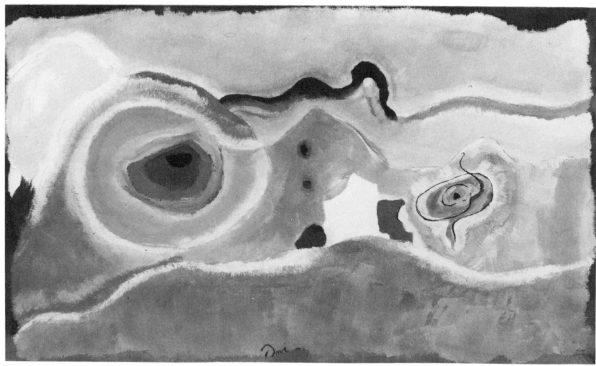

36.5

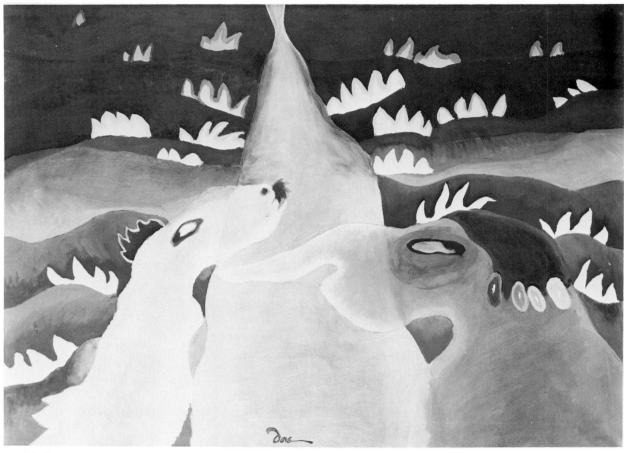

36.6

Moon presents its subject as a terrifying Cyclops eye. . . . The anthropomorphic aspect is heightened by the erectile thrust of the tree trunk, pushing into its upper branches where the moon has been momentarily caught and contained. The diagonal positioning of the trunk contributes to the intense dramatic situation. Dove has captured the climactic moment in time where reason stops and chance, accident and serendipity rule. . . . The tree in *Moon* becomes a lighted torch with its rays illuminating the night sky. . . . [It suggests] Dove's awareness of, and familiarity with, the then current Surrealism (pp. 62–63).

Exhibitions: Individual
 1936 American Place, no. 16
 1952 Downtown, no. 9, dated 1935
 1958 Whitney, no. 52, dated 1935
 1974 San Francisco Museum, dated 1935
 Group
 1936 Whitney

Reference: Metzger, Robert Paul. "Biomorphism in American Painting." Ph.D. diss., University of California, Los Angeles, 1973.

36.9
"THE MOON WAS LAUGHING AT ME"
1936 (doc)
6⅛ × 8
Signed, lower center

Collection: Phillips Collection, Washington, D.C. (bequest of Elmira Bier, with life interest to Virginia McLaughlin, 1976)

Provenance: (An American Place)
 Duncan Phillips, Washington, D.C. (1937)
 Elmira Bier, Arlington, Va. (gift of Duncan Phillips, 1943)

Remarks: The enigmatic title of this work probably derives from a popular song. The title is written in quotation marks on the reverse, along with the word *radio*, presumably to indicate that this work was inspired by music heard on the radio, rather than played on the phonograph. In its complete abstractness, it relates to other musically derived works in Dove's oeuvre. Particularly, it forecasts the abstract style of *Swing Music (Louis Armstrong)* (no. 38.19), another musical work, which itself anticipates the abstract mode that dominated Dove's work in the early 1940s.

Exhibitions: Individual
 1937 American Place, no. 5, titled *"The Moon Was Laughing . . ."*
 1981 Phillips, no. 45, dated 1937

36.10
NAPLES YELLOW MORNING
1936
25 × 35
Signed, lower center

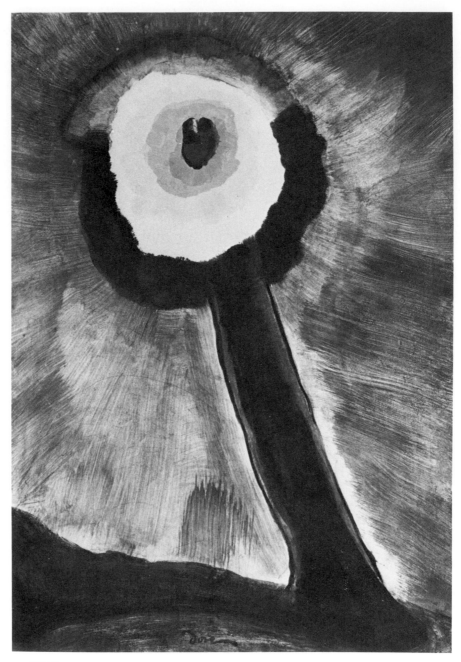

36.8

Collection: Mr. and Mrs. Meyer P. Potamkin,
 Philadelphia, Penn. (1971)

Provenance: (Downtown Gallery)
 Edith Halpert, New York City (1954)
 Rudin
 (Terry Dintenfass Gallery)

Exhibitions: Individual
 1936 American Place, no. 18
 1952 Downtown, no. 10
 1954 Ithaca, N.Y., no. 17
 1958 Whitney, no. 53
 1972 Dintenfass, no. 10
 Group
 1971 Carnegie Institute, no. 34
 1976 Pennsylvania Academy, no. 281

36.11
RED, YELLOW AND GREEN
1936
9¾ × 13¾
Signed

Collection: Elaine Graham Weitzen, New York City

Provenance: (Downtown Gallery)
 G. David Thompson

Exhibitions: Individual
 1936 American Place, no. 11
 1975 Dintenfass, "Arthur G. Dove: The Abstract
 Work," no. 6

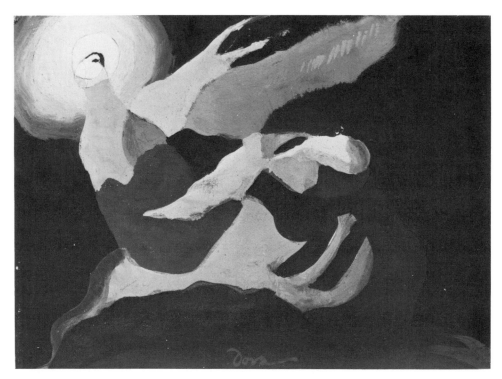

36.9

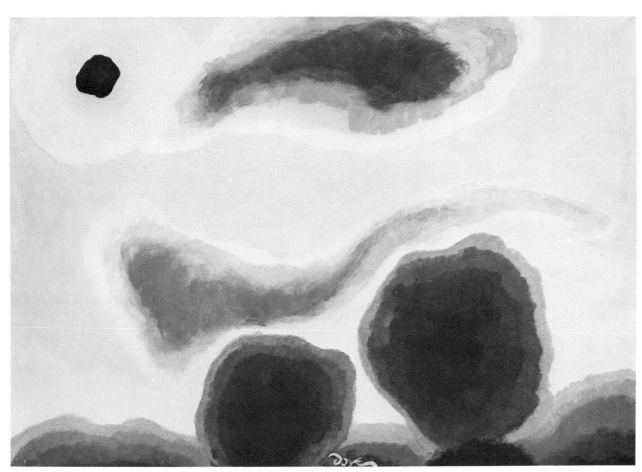

36.10

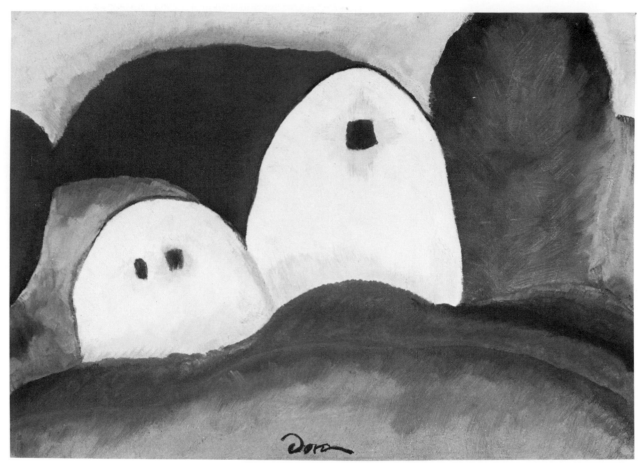

36.11

36.12
SLAUGHTER HOUSE
1936 (doc)
15¾ × 26
Signed, lower center

Collection: Lee Ehrenworth, Elizabeth, N.J.

Provenance: (Downtown Gallery)

Exhibitions: Individual
 1937 American Place, no. 7
 1952 Downtown, no. 14
 Group
 1980 Hirschl & Adler, no. 32

36.13
STORM CLOUDS
1936

Collection: Unidentified

Provenance: (Downtown Gallery)

Exhibitions: Individual
 1936 American Place, no. 1
 1952 Downtown, no. 12

36.14
SUNRISE I
1936 (doc)
25 × 35
Signed, lower center

Collection: William H. Lane Foundation, Leominster, Mass. (1954)

Provenance: (Downtown Gallery)

Exhibitions: Individual
 1937 American Place, no. 1
 1961 Worcester, Mass., no. 19
 1974 San Francisco Museum, dated 1937
 Group
 1938 Worcester, Mass., no. 33
 1958 Whitney
 1966 New York City, Public Education Association

36.15
SUNRISE II
1936 (doc)
25 × 35

Collection: Unidentified

Provenance: (Downtown Gallery)
 Mr. and Mrs. Richard J. Gonzalez, Houston, Tex.
 American Craft Council, New York City

Exhibitions: Individual
 1937 American Place, no. 2
 1956 Downtown, no. 16
 1958 Whitney, no. 58
 1974 San Francisco, dated 1937

36.12

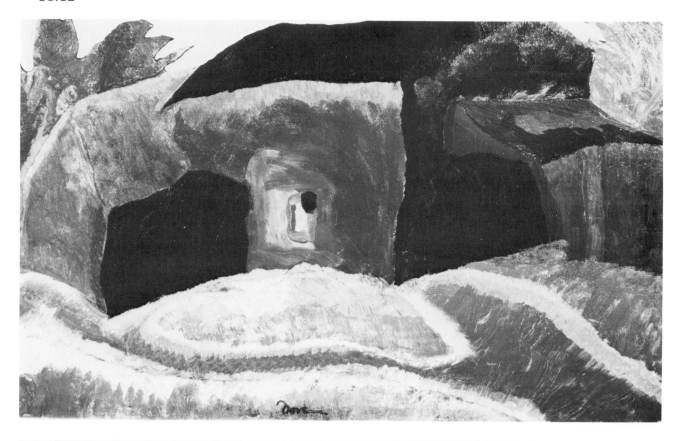

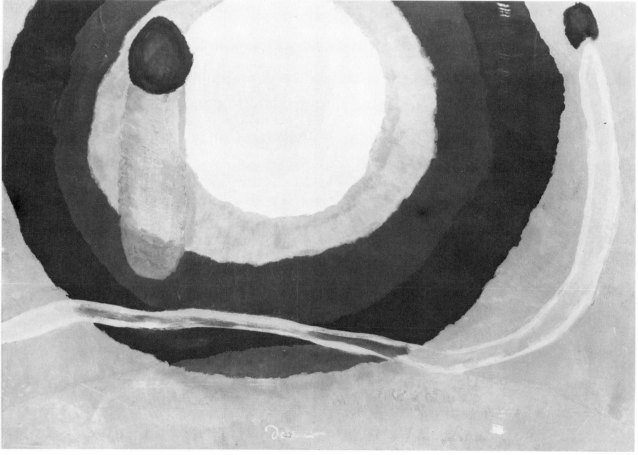

36.14

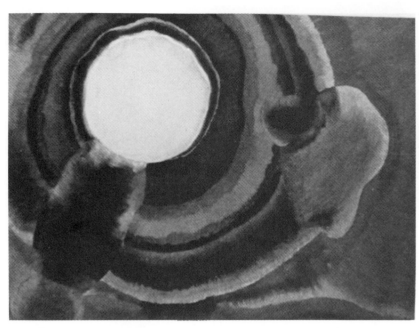

Provenance: (Downtown Gallery)
　　Katherine Dreier (1948)
　　Société Anonyme (gift of Katherine Dreier)

Exhibitions: Individual
　　1937 American Place, no. 3
　　1947 Downtown, no. 20
　　1958 Whitney, no. 59
　　1972 Dintenfass, no. 11, dated 1937
　　1974 San Francisco Museum, dated 1937
　　Group
　　1952 New London, Conn.
　　1953 Norwich, Conn.
　　1976 MOMA.
　　1977 Houston, Tex.

36.17
TRAIN COMING AROUND THE BEND
1935–36 (doc)
16 × 21½
Signed, lower center

Collection: Terry Dintenfass Gallery

Provenance: (An American Place)
　　(? Downtown Gallery)
　　Dr. Mary C. Holt, Bay Shore, N.Y.

Exhibitions: Individual
　　1936 American Place, no. 14, erroneously titled
　　　　　Train Coming Around the Fence
　　1967 Huntington, N.Y., no. 16, titled *Train Com-
　　　　　ing Round the Bend*

36.15

36.16
SUNRISE III
1936 (doc)
25 × 35⅛
Signed, lower center

Collection: Yale University Art Gallery, New Haven,
　　Conn. (gift of Collection Sociétê Anonyme, 1949)

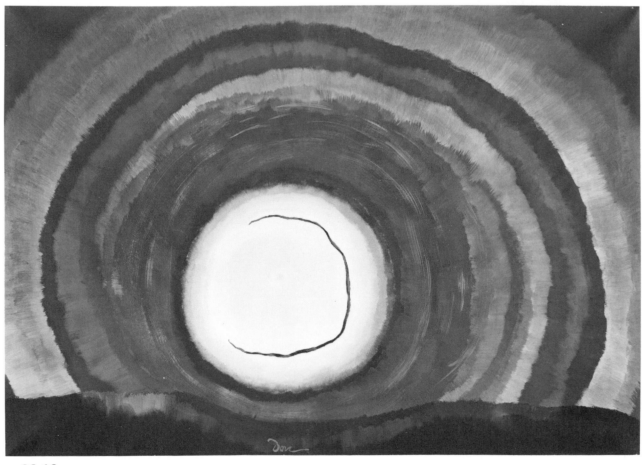

36.16

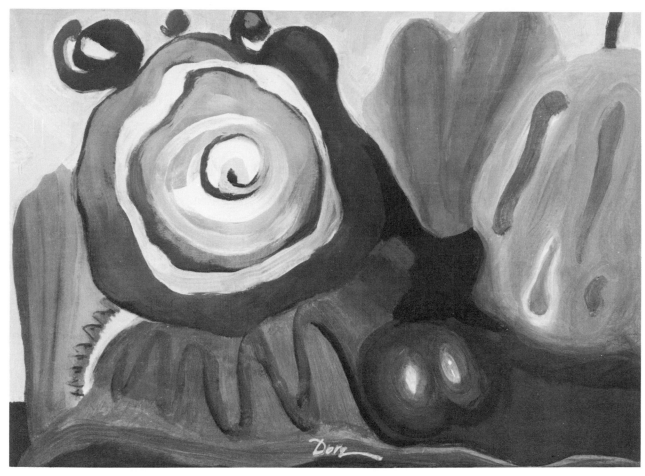

36.17

36.18
WILLOW SISTERS
1936 (doc)
14½ × 20⅝
Signed, lower center

Collection: Private collection (1976)

Provenance: (An American Place)
 Barton Perry, Mill Valley, Calif. (1937)
 (Terry Dintenfass Gallery)

Remarks: This painting is probably identical to the
 "Wet Willows" on which Dove was working in
 January 1936, according to Reds' diary.

Exhibitions: Individual
 1936 American Place, no. 3
 1947 Downtown (San Francisco only)
 1975 Dintenfass, "Arthur G. Dove: The Abstract
 Work," no. 5

36.19
WINDY MORNING
1936
19½ × 27¾
Not signed

Collection: Harvey and Francoise Rambach, New
 York City

Provenance: (An American Place)
 Barton Perry

Extended loan to San Francisco Museum of Art
(Kraushaar Galleries)

Exhibitions: Individual
 1936 American Place, no. 8
 1947 Downtown (San Francisco only)

1937

37.1
ANCHORAGE
1937
10 × 14

Collection: Unidentified

Provenance: (An American Place)

Exhibition: Individual
 1937 American Place, no. 20

37.2
CANANDAIGUA OUTLET, OAKS CORNERS
1937
Support not verified
10½ × 17½
Signed, lower center

Collection: Unidentified

Provenance: (Downtown Gallery)
 Brown (1957)

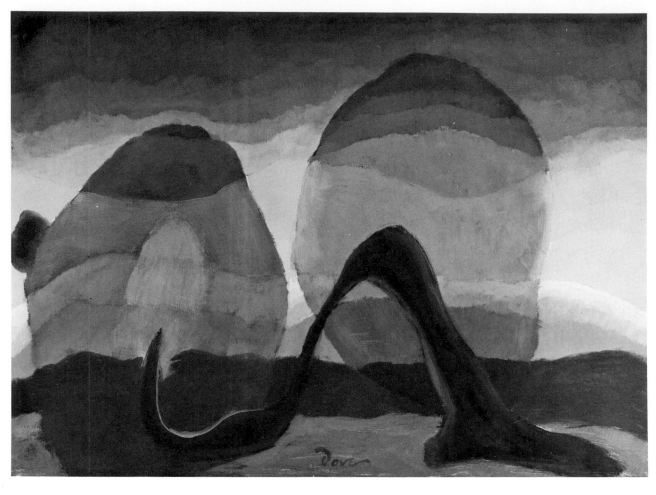

36.18

Exhibitions: Individual
 1937 American Place, no. 13
 1956 Los Angeles, Calif., no. 15

37.3
A CHEWING COW
1936–37 (doc)
15 × 21

Collection: Unidentified

Provenance: (Downtown Gallery)
 American University, Washington, D.C. (1948)

Exhibition: Individual
 1937 American Place, no. 14

37.4
CUTTING TREES IN PARK
1937 (doc)
Support not verified

Collection: Unidentified

Provenance: (An American Place)

Exhibition: Individual
 1938 American Place, no. 22

37.5
FREIGHT CAR
1937 (doc)
20 × 28
Signed, lower center

Collection: Inland Steel Company, Chicago, Ill.
 (1957)

Provenance: (Downtown Gallery)

Remarks: Permission to publish a photograph of this
 painting denied by the owner.

Exhibition: Individual
 1938 American Place, no. 16.

Reference: Morgan, Ann Lee. "Toward the Definition
 of Early Modernism in America: A Study of Ar-
 thur Dove." Ph.D. thesis, University of Iowa, 1973.
 Illustration p. 522.

37.6
FROM TREES
1937
15 × 21
Signed, lower center

Collection: Sheldon Memorial Art Gallery, Univer-
 sity of Nebraska, Lincoln (F. M. Hall Collection,
 1955)

Provenance: (Downtown Gallery)

Exhibitions: Individual
 1937 American Place, no. 15
 1945 American Place, no. 4, dated 1937
 1968 MOMA (touring), no. 20
 Group
 1946 Minneapolis, Minn., no. 33
 1951 Houston, Tex., no. 11

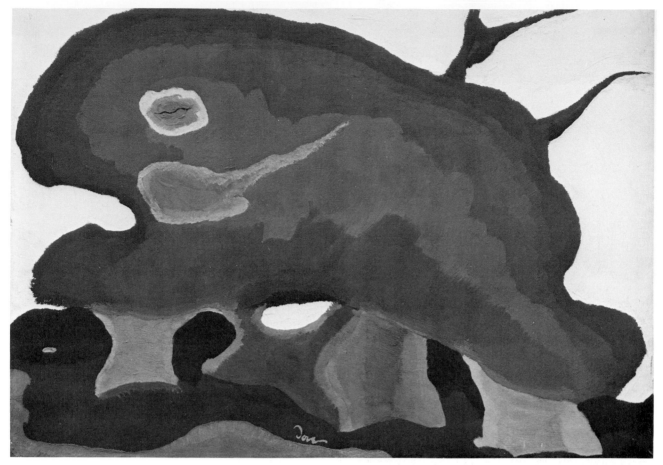

37.6

37.7
GOLDEN SUN
1937
13¾ × 9¾
Signed, lower center

Collection: Georgia O'Keeffe, Abiquiu, N.M.

Provenance: (An American Place)

Exhibitions: Individual
 1937 American Place, no. 18
 1974 San Francisco Museum, titled *Golden Sun-light*

37.8
HAPPY LANDSCAPE
1937
10 × 14
Signed, lower center

Collection: Smith College Museum of Art, North-ampton, Mass. (gift of Douglas and Darcy Davis Spencer)

Provenance: (An American Place)
 Georgia O'Keeffe
 Douglas and Darcy Davis Spencer

Exhibition: Individual
 1937 American Place, no. 19

37.9
LEANING SILO
1937 (doc)
20 × 28
Signed, lower center

Collection: Unidentified

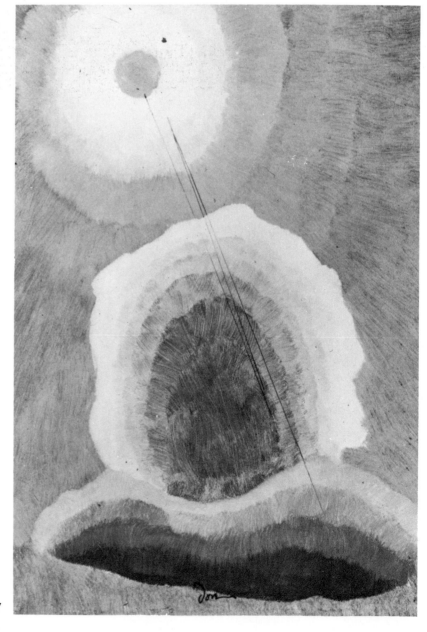

37.7

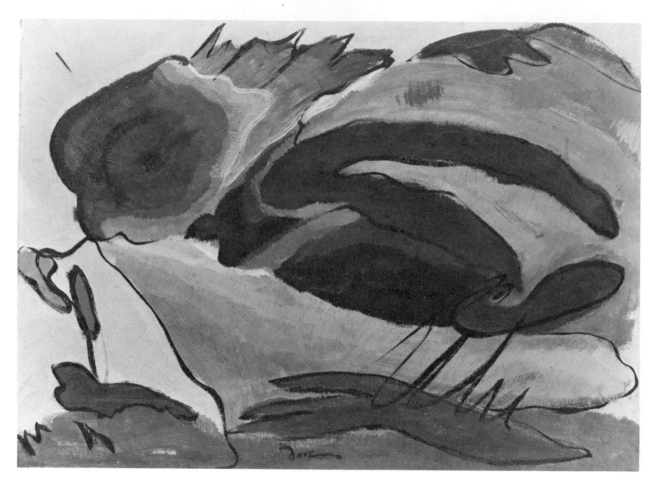

37.8

Provenance: (An American Place)

Exhibition: Individual
 1937 American Place, no. 11

37.10
REMINISCENCE
1937
14½ × 20½
Signed, lower center

Collection: Phillips Collection, Washington, D.C.
 (1937)

Provenance: (An American Place)

Exhibitions: Individual
 1937 American Place, no. 16
 1947 Phillips
 1953 Corcoran
 1974 San Francisco Museum (not in catalogue)
 1981 Phillips, no. 47

37.11
(RISE OF THE FULL MOON)
1937 (doc)
18 × 26
Signed, lower center

Collection: Phillips Collection, Washington, D.C.
 (1939)

Provenance: (An American Place)
 Alfred Stieglitz, New York City

Exhibitions: Individual
 1937 American Place, no. 12, titled *Me and the
 Moon*
 1947 Phillips
 1953 Corcoran
 1954 Ithaca, N.Y., no. 22
 1958 Whitney, no. 57
 1981 Phillips, no. 48
Group
 1937 Cleveland Museum
 1944 Phillips
 1957 Lynchburg, Va.
 1975 Phillips (touring)

37.12
SUMMER ORCHARD
1937
15 × 21
Signed, lower center

Collection: Munson-Williams-Proctor Institute,
 Utica, N.Y. (bequest of Edward W. Root, 1957)

Provenance: (An American Place)
 (? Downtown Gallery)
 Edward W. Root, Clinton, N.Y.

Exhibitions: Individual
 1937 American Place, no. 6
 1967 Geneva, N.Y.
 1974 San Francisco Museum

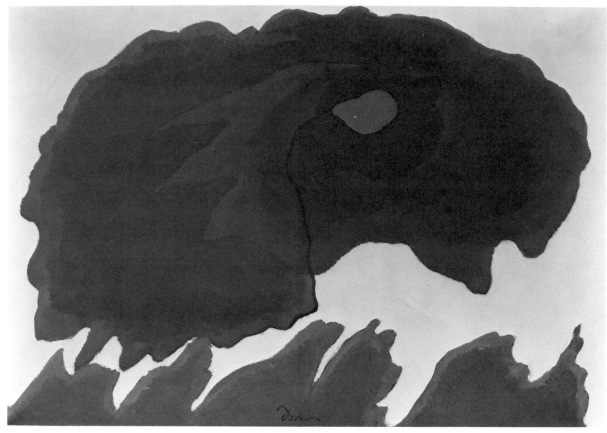

37.10

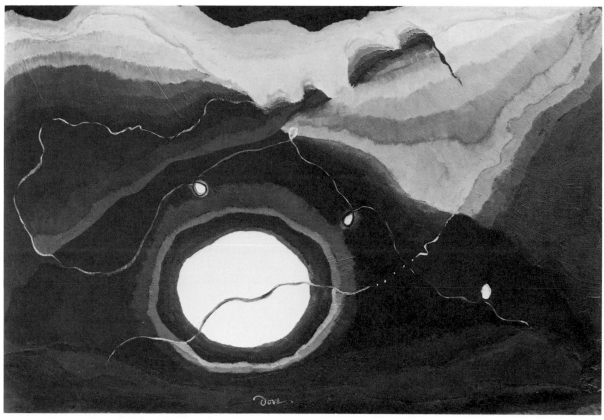

37.11

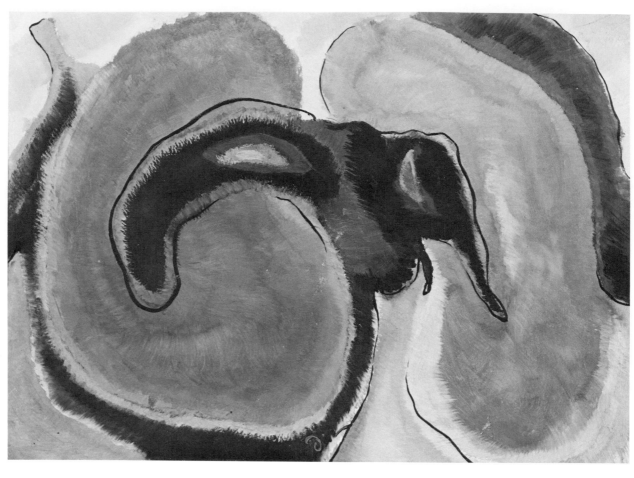

37.12

Group
1959 Schenectady, N.Y.
1960 Utica, N.Y.
1961 Schenectady, N.Y.
1969 Amherst, Mass.

37.13
SUNRISE IV
1937 (doc)
10 × 14⅛
Signed, lower center

Collection: Hirshhorn Museum and Sculpture Garden, Smithsonian Institution, Washington, D.C.

Provenance: (Downtown Gallery)
Dr. and Mrs. Michael Watter, Philadelphia, Penn. (1952)
(Parke-Bernet auction, 19 October 1967)
Joseph H. Hirshhorn, New York City (1967)

Exhibitions: Individual
1937 American Place, no. 4
Group
1951 Houston, Tex., no. 13
1957 Philadelphia Museum
1958 Pennsylvania Academy
 Philadelphia Museum
1967 Pennsylvania Academy
1974 Hirshhorn Museum

37.14
TREE COMPOSITION
1937
15¼ × 21
Signed, lower center

Collection: Munson-Williams-Proctor Institute, Utica, N.Y. (bequest of Edward W. Root, 1957)

Provenance: (An American Place)
(? Downtown Gallery)
Edward W. Root, Clinton, N.Y.

Exhibitions: Individual
1937 American Place, no. 17
1939 American Place, no. 17, dated 1937
1945 American Place, no. 10, dated 1937
Group
1952 Metropolitan Museum
1959 Smithsonian (touring)
1960 Utica, N.Y.

37.15
WATER SWIRL, CANANDAIGUA OUTLET
1937
16 × 26
Signed, lower center

Collection: Dr. and Mrs. Max Ellenberg

Provenance: (Terry Dintenfass Gallery)

37.13

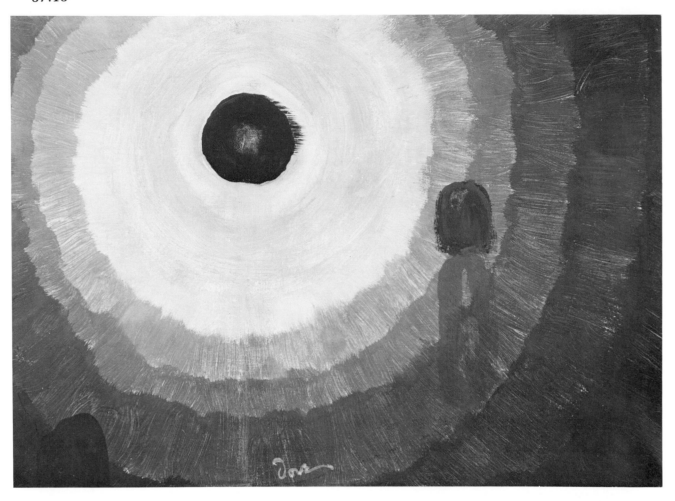

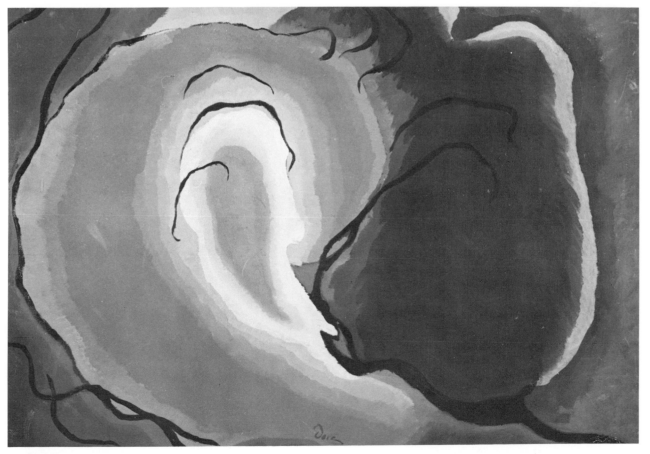

37.14

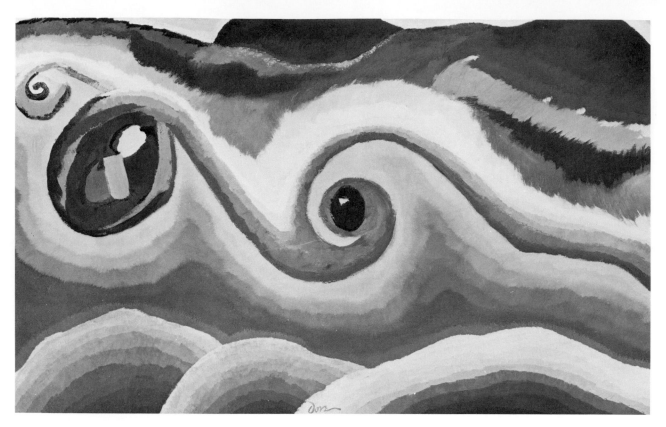

37.15

Exhibitions: Individual
 1937 American Place, no. 8
 1952 Downtown, no. 15
 1956 Los Angeles, Calif., no. 14
 1967 Huntington, N.Y., no. 10, titled *Water Swirl, Canandaigua*
 Group
 1967 West Palm Beach, Fla.

37.16
WILLOW TREE
1937 (doc)

20 × 28
Signed, lower center

Collection: Norton Gallery and School of Art, West Palm Beach, Fla. (1952)

Provenance: (Downtown Gallery)

Exhibitions: Individual
 1938 American Place, no. 12, titled *Willow-tree*
 1952 Downtown, no. 16
 1958 Whitney, no. 67

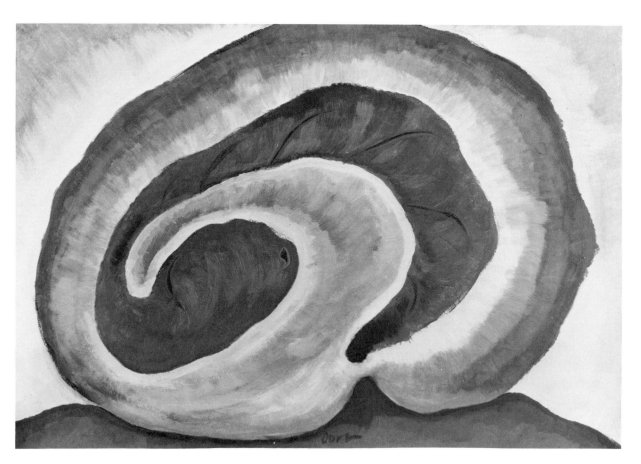

37.16

1938

38.1
BUILDING MOVING PAST A SKY
1938
34⅞ × 25
Signed, lower center

Collection: Tucson Museum of Art, Tucson, Ariz. (Lawrence J. Heller Collection, 1975)

Provenance: (An American Place)
Duncan Phillips, Washington, D.C. (1938)
Lawrence J. Heller, Washington, D.C. (gift of Duncan Phillips, 1961)

Exhibitions: Individual
1938 American Place, no. 4
1981 Phillips, no. 51

38.2
CARS IN A SLEET STORM
1937–38 (doc)
14½ × 20¼
Signed, lower center

Collection: Memorial Art Gallery, University of Rochester, Rochester, N.Y. (Marion Stratton Gould Fund)

Provenance: (An American Place)
(? Downtown Gallery)
Encyclopaedia Britannica Collection
Senator William Benton

Exhibitions: Individual
1938 American Place, no. 9, titled *Cars in Sleet and Storm*
1967 Geneva, N.Y.
1974 San Francisco Museum, dated 1925

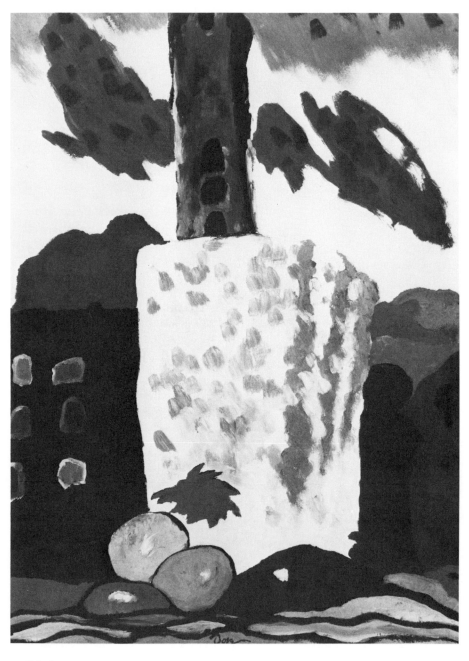

38.1

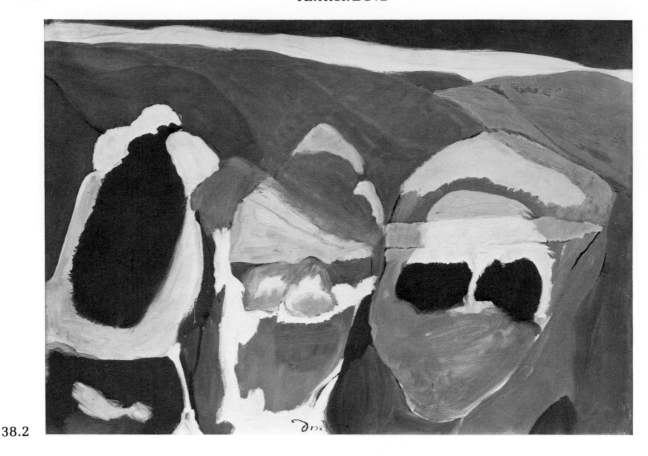

38.2

Group
1953 Syracuse, N.Y., no. 52
1964 Bloomington, Ind.
1973 Andrew Crispo Gallery, no. 64
1978 South Bend, Ind.
1982 Oklahoma City, Okla., no. 15, dated 1925

38.3
CITY MOON
1937–38 (doc)
35 × 25
Signed, lower center

Collection: Hirshhorn Museum and Sculpture Garden, Smithsonian Institution, Washington, D.C.

Provenance: (Downtown Gallery)
Joseph Shapiro, Oak Park, Ill.
(Harold Diamond)
Joseph H. Hirshhorn, New York City (1963)

Exhibitions: Individual
1938 American Place, no. 1
1958 Whitney, no. 61
Group
1951 Houston, Tex., no. 10
1974 Hirshhorn

Reference: Metzger, Robert Paul. "Biomorphism in American Painting." Ph.D. diss. University of California, Los Angeles, 1973.

38.4
FLOUR MILL I
1938
18 × 12

Signed, lower center

Collection: Max Zurier, Palm Springs, Calif.

Provenance: (Downtown Gallery)
Oliver B. James, Phoenix, Ariz. (1948)
(Downtown Gallery)

Exhibitions: Individual
1938 American Place, no. 10
Group
1949 Phoenix, Ariz.

38.5
FLOUR MILL II
1938 (doc)
26 × 16
Signed, lower center

Collection: Phillips Collection, Washington, D.C. (1938)

Provenance: (An American Place)

Remarks: Current museum title is *Flour Mill Abstraction*.

Exhibitions: Individual
1938 American Place, no. 11
1947 Downtown, no. 23
Phillips
1953 Corcoran
1954 Ithaca, N.Y., no. 23
1958 Whitney, no. 62
1974 San Francisco Museum (not in catalogue)
1981 Phillips, no. 54, titled *Flour Mill Abstraction*

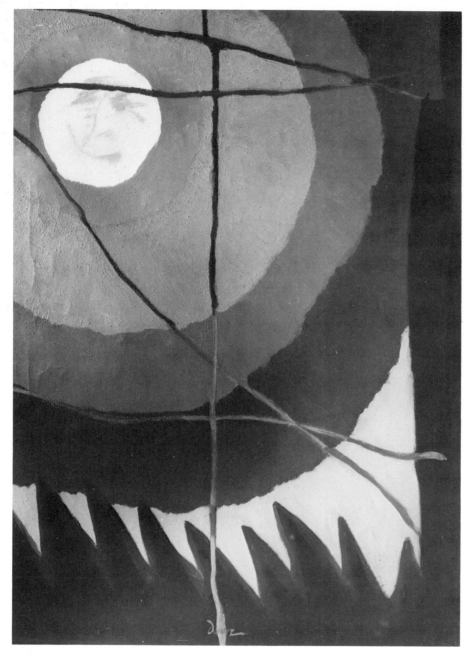

38.3

Group
1940 Baltimore, Md.
1943 Phillips
1944 Phillips, no. 64
1946 London, England
1951 Brooklyn Museum
1979 Düsseldorf, Germany

38.6
FOOT OF LAKE
1938
6 × 8
Signed, lower center

Collection: Yale University Art Gallery, New Haven, Conn. (gift of George Hopper Fitch, B.A. 1932, 1976)

Provenance: (Downtown Gallery)
George Hopper Fitch, San Francisco, Calif. (1946)
Exhibition: Individual
1938 American Place, no. 21

38.7
GRAPHITE AND BLUE
1938 (doc)
25 × 35
Signed, lower center

Collection: Warren and Jane Shapleigh, Saint Louis, Mo.

Provenance: (Downtown Gallery)
Mr. and Mrs. Irving Levick, Buffalo, N.Y. (1959)
(Bertha Schaefer Gallery)

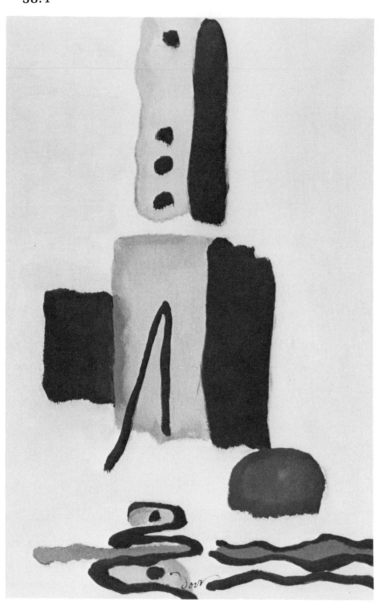

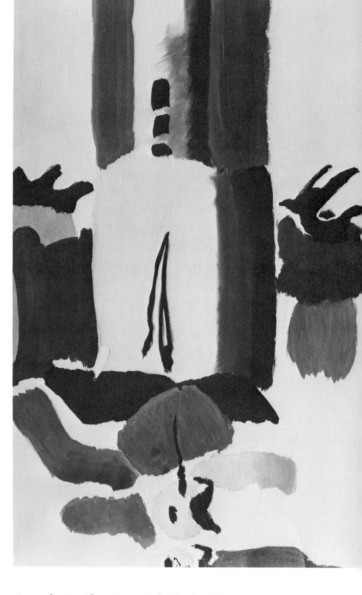

Exhibitions: Individual
 1939 American Place, no. 9, dated 1939
 1947 Downtown (San Francisco only), dated 1936
 1956 Los Angeles, no. 16
 1968 MOMA (touring), dated 1936
 1974 San Francisco Museum, dated 1936
 Group
 1951 Houston, Tex., no. 6
 1981 Munich, Germany

38.8
GREEN, BLACK AND WHITE
1938
17½ × 25½
Signed, lower center
Collection: Earl Goldberg, Los Angeles, Calif. (1982)
Provenance: (Downtown Gallery)

Joseph R. Shapiro, Oak Park, Ill.
(B.C. Holland Gallery, Chicago, Ill.)
Mr. and Mrs. Eugene V. Thaw, New York City
(Parke-Beret auction for benefit of Whitney
Museum of American Art, 11 May 1966)
Edith Halpert, New York City
(Sotheby Parke Bernet auction, 14 March 1973)
Mr. Voss, Boston
(Terry Dintenfass Gallery)
(Asher/Faure Gallery, Los Angeles, Calif.)

Exhibitions: Individual
 1938 American Place, no. 15
 1981 Los Angeles, Calif., no. 1, titled Green,
 Black and Gray, dated 1942
 Group
 1980 San Francisco, Calif., titled Green, Black
 and Gray
 1982 Oklahoma City, Okla., no. 16, titled Green,
 Black and Gray, dated 1942

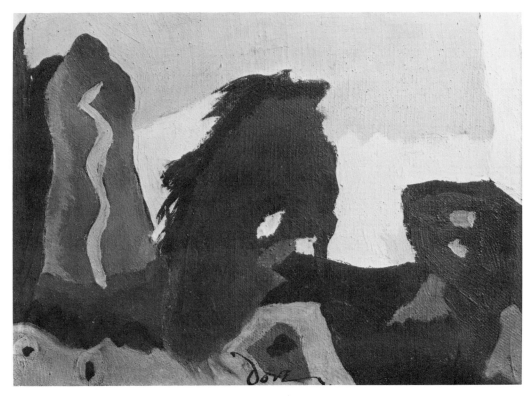

38.6

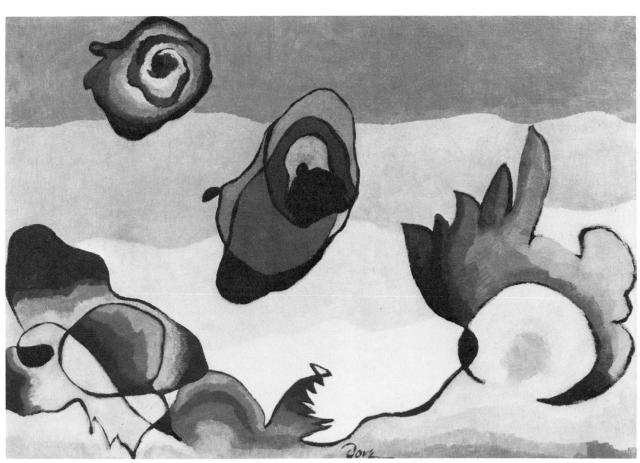

38.7

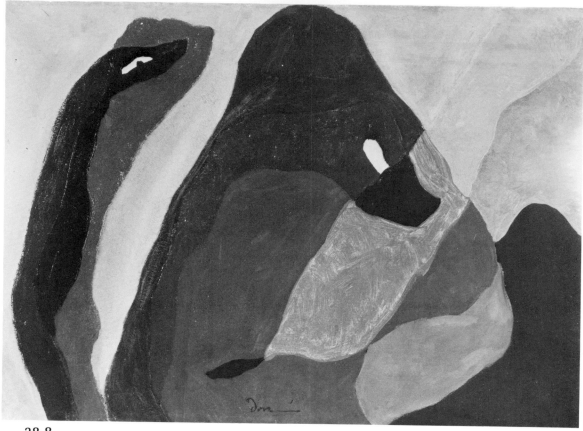

38.8

38.9
HARDWARE STORE
1938 (doc)
25 × 35
Signed, lower center

Collection: Loretta and Robert K. Lifton, New York
City

Provenance: (An American Place)
(? Downtown Gallery)
Mr. and Mrs. John Palmer Leeper, San Antonio,
Tex.

Exhibitions: Individual
1939 American Place, no. 10, titled *Hardware
Store Window*, dated 1939
1958 Whitney, no. 63
1968 MOMA (touring), no. 24
1972 Dintenfass, no. 12
1974 San Francisco Museum

38.10
HOLBROOK'S BRIDGE TO NORTHWEST
1937–38 (doc)
25 × 35
Signed, lower center

Collection: Roy R. Neuberger, New York City (1950)

Provenance: (Downtown Gallery)

Remarks: The artist dedicated this painting to the
memory of Newton Weatherly of Geneva, N.Y., an
amateur painter and naturalist who had died in
1935. Dove's affection for Weatherly went back to

childhood, when he had learned about both paint-
ing and nature from him. In a letter written to
Stieglitz on 25 March 1938, Dove said of this
painting:

That was a devotional thing to my 100-year-old
friend Mr. Weatherly with whom I used from
the age of 5 to go fishing there. And he made a
prayer each year that he would see it again.

Exhibitions: Individual
1938 American Place, no. 2, titled *Hollbrook
Bridge to N.W.*
1958 Whitney, no. 64, titled *Holbrook's Bridge,
Northwest*
1974 San Francisco Museum, titled *Holbrook's
Bridge to the Northwest*
Group
1951 New York, New Art Circle, no. 3
1952 Minneapolis, Minn., no. 40
1953 South Hadley, Mass. no. 5
1954 Whitney, no. 25
1956 Boston, Mass.
1957 New York, Fieldston School Arts Center,
no. 4
1960 M. Knoedler, no. 15
1961 Chicago, Ill.
Dallas, Tex., no. 9
1962 Ann Arbor, Mich., no. 10
1963 Portland, Ore., no. 8
1966 Syracuse, N.Y., no. 17
1971 Carnegie Institute, no. 36

38.9

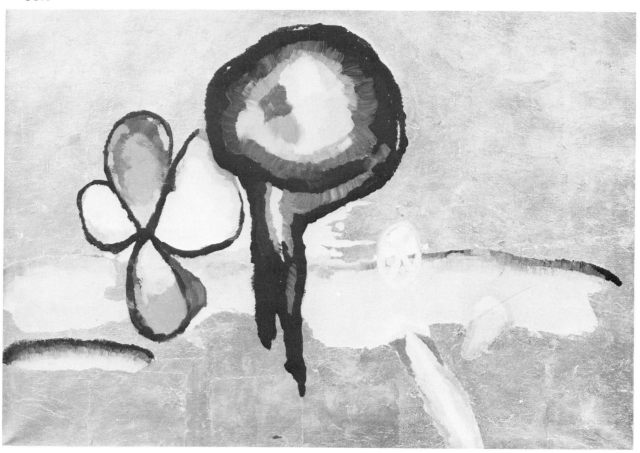

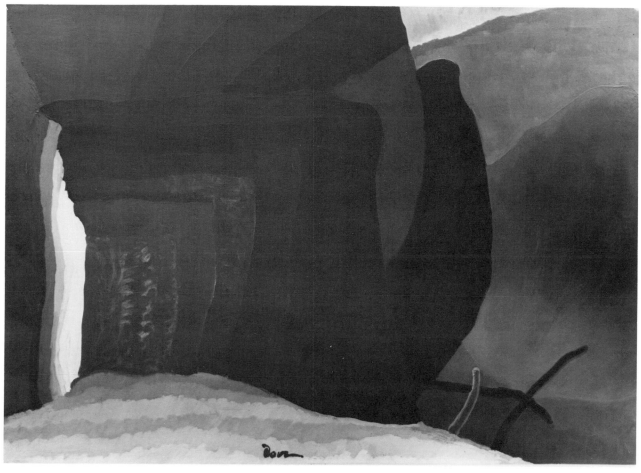

38.10

38.11

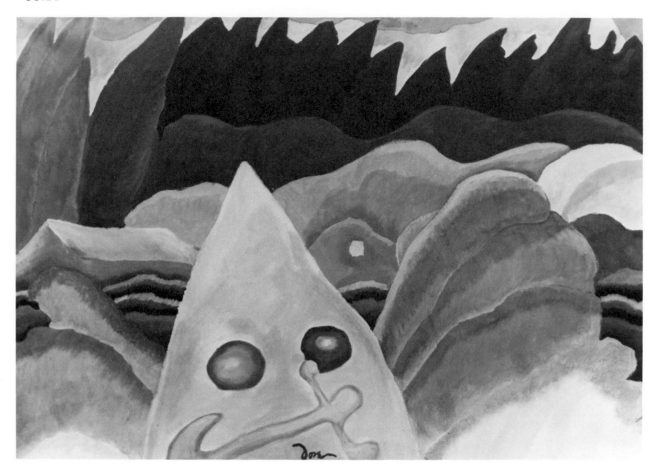

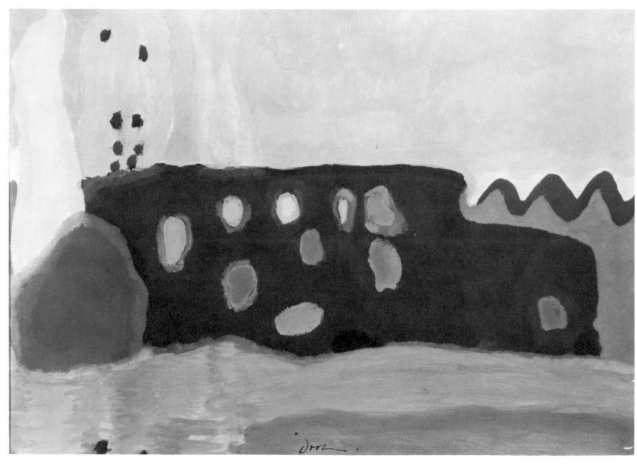

38.12

38.11
MOTOR BOAT
1938
25 × 35
Signed, lower center

Collection: William H. Lane Foundation, Leominster, Mass. (1956)

Provenance: (Downtown Gallery)

Exhibitions: Individual
 1938 American Place, no. 3
 1961 Worcester, Mass., no. 23

38.12
OLD BOAT WORKS
1938
12 × 17
Signed, lower center

Collection: Private collection

Provenance: (An American Place)
 (? Downtown Gallery)

Exhibition: Individual
 1938 American Place, no. 19

38.13
POWER PLANT I
1938 (doc)
25 × 35
Signed, lower center

Collection: Unidentified

Provenance: (Terry Dintenfass Gallery)
 (Barbara Mathes Gallery)

Exhibitions: Individual
 1938 American Place, no. 6
 1956 Downtown, no. 17
 1967 Huntington, N.Y., no. 12
 Group
 1982 San Francisco, Calif.

38.14
POWER PLANT II
1938 (doc)
25 × 35
Signed, lower center

Collection: Norton Gallery and School of Art, West
 Palm Beach, Fla. (1957)

Provenance: (Downtown Gallery)

Exhibitions: Individual
 1938 American Place, no. 11
 1956 Downtown, no. 17

38.15
SEA GULLS
1938
16 × 26
Signed, lower center

Collection: Heckscher Museum, Huntington, N.Y.

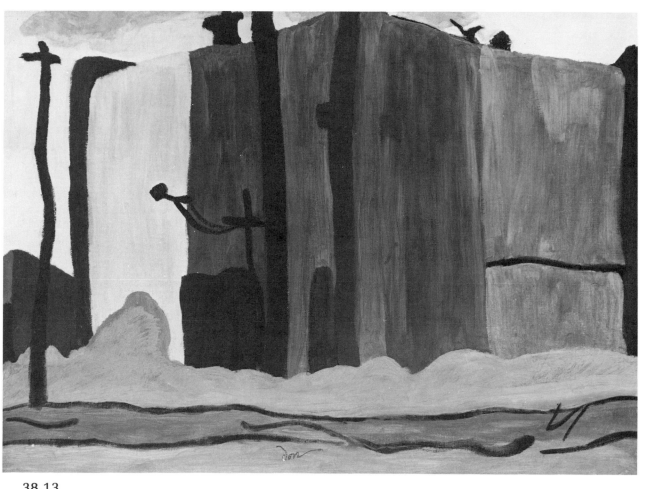

38.13

38.14

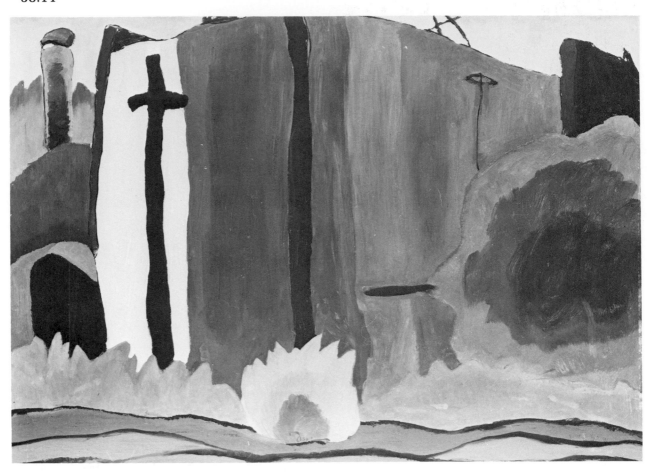

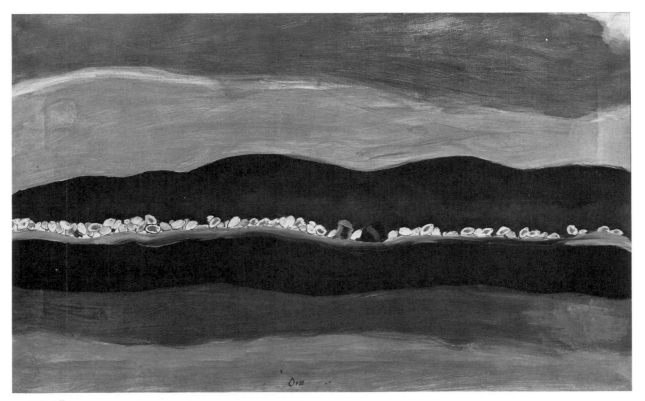

38.15

(gift of William Dove in memory of Dorothy Loynes)

Provenance: Dr. Dorothy Loynes (gift of the artist, 1938)

Helen Dove, Centerport, N.Y. (bequest of Dr. Dorothy Loynes, 1967)

William C. Dove, Mattituck, N.Y. (gift of Helen Dove, 1967)

Exhibition: Individual
1938 American Place, no. 17

38.16
SENECA LAKE
1938
6 × 8
Signed, lower center

Collection: Private collection

Provenance: (An American Place)
Mrs. Foster Boswell, Geneva, N.Y.

Exhibition: Individual
1938 American Place, no. 18

38.17
SHORE FRONT
1938
22 × 36
Signed, lower center

Collection: Phillips Collection, Washington, D.C. (1938)

Provenance: (An American Place)

Exhibitions: Individual
1938 American Place, no. 14
1947 Phillips
1953 Corcoran

38.16

1967 College Park, Md., painting no. 9
1981 Phillips, no. 53
Group
1939 Syracuse, N.Y.
1940 American Federation of Arts (touring)
1945 Pennsylvania Academy
1965 Carnegie Institute
1976 San Jose, Calif.

38.18
SUN AND THE LAKE
1938

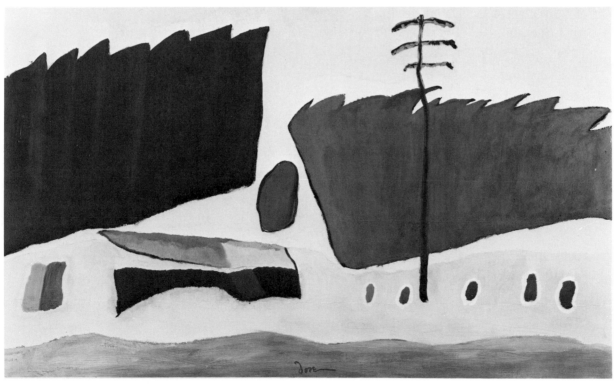

38.17

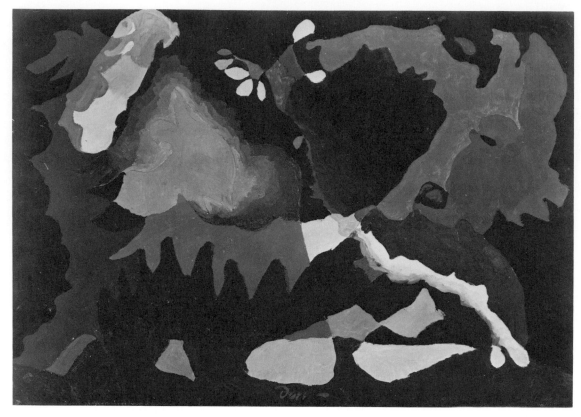

38.19

22 × 36

Signed, lower center

Collection: William H. Lane Foundation, Leominster, Mass.

Provenance: (Downtown Gallery)

Exhibitions: Individual
 1938 American Place, no. 8
 1961 Worcester, Mass., titled *Sun on the Lake*

38.19
SWING MUSIC (LOUIS ARMSTRONG)
1938 (doc)
17⅝ × 25⅞
Signed, lower center

Collection: Art Institute of Chicago, Chicago, Ill. (gift of Georgia O'Keeffe from the estate of Alfred Stieglitz, 1949)

Provenance: (An American Place)
 Alfred Stieglitz, New York City

Exhibitions: Individual
 1938 American Place, no. 13
 1939 American Place, no. 2
 Group
 1939 Pennsylvania Academy
 1940 American Place, no. 18
 Cleveland Museum
 1941 American Place, titled *Swing*
 1944 Philadelphia Museum, no. 260
 1948 AIC

38.20
TANKS
1937–38 (doc)

25 × 35

Signed, lower center

Collection: William H. Lane Foundation, Leominster, Mass. (1953)

Provenance: (Downtown Gallery)

Exhibitions: Individual
 1938 American Place, no. 5
 1958 Whitney, no. 66
 1961 Worcester, Mass., no. 22

38.21
UP THE ALLEY
1938

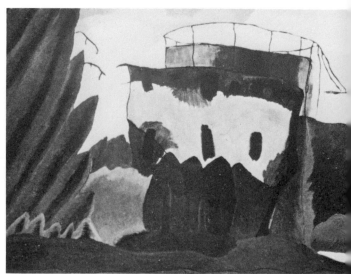

38.20

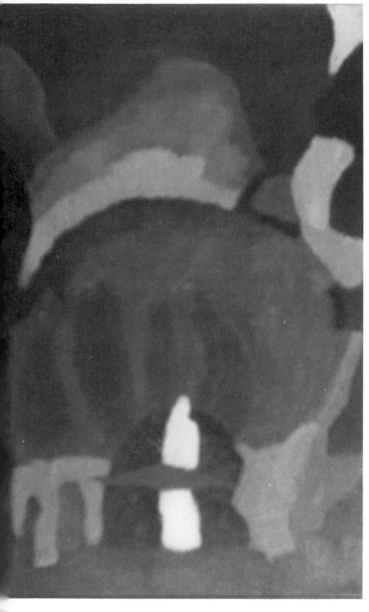

14 × 10

Signed, lower center

Collection: Mr. and Mrs. Laurence S. Pollock, Dallas, Tex.

Provenance: (Downtown Gallery)
Kaye (1955)
(Stephen Wohn Gallery)

38.22
WOOD PILE
1937–38 (doc)
10 × 14

Collection: Private collection (1971)

Provenance: (Terry Dintenfass Gallery)

Exhibitions: Individual
1938 American Place, no. 20
1967 Huntington, N.Y., no. 11
Group
1951 Houston, Tex., no. 12

1939

39.1
CONTINUITY
1939 (doc)
6 × 8

Signed, lower center

Collection: Unidentified

Provenance: (An American Place)

Exhibition: Individual
1940 American Place, no. 19

39.2
OUT THE WINDOW
1939 (doc)
15⅛ × 21

Signed, lower center

Collection: Saint Louis Art Museum, Saint Louis, Mo.

Provenance: (Downtown Gallery)

Exhibitions: Individual
1940 American Place, no. 6, titled *Out of the Window*
Group
1964 Downtown

39.3
WHAT HARBOR
1939
16 × 26

Signed and dated 39, lower center

Collection: William H. Lane Foundation, Leominster, Mass. (1957)

Provenance: (Downtown Gallery)

Exhibitions: Individual
1940 American Place, no. 9
1952 Downtown, no. 18
1961 Worcester, Mass., no. 25

1940

40.1
ACROSS THE ROAD [NO. 1]
1940
16 × 26

Signed, lower center

Collection: University Art Collections, Arizona State University, Tempe (Oliver B. James Collection of American Art, 1951)

Provenance: (Downtown Gallery)
Oliver B. James, Phoenix, Ariz. (1950)

Exhibitions: Individual
1940 American Place, no. 7
Group
1964 Flagstaff, Ariz.
1965 Tempe, Ariz.

38.22

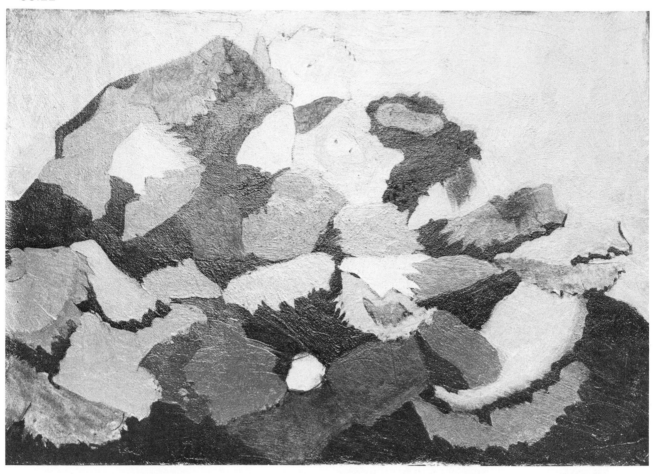

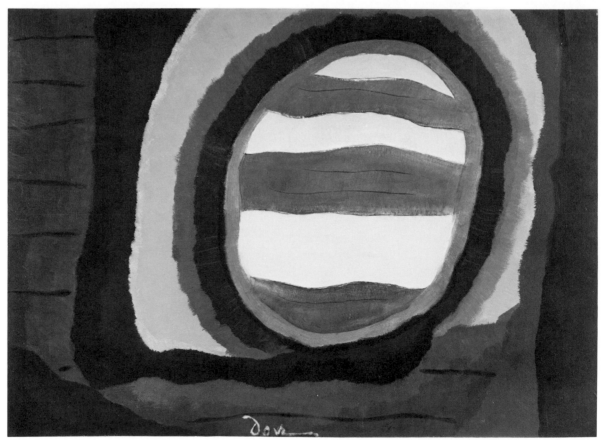

39.2

39.3

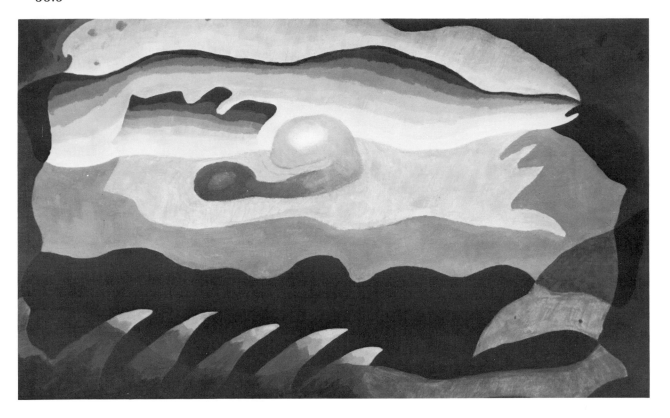

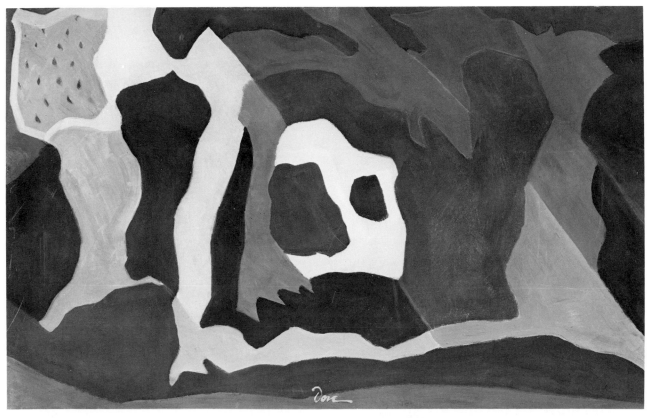

40.1

40.2
BEACH
1940 (doc)
20 × 32
Collection: Unidentified
Provenance: (Downtown Gallery)
 Makler (1958)
Exhibitions: Individual
 1940 American Place, no. 1
 Group
 1967 Pennsylvania Academy

40.3
FACESCAPE
1940
6 × 8
Signed, lower center
Collection: Unidentified
Provenance: (An American Place)
Exhibition: Individual
 1940 American Place, no. 16

40.4
A FEW SHAPES
1940
21 × 15
Signed, lower center
Collection: Museum of Fine Arts, Boston, Mass.
 (Emily L. Ainsley Fund, 1969)
Provenance: (Downtown Gallery)

Exhibitions: Individual
 1940 American Place, no. 5
 1952 Downtown, no. 17

40.5
THE GREEN BALL
1940 (doc)
12½ × 20
Signed, lower center
Collection: Phillips Collection, Washington, D.C.
 (1940)
Provenance: (An American Place)
Exhibitions: Individual
 1940 American Place, no. 12
 1947 Phillips
 1981 Phillips, no. 56

40.6
GREEN LIGHT
1940 (doc)
15 × 21
Signed, lower center
Collection: Watkins Gallery, American University,
 Washington, D. C. (gift of Duncan Phillips, 1950)
Provenance: (An American Place)
 Duncan Phillips, Washington, D.C. (1945)
Exhibitions: Individual
 1941 American Place, no. 14
 1947 Phillips
 1981 Phillips, no. 64

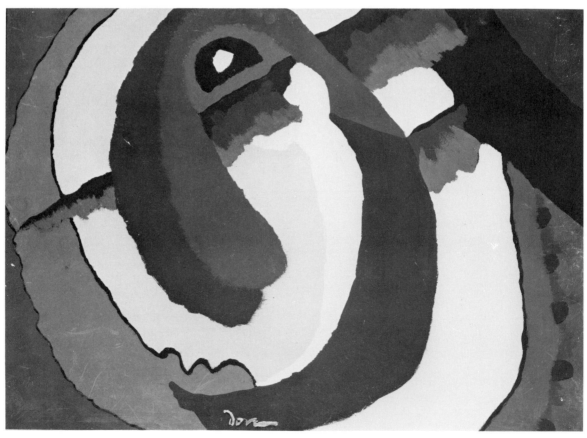

40.4

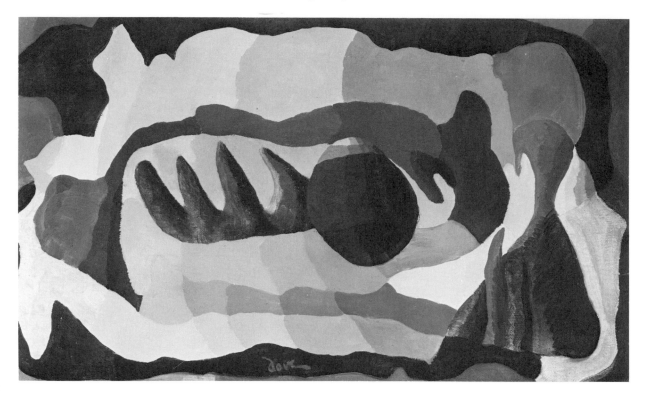

40.5

40.7
HARBOR
1940
$10^{5}/_{8} \times 17^{5}/_{8}$
Signed, lower center

Collection: Albert Petcavage, New York City (1971)

Provenance: (Terry Dintenfass Gallery)

Exhibitions: Individual
　　1940　American Place, no. 8
　　1945　American Place, no. 14, dated 1940
　　1972　Dintenfass, no. 13

40.8
ITALY GOES TO WAR
1940 (doc)
On panel
12×28
Signed, lower center

Collection: William C. Janss, Sun Valley, Idaho (1980)

Provenance: (Downtown Gallery)
　　Mrs. Sidney (Rosalie) Berkowitz (1949)
　　(Terry Dintenfass Gallery)

Remarks: Dove noted Italy's declaration of war in his diary on 10 June 1940.

Exhibitions: Individual
　　1941　American Place, no. 2
　　1947　Downtown, no. 25
　　1958　Whitney, no. 81
　　1975　Dintenfass, "Arthur G. Dove: The Abstract Work," no. 13

40.9
LONG ISLAND
1940 (doc)
20×32
Signed, lower center

Collection: Carl Lobell, New York City (1978)

Provenance: (Downtown Gallery)
　　Mr. and Mrs. George W. W. Brewster, Cambridge, Mass. (1962)
　　Galen Brewster, Concord, Mass.
　　(Chris Middendorf)

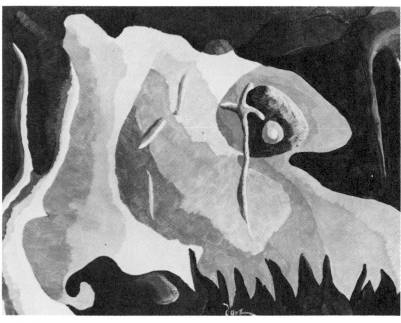

40.6

40.7

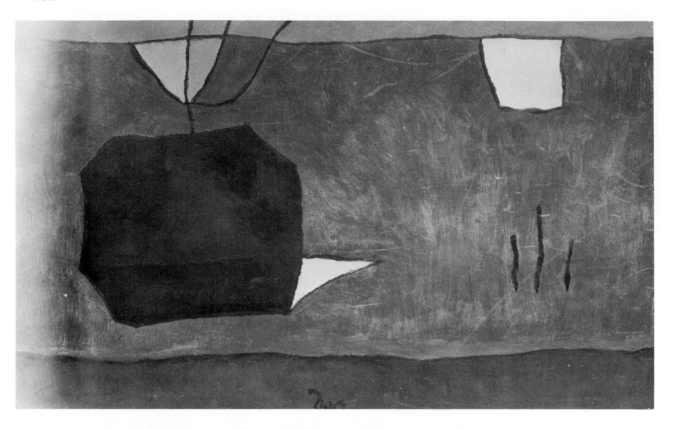

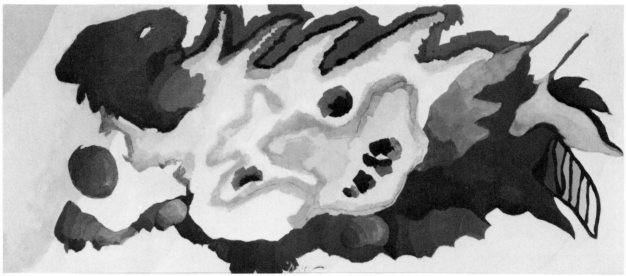

40.8

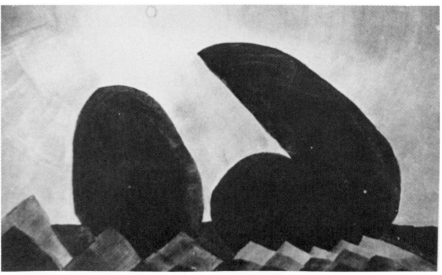

40.9

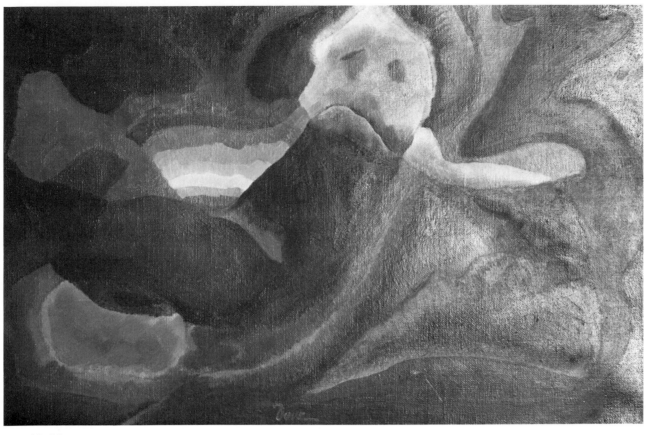

40.10

Exhibitions: Individual
 1940 American Place, no. 13
 1958 Whitney, no. 72
 1968 MOMA (touring), no. 26
 1974 San Francisco Museum

40.10
MORNING
1940
12 × 18
Signed, lower center

Collection: Hirshhorn Museum and Sculpture Garden, Smithsonian Institution, Washington, D.C.

Provenance: (Downtown Gallery)
 (Alan Gallery)
 Joseph H. Hirshhorn, New York City (1958)

Exhibitions: Individual
 1940 American Place, no. 11
 Group
 1941 American Place, no. 2, dated 1941

40.11
NO FEATHER PILLOW
1940
16 × 22
Signed, lower center

Collection: Munson-Williams-Proctor Institute, Utica, N.Y. (bequest of Edward W. Root, 1957)

 Provenance: (Downtown Gallery)
 Edward W. Root, Clinton, N.Y. (1946)

Exhibitions: Individual
 1940 American Place, no. 10
 1958 Whitney, no. 75
 1967 Geneva, N.Y.
 1968 MOMA (touring), no. 28
 1974 San Francisco Museum
 Group
 1952 Metropolitan
 1961 Utica, N.Y.

40.12
OUR HOUSE
1940 (doc)*
12 × 17
Signed, lower center

Collection: Private collection

Provenance: (An American Place)

Exhibitions: Individual
 1941 American Place, no. 9
 1945 American Place, no. 8, titled *Own House*,
 dated 1941
 1967 Huntington, N.Y., no. 17

40.13
PRIMARIES
1940
Gouache on paper mounted on canvasboard
5¼ × 7
Signed, lower center

Collection: Andrew Crispo Gallery

40.11

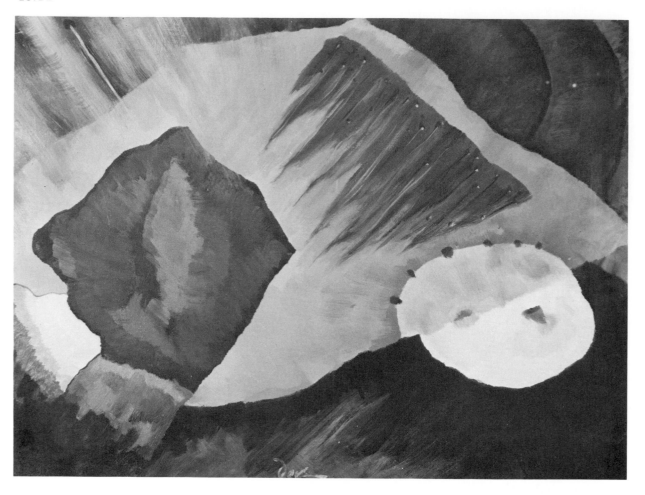

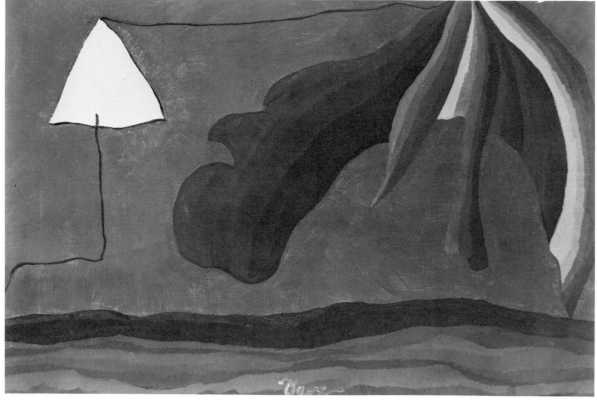

40.12

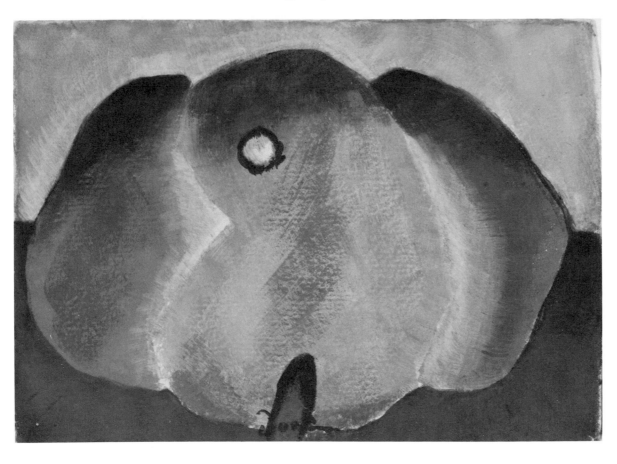

40.13

Provenance: (An American Place)
 Private collection

Exhibitions: Individual
 1940 American Place, no. 18
 Group
 1980 Crispo

40.14
RED, WHITE AND GREEN
1940
15 × 21⅛
Signed, lower center

Collection: Phillips Collection, Washington, D.C.
 (1940)

Provenance: (An American Place)

Exhibitions: Individual
 1940 American Place, no. 14
 1947 Phillips
 1981 Phillips, no. 61

40.15
RISING MOON
1940 (doc)
18 × 27
Signed, lower center

Collection: Unidentified

Provenance: (Downtown Gallery)
 J. Vandenbergh, Andover, Mass. (1948)

Exhibitions: Individual
 1941 American Place, no. 8

1945 American Place, no. 5, dated 1941
1947 Downtown, no. 36, dated 1944
 Utica, N.Y.
1958 Whitney, no. 84

40.16
SHAPES
1940 (doc)
11 × 18
Signed, lower center

Collection: Phillips Collection, Washington, D.C.
 (1941)

Provenance: (An American Place)

Remarks: Current museum title is *Shells.*

Exhibitions: Individual
 1941 American Place, no. 15
 1947 Phillips
 1981 Phillips, no. 67, titled *Shells,* dated 1941

40.17
SPIRAL ROAD
1940
6 × 8
Signed, lower center

Collection: Unidentified

Provenance: (An American Place)

Exhibitions: Individual
 1940 American Place, no. 15
 Group
 1967 Pennsylvania Academy

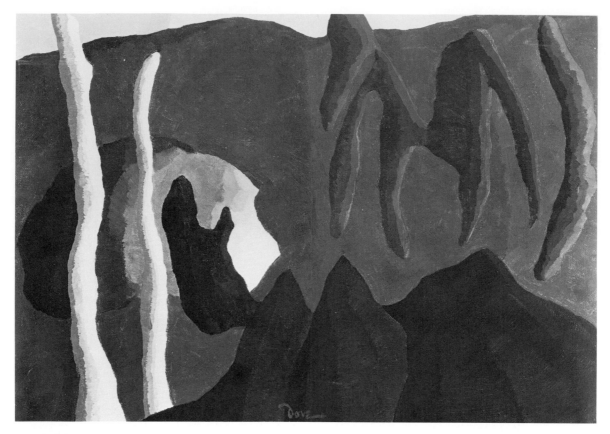

40.14

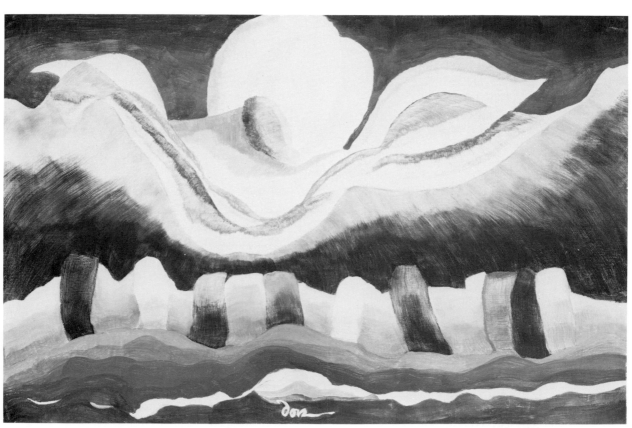

40.15

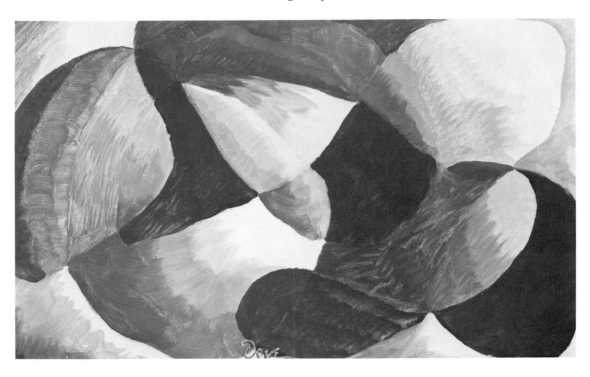

40.16

40.18
THUNDER SHOWER
1940 (doc)
20¼ × 32
Signed, lower center

Collection: Amon Carter Museum of Western Art, Fort Worth, Tex. (1967)

Provenance: (An American Place)
(? Downtown Gallery)
Dr. and Mrs. Michael Watter, Philadelphia, Penn.

(Parke-Bernet auction, 24 October 1967)

Exhibitions: Individual
1940 American Place, no. 4
1947 Downtown, no. 24, dated 1939
1958 Whitney, no. 68
Group
1952 Dallas, Tex., no. 10
1957 Philadelphia Museum
1958 Pennsylvania Academy
1967 Pennsylvania Academy

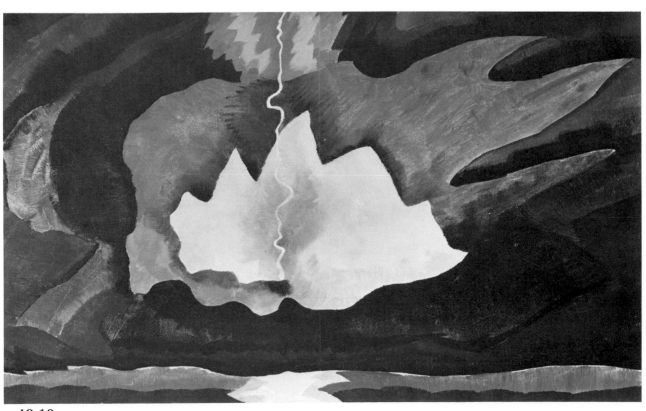

40.18

40.19
U.S.
1940
20 × 32
Signed, lower center

Collection: Sammlung Thyssen-Bornemisza, Casta-
gnola, Switzerland (1975)

Provenance: (An American Place)
Duncan Phillips, Washington, D.C. (1946)
Bernice Cross (gift of Duncan Phillips, 1950)
(Terry Dintenfass Gallery)
Carl Lobell, New York City (1975)
(Andrew Crispo Gallery)

Remarks: Sometimes titled *Color Carnival*.

Exhibitions: Individual
1940 American Place, no. 3
1947 Phillips
1975 Dintenfass, "Essences"
1981 Phillips, no. 62, titled *U.S. 1940*
Group
1940 American Place

40.20
WILLOWS
1940 (doc)
25 × 35
Signed, lower center

Collection: Museum of Modern Art (gift of Duncan
Phillips, 1941)

Provenance: (An American Place)
Duncan Phillips, Washington, D.C. (1940)

Exhibitions: Individual
1940 American Place, no. 2
1981 Phillips, no. 58
Group
1940 AIC
1941 Phillips, no. 120
1942 MOMA
1943 MOMA (touring)
1944 MOMA (touring)
1948 MOMA
1949 MOMA (touring)
1955 MOMA
 Paris, France
 MOMA (touring), no. 10
1958 Claremont, Calif.
1959 St. Louis Museum
1963 National Gallery
1976 MOMA

40.21
YELLOW BUSH
1940
5⅝ × 7⅝
Signed, lower center

Collection: William C. Janss, Sun Valley, Idaho
(1978)

Provenance: (An American Place)
Duncan Phillips, Washington, D.C. (1940)
Bernice Cross (gift of Duncan Phillips, 1942)
(Terry Dintenfass Gallery)

Exhibitions: Individual
1940 American Place, no. 17
1947 Phillips
1981 Phillips, no. 63

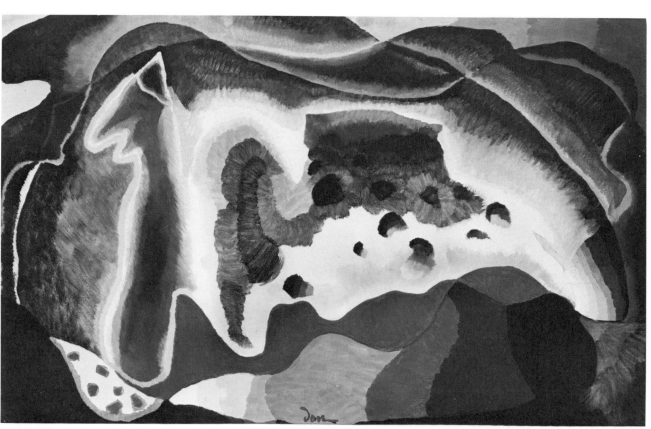

40.19

40.20

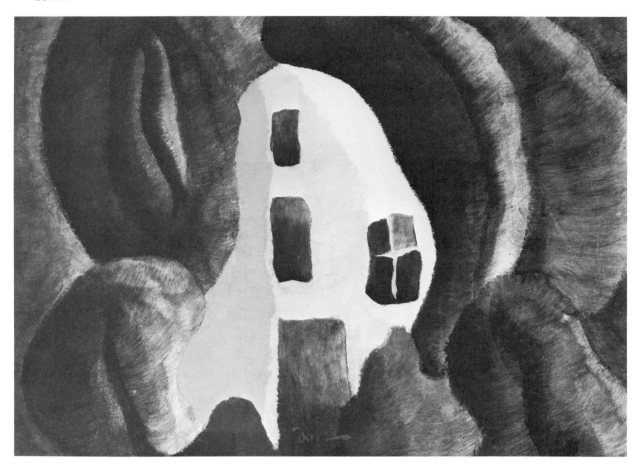

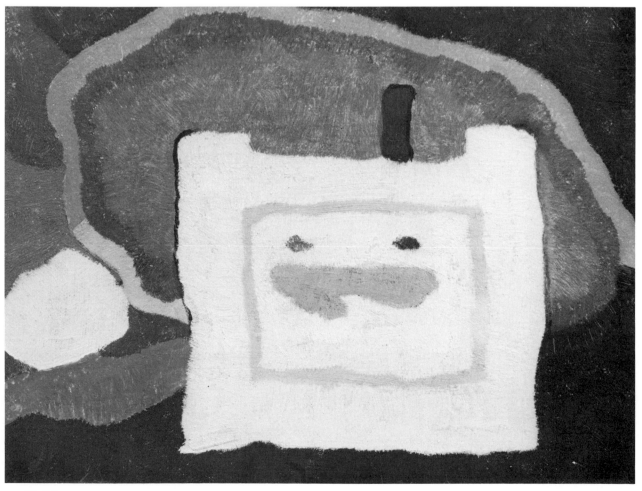

40.21

1941

41.1
ACROSS THE ROAD [NO. 2]
1941
25 × 35
Signed and dated 41, lower center

Collection: Dorothy S. Schramm, Burlington, Iowa (1951)

Provenance: (Downtown Gallery)

Exhibitions: Individual
 1942 American Place, no. 19
 1958 Whitney, no. 78
 1974 San Francisco
 Group
 1961 Iowa City, Iowa, no. 23

41.2
THE BROTHERS [NO. 1]
1941 (doc)
20 × 28
Signed and dated 41, lower center

Collection: Honolulu Academy of Arts, Honolulu, Hawaii (gift of Friends of the Academy, 1947)

Provenance: (Downtown Gallery)

Exhibitions: Individual
 1942 American Place, no. 15, titled "The Brothers"
 1947 Downtown, no. 28

41.3
COW AT PLAY
1941 (doc)
Oil on canvas mounted on masonite
20 × 30
Signed, lower center

Collection: IBM, Armonk, N.Y. (1946)

Provenance: (Downtown Gallery)

Exhibitions: Individual
 1941 American Place, no. 7
 Group
 1946 Grand Central Galleries
 1970 IBM (touring)

41.4
FIRE IN A SAUERKRAUT FACTORY, WEST X, N.Y.
1941 (doc)
10 × 12
Signed, lower edge right of center

Collection: Terry Dintenfass Gallery

Provenance: (An American Place)
 Dr. Dorothy Loynes
 Dr. Mary C. Holt, Bay Shore, N.Y.

Remarks: Although this work was dated 1936 at the time it was first exhibited, it was not actually completed until 1941. Dove wrote to Stieglitz 5 March 1941 of this painting, "drawn in 1936 and painted a few days ago."

Exhibition: Individual
 1941 American Place, no. 16, dated 1936

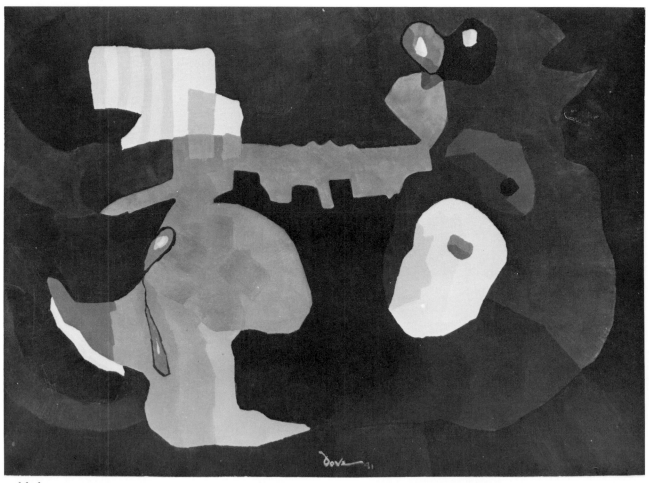

41.1

41.2

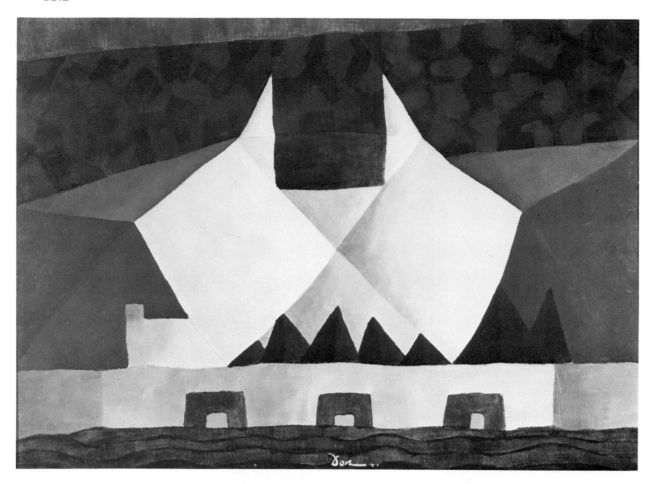

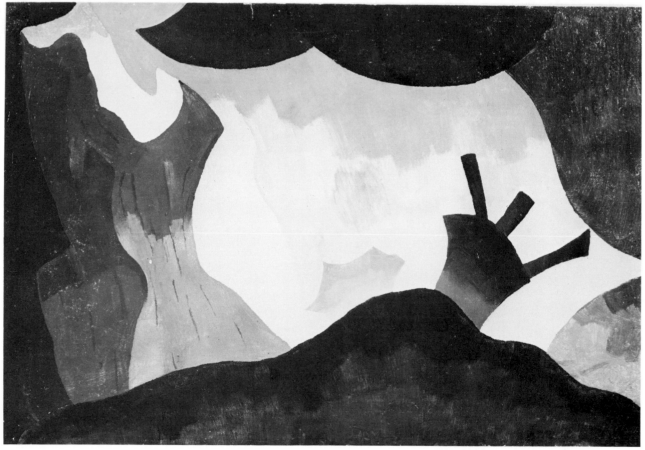

41.3

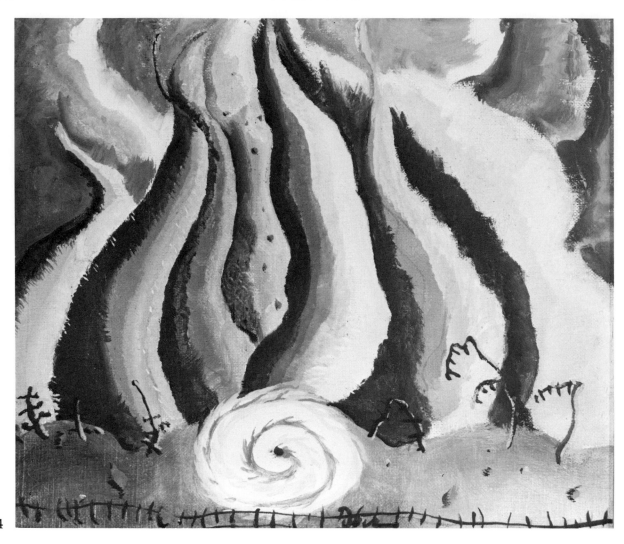

41.4

41.5
(GOLD, GREEN AND BROWN)
1940–41 (doc)
18⅛ × 27¼
Signed, lower center

Collection: Phillips Collection, Washington, D.C. (1941)

Provenance: (An American Place)

Exhibitions: Individual
 1941 American Place, no. 1, titled *Yellow, Blue Green and Brown*
 1947 Phillips
 1953 Corcoran
 1954 Ithaca, N.Y., no. 26
 1958 Whitney, no. 79, titled *Green, Gold and Brown*
 1968 MOMA (touring), no. 30, titled *Green, Gold and Brown*
 1975 Dintenfass, "Arthur G. Dove: The Abstract Work," no. 9
 1981 Phillips, no. 70
 Group
 1942 Phillips, titled *Yellow, Blue Green and Brown*
 St. Louis Museum

 1945 San Francisco, Calif.
 1951 Brooklyn Museum
 1952 Phillips
 1953 Norfolk, Va., titled *Green, Gold and Brown*

41.6
INDIAN SUMMER
1941 (doc)
20 × 28
Signed, lower center

Collection: Heckscher Museum, Huntington, N.Y. (1972)

Provenance: (Downtown Gallery)
 Dr. Howard Kaiser (1953)
 (Bernard Danenberg Galleries) (1971)

Exhibitions: Individual
 1942 American Place, no. 11
 1952 Downtown, no. 20
 Group
 1944 Philadelphia Museum, no. 261
 1951 Houston, Tex., no. 18

41.7
LAND AND SEASCAPE
1941 (doc)

41.5

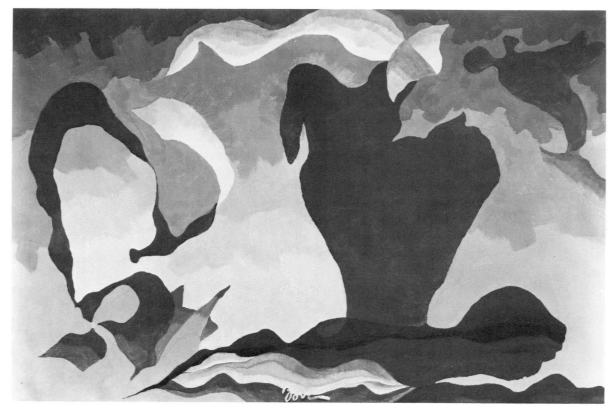

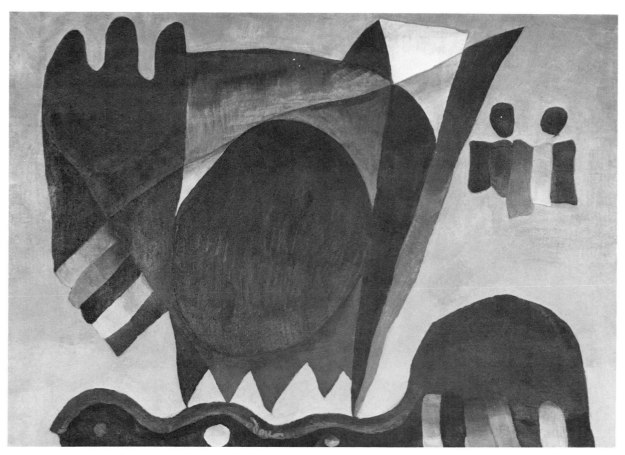

41.6

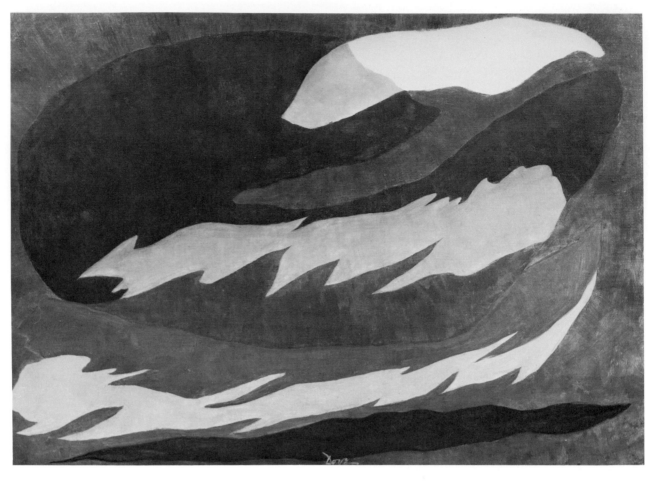

41.7

25 × 34¾
Signed, lower center

Collection: Whitney Museum of American Art (gift of Mr. and Mrs. N. E. Waldman, 1968)

Provenance: (An American Place)
Oliver B. James (1942)
(?)

Exhibition: Individual
1942 American Place, no. 14, titled *Land and Sea Scape*

41.8
LATTICE AND AWNING
1941
22¾ × 36¾
Signed, lower center

Collection: Private collection

Provenance: (An American Place)
Dr. and Mrs. J. Clarence Bernstein, Greenlawn, N.Y.
(Terry Dintenfass Gallery)

Exhibitions: Individual
1941 American Place, no. 4
1945 American Place, no. 2

41.9
LLOYD'S HARBOR
1941 (doc)
20 × 30
Signed, lower center

Collection: Detroit Institute of Arts, Detroit, Mich. (gift of Robert Hudson Tannahill)

Provenance: (Downtown Gallery)

Exhibitions: Individual
1941 American Place, no. 13, titled *Lloyd's Harbour*
1947 Downtown, no. 27

41.10
LONG ISLAND SOUND
1941
20 × 28
Signed and dated 41, lower center

Collection: Private collection, Honolulu, Hawaii

Provenance: (Downtown Gallery)
Edward Wales Root, Clinton, N.Y. (1947)
(Downtown Gallery) (1951)
Stanley J. Wolf (1953)
(Kennedy Galleries)
(Coe Kerr Gallery)
(John Berggruen Gallery, San Francisco, Calif.)

Remarks: This painting was completed on New Year's Day 1942, according to Dove's diary.

Exhibitions: Individual
1942 American Place, no. 17
1947 Downtown, no. 26
Group
1980 San Francisco, Calif.
1982 San Francisco, Calif.

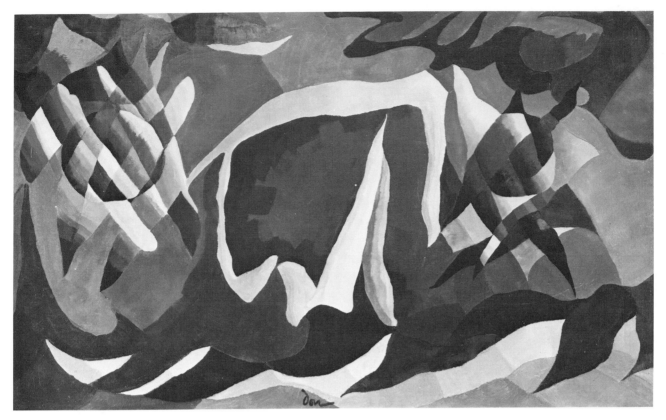

41.8

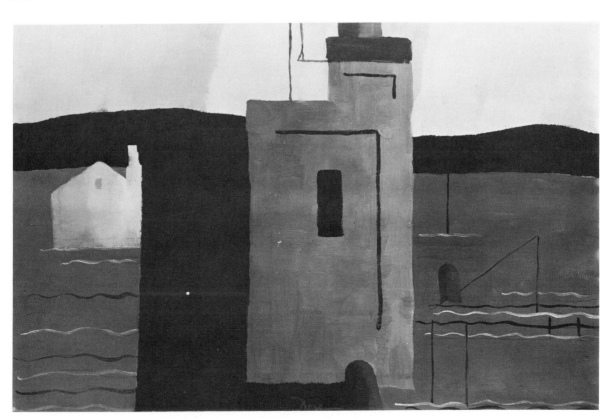

41.9

41.11
THE MOON
1941 (doc)
12 × 16
Signed, lower edge right of center

Collection: Regis Collection, Minneapolis, Minn.

Provenance: (An American Place)
Private collection, Geneva, N.Y.
(Sotheby Parke Bernet)
Private collection
(Salander-O'Reilly Galleries)

Exhibition: Individual
1941 American Place, no. 12

41.12
NEIGHBORLY ATTEMPT AT MURDER
1941
20 × 28
Signed, lower center

Collection: William H. Lane Foundation, Leomister,
Mass. (1956)

Provenance: (Downtown Gallery)

Remarks: In mid-June 1940, Dove wrote to Stieglitz
as follows about the episode that inspired this
painting:
[The doctor] allows that I would not have had
this last setback had a lady not tried to kill her
two boys and succeeded with herself just out-
side here in the early morning. Having ears like
an animal it was a bit vivid for me.
In late March 1941, in reference to the painting, he

told Stieglitz:
Do not think I would bother to satisfy just
curiosity [i.e., of those seeing the painting in
the gallery]. The drawing was made of a dead
tree without remaining consciously aware of
the tragedy that had occurred there to which I
had listened.

Exhibitions: Individual
1941 American Place, no. 10
1956 Downtown, no. 18
1961 Worcester, Mass., no. 28
Group
1941 American Place

41.13
POZZUOLI RED
1941
22 × 36

Collection: Phillips Collection, Washington, D.C.
(1941)

Provenance: (An American Place)

Exhibitions: Individual
1941 American Place, no. 3
1947 Phillips
1953 Corcoran
1954 Ithaca, N.Y., no. 25
1975 Dintenfass, "Arthur G. Dove: The Abstract
Work," no. 12
1981 Phillips, no. 68
Group
1942 Phillips
1980 Mexico City, Mexico

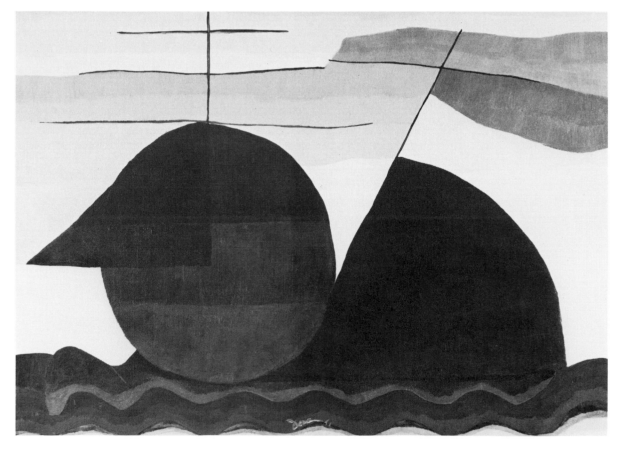

41.10

41.11

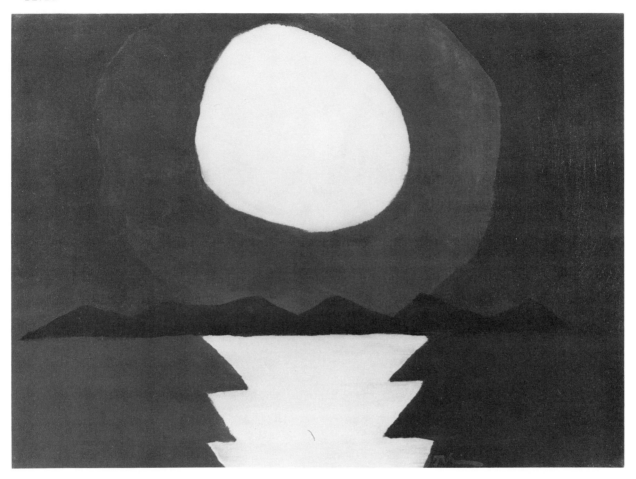

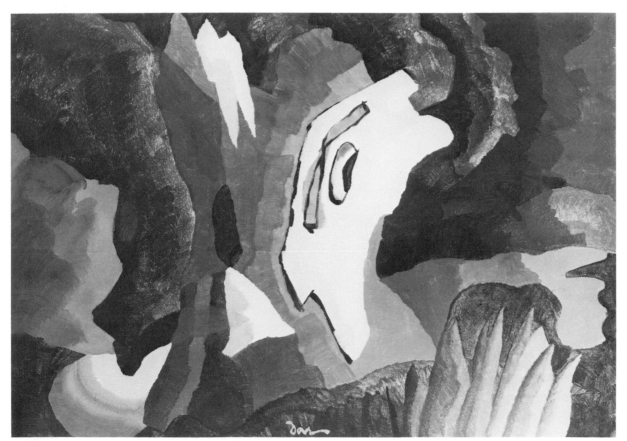

41.12

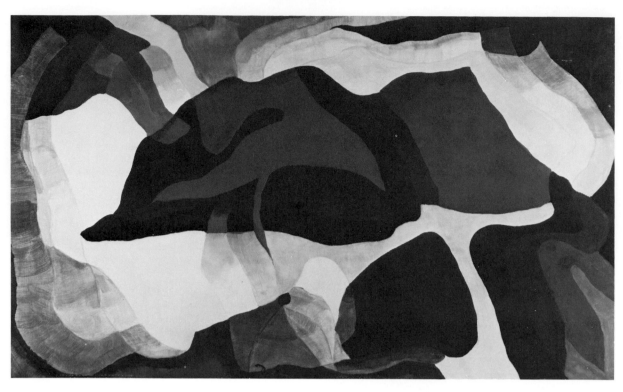

41.13

41.14
RED, OLIVE AND YELLOW
1941
15 × 21
Signed, lower center

Collection: Phillips Collection, Washington, D.C. (1945)

Provenance: (An American Place)

Remarks: Current museum title is *Woodpecker*.

Exhibitions: Individual
 1941 American Place, no. 5
 1947 Phillips
 1953 Corcoran
 1975 Dintenfass, "Arthur G. Dove: The Abstract Work," no. 10
 1980 Dintenfass
 1981 Phillips, no. 66, titled *Woodpecker*
 Group
 1955 American Federation of Arts (touring)

41.15
ROUTE 25A
1941
11 × 17
Signed, lower center

Collection: Private collection, Washington, D.C.

Provenance: (Downtown Gallery)
 Dr. and Mrs. Milton Lurie Kramer
 Robert Kramer, San Francisco, Calif.
 (?)
 William C. Janss, Sun Valley, Idaho
 (Terry Dintenfass Gallery)

Remarks: Route 25A passed Dove's house in Centerport. It is the main road along the north shore of Long Island.

Exhibitions: Individual
 1941 American Place, no. 6, titled R. *25A*
 Group
 1966 Ithaca, N.Y., no. 12

41.16
(THROUGH A FROSTY MOON)
1941 (doc)
14¾ × 20⅞
Signed, lower center

Collection: Robert H. Ginter, Los Angeles, Calif. (1979)

Provenance: (An American Place)
 Duncan Phillips, Washington, D.C. (1941)
 James McLaughlin, Washington, D.C. (gift of Duncan Phillips, 1950)
 (Terry Dintenfass Gallery)
 (Esther Robles Gallery, Los Angeles, Calif.) (1979)

Exhibitions: Individual
 1941 American Place, no. 11, titled *Frosty Moon*
 1947 Phillips
 1974 San Francisco Museum, dated 1946
 1981 Phillips, no. 65
 Group
 1944 Pennsylvania Academy, titled *Frosty Moon*
 Detroit, Mich., titled *Through a Frosty Moon*
 1946 London, England, titled *Frosty Moon*
 1952 Corcoran

41.17
1941
1941 (doc)
25 × 35
Signed and dated 41, lower center

Collection: Phillips Collection, Washington, D.C. (1942)

41.14

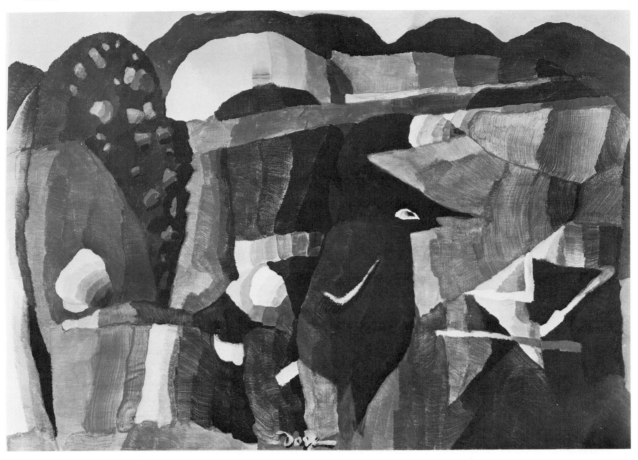

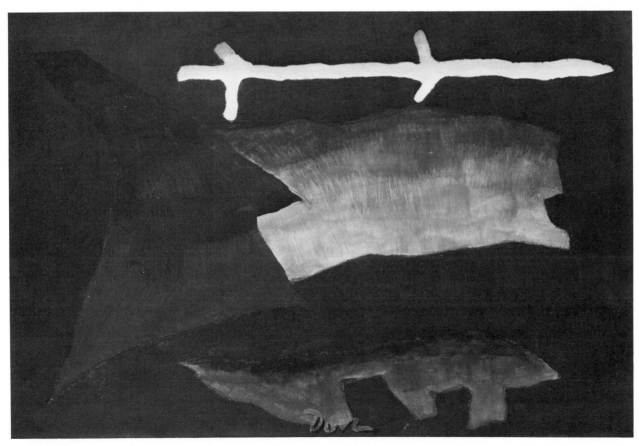

41.15

41.16

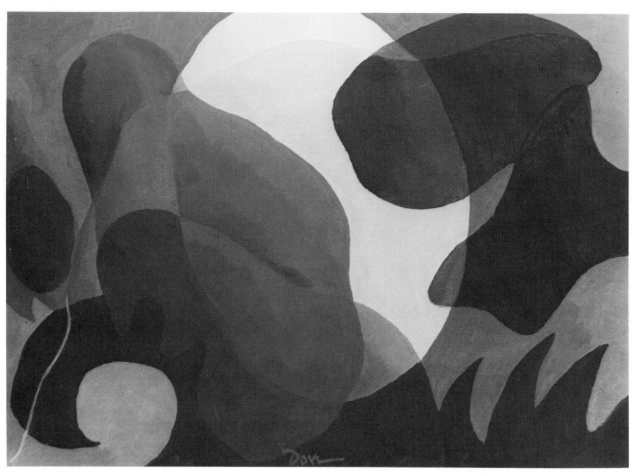

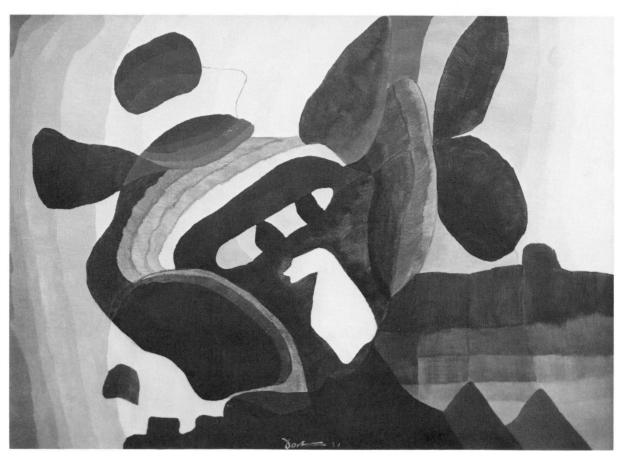

41.17

Provenance: (An American Place)

Exhibitions: Individual
 1942 American Place, no. 1, titled "*1941*"
 1947 Phillips
 1975 Dintenfass, "Arthur G. Dove: The Abstract
 Work," no. 11
 1981 Phillips, no. 69
 Group
 1944 Detroit, Mich.

1942

42.1
(ANONYMOUS)
1942
27⅞ × 20
Signed, lower center

Collection: Metropolitan Museum of Art (Alfred
 Stieglitz Collection; gift of Georgia O'Keeffe from
 the estate of Alfred Stieglitz, 1949)

Provenance: (An American Place)
 Alfred Stieglitz, New York City

Exhibitions: Individual
 1942 American Place, no. 16, titled *Shore Road*
 1945 American Place, no. 3, titled *Shore Road*
 1946 American Place, no. 9, titled *Shore Road*
 1958 Whitney, no. 86
 Group
 1948 AIC, no. 53

42.2
BLACKBIRD
1942
17 × 24
Signed and dated 42, lower center

Collection: Sammlung Thyssen-Bornemisza, Cas-
 tagnola, Switzerland

Provenance: (Downtown Gallery)
 Robert Ellison, New York City
 (Andrew Crispo Gallery)

Remarks: On 7 June 1942, Dove wrote to Stieglitz as
 follows:
 Have been watching a blackbird drying off
 after his bath—in tree—in front of me here.
 Good for one '43 Dove painting, I hope. Vigor-
 ous. . . .

Exhibitions: Individual
 1943 American Place, no. 13
 1947 Downtown (San Francisco only)
 1956 Downtown, no. 21
 1968 MOMA (touring), no. 32
 1968 Fort Worth, Tex.
 1975 Crispo, no. 3
 Group
 1942 MOMA, "Painting and Sculpture from 16
 American Cities," no. 68
 1964 Tucson, Ariz.
 1975 Crispo, no. 17

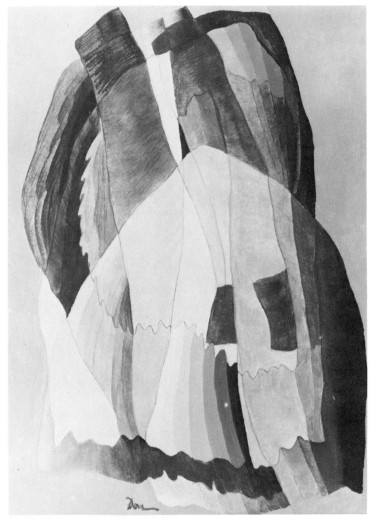

42.1

 1979 Perth, Australia, no. 72
 1982 National Gallery, no. 57

42.3
THE BROTHERS [NO. 2]
1942 (doc)
20 × 28
Signed, lower center

Collection: McNay Art Institute, San Antonio, Tex.
 (gift of Robert L. B. Tobin, through the Friends of
 the McNay, 1962)

Provenance: (Downtown Gallery)

Exhibitions: Individual
 1943 American Place, no. 8
 1947 Downtown, no. 31
 1954 Ithaca, N.Y., no. 28
 1958 Whitney, no. 93
 1968 Fort Worth, Tex.

42.4
CLAMMING
1942 (doc)
20 × 28
Signed and dated 42, lower center

42.2

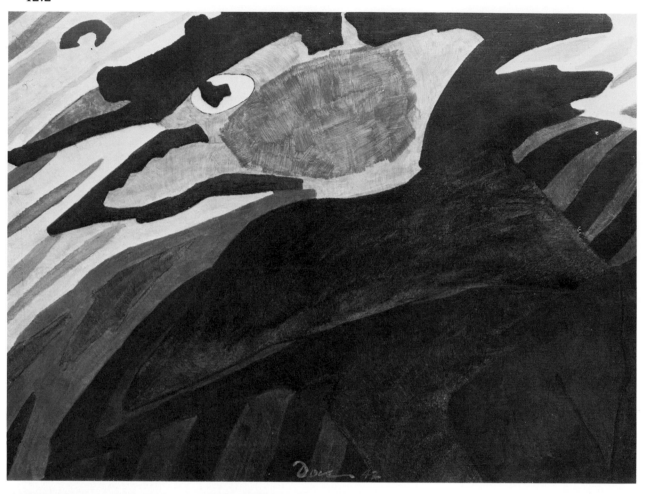

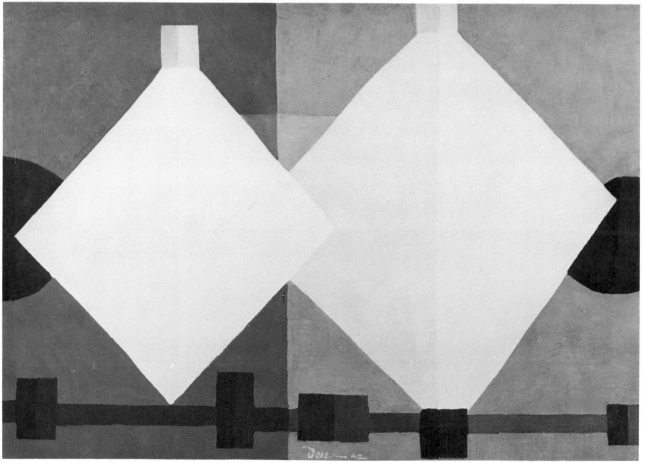

42.3

Collection: Unidentified

Provenance: (An American Place)

Exhibition: Individual
 1943 American Place, no. 7

42.5
CROSS CHANNEL
1942
21 × 15
Signed, lower center

Collection: Andrew Crispo Gallery

Provenance: (Downtown Gallery)
 Oliver James (1950)
 Robert G. Osborne

Exhibitions: Individual
 1942 American Place, no. 7
 Group
 1982 Crispo, "American Masters of the 20th Cen-
 tury," titled *White Channel*

42.6
DEEP GREENS
1942
20 × 28

Collection: Unidentified

Provenance: (Downtown Gallery)
 Sudington (1946)

Exhibitions: Individual
 1942 American Place, no. 8
 1947 Downtown, no. 30

42.7
EVENING BLUE
1942
20 × 28

Collection: William H. Lane Foundation, Leomin-
 ster, Mass. (1956)

Provenance: (Downtown Gallery)
 William H. Lane Foundation, Leominster, Mass.
 (1953)
 (Downtown Gallery) (1954)

Exhibitions: Individual
 1942 American Place, no. 13
 1961 Worcester, Mass., no. 34, titled *Evening
 Blue (Firmament)*
 Group
 1951 Houston, Tex., no. 16

42.8
FORMATION II
1942 (doc)
24 × 32
Signed and dated 42, lower center

Collection: Gordon F. Hampton, San Marino, Calif.

Provenance: (Terry Dintenfass Gallery)

Exhibitions: Individual
 1943 American Place, no. 5
 1956 Downtown, no. 19, titled *Formation #2*,
 dated 1943
 1964 Detroit, Mich., no. 10, dated 1943.
 1968 MOMA (touring), no. 33

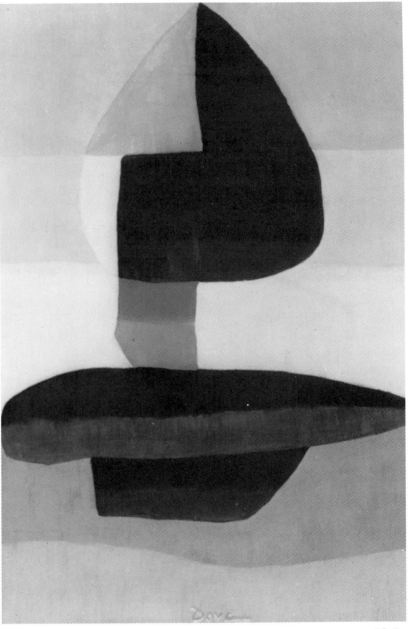

42.5

1974 San Francisco Museum, titled *Colored
 Planes (Formation II)*
 Group
 1962 MOMA (touring), dated 1943

42.9
FORMATION III
1942
20 × 28
Signed and dated 42, lower center

Collection: William H. Lane Foundation, Leomin-
 ster, Mass. (1958)

Provenance: (Downtown Gallery)

Remarks: According to his diary, Dove continued to
 work on this painting until at least 11 January
 1943.

Exhibitions: Individual
 1943 American Place, no. 10
 1961 Worcester, Mass., no. 37, titled *Green Land-
 scape (Formation No. 3)*

42.8

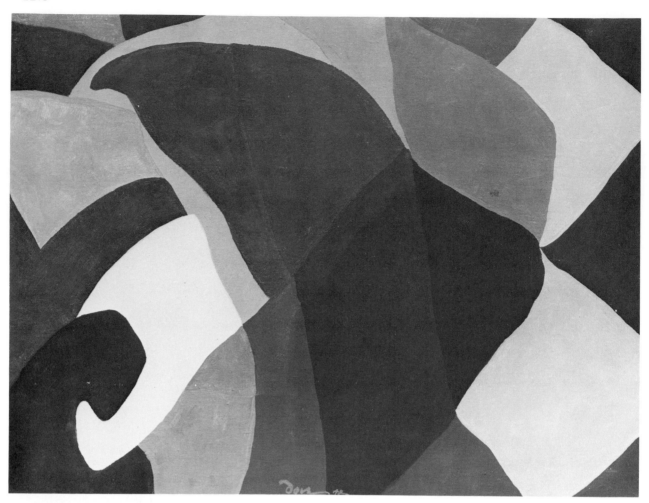

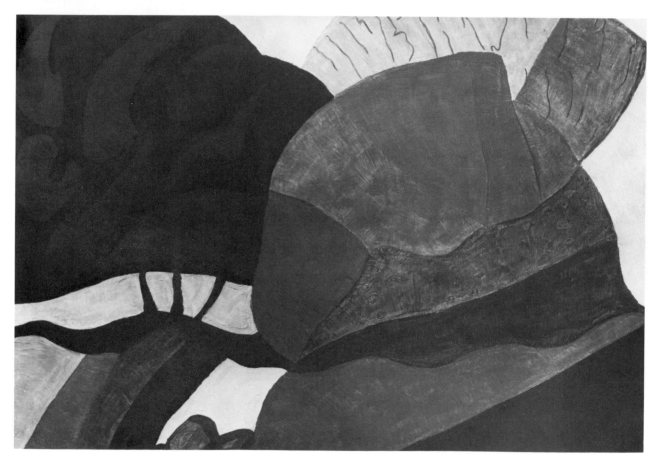

42.9

42.10
GRAY GREENS
1942
20 × 28
Signed and dated 42, lower right
Collection: Unidentified
Provenance: (An American Place)
Exhibition: Individual
 1943 American Place, no. 9

42.11
THE INN
1942 (doc)
24 × 27
Signed, lower center
Collection: Edith and Milton Lowenthal, New York
 City (1947)
Provenance: (Downtown Gallery)
Exhibitions: Individual
 1942 American Place, no. 2
 1947 Downtown, no. 29
 1958 Whitney, no. 88

42.12
MORNING GREEN
1942
20 × 28

Collection: Unidentified
Provenance: (Downtown Gallery)
 Schluger (1954)
Exhibitions: Individual
 1942 American Place, no. 12
 1945 American Place, no. 1, dated 1942
 1946 American Place, no. 8
 1952 Downtown, no. 21

42.13
PARABOLA
1942
25 × 35
Signed and dated 42, lower edge left of center
Collection: Michael Scharf, Jacksonville, Fla. (1975)
Provenance: (Downtown Gallery)
 Harry Spiro (1970)
 (Andrew Crispo Gallery)
Exhibitions: Individual
 1943 American Place, no. 2
 1954 Ithaca, N.Y., no. 27, dated 1943
 1958 Whitney, no. 94, dated 1943
 1975 Dintenfass, "Arthur G. Dove: The Abstract
 Work," no. 17
 Group
 1951 Houston, Tex., no. 7

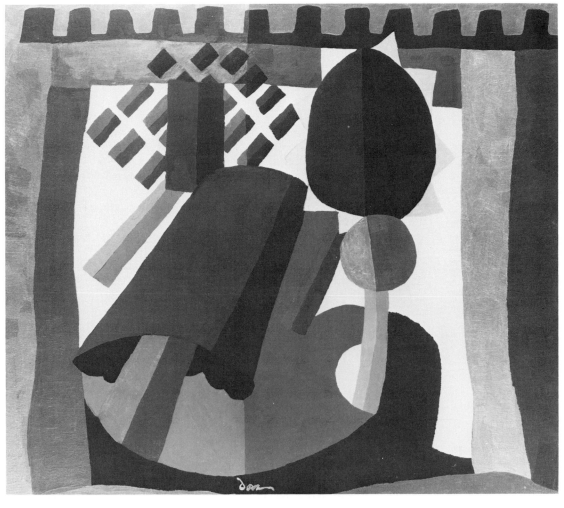

42.11

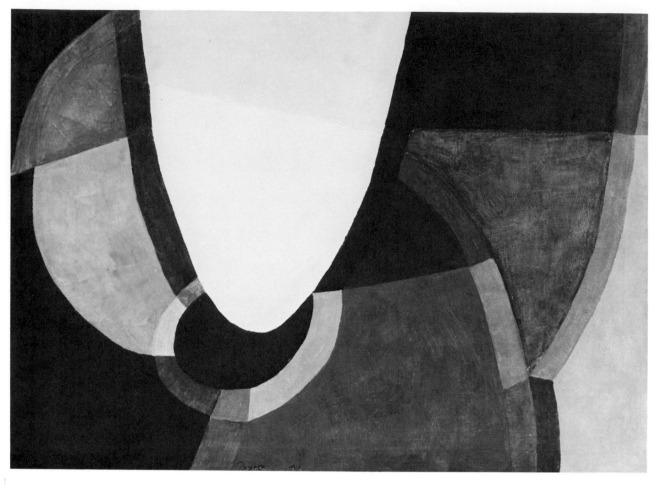

42.13

42.14
PARTLY CLOUDY
1942
Masonite support
35¼ × 25⅛
Signed, lower center

Collection: University of Arizona Museum of Art, Tucson (gift of Oliver B. James, 1950)

Provenance: (An American Place)
(? Downtown Gallery)

Exhibition: Individual
1942 American Place, no. 10, titled *"Partly Cloudy"*

42.15
QUAWK BIRD
1942
15½ × 24
Signed and dated 42, lower center

Collection: Estate of the artist, Terry Dintenfass Gallery

Remarks: On 4 February 1943, Dove wrote to Stieglitz as follows:
That one of the "Quawk Bird" is a different kind of drawing for me. Drawing the way one feels about it rather than the way one sees it. . . .

Exhibitions: Individual
1943 American Place, no. 16

Group
1982 San Francisco, Calif.

42.16
A REASONABLE FACSIMILE
1942
18⅝ × 24⅞
Signed, lower center

Collection: Art Institute of Chicago, Chicago, Ill. (Alfred Stieglitz Collection [loan])

Provenance; (An American Place)
Alfred Stieglitz, New York City

Exhibitions: Individual
1942 American Place, no. 3, titled *"A Reasonable Facsimile"*
1958 Whitney, no. 89
Group
1947 MOMA
1948 AIC

42.17
R. 25A or RED LIGHT R 25A
1942
15 × 21
Signed, lower center

Collection: Phillips Collection, Washington, D.C. (1946)

Provenance: (An American Place)

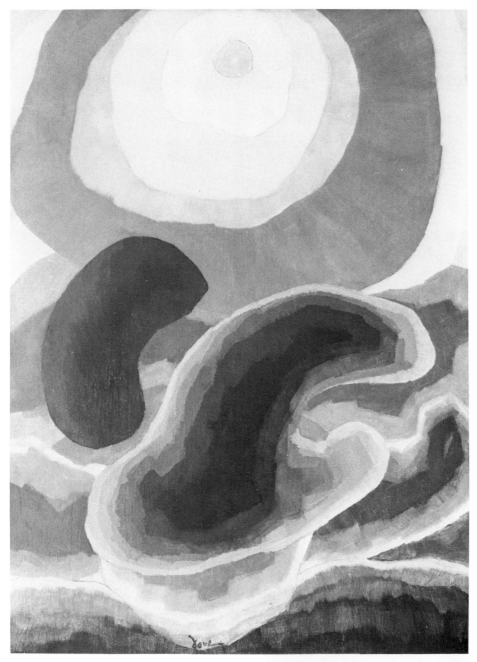

42.14

Remarks: The title refers to state route 25A, the main
road along the north shore of Long Island, which
passed Dove's house in Centerport.

Exhibitions: Individual
1942 American Place, no. 6, titled *Red Light R
25A*
1945 American Place, no. 12, titled R 25A

42.18
SILVER CHIEF
1942 (doc)
Medium includes metal powder
21 × 15
Signed, lower center

Collection: Laughlin Phillips, Washington, D.C.

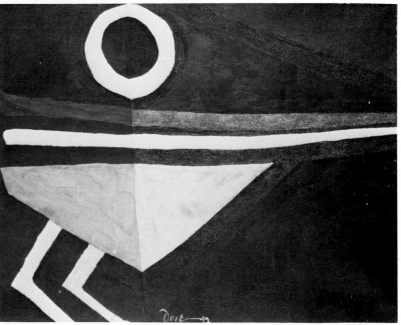

42.15

42.16

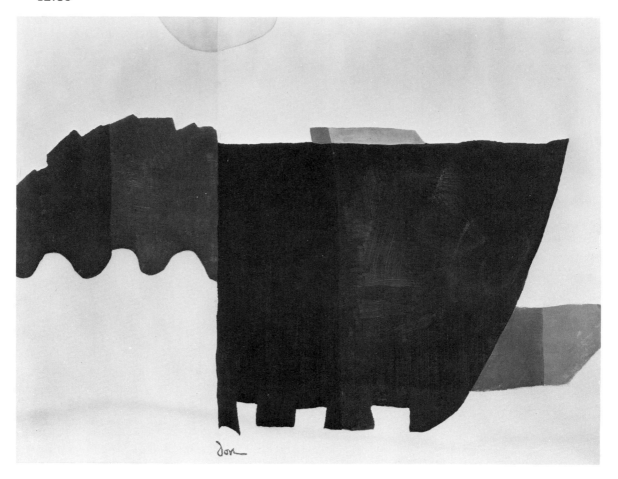

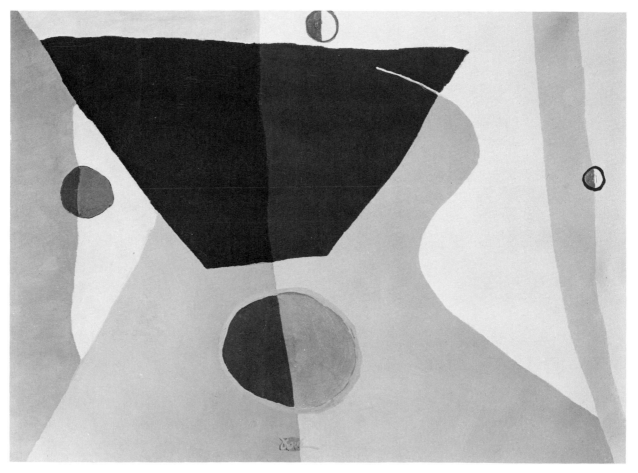

42.17

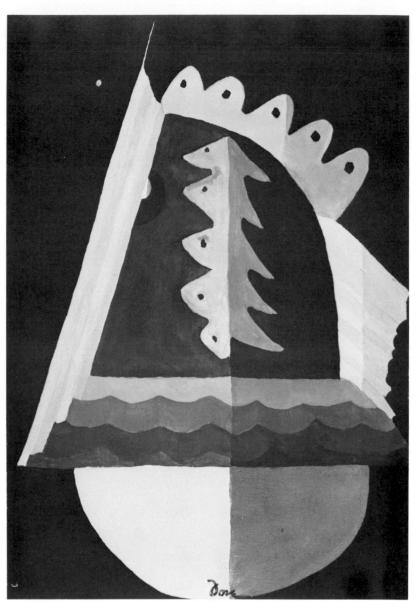

Provenance: (An American Place)
 Phillips Collection, Washington, D.C. (gift of the artist, 1942)

Exhibitions: Individual
 1942 American Place, no. 4
 1947 Phillips
 1981 Phillips, no. 72

42.19
SQUARE ON THE POND
1942
20 × 28
Signed, lower center

Collection: William H. Lane Foundation, Leominster, Mass. (1957)

Provenance: (Downtown Gallery)

Remarks: In a letter to Stieglitz on 10 March 1942, Dove commented on this painting as follows:
 Yesterday gave me a good look at the things I brought in. One thing I might hold out [i.e., from his show]—may bring in something to trade for it. No. 20 The Square on the Pond. I cared for it least. Wonder if you and Georgia agree with me? Thought I saw you give it a dirty look once. Not sure.

Exhibitions: Individual
 1942 American Place, no. 20
 1952 Downtown, no. 22
 1958 Whitney, no. 91
 1961 Worcester, Mass., no. 36
 1974 San Francisco Museum

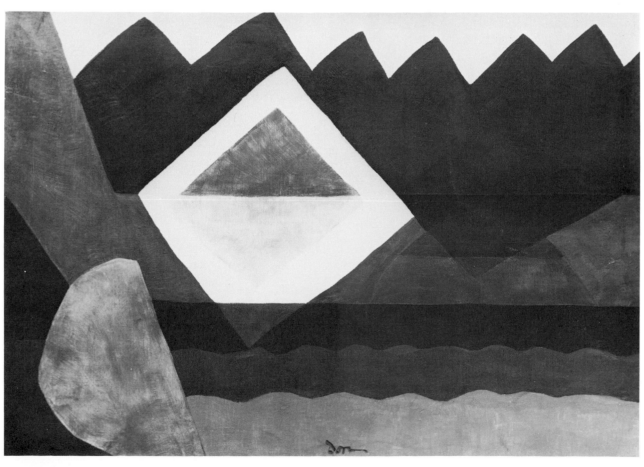

42.19

42.20
STRUCTURE
1942 (doc)
25 × 32
Signed and dated 42, lower edge left of center

Collection: Regis Collection, Minneapolis, Minn. (1981)

Provenance: (Downtown Gallery)
 Mr. and Mrs. Raymond Loewy, New York City (1946)
 Mr. and Mrs. M. A. Gribin, Los Angeles, Calif. (Salander-O'Reilly Galleries)

Exhibitions: Individual
 1943 American Place, no. 4
 1958 Whitney, no. 90, dated 1942
 1974 San Francisco Museum, dated 1942
 Group
 1982 Minneapolis Institute of Arts

42.21
TRAVELING
1942
16 × 26
Signed, lower center

Collection: William H. Lane Foundation, Leominster, Mass. (1957)

Provenance: (Downtown Gallery)

Exhibitions: Individual
 1942 American Place, no. 9
 1958 Whitney, no. 92
 1961 Worcester, Mass., no. 35
 1974 San Francisco Museum, dated 1942–43

42.22
YELLOW FORM
1942
15 × 21

Collection: Mr. and Mrs. Thomas Davis, Woodside, Calif.

Provenance: (Downtown Gallery)
 Oliver B. James, Phoenix, Ariz.
 Helen James Fane, San Diego, Calif.
 Private collection, New York City
 (Andrew Crispo Gallery)
 William C. Janss, Sun Valley, Idaho
 (John Berggruen Gallery, San Francisco, Calif.)

Exhibition: Individual
 1942 American Place, no. 18

42.23
.04%
1942

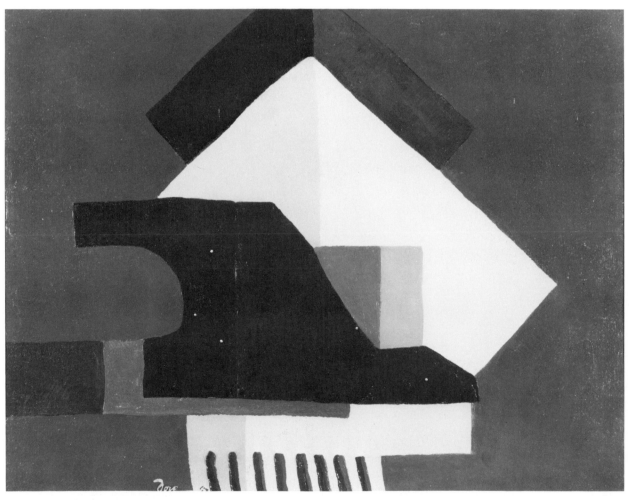

42.20

42.21

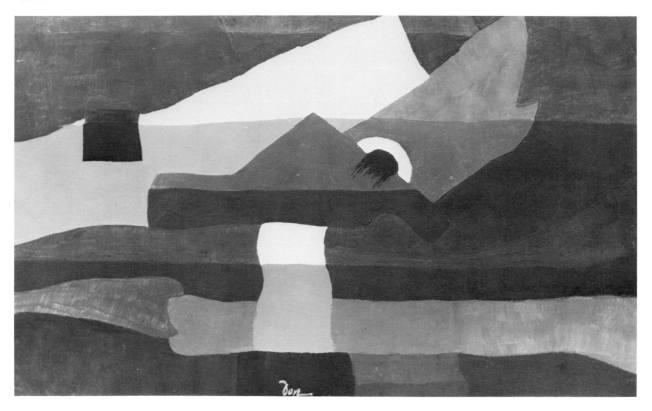

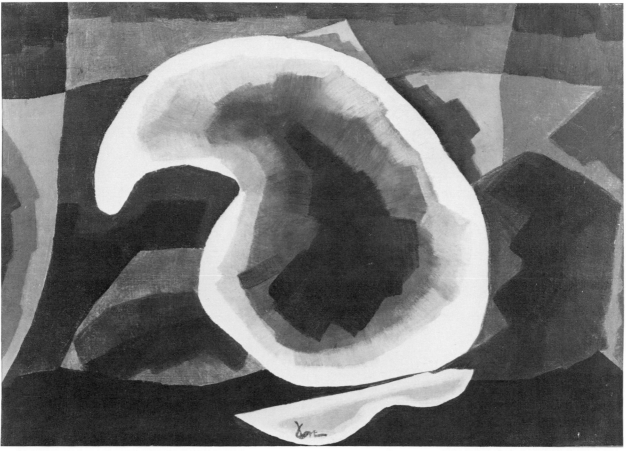

42.22

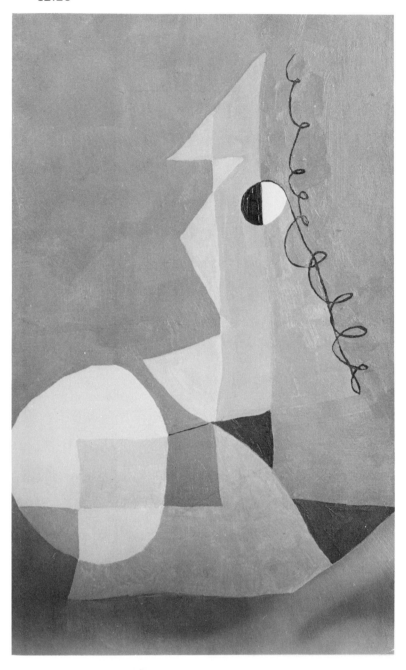

20 × 12
Not signed

Collection: Salander-O'Reilly Galleries

Provenance: (Terry Dintenfass Gallery)

Exhibitions: Individual
 1942 American Place, no. 5
 1981 Los Angeles, Calif., no. 15

1943

43.1
AND NUMBER TWENTY-TWO
1943
Cardboard support, with tinfoil
3½ × 5½
Not signed

Collection: William C. Dove, Mattituck, N.Y.

Provenance: Acquired from the artist.

Remarks: On 27 January 1943, Dove wrote to Stieglitz that this painting "is very small, about postcard size, one of the best." In a letter to Stieglitz a few days later, on 1 February 1943, Dove continued:
> The smallest one, "And Number 22," we would better mark Not for Sale. I would like to keep it, and it is done on cardboard with no ground. Reds, Bill and I like it, so might as well keep it in the family. . . .

Exhibition: Individual
 1943 American Place, no. 22

43.2
BLUE JAY FLEW UP IN A TREE
1943 (doc)
7 × 5
Signed, lower center

Collection: Private collection

Provenance: (Downtown Gallery)

Exhibitions: Individual
 1943 American Place, no. 19
 1947 Downtown, no. 32

43.3
DANCING WILLOWS
1943 (doc)
27 × 36
Signed, lower center

Collection: William H. Lane Foundation, Leominster, Mass. (1956)

Provenance: (Downtown Gallery)

Exhibitions: Individual
 1944 American Place, no. 8
 1961 Worcester, Mass., no. 39, dated 1943–44

43.4
DEPARTURE FROM THREE POINTS
1943
20 × 28

43.1

Signed, lower center

Collection: Luise Ross Joyce, New York City

Provenance: (Terry Dintenfass Gallery)

Exhibitions: Individual
 1943 American Place, no. 12
 1947 Downtown, no. 32
 1964 Detroit, Mich., no. 9
 1972 Dintenfass, no. 14
 1975 Dintenfass, "Arthur G. Dove: The Abstract
 Work," no. 14
 Group
 1945 Downtown, no. 6
 1971 Carnegie Institute, no. 38

43.5
FLIGHT
1943
12 × 20
Signed, lower center

Collection: Phillips Collection, Washington, D.C.
 (bequest of Elmira Bier, with life interest to Vir-
 ginia McLaughlin, 1976)

Provenance: (An American Place)
 Duncan Phillips, Washington, D.C. (1943)
 Elmira Bier, Arlington, Va. (gift of Duncan Phil-
 lips, 1950)

Exhibitions: Individual
 1943 American Place, no. 20
 1947 Phillips
 1974 San Francisco Museum
 1981 Phillips, no. 74

43.3

43.4

43.5

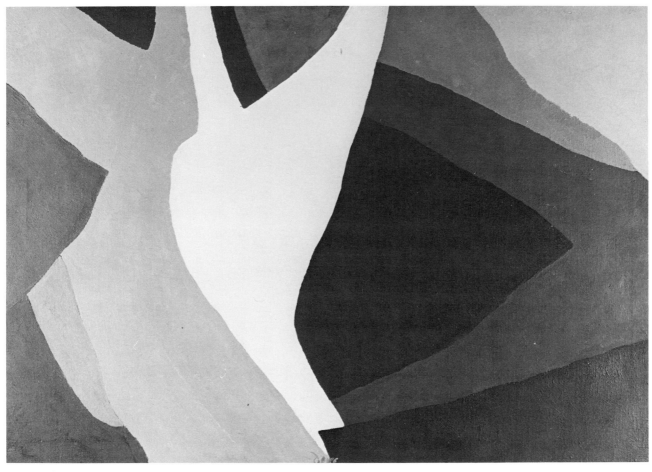

43.6

43.6
FORMATION I
1943
25 × 35
Signed, lower center

Collection: San Diego Museum of Art, San Diego, Calif. (purchased with funds from the Helen M. Towle Bequest)

Provenance: (Downtown Gallery)
(Herbert Palmer and Robert Schoelkopf Gallery)

Exhibitions: Individual
 1943 American Place, no. 1
 1956 Los Angeles, Calif., no. 20
 1963 San Francisco, Calif.
 1974 San Francisco Museum

43.7
INDIAN ONE
1943
18 × 24
Signed, lower center

Collection: Phillips Collection, Washington, D.C. (1943)

Provenance: (An American Place)

Exhibitions: Individual
 1943 American Place, no. 14
 1947 Phillips

1953 Corcoran
1981 Phillips, no. 75

43.8
MARS YELLOW, RED AND GREEN
1943
18 × 24
Signed, lower center

Collection: John and Mable Ringling Museum, Sarasota, Fla. (1974)

Provenance: (Terry Dintenfass Gallery)

Exhibitions: Individual
 1943 American Place, no. 15, titled *Mars—Yellow, Red, and Green*
 1956 Los Angeles, Calif., no. 22
 1972 Dintenfass, no. 16

43.9
PINK ONE
1943 (doc)
21 × 15
Signed, lower quarter, left of center

Collection: Salander-O'Reilly Galleries

Provenance: (Terry Dintenfass Gallery)

Exhibitions: Individual
 1943 American Place, no. 18
 1952 Downtown, no. 23

43.7

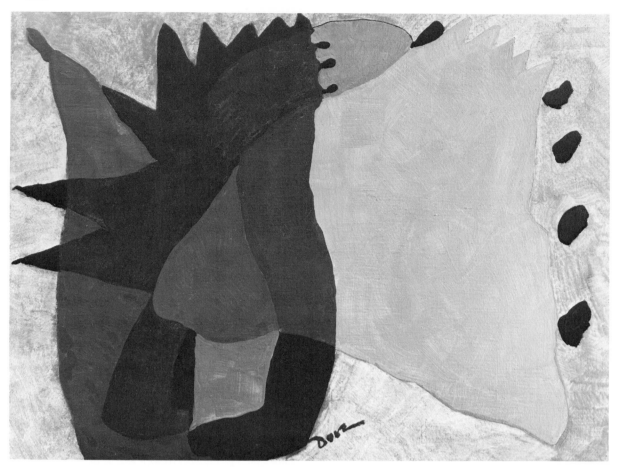

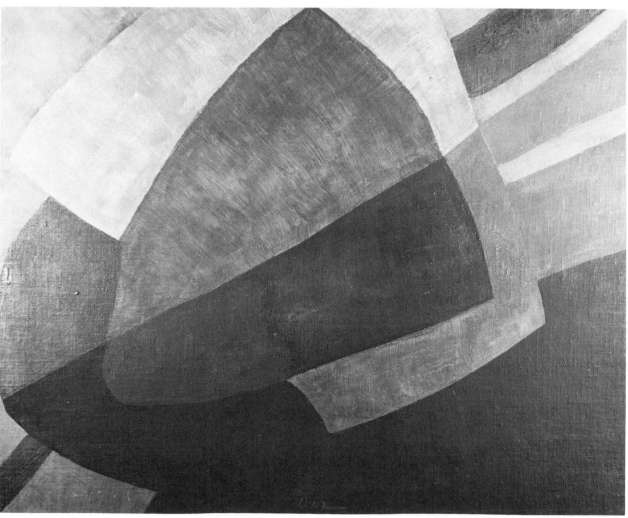

43.8

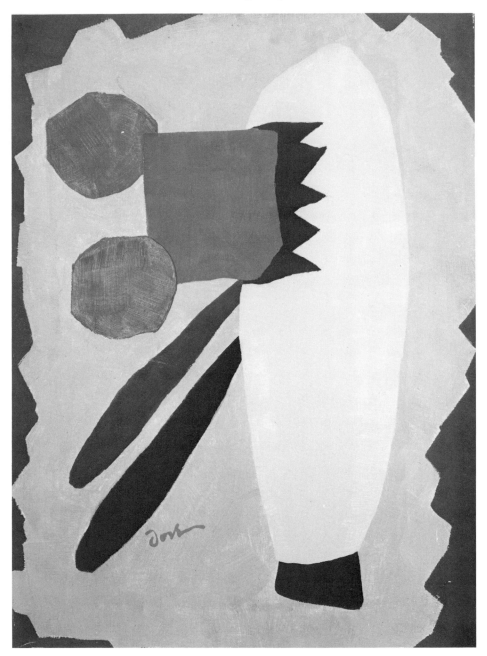

43.9

1956 Los Angeles, Calif., no. 18
1958 Whitney, no. 95
1967 Huntington, N.Y., no. 14
1975 Dintenfass, "Arthur G. Dove: The Abstract Work," no. 15, titled *That Pink One*
1981 Los Angeles, Calif., no. 13, titled *That Pink One*

43.10
RAIN OR SNOW
1943 (doc)
Medium includes silver leaf
35 × 25
Signed, lower center
Collection: Phillips Collection, Washington, D.C. (1943)
Provenance: (An American Place)

Exhibitions: Individual
1943 American Place, no. 3, titled "*Rain or Snow*"
1947 Phillips
1953 Corcoran
1954 Ithaca, N.Y., no. 29
1958 Whitney, no. 96
1974 San Francisco Museum, dated 1943–44
1981 Phillips, no. 73
Group
1945 Toronto, Canada

43.11
REACHING
1943
6 × 8
Collection: Unidentified

Provenance: (An American Place)
 Suzanne Mullett Smith

Exhibitions: Individual
 1943 American Place, no. 21
 1947 Downtown (San Francisco only)

43.12
RECTANGLES
1943
28 × 21
Signed

Collection: Unidentified

Provenance: (Downtown Gallery)
 Borman (1970)

Exhibitions: Individual
 1943 American Place, no. 11
 1952 Downtown, no. 24, dated 1944
 1967 Huntington, N.Y., no. 13

43.13
RISING TIDE
1943 (doc)
27¼ × 36¼
Signed, lower center

Collection: National Gallery of Canada, Ottawa, Ontario, Canada (gift of Mrs. Ernest F. Eidlitz, 1968)

Provenance: (Downtown Gallery)
 Mrs. Ernest F. Eidlitz, New York City and St. Andrew's, New Brunswick, Canada

Exhibitions: Individual
 1944 American Place, no. 1
 1947 Downtown, no. 34
 1954 Ithaca, N.Y., no. 31
 1958 Whitney, no. 100

43.13

43.14

43.14
ROOFTOPS
1943 (doc)
24 × 32
Signed, lower center

Collection: William H. Lane Foundation, Leomin-
ster, Mass. (1956)

Provenance: (Downtown Gallery)

Exhibitions: Individual
 1944 American Place, no. 12, titled *Roof Tops*
 1952 Downtown, no. 19, dated 1941
 1954 Ithaca, N.Y., no. 24, dated 1941
 1958 Whitney, no. 85, dated 1941
 1961 Worcester, Mass., no. 29, dated 1941
 1974 San Francisco Museum, dated 1941
 Group
 1951 Houston, Tex., no. 20

43.15
ROSE AND LOCUST STUMP
1943 (doc)
24 × 32
Signed, lower center

Collection: Phillips Collection, Washington, D.C.
 (1944)

Provenance: (An American Place)

Exhibitions: Individual
 1944 American Place, no. 20
 1947 Phillips
 1967 College Park, Md., painting no. 10
 1975 Dintenfass, "Arthur G. Dove: The Abstract
 Work," no. 18
 1981 Phillips, no. 77

43.16
SAND AND SEA
1943 (doc)

Medium includes sand
27 × 36
Signed, lower center

Collection: Washington University Gallery of Art, St.
 Louis, Mo. (1952)

Provenance: (Downtown Gallery)

Remarks: The owner titles this painting *Sea and
 Sand*.

Exhibitions: Individual
 1944 American Place, no. 5
 1945 American Place, no. 6, dated 1944
 1954 Ithaca, N.Y., no. 32

43.17
SPOTTED YELLOW
1943 (doc)
25 × 35
Signed, lower edge left of center

Collection: Andrew Crispo Gallery

Provenance: (Downtown Gallery)
 Arthur Steel, Philadelphia, Penn.
 William C. Janss, Sun Valley, Idaho
 (Hirschl & Adler Galleries)

Exhibitions: Individual
 1943 American Place, no. 6
 1956 Los Angeles, Calif., no. 19
 1972 Dintenfass, no. 15
 1975 Dintenfass, "Arthur G. Dove: The Abstract
 Work," no. 16
 1980 Dintenfass, no. 13
 Group
 1980 San Francisco, Calif., no. 31
 1982 Crispo, "Selected American Painting and
 Sculpture"

43.15

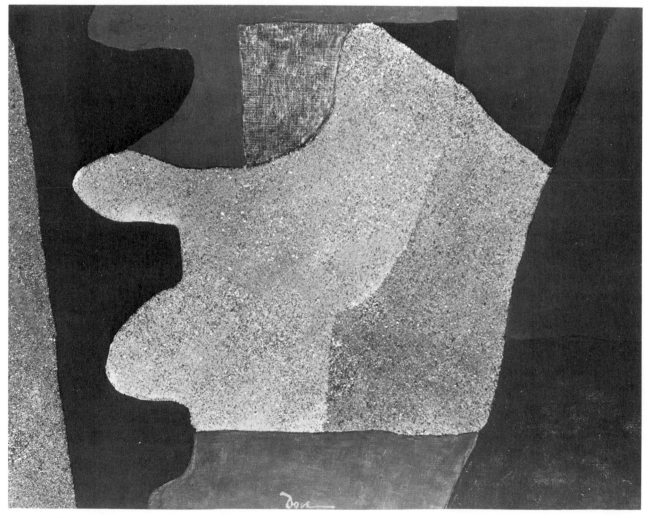

43.16

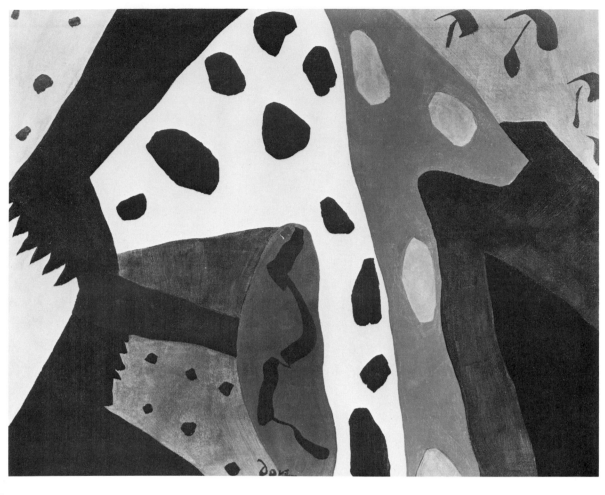

43.17

43.18
SPRING
1943 (doc)
18 × 24
Signed, lower center

Collection: Museum of Fine Arts, Boston (gift of the
Stephen and Sybil Stone Foundation, 1971)

Provenance: (Downtown Gallery)
Stephen and Sybil Stone (1959)

Remarks: The Stone Foundation refuses permission
for this painting to be reproduced.

Exhibition: Individual
1944 American Place, no. 3

43.19
SUN
1943
24 × 32
Signed and dated 43, lower center

Collection: Unidentified

Provenance: (An American Place)
Suzanne Mullett Smith

Exhibition: Individual
1943 American Place, no. 17

43.20
(U.S.A.)
1943 (doc)

23⅞ × 31⅞
Signed, lower center

Collection: Corcoran Gallery of Art, Washington,
D.C. (William A. Clark Fund, 1968)

Provenance: (Downtown Gallery)

Exhibitions: Individual
1944 American Place, no. 6, titled *Space Divided
by Line Motive*
1947 Downtown (San Francisco only)
Group
1963 East Hampton, N.Y.
1964 Downtown
1965 London, England
1978 Corcoran

1944

44.1
ANOTHER ARRANGEMENT
1944
28 × 36
Signed, lower center

Collection: Jane Voorhees Zimmerli Art Museum,
Rutgers University, New Brunswick, N.J. (1948)

Provenance: (An American Place)
(? Downtown Gallery)

Exhibition: Individual
1944 American Place, no. 16

43.20

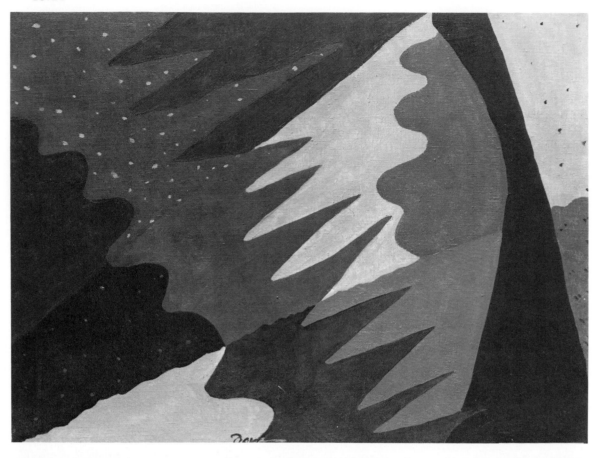

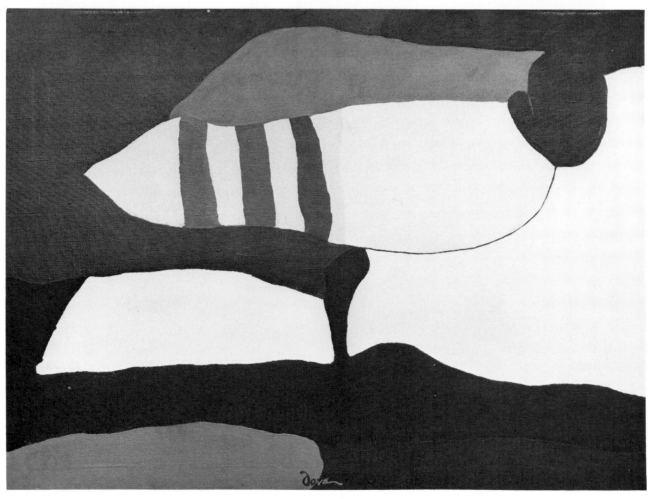

44.1

44.2
ARRANGEMENT IN FORM I
1944
18 × 24
Signed, lower center

Collection: Mr. and Mrs. Richard D. Lombard, Rye, N.Y. (1979)

Provenance: (Terry Dintenfass Gallery)

Exhibitions: Individual
 1944 American Place, no. 14
 1972 Dintenfass, no. 18
 1975 Dintenfass, "Arthur G. Dove: The Abstract Work," no. 21
 Group
 1971 Carnegie Institute, no. 39

44.3
ARRANGEMENT IN FORM II
1944
18 × 24
Signed, lower left

Collection: Private collection (on loan to the Phoenix Art Museum, Phoenix, Ariz.)

Provenance: (Downtown Gallery)
 Private collection
 (Sotheby Parke Benet auction, April 1977)
 (?)
 (Terry Dintenfass Gallery)

Exhibitions: Individual
 1944 American Place, no. 15
 1945 American Place, no. 7, dated 1944
 Group
 1945 Carnegie Institute

44.4
FLAGPOLE, APPLE TREE, AND GARDEN
1944
24 × 32
Signed, lower center

Collection: William H. Lane Foundation, Leominster, Mass.

Provenance: (Downtown Gallery)

Exhibitions: Individual
 1944 American Place, no. 11
 1958 Whitney, no. 87, dated 1942
 1961 Worcester, Mass., no. 41

44.5
HIGH NOON
1944
Composition board support
27 × 36
Signed, lower center

Collection: Wichita Art Museum, Wichita, Kan. (Roland P. Murdock Collection, 1952)

Provenance: (Downtown Gallery)

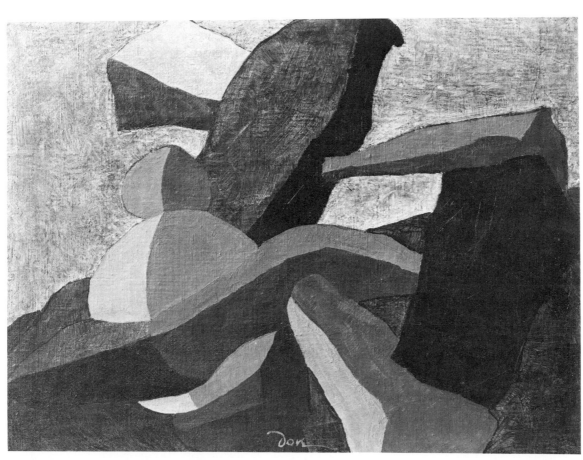

44.2

44.3

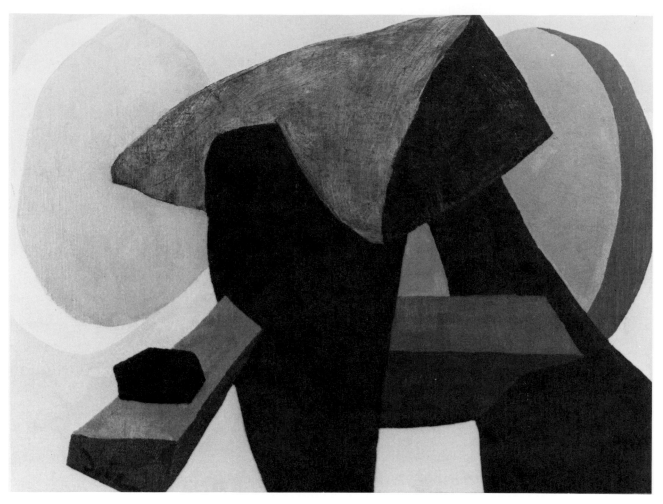

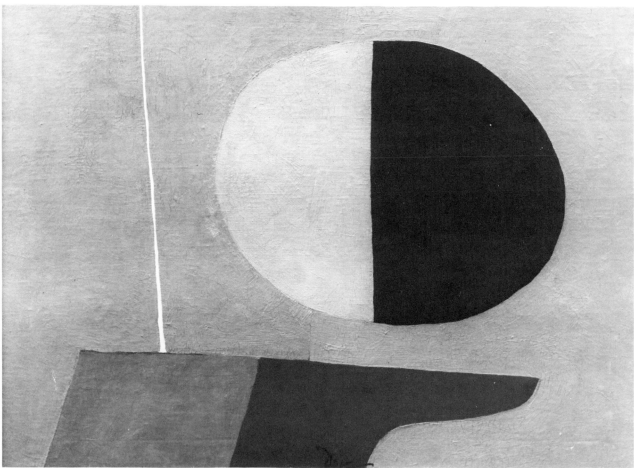

44.4

44.5

Exhibitions: Individual
 1944 American Place, no. 4
 1947 Downtown, no. 37

44.6
LOW TIDE
1944
24 × 32
Signed, lower center

Collection: Mrs. Ann Harithas, New York City (1978)

Provenance: (Terry Dintenfass Gallery)

Exhibitions: Individual
 1944 American Place, no. 2
 1956 Los Angeles, Calif., no. 25
 1964 Detroit, Mich., no. 11
 1967 Huntington, N.Y., no. 15
 1972 Dintenfass, no. 17
 Group
 1962 MOMA (touring)

44.7
THE OTHER SIDE
1944
21 × 28
Signed, lower center

Collection: Munson-Williams-Proctor Institute, Utica, N.Y. (1956)

Provenance: (Downtown Gallery)

Exhibitions: Individual
 1944 American Place, no. 9
 1956 Downtown, no. 20
 1958 Whitney, no. 97
 Group
 1957 Albany, N.Y.
 1964 Oswego, N.Y.
 1970 Schenectady, N.Y.

44.8
PAINTING IN TEMPERA
1944
21 × 28
Signed, lower center

Collection: Unidentified

Provenance: (Downtown Gallery)
 Miller (1966)
 (Terry Dintenfass Gallery)
 Robert Ellison, New York City (1975)

Exhibitions: Individual
 1944 American Place, no. 19
 1952 Downtown, no. 25
 1975 Dintenfass, "Arthur G. Dove: The Abstract Work," no. 20
 Group
 1967 Pennsylvania Academy

44.6

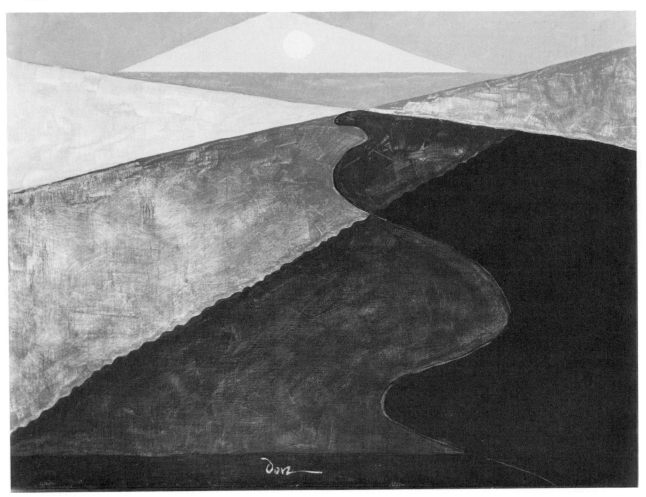

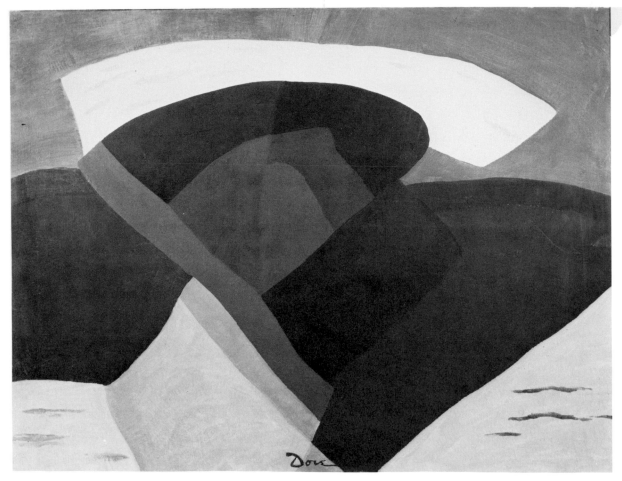

44.7

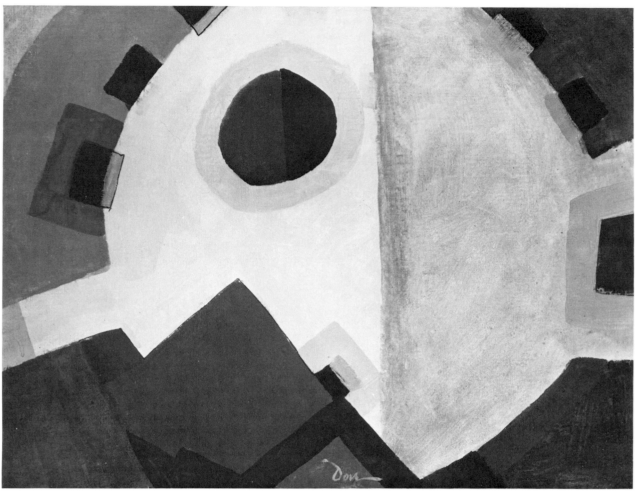

44.8

44.9
PIECES OF RED, GREEN, AND BLUE
1944
18 × 24
Signed, lower center
Collection: William H. Lane Foundation, Leominster, Mass. (1954)

Provenance: (Downtown Gallery)

Exhibitions: Individual
 1944 American Place, no. 17
 1945 American Place, no. 11, dated 1944
 1958 Whitney, no. 98
 1961 Worcester, Mass., no. 40
 1974 San Francisco Museum

44.10
POLYGONS AND TEXTURES
1943–44 (doc)
Medium and support not verified
Collection: Unidentified

Provenance: (An American Place)

Exhibition: Individual
 1944 American Place, no. 10

44.11
PRIMITIVE MUSIC
1944

18 × 24
Signed, lower center
Collection: Phillips Collection, Washington, D.C. (1944)

Provenance: (An American Place)

Exhibitions: Individual
 1944 American Place, no. 18
 1947 Downtown, no. 38
 Phillips
 1953 Corcoran
 1958 Whitney, no. 99
 1975 Dintenfass, "Arthur G. Dove: The Abstract Work," no. 19
 1981 Phillips, no. 76
 Group
 1969 College Park, Md.

44.12
THAT RED ONE
1944
27 × 36
Signed, lower center
Collection: William H. Lane Foundation, Leominster, Mass. (1958)

Provenance: (Downtown Gallery)

44.9

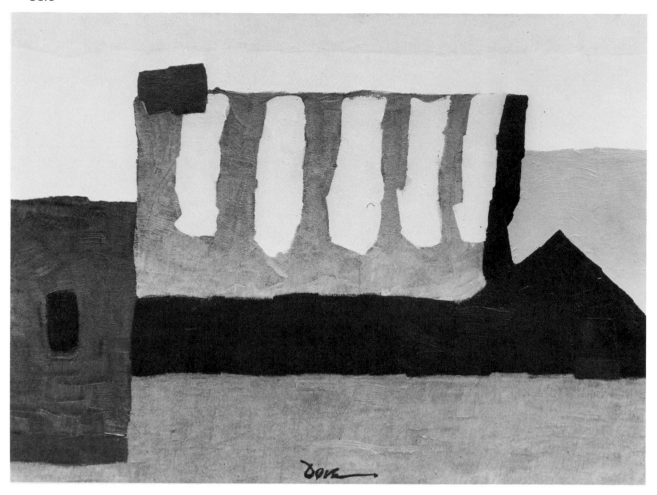

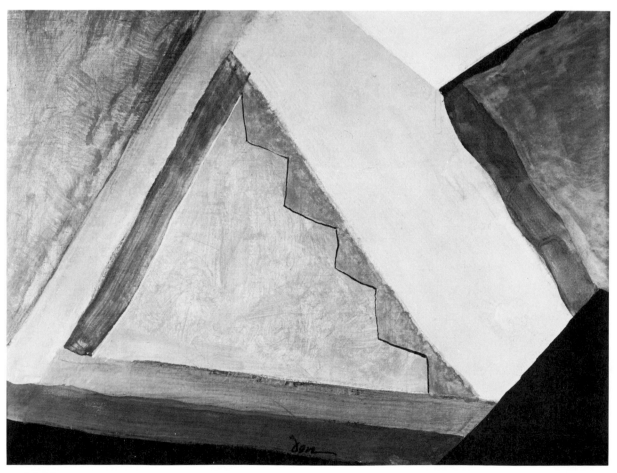

44.11

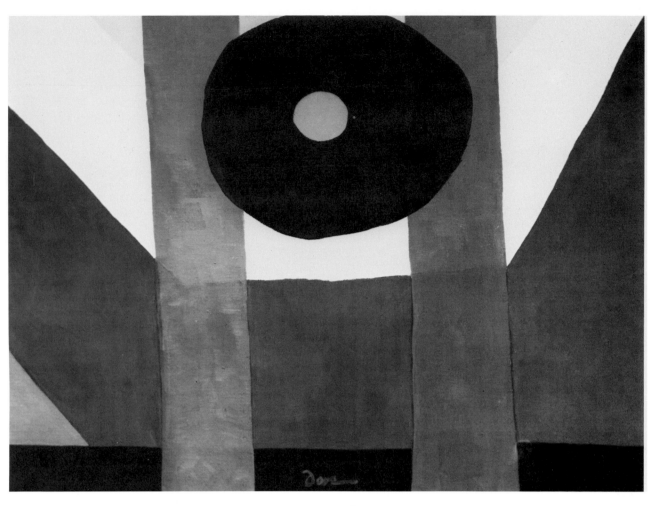

4.12

Exhibitions: Individual
 1944 American Place, no. 7
 1954 Ithaca, N.Y., no. 30
 1958 Whitney, no. 101
 1961 Worcester, Mass., no. 42.
 1974 San Francisco Museum
 Group
 1964 Whitney, no. 31

44.13

1944

1944
Medium and support not verified

Collection: Unidentified

Provenance: (Downtown Gallery)

Exhibitions: Individual
 1944 American Place, no. 13
 1947 Downtown, no. 34

1945

45.1
FIGURE FOUR
1945
18 × 24
Signed and dated 45, lower center

Collection: Estate of the artist, Terry Dintenfass Gallery

Exhibitions: Individual
 1946 American Place, no. 3, dated 1946
 1947 Downtown, no. 39
 1972 Dintenfass, no. 20
 1975 Dintenfass, "Arthur G. Dove: The Abstract Work," no. 22

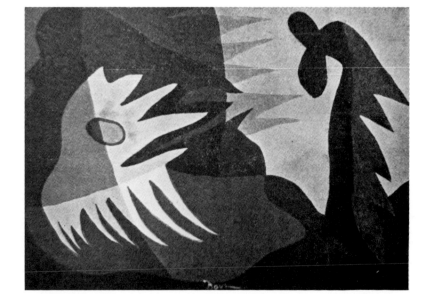

44.13

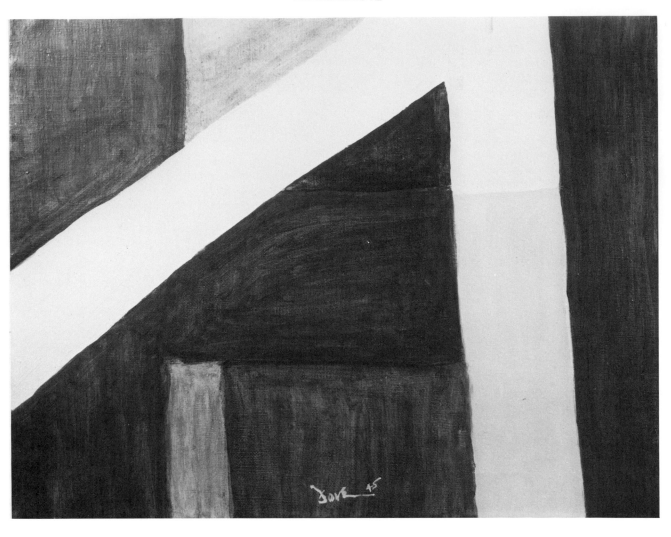

45.1

45.2
GREEN AND BROWN
1945
18 × 24
Signed, lower center

Collection: Hirshhorn Museum and Sculpture Garden, Smithsonian Institution, Washington, D.C.

Provenance: (Downtown Gallery)
Helen McMahon Cutting
(Savoy Art and Auction Galleries auction, New York, 25 June 1964)
Joseph H. Hirshhorn, New York City.

Remarks: Current museum title is *Abstract Composition.*

Exhibitions: Individual
1946 American Place, no. 7, titled *Green & Brown,* dated 1945
Group
1946 Whitney, no. 37, titled *Abstract Composition—Green and Brown,* dated 1946

45.3
IT CAME TO ME
1945
10¼ × 12½

Signed, lower center

Collection: Estate of the artist, Terry Dintenfass Gallery

Exhibitions: Individual
1946 American Place, no. 11, dated 1946
1972 Dintenfass, no. 19

1946

46.1
BEYOND ABSTRACTION
1946
12 × 9
Signed, lower center

Collection: Unidentified

Provenance: (Terry Dintenfass Gallery)
Dr. and Mrs. Leo Chalfen, New York City

Remarks: This is thought to be the last painting Dove completed.

Exhibitions: Individual
1947 Downtown, no. 41, dated 1946
1972 Dintenfass, no. 21
1974 San Francisco Museum (not all locations)

45.2

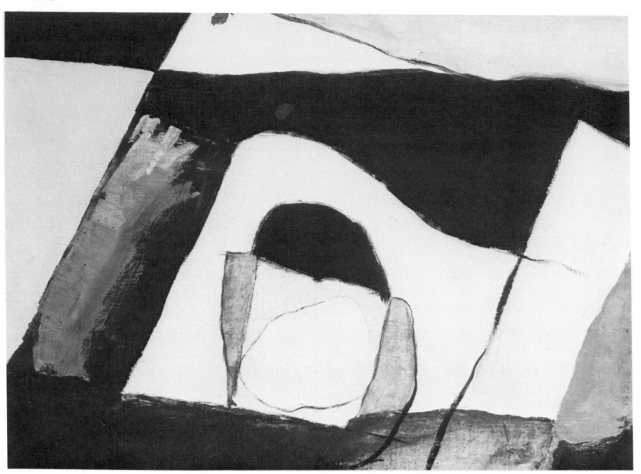

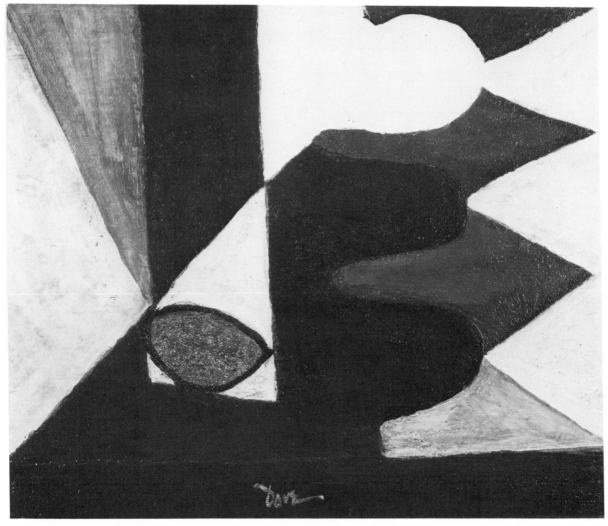

45.3

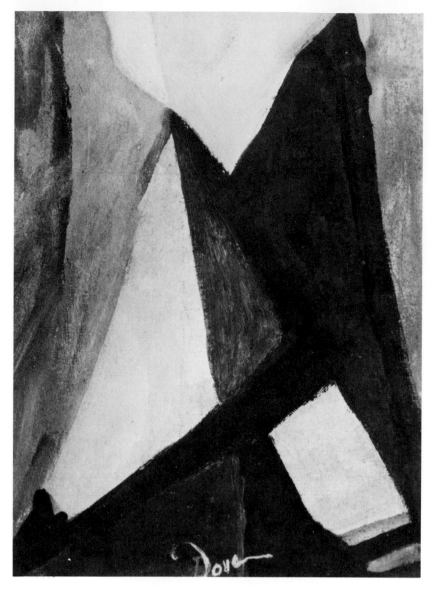

46.1

46.2
FLAT SURFACES
1946
27 × 36
Signed, lower center

Collection: Brooklyn Museum (Dick S. Ramsay Fund, 1955)

Provenance: (Downtown Gallery)

Exhibitions: Individual
 1946 American Place, no. 2
 1947 Downtown, no. 40
 1958 Whitney, no. 103
 1975 Dintenfass, "Arthur G. Dove: The Abstract Work," no. 23
 Group
 1950 Amsterdam, Netherlands, no. 43
 1951 Houston, Tex., no. 8
 1954 Baltimore, Md., no. 113
 1956 Downtown, no. 5
 1971 Katonah, N.Y., no. 13

46.3
RUNWAY
1946
18 × 24
Signed, lower center

Collection: Harold Giese, Bethesda, Md. (gift of Duncan Phillips, 1950)

Provenance: (An American Place)
 Duncan Phillips, Washington, D.C. (1946)

Exhibitions: Individual
 1946 American Place, no. 4
 1947 Phillips

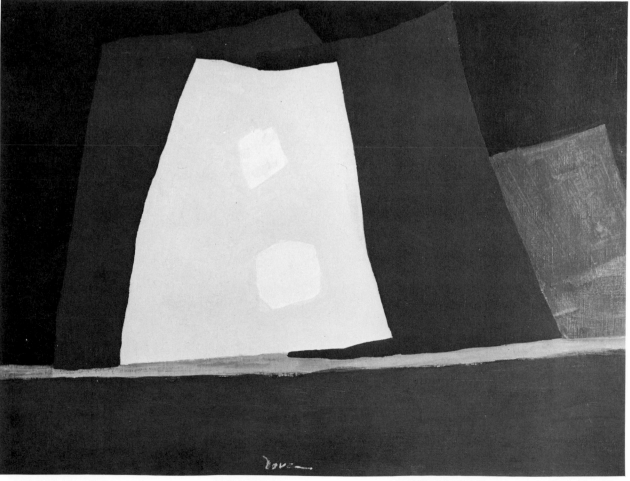

46.2

46.3

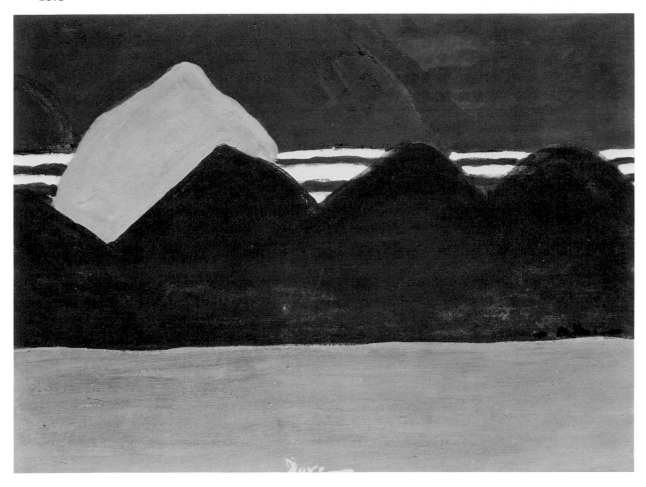

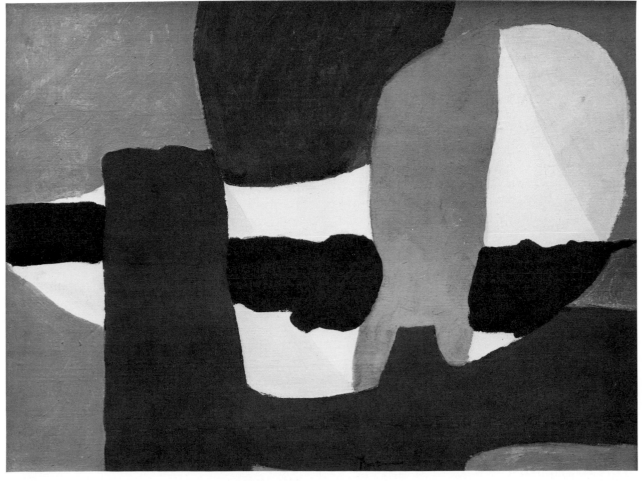

46.4

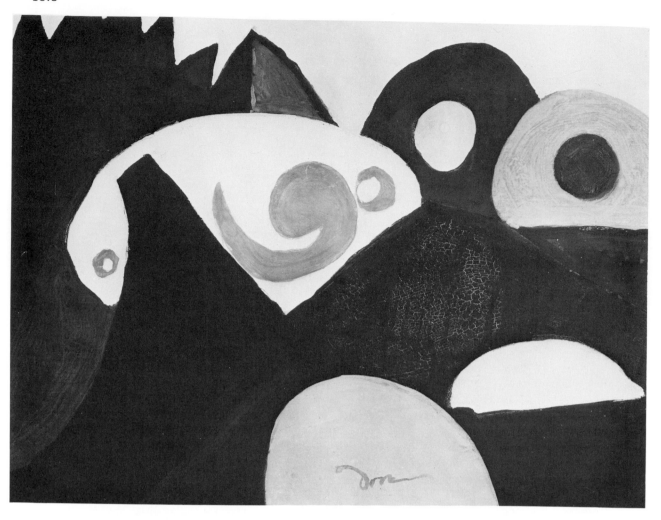

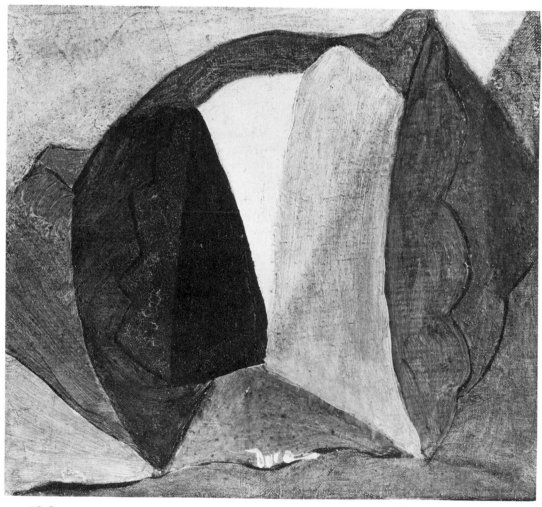

46.4
UPRIGHTS, MARS VIOLET AND BLUE
1946
18 × 24
Signed, lower edge right of center
Collection: Estate of the artist, Terry Dintenfass Gallery

Exhibitions: Individual
 1946 American Place, no. 1, titled *Uprights, Mars Violet & Blue*
 1975 Dintenfass, "Arthur G. Dove: The Abstract Work," no. 7, dated 1940
 1980 Dintenfass, dated 1940
 1981 Los Angeles, Calif., no. 14, dated 1942
Group
 1978 Zabriskie, no. 54, dated 1940

46.5
VARIETY
1946
18 × 24
Signed, near lower edge right of center

Collection: Estate of the artist, Terry Dintenfass Gallery

Exhibitions: Individual
 1946 American Place, no. 5
 1975 Dintenfass, "Arthur G. Dove: The Abstract Work, no. 24

46.6
YOUNG OLD MASTER
1946
10 × 11
Signed, lower center

Collection: Phillips Collection, Washington, D.C. (1946)

Provenance: (An American Place)

Exhibitions: Individual
 1946 American Place, no. 10
 1947 Phillips
 1953 Corcoran
 1981 Phillips, no. 79

Appendixes

THE SOURCE MATERIAL PRESENTED HERE CONSISTS of exhibition listings and bibliography. Because this type of documentation can never be truly definitive, I have favored utility and accuracy over mere tidiness. A small proportion of entries lack full details because, for one reason or another, I have been unable to verify them. Nevertheless, I have included these entries because they help to reveal the full picture of Dove's accomplishment and because I hope that they will facilitate research on this artist and the period in which he lived.

Exhibitions

Shows of Dove's work are separated into three categories. The first two detail, respectively, his one-person shows and the group exhibitions in which his work appeared along with the work of other artists. The third lists both one-person and group shows that included only watercolors and/or drawings by Dove; these are given in the interest of completeness but are separated from the others because the material they represent is not included in the catalogue.

The exhibitions in each group are listed chronologically by year of opening and alphabetically by city within the year, except that (as in the catalogue) New York shows appear first, Washington, D.C., shows second. Foreign exhibitions follow American ones, and touring shows (designed to travel only, not to be shown at the sponsoring institution) constitute the final category. As in the catalogue, galleries and museums are in New York City unless otherwise noted. Exhibitions held at auction houses preceding sales are not included.

Insofar as possible, the following information, in the order presented here, is given for each show:

Sponsor. The city is identified first (if other than New York City), then the institution, such as museum or gallery.

Title. The official title of the exhibition is indicated in quotation marks. A descriptive label is substituted when possible if the specific appellation is unknown.

Dates. Opening and closing dates of the exhibition are given with as much specificity as possible.

Documentation. Material issued by the sponsoring institution is listed whenever possible. "Catalogues" are book-length publications; "brochures" are pamphlets, generally of no more than sixteen pages and usually less. Unless otherwise noted, catalogues carry the same titles as the exhibitions they represent and were published by the sponsoring institution.

Additional showings. If the exhibition traveled from the sponsoring institution to other locations, these are listed, along with opening and closing dates if known.

Itinerary. Under this rubric are listed the locations where a touring exhibition was shown, if it was intended to circulate only and was not shown at the sponsoring institution.

References. All known contemporary reviews of the exhibition and interesting references to it are listed, except that group-show reviews that do not mention Dove are listed only when they are of some interest to the study of this artist. Newspaper and magazine exhibition announcements that give no more information than the entry in this catalogue are not included.

ARTHUR DOVE'S ONE-PERSON
EXHIBITIONS*

1909

Geneva, N.Y., Hobart College, Coxe Hall
"Arthur G. Dove"
7–9 October
Brochure with checklist

1912

Little Galleries of the Photo-Secession ("291")
"Arthur G. Dove First Exhibition Anywhere"
27 February–12 March
No catalogue or checklist
References:
 [Cary, Elisabeth Luther (?)]. "News and Notes of the Art World: Plain Pictures." *New York Times*, 3 March 1912, sec. 5, p. 15.
 Chamberlin, Joseph Edgar. "Pattern Paintings by A. G. Dove." *Evening Mail* (New York), 2 March 1912.
 "Exhibitions at the Photo-Secession." *New York Sun*, 28 February 1912.
 Haviland, Paul B. "Photo-Secession Notes: Exhibition of Pastels by Arthur G. Dove," *Camera Work*, no. 38 (April 1912): 36.
 Hoeber, Arthur. *New York Globe*. February 1912.
 Merrick, L. "Dove's 'Form and Color.'" *American Art News* 10–11 (2 March 1912): 2.
 "Notes of the Art World." *New York Herald*, 6 March 1912, 8.
 "Things Seen in the World of Art." *New York Sun*, 3 March 1912, sec. 2, p. 10.
 Tyrrell, Henry. "Up and Down Picture Lane." *New York World*, 9 March 1912.

Chicago, Ill., W. Scott Thurber Galleries
"Paintings of Arthur Dove"
14–30 March
No catalogue or checklist
(This show was presumably identical to the New York exhibition immediately preceding it.)
References:
 "Art and Artists." *Chicago Evening Post*. 16 March 1912.

 "Burlesque Art Gallery with Chicago Academy Students in Charge." *Chicago Tribune*, 30 March 1912, 3.
 Cook, George Cram. "Causerie (Post-Impressionism After Seeing Mr. Dove's Pictures)." *Chicago Evening Post Literary Review*, 29 March 1912.
 Gunn, Glenn Dillard. "'Sumurun' and the Futurists in Painting, Music, and Drama." *Chicago Tribune*, 17 March 1912, sec. 10, p. 3.
 "The Local Galleries." *Chicago Record-Herald*, 17 March 1912, sec. 7, p. 5, and 24 March 1912, sec. 7, p. 5.
 Monroe, Harriet. "'One-Man Shows' Allow Wide Choice." *Chicago Tribune*, 17 March 1912, part 2, p. 5.
 "Mr. Dove's Italian Cousins." *Chicago Evening Post*, 16 March 1912.
 Taylor, Bert Leston. "A Line-O'Type or Two: Lines Written After Viewing Mr. Arthur Dove's Exposition of the 'Simultaneousness of the Ambient.'" *Chicago Tribune*, 25 March 1912, 10. Reprinted in the *New York Tribune*, 12 April 1912, and in *Collier's*, 22 March 1913.
 ———. "A Line-O'Type or Two: Thelusay." *Chicago Tribune*, 27 March 1912, 12.
 ———. "A Line-O'Type or Two: O, Very Well." *Chicago Tribune*, 29 March 1912, 10.
 ———. "A Line-O'Type or Two: Our Village." *Chicago Tribune*, 30 March 1912, 10.
 ———. "A Line-O'Type or Two." *Chicago Tribune*, 1 April 1912, 10.
 ———. "A Line-O'Type or Two: Post Impressionism." *Chicago Tribune*, 3 April 1912, 8.
 ———. "A Line-O'Type or Two." *Chicago Tribune*, 8 April 1912, 12.
 Webster, H. Effa. "Artist Dove Paints Rhythms of Color." *Chicago Examiner*, 15 March 1912.

*See supplementary list for those exhibitions that included only watercolors and/or drawings.

1926

The Intimate Gallery
"Arthur G. Dove"
11 January–7 February
References:

"Arthur Dove: Intimate Gallery." *Art News* 24 (16 January 1926): 7.

Buranelli, Prosper. "Bricks vs. Art—A Family Drama." *New York World Magazine*, 30 May 1926.

Frank, Waldo. "The Art of Arthur Dove." *The New Republic* 45 (27 January 1926): 269–70.

"From Modernism Back to the XVIIth Century: Random Impressions in Current Exhibitions." *New York Herald Tribune*, 17 January 1926, sec. 5, p. 10.

"Independent Materials." *New York Times*, 17 January 1926, sec. 8, p. 12.

P[emberton], M[urdock]. "Art." *New Yorker* 1 (23 January 1926): 25–26.

Pemberton, Murdock. "The Art Galleries." *New Yorker* 2 (13 February 1926): 24.

1927

The Intimate Gallery
"Arthur G. Dove Paintings"
12 December—January 1928 (brochure lists closing date as 11 January, but other evidence indicates the closing was 7 January.)
Brochure with checklist and an artist's statement titled "An Idea."
References:

Fulton, D. "Arthur Dove: Intimate Gallery." *Art News*, 24 December 1927.

Jewell, E. A. "Arthur Dove's New Work." *New York Times*, 18 December 1927, sec. 9, p. 12.

McBride, Henry. "Recent Work of Arthur Dove." *New York Sun*, 17 December 1927.

Pemberton, Murdock. "The Art Galleries: Dove Comes to Terms—A Bursting Week of First-Class Things." *New Yorker* 3 (24 December 1927): 57–58.

"Rhapsody in Blue Defined in Color Terms." *New York World*, 18 December 1927.

1929

The Intimate Gallery
"Dove Exhibition"

9–28 April
Brochure with checklist and "Notes by Arthur G. Dove"
References:

Flint, Ralph. "Spring Art Shows in New York: Arthur Dove." *Christian Science Monitor* (Boston), 15 April 1929, 11.

Jewell, E. A. "Two Cryptic Artists." *New York Times*, 14 April 1929, sec. 10, p. 13.

McBride, Henry. *New York Sun*, 12 April 1929.

Pemberton, Murdock. "The Art Galleries." *New Yorker* 5 (20 April 1929).

1930

An American Place
"Arthur G. Dove"
22 March–22 April
Single-sheet checklist
References:

"Arthur Dove—An American Place." *Art News* 28 (5 April 1930): 12.

Jewell, E. A. "Other Artists: Concerning Mr. Dove." *New York Times*, 30 March 1930, sec. 8, p. 12.

———. "April Offerings in Art Galleries of New York." *New York Times*, 6 April 1930, sec. 10, p. 18.

[McBride, Henry]. "Attractions in Various Galleries." *New York Sun*, 29 March 1930.

P[emberton], M[urdock]. "The Art Galleries." *New Yorker* 6 (5 April 1930): 85–86.

1931

An American Place
"Arthur G. Dove"
9 March–4 April
Single-sheet checklist
References:

"Arthur Dove: An American Place." *Art News* 29 (21 March 1931): 12.

Burrows, Carlyle. "News and Comments on Current Art Events." *New York Tribune*, 15 March 1931, sec. 8, p. 8.

"'Clouds and Water' from Dove Exhibit." *Springfield (Mass.) Republican*, 22 March 1931.

Illustration of *Clouds and Water. Creative Art* 8 (April 1931): 256.

Jewell, E. A. "Dove Gives Annual Exhibition." *New York Times*, 11 March 1931, 20.

———. "Dove Again." *New York Times*, 15 March 1931, sec. 9, p. 12.

"Man or Quantity." *Springfield (Mass.) Union and Republican*, 18 March 1931.

[McBride, Henry]. "Attractions at Other Galleries." *New York Sun*, 14 March 1931.

Pemberton, Murdock. "The Art Galleries." *New Yorker* 7 (14 March 1931): 46–48.

———. "The Art Galleries." *New Yorker* 7 (21 March 1931): 68–70.

1932

An American Place

"Arthur G. Dove; New Paintings (1931–32)"

14 March–9 April

Single-sheet checklist with artist's notes titled "Addenda"

References:

"An American Place." *New York Times*, 20 March 1932, sec. 8, p. 10.

"Arthur Dove: An American Place." *Art News* 30 (19 March 1932): 9.

"Attractions in the Galleries." *New York Sun*, March 1932.

Bennett, Rainey. "On View in the New York Galleries: Arthur Dove, An American Place." *Parnassus* 4 (April 1932): 16–17.

Jewell, E. A. "Art: Dove's New Work Shown." *New York Times*, 18 March 1932, 24.

McCausland, Elizabeth. "Arthur G. Dove Exhibition Shows Artistic Advance." *Springfield (Mass.) Union and Republican*, 20 March 1932.

———. "Arthur Dove's Showings of Oils and Water Colors." *Springfield (Mass.) Republican*, March 1932.

[Pemberton, Murdock]. "The Art Galleries." *New Yorker* 8 (26 March 1932).

Rosenfeld, Paul. "The World of Arthur G. Dove." *Creative Art* 10 (June 1932): 426–30.

Shelby, Melvin Geer. "Around the Galleries: An American Place." *Creative Art* 10 (May 1932): 395–96.

1933

An American Place

"Arthur G. Dove, Helen Torr, New Paintings and Watercolors"

29 March–15 April

References:

"Arthur Dove, Helen Torr: An American Place." *Art News* 31 (25 March 1933): 5.

Jewell, E. A. "The Realm of Art: An Older Movement and New Trends." *New York Times*, 26 March 1933, sec. 9, p. 10.

McBride, Henry. "Attractions in the Galleries." *New York Sun*, 25 March 1933, 9.

McCausland, Elizabeth. "Painter's Progress Shown in Arthur G. Dove's Work," *Springfield (Mass.) Union and Republican*, 9 April 1933, E6.

"Modern Paintings by Dove Exhibited." *New York Post*, 28 March 1933.

Mumford, Lewis. "The Art Galleries: Cabarets and Clouds." *New Yorker* 9 (1 April 1933): 38–39.

1934

An American Place

"Arthur G. Dove. New Things and Old"

17 April–15 May (extended to 1 June)

References:

Burrows, Carlyle. "A Retrospective Show by Arthur Dove." *New York Herald Tribune*, 29 April 1934, sec. 5, p. 10.

Jewell, E. A. "Exhibition Shows Dove's Early Art." *New York Times*, 21 April 1934, 13.

[McBride, Henry]. "Attraction in Other Galleries." *New York Sun*, 28 April 1934, 16.

McCausland, Elizabeth. "Dove's Oils, Water Colors Now at An American Place." *Springfield (Mass.) Union and Republican*, 22 April 1932, E6.

Mumford, Lewis. "The Art Galleries: Surprise Party—Wit and Water Colors." *New Yorker* 10 (5 May 1934): 56.

1935

An American Place

"Arthur G. Dove; Exhibition of Paintings (1934–1935)"

21 April–22 May

Brochure with checklist.

References:

Jewell, E. A. "Three Shows Here of Abstract Art." *New York Times*, 3 May 1935, 22.

———. "In the Realm of Art: A Week of Pointed Contrasts." *New York Times*, 5 May 1935, sec. 9, p. 7.

McBride, Henry. "Attractions in Other Galleries." *New York Sun*, 4 May 1935.

McCausland, Elizabeth. "Authentic American is Arthur G. Dove." *Springfield (Mass.) Union and Republican*, 5 May 1935, E6.

Mumford, Lewis. "The Art Galleries." *New Yorker* 11 (4 May 1935): 28–34.

"Museum Buys Four Arthur Doves from Show." *Art Digest* 9 (15 May 1935): 16.

1936

An American Place
"New Paintings by Arthur G. Dove"
20 April–20 May
Brochure with checklist
References:

Jewell, E. A. "The Realm of Art: Comment on Current Shows." *New York Times*, 26 April 1936, sec. 9, p. 7.

Klein, Jerome. "Mr. Dove's Work." *New York Post*, 25 April 1936.

McBride, Henry. "Attractions in the Galleries." *New York Sun*, 25 April 1936.

Mumford, Lewis. "The Art Galleries: The Independent Show." *New Yorker* 12 (2 May 1936): 43–45.

Sayre, Ann H. "New Exhibitions of the Week: Arthur G. Dove Seeks Cosmic Rhythms." *Art News* 34 (9 May 1936): 8.

1937

An American Place
"Arthur G. Dove: New Oils and Water Colors"
23 March–16 April
Brochure with checklist and introduction by William Einstein
References:

"Abstractions of Nature by Arthur G. Dove." *Art News* 35 (10 April 1937): 15–16.

Burrows, Carlyle. "Arthur G. Dove." *New York Herald*, 28 March 1937.

Devree, Howard. "A Reviewer's Notebook: Comment on the Newly Opened Shows—Arthur Dove and Others." *New York Times*, 28 March 1937, sec. 11, p. 10.

McCausland, Elizabeth. "Arthur G. Dove's Showing of Oils and Water Colors." *Springfield (Mass.) Republican*, 28 March 1937, E6.

Mumford, Lewis. "The Art Galleries," *New Yorker* 13 (10 April 1937).

Washington, D.C.
Phillips Collection (then Phillips Memorial Art Gallery)
"Retrospective Exhibition of Works in Various Media by Arthur G. Dove"
23 March–18 April
Brochure with checklist and introduction by Duncan Phillips
References:

Graeme, Alice. "Paintings of Arthur G. Dove in Various Media at Gallery Here Show Artist's Mature Style." *Washington Post*, 11 April 1937, sec. 7, p. 9.

1938

An American Place
"Arthur G. Dove; Exhibition of Recent Paintings, 1938"
29 March–10 May
Brochure with checklist and reprint of Duncan Phillips's essay, "The Art of Arthur Dove," from the brochure for the 1937 Phillips Collection retrospective.
References:

Davidson, Martha. "Arthur Dove: The Fulfillment of a Long Career." *Art News* 36 (7 May 1938): 16.

"Exhibitions in New York: Dove." *Studio* (London) 16 (July 1938): 66.

Genauer, Emily. "Dove's Nature Studies." *New York World-Telegram*, 16 April 1938.

Jewell, E. A. "Four Art Displays Reviewed in Brief." *New York Times*, 1 April 1938, 21.

———. "Realm of Art: A Pot-pourri of Local Shows." *New York Times*, 3 April 1938, sec. 11, p. 7.

[McBride, Henry]. "Attractions in the Galleries." *New York Sun*, March 1938.

McCausland, Elizabeth. "Arthur G. Dove Exhibits at An American Place." *Springfield (Mass.) Union and Republican*, 10 April 1938, E6.

1939

An American Place
"Arthur G. Dove; Exhibition of Oils and Temperas"
10 April–7 May
Brochure with checklist

References:

Coates, Robert M. "The Art Galleries." *New Yorker* 15 (29 April 1939): 86–87.

Jewell, E. A. "In the Realm of Art: Exhibitions and Other Events." *New York Times*, 16 April 1939, sec. 10, p. 9.

L[owe], J[eannette]. "Dove's Compositions in Oil & Montage." *Art News* 37 (13 May 1939): 15.

McBride, Henry. "Attractions in the Galleries." *New York Sun*, April 1939.

McCausland, Elizabeth. "Dove Retrospective at An American Place." *Springfield (Mass.) Union and Republican*, 2 April 1939.

1940

An American Place

"Arthur G. Dove; Exhibition of New Oils and Water Colors"

30 March–14 May

Brochure with checklist and notes by the artist

References:

Coates, Robert M. "The Art Galleries: News from All Over." *New Yorker* 16 (20 April 1940): 68.

"Heard at the Galleries; Arthur G. Dove." *Pictures on Exhibit* 3 (May 1940): 29.

Jewell, E. A. "Potpourri: Shows in Museums and Galleries." *New York Times*, 7 April 1940, sec. 9, p. 9.

L[owe], J[eannette]. "A. Dove's Semi-Abstract Landscapes." *Art News* 38 (13 April 1940): 13.

McBride, Henry. "Attractions in the Galleries." *New York Sun*, 13 April 1940.

McCausland, Elizabeth. "Exhibitions in New York: Arthur G. Dove, An American Place." *Parnassus* 12 (May 1940): 43.

Rosenfeld, Paul. "Dove and the Independents." *The Nation* 150 (27 April 1940): 549.

1941

An American Place

"New Arthur G. Dove Paintings"

27 March–17 May

Single-sheet checklist

References:

Jewell, E. A. "Off the 'Literal' Trail." *New York Times*, 6 April 1941, sec. 9, p. 9.

L[ane], J[ames] W. "The Passing Shows: Arthur Dove." *Art News* 40 (1–14 May 1941): 28.

1942

An American Place

"Arthur G. Dove; Exhibition of Recent Paintings (1941–1942)"

14 April–27 May

Brochure with checklist, three brief critical comments, and the artist's poem, "A Way To Look at Things" (written in 1925)

References:

Jewell, E. A. "Abstract: New Work by Dove and Knaths." *New York Times*, 19 April 1942, sec. 8, p. 5.

Lane, James W. "Abstract Poet of Color at An American Place," *Art News* 41 (15 May 1942): 21.

McBride, Henry. "Attractions in the Galleries." *New York Sun*, 17 April 1942.

1943

An American Place

"Arthur G. Dove; Paintings—1942–43"

11 February–17 March

Brochure with checklist and a brief comment by the artist

References:

"Attractions in the Galleries." *New York Sun*, 19 February 1943.

[Genauer, Emily]. "Showing by Dove." *New York World-Telegram*, 20 February 1943.

Jewell, E. A. "Art Show Opened By Arthur Dove." *New York Times*, 13 February 1943, 12.

———. "In the Realm of Art: Current Shows and Other Events, In Miniature." *New York Times*, 21 February 1943, sec. 2, p. 11.

"The Passing Shows: Arthur Dove." *Art News* 42 (1 March 1943): 23.

R[iley], M[aude]. "Arthur Dove at An American Place." *Art Digest* 17 (1 March 1942): 9.

1944

An American Place

"Arthur G. Dove; Paintings—1944"

21 March–21 May

Brochure with checklist

References:
 "Attractions in the Galleries." *New York Sun,* 8 April 1944.
 Burrows, Carlyle. "Art of the Week: Arthur Dove." *New York Tribune,* 2 April 1944, sec. 4, p. 5.
 Coates, Robert M. "The Art Galleries: Those Abstractionists Again." *New Yorker* 20 (8 April 1944): 62–63.
 Devree, Howard. "A Reviewer's Notes." *New York Times,* 26 March 1944, sec. 2, p. 7.
 "The Passing Shows: Arthur Dove." *Art News* 43 (1 May 1944): 19.

1945

An American Place
"Arthur G. Dove; Paintings—1922–1944"
3 May–15 June
Single-sheet checklist
References:
 Jewell, E. A. "Art: Glances All About." *New York Times,* 13 May 1945, sec. 2, p. 2.
 "The Passing Shows: Arthur Dove." *Art News* 44 (15 May 1945): 7.
 Riley, Maude. "Latest Doves Make Strong Impression." *Art Digest* 19 (June 1945): 14.

1946

An American Place
"Recent Paintings (1946); Arthur G. Dove"
4 May–4 June
Typed checklist
References:
 Jewell, E. A. "Other New Shows." *New York Times,* 12 May 1946, sec. 2, p. 6.
 "Reviews and Previews: Arthur Dove." *Art News* 45 (June 1946): 50.
 Wolf, Ben. "Dove, Valid Modern." *Art Digest* 20 (June 1946): 14.

1947

Downtown Gallery
"Dove Retrospective Exhibition; Paintings: 1908 to 1946"
7–25 January (extended through 1 February)
Brochure with checklist
Additional showings:
 Los Angeles, California
 Vanbark Studios
 7 February–15 March

Santa Barbara, California
Santa Barbara Museum of Art
1–18 April
San Francisco, California
San Francisco Museum of Art (under title "Paintings by Arthur Dove")
22 April–18 May
References:
 Art Digest 11 (March 1947): 40.
 "Arthur Dove." *Critique* 1 (January–February 1947): 66–68.
 "Arthur Dove." *Daily Worker* (New York), 23 January 1947.
 Barefoot, Spencer. "The Art Galleries." *San Francisco Chronicle,* 27 April 1947, 22.
 Burrows, Carlyle. "Art of the Week: A Survey of American Drawing, Painting." *New York Herald Tribune,* 12 January 1947, sec. 5, p. 8.
C[rane], J[ane] W[atson]. *Washington Post,* 12 January 1947.
Clurman, Harold. "Nightlife and Daylight." *Tomorrow* (New York), April 1947.
Coates, Robert M. "The Art Galleries: Arthur Dove, Walter Murch, Peter Blume." *New Yorker* 22 (18 January 1947): 60.
Genauer, Emily. "This Week in Art." *New York World-Telegram,* 11 January 1947.
Hess, Thomas B. "Spotlight on Dove." *Art News* 41 (January 1947): 23, 62.
Jewell, E. A. *New York Times,* 8 January 1941, 21.
———. "Dove in Retrospect." *New York Times,* 12 January 1947, sec. 2, p. 9.
———. "Gallery Displays Work by Lachaise." *New York Times,* 21 January 1947, 21.
Kruse, A. Z. "Gallery Previews in New York: Arthur G. Dove Retrospective." *Pictures on Exhibit* 9 (January 1947): 31.
Millier, Arthur. "Arthur Dove Art Goes on Display Here." *Los Angeles Times,* 23 February 1947, sec. 3, p. 4.
"News and Comments on Art . . . San Francisco Museum of Art." *Architect and Engineer* 169 (April 1947): 6.
"A Retrospective Exhibition." *American Artist* 11 (March 1947): 40.
Reuter, Herman. "At the Galleries." *Hollywood Citizen-News,* 22 February 1947.
Wolf, Ben. "Retrospective Exhibition Given Arthur Dove." *Art Digest* 21 (January 1947): 10.

"Work of Late Geneva Artist on Exhibition." *Geneva (N.Y.) Times*, 9 January 1947.

Washington, D.C.
Phillips Collection (then Phillips Memorial Art Gallery)
"Retrospective Exhibition of Paintings by Arthur G. Dove"
18 April–22 September
Typed checklist
References:
 Crane, Jane Watson. "Phillips Shows Paintings by Dove, Gernand." *Washington Post*, 11 May 1947.
 Summerfield, Ben L. "Arthur Dove Retrospective." *Right Angle* (Washington, D.C.), June 1947, 6.

Utica, New York
Munson-Williams-Proctor Institute
"Paintings by Arthur G. Dove, 1880–1946"
7–29 December
Reference:
 "Wide Range Featured in Institute Exhibits." *Utica Observer-Dispatch*, 7 December 1947, 8.

1952

Downtown Gallery
"Arthur G. Dove (1880–1946): Paintings"
22 April–10 May
Brochure with checklist and critical comments
References:
 Burrows, Carlyle. "Dove Revival." *New York Herald Tribune*, 27 April 1952, sec. 4, p. 9.
 Chanin, A. L. "The World of Art: Dove, Cikovsky, Miro, Picasso Shine in Current Exhibitions." *The Compass*, 27 April 1952, 26.
 Coates, Robert M. "The Art Galleries: Seventeen Men." *New Yorker* 28 (3 May 1952): 95–97.
 Devree, Howard. "Pioneer Modernist." *New York Times*, 27 April 1952, sec. 2, p. 9.
 Fitzsimmons, James. "Dove's Abstract Nature." *Art Digest* 26 (1 May 1952): 16.
 "In the Art Galleries." *New York Post*, 19 April 1952.
 Pictures on Exhibit 14 (May 1952).
 P[orter], F[airfield]. "Reviews and Previews: Arthur Dove." *Art News* 51 (May 1952): 46.

1953

Washington, D.C.
Corcoran Gallery of Art
Retrospective exhibition (organized by the Institute of Contemporary Art)
2 May–14 July
Reference:
 Portner, Leslie Judd. "Art in Washington: Lahey and Dove at the Corcoran." *Washington Post*, 31 May 1953, sec. 6, p. 3.

1954

Ithaca, New York
Andrew Dickson White Art Museum, Cornell University
"Arthur G. Dove: A Retrospective Exhibition"
November
Catalogue by Alan Solomon.
References:
 "The Alchemist." *Time* 64 (8 November 1954): 89.
 George, LaVerne. "Arthur Dove." *Art Digest* 29 (15 December 1954): 11.

Minneapolis, Minnesota
Walker Art Center
"Paintings and Watercolors by Arthur G. Dove"
10 January–20 February
Catalogue in Walker Art Center Calendar

1955

Downtown Gallery
"Collages: Dove"
1–26 November
Brochure with checklist
References:
 G[eorge], L[aVerne]. "In the Galleries: Arthur Dove." *Arts* 30 (November 1955): 50.
 Kreider, Stanton. "Gallery Previews in New York: Arthur Dove." *Pictures on Exhibit* 19 (November 1955): 20.
 New York Herald Tribune, 6 November 1955.
 O'Hara, Frank. "Reviews and Previews: Arthur G. Dove." *Art News* 54 (November 1955): 52.

1956

Downtown Gallery
"Special Exhibition of Paintings by Dove"

28 February–24 March

Brochure with checklist

References:

Coates, Robert M. "The Art Galleries: Five and One." *New Yorker* 32 (10 March 1956): 81–82.

G[eorge], L[aVerne]. "In the Galleries: Arthur Dove." *Arts* 30 (March 1956): 56.

P[orter], F[airfield]. "Reviews and Previews: Arthur Dove." *Art News* 55 (March 1956): 50.

Seckler, Dorothy Gees. "Gallery Notes: Arthur Dove." *Art in America* 44 (Spring 1956): 57.

Soby, James Thrall. "Arthur Dove and Morris Graves." *Saturday Review* 39 (7 April 1956): 32–33.

Los Angeles, California

Paul Kantor Gallery

"Arthur Dove"

7 May–1 June

Brochure with checklist and critical comments

1958

Whitney Museum of American Art

"Arthur G. Dove"

30 September–16 November

Catalogue by Frederick S. Wight (published by University of California Press, Berkeley)

Additional showings:

Washington, D.C.

Phillips Collection (then Phillips Memorial Art Gallery)

30 November–5 January 1959

Boston, Massachusetts

Museum of Fine Arts

25 January 1959–28 February 1959

San Antonio, Texas

Marion Koogler McNay Art Institute

18 March 1959–18 April 1959

Los Angeles, California

Art Galleries of the University of California, Los Angeles

1 May 1959–15 June 1959

LaJolla, California

LaJolla Art Center

20 June 1959–30 July 1959

San Francisco, California

San Francisco Museum of Art

15 August 1959–30 September 1959

References:

Campbell, Lawrence. "Dove; Delicate Innovator." *Art News* 46 (October 1958): 28–29.

Devree, Howard. "Art: Pioneer Modernist." *New York Times*, 1 October 1958, 43.

Genauer, Emily. "Dove's Art Displayed at Museum." *New York Herald Tribune*, 1 October 1958, 19.

Getlein, Frank. "Critics Clash Over Arthur Dove's Work." *Milwaukee Journal*, 23 November 1958, pt. 5, p. 6.

Hoffman, Edith. "Current and Forthcoming Exhibitions: New York." *Burlington Magazine* 100 (November 1958): 406.

"Music of the Eye." *Time* 72 (20 October 1958): 84.

Ray, Martin. "Arthur Dove, 'The Boldest . . . Pioneer.'" *Arts* 32 (September 1958): 34–41.

1961

Downtown Gallery

"First Showing Major Drawings 1911–20 and Color Studies—Evolution of a Painting—Dove"

14 November–2 December

Checklist

References:

K[roll], J[ack]. "Reviews and Previews: Arthur G. Dove." *Art News* 60 (December 1961): 11.

Preston, Stuart. "Current and Forthcoming Exhibitions: New York." *Burlington Magazine* 104 (January 1962): 42.

T[illim], S[idney]. "New York Exhibitions: In the Galleries—Arthur Dove." *Arts Magazine* 36 (January 1962): 43.

Worcester, Massachusetts

Worcester Art Museum

"Paintings and Water Colors by Arthur G. Dove"

27 July–17 September

Brochure with essay by Daniel Catton Rich

Reference:

"Pioneer Abstractionist." *Time* 78 (11 August 1961): 42–45.

1963

San Francisco, California

Gump's Gallery

1964

Washington, D.C.
Phillips Collection
"Paintings by Arthur G. Dove from the Collection"
9 April–30 May
Typed checklist

Detroit, Michigan
Donald Morris Gallery
"Arthur G. Dove: Oils—Watercolors—Drawings—Collage"
3–23 May
Brochure with checklist

1967

Downtown Gallery
"Arthur G. Dove, Paintings 1911–1946"
15 March–8 April
Brochure with checklist
References:
 D[ownes], R[ackstraw]. "Reviews and Previews: Arthur Dove." *Art News* 66 (May 1967): 12.
 Kramer, Hilton. "The Loneliness of Arthur Dove." *New York Times*, 19 March 1967, sec. 2, p. 27.

College Park, Maryland
University of Maryland Art Gallery, J. Millard Tawes Fine Arts Center
"Arthur Dove: The Years of Collage"
13 March–19 April
Catalogue by Dorothy Rylander Johnson
References:
 Johnson, Dorothy Rylander. "The Collages of Arthur Dove." *Artforum* 5 (May 1967): 40–41.
 Kramer, Hilton. "The Loneliness of Arthur Dove." *New York Times*, 19 March 1967, sec. 2, p. 27.

Geneva, New York
Geneva Historical Society Museum
"Arthur G. Dove—Paintings, Drawings, Memorabilia"
15–30 October

Huntington, New York
Heckscher Museum

"Arthur G. Dove of Long Island Sound"
20 August–17 September
Brochure with foreword by E[va] I. G[atling]

1968

East Lansing, Michigan
Kresge Art Center Gallery, Michigan State University
"Arthur Dove (1880–1946)"
3–24 November
Catalogue, with essay by Paul Love, in *Kresge Art Center Bulletin* 2 (November 1968).
Museum of Modern Art (touring exhibition)
"Arthur Dove"
Brochure with checklist
Itinerary:
 Fort Worth, Texas
 Fort Worth Art Center
 3–24 March
 Austin, Texas
 University Art Museum, University of Texas
 7 April–1 May
 Macon, Georgia
 Mercer University Gallery
 11 June–8 July
 Brunswick, Maine
 Bowdoin College Museum of Art
 9 September–6 October
 South Hadley, Massachusetts
 Mount Holyoke College Gallery
 20 October–10 November
 Jacksonville, Florida
 Cummer Gallery of Art
 7–28 January 1969
 Athens, Georgia
 University of Georgia Museum of Art
 17 February–10 March 1969
 Mason City, Iowa
 Charles H. MacNider Museum
 28 March–27 April 1969

1970

Terry Dintenfass Gallery
"Arthur G. Dove: Collages"
22 December–23 January 1971
Brochure with checklist
References:
 Campbell, Lawrence. "Reviews and Previews: Arthur G. Dove." *Art News* 69 (January 1971): 18.

Kramer, Hilton. "Art: Witty Collages of Arthur Dove." *New York Times*, 9 January 1971, 23.

Marandel, J. Patrice "Lettre de New-York." *Art International* 15 (20 March 1971): 54–55.

Pincus-Witten, Robert. "Arthur Dove, Dintenfass Gallery." *Artforum* 9 (March 1971): 61–62.

1971

Houston, Texas
Galerie Ann
Retrospective exhibition
7 January–4 February

1972

Terry Dintenfass Gallery
"Arthur G. Dove: Exhibition of Paintings, 1917–1946"
1–26 February
Brochure with checklist, introduction by Thomas M. Messer, and excerpt from a letter written by the artist in 1929.
References:
B[eckley], B[ill]. "Reviews and Previews: Arthur Dove." *Art News* 70 (February 1972): 14.

Hancock, Marianne. "Arthur Dove." *Arts Magazine* 46 (March 1972): 65.

Kramer, Hilton. "Shedding More Light on Dove's Work." *New York Times*, 12 February 1972, M29.

1973

Terry Dintenfass Gallery
"Country Life; Arthur G. Dove—Paintings, Watercolors, Drawings"
18 September–13 October
Brochure with checklist
References:
"Arthur G. Dove: Country Life." *Village Voice* (N.Y.), 20 September 1973, 52.

"Goings On About Town: Art—Arthur G. Dove (1880–1946)." *New Yorker* 49 (8 October 1973): 8.

Kramer, Hilton. "Arthur G.Dove." *New York Times*, 29 September 1973, 27.

1974

San Francisco, California
San Francisco Museum of Art (now San Francisco Museum of Modern Art)
"Arthur Dove"
21 November–5 January 1975
Catalogue by Barbara Haskell
Additional showings:
Buffalo, New York
Albright-Knox Art Gallery
27 January–2 March 1975
Saint Louis, Missouri
Saint Louis Art Museum
3 April–25 May 1975
Chicago, Illinois
Art Institute of Chicago
12 July–31 August 1975
Des Moines, Iowa
Des Moines Art Center
22 September–2 November 1975
Whitney Museum of American Art
24 November 1975–18 January 1976
References:
Anderson, Alexandra C. "Arthur Dove: Abstracting Energy from Nature." *Art News* 75 (April 1976): 82–84.

"Art Across North America: The Daring of Dove." *Apollo* 103 (May 1976): 440–41.

"Arthur Dove." *Albright-Knox Art Gallery Notes* 39 (Annual Report 1974–75): 15.

Bremer, Nina. "The Whitney Museum of American Art Exhibition: Retrospective Exhibition of Arthur Dove." *Pantheon* 34 (April–May–June 1976): 166.

Derfner, Phyllis. "New York Letter: Arthur Dove." *Art International* 20 (January–February 1976): 56.

Frankenstein, Alfred. "Arthur Dove: Abstraction at Will." *Art in America* 53 (March–April 1975): 58–61.

———. "Dove's Kind of Abstract." *San Francisco Chronicle*, 5 December 1974, 50.

Genauer, Emily. "Something New: Quality." *New Haven (Conn.) Register*, 21 December 1975, D3–4.

Kramer, Hilton. "Arthur Dove—A Pastoral Outsider in Modern Painting." *New York Times*, 7 December 1975, sec. 2, pp. 1 and 41.

———. "The Intimate Art of Arthur G. Dove." *New York Times*, 28 November 1975, 48.

Steger, Pat. "Social Scene: A Preview Review." *San Francisco Chronicle*, 22 November 1974.

1975

Andrew Crispo Gallery
"Arthur Dove"
12–29 November
References:
 Derfner, Phyllis. "New York Letter: Arthur Dove." *Art International* 20 (January–February 1976): 56.
 Lorber, Richard. "Arts Reviews: Arthur Dove." *Arts Magazine* 50 (January 1976): 13.

Terry Dintenfass Gallery
"Essences: Arthur G. Dove"
28 January–22 February
References:
 Anderson, Alexandra. "New York Reviews: Arthur Dove." *Art News* 74 (February 1975): 103–4.
 Bell, Jane. "Arthur Dove." *Arts Magazine* 49 (February 1975): 78.
 Derfner, Phyllis. "New York Letter." *Art International* 19 (20 April 1975): 59.

Terry Dintenfass Gallery
"Arthur G. Dove: The Abstract Work"
2–27 December
Brochure with checklist

Houston, Texas
Robinson Galleries
"Arthur G. Dove: 'Mainly the Forties'"
4 September–6 October
Catalogue with essays by Barbara Haskell, Betty W. Hirsch, Ann Robinson, and Jim Harithas
Additional showings:
 Beaumont, Texas
 Beaumont Art Museum
 31 October–30 November
 Waco, Texas
 Waco Creative Art Center
 10 January–14 February 1976
 San Antonio, Texas
 Marion Koogler McNay Art Institute
 4 April–9 May 1976

1980

Terry Dintenfass Gallery
"Arthur G. Dove: Singular Works"
8 January–15 February
Brochure with introduction by Barbara Haskell
References:
 Lublin, Mary Ann. "Arthur Dove." *Arts Magazine* 54 (April 1980): 12.
 Russell, John. "Art: Glimpses of Arthur Dove's Many Sides." *New York Times*, 25 January 1980, C17.

1981

Washington, D.C.
Phillips Collection
"Arthur Dove and Duncan Phillips: Artist and Patron"
13 June–16 August
Catalogue by Sasha M. Newman
Additional showings:
 Atlanta, Georgia
 High Museum of Art
 11 September–30 October
 Kansas City, Missouri
 William Rockhill Nelson Gallery and Atkins Museum of Fine Arts
 13 November–3 January 1982
 Houston, Texas
 Museum of Fine Arts
 21 January–21 March 1982
 Columbus, Ohio
 Columbus Museum of Art
 18 April–9 June 1982
 Seattle, Washington
 Seattle Art Museum
 1 July–6 September 1982
 Milwaukee, Wisconsin
 New Milwaukee Art Center
 29 September–14 November 1982
References:
 Bruno, Santo. "Arthur Dove and Duncan Phillips: Artist and Patron." *Art Papers* (Atlanta), November–December 1981, 21–22.
 Clement, Tillie. "A Talented Artist." *Haddon Gazette* (Haddonfield, N.Y.), 20 August 1981, 4.
 Schall, Jan. "Rose on Dove," *Art Papers* (Atlanta), November–December 1981, 16.

Los Angeles, California
Asher/Faure Gallery
"Arthur G. Dove"
21 November–19 December

GROUP EXHIBITIONS INCLUDING
ARTHUR DOVE'S WORK*

1908

Paris, France
Grand Palais des Champs-Elysées
"Salon d'automne"
1 October–8 November
Catalogue, titled *Catalogue des ouvrages*, published for the Société du Salon d'automne by Librairie Administrative Paul Dupont.
References:
 Hepp, Pierre. "Le Salon d'automne." *Gazette des Beaux Arts*, ser. 3, 40 (November 1908): 380–401. [Dove not mentioned.]
 "Studio-Talk: Paris." *The Studio* 45 (December 1908): 233–36. [Dove not mentioned.]

1909

Paris, France
Grand Palais des Champs-Elysées
"Salon d'automne"
1 October–8 November
Catalogue, titled *Catalogue des ouvrages*, published for the Société du Salon d'automne by Société Anonyme de l'Imprimerie Kugelmann.
References:
 "American Work Wins High Favor at Autumn Salon." *New York World*, 2 October 1909.
 Goujon, Pierre. "Le Salon d'automne." *Gazette des Beaux Arts*, ser. 4, (November 1909): 371–88. [Dove not mentioned.]
 "News and Notes of the Art World." *New York Times*, 24 October 1909, sec. 5, p. 12. [Dove not mentioned.]
 "Studio-Talk: Paris." *The Studio* 48 (December 1909): 242. [Dove not mentioned.]

1910

Little Galleries of the Photo-Secession ("291")
"Younger American Painters"
9–21 March
No catalogue or checklist.

References:
 [Cary, Elisabeth Luther]. *New York Times Magazine*, 20 March 1910, 15. (Reprinted in *Camera Work*, with "Carey" by-line, no. 31 [July 1910]: 45.)
 Du Bois, Guy. *New York American*, March 1910. (Reprinted in *Camera Work*, no. 31 [July 1910]: 46–47.)
 Harrington. *New York Herald*, March 1910. (Reprinted in *Camera Work*, no. 31 [July 1910]: 45.) [Dove not mentioned.]
 Hartman, Sadakichi. Untitled article. *Camera Work*, no. 31 (July 1910): 47–49. [Dove not mentioned.]
 Hunecker, James. *New York Sun*, March 1910. (Reprinted in *Camera Work*, no. 31 [July 1910]: 43–44.)
 ————.*New York Sun*, March 1910. (Reprinted in *Camera Work*, no. 31 [July 1910]: 49–51.) [Dove not mentioned.]
 "No Faked Names on These Paintings." *New York World*, March 1910.
 "Photo-Secession Notes: Paintings by Young Americans." *Camera Work*, no. 30 (April 1910): 54.
 Stephenson, B. P. *New York Evening Post*, March 1910. (Reprinted in *Camera Work*, no. 31 [July 1910]: 44.)
 [Townsend, James B.] *American Art News*, 1910. (Reprinted in *Camera Work*, with Townsend by-line, no. 31 [July 1910]: p. 47.)
 White, Israel. *Newark Evening News*, March 1910. (Reprinted in *Camera Work*, no. 31 [July 1910]: 45–46.)

1912

Forum Exhibition
27 February–12 March

1914

National Arts Club
"Exhibition of Contemporary Art"
5 February–7 March
Catalogue by J. Nilsen Laurvik

1915

Modern Gallery
Opening exhibition
7 October–closing date unknown

*See supplementary list for those exhibitions that included only watercolors and/or drawings.

1916

Anderson Galleries
"Forum Exhibition of Modern American Painters"
13–25 March
Catalogue edited by Mitchell Kennerly
References:
 Caffin, Charles H. "News and Important Things in Art; Last Week: Forum Exhibit of Modern American Painters." *New York American*, 20 March 1916, 7.
 "The Season's Art Sensation." *New York World Magazine*, 2 April 1916.

1917

Society of Independent Artists
"First Annual Exhibition"
10 April–6 May
Catalogue

1919

Young Women's Hebrew Association, 31 West 110th Street
"Exhibition on Modern Art"
1 March–closing date unknown

1920

Los Angeles, California
Los Angeles County Museum of History, Science and Art
Exhibition of modern painting arranged by Stanton Macdonald-Wright
February

1921

Philadelphia, Pennsylvania
Pennsylvania Academy of the Fine Arts
"Exhibition of Paintings Showing the Later Tendencies in Art"
16 April–15 May
Reference:
 Craven, Thomas J. "The Awakening of the Academy." *The Dial* 70 (June 1921): 673–78.

1922

Colony Club

"Modern Sculpture, Water Colors and Drawings"
2–13 April

1924

Anderson Galleries
"Beginnings and Landmarks of 291"

1925

Anderson Galleries
"Seven Americans"
9–29 March
Brochure with checklist, essays by Sherwood Anderson and Arnold Rönnebeck, and Dove's poem "A Way to Look at Things"
References:
 "Alfred Stieglitz Presents 7 Americans." *Brooklyn Eagle*, 15 March 1925.
 "Art." *New Yorker* 1 (28 March 1925): 17.
 "Art: Exhibitions of the Week: Seven Americans." *New York Times*, 15 March 1925, sec. 8, p. 11.
 "Comment." *The Dial* 79 (August 1925): 177.
 C[omstock], H[elen]. "Stieglitz Group in Anniversary Show." *Art News* 23 (14 March 1925): 5.
 Cortissoz, Royal. "A Spring Interlude in the World of Art Shows." *New York Herald Tribune*, 15 March 1925, sec. 4, p. 12.
 Deogh, Fulton. "Cabbages and Kings." *International Studio* 81 (May 1925): 144–47.

1926

Brooklyn Museum
"International Exhibition of Modern Art, Assembled by the Société Anonyme"
19 November–1 January 1927
Catalogue by Katherine S. Dreier
Additional showing:
Anderson Galleries
25 January 1927–5 February 1927
Reference:
 P[emberton], M[urdock]. "The Art Galleries." *New Yorker* 2 (11 December 1926): 98.

Wildenstein Galleries
"Exhibition of Tri-National Art—French, British and American"
26 January–15 February
Catalogue with essay by Roger Fry

Washington, D. C.
Phillips Collection (then Phillips Memorial Gallery)
"Exhibition of Paintings by Eleven Americans and an Important Work by Odilon Redon"
1–28 February
Brochure with essay by Duncan Phillips

1929

Grand Central Palace
"National Alliance of Art and Industry—100 Important Paintings by Living American Artists"
15–27 April

Salon Américain
Spring Salon
16 April–4 May

1930

An American Place
O'Keeffe, Demuth, Marin, Hartley, Dove (retrospective)
April–May
Reference:
 "The Art Galleries." *New Yorker* 6 (17 May 1930): 66–69.

Museum of Modern Art
"Painting and Sculpture by Living Americans"
2 December–20 January 1931
Catalogue with foreword by Alfred H. Barr, Jr.

Washington, D.C.
Phillips Collection (then Phillips Memorial Gallery)
"Marin, Dove and Others"
5 October–25 January 1931
Brochure

Phillips Collection
"Twelve Americans"
5 October–25 January 1931
Brochure

1931

An American Place
Impromptu group show: Dove, Demuth, Hartley, Marin, O'Keeffe
May

Grand Central Palace
"Art Exhibition: Contribution of One Hundred American Artists to Voice the Need of Adequate Relief for the Unemployed"
25 February–5 March

Washington, D.C.
Phillips Collection (then Phillips Memorial Gallery)
"American and European Abstractions"
February (repeated February–June 1932)
Brochure

Washington, D.C.
Phillips Collection
"An American Show of Oils and Watercolors"
February (repeated February–June 1932)
Brochure

Washington, D.C.
Phillips Collection
"Twentieth-Century Lyricism"
February–March
Brochure

Cleveland, Ohio
Cleveland Museum of Art
"Eleventh Annual Exhibition of Contemporary American Oils"
12 June–12 July

Columbus, Ohio
Columbus Museum of Art (then Columbus Gallery of Fine Arts)
"Inaugural Exhibition"
January–February

Philadelphia, Pennsylvania
Philadelphia Museum of Art (then Pennsylvania Museum)
"Living Artists"
12 November–14 January 1932
Reference:
 Marceau, Henri. "Living Artists." *Pennsylvania Museum Bulletin* 27 (January 1932): 67–75.

White Plains, New York
Westchester County Center
"26 Paintings by 26 American Artists"
21 December–16 January 1932

1932

An American Place
Dove, Marin, O'Keeffe, Demuth, and Hartley
20 May–14 June
Reference:
 Jewell, E. A. "Art: Works by Five Artists Shown." *New York Times*, 20 May 1932, 17.

Whitney Museum of American Art
"First Biennial Exhibition of Contemporary American Paintings"
22 November–5 January 1933
Catalogue

Washington, D.C.
American Federation of Arts
"Abstraction in 1932"
1932–1933

Cleveland, Ohio
Cleveland Museum of Art
"12th Annual Exhibition of Contemporary American Oils"
10 June–10 July

1933

An American Place
"Selected Early Work: Dove, Marin, O'Keeffe"
May

Washington, D.C.
Phillips Collection (then Phillips Memorial Gallery)
"Modern Idioms–Lyrical and Impersonal"
5 November–15 February 1934
Brochure with essays by Duncan Phillips

Springfield, Massachusetts
Springfield Museum of Fine Arts
Opening exhibition
7 October–2 November

1934

Contemporary New Art Circle
"Paintings by Arthur Dove, Yasuo Kuniyoshi and Max Weber"
6–31 March

Rockefeller Center
"First Municipal Art Exhibition"
28 February–31 March
Reference:
 Jewell, E. A. "Fried Egg Finds Its Place in Art." *New York Times*, 9 March 1934, 17.

Whitney Museum of American Art
"Second Biennial Exhibition of Contemporary American Painting"
27 November–10 January 1935
Catalogue

Chicago, Illinois
Art Institute of Chicago
"A Century of Progress: Exhibition of Paintings and Sculpture"
1 June–1 November
Catalogue by Robert B. Harshe

1935

Whitney Museum of American Art
"Abstract Painting in America"
12 February–22 March
Catalogue with introduction by Stuart Davis
References:
 McBride, Henry. *New York Sun*, February 1935.
 Mumford, Lewis. "The Art Galleries: New High in Abstractions." *New Yorker* 11 (2 March 1935): 38.

Cincinnati, Ohio
Cincinnati Art Museum
"Paintings from the Howald Collection"
6 January–3 February
No catalogue

Cleveland, Ohio
Cleveland Museum of Art
"15th Annual Exhibition of Contemporary American Oils"
7 June–7 July
Catalogue with introduction by Henry S. Francis

1936

An American Place

"Exhibition of Paintings: Charles Demuth, Arthur G. Dove, Marsden Hartley, John Marin, Georgia O'Keeffe, and Rebecca S. Strand"
27 November–31 December
Brochure, no checklist

Museum of Modern Art
"Fantastic Art, Dada, Surrealism"
7 December–17 January 1937
Catalogue by Alfred H. Barr, Jr.

Additional showings:
 Philadelphia, Pennsylvania
 Philadelphia Museum of Art (then Pennsylvania Museum of Art)
 30 January–1 March 1937
 Boston, Massachusetts
 Boston Institute of Modern Art
 6 March–3 April 1937
 Springfield, Massachusetts
 Springfield Museum of Fine Arts
 12 April–10 May 1937
 Milwaukee, Wisconsin
 Milwaukee Art Institute
 19 May–16 June 1937
 Minneapolis, Minnesota
 University of Minnesota Gallery
 26 June–24 July 1937
 San Francisco, California
 San Francisco Museum of Modern Art (then San Francisco Museum of Art)
 6 August–3 September 1937

Rockefeller Center
"First National Exhibition of Art"
May

Whitney Museum of American Art
"Third Biennial Exhibition of Contemporary American Painting"
10 November–10 December
Catalogue

Buffalo, New York
Albright Art Gallery
"The Art of Today: An Exhibition of Contemporary Pictures and Sculpture"
3–31 January
Catalogue with foreword by Gordon B. Washburn

Philadelphia, Pennsylvania
Pennsylvania Academy of Fine Arts
"131st Annual Exhibition"

Springfield, Massachusetts
George Walter Vincent Smith Art Museum
"Mysticism in Art"
5–25 October
Catalogue

1937

An American Place
"Beginnings and Landmarks: '291', 1905–1917"
27 October–27 December
Brochure with checklist

Cleveland, Ohio
Cleveland Museum of Art
"Exhibition of American Painting from 1860 until Today"
23 June–4 October
Catalogue

Minneapolis, Minnesota
University of Minnesota Gallery
"Five Painters"
January
Catalogue with foreword by Ruth Lawrence

1938

Washington, D.C.
Phillips Collection (then Phillips Memorial Gallery)
"Thirty American Paintings by Thirty Contemporary Artists"
Checklist
Additional showings (circulated by American Federation of Arts):
 Portland, Oregon
 Portland Art Association
 July 1939
 San Francisco, California
 San Francisco Museum of Modern Art (then San Francisco Museum of Art)
 20 July–6 August 1939
 Boise, Idaho
 Boise Art Institute
 September–October 1939

Worcester, Massachusetts
Worcester Art Museum
"Third Biennial Exhibition of American Painting of Today"
19 January–27 February

Paris, France
Musée du Jeu de Paume
"Trois Siècles d'Art aux États-Unis" (organized in collaboration with the Museum of Modern Art, New York)
24 May–31 July
Catalogue with text by Alfred H. Barr, Jr.

1939

Museum of Modern Art
"Art in Our Time"
10 May–30 September
Catalogue with introduction by Alfred H. Barr, Jr.

Washington, D.C.
Whyte Gallery
"Fantasy in American Art of the 19th and 20th Centuries"
12 April–3 May

Philadelphia, Pennsylvania
Pennsylvania Academy of the Fine Arts
"134th Annual Exhibition of Paintings and Sculpture"

Syracuse, New York
Everson Museum of Art (then Syracuse Museum of Fine Arts)
"Contemporary American Paintings"
April

1940

An American Place
"Some Marins—Some O'Keeffes—Some Doves—'Some' Show"
17 October–11 December
References:
 Jewell, E. A. "Autumn Art Show at American Place." *New York Times,* 18 October 1940, 18.
 ———. "Local Shows." *New York Times,* 27 October 1940, sec. 9, p. 9.

L[owe], J[eannette]. "Reunion of Marin, Dove and O'Keeffe." *Art News* 39 (30 November 1940): 11.

Museum of Modern Art
"Living American Art"

Museum of Modern Art
"New Acquisitions: American Painting and Sculpture"
26 July–18 October

Museum of Modern Art
"We Like Modern Art"
27 December–12 January 1941.

Whitney Museum of American Art
"Annual Exhibition of Contemporary American Art"
10 January–18 February
Catalogue

Baltimore, Maryland
Baltimore Museum of Art
"Modern Painting 'ISMs' and How They Grew"
12 January–11 February
Checklist

Chicago, Illinois
Art Institute of Chicago
"Fifty-first Annual Exhibition of American Paintings and Sculpture"
14 November–5 January 1941
Brochure with introduction by Daniel Catton Rich

Cleveland, Ohio
Cleveland Museum of Art
"16th Exhibition of Contemporary American Painting"

Ithaca, New York
Cornell University
Spring art exhibition
19 May–3 June

San Francisco, California
Palace of Fine Arts
"Golden Gate International Exposition: Art"
10 May–16 October
Catalogue by Walter Hill et al.

Washington, D.C.
American Federation of Arts (touring exhibition)
"Some Individuals"
1940–1942
Itinerary:
 Springfield, Illinois
 Springfield Art Association
 Iowa City, Iowa
 State University of Iowa
 Dubuque, Iowa
 Dubuque Art Association
 Brookings, South Dakota
 South Dakota State College
 Northfield, Minnesota
 Carleton College
 Reading, Pennsylvania
 Reading Public Museum and Art Gallery
 Decatur, Illinois
 Decatur Art Institute
 Bloomington, Indiana
 Bloomington Art Association

1941

An American Place
"Arthur G. Dove, John Marin, Georgia O'Keeffe, Picasso, Alfred Stieglitz"
17 October–27 November
Checklist

Washington, D. C.
Phillips Collection (then Phillips Memorial Gallery)
"Functions of Color in Painting"
16 February–23 March
Catalogue by Duncan Phillips and C. Law Watkins

Museum of Modern Art (touring exhibition)
"Contemporary North American Painting"
May–December
Itinerary: Latin America

1942

Museum of Modern Art
"New Acquisitions and Extended Loans: Cubist and Abstract Art"
25 March–3 May

Museum of Modern Art
"Painting and Sculpture from 16 American Cities"

Washington, D.C.
Phillips Collection (then Phillips Memorial Gallery)
"American Paintings and Water Colors"
15–31 March
Catalogue

Saint Louis, Missouri
Saint Louis Art Museum (then City Art Museum)
"Trends in American Painting of Today"
27 January–28 February
Catalogue with foreword by Perry Rathbone

1943

Art of This Century
"Collages"
16 April–15 May

Bucholz Gallery
"Early Work by Contemporary Artists"
16 November–4 December
Catalogue
Reference:
 Riley, Maude. A Backward Glance at Our Contemporaries." *Art Digest* 18 (1 December 1943): 11.

Knoedler Galleries
"Exhibition of Some American Watercolors and Pastels"

Washington, D.C.
Phillips Collection (then Phillips Memorial Gallery)
"East-West: A Parallel of Chinese and Western Art"
24 October–23 November
Catalogue with essay by Martha Davidson

Museum of Modern Art (touring exhibition)
"30 European and American Paintings"
September 1943–September 1944

1944

Museum of Modern Art
"Art in Progress"
24 May–15 October
Catalogue

Washington, D.C.
Phillips Collection (then Phillips Memorial Gallery)
"American Paintings of the Phillips Collection"
9 April–30 May (extended to 18 June)
Catalogue with foreword by Duncan Phillips

Detroit, Michigan
Detroit Institute of Arts
"Advanced Trends in Contemporary American Art"
4–30 April
Catalogue with introduction by W. R. Valentiner

Philadelphia, Pennsylvania
Pennsylvania Academy of the Fine Arts
"139th Annual Exhibition of Painting and Sculpture"
23 January–27 February
Catalogue

Philadelphia, Pennsylvania
Philadelphia Museum of Art
"History of an American: Alfred Stieglitz, '291' and After"
1 July–1 November
Catalogue with introduction by Henry Clifford and Carl Zigrosser
References:
 "An American Collection." *Philadelphia Museum Bulletin* 40 (May 1945): 67.
 "Philadelphia Honors Alfred Stieglitz, Pioneer in Modern Art." *Art Digest* 18 (1 July 1944): 7.

Museum of Modern Art (touring exhibition)
"Seven American Painters"
Checklist
Itinerary:
 Amherst, Massachusetts
 Amherst College
 1–22 December

Saint Paul, Minnesota
Hamline University
3–27 January 1945
West Palm Beach, Florida
Norton Gallery
6–27 February 1945
Decatur, Georgia
Agnes Scott College
9–30 March 1945
New Orleans, Louisiana
Arts and Crafts Club
11 April–2 May 1945

1945

Downtown Gallery
"American Art"

Philadelphia, Pennsylvania
Pennsylvania Academy of the Fine Arts
"140th Annual Exhibition of Painting and Sculpture"
19 January–25 February
Catalogue

Pittsburgh, Pennsylvania
Carnegie Institute
"Painting in the U.S., 1945"
11 October–9 December

San Francisco, California
California Palace of the Legion of Honor
"Contemporary American Painting"
17 May–17 June
Catalogue with introduction by Jermayne MacAgy

Toronto, Ontario, Canada
Art Gallery of Ontario
"Museums' Choice: Paintings by Contemporary Americans"
February
Catalogue

1946

Grand Central Galleries
"60 Americans Since 1800"
19 November–5 December
Additional showings: Circulated abroad under U.S. State Department auspices.

Reference:
"60 Americans Since 1800." *Art News* 45 (December 1946): 30–39.

Whitney Museum of American Art
"Pioneers of Modern Art in America"
2 April–12 May
Catalogue by Lloyd Goodrich
Additional showings:
Ann Arbor, Michigan
University of Michigan
1–21 July
Springfield, Massachusetts
George Walter Vincent Smith Art Museum
1–21 August
Wilmington, Delaware
Wilmington Society of the Fine Arts
1–22 September
Baltimore, Maryland
Baltimore Museum of Art
2–22 October
Washington, D.C.
Phillips Collection (then Phillips Memorial Gallery)
3–30 November
New Orleans, Louisiana
Isaac Delgado Museum of Art
5–26 December
Saint Paul, Minnesota
Saint Paul Gallery and School of Art
6–26 February 1947
Utica, New York
Munson-Williams-Proctor Institute
10–30 April 1947
Northampton, Massachusetts
Smith College Museum of Art
10–30 May 1947

Whitney Museum of American Art
"Annual Exhibition of Contemporary American Painting"
10 December–16 January 1947

Dallas, Texas
Dallas Museum of Fine Arts
"200 Years of American Painting"
5 October–4 November
Catalogue

Minneapolis, Minnesota
Walker Art Center

"36 Americans"
25 August–22 September

London, England
Tate Gallery
"American Painting from the Eighteenth Century to the Present Day"
June–July
Catalogue with essay by John Rothenstein
Reference:
"American Art Abroad." *Art News* 45 (October 1946): 22.

1947

Museum of Modern Art
"Alfred Stieglitz Collection"
10 June–31 August

1948

Museum of Modern Art
"American Paintings from the Museum Collection"
21 December–13 March 1949

Museum of Modern Art
"Collage"
21 September–5 December

Chicago, Illinois
Art Institute of Chicago
"Alfred Stieglitz Collection"
Checklist

1949

Whitney Museum of American Art
"Juliana Force and American Art: A Memorial Exhibition"
24 September–30 October
Catalogue by Forbes Watson

Washington, D.C.
Corcoran Gallery of Art
"De Gustibus; An Exhibition of American Paintings Illustrating a Century of Taste and Criticism"
9 January–20 February
Catalogue by Eleanor B. Swenson, titled *American Painting and American Taste 1830–1930*

Boston, Massachusetts
Institute of Contemporary Art
"Milestones of American Painting in Our Century"
20 January–1 March
Catalogue by Frederick S. Wight

Phoenix, Arizona
Civic Center
Paintings from private collections in Phoenix
January
Reference:
"Exhibit Opens Here Friday." *Arizona Republic* (Phoenix), 9 January 1949.

San Francisco, California
California Palace of the Legion of Honor
"Illusionism and Trompe L'Oeil"
3 May–12 June
Catalogue with essay by Jermayne MacAgy

South Hadley, Massachusetts
Mount Holyoke College
"The Collection Société Anonyme"
October

Museum of Modern Art (touring exhibition)
"Modern American Painting"
September 1949–June 1952

1950

Metropolitan Museum of Art
"100 American Paintings of the 20th Century"
June
Catalogue with introduction by Robert Beverly Hale

Amsterdam, Netherlands
Stedelijk Museum
"Amerika Schildert"
Catalogue with essay by B. H. Hayes, Jr.
Reference:
"Dutch Treat Themselves to an American Show." *Art Digest* 24 (1 August 1950): 9.

1951

Brooklyn Museum
"Revolution and Tradition: An Exhibition of the Chief Movements in American Painting from 1900 to the Present"

19 November–6 June 1952
Accompanying book by John I. H. Baur, titled *Revolution and Tradition in Modern American Art* (Cambridge, Mass.: Harvard University Press).

Museum of Modern Art
"Abstract Painting and Sculpture in America"
23 January–5 March
Catalogue by Andrew Carnduff Ritchie
Reference:
Genauer, Emily. "Art and Artists: Why an Abstract Show?" *New York Herald Tribune*, 28 January 1951, sec. 4, p. 5.

New Art Circle
"Contemporary American Painting from Private Collections"
8 January–3 February

Cincinnati, Ohio
Cincinnati Art Museum
"Paintings: 1900–1925"
2 February–4 March
Catalogue

Houston, Texas
Contemporary Arts Museum
"Arthur G. Dove, Charles Sheeler"
7–23 January
Brochure with checklist and notes by Edith G. Halpert and Alfred H. Barr, Jr.

References:
"The Art Galleries." *Houston Post*, 7 January 1951, sec. 5, p. 3
"Contemporary Arts Show Set for Jan. 7." *Houston Chronicle*, 17 December 1950.
Holmes, Ann. "Paintings Glorify Beauty of Mechanical Shapes." *Houston Chronicle*, 7 January 1951.

1952

Metropolitan Museum of Art
"Edward W. Root Collection"
12 February–12 April

Wildenstein and Co.
"Loan Exhibition of Seventy XX Century American Paintings Chosen by the Art Critics of *Art Digest*, *Art News*, *Life*, *Magazine of Art*,

New York Herald Tribune, New York Times, Time"
21 February–22 March
Catalogue with foreword by Hermon More

Washington, D.C.
Corcoran Gallery of Art
"Paintings from Washington Collections"
February
Reference:
 "Corcoran Investigates What Washington Collects." *Art Digest* 26 (15 February 1952): 9.

Washington, D.C.
Phillips Collection (then Phillips Memorial Gallery)
"Painters of Expressionistic Abstractions"
16 March–15 April (extended to 29 April)

Baltimore, Maryland
Baltimore Museum of Art
"Joseph P. Gallagher Collection"
December
Reference:
 "Coast to Coast: Living Memorial." *Art Digest* 27 (15 January 1953): 12.

Dallas, Texas
Dallas Museum of Fine Arts
"Some Businessmen Collect Contemporary Art"
6–27 April
Catalogue with foreword by E. DeGolyer

Minneapolis, Minnesota
Walker Art Center
"Contemporary American Painting and Sculpture, Collection of Mr. and Mrs. Roy R. Neuberger"
24 May–19 August

New London, Connecticut
Lyman Allyn Museum
"Annual Exhibition"
March

1953

Downtown Gallery
"28th Season Exhibition; New Paintings and Sculpture by Davis, Dove, Karfiol, Kuniyoshi,

Marin, O'Keeffe, Shahn, Sheeler, Spencer, Zorach"
22 September–17 October

Norfolk, Virginia
Museum of Arts and Sciences
"Significant American Moderns"
5 March–13 April
Catalogue with foreword by John Davis Hatch, Jr., and introduction by Joseph Fulton

Norwich, Connecticut
Slater Memorial Art Gallery
"Modern Movements in Art"
November

South Hadley, Massachusetts
Mount Holyoke College
"Contemporary Paintings from the Collection of Mr. and Mrs. Roy R. Neuberger"
13 October–15 November

Syracuse, New York
Everson Museum of Art (then Syracuse Museum of Fine Arts)
"125 Years of American Art"
15 September–11 October

1954

Museum of Modern Art
"XXV Anniversary Exhibition"
19 October–2 February 1955

Whitney Museum of American Art
"Roy and Marie Neuberger Collection: Modern American Painting and Sculpture"
17 November–19 December
Additional showings:
 Chicago, Illinois
 Arts Club of Chicago
 4–30 January 1955
 Los Angeles, California
 U.C.L.A. Art Galleries
 21 February–11 March 1955
 Pasadena, California
 Pasadena Art Museum
 14 March–3 April 1955
 San Francisco, California
 San Francisco Museum of Modern Art (then San Francisco Museum of Art)

26 April–5 June 1955
Saint Louis, Missouri
Saint Louis Art Museum (then City Art
 Museum)
27 June–7 August 1955
Cincinnati, Ohio
Cincinnati Art Museum
29 August–25 September 1955
Washington, D.C.
Phillips Collection (then Phillips Memorial
 Gallery)
9–31 October 1955

Baltimore, Maryland
Baltimore Museum of Art
"Man and His Years"
19 October–21 November
Reference:
 Perlman, Bennard. "The Baltimore Museum
 of Art: Twenty-Five Years of Growth." *Art
 Digest* 29 (15 May 1955): 14–19.

Fort Worth, Texas
Fort Worth Art Museum (then Fort Worth Art
 Center)
"Inaugural Exhibition of the Fort Worth Art
 Center"
8–31 October 1954
Catalogue

1955

Museum of Modern Art
"Recent Acquisitions"
30 November–22 February 1956

Wildenstein and Co.
"American and French Modern Masters for the
 La Napoule Art Foundation"
4–28 May
Reference:
 Feinstein, Sam. "Month in Review: American
 and French Moderns." *Art Digest* 29 (1
 June 1955): 22.

Paris, France
Musée National d'Art Moderne
"50 Ans d'Art aux États-Unis: Collections du
 Museum of Modern Art de New York"
April–May
Catalogue by Holger Cahill et al.

American Federation of Arts (touring exhibi-
 tion)
"In Memoriam"
Itinerary:
 National Arts Club
 10–20 September
 Nashville, Tennessee
 Watkins Institute
 1–22 October
 Chattanooga, Tennessee
 Hunter Gallery
 10–30 November
 Port Arthur, Texas
 Gates Gallery
 14 December–4 January 1956
 Dallas, Texas
 Dallas Museum of Fine Arts
 18 January–8 February 1956
 Winnipeg, Manitoba, Canada
 University of Manitoba
 25 February–24 March 1956
 Atlanta, Georgia
 Atlanta Public Library
 7–28 April 1956
 Des Moines, Iowa
 Des Moines Art Center
 12 May–3 June 1956
 Iowa City, Iowa
 University of Iowa (then State University of
 Iowa)
 17 June–21 August 1956

Museum of Modern Art (touring exhibition)
"American Art of the XX Century"
February 1955–September 1956

1956

Downtown Gallery
"The Recurrent Image"
25 January–25 February

Downtown Gallery
"Spring 1956"
29 May–29 June

Boston, Massachusetts
Institute of Contemporary Art

"20th-Century American Paintings from the
 Collection of Mr. and Mrs. Roy R. Neuberger"

13 March–8 April
No catalogue

Deerfield, Massachusetts
Deerfield Academy
"Dove and Sheeler, from the William H. Lane Foundation Collection"
12 February–11 March

1957

Fieldston School Arts Center
"Collector's Choice"
31 March–3 April

Albany, New York
Albany Institute of History and Art
"20th-Century Moderns"
1–23 February

Lynchburg, Virginia
Randolph-Macon Woman's College
"46th Annual Exhibition"
28 April–4 June

Lynchburg, Virginia
Randolph-Macon Woman's College
"Autumn Exhibition"
13 October–17 November

Philadelphia, Pennsylvania
Philadelphia Museum of Art
"Philadelphia Collects 20th Century"

Worcester, Massachusetts
Worcester Art Museum
"William H. Lane Foundation Exhibition"
July–September

1958

Museum of Modern Art
"Philip L. Goodwin Collection"
8 October–9 November
Catalogue

Whitney Museum of American Art
"Nature in Abstraction"
14 January–16 March
Catalogue by John I. H. Baur
Additional showings:
 Washington, D.C.

Phillips Collection (then Phillips Memorial Gallery)
2 April–4 May
Fort Worth, Texas
Fort Worth Art Center
2–29 June
Los Angeles, California
Los Angeles County Museum
16 July–24 August
San Francisco, California
San Francisco Museum of Modern Art (then San Francisco Museum of Art)
10 September–12 October
Minneapolis, Minnesota
Walker Art Center
29 October–14 December
Saint Louis, Missouri
Saint Louis Art Museum (then City Art Museum)
7 January–8 February 1959

Whitney Museum of American Art
"The Museum and Its Friends: Twentieth-Century American Art from Collections of the Friends of the Whitney Museum"
30 April–15 June
Catalogue with foreword by Flora Whitney Miller and introduction by Milton Lowenthal

Buffalo, New York
Albright Art Gallery
"Contemporary Art—Acquisitions 1957–58"
8 December–18 January 1959

Claremont, California
Galleries of the Claremont Colleges (then Pomona College Gallery)
"The Stieglitz Circle: Demuth, Dove, Hartley, Marin, O'Keeffe, Weber"
9 October–15 November
Catalogue with introduction by E. Wilson Lyon, foreword by Peter Selz, and essay by Frederick S. Wight
Reference:
 Seldis, Henry J. "The Stieglitz Circle Show at Pomona College." *Art in America* 46 (Winter 1958–59): 62–65.

Philadelphia, Pennsylvania
Philadelphia Museum of Art
"Watter Collection"

1959

Washington, D.C.
St. Albans School
"50th Anniversary Exhibition"
May

Fort Worth, Texas
Fort Worth Art Center
"Member's Choice"
23 February–23 March

Philadelphia, Pennsylvania
Pennsylvania Academy of the Fine Arts
"Artists' Collections"

Schenectady, New York
Union College
"Five Decades of American Painting"
27 September–23 October

Washington, D.C.
Smithsonian Institution (touring exhibition)
"20th-Century American Paintings from the Edward W. Root Collection"
Catalogue with introductory statements by Charles E. Burchfield and Theodoros Stamos

Itinerary:
Ann Arbor, Michigan
Michigan Museum of Art
22 April–14 June
Raleigh, North Carolina
North Carolina Museum of Art
1 July–24 August
Louisville, Kentucky
J. B. Speed Art Museum
9–30 October
Binghamton, New York
Roberson Memorial Center
11 November–2 December
Rochester, New York
Rochester Memorial Art Gallery
15 December–5 January 1960
Chapel Hill, North Carolina
Ackland Art Center, University of North Carolina
23 February–16 March 1960
Poughkeepsie, New York
Vassar College
1–22 April 1960

Baltimore, Maryland
Baltimore Museum of Art
4–31 May 1960

Saint Louis, Missouri
Saint Louis Art Museum (then City Art Museum) (touring exhibition)
"American Painting of the Last 25 Years"
Itinerary:
Naples, Italy
Palazzo Reale
November
Rome, Italy
Gallery of Modern Art
December 1959–January 1960
Florence, Italy
February 1960
Milan, Italy
March 1960
Palermo, Italy
April 1960
Frankfurt, Germany
Landesmuseum
June 1960
Gothenburg, Sweden
Gothenburg Art Museum
15 July–7 August 1960
York, England
City Art Gallery
August–September 1960

1960

Downtown Gallery
"35th Anniversary Exhibition"
October

Knoedler and Co.
"American Art, 1910–1960, Selections from the Collection of Mr. and Mrs. Roy R. Neuberger"
8 June–9 September
Catalogue

Museum of Modern Art
"Portraits from the Museum Collection"
4 May–5 July

Washington, D.C.
Corcoran Gallery of Art

"Edith Gregor Halpert Collection"
16 January–28 February
Catalogue with introduction by Hermann Warner Williams, Jr.

Saint Louis, Missouri
Saint Louis Art Museum (then City Art Museum)
"Collector's Choice IV"
2–11 December

San Francisco, California
San Francisco Museum of Modern Art (then San Francisco Museum of Art)
"25th Anniversary Exhibition"
October

Utica, New York
Munson-Williams-Proctor Institute
"Edith G. Halpert Collection"
Catalogue

Utica, New York
Munson-Williams-Proctor Institute
"Inaugural Exhibition" (for opening of new building)
15 October–31 December

1961

Downtown Gallery
"Christmas Show"
December

Museum of Modern Art
"The Art of Assemblage"
4 October–12 November
Catalogue by William C. Seitz
Additional showings:
 Dallas, Texas
 Dallas Museum for Contemporary Arts
 9 January–11 February 1962
 San Francisco, California
 San Francisco Museum of Modern Art (then San Francisco Museum of Art)
 5 March–15 April 1962

Chicago, Illinois
McCormick Place
"The Roy R. Neuberger Collection"
5 January–1 March
No catalogue

Additional showing:
 Dallas, Texas
 Dallas Museum of Fine Arts
 19 March–16 April

Iowa City, Iowa
University of Iowa (then State University of Iowa)
"Paintings, Drawings, Sculpture, Prints from Twenty-Three Iowa Collections:
9 May–6 August
Catalogue

Milwaukee, Wisconsin
Milwaukee Art Center
"Ten Americans"
21 September–5 November
Catalogue with introduction by Edward H. Dwight

Schenectady, New York
Union College
"New Trends in 20th-Century American Painting"
5–26 March

Utica, New York
Munson-Williams-Proctor Institute
"Edward Wales Root Bequest Exhibition"
5 November–24 February 1962

Wilmington, Delaware
Delaware Art Museum (then Delaware Art Center)
"A Stieglitz Group: Bluemner, Demuth, Dove, Hartley, Marin, O'Keeffe, Weber"
30 March–23 April
Brochure with essay by Roland Elzea

Museum of Modern Art (touring exhibition)
"Art in Embassies"

1962

Downtown Gallery
"Abstract Art in America, 1903–1923"
27 March–21 April
Brochure
Reference:
 F[aunce], S[arah] C. "Reviews and Previews: American Abstraction 1903–23." *Art News* 61 (April 1962): 17.

Downtown Gallery
"The Figure"
21 May–15 June

Washington, D.C.
Corcoran Gallery of Art
"Edith Gregor Halpert Collection"
28 September–11 November
Catalogue with foreword by George E. Hamilton, Jr.

Ann Arbor, Michigan
University of Michigan Museum of Art
"Contemporary American Painting, Selections from the Collection of Mr. and Mrs. Roy R. Neuberger
21 October–18 November

Iowa City, Iowa
University of Iowa (then State University of Iowa)
"American Pioneer Artists"
24 May–2 August
Catalogue

Kansas City, Missouri
William Rockhill Nelson Gallery of Art
"The James A. Michener Collection of Twentieth-Century American Paintings"
15 July–30 September

University Park, Pennsylvania
Pennsylvania State University
"James A. Michener, Art Collector"
15 March–5 April

Museum of Modern Art (touring exhibition)
"The Stieglitz Circle"
Itinerary
 Louisville, Kentucky
 J. B. Speed Art Museum
 1–22 February
 Quincy, Illinois
 Quincy Art Club
 9–30 March
 Seattle, Washington
 Charles and Emma Frye Art Museum
 20 April–11 May
 Eugene, Oregon
 University of Oregon Museum of Art
 21 May–11 June

Boise, Idaho
Art Association
26 June–17 July
Allentown, Pennsylvania
Allentown Art Museum
4–25 September
Charlestown, South Carolina
Gibbes Art Gallery
10–31 October
Memphis, Tennessee
Brooks Memorial Art Gallery
11 November–2 December
Winston-Salem, North Carolina
Public Library of Winston-Salem and Forsyth County
21 December–11 January 1963
Durham, North Carolina
Duke University
28 January–18 February 1963
Rochester, New York
Memorial Art Gallery, University of Rochester
1–24 March 1963
Rock Island, Illinois
Augustana College
8–29 April 1963
Newport Beach, California
Fine Arts Patrons of Newport Harbor
13 May–19 June 1963

1963

Whitney Museum of American Art
"The Decade of the Armory Show"
9 April–19 May
Catalogue by Lloyd Goodrich
Additional showings:
 Saint Louis, Missouri
 Saint Louis Art Museum (then City Art Museum)
 1 June–14 July
 Cleveland, Ohio
 Cleveland Museum of Art
 6 August–15 September
 Philadelphia, Pennsylvania
 Pennsylvania Academy of the Fine Arts
 30 September–30 October
 Chicago, Illinois
 Art Institute of Chicago
 15 November–29 December
 Buffalo, New York

Albright-Knox Art Gallery
20 January–23 February 1964

Washington, D.C.
Corcoran Gallery of Art
"The New Tradition: Modern Americans Before
 1940"
26 April–3 June
Catalogue by Gudmund Vigtel

Washington, D.C.
National Gallery of Art
"Paintings from the Museum of Modern Art,
 New York"
16 December–22 March 1964

Allentown, Pennsylvania
Allentown Art Museum
"The James A. Michener Foundation Collec-
 tion"
2 February–20 March

East Hampton, New York
Guild Hall
"Then and Now"
July

Portland, Oregon
Portland Art Museum
"Twentieth-Century American Paintings from
 the Collection of Mr. and Mrs. Roy R. Neuber-
 ger"
25 September–27 October
Catalogue

Rochester, New York
Memorial Art Gallery, University of Rochester
"Selections from the James A. Michener Foun-
 dation Collection"
4–27 October

Swarthmore, Pennsylvania
Swarthmore College
"Selections from the James A. Michener Foun-
 dation Collection"
14 September–9 June

Waltham, Massachusetts
Rose Art Museum, Brandeis University
"American Modernism: The First Wave, Paint-
 ing from 1903 to 1933"

4 October–10 November
Catalogue with introduction by Sam Hunter and
 statement by Edith Gregor Halpert

1964

Downtown Gallery
"39th Anniversary Exhibition"
October

Whitney Museum of American Art
"Between the Fairs; 25 Years of American Art,
 1939–1964"
24 June–23 September
Catalogue by John I. H. Baur

Ashland, Virginia
Randolph-Macon College
"Art Between the Two World Wars"
10–12 April

Bloomington, Indiana
Indiana University Art Museum
"American Painting 1910–1960"
17 April–10 May

Flagstaff, Arizona
Arizona State College Art Gallery
"Arizona State College Exhibition of Paintings
 and Sculpture of the Arizona State University
 Permanent Collection of American Art"
15 March–8 April

Oswego, New York
Oswego Art Gallery
"Yesterday and Today"
30 May–14 June

Philadelphia, Pennsylvania
Pennsylvania Academy of the Fine Arts
"Small Paintings of Large Import: The Collec-
 tion of Lawrence and Barbara Fleischman"

Saint Louis, Missouri
Saint Louis Art Museum (then City Art
 Museum)
"200 Years of American Painting"
1 April–31 May
Catalogue with introduction by Merrill C. Ruep-
 pel in *St. Louis Museum Bulletin* 48 (1964).

Tucson, Arizona
University of Arizona
"The Bird in Art"
7 November–3 January 1965

1965

Downtown Gallery
"A Gallery Survey of American Art"

Metropolitan Museum of Art
"American Painting in the 20th Century"
Catalogue by Henry Geldzahler

Washington, D.C.
Washington Gallery of Modern Art
"20th-Century American Painting and Sculpture"
17 September–24 October
Catalogue with introduction by Gerald Nordland
Additional showing:
 Hartford, Connecticut
 Wadsworth Atheneum
 28 October–6 December
 Catalogue with introduction by C. C. Cunningham

Washington, D.C.
National Museum of American Art (then National Collection of Fine Arts)
"Roots of Abstract Art in America 1910–1930"
1 December–9 January 1966
Catalogue with introduction by Adelyn D. Breeskin
References:
 Ashton, Dore. "Commentary from Washington and New York: Washington." *Studio International* 171 (February 1966): 78–80.
 Stevens, Elisabeth. "Washington: A Half-Century of Abstraction." *Arts* 40 (March 1966): 46–48.

Pittsburgh, Pennsylvania
Carnegie Institute
"The Seashore: Paintings of the 19th and 20th Centuries"
22 October–5 December
Catalogue with introduction by Gustave von Groschwitz

Tempe, Arizona

Arizona State University
"Points of View"
12 November–3 December

London, England
Leicester Galleries
"Six Decades of American Art"
14 July–18 August
Catalogue with introduction by John I. H. Baur and Bryan Robertson

1966

Public Education Association
"Seven Decades, 1895–1965; Crosscurrents in Modern Art"
26 April–21 May 1966
Catalogue

Whitney Museum of American Art
"Art of the United States: 1670–1966"
28 September–27 November
Catalogue by Lloyd Goodrich

Ithaca, New York
Andrew Dickson White Museum of Art, Cornell University
"The Dr. and Mrs. Milton Lurie Kramer Collection"
December
Catalogue with introduction by William C. Lipke

Providence, Rhode Island
Rhode Island School of Design
"Herbert and Nanette Rothschild Collection"
7 October–6 November
Catalogue with foreword by William H. Jordy

Reading, Pennsylvania
Reading Public Museum and Art Gallery
"Selections from the James A. Michener Foundation Collection"
3 April–8 May

Syracuse, New York
Art and Home Center, New York State Exposition Grounds
"125 Years of New York State Painting and Sculpture"
30 August–5 September
Catalogue

1967

Chester, Pennsylvania
Pennsylvania Military College
"American Paintings from the James A. Michener Foundation Collection"
14 February–30 March

Philadelphia, Pennsylvania
Pennsylvania Academy of the Fine Arts
"An Exhibition of Paintings, Drawings, and Sculpture by Charles Demuth, Arthur Dove, John Marin and Elie Nadelman"
2 February–12 March

Poughkeepsie, New York
Vassar College Art Gallery
"Selections from the Permanent Collection"
Catalogue

West Palm Beach, Florida
Norton Gallery
"Dove, Avery and Rattner"

1968

Whitney Museum of American Art
"The 1930's: Painting and Sculpture in America"
15 October–1 December
Catalogue by William C. Agee

Washington, D.C.
Smithsonian Institution
"The Art of Organic Forms"
14 June–31 July

Philadelphia, Pennsylvania
Pennsylvania Academy of the Fine Arts
"Early Moderns"
31 January–3 March

Providence, Rhode Island
Rhode Island School of Design
"The Neuberger Collection: An American Collection; Paintings, Drawings, and Sculpture"
8 May–30 June
Catalogue with introduction by Daniel Robbins, titled *An American Collection.*
Additional showing:
Washington, D.C.

National Museum of American Art (then National Collection of Fine Arts)
15 August–25 September

Storrs, Connecticut
University of Connecticut Museum of Art
"Edith Halpert and the Downtown Gallery"
25 May–1 September
Catalogue with introduction by Marvin S. Sadik

1969

Bernard Danenberg Galleries
"The Second Decade"
24 March–12 April
Catalogue

Amherst, Massachusetts
Amherst College
"American Art of the Depression Era"
25 February–19 March

Austin, Texas
University of Texas
"Seventy American Paintings"
November 1969–January 1970

Baltimore, Maryland
Baltimore Museum of Art
"Edward Joseph Gallagher III Memorial Collection"
11 May–22 June

College Park, Maryland
J. Millard Tawes Fine Arts Center, University of Maryland
"Retrospective for a Critic: Duncan Phillips"
12 February–16 March
Catalogue with introduction by William H. Gerdts and essay by Bess Hormats

American Federation of Arts (touring exhibition)
"A University Collects: Georgia Museum of Art"
Itinerary:
 Mobile, Alabama
 Art Gallery
 7–28 September
 Quincy, Illinois
 Art Club
 12 October–9 November

Storrs, Connecticut
University of Connecticut
30 November–20 December

Memphis, Tennessee
Memphis State University
11 January–1 February 1970

Towson, Maryland
Goucher College
22 February–15 March 1970

Amarillo, Texas
Junior League of Amarillo
5–26 April 1970

Ardmore, Oklahoma
Charles B. Goddard Center
17 May–7 June 1970

Jacksonville, Florida
Cummer Gallery of Art
9–30 August

Nashville, Tennessee
Tennessee Fine Arts Center
20 September–11 October 1970

1970

Wildenstein and Co.
"Howald Collection"
19 May–3 July
Reference:
 Linville, Kasha. "The Howald Collection at Wildenstein." *Arts Magazine* 44 (Summer 1970): 16–18.

Dayton, Ohio
Dayton Art Institute
"The Ferdinand Howald Collection of the Columbus Gallery of Fine Arts"
11 January–15 February
No catalogue

Hagerstown, Maryland
Washington County Museum of Fine Arts
"Gallagher Collection"
3–31 January

Huntington, New York
Heckscher Museum
"Salute to Small Museums"
8 May–21 June

Palm Beach, Florida
Society of the Four Arts

"Paintings from The Phillips Collection"
7 February–1 March
Catalogue with introduction by John Gordon

Schenectady, New York
Schenectady Museum
"Exhibition of American Paintings"
20 March–30 April

American Federation of Arts (touring exhibition)
"Selections from the Ferdinand Howald Collection"
Catalogue
Itinerary:
 San Antonio, Texas
 Witte Memorial Museum
 20 September–18 October

 Jacksonville, Florida
 Cummer Gallery of Art
 2–31 January 1971

 Athens, Georgia
 Georgia Museum of Art
 21 February–21 March 1971

 Phoenix, Arizona
 Phoenix Art Museum
 11 April–9 May 1971

 Milwaukee, Wisconsin
 Milwaukee Art Center
 30 May–27 June 1971

IBM (touring exhibition)
"American Painting 1900–1950"

1971

Katonah, New York
Katonah Gallery
"Alfred Stieglitz and His Circle"
9 May–27 June

Pittsburgh, Pennsylvania
Carnegie Institute
"Forerunners of American Abstraction"
18 November–9 January 1972
Catalogue by Herdis Bull Teilman

San Diego, California
Fine Arts Gallery of San Diego
"Color and Form 1909–1914"
20 November–2 January 1972

Catalogue by Henry G. Gardiner
Additional showings:
 Oakland, California
 Oakland Museum
 25 January–5 March 1972
 Seattle, Washington
 Seattle Art Museum
 24 March–7 May 1972

1972

Washburn Gallery
"Mind Over Matter: Painters of Immanent Things"
20 September–21 October
Reference:
 Mellow, James R. "Landscapes—The Real and the Imaginary—in American Art." *New York Times*, 8 October 1972, sec. 2, p. 27.

Washington, D.C.
National Museum of American Art (then National Collection of Fine Arts)
"Edith Gregor Halpert Memorial Exhibition"

Austin, Texas
Art Museum, University of Texas
"Not So Long Ago; Art of the 1920's in Europe and America"
15 October–17 December
Catalogue with introduction by George S. Heyer, Jr.

1973

Andrew Crispo Gallery
"Pioneers of American Abstraction"
17 October–17 November
Catalogue with introduction by Andrew J. Crispo
Reference:
 Smith, Roberta. "Pioneers of American Abstraction." *Artforum* 12 (January 1974): 74–75.

Washburn Gallery
" '291' "
7 February–3 March
Brochure

La Jolla, California

La Jolla Museum of Contemporary Art
"Kurt Schwitters and Related Developments"
9 March–6 May

Minneapolis, Minnesota
Minneapolis Institute of Arts
"Painters and Photographers of Gallery 291"
1 August–1 August 1974

London, England
Wildenstein and Co.
"Ferdinand Howald: Avant-Garde Collector"
20 June–21 July
Catalogue
Additional showings:
 Dublin, Ireland
 National Gallery of Ireland
 2 August–10 September
 Cardiff, Wales
 National Museum of Wales
 28 September–28 October

1974

Washburn Gallery
"Seven Americans: Arthur G. Dove, Marsden Hartley, John Marin, Charles Demuth, Paul Strand, Georgia O'Keeffe, Alfred Stieglitz"
6 February–2 March
Brochure

Washington, D.C.
Hirshhorn Museum and Sculpture Garden
"Inaugural Exhibition"
1 October–15 September 1975

1975

Andrew Crispo Gallery
"Selected American Masters
July–October

Omaha, Nebraska
Joslyn Art Museum
"The Growing Spectrum of American Art"
20 September–9 November
Catalogue with foreword by Harrison C. Taylor

Palm Beach, Florida
Society of the Four Arts
"Ferdinand Howald: Avant-Garde Collector"
7 February–2 March

Storrs, Connecticut
William Benton Museum of Art, University of
Connecticut
"Selections from the William H. Lane Founda-
tion"
17 March–25 May
Catalogue with introduction by Stephanie
Terenzio

Wilmington, Delaware
Delaware Art Museum
"Avant-Garde Painting and Sculpture in
America 1910–25"
4 April–18 May
Catalogue by William Homer et al.

Washington, D.C.
Phillips Collection
"American Art from the Phillips Collection; A
Selection of Paintings, 1900–1950"
29 May–5 September 1976
Catalogue with introduction by Laughlin Phil-
lips
Additional Showings:
 Laramie, Wyoming
 University of Wyoming Art Museum
 28 September–2 November
 Logan, Utah
 Utah State University Galleries
 14 November–19 December
 Provo, Utah
 Brigham Young University
 29 December–2 February 1976
 Denver, Colorado
 Denver Art Museum
 18 February–28 March 1976
 Albuquerque, New Mexico
 University of New Mexico
 6 April–9 May 1976

1976

Andrew Crispo Gallery
"20th-Century American Painting and Sculp-
ture"
June–September

Museum of Modern Art
"The Natural Paradise; Painting in America
1800–1950"
29 September–30 November

Catalogue edited by Kynaston McShine
Reference:
 Russell, John. "Roots of U.S. Abstract Paint-
 ing," New York Times, 30 September
 1976, 34

Huntington, New York
Heckscher Museum
"Artists of Suffolk County, Part X; Recorders of
History"
9 May–20 June
Catalogue with introduction by Ruth Solomon

Philadelphia, Pennsylvania
Pennsylvania Academy of the Fine Arts
"In This Academy"
Catalogue

Richmond, Virginia
Virginia Museum
"American Marine Painting"
Catalogue with text by John Wilmerding
Additional showing:
 Newport News, Virginia
 Mariners Museum

San Jose, California
San Jose Museum of Art
"America VII: America Between the Wars"
19 October–28 November

Westport, Connecticut
Westport Public Library
"Westport Artists of the Past"
12–30 June
Catalogue
Reference:
 Kramer, Hilton. "Art: 'Westport Artists of
 Past,' A Frame of Historic Reference," New
 York Times, 18 June 1976, C17.

Washington, D.C.
U.S.I.A. (touring exhibition, organized by the
Baltimore Museum of Art)
"200 Years of American Art"
Catalogues published separately by each host
museum
Itinerary:
 Bonn, Germany
 Landesmuseum

30 June–28 July
Belgrade, Yugoslavia
Belgrade Museum of Modern Art
16 August–11 September
Rome, Italy
Galleria Nazionale d'Arte Moderna
28 September–26 October
Warsaw, Poland
National Museum of Poland
12 November–10 December
Baltimore, Maryland
Science Center
16 January–6 February 1977

1977

Andrew Crispo Gallery
"20th-Century American Masters"
1 June–30 July

Andrew Crispo Gallery
"20th-Century American Painting and Sculpture"
June

Andrew Crispo Gallery
"Twelve Americans: Masters of Collage"
17 November–30 December
Catalogue with introduction by Gene Baro

Davis and Long Co.
"American Collage"
6 June–1 July
Brochure

Grand Rapids, Michigan
Grand Rapids Art Museum
"Themes in American Painting"
1 October–30 November
Catalogue by J. Gray Sweeney

Houston, Texas
Museum of Fine Arts
"Modern American Painting 1910–1940: Toward a New Perspective"
1 July–25 September
Catalogue by William Agee

Madison, Wisconsin
Elvehjem Art Center, University of Wisconsin
"Ferdinand Howald, Avant-Garde Collector"
21 April–5 June

Edinburgh, Scotland
Royal Scottish Academy
"The Modern Spirit: American Painting 1908–1935"
20 August–11 September
Catalogue by Milton Brown
Additional showing:

London, England
Hayward Gallery
28 September–20 November

Paris, France
Centre National d'Art et de Culture Georges Pompidou
"Paris-New York"
1 June–19 September
Catalogue edited by Pontus Hulten

1978

Andrew Crispo Gallery
"American Masters of the 20th Century"
June–September

Andrew Crispo Gallery
"20th-Century American Masters"
September–November

Hirschl and Adler Galleries
"The Eye of Stieglitz"
7 October–2 November
Catalogue with introduction by Richard T. York

Washburn Gallery
"From the Intimate Gallery: Room 303"
4–28 October
Brochure

Whitney Museum of American Art
"Synchromism and American Color Abstraction 1910–1925"
24 January–26 March
Catalogue by Gail Levin
Additional showings:
Houston, Texas
Museum of Fine Arts
20 April–18 June
Des Moines, Iowa
Des Moines Art Center
6 July–3 September
San Francisco, California

San Francisco Museum of Modern Art
22 September–19 November
Syracuse, New York
Everson Museum
15 December–28 January 1979
Columbus, Ohio
Columbus Museum of Art (then Columbus
 Gallery of Fine Arts)
15 February–24 March 1979

Zabriskie Gallery
"Alfred Stieglitz and An American Place 1929–
 1946"
2 May–3 June

Washington, D.C.
Corcoran Gallery of Art
"The William A. Clark Collection"
26 April–16 July

South Bend, Indiana
The Art Center
"Twentieth-Century American Masters"
13 January–26 February

1979

Andrew Crispo Gallery
"20th-Century American Masters"
February

Grey Art Gallery, New York University
"American Imagination and Symbolist Paint-
 ing"
24 October–8 December
Catalogue by Charles C. Eldredge
Additional showing:
 Lawrence, Kansas
 Helen Foresman Spencer Museum of Art,
 University of Kansas
 20 January–2 March 1980
Reference:
 Ratcliff, Carter. "The Symbolist Connection."
 Art in America 68 (April 1980): 84–87.

Washington, D.C.
Phillips Collection
"The Phillips Collection in the Making"
5 May–10 June
Catalogue with essays by Kevin Grogen and
 Bess Hormats

Additional showings:
 Memphis, Tennessee
 Brooks Memorial Art Gallery
 14 July–26 August
 Omaha, Nebraska
 Joslyn Art Museum
 15 September–28 October
 Dayton, Ohio
 Dayton Art Institute
 17 November–30 December
 Coral Gables, Florida
 Metropolitan Museum and Art Center
 19 January–2 March 1980
 Tulsa, Oklahoma
 Philbrook Art Museum
 22 March–4 May 1980
 San Antonio, Texas
 Marion Koogler McNay Art Institute
 24 May–6 July 1980
 Portland, Oregon
 Portland Art Museum
 26 July–31 August 1980
 Santa Ana, California
 Bowers Museum
 20 September–2 November 1980
 Allentown, Pennsylvania
 Allentown Art Museum
 22 November 1980–4 January 1981

Montclair, New Jersey
Montclair Art Museum
"Collage: American Masters of the Medium"
6 May–24 June
Catalogue with introduction by Robert J. Koenig

Düsseldorf, Germany
Kunsthalle
"2 Jahrzehnte Amerikanische Malerei 1920–
 1940"
10 June–5 August
Additional showings:
 Zürich, Switzerland
 Kunsthaus
 23 August–28 October
 Brussels, Belgium
 Palais des Beaux-Arts
 10 November–30 December

Perth, Australia
Art Gallery of Western Australia

"America and Europe: A Century of Modern Masters from the Thyssen-Bornemisza Collection"
2 October–18 November
Catalogue
Additional showings:
 Adelaide, Australia
 Art Gallery of South Australia
 7 December–3 February 1980
 Brisbane, Australia
 Queensland Art Gallery
 12 February–30 March 1980
 Melbourne, Australia
 National Gallery of Victoria
 16 April–30 May 1980
 Sydney, Australia
 Art Gallery of New South Wales
 26 July–24 August 1980
 Wellington, New Zealand
 National Art Gallery
 4 September–1 October 1980
 Auckland, New Zealand
 Auckland City Art Gallery
 8 October–4 November 1980
 Christchurch, New Zealand
 Robert McDougall Art Gallery
 11 November–7 December 1980

1980

Andrew Crispo Gallery
"20th Century American Painting and Sculpture"
20 April–1 June

Hirschl and Adler Galleries
"Buildings: Architecture in American Modernism"
29 October–29 November
Catalogue with introduction by Richard T. York

Richmond, Virginia
Virginia Museum of Fine Arts (touring exhibition)
"Images of America: Impact of the 30's"
Circulated by Art Mobile, January 1980–January 1981

San Francisco, California
John Berggruen Gallery

"American Paintings and Drawings"
15 July–6 September
Catalogue

Berlin, Germany
Neue Gesellschaft für bildende Kunst
"America Traum und Depression 1920/40"
9 November–28 December
Catalogue
Additional showing:
 Hamburg, Germany
 Kunstverein Hamburg
 15 January–15 February 1981

London, England
Tate Gallery
"Abstraction: Towards a New Art; Painting 1910–1920"
5 February–13 April
Catalogue with introduction by Peter Vergo and texts by Christopher Green, Jane Beckett et al.

Mexico City, Mexico
Museo del Palacio de Bellas Artes
"La Pintura de Los Estados Unidos de Museos de la Ciudad de Washington"
18 November–4 January 1981
Catalogue with introduction by Milton Brown

1981

Cincinnati, Ohio
Taft Museum
"Small Paintings from Famous Collections"
4 April–7 June
Catalogue by Marsha Semmel

Munich, Germany
Haus der Kunst
"Amerikanische Malerei 1930–1980"
14 November–31 January 1982

1982

Andrew Crispo Gallery
"Selected American Painting and Sculpture"
January–February

Andrew Crispo Gallery
"American Masters of the 20th Century"
May–June

Martin Diamond Fine Arts
"Four Decades of American Modernism 1909–
 1949"
5 October–13 November

Washington, D.C.
Hull Gallery
"American Paintings, Drawings 1830–1950"
13 January–27 February

Washington, D.C.
National Gallery of Art
"20th-Century Masters: The Thyssen-
 Bornemisza Collection"

Catalogue
Additional showings:
 Hartford, Connecticut
 Wadsworth Atheneum
 Toledo, Ohio
 Toledo Museum of Art
 Seattle, Washington
 Seattle Art Museum
 San Francisco, California
 San Francisco Museum of Modern Art
 Metropolitan Museum of Art

Minneapolis, Minnesota
Minneapolis Institute of Arts
"Focus on American Art: Paintings from a Cor-
 porate Collection"
1982–2 January 1983

Oklahoma City, Oklahoma
Oklahoma Art Center
"American Masters of the Twentieth Century"
7 May–20 June
Catalogue by John I. H. Baur
Additional showing:
 Evanston, Illinois
 Terra Museum of American Art
 11 July–15 September

San Francisco, California
John Berggruen Gallery
"Three Decades: American Paintings of the 20s,
 30s and 40s"
6 January–3 February

EXHIBITIONS INCLUDING ONLY WATERCOLORS AND/OR DRAWINGS BY ARTHUR DOVE

1933

Springfield, Massachusetts
Springfield Museum of Fine Arts
"Selection of Watercolors by Arthur G. Dove"
3 December–closing date unknown
References:
 " 'Contemporary Architecture and Design' at
 Three—Watercolor Exhibition Opening
 This Afternoon." Springfield (Mass.) Un-
 ion and Republican, 3 December 1933, E6.
 "Traveling Water-Color Show Exhibited at
 Springfield Museum of Fine Arts."
 Springfield (Mass.) Republican, 4 Decem-
 ber 1933.
 "Water Color Show to Open Exhibitions for
 December." Springfield (Mass.) Union and
 Republican, 26 November 1933, E6.
 "Watercolor—Dove Presented to Museum."
 Springfield (Mass.) Republican, 4 Decem-
 ber 1933.
 "Works by Dove and Cleveland Artists
 Shown." Springfield (Mass.) Union, 4 De-
 cember 1933.

1936

College Art Association (touring exhibition)
"Decade in American Watercolors"
October 1936–October 1937

1939

Boston, Massachusetts
Museum of Fine Arts
"Ten American Watercolor Painters"
15 April–7 May
Brochure

1940

An American Place
"Exhibition of Marin, O'Keeffe and Dove"
May–June
Reference:
 Devree, Howard. "A Reviewer's Notebook."
 New York Times, 2 June 1940, sec. 9, p. 8.

1944

Museum of Modern Art
"Modern Drawings"

Palm Beach, Florida
Society of the Four Arts
"Watercolors"
8–31 December

1947

Philadelphia, Pennsylvania
Pennsylvania Academy of the Fine Arts
"44th Annual Water Color Exhibition"

1949

Downtown Gallery
"An Exhibition of Watercolors 1929–1946 by
 Arthur G. Dove"
3–21 May
References:
 "Attractions in the Galleries: Downtown Gal-
 lery." *New York Sun,* 6 May 1949, 15.
 Breuning, Margaret. "Dove Makes Posthu-
 mous Watercolor Debut." *Art Digest* 23 (15
 May 1949): 13.
 Burrows, Carlyle. "Art in Review: Arthur
 Dove." *New York Herald Tribune,* 8 May
 1949, sec. 5, p. 6.
 Coates, Robert M. "The Art Galleries." *New
 Yorker* 25 (14 May 1949): 83.
 Devree, Howard. "Chiefly Modern; A Water-
 Color Biennial, Dove and Others; Personal
 Modernist." *New York Times,* 8 May 1949,
 sec. 2, p. 8.
 Genauer, Emily. "This Week in Art." *New
 York World-Telegram,* 9 May 1949.
 L[a]F[arge], H[enry]. "Reviews and Previews:
 Arthur Dove." *Art News* 48 (May 1949): 43.

1954

Downtown Gallery
"Dove and Demuth Watercolor Retrospective "
6 April–1 May
Brochure, no checklist
References:
 Breuning, Margaret. "Fortnight in Review:
 Charles Demuth, Arthur Dove." *Art Digest*
 28 (15 April 1954): 20.

G[uest], B[arbara]. "Reviews and Previews:
 Charles Demuth, Arthur Dove." *Art News*
 53 (April 1954): 43.

1958

Downtown Gallery
"Dove: First Public Presentation, Group of
 Watercolors 1929–1946"
30 September–11 October
References:
 Campbell, Lawrence. "Dove: Delicate In-
 novator." *Art News* 47 (October 1958): 28–
 29.
 Devree, Howard. "Art: Pioneer Modernist."
 New York Times, 1 October 1958, 43.
 G[etlein] F[rank]. "Critics Clash Over Arthur
 Dove's Work." *Milwaukee Journal,* 23
 November 1958, pt. 5, p. 6.
 Kramer, Hilton. "Month in Review." *Arts
 Magazine* 33 (October 1958): 49.

1961

Downtown Gallery
"First Showing Major Drawings 1911–20 and
 Color Studies—Evolution of a Painting—
 Dove"
14 November–2 December
Checklist, titled "Arthur G. Dove Exhibition"

1966

Metropolitan Museum of Art
"Two Hundred Years of Watercolor Painting in
 America; An Exhibition Commemorating the
 Centennial of the American Watercolor Soci-
 ety"
8 December–29 January 1967
Catalogue with foreword by Stuart Feld

1967

Albany, New York
Albany Institute of History and Art
"American 20th-Century Watercolors from the
 Munson-Williams-Proctor Institute, Utica"
10 September–4 October

1968

Washington, D.C.
Phillips Collection

"Watercolors in the Phillips Collection"
2 October–10 November

Los Angeles, California
Los Angeles County Museum of Art
"Eight American Masters of Watercolor"
23 April–16 June
Catalogue by Larry Curry
Additional showings:
 San Francisco, California
 M. H. de Young Memorial Museum
 28 June–18 August
 Seattle, Washington
 Seattle Art Museum
 5 September–13 October

1969

Solomon R. Guggenheim Museum
"Selected Sculpture and Works on Paper"
8 July–14 September

1970

Terry Dintenfass Gallery
"Arthur G. Dove: Exhibition of Watercolors and
 Drawings"
31 March–25 April
References:
 Kramer, Hilton. "Art: The Lyricism of Ar-
 thur G. Dove." New York Times, 4 April
 1970, 25.
 R[atcliff], C[arter]. "Reviews and Previews:
 Arthur Dove." Art News 69 (May 1970): 28.
 Ratcliff, Carter. "New York." Art Interna-
 tional 14 (Summer 1970): 139.

1971

San Francisco, California
California Palace of the Legion of Honor
"Twentieth-Century American Watercolors;
 The Collection of Mr. and Mrs. George Hop-
 per Fitch"
June–6 September

1972

Boston, Massachusetts
Alpha Gallery
"Arthur Dove: Watercolors"
March

Syracuse, New York
Syracuse University
"Arthur Dove Watercolors"
19 December–19 January 1973
Brochure

Wilmington, Delaware
Delaware Art Museum
"The Golden Age of American Illustration
 1880–1914"
14 September–15 October
Catalogue

1974

Andrew Crispo Gallery
"Ten Americans: Masters of Watercolor"
16 May–15 July
Catalogue with foreword by Andrew J. Crispo,
 texts by Larry Curry et al.
Reference:
 Frackman, Noel. "The Enticement of Water-
 color." Arts Magazine 48 (June 1974): 46–
 48.

Los Angeles, California
Esther Robles Gallery
"Watercolors: Dove"
3–26 October
Brochure

1976

Solomon R. Guggenheim Museum
"Twentieth-Century American Drawing: Three
 Avant-Garde Generations"
23 January–21 March
Catalogue with text by Diane Waldman

Los Angeles, California
Frederick S. Wight Art Gallery, University of
 California at Los Angeles
"The Artist-Illustrator of Life in the United
 States, 1860–1930"
12 October–12 December
Catalogue
Additional showing:
 Fort Worth, Texas
 Amon Carter Museum of Art
 8 July–22 August

1978

Washington, D.C.
Adams Davidson Galleries
"A Selection of Important Works on Paper by
 American Artists of the Nineteenth and
 Twentieth Century"
12 October–7 November
Catalogue

1980

Akron, Ohio
Akron Art Institute
"Arthur Dove Watercolors"
Reference:
 Carr, Carolyn Kinder. "Arthur Dove Water-
 colors." *Dialogue* (September–October
 1980).

New Haven, Connecticut
Yale University Art Gallery
"American Watercolors from the Collection of
 George Hopper Fitch"
13 April–31 August
Catalogue with preface by Alan Shestak and es-
 says by George T. M. Shackelford et al. in
 Yale University Art Gallery Bulletin 37
 (Spring 1980).

1982

Miami, Florida
Frances Wolfson Art Gallery, Miami-Dade Com-
 munity College
"The Spirit of Paper: Twentieth-Century Ameri-
 cans"
3 June–29 July
Catalogue with essay by Addison Parks

Bibliography

The bibliography consists of two sections. The first lists sources on Dove. The second lists other material to which reference is made in the text.

The Dove bibliography is constructed to be used in conjunction with the exhibition lists. Material cited in those lists is not repeated here. Thus, the bibliography does not include catalogues for exhibitions in which Dove's work appeared, reviews of those shows, or other journalistic reports on them.

With the exception of only the most uninformative sort of references to upcoming shows and the like, the Dove bibliography is as complete as possible for the years through 1946, or during his lifetime, since it is often of some historical interest to know the contexts in which Dove appeared in print during his own time. The entries from 1947 through 1982 are slightly more selective. Publications of a general nature in which Dove is cited only in passing have not been included unless they are of some substantial interest for the understanding of the art or environment of Dove's era.

Entries are arranged first by year of publication, then alphabetically. If two or more items by a single author cannot be chronologically arranged within a single year, they are ordered alphabetically by title, with the exception that books precede articles. At the end of the chronological listing of published sources on Dove is a separate category of unpublished material, including letters, diaries, artist's notes, interviews, and so on. (Although they are unpublished, academic dissertations and theses, because of their public nature, are listed among the chronologically organized publications.)

PUBLISHED SOURCES ON DOVE

1913

Aisen, Maurice. "The Latest Evolution in Art and Picabia." *Camera Work*, Special Number (June 1913): 14–21.

Hapgood, Hutchins. "The Live Line." *The Globe and Commercial Advertiser* (New York), 8 March 1913, 7.

"New York by Cubist Is Very Confusing," *New York Sun*, 18 March 1913, 9.

Swift, Samuel. Review of Picabia show. *New York Sun*, March 1913. Reprinted in *Camera Work*, no. 42–43 (April–July 1913): 48–49.

Taylor, Bert Leston. "A Line-O'Type or Two: Post-Impressionism." *Chicago Tribune*, 25 March 1913, 8.

———. "A Line-O'Type or Two: The Brooding Dove." *Chicago Tribune*, March 1913.

Weichsel, John. "Cosmism or Amorphism?" *Camera Work*, no. 42–43 (April–July 1913): 69–82.

1914

Dove, Arthur. "291." *Camera Work*, no. 47 (July 1914): 37.

Eddy, Arthur Jerome. *Cubists and Post-Impressionism*. Chicago: A. C. McClurg, 1914.

1915

Wright, Willard Huntington. *Modern American Painting and Its Tendency*. New York: John Lane, 1915.

1916

"'291' and the Modern Gallery." *Camera Work*, no. 48 (October 1916): 63–64.

1917

[Tyrrell, Henry (?)]. "The Wherefores of Modern Art." *Christian Science Monitor* (Boston), 28 September 1917, 8.

1919

"News and Comment in the World of Art." *New York Sun*, 6 April 1919, 12.

1921

Hartley, Marsden. *Adventures in the Arts*. New York: Boni and Liveright, 1921.

1923

Herford, Oliver. "The Crime Wave in Art." *Ladies Home Journal*, January 1923, 8, 98–102.

Seligmann, Herbert J. "Why Modern Art." *Vogue*, 15 October 1923.

1924

Cheney, Sheldon. *Primer of Modern Art*. New York: Boni and Liveright, 1924.

Freed, Clarence. "Alfred Stieglitz—Genius of the Camera." *The American Hebrew*, 18 January 1924, 305–24.

Rosenfeld, Paul. *Port of New York*. New York: Harcourt Brace, 1924. Reissued, with an introduction by Sherman Paul (Urbana: University of Illinois Press, 1966).

1925

Broun, Heywood. "It Seems to Me." *New York World*, 20 March 1925.

———. "It Seems to Me." *New York World*, 2 April 1925.

"The Conning Tower: The Diary of Our Own Samuel Pepys," *New York World*, 22 March 1925.

"The Conning Tower: The Diary of Our Own Samuel Pepys." *New York World*, 28 March 1925.

Frank, Waldo. "Our America." *The New Warheit*, 14 March 1925, 24.

McBride, Henry. *New York Sun*, 14 March 1925.

1926

Broun, Heywood. "It Seems to Me." *New York World*, 29 January 1926.

Buranelli, Prosper. "Bricks vs. Art—A Family Drama." *New York World Magazine*, 30 May 1926, 12.

Fielding, Mantle. *Dictionary of American Painters, Sculptors and Engravers*. Rev. and enl. ed. Greens Farms, Conn.: Modern Books and Crafts, 1974.

[Frank, Waldo]. *Time Exposures*. New York: Boni and Liveright, 1926. [Dove mentioned only in passing.]

Matthias, Blanche C. "Georgia O'Keeffe and the Intimate Gallery." *Chicago Evening Post Magazine of the Art World*, 2 March 1926, 1, 14.

Phillips, Duncan. *A Collection in the Making*. New York: E. Weyhe, and Washington, D.C.: Phillips Memorial Gallery, 1926.

Wilson, Edmund. "Opera Comique." *New Republic*, 20 January 1926, 241.

1927

"Has Too Much Art." *Geneva (N.Y.) Times*, December 1927.

Mather, Frank J. *The American Spirit in Art*. New Haven, Conn.: Yale University Press, 1927.

1930

Barr, Alfred H., Jr. *Max Weber*. New York: Museum of Modern Art, 1930. Exhibition catalogue.

Jewell, E. A. *Modern Art: Americans*. New York: Alfred A. Knopf, 1930.

Kootz, Samuel. *Modern American Painters*. New York: Brewer and Warren, 1930.

1931

Neuhaus, Eugen. *The History and Ideals of American Art*. Stanford, Calif.: Stanford University Press, 1931.

Phillips, Duncan. *The Artist Sees Differently*. 2 vols. New York: E. Weyhe, and Washington, D.C.: Phillips Memorial Gallery, 1931.

1932

Cary, Elisabeth Luther. "Art Magazines." *New York Times*, 19 June 1932, sec. 9, p. 6.

Flandrau, Grace. "The Happiest Time." *Scribner's* 91 (June 1932): 335–40, 371–84. [The fictional Arthur in this story is based on Dove.]

Phillips, Duncan. "Original American Painting of Today." *Formes* 21 (January 1932); 197–201.

1933

Bulliet, C. J. *Apples and Madonnas*. 3d ed. rev. New York: Covici, Friede, 1933.

McCausland, Elizabeth. "Water Color by Arthur G. Dove Presented Museum; Life and Work of a Fine American Abstractionist." *Springfield (Mass.) Union and Republican*, 21 May 1933.

"Stieglitz's 50-Year Fight for Photography Triumphant." *Springfield (Mass.) Union and Republican*, 14 May 1933, 3E.

1934

"America, Alfred Stieglitz." *Springfield (Massachusetts) Republican*, 2 December 1934, 6E. Review of *America and Alfred Stieglitz*, ed. Waldo Frank et al.

Craven, Thomas. *Modern Art: The Men, the Movements, the Meaning*. New York: Simon and Schuster, 1934. [Dove mentioned only in passing.]

Fadiman, Clifton. "Books." *New Yorker* 10 (8 December 1934): 108–11. [Dove mentioned only in passing.]

"Few Genevans Aware Artist of Prominence is Resident." *Syracuse (N.Y.) Post-Standard*, 2 May 1934.

Frank, Waldo, et al., eds. *America and Alfred Stieglitz: A Collective Portrait*. Garden City, N.Y.: Doubleday, Doran, 1934. [Includes Dove's contribution, "A Different One," 243–45.]

McCausland, Elizabeth. "North Pier—Seneca Lake." *Springfield (Mass.) Union and Republican*, 10 June 1934.

O'Brien, Emmet N. "Leader of Modern Artists Paints in Geneva Farmhouse." *Rochester (N.Y.) Democrat and Chronicle*, 14 January 1934.

1935

Benson, E. M. "Forms of Art: III; Phases of Fantasy." *American Magazine of Art* 28 (May 1935): 290–99.

Devree, Howard. "A Reviewer's Week: Varied Fare in the Galleries." *New York Times*, 20 January 1935, sec. 10, p. 8.

Zorach, William. "Ideas on American Sculpture." *The Art of Today* 6 (April 1935): 5–6. [Dove only illustrated.]

1936

Mumford, Lewis. "The Art Galleries." *New Yorker* 12 (6 June 1936): 29.

1937

Baldinger, W. S. "Formal Change in Recent American Painting." *Art Bulletin* 19 (December 1937): 580–91.

Jewell, E. A. "Concerning That Plea for Motion." *New York Times,* 19 September 1937, sec. 11, p. 9.

McCausland, Elizabeth. "Dove: Man and Painter." *Parnassus* 9 (December 1937): 3–6.

1939

Jewell, E. A. *Have We An American Art?* New York: Longmans, Green, 1939. [Dove mentioned only in passing.]

1940

McCausland, Elizabeth. "Living American Art Received by Museum." *Springfield (Mass.) Union and Republican,* 4 August 1940, 6E.

"Modern Museum Acquires New Art." *New York Times,* August 1940.

1942

Frost, Rosamund. *Contemporary Art: The March of Art from Cézanne until Now.* New York: Crown, 1942.

Kazin, Alfred. *On Native Grounds.* New York: Harcourt, Brace, 1942. [Dove mentioned only in passing.]

Mellquist, Jerome. *The Emergence of an American Art.* New York: Scribner's, 1942.

Painting and Sculpture in the Museum of Modern Art. New York: Museum of Modern Art, 1942.

1943

Barr, Alfred H., Jr. *What Is Modern Painting?* Rev. ed. New York Museum of Modern Art, 1956.

1944

Janis, Sidney. *Abstract and Surrealist Art in America.* 1944. Reprint. New York: Arno Press, 1969.

Mullett, Suzanne M. "Arthur G. Dove (1880–): A Study in Contemporary Art." Master's thesis, American University, Washington, D.C., 1944.

1945

O'Hara, Eliot. "O'Hara's Amateur Page." *American Artist* 9 (January 1945): 30.

1946

"Arthur Dove Dies; Abstractionist, 66." *New York Times,* 24 November 1946, 78.

"Arthur Dove, Modern." *Art Digest* 31 (1 December 1946): 14.

"Arthur G. Dove, 66, Abstract Painter" [obituary]. *New York Herald Tribune,* 24 November 1946, sec. 1, p. 46.

Jewell, E. A. "Pioneer Modernists." *New York Times,* 1 December 1946, sec. 2, p. 9.

"Obituaries: Arthur G. Dove," *Art News* 45 (December 1946): 9.

Pagano, Grace. *The Encyclopaedia Britannica Collection of Contemporary American Painting.* Encyclopaedia Britannica, Inc., 1946.

Watkins, C. Law. *The Language of Design.* Washington, D.C.: Phillips Memorial Gallery, 1946.

1947

Larkin, Oliver. "Alfred Stieglitz and '291.'" *Magazine of Art* 40 (May 1947): 179–83.

Phillips, Duncan. "Arthur Dove, 1880–1946." *Magazine of Art* 40 (May 1947): 192–97.

"We Regret." *Magazine of Art* 40 (May 1947).

1948

Barr, Alfred H., Jr., ed. *Painting and Sculpture in the Museum of Modern Art.* New York: Museum of Modern Art (Simon and Schuster), 1948.

1949

Goodrich, Lloyd. *Max Weber.* New York: Whitney Museum of American Art, 1949. Exhibition catalogue.

Larkin, Oliver. *Art and Life in America.* 2d ed. rev. New York: Holt, Rinehart and Winston, 1960.

Marin, John. *Selected Writings.* Edited by Dorothy Norman. New York: Pellegrini and Cudahy, 1949.

O'Keeffe, Georgia. "Stieglitz: His Pictures Collected Him." *New York Times Magazine,* 11 December 1949, 24–30.

Rich, Daniel Catton. "The Stieglitz Collection." *Chicago Art Institute Bulletin* 42 (15 November 1949): 68.

1950

Collection of the Société Anonyme: Museum of Modern Art 1920. New Haven, Conn.: Yale University Art Gallery, 1950.

Louchheim, Aline B. "Venice to Glimpse Our Modernists." *New York Times,* 28 May 1950, sec. 2, p. 7.

Turner, Theodore. "Arthur G. Dove." Master's thesis, Institute of Fine Arts, New York University, 1950.

1951

Baur, John I. H. "Modern American Art and Its Critics." *Art in America* 39 (April 1951): 53–65.

Davidson, Jo. *Between Sittings.* New York: The Dial Press, 1951.

Hess, Thomas B. *Abstract Painting: Background and American Phase.* New York: Viking, 1951.

"La Peinture aux États-Unis d'Amérique: Vue d'ensemble et des tendances diverses," *Art d'Aujourd'hui,* ser. 2, no. 6 (June 1951): 1–31.

McCausland, Elizabeth. *A. H. Maurer.* New York: A. A. Wyn for Walker Art Center, Minneapolis, 1951.

1952

McCausland, Elizabeth. *Marsden Hartley.* Minneapolis: University of Minnesota Press, 1952.

Phillips, Duncan. *The Phillips Collection Catalogue: A Museum of Modern Art and Its Sources.* Washington, D.C.: Philips Collection, 1952.

1953

Goldwater, Robert. "Arthur Dove." *Perspectives USA,* no. 2 (Winter 1953): 78–88.

Meyer, Agnes. *Out of These Roots.* Boston: Little, Brown, 1953.

Vollmer, Hans. *Allgemeines Lexikon Der Bildenden Künstler des XX Jahrhunderts.* Vol. 1. Leipzig: E. A. Seemen Verlag, 1953.

1954

Barr, Alfred H., Jr. *Masters of Modern Art.* New York: Museum of Modern Art, 1954.

Hale, Robert Beverly. "American Paintings 1754–1954." *Metropolitan Museum Bulletin,* n.s., 12 (March 1954), 190.

1955

Brown, Milton. *American Painting from the Armory Show to the Depression.* Princeton, N.J.: Princeton University Press, 1955.

Gordon, J. "Flat Surfaces." *Brooklyn Museum Bulletin* 17 (Fall 1955): 27.

Newmeyer, Sarah. *Enjoying Modern Art.* New York: New American Library (Mentor), 1955.

1956

"The Age of Experiment." *Time* 67 (13 February 1956): 62–67.

Kirsch, Dwight. "The Roland P. Murdock Collection, Wichita, Kansas." *Art in America* 44 (Winter 1956–57): 40–47.

Richardson, E. P. *Painting in America.* New York: Crowell, 1956.

1957

Baur, John I. H., ed. *New Art in America.* New York: Frederick A. Praeger, 1957.

Eliot, Alexander. *Three Hundred Years of American Painting.* New York: Time, Inc., 1957.

"Painting and Sculpture Acquisitions, July 1955–Dec. 1956." *Museum of Modern Art Bulletin* 24 (Summer 1957): 21.

1958

Painting and Sculpture in the Museum of Modern Art. New York: Museum of Modern Art, 1958.

Werner, Alfred. "Max Weber at Seventy-Seven." *Arts Magazine* 32 (September 1958): 27–29, 64.

1959

Canaday, John. "New Talent Fifty Years Ago." *Art in America* 47 (Spring 1959): 19–33.

Gerdts, William H., Jr. *Max Weber.* Newark, N.J.: Newark Museum, 1959. Exhibition catalogue.

Hunter, Sam. *Modern American Painting and Sculpture.* New York: Dell (Laurel), 1959.

Kerrigan, Anthony. "Cronica de norteamerica." *Goya,* no. 28 (January–February 1959): 251–55.

"Painting and Sculpture Acquisitions, Jan.–Dec. 1958." *Museum of Modern Art Bulletin* 26 (July 1959): 20.

Read, Herbert. *A Concise History of Modern Painting.* New York: Praeger, 1959.

1960

"American Masterpieces." *Town and Country* 114 (June 1960).

Kuh, Katherine. *The Artist's Voice.* New York: Harper and Row, 1960.

Norman, Dorothy. *Alfred Stieglitz: Introduction to an American Seer.* New York: Duell, Sloan and Pearce, 1960. Reissued as *Alfred Stieglitz: An American Seer.* New York: Random House, 1973.

Rich, Daniel Catton. *Georgia O'Keeffe.* Worcester, Mass.: Worcester Art Museum, 1960. Exhibition catalogue.

1961

Goodrich, Lloyd, and John I. H. Baur. *American Art of Our Century.* New York: Praeger, 1961.

Rochester Memorial Art Gallery Handbook. Rochester, N.Y.: University of Rochester, 1961.

Wolfer, George Raymond. "Arthur Garfield Dove." Master's thesis, Hunter College, 1961.

1962

Baur, John I. H. "Art in America—Four Centuries of Painting and Sculpture: A Show Proposed for the New York World's Fair: Catalogue." *Art in America* 50 (Fall 1962): 42–68.

Perlman, Bennard B. *The Immortal Eight.* New York: Exposition Press, 1962.

1963

Coplans, John. "West Coast Art: Three Images; II, The Art in the Exhibitions." *Artforum,* 1 (June 1963): 23–25.

Dochterman, Lillian N. "The Stylistic Development of the Work of Charles Sheeler." Ph.D. diss., University of Iowa, 1963.

Richardson, E. P. *A Short History of Painting in America.* New York: Thomas Y. Crowell, 1963.

Steichen, Edward. *A Life in Photography.* Garden City, N.Y.: Doubleday, 1963.

1964

Constable, W. G. *Art Collecting in the United States of America*. London: Thomas Nelson and Sons, [1964].

Dictionary of Modern Painting. New York: Tudor, 1964.

Kindlers Malerei Lexikon. 5 vols. Zürich: Kindler Verlag, 1964.

Rueppel, Merrill C. "200 Years of American Painting." *Bulletin of the City Art Museum of St. Louis* 48 (1964 special issue).

1965

The Beauty of America in Great American Art. Waukesha, Wis.: Country Beautiful Foundation, and New York: William Morrow, 1965.

Haftmann, Werner. *Painting in the Twentieth Century*. Translated by Ralph Mannheim. New York: Praeger, 1965.

"Reaction and Revolution, 1900–1930." *Art in America* 53 (August 1965): 85–86.

St. John, Bruce, ed. *John Sloan's New York Scene*. New York: Harper and Row, 1965.

1966

Cummings, Paul. *A Dictionary of Contemporary American Artists*. 2d ed. London: St. James Press, 1971.

Gardner, A. T. *History of Water Color Painting in America*. New York: Reinhold Publishing Co., 1966.

Geske, Norman A., ed. "College Museum Notes: Acquisitions." *Art Journal* 25 (Summer 1966): 392–402.

Green, Samuel. *American Art*. New York: Ronald Press, 1966.

Reich, Sheldon. "John Marin." Ph.D. diss. University of Iowa, 1966.

A University Collects: Georgia Museum of Art. Athens: Georgia Museum of Art, and New York: American Federation of Arts, 1966.

1967

Gardner, Albert Ten Eyck, and Milton Brown. *The New York Painter; A Century of Teaching: Morse to Hofmann*. New York: New York University Press, 1967. Exhibition catalogue (Marlborough-Gerson Gallery).

Muhlert, Jan Keene. "Arthur G. Dove, Early American Modernist." Master's thesis, Oberlin College, 1967.

Rose, Barbara. *American Art Since 1900*. Rev. ed. New York: Praeger, 1975.

Vassar College Art Gallery: Selections from the Permanent Collection. Poughkeepsie, N.Y.: Vassar College, 1967.

1968

Academy Album. Honolulu: Honolulu Academy of Arts, 1968

Georgia Museum of Art—Highlights from the Collection. Athens: University of Georgia, Georgia Museum of Art, 1968.

Hess, Thomas B., and John Ashberry, eds. *Avant-Garde Art*. New York: Macmillan (Collier Books/Art News Series), 1968.

Kozloff, Max. *Renderings: Critical Essays on a Century of Modern Art*. New York: Simon and Schuster, 1968.

McLanathan, Richard. *The American Tradition in the Arts*. New York: Harcourt, Brace and World, 1968.

Robbins, Daniel. "Collector: Roy Neuberger," *Art in America* 56 (November 1968): 53.

Rose, Barbara, ed. *Readings in American Art Since 1900: A Documentary Survey*. New York: Praeger, 1968.

Rubin, William S. *Dada, Surrealism, and Their Heritage*. New York: Museum of Modern Art, 1968. Exhibition catalogue.

Young, William. *A Dictionary of American Artists, Sculptors and Engravers.* Cambridge, Mass.: William Young and Co., 1968.

1969

American Paintings in the Ferdinand Howald Collection. Columbus, Ohio: Columbus Gallery of Fine Arts, 1969.

American Paintings in the Museum of Fine Arts, Boston. 2 vols. Greenwich: New York Graphic Society, 1969.

Homer, William Innes. *Robert Henri and His Circle.* Ithaca, N.Y.: Cornell University Press, 1969.

Kozloff, Max. "Men and Machines." *Artforum* 7 (February 1969): 22–29.

Myers, Bernard S., ed. *McGraw-Hill Dictionary of Art.* 5 vols. New York: McGraw-Hill, 1969.

Novak, Barbara. *American Painting of the Nineteenth Century.* New York: Praeger, 1969.

1970

Goodrich, Lloyd, and Doris Bry. *Georgia O'Keeffe.* New York: Whitney Museum of American Art, 1970. Exhibition catalogue.

Hamilton, George Heard. "The Alfred Stieglitz Collection." *Metropolitan Museum Journal* 3 (1970): 371–92.

Jaffe, Irma. *Joseph Stella.* Cambridge, Mass.: Harvard University Press, 1970.

Phillips, Marjorie. *Duncan Phillips and His Collection.* New York: Little, Brown, 1970.

Reich, Sheldon. *John Marin.* 2 vols. Tucson: University of Arizona Press, 1970.

Rose, Barbara. *American Painting.* Vol. 2. Cleveland, Ohio: World Publishing Co., 1970.

Rubin, William S. *Frank Stella.* New York: Museum of Modern Art, 1970. Exhibition catalogue.

Spector, Stephen. Review of *John Marin,* by Sheldon Reich. *Arts Magazine* 44 (Summer 1970): 14.

1971

Baigell, Matthew. *A History of American Painting.* New York: Praeger, 1971.

Farnham, Emily. *Charles Demuth: Behind a Laughing Mask.* Norman: University of Oklahoma Press, 1971.

Frankenstein, Alfred. "Flowers, Bones and the Blue." *San Francisco Examiner,* 14 March 1971, 31.

Reich, Sheldon. "Abraham Walkowitz: Pioneer of American Modernism." *American Art Journal* 3 (Spring 1971): 72–82.

Scott, David W., and E. John Bullard. *John Sloan 1871–1951.* Washington, D.C.: National Gallery of Art, 1971. Exhibition catalogue.

1972

Davidson, Abraham. Review of *John Marin,* by Sheldon Reich. *Art Journal* 31 (Spring 1972): 358–59.

Eiseman, Alvord L. "A Charles Demuth Retrospective Exhibition." *Art Journal* 31 (Spring 1972): 283–86.

———. Review of *Charles Demuth: Behind a Laughing Mask,* by Emily Farnham. *Art Journal* 32 (Fall 1972): 116.

Gussow, Alan. *A Sense of Place: The Artist and the American Land.* New York: Saturday Review Press, 1972.

Hunter, Sam. *American Art of the 20th Century.* New York: Abrams, 1972.

O'Connor, Francis V., ed. *The New Deal Art Projects: An Anthology of Memoirs.* Washington, D.C.: Smithsonian Institution Press, 1972.

Paul, William D., Jr. "The Georgia Museum of Art at the University of Georgia," *Art Journal* 31 (Spring 1972): 287–91.

Reich, Sheldon. Review of *Charles Demuth: Behind a Laughing Mask,* by Emily Farnham. *Art Bulletin* 54 (June 1972): 228–29.

Ritchie, Andrew C., and K. B. Nelson. *Selected Paintings and Sculpture from the Yale University Art Gallery*. New Haven, Conn.: Yale University Press, 1972.

Shirey, David L. "The Art of Helen Torr." *New York Times*, 15 July 1972.

Williams, Mary F. "The Painting Collection at Randolph-Macon." *Art Journal* 32 (Winter 1972–73): 192–95.

1973

Doty, Robert. "The Articulation of American Abstraction." *Arts Magazine* 48 (November 1973): 47–49.

Edens, Stephanie T. "The Silent Decade, 1900–1910, Chronology." *Art in America* 61 (July–August 1973): 33.

Eldredge, Charles. "The Arrival of European Modernism." *Art in America* 61 (July–August 1973): 35–41.

Franc, Helen M. *An Invitation to See: 125 Paintings from the Museum of Modern Art*. New York: Museum of Modern Art, 1973.

Havlice, Patricia Pate. *Index to Artistic Biography*. 2 vols. Metuchen, N.J.: Scarecrow Press, 1973.

Homer, William. "Stieglitz and 291." *Art in America* 61 (July–August 1973): 50–57.

Kramer, Hilton. *The Age of the Avant-Garde*. New York: Farrar, Straus and Giroux, 1973. Reprint of "The Loneliness of Arthur Dove," from the *New York Times*, 19 March 1967.

Lynes, Russell. *Good Old Modern: An Intimate Portrait of the Museum of Modern Art*. New York: Atheneum, 1973.

Metzger, Robert P. "Biomorphism in American Painting." Ph.D. diss., University of California, Los Angeles, 1973.

Morgan, Ann Lee. "Toward the Definition of Early Modernism in America: A Study of Arthur Dove." Ph.D. diss., University of Iowa, 1973.

Phaidon Dictionary of 20th-Century Art. New York: E. P. Dutton, 1973.

Reich, Sheldon. *Alfred H. Maurer, 1868–1932*. Washington, D.C.: Smithsonian Institution Press, 1973. Exhibition catalogue.

Rugoff, Milton, ed. *The Britannica Encyclopedia of American Art*. New York: Simon and Schuster, 1973.

Taylor, Larry. "Alfred Stieglitz and the Search for American Equivalents." Ph.D. diss., University of Illinois, 1973.

Teilman, Herdis Bull, et al. *Catalogue of Painting Collection*. Pittsburgh, Pa.: Museum of Art, Carnegie Institute, 1973.

Young, Mahonri Sharp. *The Eight: The Realist Revolt in American Painting*. New York: Watson-Guptill, 1973.

1974

Brooks, Charles. *Sensory Awareness: The Rediscovery of Experiencing*. New York: Viking Press, 1974.

Gordon, Donald E. *Modern Art Exhibitions 1900–1916; Selected Catalogue Documentation*. 2 vols. Munich: Prestel-Verlag, 1974.

Plagens, Peter. *Sunshine Muse: Contemporary Art on the West Coast*. New York: Praeger, 1974.

Schwarz, Arturo. *New York Dada: Duchamp, Man Ray, Picabia*. Munich: Prestel-Verlag, 1974. Exhibition catalogue.

Tomkins, Calvin. "Profiles (Georgia O'Keeffe)." *New Yorker* 50 (4 March 1974): 40–66.

Young, Mahonri Sharp. *Early American Moderns: Painters of the Stieglitz Group*. New York: Watson-Guptill, 1974.

1975

Butterfield, Bruce. "Paul Rosenfeld: The Critic as Autobiographer." Ph.D. diss., University of Illinois, 1975.

Davidson, Abraham A. "Two from the Second Decade: Manierre Dawson and John Covert." *Art in America* 63 (September–October 1975): 50–55.

Haskell, Barbara. "Arthur G. Dove (1880–1946)." *American Art Review* 2 (January–February 1975): 131–41.

Livingston, Jane. Review of *Sunshine Muse: Contemporary Art on the West Coast*, by Peter Plagens. *Art in America* 63 (September–October 1975): 23.

McBride, Henry. *The Flow of Art: Essays and Criticisms of Henry McBride*. Edited by Daniel Catton Rich. New York: Atheneum, 1975.

Meador, Shirley. "Arthur G. Dove: Ahead of His Time." *American Artist* 39 (November 1975): 48–53 and 93–95.

Rose, Barbara. *Frankenthaler*. New York: Abrams, 1975.

Rosenblum, Robert. *Modern Painting and the Northern Romantic Tradition: Friedrich to Rothko*. New York: Harper and Row, 1975.

Schwartz, Sanford. Review of *Early American Moderns: Painters of the Stieglitz Group*, by Mahonri Sharp Young. *Art in America* 63 (November–December 1975): 29–31.

Tashjian, Dickran. *Skyscraper Primitives: Dada and the American Avant-Garde 1910–1925*. Middletown, Conn.: Wesleyan University Press, 1975.

1976

Davidson, Abraham A. Review of *Skyscraper Primitives: Dada and the American Avant-Garde 1910–1925*, by Dickran Tashjian. *Art Bulletin* 63 (June 1976): 312–14.

Jordan, Jim. "Arthur Dove and the Nature of the Image." *Arts Magazine* 50 (February 1976): 89–91.

Levin, Sandra Gail. "Wassily Kandinsky and the American Avant-Garde, 1912–1950." Ph.D. diss., Rutgers University, 1976.

"News; College Museum News: Acquisitions," *Art Journal* 36 (Winter 1976): 152 and 158.

Powell, Earl A. "Manierre Dawson's *Woman in Brown*." *Arts Magazine* 51 (September 1976): 76–77.

Schwartz, Sanford. "On Arthur Dove." *Artforum* 14 (February 1976): 28–33.

Stebbins, Theodore. *American Master Drawings and Watercolors*. New York: Harper and Row, 1976.

1977

Barr, Alfred H., Jr. *Painting and Sculpture in the Museum of Modern Art 1929–1967*. New York: Museum of Modern Art, 1977.

Frankenstein, Alfred. Review of *Alfred Stieglitz and the American Avant-Garde*, by William Innes Homer. *Art News* 76 (November 1977): 64–65.

———. "Masters Since 1900." *San Francisco Examiner and Chronicle*, "World" magazine, 4 December 1977.

Glueck, Grace. "The 20th Century Artists Most Admired by Other Artists." *Art News* 76 (November 1977): 78–103.

Homer, William Innes. *Alfred Stieglitz and the American Avant-Garde*. Boston: New York Graphic Society, 1977.

Kramer, Hilton. "A Nativist Who Painted with Light." *New York Times*, 23 October 1977, D27.

Naylor, Colin, and Genesis P-Orridge, eds. *Contemporary Artists*. London: St. James Press, and New York: St. Martin's Press, 1977.

Pomeroy, Ralph. *Stamos*. New York: Abrams, 1977.

"A Private Artist at 90." *San Francisco Chronicle*, 14 November 1977, 20.

1978

Crozier, A. T. K. Review of *Alfred Stieglitz and the American Avant-Garde*, by William Innes Homer. *Journal of American Studies* 12 (December 1978): 404–5.

Davidson, Abraham. "Demuth's Poster Portraits." *Artforum* 18 (November 1978): 54–58.

Hobbs, Robert Carleton, and Gail Levin. *Abstract Expressionism: The Formative Years.* New York: Whitney Museum of American Art, and Ithaca, N.Y.: Herbert F. Johnson Museum of Art, 1978. Exhibition catalogue. Reissued by Cornell University Press, Ithaca, New York, 1981.

Naef, Weston. *The Collection of Alfred Stieglitz: Fifty Pioneers of Modern Photography.* New York: Metropolitan Museum of Art and Viking Press, 1978.

1979

Baigell, Matthew. *Dictionary of American Art.* New York: Harper and Row, 1979.

Morgan, Ann Lee. "An Encounter and Its Consequences: Arthur Dove and Alfred Stieglitz, 1910–1925." *Biography* 2 (Winter 1979): 35–59.

Petruck, Peninah. "American Art Criticism 1910–1939." Ph. D. diss., Institute of Fine Arts, New York University, 1979.

1980

Corn, Wanda M. "Apostles of the New American Art: Waldo Frank and Paul Rosenfeld." *Arts Magazine* 54 (February 1980): 159–63.

DeZayas, Marius. "How, When and Why Modern Art Came to New York," with introduction and notes by Francis M. Naumann. *Arts Magazine* 54 (April 1980): 96–126.

Homer, William Innes. "Identifying Arthur Dove's 'The Ten Commandments,'" *American Art Journal* 12 (Summer 1980): 21–32.

1981

Davidson, Abraham. *Early American Modernist Painting 1910–1935.* New York: Harper and Row, 1981.

Forgey, Benjamin. "The Odyssey of Duncan Phillips." *Portfolio* (November–December 1981): 66–71.

Schall, Jan. "Rose on Dove," *Art Papers* (Atlanta). November–December 1981, 16.

1982

Yeh, Susan Fillin. "Innovative Moderns: Arthur G. Dove and Georgia O'Keeffe." *Arts Magazine* 56 (June 1982): 68–72.

UNPUBLISHED SOURCES ON DOVE

New Haven, Conn., Yale University, Beinecke Library, Collection of American Literature. Papers of Charles Caffin, Arthur B. Carles, Charles Daniel, Elizabeth Davidson, Marius De-Zayas, Charles Duncan, Marsden Hartley, John Marin, Lewis Mumford, Marie Rapp (Boursault), Paul Rosenfeld, Herbert J. Seligmann, Paul Strand, Rebecca Strand, Abraham Walkowitz, and others, as well as miscellaneous files of gallery material, clippings, etc.

Washington, D.C., Smithsonian Institution, Archives of American Art. Downtown Gallery files and Elizabeth McCausland papers.

Philadelphia, Pa., University of Pennsylvania Library. Van Wyck Brooks Collection.

Washington, D.C. Phillips Collection. Correspondence files.

Chicago, Ill., Newberry Library. Sherwood Anderson papers.

New York, Whitney Museum of American Art. Clipping files.

New York, Metropolitan Museum. Clipping files.

New York, New York Public Library. Clipping files.

Privately owned papers of William Dove, Sue Davidson Lowe, Charles Brooks, and Paul Dove.

Interviews with Dr. J. Clarence Bernstein, Julia Bernstein, Aline Dove, Paul Dove, William Dove, Dr. Mary Holt, Lila Howard, Sue Davidson Lowe, John Marin, Jr., James McLaughlin, Dorothy Norman, Emmet O'Brien, Georgia O'Keeffe, Marjorie Phillips, Mary Rehm, Herbert J. Seligmann, Archer Winsten, and, by telephone, with Holly Raleigh Beckwith and Claire O'Brien.

ADDITIONAL SOURCES CITED

Anderson, Sherwood. *A Story-Teller's Story*. 1924. Reprint. New York: Grove Press, 1958.

Balakian, Anna. *The Symbolist Movement: A Critical Appraisal*. New York: Random House, 1967.

Barr, Alfred H., Jr. *Cubism and Abstract Art*. New York: Museum of Modern Art, 1936. Exhibition catalogue.

Brooks, Van Wyck. *The Wine of the Puritans*. London: Sisley's Ltd., 1908.

Corn, Wanda M. *The Color of Mood: American Tonalism 1880–1910*. San Francisco: M. H. de Young Memorial Museum and the California Palace of the Legion of Honor, 1972. Exhibition catalogue.

Ernst, Max. *Histoire naturelle*. Paris, 1926.

Firestone, Evan R. "James Joyce and the First Generation New York School." *Arts Magazine* 56 (June 1982): 116–21.

Grohmann, Will. *Wassily Kandinsky, Life and Work*. Translated by Norbert Guterman. New York: Harry N. Abrams [1958].

Hapgood, Hutchins. "Life at the Armory." *The Globe and Commercial Advertiser* (New York), 17 February 1913.

Hofstadter, Richard. *Anti-Intellectualism in American Life*. New York: Random House (Vintage), 1962.

Lasch, Christopher. *The New Radicalism in America, 1889–1963*. New York: Random House (Vintage), 1965.

Marx, Leo. *The Machine in the Garden: Technology and the Pastoral Ideal in America*. New York: Oxford University Press, 1964.

Mumford, Lewis. *The Brown Decades*. 2d ed. rev. New York: Dover, 1955.

Nash, Roderick. *Wilderness and the American Mind*. New Haven, Conn.: Yale University Press, 1967. Rev. ed. 1973.

Pollock, Jackson. "My Painting." *Possibilities* (Winter 1947–48): 79.

Risatti, Howard. "The American Critical Reaction to European Modernism, 1908–1917." Ph.D. diss., University of Illinois, 1978.

———. "Music and the Development of Abstraction in America." *Art Journal* 39 (Fall 1979):8–13.

Shapiro, Meyer. "Nature of Abstract Art." *Marxist Quarterly* 1 (January–March 1937): 77–98.

Smith, Henry Nash. *Virgin Land: The American West as Symbol and Myth*. Cambridge, Mass.: Harvard University Press, 1950.

Stein, Gertrude. *Autobiography of Alice B. Toklas*. 1933. Reprint. London: Arrow Books, 1960.

Turner, Frederick Jackson. "The Significance of the Frontier in American History." Paper read before the American Historical Society at the World's Columbian Exposition, Chicago, Ill., 1893.

Wechsler, Jeffrey. *Surrealism and American Art 1931–1947*. New Brunswick, N.J.: Rutgers University Art Gallery, 1977. Exhibition catalogue.

White, Morton. *Social Thought in America: The Revolt Against Formalism*. 1949. Reprint. Boston: Beacon, 1957.

PHOTO CREDITS FOR CATALOGUE ILLUSTRATIONS:

Subject Index

Abbott, Berenice, 30
Abstract expressionism, 62, 72 n.76, 80
Abstraction, 38, 40–41, 43, 48, 52–54, 55, 58, 60–64, 74–75
Aisen, Maurice, 18
American experience, 75–76
American Place, An, 25, 26, 27, 29, 30, 34, 54, 74
Anderson, Sherwood, 21, 76, 78–79
Anderson Galleries, 19, 21, 22
Apollinaire, Guillaume, 52
Arensberg, Walter, 71 n.54
Armory Show, 18, 25, 46, 69 n.23
Arp, Jean, 48, 70 n.41, 72 n.68, 72 n.75
Art nouveau, 40, 43, 48, 68 n.22
Assemblages, 22, 49–52, 71 nn. 55 and 56, 81 n.19
Atlantic, 52
Automatism, 48

Barr, Alfred, 30, 58, 70 n.41
Baziotes, William, 48, 81
Beldon Pond Farm, 19
Bellows, George, 82 n.26
Bergson, Henri, 46, 79, 82 n.39
Bernstein, Dr. J. Clarence ("Jake"), 33, 34
Brancusi, Constantin, 143
Braque, Georges, 51
Brinley, G. Putnam, 18
Brooks, Charles, 25, 30
Brooks, Van Wyck, 25, 75–76, 81 n.15

Cagnes, France, 15
Cahiers d'art, 52
Calder, Alexander, 80
Camera Work, 16, 19, 20, 46, 71 n.54
Canandaigua, N.Y., 11
Carles, Arthur, 15, 18
Cennini, Cennino, 72 n.78
Centerport, N.Y., 32, 34, 60
Cézanne, Paul, 57
Coolidge, Calvin, 22
Cornell University, 12
Cortissoz, Royal, 50
Craib, Marian. See Dove, Marian
Crawford, Ralston, 68 n.22
Cubism, 40, 46–47, 48, 52, 57, 69 n.23, 70 n.53, 74

Dadaism, 51, 52, 71 n.54
Davidson, Donald, 30
Davidson, Elizabeth, 30
Davidson, Jo, 15, 34 n.5
Davis, Stuart, 80

de Kooning, Willem, 70 n.41
de Lara, Aline. See Dove, Aline
Demuth, Charles, 21, 35 n.20, 49, 70 n.49, 71 n.54, 80
Dewing, Thomas, 38
de Zayas, Marius, 70 n.49, 71 n.54
Dial, The, 52
Dickinson, Preston, 68 n.22
Dorsey, Florence. See Dove, Florence
Dove, Aline, 33, 34
Dove, Anna Elizabeth, 11, 26
Dove, Arthur: begins abstract painting, 18; birth of, 11; childhood of, 11; critical reaction to, 18, 22, 40, 54; death of, 34; and death of father, 20; and death of mother, 26; and the Depression, 25; education of, 12; in Europe, 13, 38–39; illness of, 32; as illustrator, 12, 15, 19, 22, 54; influence of, 79–80; lives with Helen Torr, 20; marriage of, to Florence Dorsey, 12; marriage of, to Helen Torr, 25; meets Alfred Stieglitz, 16, 35 n.15; in Westport, 15, 19; and World War II, 33; and WPA, 29
Dove, Florence, 12, 19, 20, 24, 54
Dove, Helen. See Torr, Helen
Dove, Marian, 28, 30, 32
Dove, Paul, 11, 26, 27
Dove, Reds. See Torr, Helen
Dove, Toni, 34
Dove, William C., 15, 24, 28, 30, 32, 33, 34, 54, 82 n.23
Dove, William George, 11, 20
Dove Block, 26, 30
Dreier, Katherine, 28
Ducasse, Isidore, 71 n.66
Duchamp, Marcel, 18, 28, 49, 51

Eddy, Arthur Jerome, 39, 43–44, 67 n.6, 77, 79
Eight, The, 12
Eliot, T. S., 78

Fauvism, 39, 40, 70 n.41
Fellows, Lawrence, 18
Flint, Ralph, 30
Force, Juliana, 29
Forum Exhibition, 18, 79
Frank, Waldo, 30, 82 n.45
Furlong, Charles Wellington, 12

Gauguin, Paul, 70 n.41
Geneva, N.Y., 11, 15, 24, 26, 27, 28, 30, 31–32, 54, 55, 60
Gogh, Vincent van, 70 n.41
Gorky, Arshile, 48, 64, 70 n.41, 71 n.66, 81
Gottlieb, Adolph, 64, 81

Halesite, N.Y., 20, 22–23, 24, 32, 54
Hambidge, Jay, 77
Hare, David, 64
Harper's, 52
Hartley, Marsden, 16, 18, 21, 71 n.54, 80
Haskell, Ernest, 70 n.37
Henri, Robert, 43, 82 n.27
Hobart College, 12, 15
Hoffman, Malvina, 30
Howard, Lila, 35 n.16, 36 n.28

Impressionism, 38, 39, 40, 44
Individualism, 75–76, 79
Inness, George, 38
Intimate Gallery, The, 22, 25

Joyce, James, 71 n.62

Kandinsky, Wassily, 40–41, 43, 47, 48, 52, 68 n.14,
 70 n.41, 74, 81
Ketewomoke Yacht Club, 22–23
Klee, Paul, 64, 70 n.41
Kootz, Samuel, 35 n.6, 68 n.23
Kreymborg, Alfred, 82 n.45

Lake George, 34
Landscape, meaning of, 74, 81 n.14
Lane, Fitz Hugh, 75
Lawson, Ernest, 12
Léger, Fernand, 52
Lewis, Sinclair, 76
Lipton, Seymour, 64
Little Galleries of the Photo-Secession, 16
Little Review, The, 52
Louis, Morris, 72 n.75
Loynes, Dr. Dorothy, 33

McCausland, Elizabeth, 30
Maratta, Hardesty, 77, 82 n.24
Marin, John, 16, 18, 21, 22, 25, 30, 31, 37 n.89, 79–80
Martin, Homer, 38
Masson, André, 48, 70 n.41
Materialism, critique of, 16
Matisse, Henri, 15, 39
Maurer, Alfred, 15, 16, 18, 25, 35 n.11, 35 n.15, 39,
 80, 82 nn. 23 and 26
Mechnical imagery, 21, 48–49
Miró, Joan, 48, 70 n.41, 72 n.68
Modernism, birth of, 73–74
Mona, 20, 23, 27
Mondrian, Piet, 75
Monet, Claude, 15, 39
Moret, France, 15, 35 n.11
Motherwell, Robert, 64
Mouquin's restaurant, 12
Mumford, Lewis, 30, 82 n.45
Musical analogy, 47, 69 nn. 35 and 36

Nature imagery, 38, 53, 55–56, 62, 74–75
New Yorker, 52
Nietzsche, Friedrich, 76
Noland, Kenneth, 63
Norman, Dorothy, 25

Objective correlative, 78
O'Keeffe, Georgia, 20, 21, 22, 25, 30, 31, 33, 36 n.54,
 49, 68 n.22, 79–80

Paris, 13, 40–41

Phillips, Duncan, 25, 26–27, 28, 29, 30–31, 32, 33,
 54, 82 n.27, 198
Phillips, Marjorie, 26, 30
Photo-Secession, 16
Picabia, Francis, 18, 46, 49, 70 n.49, 71 n.54
Picasso, Pablo, 18, 41–43, 45, 48, 51, 52, 64, 68 n.15,
 70 nn. 39 and 46, 72 n.69, 81
Pollock, Jackson, 70 n.41, 72 n.77, 75
Post-impressionism, 40
Pragmatism, 75
Pratt's Island, 22–23
Precisionism, 49, 68 n.22
Public Works of Art Project, 29

Raleigh, Henry, 169
Raleigh, Holly, 169
Redon, Odilon, 67 n.3
Renoir, Pierre Auguste, 15, 35 n.12, 39, 67 n.6
Rodin, Auguste, 15
Rönnebeck, Arnold, 21, 22
Rosenfeld, Paul, 16, 20, 22, 37 n.89, 82 n.45
Ross, Cary, 30
Ross, Denman, 77
Rothko, Mark, 48, 63, 81
Ryder, Albert, 75

Schamberg, Morton, 49, 51
Schwitters, Kurt, 71 n.54
"Seven Americans" exhibition, 21, 50
Sheeler, Charles, 68 n.22
Sloan, John, 12, 34 n.6, 82 n.27
Smith, Pamela Colman, 16
Société Anonyme, 28
Spencer, Niles, 68 n.22
Stamos, Theodoros, 48, 80, 81
Steichen, Edward, 16, 18
Stein, Gertrude, 15
Stieglitz, Alfred, 12, 15–17, 19–22, 26–27, 28–33,
 35 nn. 15 and 21, 41, 46, 47, 51, 52, 54, 71 n.54,
 73–74, 76, 77, 78, 80, 82 n.31; and An American
 Place, 25; and battle for modernism, 22; death of,
 34; meets Dove, 16; and The Intimate Gallery, 22;
 and O'Keeffe, 20
Strand, Paul, 21, 22, 25, 49
Strand, Rebecca, 22, 25
Surrealism, 48, 52–53, 71 nn. 65 and 66, 81, 223, 233
Symbolism, 38, 67 n.3, 74–75, 76, 78–79
Synesthesia, 70 n.36

Taine, Hippolyte, 81 n.15
"Ten Commandments," 18, 43–49, 53, 68 n.23,
 69 n.29
Thurber Gallery, 18, 43
Tobey, Mark, 70 n.41
Tonalism, 38, 67 n.5
Toomer, Jean, 82 n.45
Torr, Helen, 20, 23, 27, 28, 30, 33, 47, 52, 54; as artist,
 26, 36 n.54; lives with Arthur Dove, 20; marriage
 of, to Arthur Dove, 25
Transcendentalism, 75
transition (magazine), 52, 71 n.62
Tryon, Dwight, 38
"291," 15, 17, 18, 39, 41, 43, 48, 69 n.23, 71 n.54;
 closing of, 19
291 (magazine), 71 n.54

Walkowitz, Abraham, 43, 82 n.34
Watercolors, 54
Weatherly, Newton, 12, 252

Weber, Max, 18, 43, 80
Weed, Clive, 20, 35 n.16
Westport, Conn., 15, 19, 20, 24, 47

Whistler, James A. M., 38
WPA, 29
Wyant, Alexander, 38

Index to Titles of Works by Arthur Dove

Italicized numbers indicate illustrations.

Abstract Composition, 312, *313*
Abstract from Threshing Engine, 188, *189*
Abstraction [14/17.1], 48, 116, *117, 118*
Abstraction [14/17.2], 47, 48, *118*
Abstraction No. 1, 18, *100*
Abstraction No. 2, 18, 40, 100–101, *101*
Abstraction No. 3, 18, 101–2, *102*
Abstraction No. 4, 18, *102*
Abstraction No. 5, 18, 102–3, *103*
Abstraction No. 6, 18, 103–4, *103*
Abstraction of a Threshing Engine No. 2, 188–89
Abstraction Threshing Engine II, 189
Abstract of a Threshing Engine Sawing Wood II, 188–89
Across the Road [No. 1], 63, 259, *261*
Across the Road, [No. 2], 62, *272*
After Images, 197, *199*
After the Storm, 127
After the Storm, Moon and Clouds, 137
After the Storm, Silver and Green (Translucent Sky), 127
After the Storm, Silver and Green (Vault Sky), 49, 127–28, *128*
Alfie's Delight, 53–54, 55, 166–67, *166*
Alfred Stieglitz (Portrait), 51, 129–30, *131*
Anchorage, 239
And Number Twenty-Two, 294
Anonymous, 283
Another Arrangement, 303, *304*
Approaching Snowstorm, 212
Arrangement in Form I, 64, *305*
Arrangement in Form II, 64, 305, *306*
Autumn, 217, *219*

Barge and Bucket, 197, *199*
Barge, Trees, Silver Ball, 177, *178, 179*
Barn Next Door, The, 56, 212–13, *213*
Barnyard Fantasy, 55, 217, *219*
Based on Leaf Forms and Spaces, 43, 104
Beach, 262
Below the Flood Gates, 179
Below the Flood Gates, Huntington Harbor, *179*

Bessie of New York, 55, 72 n.68, 198, *200*
Beyond Abstraction, 312, *314*
Blackbird, 283, *284*
Black Sun, Thursday, 200
Blue Jay Flew up in a Tree, 294, *295*
Boat Going through Inlet, 179, *180*
Boats at Night, 146
Breezy Day, 189, *190*
Brick Barge with Landscape, 179, *180, 181*
Brickyard Shed, 213, *214*
Bridge at Cagnes, 39, 97, *98*
Broom, 118
Broome County from the Black Diamond, 200, *201*
Brothers, The [No. 1], 62, 272, *273*
Brothers, The [No. 2], 283, *284*
Brown, Black and White, 115
Brown, Carmine and Blue, 160
Brown Sun and Housetop, 230
Brush Broom, 118
Building Moving past a Sky, 247
Buttonwood Tree, 217–18

Calendar of Birds and Beasts, 13
Calf, 46, 48, 69 n.23, *111*
Canandaigua Outlet, Oaks Corners, 239–40
Car, 189, *190*
Car in Garage, 218, *220*
Carnival, 218, *220*
Cars in a Sleet Storm, 247–48, *248*
Cat, 220, *221*
Centerport Series No. 28 [gouache], 63
Chair, 160, *162*
Chewing Cow, 240
Chinese Bowl, 115, *116*
Chinese Music, 49, 128–29, *129*
Churches, 121
Cinder Barge and Derrick, 189, *191*
Circles and Squares, 10, 44, *104*
City Moon, 248, *249*
Clamming, 283–84
Clay Wagon, 56, 220, *221*
Clouds, *152*

Clouds and Water, 181
Coal Car, 181–82, 181
Coal Carrier (Large), 181–82, 181
Coal Carrier (Small), 182
Color Carnival, 270
Colored Barge Man, 167
Colored Drawing, Canvas, 52, 167, 168
Colored Drawing in Oil, 167, 168
Colored Planes, 62
Colored Planes (Formation II), 285, 286
Composition, 162
Composition Brown, Blue, Violet, 182
Composition on Plaster, 143
Connecticut River, 46, 111–12, 112
Continuation, 215, 216
Continuity, 259
Corn Crib, 220–21, 222
Country Road, France, 93
Cow, 46, 48, 69 n.23, 112–13, 112
Cow I, 55, 230, 231
Cow at Play, 272, 273
Cows and Calves, 230–31, 231
Cows in Pasture, 5, 55, 56, 62, 72 n.69, 221, 222
Critic, The, 50, 137
Cross and Weathervane, 231, 232
Cross Channel, 285
Cross in the Tree, A, 221, 223
Cutting Trees in Park, 240

Dancing, 58, 213, 214
Dancing Tree, 54, 191, 192
Dancing Willows, 294, 295
Dark Abstraction, 49, 121, 122
Dawn I, 200
Dawn II, 200, 201
Dawn III, 54, 200, 202
Deep Greens, 285
Departure from Three Points, 294–95, 296
Derrick, The, 191, 192
Derrick, Harlem, 122, 123
Distraction, 167, 168, 169
Dogs Chasing Each Other, 169

East from Holbrook's Bridge, 231, 232
Eclipse of the Sun, 202, 203
Electric Orchard, 223–24, 224
Electric Peach Orchard, 223–24, 224
Evening Blue, 285

Facescape, 262
Factory Chimneys, 105
Factory Music, Silver, Yellow, Indian-Red and Blue, 129
Fantasy, 217, 219
Ferry Boat Wreck, Oyster Bay, 191, 193
Ferry Wreck, 193
Few Shapes, A, 262
Fiction, 162
Fields from Train, 193, 194
Fields of Grain as Seen from Train, 193, 194
Figure Four, 311, 312
Fire House, 182
Fire in a Sauerkraut Factory, West X, N.Y., 272, 274
Fishboat, 182, 183
Fishing Nigger, 137, 138
Flagpole, Apple Tree, and Garden, 305, 306
Flat Surfaces, 314
Flight, 296, 296
Floating Tree, 162
Flour Mill [watercolor], 59

Flour Mill I, 60, 248, 250
Flour Mill II, 60, 248–49, 250
Flour Mill Abstraction, 248–49, 250
Fog Horns, 70 n.36, 169–70 170
Foot of Lake, 249, 251
Formation I, 297
Formation II, 62, 285, 286
Formation III, 285, 286
Forms against the Sun, 146–47, 147
Freight Car, 240
From a Wasp, 115, 117
From Trees, 240, 241
Frosty Moon, 280, 282
Frozen Pool at Sunset, 208

Gale, 30, 54, 202, 203
Garden, 125
Garden, Rose, Gold, Green, 125
Gas Ball and Roof [drawing], 55
Gear, 49, 125–26, 126
George Gershwin—"Rhapsody in Blue," Part I, 52, 153
George Gershwin—"Rhapsody in Blue," Part II, 52, 153–54, 154
Goat, 55, 58, 224
Goin' Fishin', 30–31, 51, 137, 138
Going thro' Inlet, 179, 180
Gold, Green and Brown, 274, 275
Golden Storm, 53, 137–38, 138
Golden Sun, 241
Good Breeze, 189, 190
Grandmother, 76, 138–39, 139
Graphite and Blue, 60, 249–50, 251
Graphite and Blue [drawing], 60
Gray Day, 113
Gray Greens, 287
Green and Brown, 64, 312, 313
Green Ball, The, 62, 262, 263
Green, Black and Gray, 250, 252
Green, Black and White, 250, 252
Green, Gold and Brown, 62, 63, 274, 275
Green House, 213, 215
Green Landscape (Formation No. 3), 285, 286
Green Light, 262, 263

Hand Sewing Machine, 71 n.66, 154
Happy Landscape, 241, 242
Harbor, 64, 263, 264
Harbor [watercolor], 65
Harbor Docks, 202, 204
Harbor in Light, 170, 171
Hardware Store, 60, 252, 253
Hardware Store Window, 60, 252, 253
Harlem River Boats, 122, 123
Haystack, 193, 194
High Noon, 63, 305, 307
Holbrook's Bridge, 224, 225
Holbrook's Bridge [watercolor], 58
Holbrook's Bridge to Northwest, 12, 60, 252, 253
Horses in Snow, 69 n.23, 110–11, 110
Horses Plowing on a Hill, 154, 155
Hound, 213, 215
Houses and Trees, 115
Huntington Harbor, 49–50, 130, 131
Huntington Harbor—I, 147–48, 148
Huntington Harbor—II, 148, 149
Huntington Harbor No. 2, 148

Ice and Clouds, 193, 195
I'll Build a Stairway to Paradise—Gershwin, 154–55, 156

Image, 170
Improvisation, 52, 155, 157
Indian One, 297, 298
Indian Shrine, 139, 140
Indian Spring, 139, 140
Indian Summer, 274, 275
Inn, The, 64, 287
Intellectual, The, 139–40, 141
Italian Christmas Tree, 70 n.45, 193, 195
Italy Goes to War, 263, 264
It Came to Me, 64, 312, 313

Just Painting, 155

Lake Afternoon, 72 n.68, 232, 233
Land and Seascape, 274, 276
Landscape, 40, 97, 98
Landscape [No. 1], 94
Landscape [No. 2], 94
Landscape [No. 3], 94
Landscape [No. 4], 94
Landscape, Alpes-Maritimes, 94
Landscape, Cagnes [No. 1], 95
Landscape, Cagnes [No. 2], 95
Landscape, Cagnes [No. 3], 95–96
Landscape, Cagnes [No. 4], 96
Landscape, Cagnes [No. 5], 96
Landscape, Cagnes [No. 6], 96
Landscape, Cagnes, Alpes-Maritimes, 96
Landscape, Celle-sur-Seine, 96
Landscape, Geneva, N.Y., 97
Landscape in Red, Yellow and Ultramarine, 97, 99
Landscape, Moret [No. 1], 96
Landscape, Moret [No. 2[, 96
Landscape, Moret [No. 3], 96
Landscape, Moret [No. 4], 96
Landscape, Moret-sur-Loing, 96
Landscape, Naples, N.Y. [No. 1], 99
Landscape, Naples, N.Y. [No. 2], 99
Landscape, St. Mammes, 96
Lantern, 49, 126–27, 127
Lattice and Awning, 62, 276, 277
Lavoir, Gréz-sur-Loing, 96, 97
Leaf Forms, 43, 104
League of Nations, 47, 69 n.23, 118–19, 119
Leaning Silo, 241–42
Lemon in a Bedspread, 129
Life Goes On, 58, 215, 216
Little House, 115–16, 117
Little Sail Boat, 147–48, 148
Lloyd's Harbor, 276, 277
Lobster, The, 18, 39–40, 92, 93
Long Island, 140, 142, 263, 264, 265
Long Island Sound, 276, 277
Low Tide, 307, 308

Machinery, 122, 123, 124
March, April, 170, 171
Mars and Blue Hillside, 155, 157
Mars Orange and Green, 232
Mars Orange and Green [watercolor], 57
Mars Yellow, Red and Green, 297, 298
Mary Goes to Italy, 130
"Me and the Moon," 242, 243
Mill Wheel, Huntington Harbor, The, 55, 183, 184
Miss Woolworth, 132
Monkey Fur, 162
Moon, 57, 163, 232–33, 234
Moon, The, 278, 279
Moon and Sea No. I, 128, 140

Moon and Sea No. II, 128, 140–41, 142
"Moon Was Laughing at Me, The", 233, 235
Morning, 62, 265
Morning Green, 287
Morning Sun, 225, 226
Moth Dance, 170, 172
Motor Boat, 254, 255
Movement No. 1, 43, 44, 104–5, 105
Mowing Machine, 122, 123, 124
Music, 46–47, 114

Naples Yellow Morning, 56, 233–34, 235
Nature Symbolized, 18, 19
Nature Symbolized No. 1, 43, 44, 49, 104, 105–6, 106
Nature Symbolized No. 2, 43, 106–7, 107
Nature Symbolized No. 3, 43, 49, 68 n.23, 107–8, 108
Nearly White Tree, 208, 209
Neighborly Attempt at Murder, 278, 279
Nigger Goes A Fishing, A, 137, 138
1941, 280, 282
1944, 311
No Feather Pillow, 265, 266
Northport Harbor, 204
No Title—I, 163
No Title—II, 163
No. 4 Creek, 50
Number 1, 47, 119, 120
Number Twenty-Two, And, 294

October, 56, 225, 226
Oil Drums, 183, 184, 188
Oil Tanker, 204
Old Boat Works, 245, 255
"Old Miss Moray Looks Around Astonished" [drawing], 14
Orange Grove in California—Irving Berlin, 52, 155–56, 158
Other Side, The, 62, 307, 308
Our House, 265, 266
Outboard Motor, 156, 158
Out the Window, 259, 260
Out the Window [watercolor], 62

Pagan Philosophy, 47, 69 n.23, 69 n.33, 114, 115
Painted Forms, Friends, 51, 141, 143
Painted Forms, Sacreligion, 141
Painting in Tempera, 307, 309
Painting Only, 204, 205
Parabola, 63, 287, 288
Park, The, 52, 158, 159
Partly Cloudy, 62, 288, 289
Pen and Razor Blade, 143, 144
Penetration, 49, 132, 133
Pheasants, 172
Pieces of Red, Green and Blue, 63, 309, 310
Pine Tree, 195
Pink One, 297, 299
Plant Forms, 43–44, 108–9, 109
Plaster and Cork, 51, 141, 143
Ploygons and Textures, 309
Pont Croix, Finistère, 96
Poplar Tree, 113–14, 113
Portrait, Italian, 96
Portrait of Alfred Stieglitz, 130, 13
Power House, 204–5, 205
Power House I, 196
Power Plant I, 255
Power Plant II, 255, 256

Pozzuoli Red, 62, 63, 278, 279
Primaries, 265, 267
Primitive Music, 63, 309, 311

Quawk Bird, 288, 289

Rain, 312–33, 134
Rain or Snow, 299, 300
Ralph Dusenberry, 133, 135, 134
Reaching, 299–300
Reaching Waves, 53, 172–73, 172
Reasonable Facsimile, A, 288, 290
Rectangles, 300
Red Barge, 196
Red Barge, Reflections, 55, 196
Red Horse Climbing Hill, 154, 155
Red Light R 25A, 288–89, 290
Red, Olive and Yellow, 63, 280, 281
Reds, 149
Red Sun, 56, 57, 225–26, 227
Red Tree and Sun, 173
Red, White and Green, 62, 267, 268
Red, Yellow and Green, 234, 236
Reflections [No. 1], 185, 186
Reflections [No. 2], 226
Reminiscence, 56, 57, 198, 242, 243
Rhapsody in Blue, Part I—Gershwin, 153
Rhapsody in Blue, Part II—Gershwin, 153–54, 154
Rhythm Rag, 160
Rise of the Full Moon, 56, 242, 243
Rising Moon, 62, 267, 268
Rising Tide, 62, 63, 300
River Bottom, Silver, Ochre, Carmine, Green, 129, 130
Roofs, 43, 104, 105–6, 106
Rooftops, 63, 301
Rope, Chiffon and Iron, 149, 150
Rose and Locust Stump, 62, 301, 302
Route 25A, 280, 281
R. 25A, 280, 288–89, 290
Ruggedness, 119
Runnings Dogs, 169
Running River, 158, 160
Runway, 314, 315

Sail Boat, 147–48, 148
Sails, 43, 109–10, 110
Sails at Night, 146
Sand and Sea, 301, 302
Sand Barge, 55, 183, 185
Sanding Machine, 196
Scenery, 205, 206
Sea I, 144, 150
Sea II, 144, 145
Sea and Sand, 301, 302
Sea Drawing Water, A, 144, 150
Sea Gull, 208, 209
Sea Gull Motif, 151–52, 152
Seagull Motif, 163, 163–64
Sea Gulls, 255, 256, 257
Seaside, The, 150, 151
Sea Thunder, 151–52, 152
Seneca Lake, 257
Sentimental Music, 47, 69 n.23, 114–15, 115
Shapes, 267, 269
Shore Front, 257
Shore Road, 283
Silver and Blue, 174
Silver Ball, 173
Silver Ball No. 2, 185, 186, 188

Silver Cedar Stump, 51, 173
Silver Chief, 289, 291
Silver Log, 164
Silver Storm, 145
Silver Sun, 174
Silver Tanks, 185
Silver Tanks and Moon, 55, 185, 187
Slaughter House, 236, 237
Snow and Water, 164
Snow, Huntington Harbor, 164
Snow on Ice, Huntington Harbor, 186, 187
Snowstorm, 55, 226, 227
Snowstorm on Ocean, 164
Snow Thaw, 54–55, 186, 187
Something in Brown, Carmine and Blue, 53, 160
Sowing Wheat, 215–16
Spiral Road, 267
Spotted Yellow, 301, 303
Spring, 303
"Spring" [illustration], 13
Square on the Pond, 63, 291
Starry Heavens, 135
Steam Shovel, Port Washington, 196–97, 197
Steeple and Trees, 43
Still Life [1908/09], 96, 99
Still Life [1912/14], 115, 116
Still Life Against Flowered Wallpaper, 96, 99
Storm at Sea, No. 1, 150
Storm at Sea, No. 2, 150
Storm at Sea, No. 3, 150
Storm at Sea, No. 4, 150–51
Storm at Sea, No. 5, 151
Storm, Blue and Brown (Ice and Sea-Gull Motive), 145
Storm Clouds, 236
Storm-Clouds in Gold, 138
Storm-Clouds in Silver, 145
Stove Pipe, 120, 121
Structure, 292
Study in Still Life, 115, 116
Stuyvesant Square, 38, 67 n.3, 92, 93
Summer, 57, 226–27, 228
Summer Orchard, 243–44, 244
Sun, 303
Sun and Moon, 205
Sun and the Lake, 257–58
Sunday, 205–7, 206
Sun Drawing Water, 208, 210
Sun on the Lake, 258
Sun on the Water, 53, 174, 175
Sunrise, 228, 135–36, 136
Sunrise I, 57, 60, 236, 237
Sunrise II, 57, 60, 236, 238
Sunrise III, 57, 60, 238
Sunrise IV, 57, 60, 244, 245
Sunrise at Northport [No. 1], 174
Sunrise at Northport [No. 2], 174, 175, 176
Sunrise in Northport Harbor, 53, 174, 175, 176
Sunrise, Seneca Lake, 216
Sunset [No. 1], 55, 186, 188
Sunset [No. 2], 228, 229
Swamp, 228
Swing, 258
Swinging in the Park, 188
Swing Music, 62
Swing Music (Louis Armstrong), 258

Tanks, 258
Tanks and Snowbank, 124, 210, 211
Tar Barrels, Huntington Harbor, 183, 188

Team of Horses, 43, 110, 110–11
Telegraph Pole, 53, 176
Ten-Cent Store, 136
Terre Verte, Golden Ochre, 49, 124
That Pink One, 299
That Red One, 63, 309, 311
Through a Frosty Moon, 62, 280, 282
Thunder Shower, 269
Thunderstorm, 124–25, 125
Town Scraper, 210
Train, The, 216, 217
Train Coming Round the Bend, 238, 239
Train Coming Around the Fence, 238, 239
Traveling, 292, 293
Tree, 216
Tree and Covered Boat, 210, 211
Tree Branch, 176
Tree Composition, 57, 244, 245
Tree Forms [No. 1], 53, 165
Tree Forms [No. 2], 216–17, 218
Tree Forms [No. 3], 228, 229, 230
Tree Forms II, 228, 229, 230
Tree Forms and Water, 53, 165, 166
Tree Trunk, 176
Trees, 151
Tug Boat, 160, 161
Two Brown Trees, 210, 212
Two Forms, 197, 198

U.S., 270
U.S.A., 303, 304
Untitled [c. 1920], 121–22
Untitled [1925], 141, 143
Untitled [1929], 176, 177
Untitled [watercolor], 61
Uprights, Mars Violet and Blue, 64, 315, 317
Up the Alley, 258–59, 259

Variety, 316, 317
Violet and Green, 52, 163, 163–64

Walk: Poplars, A, 46, 113, 113–14
Wasp, 115, 117
Waterfall, 53, 145–46, 146
Water Swirl, Canandaigua Outlet, 244, 246
Wave, The, 151–52, 152
Wednesday, Snow, 207
Westport, 120, 121
Wet Sunset, 212
What Harbor, 259, 261
Whew, 176–77, 178
White Channel, 285
White Tank, 188
Whow!, 176–77, 178
Willows, 270, 271
Willow Sisters, 239, 240
Willow Tree, 56, 57, 246
Wind [No. 1], 177
Wind [No. 2], 207
Wind [No. 3], 230
Wind and Clouds, 181
Wind on a Hillside, 43, 106–7, 107
Wind, Waves, Clouds, 181
Windy Morning, 239
Woodland Pond [watercolor], 56
Woodpecker, 280, 281
Wood Pile, 259, 260
Woods, 197, 121, 122

Yachting, 46, 114
Yellow, Blue and Violet, 165–66
Yellow, Blue Green and Brown, 274, 275
Yellow Bush, 270, 271
Yellow Form, 292, 293
Young Old Master, 316, 317
Yours Truly, 52, 160, 161

.04%, 64, 292, 294